1001 PHOTOGRAPHS
YOU MUST SEE IN YOUR LIFETIME

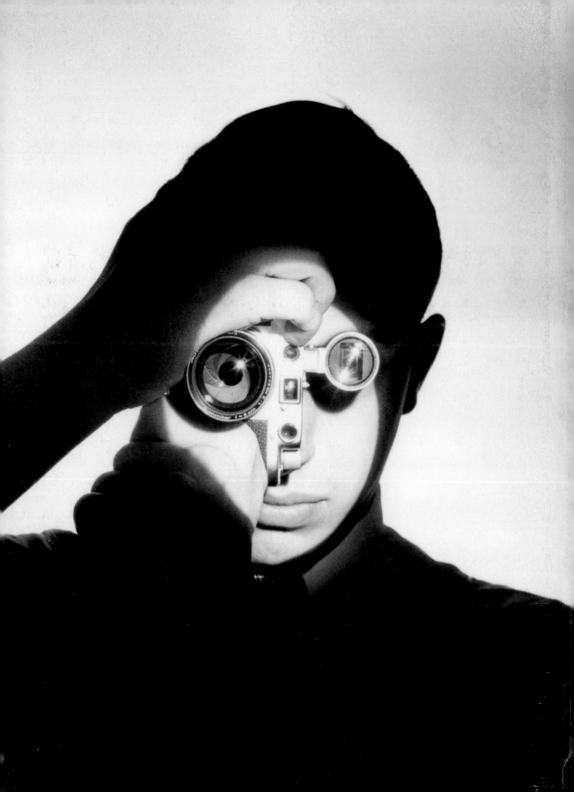

1001 PHOTOGRAPHS
YOU MUST SEE IN YOUR LIFETIME

GENERAL EDITOR PAUL LOWE

FOREWORD BY FRED RITCHIN

The Photojournalist (1951) by Andreas Feininger.

UNIVERSE

A Quintessence Book

First published in the United States of America in 2017 by
UNIVERSE PUBLISHING
A Division of Rizzoli International Publications, Inc.
300 Park Avenue South
New York, NY 10010
www.rizzoliusa.com

2017 2018 2019 2020 / 10 9 8 7 6 5 4 3 2 1

ISBN: 978-0-7893-2768-0
QSS.KPHO

Library of Congress Control Number: 2017933042

This book was designed and produced by
Quintessence Editions Ltd.
6 Blundell Street
London N7 9BH

Senior Editor	Elspeth Beidas
Editors	Rebecca Gee, Carol King, Fiona Plowman, Frank Ritter
Designer	Damian Jaques
Picture Researcher	Jo Walton, Emma Brown
Production Manager	Anna Pauletti
Editorial Director	Ruth Patrick
Publisher	Philip Cooper

Color reproduction in Hong Kong
Printed in China

FSC
www.fsc.org
MIX
Paper from
responsible sources
FSC® C018479

Contents

FOREWORD

BY FRED RITCHIN

Since its invention in the early nineteenth century, photography has played a pivotal role in society, capable of recording appearances quickly and with extraordinary exactitude. Although essentially an interpretive medium, this ability of the photograph to serve as a visual "trace," to appear to constrain the subjectivity of the observer through a combination of mechanical and chemical processes, has given photography an aura of popular credibility that has made it both an essential contemporary witness and historical record.

Whereas one might not always immediately attribute such authority to other media, such as painting or even writing, photography has long benefited from a widespread sense that the "camera never lies," providing a wealth of detail that made each image "worth a thousand words." As a result photography has served as a way of attempting to certify experience, so that the evidence of the photograph is generally favored over the vagaries of human memory. The photograph is viewed as explicitly arguing that something happened, when in fact the specificity of the argument often relies upon the caption accompanying the photograph rather than by any intrinsic judgment within the image itself.

Photography has also been used as a way to ritualize events, so that a wedding or graduation is judged as almost not to have happened without a photograph memorializing the occasion. In its permanence it has been seen as a way of transcending the limitations of existence, according a certain level of immortality to those depicted within its frame. And it has been thought of as a universal language, even though people from different cultures and different time periods read photographs differently.

Some of the most well-known photographers have been quite articulate about the capabilities of the photograph, and modest as well. The French photographer Henri Cartier-Bresson, expressed his theory of the "decisive moment" in his extraordinary 1952 book of the same name: "To me, photography is the simultaneous recognition, in a fraction of a second, of the significance of an event as well as of a precise organization of forms which give that event its proper expression." But he also prefaced the book with a powerful disclaimer: "These photographs taken at random by a wandering camera do not in any way attempt to give a general picture of any of the countries in which that camera has been at large."

Rather than the temporal, his colleague Robert Capa suggested that "If your pictures aren't good enough, you aren't close enough," arguing for both spatial and emotional proximity. Emphasizing the complexity of the photographic process, this statement would later be contested by Tod Papageorge's declaration that "If your pictures aren't good enough, you don't read enough." And then, of course, there is Garry Winogrand's assertion that "I photograph to see what things look like when they are photographed."

Critics, too, have both marveled at photography's capacities and been highly critical of its distorting processes. French philosopher Roland Barthes's observation in his 1980 book *Camera Lucida* enthusiastically argues for photography's direct line through history: "One day, quite some time ago, I happened on a photograph of Napoleon's youngest brother, Jerome, taken in 1852. And I realized then, with an amazement I have not been able to lessen since: 'I am looking at eyes that looked at the Emperor.'" Susan Sontag's perspective three years earlier was more critical: "Through photographs, the world becomes a series of unrelated, free-standing particles; and history, past and present, a set of anecdotes and faits divers," she wrote in her 1977 book *On Photography*. "The camera makes reality atomic, manageable, and opaque. It is a view of the world which denies interconnectedness, continuity, but which confers on each moment the character of a mystery."

In today's era of the digital, what we think of as photography has changed. Whereas extraordinary photographs continue to be made by professionals trained in its use, both documentarians and artists, now billions of amateurs equipped with smartphones and digital cameras are making enormous numbers of both photographs and videos. This extraordinary amount of imagery, much of it widely available online, is in turn dwarfed by the number of photographs made by machines, whose code is to be read primarily by other machines, particularly for purposes of identification and surveillance.

Digital photographs, made of pixels and based upon code rather than film, highly malleable and easy to modify with software, can be almost immediately published and distributed globally. Their overwhelming abundance and comparative ephemerality on the screen encourages a questioning of the qualities of certitude and permanence previously attributed to photography, as they deliver innumerable, often decontextualized perspectives regarding events both big and small. These digital images provide both an immense opportunity to understand the permutations of human behavior and the planet upon which we live, as well as an immense obfuscation of what in fact might be going on.

This volume's idiosyncratic, wide-ranging selection of 1,001 photographs, many of them well-chosen surprises juxtaposed in stimulating ways, provides a new opportunity to try and make sense of who we are and where we have come from. Given today's torrents of raw, unfiltered imagery, this considerable array of contextualized photographs represents for the reader both an enormous challenge and, at the same time, a welcome relief. Essentially, this is a book about what photographs can, and cannot, do, the gratification we derive from looking at them, and, most importantly, the world in which we live.

INTRODUCTION

BY PAUL LOWE

In its relatively short history, photography has arguably become the predominant medium through which we represent the world around us. It is hard to imagine a world without the photographic image, so ubiquitous has it become as a form of communication, documentation, and personal and artistic expression. Today, more photographs are taken every two minutes than in the whole of the nineteenth century. The explosion of digital capture has exponentially increased the role the photograph plays in documenting every detail of our lives. In 2000, when digital technologies were only just beginning to become widespread, Kodak announced that consumers around the world had taken 80 billion photos that year, setting an all-time record. In 2017, it is estimated that collectively the world will take over 1.3 trillion photographs, mostly on cell phones, and this exponential growth is expected to continue. We now photograph everything, every moment of our lives and the world around us. Photography has become the means through which we most strongly remember the past—and represent the present—forming the foundation of not only our collective social memory, but also our personal memories too.

Given this vast number of images in circulation—estimated to be over 4 trillion at the time of writing—choosing the selection of 1,001 photographs to represent the medium was therefore as much a question about what to leave out as what to include. The photographs chosen for this book are in no way intended to be a definitive list of the world's greatest images—such a task would be impossible, even with a much larger sample than 1,001. Instead, the intention was to give a broad historical sweep that explores photography's technological and aesthetic development, surveys the main genres of the form, and gives a sense of the global reach of the medium. We wanted not just to showcase the work of the great photographers of the canon and map the evolution of the medium, but also to mark significant historical events, major social trends, key scientific innovations and insights, and uncover unique and unusual images that demonstrate how photography has pervaded human activity. Many of the "greats" of photography are included, of course, and the book provides a starting point from which to explore their work in more detail. But equally there are many anonymous images, and arresting and powerful photographs by lesser-known photographers. One of the joys of producing the book was in discovering these hidden gems, mining photographic archives in search of the unique and the unusual.

The book is also in some ways a meditation on the medium itself, and how the still photograph has been used for a vast range of purposes. A starting point was to categorize the images loosely into genres such as news, photojournalism, documentary, portrait, landscape, fashion, scientific, and so on. We wanted to reflect how the camera is a tool

that can be used on the one hand for purely objective recording of scientific fact, and on the other for the deepest and most personal form of artistic expression. The ubiquity of the photographic image reflects the universality of the purposes for which it has been used. Photographs can show us events that happened long ago or far away; they can allow us to see details invisible to the human eye, or freeze motion to make the unseen seen. Photographers have explored the full range of ways in which the camera can be used to describe, document, interpret, explain, and represent the world, in a continuous, ongoing process of testing the limits of the medium to see what it can be pushed to do. This process has been driven by technology, as new inventions changed and expanded the ability of the photographic process to record, and as photographers exploited these new abilities in ways often unforeseen by their inventors. The fundamental process of translating the three-dimensional depth of the world around us into a two-dimensional, flat representation of it is, of course, an abstraction. But it is extraordinary how that same two-dimensional object can appear to have three dimensions, to have visual depth and breadth, and to appear like a window into the real. As Henri Cartier-Bresson famously noted, the best photographs involve lining up the hand, the head, and the eye to create images that stimulate us aesthetically, emotionally, and intellectually at the same time.

It is perhaps hard to better William Fox Talbot's assertion on the nature of the medium when he wrote in 1839 that the "most transitory of things, a shadow, the proverbial emblem of all that is fleeting and momentary, may be fettered by the spells of our 'natural magic' and may be fixed forever in the position which it seemed only destined for a single instant to occupy." Photographs capture a moment in time and in space, condensing and concentrating experiences into artifacts. They preserve within the frame the ghostly traces of the past as well as the knowledge that that past is no longer there, and therefore serve to preserve our sense of history and memory. As such, they form an important part of remembering, fluctuating between past and present, connecting moments in time. This is not necessarily a "stilling" of time, but rather a concentration of experience into an image that suggests time interrupted, retaining the sense of a time before the image and a time after it. As soon as the shutter closes, that moment of representation is forever in the past, yet still preserved in the present and into the future. The paradox is that although the still image is a single, discrete temporal event, it has the ability to transcend time; by playing on the imagination of the viewer, it can project backward and forward through time. The image retains within the frame a self-contained story, a sense of occurrences before the photograph and possibilities afterward.

One of the key traits of the photographer is to pay attention to things that would otherwise go unseen. Finding that composition, moment, or detail that others have not noticed, and then framing it so as to draw attention to it, is fundamental to the craft of photography. Often central to the photograph's power is its ability to render everything in front of the lens, to describe to excess the minute detail of the scene. Often this gives the viewer the opportunity to see things that cannot be seen in any other way, either because the moment is too fleeting, the detail too small, or the hidden structures of the scene too complex to be revealed except in the still image. The material qualities of the photograph and its unique nature as a form of representation allow it to tap into a range of emotional, psychological, and imaginative realms, bringing attention to things often left unnoticed by other media and other observers. As the radio extends human powers of hearing and the internal combustion engine those of movement, the photographic process amplifies our ability to see things that would otherwise remain unobserved. The camera acts as a kind of visual prosthesis, extending our ability to see in both spatial and temporal realms, allowing representations of the world to be recorded, stored, transmitted, distributed, archived, and interpreted long after the image has been made.

The sense that the lens of the camera is objective sustains the belief that the thing it produces, the photograph, should have some truth value. Optically speaking, there is a direct linear linkage from the ray of light radiating from the surface of the object, though the lens, to the sensitized surface of the film or digital chip. As such, despite all the variability and uncertainty that can interfere with the production of a photograph, the tenuous thread between the world and the image remains unbroken, even if it is often stretched to breaking point. Although the fixed surface of the image appears to be a faithful record of what was before the lens, it is far from an objectively neutral one; it is highly selective, fragmentary, momentary, and subjective. For an image created explicitly by human agency, the myriad of variables of the technology, combined with the multitude of possibilities of what is included and what is excluded from the frame by the photographer, means that any photograph is only one possible variation on an infinite number of images that could be generated from any given encounter. The meaning of a photograph to any particular viewer is therefore difficult to predict. Photographs contain material content that is in some sense factual, but they also carry the potential to engage with the viewer in a nonverbal way. This dichotomy between the content of the image and how that content makes the viewer think and feel is at the core of understanding how photographs operate as social actors.

This sense of the duality of photographs as operating both within the descriptive and the imaginative realms is central to their nature, and central to the way that photography often seeks to engender an empathetic engagement with the real world. The photograph can therefore become an imaginatively performative space: in the performance of taking the image, the choreography of photographer, subject, and environment; in terms of the production and dissemination of images in an variety of formats; and in terms of the invitation to the viewer to engage in a performative reading of the imaginative meaning of the image. This is a complex process of continuous feedback between the image itself, its formal and descriptive resonance, its distribution through the media, and its reception by an audience. The photograph therefore allows for a myriad of readings and interpretations on a variety of levels depending on the viewer's associations.

Photographs are essentially fragments of existence. The viewpoint of a photograph is partial, its framing selective, and it represents only a brief fraction of time. Yet in its indexicality, its umbilical link to the thing in front of the camera at the moment of exposure, in its economy of description, and in its emotional charge, it generates a visceral connection to the real. Photographs allow us to connect to their subjects on an emotional level, as the viewer generally responds to flesh and blood more directly than to theoretical concepts. This sense that photographs render the private space public operates in reverse too; the photograph as a discrete object is often viewed in private, compressing the spatial distance between the viewer and the event, bringing the distant into the domestic spaces of the audience.

Products of technology, mediated by human action, photographs are tangible, material objects (whether physically as a print or virtually on a computer screen). They can, therefore, in some ways be described as having a life of their own, independent of their author. Many of the iconic images in this volume have transcended the person who took them, becoming almost independent agents out in the world. Significant events are made visible by the operation of the frame, miniaturizing history into a tangible object that can be intimately viewed at close range. This forms a chain of linkages between the subject, the media, and the viewer, establishing a relationship of interaction between the different parties. After their first appearance as rallying points for public awareness of an issue, iconic images become part of the process of establishing the moment as a historical one, with a process of sifting and editing out some images in preference to others. Over time, these iconic images come to act as markers of collective memory, so familiar to us that as such they can determine how and what society chooses to remember.

INDEX BY TITLE

VIEW FROM THE WINDOW AT LE GRAS

JOSEPH NICÉPHORE NIÉPCE

Date 1826
Location Saint-Loup-de-Varennes, France
Format Bitumen-coated pewter plate

Joseph Nicéphore Niépce (1765–1833) tried to find a way to capture the images he saw in the camera obscura, an optical device of the time used by artists to produce detailed drawings.

He experimented with light-sensitive silver salts, but he was unable to fix the images they created, and so moved his research to bitumen of Judea, a naturally occurring asphalt with light-sensitive properties. By coating a metal plate with bitumen dissolved in a solvent, Niépce found that he could create a lasting image, a process he dubbed "heliography."

This image showing the courtyard outside his house was taken using this method and is thought to be the earliest surviving photograph. The exposure took around eight hours, and the image is indistinct, and Niépce continued to refine his method. In 1829 he began to collaborate with Louis Daguerre but died four years later, so Daguerre ended up receiving much of the credit for Niépce's work. LB

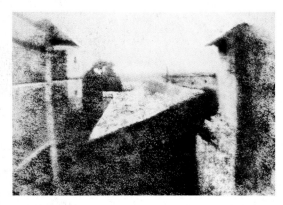

THE LATTICED WINDOW

WILLIAM HENRY FOX TALBOT

Date 1835
Location Lacock Abbey, UK
Format Photogenic drawing negative

In 1833 English gentleman and amateur scientist William Henry Fox Talbot (1800–77) began experimenting with sheets of paper that he made light sensitive by coating them with silver salts. He succeeded in making what he called "photogenic drawings"—silhouette images of objects such as leaves or lace, produced by direct contact printing. Talbot also tried, unsuccessfully, to capture images by placing his sensitized paper in a camera obscura.

In the summer of 1835, Talbot tried again. He had a number of small wooden boxes constructed for him, which he fitted with lenses taken from the eyepieces of telescopes and microscopes. He inserted pieces of sensitized paper in these boxes, placed them around his ancestral family home, Lacock Abbey in Wiltshire, and waited for the sun to work its "little bit of magic." Talbot's wife, Constance, called these little boxes "mousetraps," and on reflection they do indeed resemble simple Victorian mousetraps, designed in this case to capture the sun rather than unwanted vermin.

With his "mousetrap" cameras, Talbot reduced the exposure times needed to produce an image to as little as ten minutes on a bright day. Talbot described the resulting images, no bigger than postage stamps, as being like the work of Lilliputian artists. In August 1835, using one of these little cameras, Talbot took the world's earliest surviving photographic negative. The subject is a latticed window at Lacock Abbey. He wrote of the image at the time: "When first made, the squares of glass about 200 in number could be counted, with help of a lens." Photography's potential for capturing detail was on its way to realization. CH

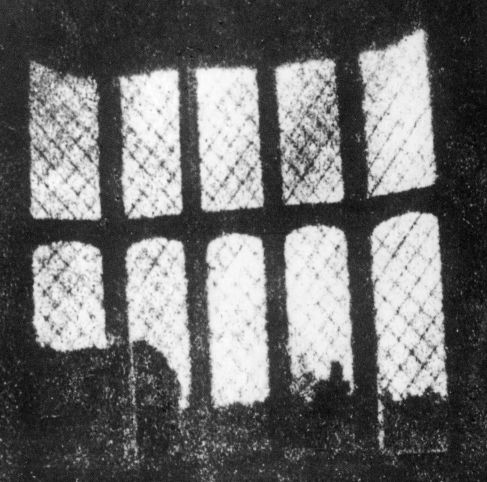

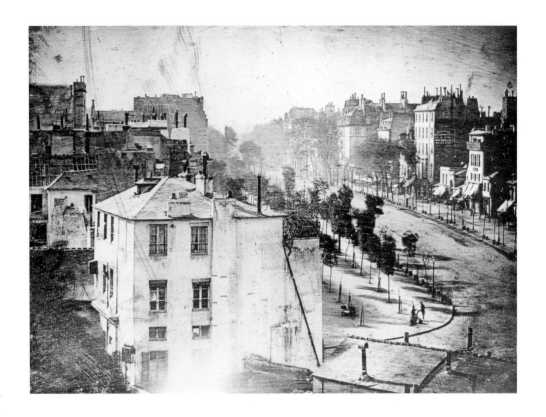

BOULEVARD DU TEMPLE OR PARIS BOULEVARD

LOUIS DAGUERRE

Date 1838 or 1839
Location Paris, France
Format Daguerreotype

Taken at eight o'clock in the morning, this image by Louis Daguerre (1787–1851) of a central Parisian boulevard appears eerily empty. This is due to the properties of the early photographic method used to create it. The daguerreotype required between seven and fifteen minutes' exposure time. Moving figures on this normally bustling street are thus invisible; only the figures of a shoeshiner and his client appear on the sidewalk in the lower left of the frame. They are believed to be the first humans ever photographed. Although the image is badly scratched, many of its features remain remarkably clear.

Starting in 1829, Daguerre worked with Joseph Nicéphore Niépce to create a process to capture moving images. Niépce died in 1833, but Daguerre succeeded in 1834, using a process that involved passing mercury vapor over a light-sensitive silver iodide solution on a copper plate. The result was a unique and remarkably sharp mirrored image. Daguerre published his findings in 1835 and made a deal with the French government for the rights to the process, securing lifetime pensions for himself and Niépce's son. In 1839, France gifted the daguerreotype process to the world. CP

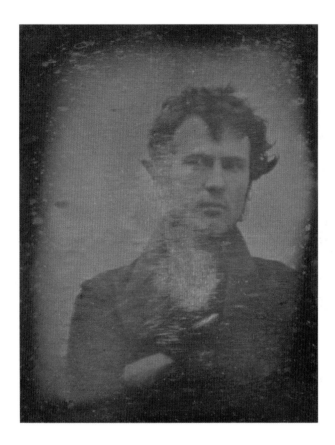

ROBERT CORNELIUS, SELF-PORTRAIT

ROBERT CORNELIUS

Date 1839
Location Philadelphia, USA
Format Daguerreotype

This image is a photographic equivalent of an archaeological finding. Robert Cornelius (1809–93) was an American of Dutch descent. In 1831 he began to work for his father, specializing in silver plating and metal polishing. He became so well renowned for his work that shortly after he was asked to create silver plates for daguerreotypes.

Cornelius, developing an interest in photography himself, worked on perfecting the notoriously time-consuming and unreliable process. Sometime in 1839 he made this self-portrait; it is the oldest known existing portrait of a human in America, and may well be considered an archetype of today's selfie. He stares back at us across more than 170 years, yet his gaze is as compelling as the moment he faced the camera.

Photography was embraced as a replacement for painted portraits, quickly becoming fashionable among the wealthy. Cornelius went on to open two of the earliest photography studios in America, between 1841 and 1843, but ironically he gave up the profession shortly after, perhaps because of increased competition, or because he realized that he could make more money in the family's profitable gas and lighting company. ZG

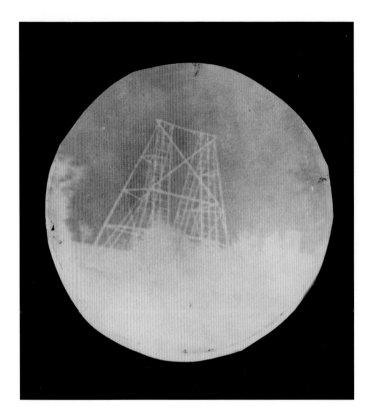

PHOTOGRAPH OF THE FRAME OF WILLIAM HERSCHEL'S 40-FOOT (12M) TELESCOPE TAKEN BY HIS SON, JOHN

JOHN HERSCHEL

Date 1839
Location Slough, UK
Format Glass plate

Sir John Herschel (1792–1871) is better known for his contributions to science than for his work on photography. The son of astronomer William Herschel, John acquired his own reputation as Britain's leading astronomer, and was awarded the Copley Medal by the Royal Astronomical Society in 1821. His research and publications were influential across a broad swathe of the sciences and reportedly inspired the young Charles Darwin to search for a unified answer to the origins of life.

Herschel used detailed drawings to record his observations, but he was intensely aware of the shortcomings of this method and sought a way to capture the exact image he saw in his telescopes. He experimented with light-sensitive chemistry, helping to develop new photographic techniques and improve existing ones like the cyanotype.

Herschel took this image of his father's telescope shortly before the rotting structure was dismantled. This was the first glass negative of its kind, and glass would remain the primary medium for photography until well into the twentieth century. In the same year Herschel also coined the word "photography" by combining the Greek words for light and writing. LB

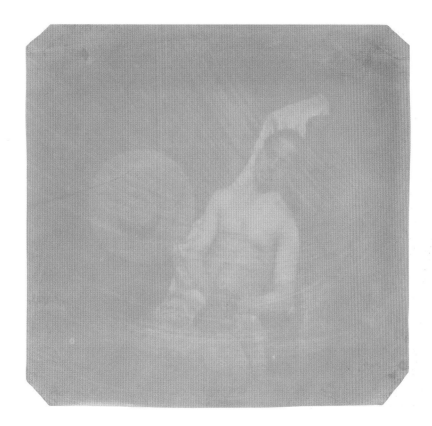

SELF-PORTRAIT AS A DROWNED MAN

HIPPOLYTE BAYARD

Date 1840
Location Paris, France
Format Direct positive

Self-portrait as a Drowned Man, or *Le Noyé*, by Hippolyte Bayard (1801–87) is among the earliest photographic images in existence. It purports to show its creator's suicide. To ensure his intention was understood, Bayard wrote on the back of the print:

"The corpse you see here is that of M. Bayard, inventor of the process that has just been shown to you. As far as I know this indefatigable experimenter has been occupied for about three years with his discovery. The Government, which has been only too generous to M. Daguerre, has said it can do nothing for M. Bayard, and the poor wretch has drowned himself. Oh the vagaries of human life …!"

Bayard was raging against his nation's lack of recognition of his pivotal role in the birth of photography. His compatriot Louis Daguerre was widely fêted, and the process he created will forever bear his name. However, Bayard's early experiments with direct positive printing were also valuable, and in 1839 he created what is believed to have been the first public photo exhibition.

Bayard's response to this perceived injustice was at once funny—he did not drown—and challenging in the way it addressed the inherent difficulty of using photographs as evidence. MH

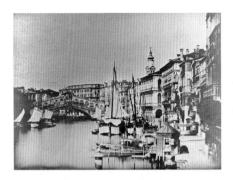

THE RIALTO BRIDGE, VENICE

ALEXANDER JOHN ELLIS

Date 1841
Location Venice, Italy
Format Daguerreotype

In 1841, Alexander John Ellis (1814–90) was making the Grand Tour of Europe, a traditional adventure for young English gentlemen of the period. He knew of Daguerre's discovery of a practical photographic process, and planned to produce a series of engravings to be published as a book provisionally titled *Italy Daguerreotyped*, which would offer "that verisimilitude which is required by the traveler to all who wish to know what the buildings of Italy really are."

Ellis entered Italy in May 1841 and eventually reached Venice in July. During this time he made more than 100 daguerreotypes, meticulously recording the date, location, subject, and exposure time of each image. Exposure times were measured in minutes rather than seconds, and every successful, sharply focused result amounted to a significant achievement.

This photograph was taken from an upstairs window in the White Lion Inn between 3:29 and 3:42 p.m.—an exposure of thirteen minutes. Venice appears strangely quiet. The long exposure meant that any moving objects, such as people or boats, were not recorded.

Ellis's book was never published, but his daguerreotypes are the earliest photos of Italy. CH

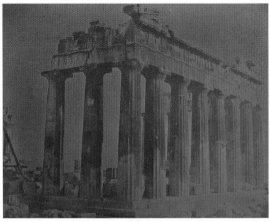

THE ATHENIAN TEMPLE OF OLYMPIAN ZEUS

JOSEPH-PHILIBERT GIRAULT DE PRANGEY

Date 1842
Location Paris, France
Format Daguerreotype

The beautiful images of daguerreotype pioneer Girault de Prangey (1804–92) were unknown until the 1920s, when they were discovered by the purchaser of his derelict former home. It was another eighty years before they came to public attention when, at a London auction in 2003, Sheikh Saud Al-Thani of Qatar purchased this image for a then world-record price for any photograph of £565,250 ($922,488). The whole collection sold for a total of £3,798,126 ($6.2 million).

Girault de Prangey trained as a painter, but began experimenting with daguerreotypes in 1841. In the following year, he began a three-year expedition to Italy, Greece, Egypt, Turkey, Syria, and Palestine. He carried hundreds of pounds of photography equipment and created more than 800 daguerreotypes. On his return, he published a limited edition of lithographs, but did not exhibit the daguerreotypes on which they were based. PL

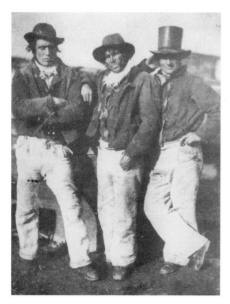

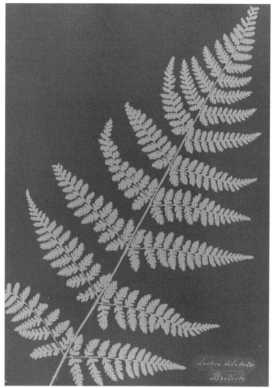

ALEXANDER RUTHERFORD, WILLIAM RAMSAY, AND JOHN LISTON

DAVID OCTAVIUS HILL AND ROBERT ADAMSON

Date 1843–47
Location Newhaven, Scotland
Format Calotype

In 1843, engineer Robert Adamson (1821–48) and painter David Octavius Hill (1802–70) opened the first photography studio in Scotland. Their collaboration produced 3,000 photographs taken over a period of four years. Adamson provided the technical know-how and handled the camera and the chemical processes needed to make the calotype prints; Hill was responsible for the compositions and he also controlled the lighting. The pair photographed the great and the good of Scotland and documented the daily lives of the working classes, especially the fishermen of Newhaven, as seen in this striking portrait that is arguably the first independent documentary photography project. PL

CYSTOSEIRA GRANULATA

ANNA ATKINS

Date 1843
Location UK
Format Cyanotype

Anna Atkins (1799–1871) was the first person to bring together science, photography, and publishing. The daughter of a distinguished chemist and zoologist, she began a photographic record of British algae in 1843. Atkins used the cyanotype process, in which a sheet of paper coated with a solution of iron salts was exposed to sunlight in direct contact with a negative or, as here, a flat specimen. After exposure, the paper was washed in water, from which came the oxygen that produced the vivid blue (cyan) image that gives the process its name. CH

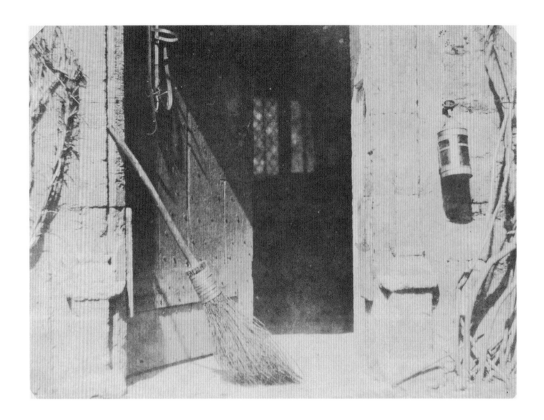

THE OPEN DOOR

WILLIAM HENRY FOX TALBOT

Date 1844
Location Lacock Abbey, UK
Format Calotype

The Pencil of Nature, produced in six installments between 1844 and 1846 by William Henry Fox Talbot (1800–77), was the first commercial book to be illustrated with photographs—twenty-four calotype prints, each accompanied by explanatory text. The work was introduced with an account of the process by which Talbot had discovered the new medium of photography.

The carefully composed study reproduced above was presented as the sixth plate in the folio, with Talbot acknowledging it as influenced by genre painting. He wrote: "We have sufficient authority in the Dutch school of art, for taking as subjects of representation scenes of daily and familiar occurrence. A painter's eye will often be arrested where ordinary people see nothing remarkable. A casual gleam of sunshine, or a shadow thrown across his path, a time-withered oak, or a moss-covered stone may awaken a train of thoughts and feelings, and picturesque imaginings."

Talbot here showed how even such a mundane subject as a door can be transformed by the camera into a formal study of light and shade, of exterior and interior, and of texture and form. PL

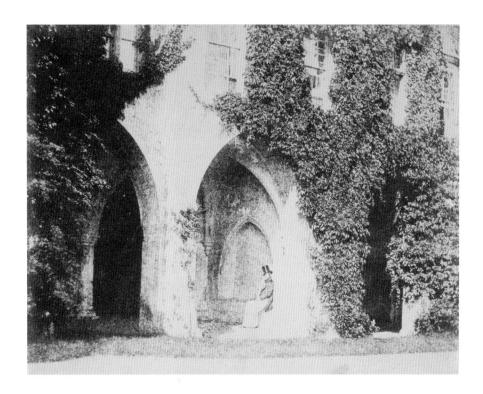

THE ANCIENT VESTRY: CALVERT JONES IN
THE CLOISTERS AT LACOCK ABBEY

WILLIAM HENRY FOX TALBOT

Date 1845
Location Lacock Abbey, UK
Format Salt print

William Henry Fox Talbot (1800–77) made many of his most important photographs at his family home, the beautiful Lacock Abbey in Wiltshire, large parts of which date from the twelfth century. Talbot was a true polymath, who published books and scholarly articles on a variety of subjects including mathematics, astronomy, chemistry, optics, botany, and philosophy. Laycock Abbey was the focal point of his experimentations with photography, and served as a place where he could meet with his wide range of friends to explore the potential of the new medium.

One of these friends was the Reverend Calvert Jones, who became a noted photographer in his own right. In 1845, Jones and Talbot traveled to York, Bristol, and parts of Devon, as well as spending time together at Lacock Abbey, where this image was made. Talbot made skillful use of the light in this scene, positioning Jones in his top hat in a patch of sunlight and framing him within one of the arches of the medieval cloisters.

Lacock Abbey is now owned by the National Trust of England and Wales and is preserved as a site of pilgrimage to one of the founding fathers of photography. PL

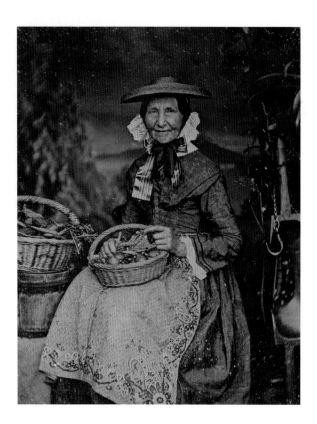

MOTHER ALBERS, THE FAMILY VEGETABLE WOMAN

CARL FERDINAND STELZNER

Date c. 1845
Location Germany
Format Daguerreotype

Carl Ferdinand Stelzner (1805–94) began his career as a painter in Germany, traveling around the country to paint portraits and studies and eventually opening his own studio in Hamburg. He was excited to hear about the discovery of photography, and in 1839 he traveled to Paris to learn the technique from Louis Daguerre, the inventor of the daguerreotype process. He continued to make daguerreotypes until 1854, when he began to use paper. He worked in photography until his death in Hamburg in 1894.

In this image, Stelzner has posed a woman he calls "Mother Albers" in a kind of constructed environmental portrait; the studio setting is designed to convey her work as a vegetable seller. She is seated on a stool in front of a painted landscape backdrop, holding a basket of vegetables—with more nearby—and her expression is benign compared to the blank neutrality of many early daguerreotype portraits. Stelzner's experience as a portrait painter informs his composition of the image of Mother Albers; the composition is neat and balanced, with elements arranged to suggest her role in society, while her clothes and expression convey a sympathetic sense of the woman herself. AZ

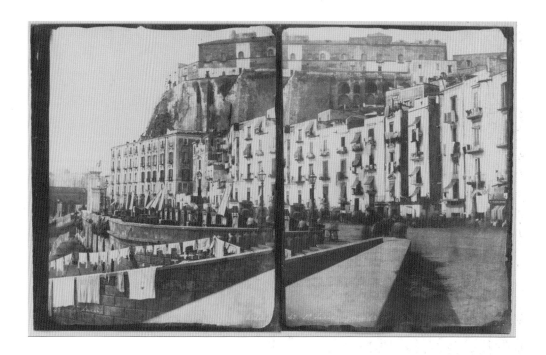

SANTA LUCIA, NAPLES

REVEREND CALVERT JONES

Date 1845–46
Location Naples, Italy
Format Salt print

The Reverend Calvert Jones (1804–77) applied the skills he had acquired as a watercolorist and draftsman to the emerging art of photography. Initially using daguerreotype, he then began to use calotype, a process demonstrated to him by his friend William Henry Fox Talbot.

Jones's subject matter as a painter was largely street scenes, marine views, and shipping studies, and he carried these interests into his photography. In 1841, he met Hippolyte Bayard, the French inventor of direct positive prints on paper, whom he in turn introduced to Talbot, bringing together two pioneers of photography.

From the negatives of photographs Jones took on his trips to Europe, Talbot made and sold a series of prints. Jones had a fine eye for composition and experimented with the novel technique of making two exposures of a scene, moving the camera fractionally for each one, in order to give a wider field of view than was possible with the fixed lenses of the time. This was technically challenging, but his success was evident in creating two photographs that work perfectly individually, and also together form a more complex arrangement. PL

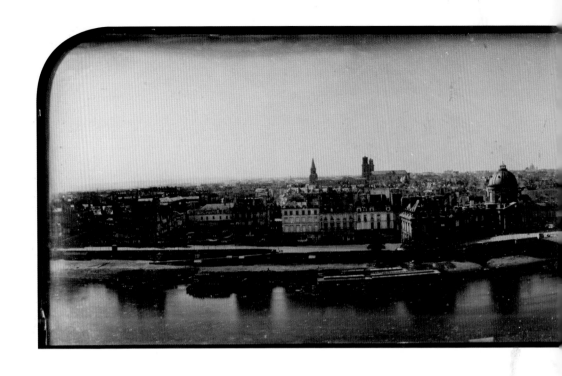

LA SEINE, LA RIVE GAUCHE, ET L'ÎLE DE LA CITÉ

FRÉDÉRIC MARTENS

Date 1846
Location Paris, France
Format Panoramic

Frédéric Martens (1809–75)—born in Venice but resident for most of his life in France—was one of the early pioneers of panoramic photography, inventing arguably the first camera capable of taking an image with a field of view wider than the human eye could apprehend without moving the head. Called the Megaskop camera, this instrument featured the vital innovation of a hand-cranked set of gears that ensured a smooth movement of the lens across the set of fourteen curved daguerreotype plates that were necessary to cover the 150-degree field of view. The camera also had the clever feature of an aperture behind the lens that narrowed toward the top, to prevent the sky being overexposed in comparison with the ground below.

The Megaskop camera was made by the company of opticians and printmakers run by Marc Secrétan and Noël Marie Paymal Lerebours, who also produced albums of engravings based on Martens's photographs.

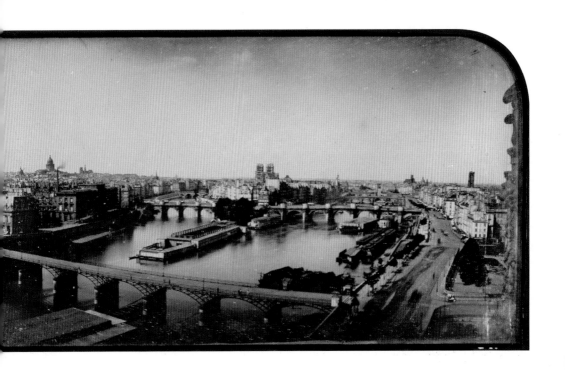

Martens traveled extensively across Europe, documenting cities such as his native Venice, as well as Trieste, Frankfurt, and Rouen. Martens displayed his panoramas at the Great Exhibition in London in 1851, where he was awarded a medal for his images, which were described in the citation as having a "richness, effect and perfection of definition" that made them "the finest specimens it seems possible to produce."

The image above shows conclusively that the judges knew what they were talking about. It is a stunning panorama of the center of Paris, 15.75 inches (40cm) long, in which the detail of the medieval layout of the city is still visible. It marks a significant turning point in the history of the French capital: two years later, after the trauma of the Revolutions of 1848, the government of the Emperor Napoléon III (Louis Napoléon) undertook extensive reconstruction, specifically to fill the city with broad plazas and wide avenues to make it easier for the authorities to quell further civic unrest. Thus this view is not only a magnificent artistic and technical achievement in its own right; it is also a valuable historical document that provides evidence of an urban layout that has now largely vanished. PL

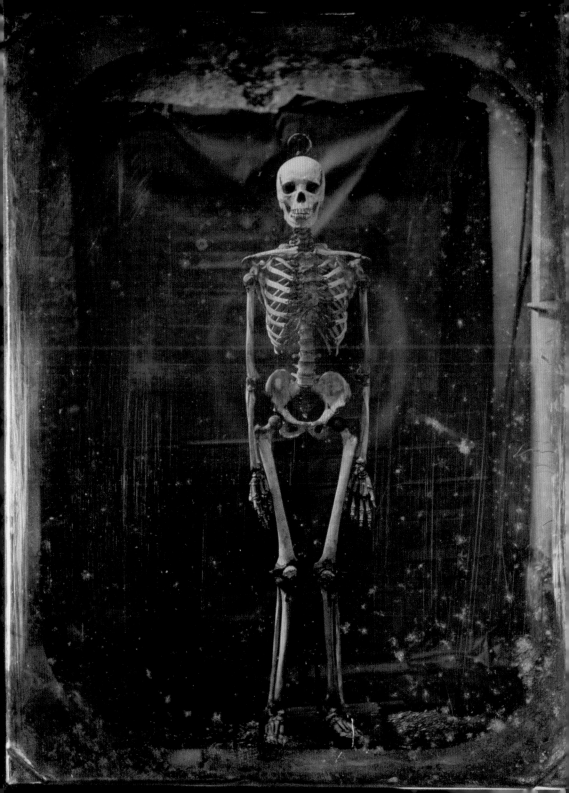

SKELETON OF A NEGRO

HENRI JACQUART AND ÉMILE DERAMOND

Date 1847
Location Paris, France
Format Daguerreotype

Sometimes known as "the mirror with a memory," the daguerreotype—invented in the late 1830s in Paris by Louis Daguerre—revolutionized the emerging photographic medium. Since it was not a process that could capture movement, it stimulated a drive toward formal portraiture of both the living and the dead. Funerary portraits—sometimes of bodies in caskets, but at other times depicting the recently deceased propped up in chairs or in other quotidian poses—rapidly became widespread. The new technique was also utilized for pseudoscientific studies conducted by self-styled "ethnographers" who were attempting to map human evolution to prove what they saw as distinctions between races.

The photograph reproduced here, taken by Henri Jacquart (1809–73) and the young Émile Deramond (1828–?), is a product of these times. The two Frenchmen worked together to create several "daguerreotypes of racial types sometimes using human casts." This is one of the earliest-known photographs of a skeleton, although there is no certainty about whether the image is an original or a copy. The skeleton hangs by its neck. The photograph is now housed in the Musée de l'Homme (Museum of Mankind) in Paris.

The idea that people's abilities and characters can be extrapolated from their bone structures fueled notions of ethnic superiority. However, it was not universally credited at the time and has since been thoroughly debunked. This image, however, remains an important document in the early history of photography. SY

LOUIS DODIER AS A PRISONER, 1847

LOUIS ADOLPHE HUMBERT DE MOLARD

Date 1847
Location Paris, France
Format Daguerreotype

Baron Louis Adolphe Humbert de Molard (1800–74) was typical of the wealthy amateurs who could afford to explore the new medium of photography. He began with daguerreotypes in 1843, and in the mid-1850s he became one of the first French photographers to use calotype. He was a keen experimenter and innovator in the chemical processes required by the various techniques, and in 1854 he was a cofounder of the Société Française de Photographie. He specialized in carefully composed and staged genre scenes, influenced by the pictorial tradition and determined in part by the long exposure times necessary for the early photographic technologies. He frequently evoked peasant and rural life, using his friends, family, and servants as models. This striking image is of his steward, Louis Dodier. De Molard made several versions of this image, exploring how different poses and expressions changed the subject. PL

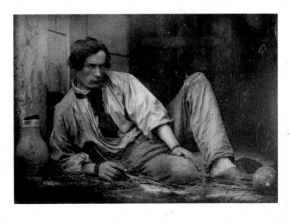

THE 1848 REVOLUTION

THIBAULT

Date 1848
Location Paris, France
Format Daguerreotype

This image, by a daring photographer known only as Thibault, was one of the first ever photographs to be published in a newspaper. Thibault broke the curfew set by the authorities and clambered onto a rooftop above the Rue Saint-Maur-Popincourt to show the aftermath of an attack on the revolutionaries by General Christophe Lamoricière's troops. The image was printed in the weekly newspaper *L'Illustration, Journal Universel* alongside another photo of the same location before the attack.

That Thibault was unable to show the military action itself was due partly to the curfew but mainly to the fact that early equipment needed exposure times too long to capture the events as they unfolded. But an imagined horror can sometimes play more powerfully on the mind than the real thing, and the thought of what might have caused this level of destruction does indeed give sobering pause for thought. PL

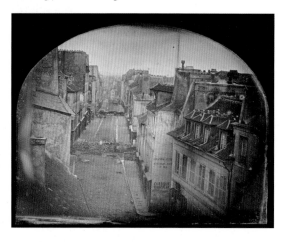

ALBERT SANDS SOUTHWORTH

ALBERT SANDS SOUTHWORTH

Date 1848
Location Boston, Massachusetts, USA
Format Daguerreotype

With Josiah Johnson Hawes, Albert Sands Southworth (1811–94) ran one of the most successful early photography studios in the United States—the Boston-based Southworth & Hawes. They photographed the city's rich and famous, as well as the burgeoning middle classes, maintaining in their advertisements that "[A] likeness for an intimate acquaintance or one's own family should be marked by that amiability and cheerfulness, so appropriate to the social circle and the home fireside. Those for the public, of official dignitaries and celebrated characters admit of more firmness, sternness and soberness."

Hawes and Southworth worked almost entirely in daguerreotypes, using the 8½x6½-inch (21.6x15.2cm) whole-plate format that gave their images fine detail and a brilliant, mirrorlike surface. In *The Photographic and Fine Art Journal* of August 1855, critic Marcus A. Root remarked that "[T]heir style, indeed, is peculiar to themselves; presenting beautiful effects of light and shade, and giving depth and roundness together with a wonderful softness or mellowness."

The partnership's studio was situated on the top floor of a Boston building, with vast skylights to allow in the huge amounts of light necessary for the relatively "short" exposures of portraits of their subjects.

The striking image here hints at nudity, a rare feature of early photography. Although probably a self-portrait by Southworth, Hawes may have made the actual exposure, as he developed this technique of vignetting the corners of the image to highlight the central subject. PL

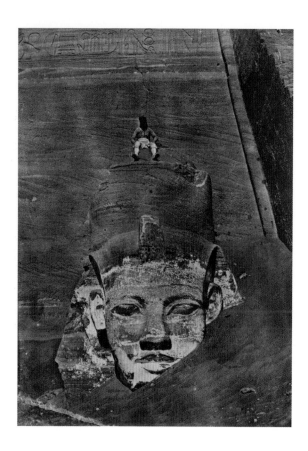

ABU SIMBEL. WESTERNMOST COLOSSUS OF THE GREAT TEMPLE

MAXIME DU CAMP

Date 1850

Location Abu Simbel, Egypt

Format Salt print

In 1849, Maxime Du Camp (1822–94) was commissioned by the French government, to photograph ancient monuments in Egypt. A journalist with no knowledge of photography, Du Camp took lessons from Gustave Le Gray. By the time he arrived at Abu Simbel in March 1850, Du Camp was a confident and proficient, if not inspired, photographer.

Du Camp was accompanied by novelist Gustave Flaubert. After an initial stay in Cairo, the two men hired a boat to take them up the Nile River as far as the second cataract, after which they descended the river at leisure, exploring archaeological sites along its banks. For this study of part of the colossal rock-cut temples built by Ramesses II, Du Camp arranged for the face of the statue to be dug out from the sand and instructed one of his assistants to sit on top of the statue to give a sense of scale. Flaubert was unimpressed, remarking: "The Egyptian temples bore me profoundly."

In 1852, Du Camp published a limited-edition book of 200 copies, illustrated with 125 pasted-in salt prints; this was the first photographic record of the ancient monuments of the Middle East. **CH**

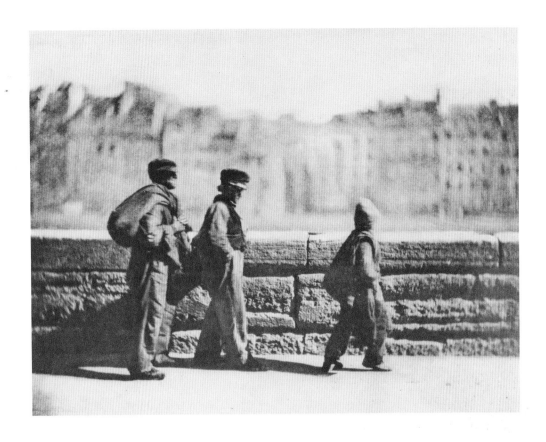

CHIMNEY SWEEPS WALKING

CHARLES NÈGRE

Date 1851
Location Paris, France
Format Salt print

Charles Nègre (1820–80) was a painter who studied under Paul Delaroche and participated regularly in the Salon des Beaux-Arts exhibitions in Paris in the 1840s and 1850s. Delaroche encouraged the use of photography in research for painting, and in 1844 Nègre took up his suggestion with enthusiasm, roaming the streets of Paris to capture scenes of daily life.

The image shown here may look like a spontaneous photograph, but long exposure times meant that capturing movement was impossible, even on a bright sunny day such as this, as evidenced by the strong shadows. In reality, Nègre carefully posed the sweeps to simulate the appearance of motion. The boy at the front has bent his knee to imitate the action of walking. To shorten the exposure as much as possible, Nègre used a lens with a very wide aperture, creating a shallow depth of field, and blurring the background buildings.

Unlike numerous painters who turned to photography and never looked back, Nègre continued painting throughout his life, and indeed *Chimney Sweeps Walking* may have been a staged study for a projected work in oils. CH

VACUUM SUGAR APPARATUS

CLAUDE-MARIE FERRIER

Date 1851
Location London, UK
Format Salt print

The Great Exhibition of the Works of Industry of All Nations, held in London's Hyde Park in 1851, was a celebration of British national pride and industrial progress. As examples of scientific and technological progress, more than 700 photographs were shown alongside a bewildering selection of objects from all over the world. Photographs also played an important role in documenting the exhibition. Before the Great Exhibition opened, it was agreed that a special publication would be created for presentation to foreign governments and others who were involved in the organization of the event, as a record and a token of appreciation. Only 140 presentation sets of this work, requiring more than 20,000 individually processed and then trimmed photographs, were to be produced.

Two men were commissioned to take the photographs: Frenchman Claude-Marie Ferrier (1811–89) and Englishman Hugh Owen. This photograph by Ferrier shows a vacuum apparatus used in the manufacture of sugar, manufactured by Heckmann of Prussia. Adopting an objective aesthetic, both men relied on the physicality of the exhibits themselves to create striking images. Here, the result is sculptural and enigmatic. CH

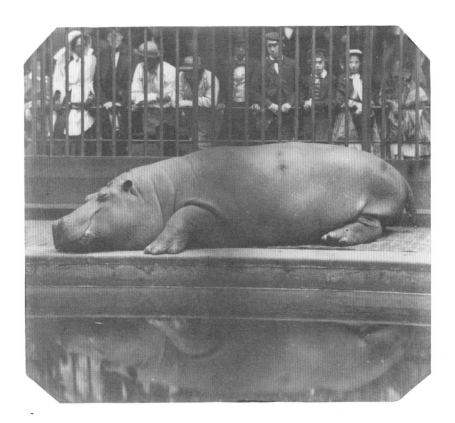

THE HIPPOPOTAMUS AT THE ZOOLOGICAL GARDENS, REGENT'S PARK

JUAN DE BORBÓN, COUNT DE MONTIZÓN

Date 1852
Location London, UK
Format Salt print

Don Juan Carlos María Isidro de Borbón, Count of Montizón (1788–1855), was the nephew of King Fernando VII of Spain and pretender to the Spanish throne. Raised in Spain, he spent most of his life in exile in Britain following his father's violent challenge to the succession of Fernando's daughter Isabel II in 1833. His passions were physics, chemistry, and natural history; in photography he found a pursuit that combined all three interests.

In 1852, Don Juan photographed dozens of animals at the Zoological Gardens in London's Regent's Park, including a camel, a giraffe, a pelican, and this hippopotamus. He later chose this photograph as his contribution to *The Photographic Album for the Year 1855*. The text accompanying it reads: "This animal was captured in August 1849, when quite young, on the banks of the White Nile; and was sent over to England by the Pasha of Egypt as a present to Queen Victoria. He arrived at Southampton on May 25, 1850; and on the evening of the same day was safely housed in the apartment prepared for him at the Zoological Gardens, where he has ever since been an object of great attraction." CH

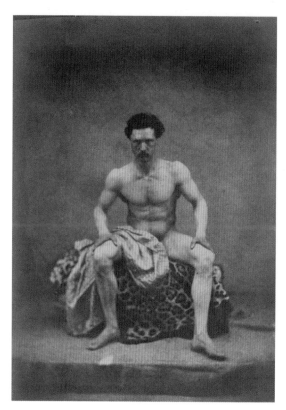

NUDE MALE SEATED WITH LEGS SPREAD

EUGÈNE DURIEU

Date 1852
Location Paris, France
Format Glass plate

Originally a lawyer, Jean Louis Marie Eugène Durieu (1800–74) was a member of the Commission des Monuments Historiques, a French government agency that created the *Mission Héliographique*, which hired notable photographers—including Charles Marville, Gustave Le Gray, and Henri Le Secq—to document historic architecture in France.

Perhaps inspired by this experience, Durieu took early retirement, bought a camera, and coauthored with his friend, the artist Eugène Delacroix, an extensive series of nude studies that are among the earliest explorations of the human form in the history of photography. Delacroix had immediately realized the potential value of the camera for the artist, writing that photographs are "an intermediary charged with initiating us more deeply into the secrets of nature . . . a copy, in some ways false by dint of being exact."

The work of Delacroix and Durieu was a true collaboration, with the former selecting the models and directing the poses and the latter making the exposures. Delacroix then drew upon the studies for inspiration in his paintings. Ironically, while Delacroix saw the key attribute of the photograph as the accurate transcription of reality, Durieu knew that it was also an interpretation of the subject and an expression of the photographer's vision and intent. He wrote that the photographer must previsualize the final image in order to produce "a picture, not just a copy." Durieu soon became president of the Société Française de Photographie, which included among its members Hippolyte Bayard, Alexandre-Edmond Becquerel, and Jean-Baptiste Louis Gros. **PL**

"[W]e begin to see the lost strangeness of the Delacroix-Durieu calotypes."
Alexi Worth

THE LADDER

HENRI-VICTOR REGNAULT

Date 1852
Location Sèvres, France
Format Salt print

Henri-Victor Regnault (1810–78) is one of the most significant figures in early French photography. A founding member of the Société Héliographique in 1851, he was also the founding president of the Société Française de Photographie in 1854. Regnault occupies an important—indeed unique—position in that his interests spanned the diverse but overlapped fields of science, industry, photography, and art. He was one of the first in France to use William Henry Fox Talbot's paper negative, or calotype, process. In 1843, Regnault met Talbot when the latter visited Paris.

A distinguished chemist, professor of physics, and member of the French Académie des Sciences, in 1852 Regnault was appointed director of the Sèvres porcelain factory, where he established a photography department. Regnault also had a keen artistic sensibility. In his time off from official duties, he took a series of photographs in the grounds of the Sèvres factory. *The Ladder* was taken in a quiet corner of the works, between the stables and the porter's lodge. A carefully arranged collection of rustic objects creates a picturesque composition. The scene is divided vertically into two balanced halves of light and shadow. The varied textures of the objects and the rough plaster wall are echoed in the surface texture of the paper on which the photograph is printed. Furthermore, it is surely more than just coincidental that the photograph's motif of a still life of rustic objects is very like the painted scenes on some of the finest eighteenth-century Sèvres porcelain—pieces with which Regnault would naturally have been intimately familiar. CH

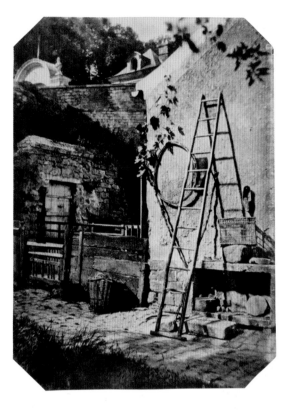

"The personification of the genius of precision."

Posthumous tribute to Regnault by French chemist Marcellin Berthelot

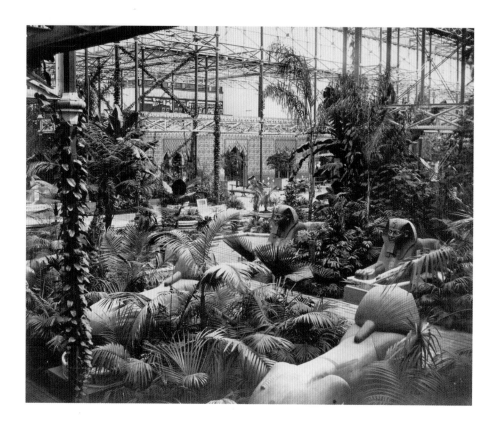

THE UPPER GALLERY, CRYSTAL PALACE, SYDENHAM

P. H. DELAMOTTE

Date 1853
Location London, UK
Format Albumen print

Philip Henry Delamotte (1821–89) followed in the footsteps of his father, the artist William Alfred Delamotte, and eventually became professor of drawing and perspective at King's College, London. He took up photography in the late 1840s, and his book, *The Practice of Photography: A Manual for Students and Amateurs*, published in 1853, was one of the earliest practical works on the subject.

After the closure of the 1851 Great Exhibition, Joseph Paxton's innovative Crystal Palace in Hyde Park, which had housed it, was dismantled and moved to Sydenham in South London. Photography, itself a product of a technical age, was chosen to capture the rebuilding of this physical manifestation of progress and industrialization. Delamotte was commissioned to record the relocation of the building, from laying the foundations to the opening ceremony. The resulting photographic record is widely recognized as his finest work. In 1855 more than 100 of Delamotte's photographs were published in book form as *Photographic Views of the Progress of the Crystal Palace, Sydenham*. Opened by Queen Victoria in 1854, the Crystal Palace survived until 1936, when it was destroyed by fire. **CH**

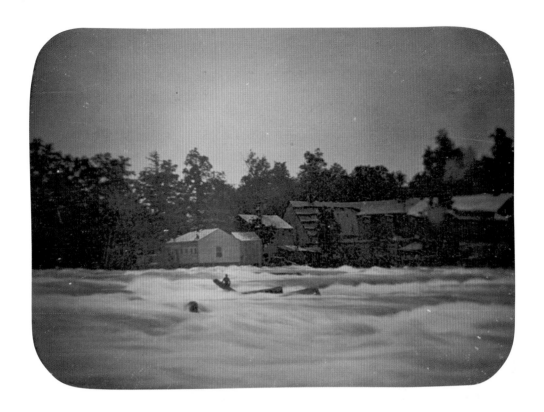

JOSEPH AVERY STRANDED ON ROCKS IN THE NIAGARA RIVER

PLATT D. BABBITT

Date 1853
Location Niagara, New York, USA
Format Daguerreotype

Platt D. Babbitt (1823–79) was by no means the first person to photograph Niagara Falls, but he was the first resident photographer, enjoying a monopoly of daguerreotyping the American side of the falls. He set up his camera on a permanent tripod, and photographed tourists viewing the Horseshoe Falls from Prospect Point. He went to great lengths to protect his monopoly. One visitor recalled that every time he removed the lens cap on his own camera, Babbitt leaped in front of him with a large umbrella.

Babbitt was the first souvenir photographer. He was also an accomplished landscape photographer and, by chance, the creator of the first news photograph. Joseph Avery was boating in the Niagara River with two friends when, overwhelmed by the strong current, their boat hit a rock and overturned. Avery's friends were swept over the falls. Avery, however, managed to cling on to a log that had jammed between two rocks. Witnessing Avery from the shore, Babbitt set up his camera and photographed the unfortunate man fighting for his life. With help unable to reach him, Avery managed to survive for eighteen hours before finally succumbing to the power of the river and being carried over the brink to his death. CH

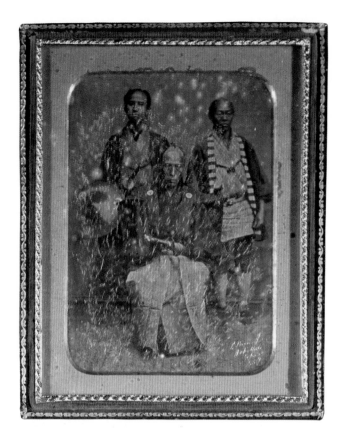

YENDO MATAZAIMON AND HIS ATTENDANTS

ELIPHALET M. BROWN

Date 1854
Location Shimoda, Japan
Format Daguerreotype

Eliphalet M. Brown (1816–86) took some of the earliest recorded images of Japan. He was the official photographer for the historic American mission, led by Commodore Matthew C. Perry, to the newly opened ports of Japan. The expedition visited Japan twice over the course of two years, in 1853 and 1854, and Brown is recorded as having taken some 400 daguerreotypes, from which only a handful have survived. However, the photographs appeared in a series of lithographs published in

1856 as the *Narrative of the Expedition of an American Squadron to the China Seas and Japan.*

This imposing study is of the governor of Hakodate, Yendo Matazaimon, accompanied by Ishuka Konzo and Kudo Mogoro, identified as "two of the principal personages of his suite." In total, Brown's images form a charming yet informative study of the traditions of Japanese life and include a wide range of subjects, including landscapes, urban scenes, and portraits of kimono-clad ladies and senior Japanese politicians and leaders.

The expedition saw the successful signing of the Convention of Kanagawa on March 31, 1854, opening up the ports of Shimoda and Hakodate to American shipping. PL

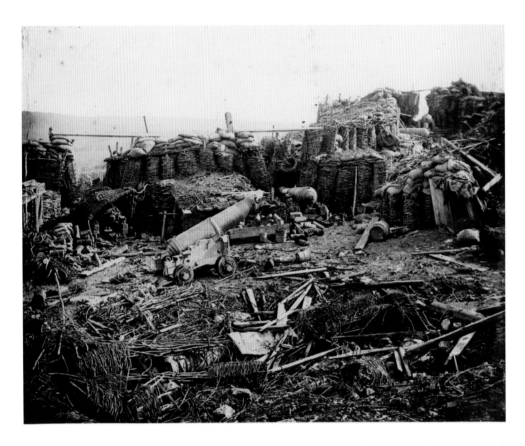

INTERIOR OF THE REDAN

JAMES ROBERTSON

Date 1855
Location Sevastopol, Crimea, Ukraine
Format Salt print

The photographer most commonly associated with the Crimean War (1854–56) is Roger Fenton. However, Fenton was not the only photographer to record the conflict. Suffering from cholera, Fenton returned to Britain in June 1855, leaving another Briton, James Robertson (1813–88), to photograph the war's final stages.

At the beginning of September 1855, British and French troops launched an assault on the Redan, a Russian fortification defending Sevastopol.

Following a three-day bombardment and fierce fighting, the Russians withdrew. Two days later, when Captain Godman of the British 5th Dragoon Guards visited the abandoned fort, he witnessed a scene of death and devastation: "There was not a place an inch large that was not ploughed up by our shot and shell . . . pieces of human flesh of every shape and size were scattered about; it was absolutely torn to pieces, and one mass of rubbish and confusion impossible to describe."

The human remains had been removed by the time Robertson arrived, but his photograph is still a powerful evocation of the horror and futility of war and a far more graphic depiction than the carefully posed tableaux photographed by Fenton. **CH**

VALLEY OF THE SHADOW OF DEATH

ROGER FENTON

Date 1855
Location Crimea, Ukraine
Format Wet collodion negative

This haunting and desolate landscape, named for Psalm 23 in the Bible, is perhaps best described in the words of its creator, Roger Fenton (1819–69): "…in coming to a ravine called the valley of death the sight passed all imagination—round shot & shell lay in a stream at the bottom of the hollow all the way down; you could not walk without treading upon them." Even had he wished to, Fenton would not have been adequately able to capture one of the many deadly cannon assaults that British troops faced here in action. Fenton used a large-format wet collodion glass plate camera with exposure times of up to twenty seconds. This limited his coverage of the Crimean War (1854–56) to static tableaux showing the camp life of soldiers, portraits of them, and battle landscapes, such as this one. Fenton's success in documenting the war, the first systematic photographic representation of armed conflict in history, is remarkable in itself, given that he had to carry a mobile darkroom in a converted wine merchant's wagon, which was often a target for Turkish artillery.

Although the technology did not yet exist for photographs to be reproduced directly in newspapers, Fenton's images were used as models for woodcuts that were printed in *The Illustrated London News*, allowing the British public its first chance to see war from a distance. While this image suggests many of the horrors that soldiers faced, Fenton avoided creating photographs of death and injury even when it was possible to do so. He was concerned, like the British government, about stirring further public outcry against this already unpopular war. CP

PATIENT, SURREY COUNTY LUNATIC ASYLUM

HUGH WELCH DIAMOND

Date 1855
Location Surrey, UK
Format Salt print

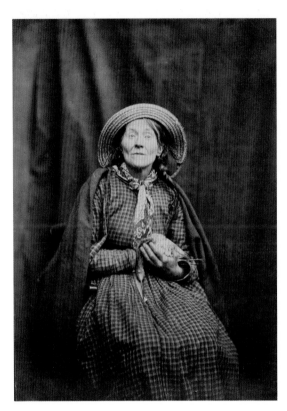

Hugh Welch Diamond (1809–86) was one of the most important figures in early British photography. He photographed landscapes and still lifes, but he is now remembered primarily for his remarkable portraits of people with mental health problems.

In the 1840s, Diamond studied psychiatry at the Bethlem Hospital in the City of London. In 1848, he was appointed superintendent of the female department at the Surrey County Lunatic Asylum, where he began to photograph his patients. Arranged in simple poses against a plain background, the images are poignant echoes of the conventional studio portraits of the time.

Diamond's works were reproduced in medical journals and also shown in photographic exhibitions where they received mixed reviews. They were neither art nor science, so many people were unsure how to respond to them.

In 1858, Diamond opened a private asylum in Twickenham. He seems to have stopped taking portraits of his patients at this time. What was acceptable in a public institution for the poor may have been viewed by the families of his well-off, private patients as a violation of privacy.

As a doctor and a photographer, Diamond embodied the new humanitarianism and the belief in scientific observation that typified the Victorian age. Through his portraits he sought to reveal a connection between his patients' disturbed minds and their physical appearances, feeling that "[t]he [p]hotographer needs in many cases, no aid from any language of his own but prefers rather to listen, with the picture before him, to the silent but telling language of nature." CH

"The dawn of a new day . . . [T]he faithful register of the camera . . . will now render . . . an actual science."

The Cornhill Magazine, 1861

FANTAISIES

HENRI LE SECQ

Date 1856
Location Paris, France
Format Waxed-paper negative

Born in Paris, Henri Le Secq (1818–82) studied painting under Paul Delaroche and was taught photography by Gustave Le Gray. Le Secq favored the waxed-paper negative process, which he continued to use even when most of his contemporaries had begun to use glass negatives.

In 1851 he became a founding member of the Société Héliographique, the world's first photographic society. He was also a member of the Missions Héliographiques, a group of photographers who were commissioned by the French government to record the nation's architectural heritage. Le Secq took hundreds of photographs of ancient monuments, buildings, and churches, earning recognition as one of France's finest architectural photographers. One critic remarked that he thought that it was more informative to look at Le Secq's photographs than to study the actual buildings.

In 1856, in a radical departure from his usual subject matter, Le Secq made a series of still-life studies, photographing various arrangements of objects, fruits, and vegetables. This new activity was possibly informed by his early training as an artist in Delaroche's studio. Le Secq made the photograph shown here as the frontispiece for a portfolio of his still lifes. While clearly a still life, it may also be interpreted as a form of portraiture— part self-portrait and part portrait of his beloved France. A bottle of French wine labeled *Fantaisies* ("Fantasies") and two filled wineglasses stand invitingly beside a camera lens. Yet for the last two decades of his life, Le Secq returned to painting, exhibiting regularly at the Salon in Paris. **CH**

"Le Secq's camera captured details not easily visible to the casual observer; his work is an outstanding example of the realist trend in nineteenth-century photography." lineature.com

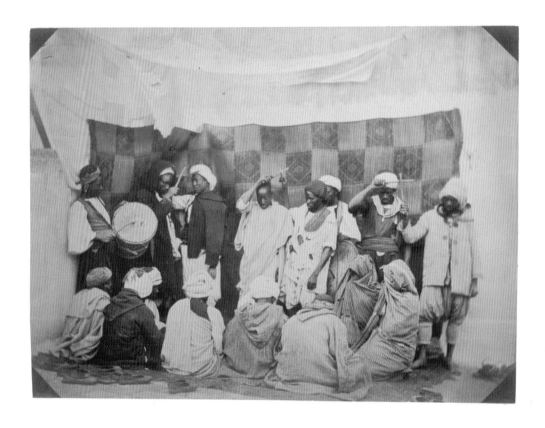

DANSE DES BÂTONS PAR LES NÈGRES

FÉLIX-JACQUES ANTOINE MOULIN

Date 1856
Location Algeria
Format Daguerreotype

Félix-Jacques Antoine Moulin (1802–75) was among the very first photographers to make nude portraits. In 1851 he opened a photography studio, in Montmartre, Paris, where he produced daguerreotype photographs of naked teenage girls that bordered on pornography. Very quickly his work was picked up on by the authorities, who made him serve a prison term for obscenity.

However, in 1856, Moulin was commissioned by the French government to produce images of Algeria, then a French colony. Despite the volatile African temperatures and humidity —harsh conditions for making daguerrotypes— he returned with a substantial collection of images. Among them is this portrait of a group of musicians, photographed against a backdrop of traditional African patterned fabric.

A large selection of Moulin's images were published upon his return from Algeria in a book entitled *L'Algérie Photographiée*. The photographs became official merchandise of the colonial rule of Napoléon III, to whom the work was dedicated. Moulin's work thus may be considered as among the first examples of photography being used as propaganda to support colonial rule. ZG

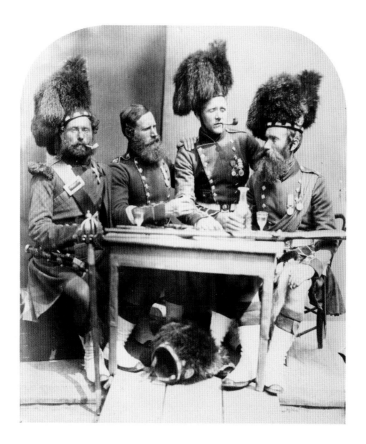

HIGHLANDERS

JOSEPH CUNDALL

Date 1856
Location London, UK
Format Albumen print

This group portrait was taken in the London studio of Joseph Cundall (1818–95), a founder member of the Photographic Society in 1853. A well-respected photographer, Cundall formed a successful partnership with Robert Howlett, best known for his iconic portrait of the great engineer Isambard Kingdom Brunel.

In the summer of 1856, Cundall and Howlett were commissioned by Queen Victoria to photograph soldiers who had just returned from the Crimean War (1854–56). The resulting portraits were mounted in an album entitled *Crimean Heroes*. Victoria gave very specific instructions as to how the groups were to be photographed: three or four of the most distinguished and handsome men in each regiment were to be selected and photographed as soon as possible, so that they would not change their unshaven martial appearance.

This group from the 42nd Highlanders are pictured as if gathered around the mess table, sharing a "wee dram." Carefully posed, one of them places a hand on his comrade's shoulder, reinforcing the regimental bond of mutual trust and support. All four men proudly wear the Crimean campaign medal on their left breast. CH

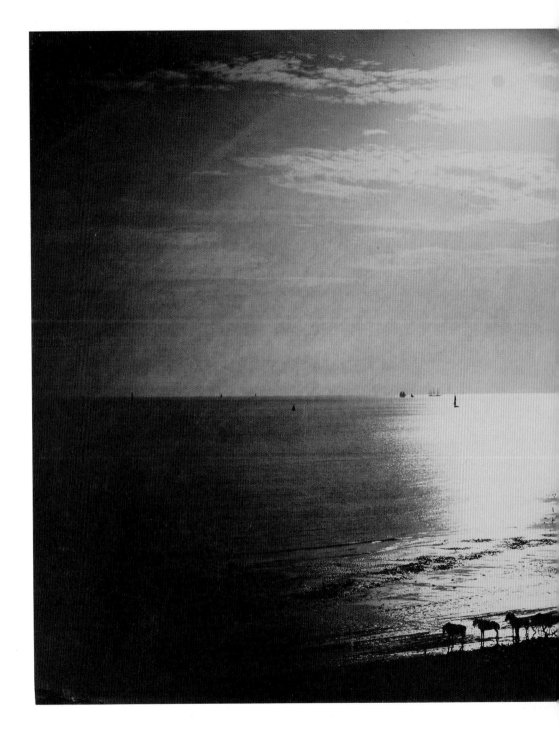

SOLAR EFFECT IN THE CLOUDS—OCEAN

GUSTAVE LE GRAY

Date 1856
Location Normandy, France
Format Albumen print

The English artist John Constable wrote that skies were "the chief organ of sentiment" in landscape painting. This thought was shared by early photographers, but landscapes were at first beyond their technical capabilities. Early photographic emulsions were not equally sensitive to all parts of the spectrum; a negative correctly exposed for the landscape left the sky badly overexposed. Most photographers avoided the problem by painting out the sky on their negatives, giving a perfectly blank and even sky in the final print. However, another, far more difficult, technique was to make the final print by combining two separate negatives—one exposed properly for the landscape, the other for the sky. This was the approach adopted with enormous technical and aesthetic success by Gustave Le Gray (1820–84).

Like many early photographers, Le Gray trained initially as a painter. Although he was also a portraitist and an architectural photographer, his seascapes are his greatest achievement. They are sometimes mistaken for moonlit studies, but Le Gray achieved this effect by pointing his camera in the direction of the sun during daylight. When they were exhibited in 1857, Le Gray's seascapes received rapturous praise. One reviewer wrote: "We stop with astonishment before M. Le Gray's 'Sea and Sky,' the most successful seizure of water and cloud yet attempted. The effect is the simplest conceivable. There is a plain, unbroken prairie of open sea, lined and rippled with myriad smiling trails of minute undulations, dark and sombrous and profoundly calm, over the dead below—smooth as a tombstone." CH

THE TWO WAYS OF LIFE

OSCAR GUSTAVE REJLANDER

Date 1857
Location UK
Format Albumen print

Oscar Gustave Rejlander (1813–75) studied painting in Rome, where he made a living making copies of Renaissance masterpieces. In the 1840s, he moved to Britain and took up photography in 1853.

His choice of subject matter was influenced by the works of art he had studied as a young man. He favored sentimental genre studies, narrative tableaux, and portraits with a strong theatrical or emotional element. He was convinced that photography could be an art form in its own right.

Rejlander was a pioneer of the painstaking technique of combination printing—joining several different negatives to create a single final image. He used this technique to produce his best-known photograph. Created using more than thirty separate negatives, this scene depicts a complex moral allegory. At the center, a wise old man guides two young men who face a choice between "the two ways of life"—sin or virtue.

The work was controversial for its inclusion of naked figures. Photography, many felt at the time, was too realistic a medium to show nudity. Queen Victoria, however, was not shocked: she bought a copy for her husband, Albert, after seeing it at the 1857 Manchester Art Treasures Exhibition. CH

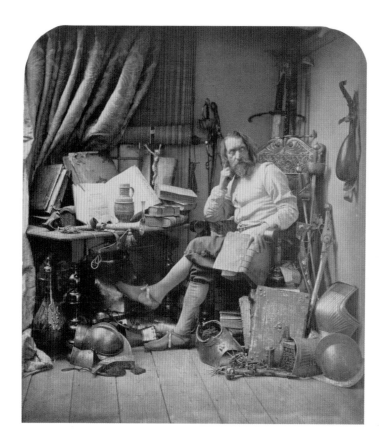

DON QUIXOTE IN HIS STUDY

WILLIAM LAKE PRICE

Date c. 1857
Location UK
Format Albumen print

William Lake Price (1810–96) trained as an architectural and topographical artist in the studio of Augustus Charles Pugin. He was a member of the Old Watercolour Society, exhibiting his work regularly. Price took up photography in the early 1850s and began to produce carefully staged photographic tableaux, echoing the subject matter of contemporary genre painters.

Price was one of the first photographers to try to raise the nascent medium to the level of "high art" by mimicking the subject matter, poses, and period details of history painting. Here, an unknown model posing as Miguel de Cervantes's Don Quixote is depicted in his "study" surrounded by books and antique props. Rolling his eyes, the model tries hard to convey a sense of his character's eccentricity. A contemporary critic wrote that Price's pictures were "of an entirely new character, being marked by great artistic feeling."

In 1856, seeing one of Price's pictures at an exhibition inspired the writer, mathematician, and Anglican deacon Lewis Carroll to take up photography as a hobby. He was to write in his diary: "This is a very beautiful historical picture . . . a capital idea for making up pictures." CH

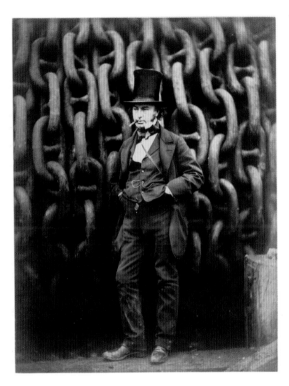

ISAMBARD KINGDOM BRUNEL AND THE LAUNCHING CHAINS OF THE *GREAT EASTERN*

ROBERT HOWLETT

Date 1857
Location London, UK
Format Glass plate

Robert Howlett (1831–58) was a pioneer of early photography. He rose to prominence while working for the Photographic Institute on New Bond Street, London, working on commission on portraits and other assignments. Among his published works is *On the Various Methods of Printing Photographic Pictures Upon Paper: With Suggestions for their Preservation* (1856), and he was commissioned by Queen Victoria to photograph Buckingham Palace. Today, his work is displayed by galleries including the National Portrait Gallery, London, and the San Francisco Museum of Modern Art.

Howlett was commissioned by *The Illustrated Times* to cover the construction of the world's hitherto largest steamship, the SS *Great Eastern*. The photographs were later translated into engravings for the magazine. In this, one of his best-known images, he shot a portrait of the ship's creator and engineer, Isambard Kingdom Brunel, in front of launching chains near the construction in Millwall shipyard. This unusual backdrop, so different from the usual indoor studio settings of the time, is thought to be one of the first examples of environmental portraiture. The picture is beautifully composed, with Brunel standing in a casual manner, his hands jammed into his pockets and a cigar dangling from his mouth, his gaze away from the camera. Our interest in the image today is partly anthropological, as a relic of past costumes and customs, but Howlett also gives the viewer a keen sense of Brunel's character. He stands unbothered by the smudges of paint on his clothes or the creases of his suit, and his pose is natural and unaffected before the camera. **AZ**

"[Howlett] died less than a year after this picture was taken, poisoned, it was suggested, by his own photographic chemicals."
National Portrait Gallery, London

PASHA AND *BAYADÈRE*

ROGER FENTON

Date 1858
Location London, UK
Format Wet collodion negative

Roger Fenton (1819–69) was one of the most important British photographers of the nineteenth century. He is best known for his pioneering work as a war photographer, and in 1855 Fenton visited Constantinople en route to photograph the Crimean War (1854–56). The visit was to inspire this photograph, which, despite initial appearances, is not a documentary image taken by Fenton during his travels but a carefully staged tableau photographed three years later in his London studio, using a model, costumes, and props. A *bayadère* (dancing girl) performs for the enjoyment of the *pasha*, who watches her intently, entranced by her sinuous movement. Seated on the floor, a musician accompanies her on a stringed instrument.

This image is one of a series of about fifty photos taken by Fenton during the summer of 1858; they are known collectively as his *Orientalist Studies*. Fenton himself appears as the bearded *pasha*, while the role of the musician is played by English landscape painter Frank Dillon, known especially for his paintings of Egypt.

Fenton hired a professional artist's model to represent the dancing girl, but even an experienced model would not have been able to remain motionless in the required position for the long exposure time essential for the photograph. Fenton came up with an ingenious idea to solve the problem—he suspended the model's arms from the ceiling. Fenton tried to disguise this by retouching the negative, but a very close look reveals the string attached to her wrists—Artifice in the service of Art. CH

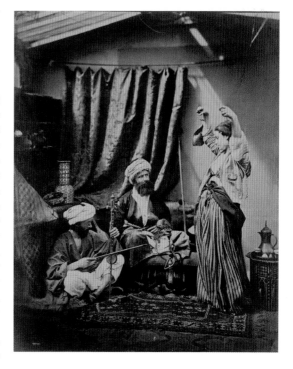

"This captivating tableau is of huge importance to the display and study of photography. The intriguing interplay between the characters and Fenton's visual trickery are sure to fascinate viewers . . ." Stephen Deuchar, director of the Art Fund, UK

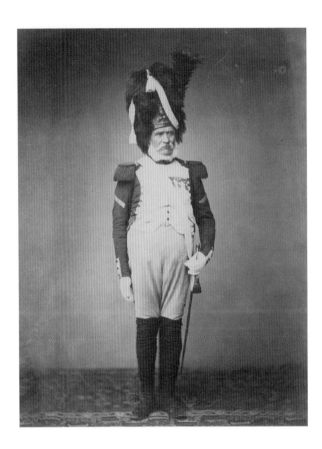

GRENADIER BURG

UNKNOWN

Date 1858
Location Paris, France
Format Glass plate

This poignant image of an aged soldier is part of a collection of fifteen portraits of the last survivors of the French Grande Armée from the Napoleonic Wars of 1803–15. The veterans had gathered in Paris for the annual reunion on May 5, 1858, to celebrate the anniversary of the death of the Emperor Napoléon Bonaparte, and must have all been in their sixties and seventies at the time. *The Times* of London described the atmosphere of the parade thus: "The base and railings of the column of the Place Vendôme appear this day decked out with the annual offerings to the memory of the man whose statue adorns the summit. The display of garlands of immortelles, and other tributes of the kind, is greater than usual . . . the old soldiers of the Empire performed their usual homage yesterday at the same place."

The soldier pictured here is Grenadier Burg, resplendent in his full dress uniform and bearskin hat, proudly wearing the Saint Helena medal that was awarded in 1857 to all veterans of the wars of the French Revolution and the Napoleonic Empire. Grenadiers were the elite infantry of the French Army, selected for being the tallest and most physically powerful soldiers. PL

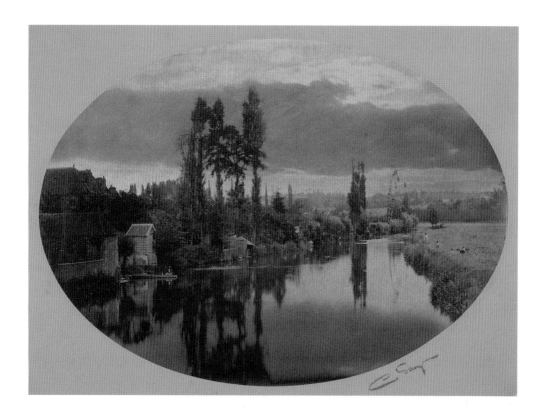

RIVER SCENE, FRANCE

CAMILLE SILVY

Date 1858
Location Nogent-le-Rotrou, France
Format Albumen print

Camille Silvy (1834–1910) took up photography in 1857 when he visited Algeria and was frustrated by his inability to draw to his satisfaction the places he saw. In 1858 he joined the Société Française de Photographie, and he first exhibited in 1859.

Silvy's best-known photograph, *River Scene, France*, was taken in 1858 on the river Huisne near his birthplace of Nogent-le-Rotrou, a small market town near Chartres. An idyllic, carefully composed scene, it shows riverside houses and trees reflected in the smooth, mirrorlike surface of the river. Early photographic emulsions were so insensitive that Silvy was unable to successfully record both land and sky in the same exposure. He therefore made a separate negative of the cloudy sky and printed it in combination with his negative of the landscape. The result is a technical, as well as an artistic, triumph, and reviews of *River Scene* were exceptional. One read: "The natural beauty of the scene itself, rich in exquisite and varied detail, with the broad, soft shadows stealing over the whole, produce a picture which for calm, inviting beauty we have not seen equalled." In 1859, Silvy moved to London, where he established a photographic studio specializing in carte-de-visite portraits. CH

PHOTOGRAPH OF A PLASTER MODEL SHOWING CRATERS ON THE MOON

JAMES NASMYTH AND JAMES CARPENTER

Date 1858
Location UK
Format Woodburytype

James Nasmyth (1808–90) was born in Edinburgh, Scotland, and began work as a draftsman in London before establishing his own works producing machine tools. He rose to become a leading manufacturer of the machines that were driving the Industrial Revolution. In 1837, in response to the engineering challenges of constructing Isambard Kingdom Brunel's vast steamship the SS *Great Britain*, Nasmyth sketched out the design for the first steam hammer, a piece of machinery that perhaps more than any other would become emblematic of the heavy industry of the era.

Nasmyth retired in 1858 and focused on his hobbies, which included astronomy. Continually inventive, he made a series of innovations in this field, and undertook extensive observations of the moon. Nasmyth was interested in using the newly invented technology of photography to record and illustrate his observations, but neither the cameras nor the telescopes of the time were capable of producing usable images. Collaborating with English astronomer and photographer James Carpenter (1840–99), Nasmyth instead turned to making highly detailed plaster models of the craters he saw each night through his telescope. The photographs he made of these models were eventually published in 1874 as *The Moon: Considered as a Planet, a World, and a Satellite*. While the purpose of this work was purely scientific, these images of detailed and highly realistic models contain an early hint of the capacity of the camera to deceive, posing the question of how do we ever know what is real. **LB**

"A new science has arisen that furnishes us with fresh powers of penetration into the vast and secret laboratories of the universe."

James Nasmyth and James Carpenter

INTERIOR OF THE HALL OF COLUMNS, KARNAC

FRANCIS FRITH

Date 1858
Location Karnak, Egypt
Format Albumen print

Francis Frith (1822–98) was one of the most adventurous of the early travel photographers. A businessman-turned-photographer, during the late 1850s he made three extended journeys through Egypt and the Holy Land to "follow [his] quest toward the romantic and perfected past rather than to the bustling and mature present."

Frith faced enormous challenges using the wet collodion process in the heat and dust of North Africa and the Middle East, but succeeded in taking a magnificent series of photographs of sites such as the pyramids, Karnak, Luxor, and Thebes. *The Times* newspaper in London wrote of his photographs: "[They] carry us far beyond anything that is in the power of the most accomplished artist to transfer to his canvas." Frith uses bright sunlight to dramatic effect, capturing the elaborate carvings on the temple columns. He includes a human figure in his composition to emphasize the monumental scale of the ruins.

Frith sold his photographs in a variety of formats in order to make them available to as wide a public as possible. In 1859, after returning from his final expedition to the Middle East, Frith opened a photography and printing establishment in Reigate, Surrey, that was to become one of the largest suppliers of topographical photographs in the world. His photographs of Egypt brought him recognition and acclaim, but it was with his later photographs of Britain that he gained true fame and the wealth that came with it. The successful company that Frith founded on the strength of this survived long after his death, remaining a family business until the 1960s. CH

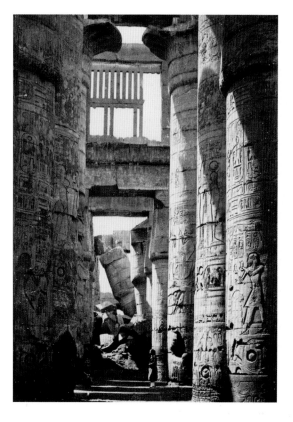

"I am what circumstances over which I have had little or no control from my very birth have made me."
Francis Frith

FADING AWAY

HENRY PEACH ROBINSON

Date 1858
Location UK
Format Albumen print

Henry Peach Robinson (1830–1901) specialized in combination printing, a technique he learned from Oscar Rejlander. Robinson used this process of combining separate negatives in a single print for much of his career and regarded the technique as an indispensable tool for proving that photography could achieve the status of art.

Robinson created many elaborate tableaux from multiple negatives. The above image was his first and best-known combination print—a narrative tableau comprising five separate negatives. It depicts the final moments of a young woman dying from tuberculosis. Her sister stands behind her; her mother sits at her feet, the book in her hand is closed—the story has come to an end. In the background, a male figure—perhaps her father or her fiancé—gazes out of the window at the setting sun, the dying light a metaphor for the young woman as she too fades away.

When this image was first exhibited, some critics approved, but others considered the subject matter morbid and intrusive. Robinson's skillful blend of theatricality, sentimentality, and artifice did, however, appeal to Prince Albert, who purchased a copy for the British Royal Collection. CH

INTERIOR OF SECUNDRA BAGH AFTER THE MASSACRE

FELICE BEATO

Date 1858
Location Lucknow, India
Format Glass plate

Felice Beato (1832–1909) was one of the earliest photojournalists. He worked as an assistant to James Robertson during the Crimean War (1854–56) and then traveled across India, China, Japan, Korea, Sudan, and finally Burma on trips that were funded by the sale of prints and albums back in England.

Beato made arguably the first images of dead bodies when he photographed the Sikandar Bagh Palace in Lucknow after the killing of 2,000 rebels by the British during the Indian Mutiny (1857). Following the battle, the dead British soldiers were buried in a deep trench, but the Indian corpses were intentionally left in the open air to rot.

Beato arrived in the city in March 1858 after it had been recaptured by the British. He carefully composed this scene, using the figures of the workers and the horse to give scale to the ruined facade of the palace. The scattered bones of the dead that litter the foreground form poignant evidence of the violence, although some historians have claimed that Beato staged the bodies to enhance the image's impact. He photographed a similar scene again in 1860 during the Second Opium War in China, when he documented the aftermath of the capture of the Taku forts. PL

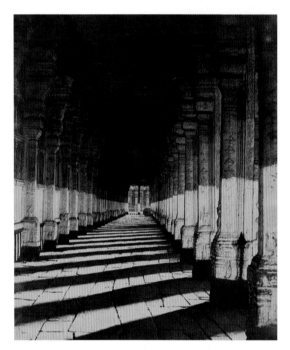

AISLE ON THE SOUTH SIDE OF THE PUTHU MUNDAPUM, FROM THE WESTERN PORTICO

LINNAEUS TRIPE

Date 1858
Location Madurai, India
Format Albumen print

Born in Devon, England, the wonderfully named Linnaeus Tripe (1822–1902) enlisted in the army of the East India Company and was sent out to the Asian subcontinent in 1839, aged just seventeen years. His earliest-known photographs date from around 1853. For his photography, he preferred to use the waxed paper process rather than the recently introduced, but more inconvenient, collodion-on-glass process.

In 1857, Tripe was appointed as the official photographer for the colonial government of Madras. With his heavy and bulky equipment, he traveled hundreds of miles through Burma and southern India, documenting the region's ancient temples and palaces and its scenery. He managed to overcome the enormous difficulties facing the nineteenth-century photographer in southern Asia—heat, dust, and poor transportation—to capture a host of superlative images of landscapes and buildings.

The Puthu Mundapum (New Hall) in Madurai dates from the seventeenth century. It is renowned for its magnificent sculpted columns, carved with mythical creatures and portrait sculptures of the Nayaka rulers. Here, Tripe has brilliantly utilized the bright Indian sunlight to great dramatic effect. The sun has cast long shadows over the paved stone floor, creating a striking, almost abstract, geometric composition.

In 1859, the new governor of Madras decided to close down the photographic survey to save money. The following year, Tripe gave up photography, selling all his cameras and photographic equipment. CH

"He had a distinctive eye. He looked at sites as if he were a surveyor, which I think is to do with his military background. He looked at things descriptively." Roger Taylor, Victoria and Albert Museum

ALICE LIDDELL AS "THE BEGGAR MAID"

LEWIS CARROLL

Date 1858
Location Oxford, UK
Format Albumen print

Charles Lutwidge Dodgson (1832-98) is better known to the world as Lewis Carroll, the pseudonym he chose as the author of *Alice's Adventures in Wonderland* (1865) and *Through the Looking-Glass, and What Alice Found There* (1871). Dodgson was a young mathematics lecturer at Oxford University when he took his first photograph in 1856. For the next twenty-four years he was an obsessive amateur photographer, taking thousands of photographs, mostly portraits of his family, friends, and acquaintances.

In 1856, the same year he took up photography, Dodgson became friendly with the Liddell family, who had come to live in the deanery of his Oxford college, Christ Church. Ill at ease in adult society, Dodgson preferred the company of children. The three young Liddell sisters—Edith, Ina, and Alice—soon found themselves posing for his camera. For Dodgson, Alice, in particular, was much more than simply a favorite model; she was his "ideal child-friend." Carroll's two literary masterpieces were inspired by Alice Liddell.

This powerful and provocative study of Alice, aged around seven years, was inspired by Alfred Lord Tennyson's poem "The Beggar Maid," written in 1842. The work tells the story of Cophetua, an African king who encounters a barefoot beggar maid on the road and is so enraptured by her beauty that he marries her. Dressed in tattered clothes, Alice Liddell is playing a role for the camera but also, perhaps, for Dodgson. She gazes at the lens with a degree of suspicion, as if aware that she is part of a wider narrative that is beyond her comprehension. **CH**

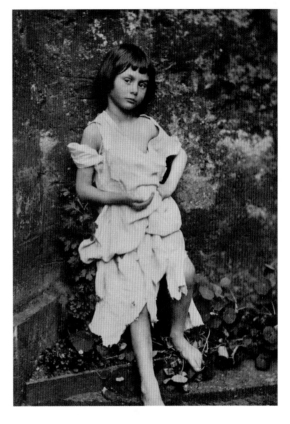

"Her arms across her breast
 she laid;
She was more fair than
 words can say:
Bare-footed came the
 beggar maid
Before the king Cophetua."

Alfred Lord Tennyson

PRINCE LOBKOWITZ

ANDRÉ-ADOLPHE-EUGÈNE DISDÉRI

Date 1858
Location Paris, France
Format Albumen print

Disdéri (1819–89) is credited with the invention of the carte de visite ("visiting card"), and ushered in a new role for the photograph as a token of esteem and respect. On November 27, 1854, he filed a patent for his technique of printing up to ten photographs on a single sheet of paper. His cartes de visite measured 2½ x 3½ inches (6 × 9 cm) and were produced by a camera with four lenses and a sliding holder for the glass plates, a design influenced by stereoscopic cameras. This allowed for several poses to be recorded, as in this series of Joseph Franz von Lobkowitz, Prince of Bohemia.

Disdéri also developed the twin-lens reflex camera. His business expanded rapidly after May 1859, when he photographed Napoléon III. The novelty of cartes de visite rapidly gained popularity, and the ability to reproduce photographic cards cheaply in large quantities led to the demise of the expensive, time-consuming daguerreotype.

Despite his achievements, Disdéri died penniless in 1889 in the Hôpital Sainte-Anne in Paris, "an institution for indigents, alcoholics, and the mentally ill." He was a victim of his own success; his process was too easily copied by competitors. **PL**

EXHIBITION OF THE PHOTOGRAPHIC SOCIETY OF LONDON

CHARLES THURSTON THOMPSON

Date 1858
Location London, UK
Format Glass plate

Charles Thurston Thompson (1816–68) was hired by London's South Kensington Museum—now the Victoria and Albert Museum—as its first official photographer. He started as a wood engraver, but he began taking photographs for the museum in 1853 and was formally appointed to the role in 1856. As part of his duties, he trained military engineers. In 1858, he photographed the queen's collection of Raphael cartoons for use in art schools.

In the same year, the Photographic Society of London organized the first-ever photography exhibition in a museum. It comprised 1,009 photographs, including works by Roger Fenton, Francis Frith, and Gustave Le Gray. Thompson recorded the display with his camera, and thus created the earliest-known photograph of a photographic exhibition. **PL**

NAPOLÉON III AND THE PRINCE IMPERIAL

PIERRE-LOUIS PIERSON

Date c. 1859
Location France
Format Wet collodion negative

In 1844, Pierre-Louis Pierson (1882–1913) opened a photographic studio in Paris that offered hand-colored daguerreotypes. In 1855 he expanded the business by forming a partnership with Léopold Ernest and Louis Frédéric Mayer, who had recently been appointed as "Photographers of His Majesty the Emperor" by Napoléon III.

In this charming, behind-the-scenes image, Napoléon III is seen offstage, supervising the arrangement of his son, then two or three years old, in a regal pose on top of a horse while a white-gloved attendant stands guard. The emperor's white dog provides a visual mirror to the horse in the corner of the frame. For public consumption, the photograph was cropped to make a carte de visite that showed only the young prince. PL

QUEEN VICTORIA AND PRINCE ALBERT

JOHN JABEZ EDWIN MAYALL

Date 1860
Location UK
Format Carte de visite

On July 28, 1855, Queen Victoria wrote in her journal: "From 10 to 12 was occupied in being photographed by Mr. Mayall, who is the oddest man I ever saw, but an excellent photographer." John Mayall (1810–1901) made his reputation in the United States, but returned to his native England in 1846. In 1860, the queen, who had not forgotten her earlier photo shoot, asked Mayall to take a series of miniature *carte de visite* portraits of members of the royal family, which would be for sale to the public. Being allowed to purchase such photographs made the monarch seem more accessible to her subjects, resulting in a boost to her popularity. CH

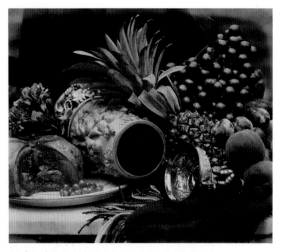

STILL LIFE WITH TANKARD
AND FRUIT

ROGER FENTON

Date 1860
Location UK
Format Albumen print

Roger Fenton (1819–69) is best known for his pioneering war photography in the Crimea, but he also excelled in portraiture, landscape, and architectural photography. However, he took some of his most glorious images, a magnificent combination of technical excellence and aesthetic sensibility, just before he decided to give up photography. In the summer of 1860, Fenton took a series of exquisite still-life images.

Fenton's photographs were inspired by the work of English painters such as George Lance, whose work he admired and collected. When he showed some of his still lifes in 1861, a review in the *British Journal of Photography* must have been particularly pleasing to Fenton as he was compared directly to Lance: "Mr. Roger Fenton has come out in an entirely new character, and may now be regarded in the photographic world in the same light as Lance among painters." CH

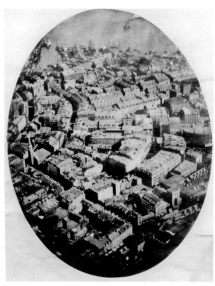

BOSTON, AS THE EAGLE AND
THE WILD GOOSE SEE IT

JAMES WALLACE BLACK

Date 1860
Location Boston, Massachusetts, USA
Format Glass plate

This photograph was part of a series of aerial views of Boston by James Wallace Black (1825–96) taken from Samuel King's balloon the *Queen of the Air*. It shows several of the city's significant landmarks, including Washington Street and the Old South Church. It was the first aerial photograph taken in the United States and is the world's earliest surviving aerial photograph.

The first photographs taken from a balloon are thought to have been taken two years earlier by Gaspard-Félix Tournachon, better known as Nadar, from a balloon tethered over Paris. The pioneering work of Black and Nadar began a new branch of photography, and within two years, the Union army was employing aerial cameras to spot Confederate troops during the American Civil War (1861–65). LB

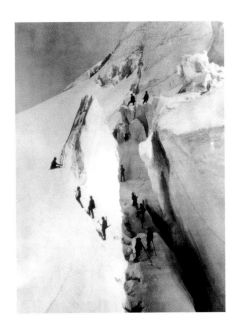

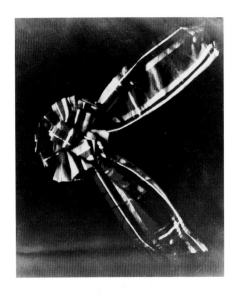

TARTAN RIBBON

JAMES CLERK MAXWELL

Date 1861 (printed 1937)
Location London, UK
Format Vivex print

THE ASCENT OF MONT BLANC

LES FRÈRES BISSON

Date 1860
Location Mont Blanc, France
Format Albumen print

Brothers Louis-Auguste (1814–76) and Auguste-Rosalie (1826–1900) Bisson, known as Les Frères Bisson, learned photography directly from one of its inventors, Louis Daguerre, in the 1840s.

In the 1850s the brothers became associated with French industrialist Daniel Dollfus-Ausset, who funded a series of photographic expeditions to the Alps. In 1858 and again in 1860, the brothers made unsuccessful attempts to reach the summit of Mont Blanc, the highest peak. In July 1860 the goal was finally achieved by the younger brother, Auguste-Rosalie, using an experienced guide and with a team of porters carrying his glass plates, cameras, chemicals, and portable darkroom tent. Returning from the summit, Bisson set up his tent and cameras, posed the climbers as if they were ascending, and took three exposures. **CH**

In May 1861, Scottish physicist James Clerk Maxwell (1831–79) gave a lecture at the Royal Institution in London, "On the Theory of Primary Colors." He sought to demonstrate that all colors can be synthesized by mixing red, green, and blue light. A small tartan ribbon was photographed three times—through red, green, and blue filters. The resulting negatives were used to make three positive transparencies, which were placed in three magic lanterns and projected through the same three filters. These superimposed images combined to reproduce the colors of the original ribbon.

Maxwell's experiment worked, but it should not have. His plates were insensitive to red light, and no image should have been recorded through the red filter. But by chance the red dye in the ribbon reflected ultraviolet radiation, as opposed to red light, which was transmitted by the chemicals of the red filter. **CH**

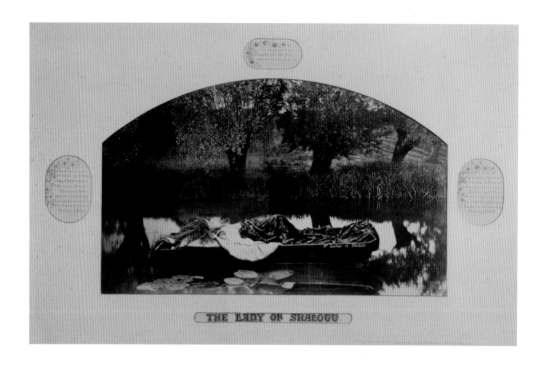

THE LADY OF SHALOTT

HENRY PEACH ROBINSON

Date 1861
Location UK
Format Albumen print

Henry Peach Robinson (1830–1901) was deeply influenced by the painters of the Pre-Raphaelite (PR) movement. He felt that parallels could be drawn between photography and the artists' emphasis on "realistic" detail and static composition.

Robinson championed the illustrative power of photography when associated with poetry, thereby combining his two great passions. The photograph shown here was inspired by Alfred Lord Tennyson's poem "The Lady of Shalott":

"And at the closing of the day
She loosed the chain, and down she lay;
The broad stream bore her far away,
 The Lady of Shalott."

It was created by combining images from two separate negatives. Robinson explained: "I made a barge, crimped the model's hair, PR-fashion, laid her on the boat in the river among the water lilies, and gave her a background of weeping willows, taken in the rain so that they might look dreary."

The photographer himself later called this image "a ghastly mistake"; this is harsh, but it could be argued that the inherent naturalism of photography diminishes rather than enhances Tennyson's dreamlike vision. **CH**

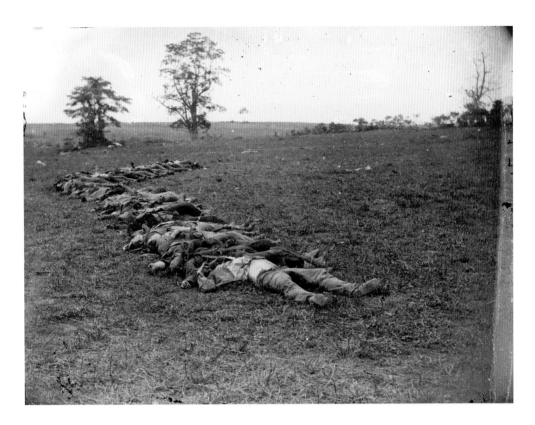

CONFEDERATE DEAD GATHERED FOR BURIAL AFTER THE BATTLE OF ANTIETAM

ALEXANDER GARDNER

Date 1862

Location Washington County, Maryland, USA

Format Large-format glass plate

Alexander Gardner (1821–82) was an assistant to Mathew Brady, the photographer most famously associated with documenting the American Civil War (1861–65). That conflict's Battle of Antietam was "the bloodiest day in American history," and Gardner's photograph is one of a set that Brady exhibited showing some of its 22,717 casualties. The New York exhibition "The Dead of Antietam" was most Americans' first opportunity to witness the reality of war, and it made a huge impression. The

New York Times reported that it was as if Gardner and his fellow photographers had "brought bodies and laid them in our dooryards and along the streets." Describing the atmosphere in the gallery, the paper noted "hushed, reverend groups standing around these weird copies of carnage . . . chained by the strange spell that dwells in dead men's eyes."

It is argued that Brady and his team routinely manipulated these aftermath scenes, moving bodies around to create more striking compositions. The accepted ethical standards that now govern war photography were not yet established in 1862, and it was understood that the value of these images lay in their poetic and evocative powers as much as in their historical accuracy. JG

JOHN EVERETT MILLAIS

DAVID WILKIE WYNFIELD

Date 1862
Location London, UK
Format Albumen print

Distantly related to and named after acclaimed Scottish painter Sir David Wilkie, David Wilkie Wynfield (1837–87) was himself a painter of some distinction who exhibited regularly at the British Royal Academy. He was a member of the London-based St. John's Wood group of artists and specialized in genre scenes based on subjects in English history.

Wynfield began the photographic project for which he is best known in around 1861. He took a series of portraits of artists dressed in Elizabethan and Renaissance costume. In 1864 these were published under the title *The Studio: A Collection of Photographic Portraits of Living Artists, Taken in the Style of the Old Masters, by an Amateur*.

At the time the portrait shown here was published, the subject, John Everett Millais, one of the founders of the Pre-Raphaelite Brotherhood, was probably the most famous artist of the day; his best-known painting was *Ophelia* (1852), a study of the character from Shakespeare's tragedy *Hamlet* after her death in a river. Wynfield has chosen here to depict Millais dressed as Dante Alighieri, the great early Renaissance Italian poet.

Another portrait photographer, one who is now far more acclaimed, was originally inspired by Wynfield's work. The young Julia Margaret Cameron asked Wynfield for a lesson, and later wrote that "to . . . his beautiful photography I owe all my attempts and indeed consequently all my successes." Wynfield's portraits certainly exhibit many of the qualities now more generally associated with Cameron's work—close-up format, soft focus, and dramatic lighting. **CH**

"By pressing a button, [Wynfield] achieved . . . perfect verisimilitude. He invented, one might say, instant Pre-Raphaelitism."

Bevis Hillier

BRONSON MURRAY

WILLIAM H. MUMLER

Date c. 1862–75
Location Boston, Massachusetts, USA
Format Albumen print

William H. Mumler (1832–84) was probably the best known of a large number of photographers who profited from photography's novelty and the public's limited understanding of it to produce so-called "spirit photographs." These were images that purported to show the spirits of the dead and other supernatural phenomena, but that in reality employed trick photography and double exposures for their effect. These images found a ready audience among members of the spiritualist movement, which was very strong at the time, and also among people grieving for recently departed relatives and friends. Mumler was particularly active in the aftermath of the American Civil War (1861–65), in which close to a million people had been killed. Mumler's promise to reveal dead loved ones through the medium of photography was a powerful enticement that allowed him to charge well over the going rate for a portrait session.

Not everyone was fooled by spirit photography, however, and Mumler faced sharp criticism from skeptics throughout his career. Moreover, there were accusations that he had broken into the homes of some of his subjects to steal photographs of the dead, so that he could find a suitable match for them, and it was also discovered that some of his "ghosts" were, in fact, still very much alive. In 1869 he was brought to trial for fraud, and the case became a battleground for spiritualist believers and scientific rationalists. While Mumler was eventually acquitted, the accusations that his images were hoaxes stuck, and the trial marked the start of a fatal downturn in his business. LB

"What joy to the troubled heart! . . . To know that our friends who have passed away can return and give us unmistakable evidence of a life hereafter." William H. Mumler

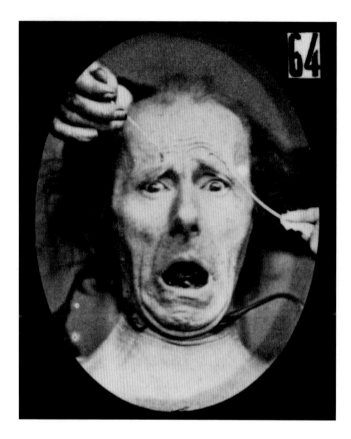

PLATE 64 FROM MÉCANISME DE LA PHYSIONOMIE HUMAINE

GUILLAUME-BENJAMIN-AMAND DUCHENNE DE BOULOGNE

Date 1862
Location Paris, France
Format Unknown

The son of a fisherman, Duchenne de Boulogne (1806–75) resisted family pressure to become a sailor and opted instead to study medicine. After spending an unhappy decade practicing as a doctor in his native Boulogne, he moved to Paris and began experimenting with electrical currents, which was then a relatively new and imperfectly understood medical tool. Previously, electricity had been used largely as a therapeutic aid, but Duchenne recognized that it could also be used to stimulate nerves and muscles in living patients, and hence to reveal new information about anatomy.

Duchenne conducted extensive experiments that led him to significant conclusions about the nervous system. Initially recording his findings with drawings, Duchenne increasingly employed photography, producing images of facial muscle stimulations for his landmark 1862 publication *Mécanisme de la Physionomie Humaine*. Along with Duchenne's many other writings, this work proved influential in a range of fields beyond neurology and provided an important source for Charles Darwin's work, *The Expression of the Emotions in Man and Animals* (1872). LB

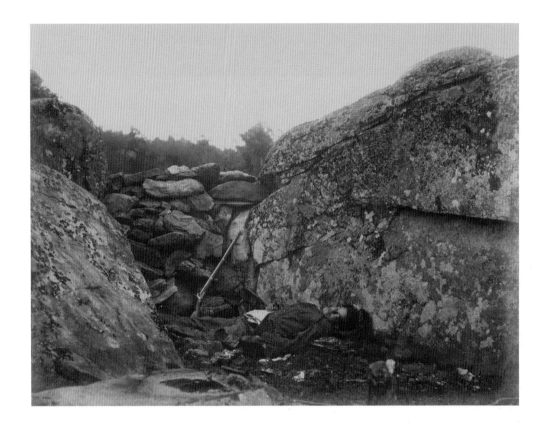

HOME OF THE REBEL SHARPSHOOTER

ALEXANDER GARDNER

Date 1863
Location Gettysburg,
Pennsylvania, USA
Format Large-format glass plate

"Here are the dreadful details!" So wrote Scotsman Alexander Gardner (1821–82) about his shocking photographs of the American Civil War (1861–65). Gardner was in the vanguard of war photographers in the United States who were among the first to document history with the use of a camera and who brought images of the killing fields of places such as Antietam and Gettysburg to public attention. Gardner produced more than

1,000 photographs of the corpses of young men scattered across the battlefields and hoped that these stark images would serve as a "useful moral" of the "horror and reality of war, in opposition to its pageantry."

At Gettysburg, Gardner and his crew set up their stereographic cameras to document the aftermath of the battle and the "rotting corpses" that lay strewn in its aftermath. This photograph of a sharpshooter is perhaps his most famous. According to historian William A. Frassanito, it is most likely that the corpse was dragged to what was called the "Devil's Den" for effect. Gardner is thought to have frequently set up scenes in this manner in order to capture the viewers' sympathies. SY

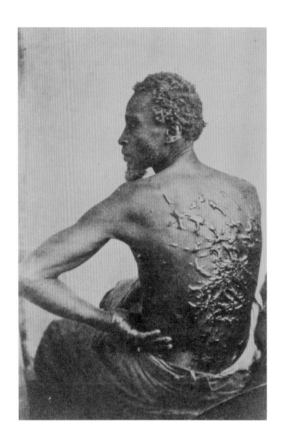

THE SCOURGED BACK

MCPHERSON & OLIVER

Date 1863
Location Baton Rouge, Louisiana, USA
Format Albumen print

Some of the horror of American slavery is graphically conveyed in this famous image, taken at a Union encampment in Baton Rouge, Louisiana, during the American Civil War (1861–65). A fugitive African American known only as Gordon found safety in the encampment after fleeing his plantation. Doctors examining him after his arrival found evidence of horrific lashings by his owner, and a photographic team based in the area—William McPherson (1833–67) and his partner, credited only as Mr. Oliver—posed Gordon and documented the visible damage. Photographs also exist of Gordon in his new uniform; he enlisted to fight the Confederacy in an African-American regiment.

The subsequent story of this image speaks to the prolific capabilities of photography at this time, as well as to its value as a tool for education and propaganda. Three images of Gordon were reproduced in *Harper's Weekly*, along with an account of his story, and in the abolitionist newspaper *The Liberator* wrote:

"Upon that back, horrible to contemplate! is a testimony against slavery more eloquent than any words. Scarred, gouged, gathered in great ridges, knotted, furrowed, the poor tortured flesh stands out a hideous record of the slave-driver's lash."

Presented as a courageous figure, Gordon was used to inspire free African Americans in the northern United States to enlist in the Union army. His lashed back also appeared on numerous cartes de visite, and negatives were reproduced in Philadelphia, New York, Boston, and London (England), where they were used by abolitionists to advocate an end to slavery. **CP**

"Few sensation writers ever depicted worse punishments than this man must have received." Samuel K. Towle, Union army surgeon

CLEMENTINA MAUDE

LADY CLEMENTINA HAWARDEN

Date 1863
Location London, UK
Format Albumen print

Lady Clementina Hawarden (1822–65) was born Clementina Elphinstone Fleeming on June 1, 1822. In 1845 she married Cornwallis Maude, an officer in the British Life Guards. In 1856, following the death of Maude's father, Viscount Hawarden, his title and considerable wealth passed to his son and Clementina became Lady Hawarden. It was at about this time that Lady Hawarden first took up photography—her husband's wealth easily allowed her the time, money, and space that were essential for photography at the time.

In 1859 the family moved to a large house in South Kensington, London. Lady Hawarden turned the entire first floor into her photography studio, and it was here that she took most of her images, creating exquisitely lit and composed tableaux featuring her daughters, Isabella Grace, Clementina Maude, and Florence Elizabeth. The girls were often dressed in costume and photographed in romantic poses, near a window or in front of a mirror. Her images were very different to those of her contemporaries. Languid, sensual, even sexual, in tone, they exhibit a subtle, skillful, and sophisticated use of natural light.

Lady Hawarden became a member of the Photographic Society of London in 1863 and showed at the society's annual exhibition later that year, where she was awarded a silver medal. Her work was well received by her peers. In 1864 another well-known amateur photographer of the time, Lewis Carroll, wrote in his diary: "Went to the Photographic Exhibition . . . I did not admire Mrs. Cameron's large heads taken out of focus. The best of the life-ones were Lady Hawarden's." CH

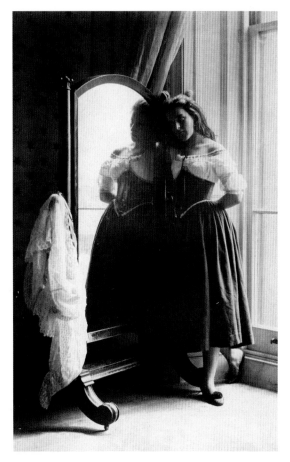

"Clementina Hawarden struck out into areas and depicted moods unknown to the art photographers of her age."
Graham Ovenden

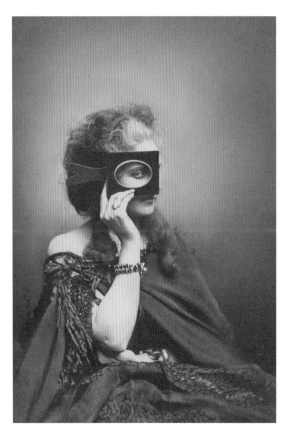

COUNTESS VIRGINIA OLDOINI VERASIS DI CASTIGLIONE

PIERRE-LOUIS PIERSON

Date 1863
Location Unknown
Format Wet collodion negative

The lengthy collaboration between one of Paris's most celebrated portraitists and the Countess Virginia Oldoini Verasis di Castiglione is one of the richest and most productive relationships between artist and muse of all time.

Oldoini was born in Florence in 1837 and was married at age seventeen to the Count Verasis di Castiglioni. In 1856 she was dispatched to Paris by her cousin, the Count of Cavour, on a diplomatic mission to petition Napoléon III to support the cause of Italian unity, with instructions to "succeed by whatever means you wish—but succeed!"

She certainly caught the French emperor's attention; they quickly became lovers. Her collaboration with Napoléon's court photographer, Pierre-Louis Pierson (1822–1913), produced more than 400 striking images, as she adopted a range of personalities, costumes, and poses for him over a forty-year period. The photographs were her entrée into French society, as well as a form of self-expression through which she projected herself variously as a naive virgin, a pretty coquette, and a dark and mysterious seductress. She would send them to potential and actual lovers as tokens of affection. The images were true collaborations: she directed Pierson in the compositions, choice of clothing and accessories, and in the staging of the photographs. Each photograph was given a formal title, such as *Scherzo di Follia* after Giuseppe Verdi's 1858 opera *Un Ballo in Maschera*. In their exploration of multiple personalities, these portraits foreshadow the work of Cindy Sherman. In the image reproduced here, Oldoini plays with a photo frame to isolate and emphasize her eye. PL

"The countess's raging narcissism found in photography the perfect ally."

MoMA, New York

SARAH BERNHARDT

NADAR

Date 1864
Location Paris, France
Format Glass plate

French photographer Nadar—Gaspard-Félix Tournachon (1820–1910)—was a showman and an expert at self-promotion. His studio became a magnet for the rich and famous, including the novelists Victor Hugo, George Sand, and Alexandre Dumas; the poet Charles Baudelaire; the painter Eugène Delacroix; the composers Franz Liszt and Giuseppe Verdi; and—depicted here at the start of her career—the actress Sarah Bernhardt.

Aged just twenty years when she posed for this classically inspired study, Berhardt was the subject of numerous portraits by a range of artists and photographers. Nadar rejected the stiff poses, eccentric costumes, and elaborate backdrops typically used by other portrait photographers of the time and instead focused on the sitter's face by tight framing against a simple plain backdrop. He explained how his aim was to understand the true character of his subject, saying: "What cannot be taught is the moral intelligence of the subject, or the instinctive tact that puts you in touch with the model, allowing you to size them up and to steer them toward their habits, their ideas, according to each person's character . . . It enables you to achieve the most familiar, the most positive resemblance: a speaking likeness. This is the psychological side of photography. I don't think that is too ambitious a term."

Taking the lead from his trademark red hair, Nadar painted his studio red and had his name illuminated outside in giant red neon letters. Crowds gathered at night to peer through the windows and many, he said, "could not resist climbing the stairs to see what happened there." PL

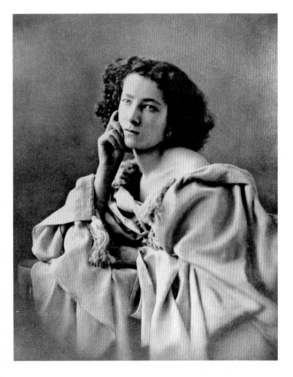

"In photography, like in all things, there are people who can see and others who cannot even look." Nadar

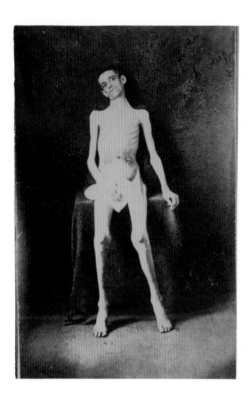

EMACIATED PRISONER OF WAR FROM BELLE ISLE, RICHMOND, PRIVATE WILLIAM M. SMITH OF CO. D OF 8TH KENTUCKY VOLUNTEERS, AT THE US GENERAL HOSPITAL, DIV. 1, ANNAPOLIS

UNKNOWN

Date 1864
Location Annapolis, Maryland, USA
Format Glass plate

Prisoner-of-war camps on the Confederate side during the American Civil War (1861–65) had a terrible reputation for maltreatment of their Union inmates. The names of camps, such as Andersonville, still evoke images of horror. Robert H. Kellogg, a sergeant major in the 16th Regiment Connecticut Volunteers, described his arrival there as a prisoner on May 2, 1864 thus: "As we entered the place, a spectacle met our eyes that almost froze our blood with horror, and made our hearts fail within us. Before us were forms that had once been active and erect—stalwart men, now nothing but mere walking skeletons, covered with filth and vermin. Many of our men, in the heat and intensity of their feeling, exclaimed with earnestness: 'Can this be hell?' 'God protect us!' and all thought that He alone could bring them out alive from so terrible a place."

Another notorious camp was at Belle Isle in Virginia, and the harrowing images of survivors such as this one have come to define the war. The images were published in the House Committee's Report No. 67, which included eight pictures of naked or partly clothed prisoners, and declared that the evidence proved that the Confederates intended to murder captured Union soldiers. PL

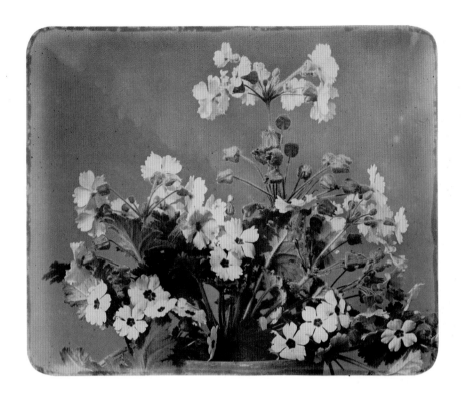

FLOWER STUDY

ADOLPHE BRAUN

Date 1865
Location France
Format Albumen print

Originally a fabric designer, Adolphe Braun (1812–77) photographed flowers to aid the design of floral patterns for printing blocks for textiles and wallpapers. His catalog of 300 plates, *Fleurs Photographiées* (c. 1854), caught the attention of the Paris arts scene, and Braun published a second volume to coincide with the Exposition Universelle of 1855. Two years later, Braun set up a photography company. His studio became highly successful, and by 1870 it was producing up to 8,000 images a year of Paris street scenes and alpine landscapes, which were sold throughout Europe and North America.

This image is one of the floral studies that propelled Braun to success. He brought an artistic rather than a scientific eye to the objects he photographed. His elegant studies show flowers arranged against neutral backgrounds, as if they are bouquets or still-life paintings. His photographic skill meant he created pictures with a rich tonal quality and crispness that captures every petal, leaf, and stem. His sense of pattern meant that he rendered images that were carefully composed and framed, utilizing space to often lyrical effect. CK

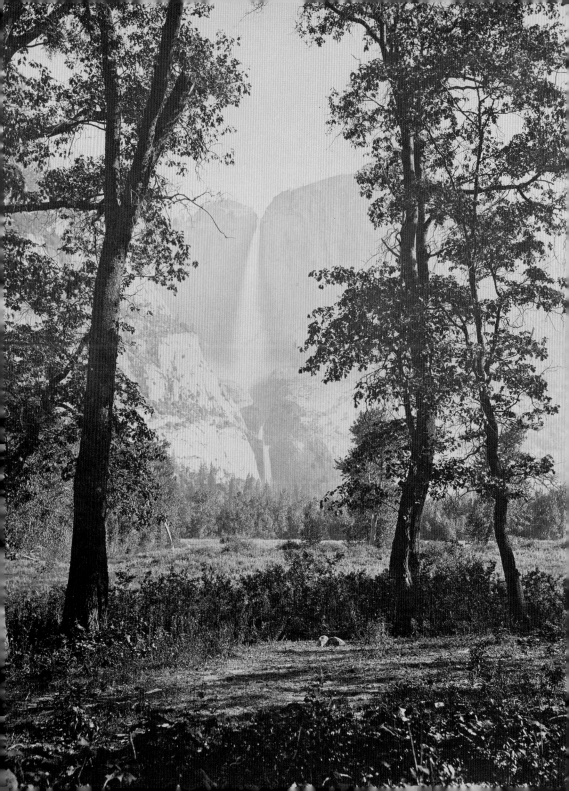

YOSEMITE FALLS

CARLETON E. WATKINS

Date 1865
Location Yosemite Valley, California, USA
Format Mammoth-format plate

One of the landscape photographers responsible for shaping the idea of the American West within the global public imagination, Carleton E. Watkins (1829–1916) was (together with his main rival Eadweard Muybridge) a pioneer of "mammoth plate" photography, working with huge glass plates that were even more cumbersome than the standard equipment of the time and that required great skill, endurance, and a huge amount of carefully planned labor.

Watkins was born in New York and moved to California at the start of the Gold Rush (1848–55). He found no precious metal, so he took up photography. His images of Yosemite are masterworks of composition, detail, and fine printing. Notable in this example in particular is the depth of field, in which the rocks surrounding the falls are as sharply focused as the trees in the foreground. Also remarkable are the rich breadth of tones and the artful framing of the scene.

Watkins made several expeditions to the area via the new railroad system that had recently opened up the North American frontier. Watkins's work simultaneously created and fed a huge commercial appetite for representations of an unspoiled, unpeopled American "wilderness"— representations that did not recognize the historic presence of the Native Americans, who were being driven out of areas like Yosemite in order to make room for European settlers. Watkins's many prints, exhibitions, and albums drew political attention to the area and led first to 1864's Yosemite Grant Act and later to the establishment of the US National Park Service. JG

ARC DE TRIOMPHE

ÉDOUARD-DENIS BALDUS

Date c. 1865
Location Paris, France
Format Albumen print

Trained as a painter, Édouard-Denis Baldus (1813–89) was accepted into the Paris Salon in 1842. In 1851 he was a founding member of the French Société Héliographique and in 1857, of the Société Française de Photographie. In 1851 he was commissioned by the Historic Monuments Commission of France to photograph buildings and bridges of Paris, many of which were being demolished to make way for Baron Haussmann's grand boulevards.

This is one of a series of photographs by Baldus published in an album entitled *Vues de Paris en Photographie* (c. 1865). The Arc de Triomphe was commissioned by Napoléon Bonaparte in 1806, but not finished until 1836. Engraved around the top of the arch are the names of major French victories during the revolutionary and Napoleonic periods. Baldus's photograph is formal and majestic, and his mastery of light and shadow captures all of the detail and texture of the stonework. CH

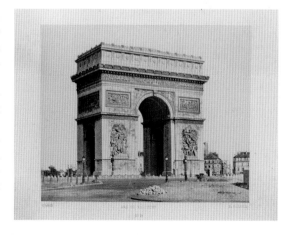

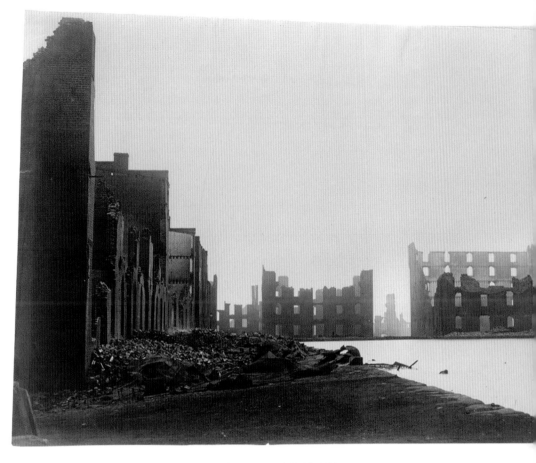

RUINS OF GALLEGO FLOUR MILLS, RICHMOND

ALEXANDER GARDNER

Date 1865
Location Richmond, Virginia, USA
Format Large-format glass plate

Richmond, Virginia, was the de facto capital of the Confederate States of America for the greater part of the Civil War (1861–65). It was a vital center for the Confederacy, not just economically—it had numerous factories producing munitions and food, including the famous Gallego Flour Mills, at the time the largest flour factory in the world—but also strategically, because of its proximity to the

federal capital, Washington, D.C., just 100 miles (160km) to the north.

Toward the end of the war, on April 2, 1865, as the Union army threatened to capture Richmond, Confederate General Robert E. Lee gave orders to evacuate the city. His retreating forces tried to destroy any supplies that might be of use to the enemy by burning them, but the fires quickly raged out of control and tore though the heart of the city, reducing large parts of it to smoldering ruins. At least twenty city blocks were destroyed, including the area around the Gallego Flour Mills. *The New York Times* reported:

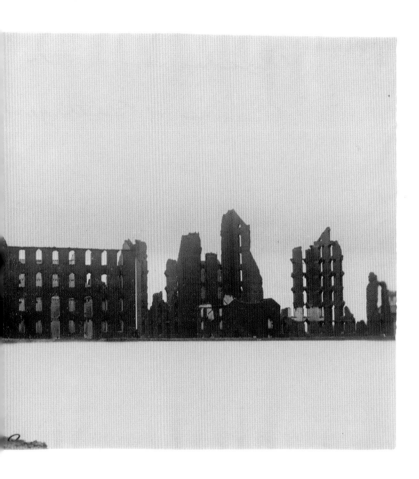

"At sunrise on Monday morning Richmond presented a spectacle that we hope never to witness again. The last of the Confederate officials had gone; the air was lurid with the smoke and flame of hundreds of houses weltering in a sea of fire."

After the city fell to the Union forces, the area became known as "the Burnt District," and Alexander Gardner (1821–82) made a series of dramatic photographs of the bleak and barren ruins, including this one, in which he combined two separate negatives to make a panorama. The charred remains of the Gallego Flour Mills became an iconic image of the fall of the Confederacy and the utter devastation of the Civil War. The war ended soon after the fall of Richmond, when on April 9, 1865, Lee surrendered to Union General Ulysses S. Grant. These stark images became a haunting and iconic symbol of the devastation wrought by the conflict on civilian infrastructure; this landscape needs no human figure to convey the desolation of war. Gardner described his work thus: "It is designed to speak for itself. As mementos of the fearful struggle through which the country has just passed, it is confidently hoped that it will possess an enduring interest." PL

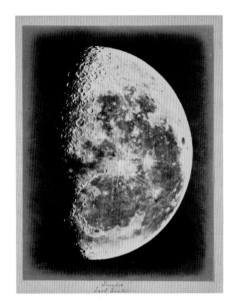

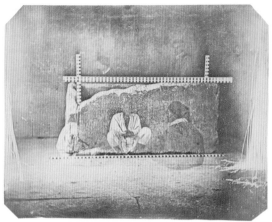

TOMB IN THE KING'S CHAMBER OF THE GREAT PYRAMID AT GIZA, EGYPT

CHARLES PIAZZI SMYTH

Date 1865
Location Giza, Egypt
Format Unknown

THE MOON, PHOTOGRAPHED FROM NEW YORK

LEWIS MORRIS RUTHERFURD

Date 1865
Location New York, New York, USA
Format Albumen print

Lewis Morris Rutherfurd (1816–92) was a rich lawyer who quit his practice in 1849 to devote himself full-time to science, particularly astronomy.

In 1860 he set up a private observatory, which he had constructed in the garden of his family mansion, known as Tranquility, in New York. By the end of 1864 he had completed the first telescope designed specifically for astrophotography. It was fitted with an 11¼-inch (28.5cm) diameter lens with a focal length of about 15 feet (4.5m). With it he took unprecedented photographs of the sun, the planets, stars, and constellations. However, it is for his images of the moon that he received the most praise and is best known today. Between about 1860 and 1877, he took nearly 500 photographs of the moon, and this is one of his finest. **CH**

Charles Piazzi Smyth (1819–1900), Astronomer Royal for Scotland from 1846 to 1888, is best known for his studies of the Great Pyramid of Giza, from which he concluded that it had been built using a unit of measurement called the "sacred cubit." According to Smyth, this was a divine measure handed down through the centuries from the time of Shem (Noah's son). To back his theory, he measured and photographed the Great Pyramid—its interior passages and the burial chamber located at its heart. By using the light emitted from burning magnesium, Smyth was able to photograph within the pyramid's darkest chambers. This was one of the earliest recorded examples of photographing with artificial light.

In this image, the ethereal forms of two Egyptian guides and Smyth's wife, Jessie, crouch in front of the royal sarcophagus, making them look as if they, too, are sealed inside the tomb. **EC**

REVOLVING SELF-PORTRAIT

NADAR

Date 1865
Location Paris, France
Format Glass plate

Gaspard-Félix Tournachon (1820–1910) began his career as a caricaturist, adopting the nickname *tourne à dard* ("one who stings or twists the dart"), later shortened to "Nadar." His drawing helped him to develop a sense of his subjects' key features, a talent he carried through into his later photography.

This remarkable 360-degree self-portrait may have been a study to help him explore the ways in which the human face changes when viewed from a variety of angles. Nadar commented: "The theory of photography can be taught in an hour; the technique in a day. What can't be taught is the feeling for light . . . it's the understanding of this effect which requires artistic perception. What is taught even less is the immediate understanding of your subject . . . that enables you to make . . . a likeness of the most intimate and happy kind." PL

MANAUS COLLECTION

WALTER HUNNEWELL AND LOUIS AGASSIZ

Date 1865–66
Location Manaus, Brazil
Format Albumen print

Swiss-born biologist and anthropologist Louis Agassiz (1807–73) believed in creationism and polygenesis, a pluralist theory that all races were created separately and endowed with unequal attributes. In 1865, on an expedition to Brazil, Agassiz turned his attention to the mixed races of the region. Part of what is called the "Manaus Collection" or "Mixed-Race Series," this photograph was actually taken by Agassiz's student, Walter Hunnewell. Together, the two documented the local population in order to reinforce Agassiz's race theories. The photographs were never published, but Agassiz's mixed-race series is viewed as an important early example of both the documentation of native populations and the darker side of nineteenth-century anthropology. SY

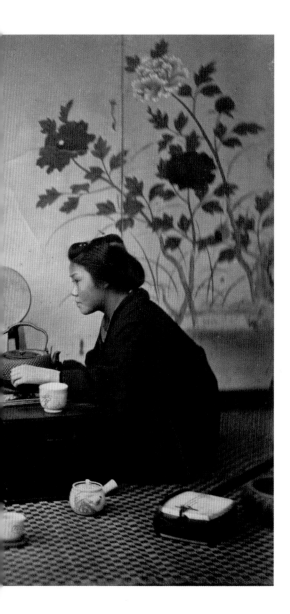

MODE OF SHAMPOOING

FELICE BEATO

Date 1866–67
Location Japan
Format Wet collodion negative

This carefully posed photograph of two attendants preparing to shampoo a woman's hair has the look of something created within the confines of a film set. However, it was produced by a photographer who was one of the earliest and most widely traveled photojournalists and documentarians. Italian-British photographer Felice Beato (1832–1909) covered wars and uprisings in the Crimea, India, and China throughout the 1850s and early 1860s, before settling in Japan in 1863–84. This was the longest period he spent in any one country and was his most prolific in terms of the number of images that he produced. Beato developed good relations with the ruling shogunate, enabling him to travel the country to places no Westerner had ever been. Initially, he followed the method of preceding documentarians in Japan, such as Eliphalet Brown, capturing outdoor scenes of temples and cities. However, Beato also based himself in a studio in Yokohama, producing static portraits of Japanese society, including everyone from geishas, samurai, and sumo wrestlers to sake vendors and basket weavers. Much of the tradition that Beato captured in these photos was soon to disappear.

Beato used a wet collodion method to produce his images, creating albumen prints from glass negatives. The black-and-white prints were hand-painted with watercolors, oils, and dyes to create one of the earliest forms of color photography. Beato's photos and albums were very popular in Japan, and remained so after he moved on to Africa to cover the Anglo-Sudanese wars before settling in Burma. **CP**

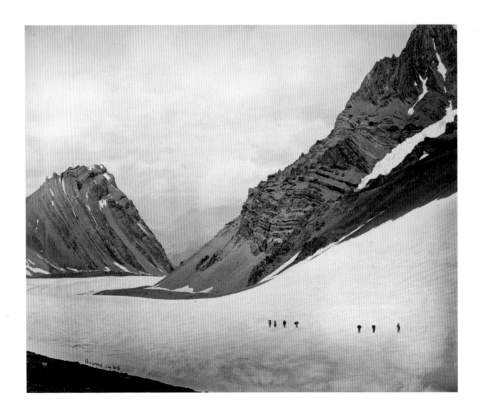

THE MANIRANG PASS BETWEEN THE SPITI VALLEY AND THE ROPA VALLEY OF KINNAUR DISTRICT IN INDIA

SAMUEL BOURNE

Date 1866
Location Manirang Pass, India
Format Wet collodion negative

Having established his reputation with a series of photographs of the English Lake District, Samuel Bourne (1834–1912) set off in 1862 for India, where, with fellow photographer Charles Shepherd, he set up a studio that remained in business until 2016.

Meanwhile, Bourne mounted a series of expeditions across the Asian subcontinent. Over a six-year period, he amassed more than 2,200 glass plate negatives, using the wet collodion process. His work displays a fine sense of composition and

light and remains a significant document of the region, unsurpassed at the time in its scale, scope, and striking beauty.

Perhaps Bourne's most dramatic achievement was his trek to Manirang Pass, at an elevation of over 18,600 feet (6,500m) in Himachal Pradesh, on the way to the remote valley of Spiti. He was accompanied by a team of thirty people to help carry his supplies, which included 650 large glass plates of various sizes and all the chemicals needed to process them in the field. The resulting photographs held the record for the highest-altitude photographs at the time. The trip produced 147 exposed negatives, including this image, which captures some of the splendor of the Himalayas. PL

PHOTOCOLLAGE FROM THE BERKELEY ALBUM

GEORGINA LOUISA BERKELEY

Date 1867–71
Location London, UK
Format Composite photocollage

The Berkeley Album, created by Georgina Louisa Berkeley (1831–1919), the great-granddaughter of the fourth Earl of Berkeley, is an intriguing example of the Victorian trend for photocollage. Such scrapbook-like albums, predominantly a pastime of educated society ladies, often show extraordinary creativity and wit, combining personal photography collections (including cartes de visite) with watercolors and drawings. The 1860s and 1870s saw a huge rise in the accessibility of photography,

allowing for such playful experiments long before the embrace of photocollage by avant-garde art.

Ladies would cut and paste photographs to depict their unique commentary on issues such as fashion and art, social hierarchies and convention, and scientific advances of the day. Berkeley was related to Lord Byron, and her album references aristocratic families such as the Penrhyns, the Cavendishes, the Smith-Marriotts, and the Douglas Pennants. Each carefully rendered element of her collages tells us much about her life and the society in which she lived. With great wit and a surreal sense of humor, she created an *Alice in Wonderland*–like world full of fun and fantasy, but also shot through with sharp social insights. JG

IAGO, STUDY FROM
AN ITALIAN, 1867

JULIA MARGARET CAMERON

Date 1867
Location UK
Format Albumen print

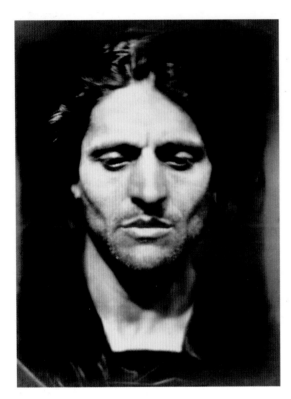

Julia Margaret Cameron (1815–79) took up photography in 1863 after she received a camera as a gift from her daughter. In little more than a decade she went on to produce a collection of unrivaled portraits of influential artistic and literary figures, family, friends, and servants—works characterized by their intensity and intimacy. Largely self taught, Cameron transformed the photographic aesthetic and immortalized the Victorian age. Combining an unorthodox technique with a deeply personal vision, she set out to show that photography could rightfully be placed alongside painting, sculpture, and other established art forms.

Cameron had a great love and knowledge of literature. She found inspiration in the works of contemporaries, such as her good friend, the poet Alfred Lord Tennyson, and also earlier literary giants, such as William Shakespeare. The subject of this powerful portrait is Iago, the villain of Shakespeare's *Othello*. Close up and full face, Iago is portrayed with no props and with only the hint of a costume. The emotional intensity of the portrait is conveyed by the strong shadows, downcast eyes, and firm jawline.

Cameron subtitled this portrait *Study from an Italian*. This is a reference to her use of a human model—the only occasion on which she is known to have used the services of a professional male mannequin. The sitter had been identified as Angelo Colarossi, but recent research has suggested that he might be another Italian model, Alessandro di Marco. One of Cameron's best-known works, only one print of this iconic portrait is known to exist. **CH**

"From the first moment I handled my lens with a tender ardor . . . it has become to me as a living thing, with voice and memory and creative vigor."

Julia Margaret Cameron

THE SHIRT OF THE EMPEROR, WORN DURING HIS EXECUTION

FRANÇOIS AUBERT

Date 1867
Location Mexico
Format Unknown

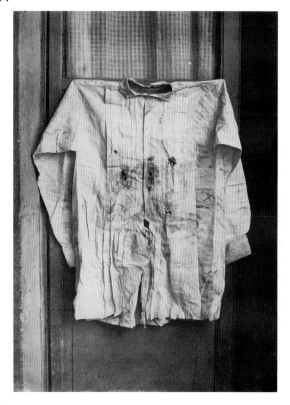

The forensic nature of this unsettling image gives it a power that stays in the mind and haunts the imagination. It shows the bloody shirt worn by the ill-fated Austrian Archduke Maximilian I, a naive liberal. He was appointed Emperor of Mexico by Napoléon III in 1864, but was executed in the Cerro de las Campanas in Querétaro on June 19, 1867 by the nationalist followers of Benito Juárez after the French withdrew their support for him.

François Aubert (1829–1906) was a French painter and photographer who emigrated to Mexico in 1864 and soon became the semiofficial photographer to the new imperial court and the city's burgeoning middle classes. He evidently used his connections to acquire admission to the grim spectacle of this execution and took full advantage of the opportunity by photographing the firing squad in action and Maximilian's body in its casket afterward. Nevertheless, it is perhaps the image shown here that is the most powerful—the delicate nature of the thin cloth that hangs as if awaiting the return of its owner. The materiality of the garment, rent by bullets, suggests the fragile nature of both life and worldly power, and the striking abstraction of the hanging fabric is potentially even more troubling than the dead body itself would have been.

Aubert's photographs of the developing drama are perhaps best known as the source material for *The Execution of Emperor Maximilian* (1867–69), a series of five oil paintings by the French Impressionist Édouard Manet, which depicted the moment when the riflemen's bullets ripped through the white shirt of the hapless victim. PL

"I will die for a just cause, that of the independence and freedom of Mexico. Let my blood seal the misfortunes of my new homeland."

Maximilian I, last words

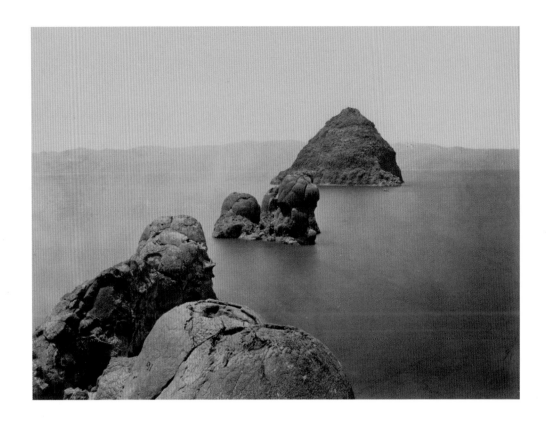

THE PYRAMID AND DOMES, PYRAMID LAKE, NEVADA

TIMOTHY H. O'SULLIVAN

Date 1867
Location Nevada, USA
Format Wet collodion negative

Timothy H. O'Sullivan (c. 1840–82) started out as an assistant to Mathew Brady in what was known informally as "the photographic corps" during the American Civil War (1861–65). Brady later quarelled with another of his assistants, Alexander Gardner, who left to set up his own studio. O'Sullivan joined Gardner in 1863 and contributed to *Gardner's Photographic Sketch Book of the War* (1865–66), notably his poignant image of the casualties of Gettysburg, entitled *A Harvest of Death*. O'Sullivan's

experiences in the field in handling the technically challenging medium of wet collodion glass plates helped him to secure a position in 1867 as a photographer for the Geological Exploration of the Fortieth Parallel, aka the King Survey, after its leader, Clarence King. This mission was charged with surveying the natural resources and geological formations along the new railroads of the US frontier.

O'Sullivan's topographic images represented the terrain as untamed, with a strong personal vision that subverted established conventions of landscape painting, combining the accuracy of science with the cool eye of art. This is a striking view of the tufaceous domes in the Pyramid Lake, 40 miles (64km) northeast of Reno, Nevada. **PL**

TERNATE, MALAGASY, MALE, 25 YEARS OLD; FULL LENGTH; FULL FACE

JOHN LAMPREY

Date 1868
Location Unknown
Format Albumen print

John Lamprey was librarian of the Royal Geographical Society and assistant secretary of the Ethnological Society of London. Little else is known about him, apart from his one notable contribution to photography: the creation of one of the first systematized methods of producing anthropometric photographs.

Photography had begun to play a prominent role in the ethnological studies used to document the people of the British Empire. However,

photography's perceived usefulness in this role was undermined by the inconsistency with which it was employed in works like *The People of India* (1868), an epic eight-volume photographic study by John Forbes Watson and John William Kaye.

As a solution Lamprey proposed a system of two full-length portraits—full frontal and in profile—in front of what became known as the Lamprey grid, a backdrop of silk threads at two-inch (5cm) intervals. This allowed for more accurate comparison of subjects across sets of images that might have been taken by different photographers thousands of miles apart. Other photographers developed similar systems, but Lamprey's was the most effective because it was the simplest. **LB**

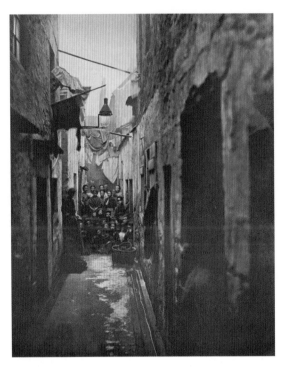

CLOSE, NO. 118 HIGH STREET

THOMAS ANNAN

Date 1868
Location Glasgow, UK
Format Carbon print

The Industrial Revolution brought prosperity to Glasgow, but with the wealth came a great influx of workers and a 400 percent increase in the resident population between 1800 and 1850. The city struggled to cope. The poor were crammed into squalid slums at the heart of the city. Frederick Engels, who visited Glasgow in 1844, wrote: "I did not believe, until I visited . . . Glasgow, that so large an amount of filth, crime, misery, and disease existed in one spot in any civilized country." By the 1860s, the situation had become so bad that the authorities were forced to take action, forming a Glasgow City Improvement Trust with sweeping powers to replace the slums with better housing.

The trust commissioned Thomas Annan (1829–87), a Scottish commercial photographer, to document the slum areas before their demolition. Facing enormous technical difficulties due to the lack of light, Annan used the wet collodion process to photograph the dark and narrow alleyways and tenements. In 1868 he presented the city council with a bound set of thirty-one albumen prints. Although they were intended to provoke social change, Annan's photographs are now recognized as some of the earliest and most important examples of social documentary photography.

Ten years later Annan's photographs were published as carbon prints in a limited edition of 100 copies. In 1900, thirteen years after Annan's death, his son, James Craig Annan, who was himself a distinguished photographer, published his father's photographs as a series of photogravures titled *The Old Closes and Streets of Glasgow*. **CH**

"Through his dispassionate attention to the visual, Annan initiated what later came to be known as the documentary tradition."
National Galleries of Scotland

A PATIENT RESTRAINED FOR THE PURPOSES OF PHOTOGRAPHY

JAMES CRICHTON-BROWNE

Date 1869
Location Wakefield, UK
Format Glass plate

James Crichton-Browne (1840–1938) was born into a prominent scientific family: his father was a pioneering psychiatrist and the coauthor with relatives of books on mental illness and the subsequently discredited pseudoscience of phrenology. Crichton-Browne studied medicine, and in 1866 was appointed medical director of the West Riding Pauper Lunatic Asylum in Wakefield, England. There he instituted wide-ranging innovations that greatly improved conditions at the hospital, reducing the use of restraints on patients and instead employing activities, therapies, and drugs, some of which he first tested on himself.

In his use of photography, Crichton-Browne was significantly influenced by pioneers such as French neurologist Duchenne de Boulogne, whose images were intended to reveal processes and conditions that were subtle or invisible to the naked eye.

Similarly, Crichton-Browne's photographs sought to document specific conditions, such as "imbecility" or "acute melancholia," with a view to categorizing and perhaps eventually treating them. Many of his images provide emotionally powerful records of people who, as the nineteenth century progressed, were increasingly moved out of public view and into secluded institutions. In the image shown here, Crichton-Browne also captures the repressive side of mental health care of the period. The photograph is a reminder that, despite his enlightened attitude, the general approach to people with mental illnesses was driven more by the perceived need to control them than the wish to alleviate their suffering or cure them. LB

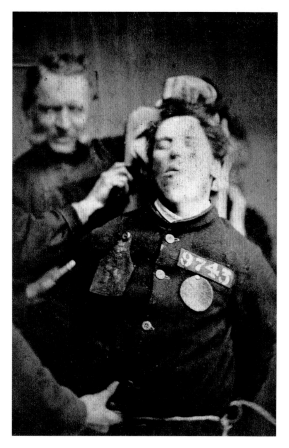

"Crichton-Browne can be construed as more than someone who successfully . . . integrated neurological research with asylum administration."

Michael Neve and Trevor Turner

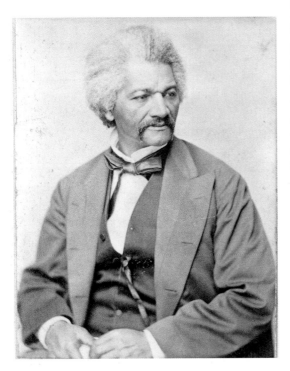

FREDERICK DOUGLASS

GEORGE FRANCIS SCHREIBER

Date 1870
Location Philadelphia, Pennsylvania, USA
Format Glass plate

This compelling portrait of the African-American orator and social reformer Frederick Douglass was taken in Philadelphia by the renowned studio of Schreiber & Sons (founded by George Francis Schreiber, 1803–92), which was also notable for its fine studies of thoroughbred horses. The photograph was one of more than 160 taken during Douglass's lifetime, making him the most photographed American of the nineteenth century.

Douglass was a former slave who escaped his captivity in Maryland to become a national leader of the abolitionist movement. His fierce intellect and powerful speeches gave lie to the myth that slaves were unintelligent and unable to contribute to civic life. Douglass believed that the cause of freedom was worth fighting for, arguing that "I would unite with anybody to do right and with nobody to do wrong." He realized the power of photography to communicate ideas and wrote several essays arguing for the value of the visual, commenting: "The few think, the many feel, the few comprehend a principle, the many require an illustration." He felt that art was needed to spur the public into action by mobilizing "the soul of truth."

Douglass sat for his first daguerreotype in 1841, shortly after gaining his freedom, and continued to have his portrait taken until his death, forming an extraordinary document. The images were widely circulated, and many have since become rallying points for the struggle for African-American rights. Douglass often posed for photographers associated with the antislavery movement, such as Ezra Greenleaf Weld, Benjamin Reimer, and John White Hurn. **PL**

"By their own appliances [Messrs. Schreiber & Sons, of Philadelphia] have demonstrated their ability to make not only truthful, but elegant pictures."

Wallace's Monthly, October 1875

CHINESE PRISONERS WITH CANGUES

LAI AFONG

Date c. 1870
Location Hong Kong, China
Format Glass plate

Lai Afong (c. 1839–90), aka Lai Fong, was arguably the most successful and famous Chinese commercial photographer of the nineteenth century. He owned the longest-established photography studio of the time in Hong Kong, which opened in 1859 and continued to operate until the Communist Revolution. Lai photographed a wide range of subjects, including portraits of wealthy Chinese, landscapes and topographic views, and moments of daily life. His images offer a rare and fascinating insight into Chinese society, which he gained through his access to regions and places that were barred to foreign photographers.

Little is known about the development of the photography industry in China, but most of the early practitioners were export trade painters who learned their craft as assistants to Westerners. They quickly mastered the profession and even hired Western photographers in their own studios. Lai cultivated friendships with Westerners and greatly impressed the Scottish photographer John Thompson, who wrote that Lai had "exquisite taste, and produces work that would enable him to make a living even in London." Lai's images were seen as highly collectible, and many were exported from China to the West.

In this disturbing image, Lai recorded the use of the cangue, a brutal device that was used for corporal punishment and public humiliation in China until the early years of the twentieth century. Devices of this kind restricted the wearers' movements, preventing them from feeding themselves and often proving lethal as the victims starved to death. PL

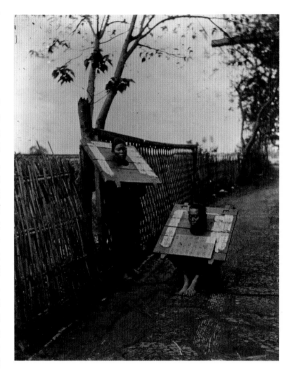

"Lai's serene compositions reflected the conventions of the long-standing tradition of Chinese landscape painting."

Encyclopedia Britannica

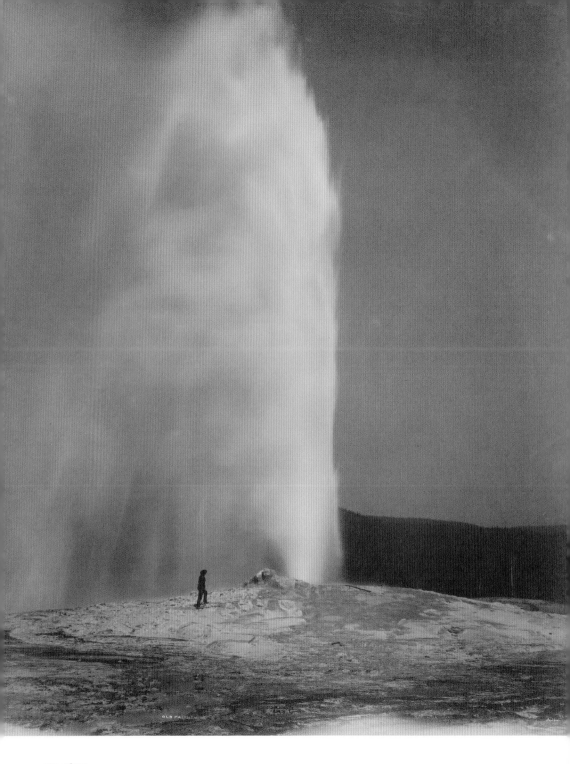

OLD FAITHFUL

WILLIAM HENRY JACKSON

Date 1870 Location Yellowstone National
Park, Wyoming, USA
Format Mammoth-format plate

William Henry Jackson (1843–1942) served in
the Union army during the American Civil War
(1861–65). Two years after the end of the conflict
he opened a photography studio with his brother
Edward, but shortly thereafter embarked on the
travels that would define his career: exploring the
American West as it was opened up by the newly
laid railroads.

Between 1870 and 1879, Jackson photographed
extensively in Utah, Wyoming, Montana, and
Colorado as a member of the US Geological
and Geographical Survey of the Territories.
He worked on a monumental scale, using the
mammoth size of glass plate negatives measuring
20x24 inches (51x61cm). The trips were arduous,
not merely because of the inhospitable terrain,
but also because of the need to prepare, expose,
and develop the plates using the wet collodion
process, which could take more than an hour
per exposure to complete. Jackson eventually
discovered that washing the plates in hot water
from natural springs could halve the drying time.
He traveled with a team of five to seven men
armed with rifles, carrying the heavy equipment
on mules. On one occasion, when one of the
pack animals fell, the plates were broken, and he
lost a whole month's work, forcing him to return
to the same landscapes again to remake the
photographs.

This is Jackson's imposing and dramatic image
of Old Faithful, the geyser in Yellowstone Valley
that regularly spurts thousands of gallons of steam
and water more than 170 feet (52m) into the air
around eleven times a day. PL

CORCOVADO

MARC FERREZ

Date 1870
Location Rio de Janeiro, Brazil
Format Panoramic

French émigré Marc Ferrez (1843–1923) documented
the emergence of his adopted homeland of Brazil
as a nation-state. He was one of the first artists to
use the panorama, an experimental technique
new to photographers of his era.

Ferrez became known for his depiction of the
urban landscapes of Rio de Janeiro. After a fire
destroyed his studio in 1873, he returned to Paris,
where he purchased the panoramic camera that
could capture 180-degree views and that would
become a hallmark of his style.

In 1870, Ferrez took this photograph of the
Corcovado (meaning "hunchback" in Portuguese)
that reads "Entrance to Rio" in French. The
Corcovado is now known mainly for the statue of
Christ the Redeemer, which was installed on the
mountaintop in 1931, but Ferrez's view provides
an early insight into the imposing position of
the mountain above the developing city on the
sheltered bay. SY

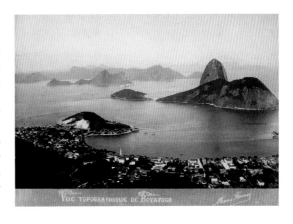

PORTRAIT OF WILFRID SCAWEN BLUNT

LADY ALICE MARY KERR

Date c. 1870
Location Unknown
Format Glass plate

The portrait is one of the defining themes of photography, seemingly offering a window into the soul of the subject. The greatest portrait photographers are able to ascertain the most photogenic and compelling viewpoint from which to observe the human face and to offer psychological and emotional insights into the character of the sitter. Soon after the invention of photography, the formal portrait became one of the most popular forms of the new medium, and businesses offering lifelike mementos flourished. The long exposure times needed for early cameras usually meant that the poses of the subjects were stiff and formal and were often presented against studio backdrops with various props that were meant to suggest the occupation or personality of the subject. However, a few early pioneers of the genre made less formal images that were stripped down to the essentials of the human physiognomy, concentrating the attention purely on the face. Notable among these was Julia Margaret Cameron, whose shallow-focus portraits of Victorian celebrities are some of the most affecting studies of the human visage ever made.

Lady Alice Mary Kerr (1837–92) may have been influenced by Cameron's groundbreaking work. She came from a wealthy Scottish noble family and mostly photographed her immediate social circle. Few of her photographs survive. Her powerful frontal study of the youthful and rebellious English poet and writer Wilfrid Scawen Blunt concentrates the viewer's attention on his gaze, his face looming out of the darkness, creating a dramatic and compelling effect. PL

"Portraiture . . . had developed into a major industry by 1850. But some of the best work was, in fact, being produced by amateurs, among them Lady Alice Mary Kerr."

Creative Review

UNTITLED
(MAN SELLING MUMMIES)

FÉLIX BONFILS

Date c. 1870
Location Unknown
Format Glass plate

Félix Bonfils (1831–85) trained as a bookbinder. In 1860 he joined a French expeditionary force on its mission to the Ottoman territory of Syria, where it sought to protect the minority Christian population. On his return to France, Bonfils began to practice as a photographer, and 1867 he relocated his family to Beirut, where he opened a photography studio. In the following years he traveled extensively around the Middle East, photographing landscapes and people, and also staging scenes from literature and the Bible, in the process producing an output that has been estimated at 15,000 prints of Egypt, Palestine, Syria, and Greece, and as many as 9,000 stereoscopic photographs.

Bonfils and his wife and son (themselves accomplished photographers) were operating in a period of enormous change for the region, as locations that had been unaltered for centuries began to modernize and opened up to increasingly large numbers of European tourists. This was a lucrative commercial opportunity, and Bonfils cannily marketed his photographs as souvenirs. For a time there had been a vogue for bringing back Middle Eastern artifacts, particularly mummies, as souvenirs. Mummies were also used for a variety of other purposes, including as medicines, pigments, and fuel, which led to extensive tomb robbing and inevitably a decline in supply, in turn initiating a trade in counterfeit mummies, which were often, in fact, recently deceased bodies that had been dressed or prepared to look older than they really were. Bonfil's photographs offered tourists a far more affordable and significantly less macabre way to remember their travels. LB

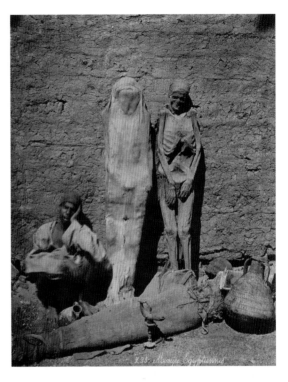

"Bonfils was an accomplished commercial photographer, who made beautiful, if conventional, images to satisfy a broad audience."

Andrew Szegedy-Maszak

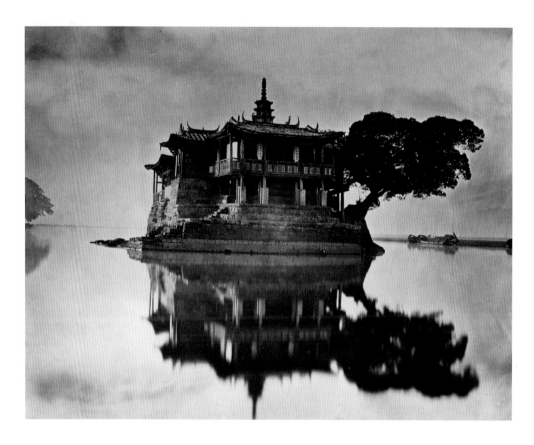

THE ISLAND PAGODA

JOHN THOMSON

Date 1870
Location Fuzhou, China
Format Carbon print

Scottish photographer John Thomson (1837–1921) undertook four momentous journeys through China. He traveled up the Pearl River, up the Min River to Fuzhou, to Beijing, and finally up the Yangtze River. After he returned to Britain in 1872, he set in motion plans to publish a selection of his China photographs in book form. In 1873 *Foochow and the River Min* appeared. This privately produced edition of only forty-six copies is regarded as one of the most beautiful, photographically illustrated books

of all time. In 2012, a copy was sold at Sotheby's in London for £350,000 ($425,000), a world record for a book of photographs.

The image reproduced here is one of the highlights. The Jin Shan ("Gold Mountain") Temple has sat on an island on the Min River for nearly 1,000 years. Thomson photographed the temple from a low viewpoint, close to the surface of the river, and from a position where the building appears totally isolated. The mist has made the surrounding hills invisible, and the long exposure has turned the river into a mirror, as if the temple were resting on a sheet of glass. The result is an image of near-perfect serenity, with echoes of Buddhist-inspired landscape paintings by Chinese artists. CH

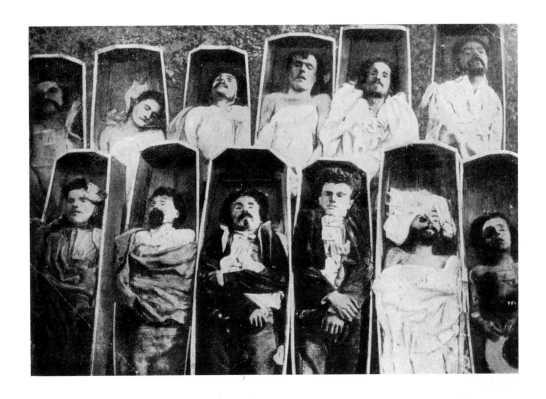

DEAD COMMUNARDS

ANDRÉ-ADOLPHE-EUGÈNE DISDÉRI

Date 1871
Location Paris, France
Format Glass plate

André-Adolphe-Eugène Disdéri (1819–89) was caught up in the violent events of the Paris Commune, the radical attempt at a socialist government, whose proponents (Communards) controlled the French capital from March to May 1871 until they were overthrown by government troops during *La semaine sanglante* ("the Bloody Week"). Many of the revolutionaries were killed in the fighting, and many more were summarily executed after the military rounded up thousands of suspected Communards. Estimates of the total casualties vary from 6,000 to 20,000. Disdéri initially documented the physical destruction of the city's architecture, touring Paris in a darkroom on wheels, photographing the destroyed Tuileries Gardens and burned-out civic buildings. He later published these images in an album titled *Ruines de Paris et de ses Environs*. He also took this disturbing image of the bodies of dead Communards laid out in their caskets but did not publish it in the album. The exact circumstances are unknown, but one theory is that Disdéri was commissioned by the authorities to record the faces of the revolutionaries, and perhaps the corpses were shown on film as a warning to others of the price of dissent. PL

THE CRAWLERS

JOHN THOMSON

Date 1877
Location London, UK
Format Woodburytype

Between 1862 and 1872, John Thomson (1837–1921) traveled extensively in Asia, photographing in Malaysia, Siam, Cambodia, and China. Following his return to Britain, he settled in London, where he began the project for which he is now best known. *Street Life in London*, which documented the day-to-day living conditions of the city's poor, first appeared in 1877 as a monthly magazine. Each issue contained three of Thomson's photographs. At the end of that year, the work was published as a book, with the same title. For *Street Life*, Thomson collaborated with well-known journalist and social reformer Adolphe Smith, who contributed the essays that accompanied Thomson's photographs.

The most famous image in *Street Life in London* is *The Crawlers*. This portrait, perhaps more than any of the others, expresses most movingly the misery and hopelessness of urban poverty. Too weak even to beg, crawlers crawled on their hands and knees, relying on the charity and sympathy of passersby to survive. In Smith's words, they have been "reduced by vice and poverty to that degree of wretchedness which destroys even the energy to beg." The woman is not the infant's mother; she is babysitting the child while the mother is at work. Despite the book's claims to "unquestionable accuracy," all of Thomson's photographs were very carefully staged, with the full knowledge and cooperation of his subjects. Given the state of photographic technology in the 1870s, spontaneous, candid photography was impossible. However, Thomson's photographs appear naturalistic, because the subjects and surroundings are always authentic. **CH**

"It is apparent that [Thomson] was not as dispassionate about his subjects as his documentary style suggests."

wolvesphoto.wordpress.com

"HOOKEY ALF"
OF WHITECHAPEL

JOHN THOMSON

Date 1877
Location London, UK
Format Woodburytype

John Thomson (1837–1921) was a pioneering social documentary photographer who is regarded as a forerunner of modern photojournalism. Born in Edinburgh, Scotland, he traveled widely before settling in Brixton, south London, in 1872. There he teamed up with a radical journalist, Adolphe Smith, and together they produced the book *Street Life in London*, published in 1877. This work portrayed the hard experiences of laborers in London, providing a sympathetic account of the lives of the poor in the city and trying to challenge attitudes to working people.

This photograph depicts a scene from the life of Ted Coally, or "Hookey Alf" as he was known. Though clearly arranged, it attempts to convey a sense of social realism. Hookey Alf waits outside a Whitechapel pub hoping to attract work from passing coal merchants. The older woman at the table has a rather troubled expression, perhaps reflecting the hardships faced in her world. The young girl appears to have wandered into the frame almost by chance; she adds an air of authenticity to the image and also hints at a well-documented Victorian theme—that of the child having to lead home a drunken parent.

Thomson's sympathies were aroused by the story of Hookey Alf's life. Apprenticed in a brewery, Alf suffered a serious accident that left him with epilepsy and a hook after his left arm was amputated. He resorted to whatever casual labor he could find to support his family. Thomson and Smith presented Hookey Alf not as feckless and irresponsible, but as a dignified man worthy of respect and sympathy. CJ

"There is no sight to be seen in the streets of London more pathetic than this oft-repeated story—the little child leading home a drunken parent."

Street Life in London

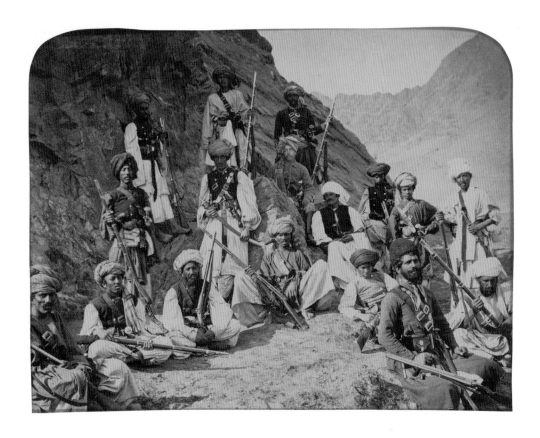

PESHAWUR VALLEY FIELD WARRIORS RESTING AGAINST A HILLSIDE

JOHN BURKE

Date 1878
Location Peshawar Valley, Afghanistan
Format Glass plate

John Burke (died 1900) was the first photographer to make pictures in Afghanistan, when he accompanied British forces during the Second Anglo-Afghan War (1878–80). As well as topographic scenes of the mountains and British encampments, he made large-scale group portraits of the soldiers, since the heart of his business was selling photographs to the officers and units involved in the campaign. A whole album cost 230 rupees, which was about half the monthly salary of a colonial official, so it was a major investment; most of these collections were commissioned by regimental museums or by leading commanders for their personal libraries; the viceroy of India, Lord Lytton, gave an album to Queen Victoria. Burke was also working for *The Graphic*, a weekly newspaper in London, and it is likely that Frederic Villiers, the publication's war artist, copied directly from Burke's plates and sent the drawings back to London. By the standards of the day, they arrived very quickly, with six to eight weeks between Burke photographing an event and the etching being published. In this striking image, the British officer is surrounded by soldiers of the Indian units with whom he fought. PL

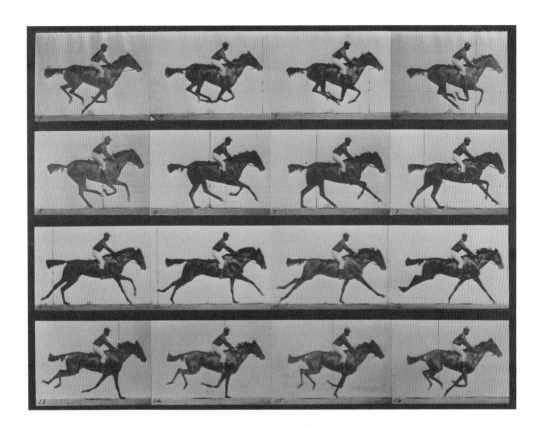

SALLIE GARDNER AT A GALLOP

EADWEARD MUYBRIDGE

Date 1878
Location Palo Alto, California, USA
Format Composite from multiple glass plates

Eadweard Muybridge (1830–1904) was hired by wealthy industrialist Leland Stanford to determine whether there was a moment during a horse's gallop when all four of its feet left the ground. The movement was too quick for the human eye to perceive, and had always been a matter of debate.

Photographic technology at the time was basic, and answering Stanford's question required considerable innovation. Muybridge assembled a row of cameras, each spaced around 27 inches (69cm) apart and mounted with a new design of high-speed shutter. Each camera was triggered by a trip wire as the horse passed in front of it.

His first successes with these experiments came in 1877, but since the resulting images were retouched before publication, there was still some doubt about whether they were genuine. In June 1878, in front of an audience of journalists, Muybridge recorded the mare Sallie Gardner galloping down the track at Stanford's Palo Alto horse farm. The results, arrayed as a grid of sixteen images, answered the question once and for all: all four hooves do indeed come off the ground, but while they are all pulled in, not while they are outstretched. LB

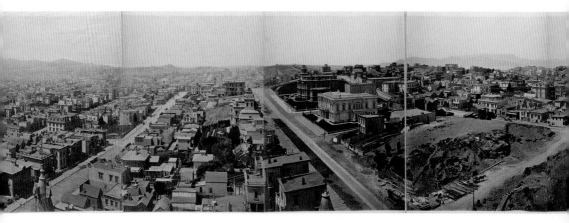

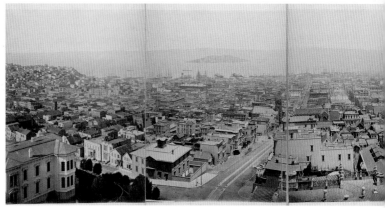

PANORAMA OF SAN FRANCISCO

EADWEARD MUYBRIDGE

Date 1878
Location San Francisco, California, USA
Format Panorama

Born in Kingston upon Thames, England, Edward Muggeridge (1830–1904) styled himself "Eadweard Muybridge" from a young age because he believed that that was the original Anglo-Saxon version of his name. He emigrated to the United States in 1850 at the age of twenty. During his first few decades in the country, he carried out a variety of

jobs, including working as a publisher's agent and bookseller in New York and then as a commercial photographer operating under the trade name Helios, after the Greek god of the sun.

Muybridge then returned to Britain, where he honed his photographic techniques, and then in 1867 he set sail again, this time to try his luck in California. There, he quickly established his reputation as a photographer with a technically accomplished and commercially successful series of images of the Yosemite Valley area. As soon as he settled in San Francisco, he was inundated with lucrative, official commissions, including one to

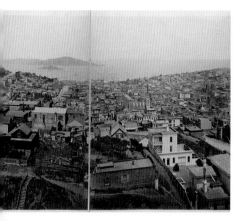

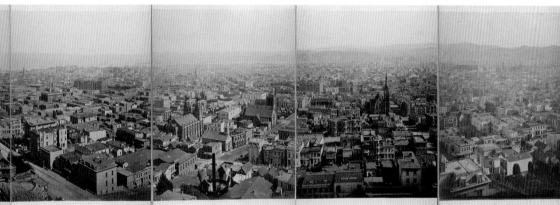

document construction of the San Francisco Mint at 88 Fifth Street, for which he employed time-lapse photography.

The enormous city panorama reproduced above shows Muybridge continuing to push his photographic abilities and equipment to the limits. Taken from Nob Hill and composed of thirteen separate images, each produced on a mammoth-format wet collodion plate, the result is an intensely detailed 360-degree view of the city.

As well as a notable technical achievement, this group of photographs is a remarkable historical document of a city at the heart of the West's new frontiers. Over the course of just thirty years, San Francisco had been swollen by the lure of the Gold Rush (1848–55) and a host of attendant commercial opportunities. During this boom period, the settlement grew from a town of around 1,000 inhabitants to a metropolis with a population of more than 200,000.

After an eventful life—during the course of which he survived a major stagecoach crash, killed the man with whom he suspected his wife of having an affair, and was acquitted of his murder—Muybridge retired in 1894 to his native Britain and died there peacefully ten years later. LB

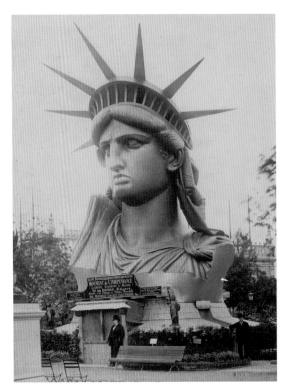

PUBLIC EXHIBITION OF THE STATUE OF LIBERTY'S HEAD

CHARLES MARVILLE

Date 1878
Location Paris, France
Format Glass negative

Charles Marville (1816–c. 1879) was born in Paris and worked there for most of his life. He began as a wood engraver and illustrator, but took up photography in about 1850. He made studies of landscapes and architecture throughout France, Germany, and Italy, but his native Paris was his primary subject matter and source of inspiration. From 1862, as official photographer for the city of Paris, Marville documented the radical rebuilding and modernization projects initiated by the Emperor Napoléon and Baron Haussmann. Commissioned by the Service des Travaux Historiques, he took hundreds of photographs of districts that were scheduled for demolition. In 1877 he was commissioned once more, this time to record the modern, wide boulevards that had swept away the earlier, medieval streets.

Alongside Albert Fernique and Pierre Petit, Marville was among the photographers chosen by sculptor Frédéric Auguste Bartholdi to document the construction of his greatest work, the Statue of Liberty. When Liberty's head was completed in 1878, Marville photographed it on exhibition at the third Paris World's Fair on the Champ de Mars esplanade, with its associated souvenir stand. The completed statue was eventually presented as a gift to the United States from the people of France, and was shipped to New York in 1885.

By the time of his death, Marville had fallen into relative obscurity, with much of his work stored in municipal or state archives rather than museums or galleries. However, he is now acknowledged as one of the most talented photographers of the nineteenth century. CH

"The entire promotional phase and diffusion of images of the Statue of Liberty is through photography—because Bartholdi had a lot of trouble financing the project."

Sam Stourdzé

SELF-PORTRAIT WITH
A BICYCLE

FRANCES BENJAMIN JOHNSTON

Date 1880
Location Washington, D.C., USA
Format Glass plate

Frances Benjamin Johnston (1864–1952) was one of the female pioneers of photography as a profession. In her sixty-year career as a photographer, she worked in a variety of genres—including portrait, news, and documentary, later shifting her focus to architecture and gardens—concluding her work with a survey of historic buildings in the southern United States.

Johnston was given her first camera by George Eastman, inventor of the Kodak camera and a close friend of her family, and worked for the Kodak company in Washington, D.C., developing films and repairing cameras. She set up her own photography studio in 1894, becoming the only female photographer in the US capital at the time. Her society connections allowed her access to the city's elites: she photographed Mark Twain and Booker T. Washington, made Alice Roosevelt's wedding portrait, and became the official White House photographer.

Johnston was a leading proponent of the role of women in the art of photography, curating an exhibition of photographs at the 1900 Exposition Universelle (International Exhibition) that showcased the work of twenty-eight women photographers, and which subsequently toured Russia. In 1897, she published an article, "What a Woman Can Do with a Camera," in *Ladies' Home Journal*, where she maintained that "[t]he woman who makes photography profitable must have . . . good common sense, unlimited patience to carry her through endless failures, equally unlimited tact, good taste, a quick eye, a talent for detail, and a genius for hard work." PL

"Miss Frances Benjamin Johnston is the only lady in the business of photography in the city, and in her skillful hands it has become an art that rivals the geniuses of the old world." *The Washington Times*

MAN WALKING

ÉTIENNE-JULES MAREY

Date 1882
Location Paris, France
Format Glass plate

Étienne-Jules Marey (1830–1904) was a French doctor and an inventor who developed or improved dozens of mechanical devices for the measurement of biological phenomena. Among his achievements was a vast improvement to the sphygmograph, a noninvasive mechanical device for measuring blood pressure.

In the 1880s Marey began to use photography to record things that had been difficult to document: for example, the beating of a bird's wings and the gait of a running man. His work was similar to that undertaken around the same time by Eadweard Muybridge, and there is evidence that the two were aware of each other's work. Marey developed a number of innovations in the course of this research, including a method of creating multiple high-speed exposures on a single plate, as in this image. He also developed a chronophotographic gun, a camera resembling a rifle that could record twelve photographs onto a spinning disk at high speed. These images formed a sequence that could be watched by spinning the disk, thus animating the images into rudimentary movies. **LB**

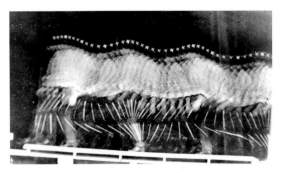

OSCAR WILDE NO. 18

NAPOLEON SARONY

Date 1882
Location New York, New York, USA
Format Large format

Napoleon Sarony (1821–96) was New York's most celebrated portrait photographer. His studio at Union Square employed more than thirty technicians who printed, hand-tinted, painted, and produced his photographs of the celebrities of the day. In a commercial innovation, he would pay the famous sitters a fee for the rights to sell their likeness, reputedly giving actress Sarah Bernhardt $1,500 to pose for his camera. Being photographed by Sarony was a performance worthy of the theater, and aware of the value of self-promotion and a visible brand, he often dressed himself in a fez and military-style uniform. He employed an assistant, Benjamin Richardson, to operate the camera, and would engage the subject in banter and conversation until he felt the moment was right; he would then subtly signal Richardson to fire the shutter. He recalled in an interview: "We photographers have queer experiences. Ours is a most excellent opportunity to study human nature, and making a baby laugh is not the one trick of the calling. In order to take a good photograph one should know something about the sitter's habits and surroundings. This he must learn at a single glance or by an adroit question."

The complexity of this process was a key factor in helping the Supreme Court to decide whether photographs merited copyright protection. Sarony made this study of Oscar Wilde, as usual paying for the rights for the session. When Burrow-Giles Lithograph Co. stole the photograph and published it themselves, Sarony sued. He won damages and the court ruling in his favor established copyright protection for photography in the United States. **PL**

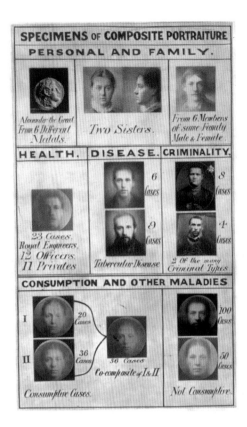

Specimens of composite portraiture. Personal and family. Alexander the Great from 6 Different Medals. Two Sisters. From 6 Members of same family. Male & Female. Health. 23 Cases. Royal Engineers. 12 Officers. 11 Privates. Disease. 6 Cases. 9 Cases. Tubercular Disease. Criminality. 8 Cases. 4 Cases. 2 of the many Criminal Types. Consumption and other maladies. I. 20 Cases. II. 36 Cases. 56 Cases. Co-composite of I & II. Consumptive Cases. 100 Cases. 50 Cases. Not Consumptive.

SPECIMENS OF COMPOSITE PORTRAITURE

FRANCIS GALTON

Date 1883
Location UK
Format Unknown

In the mid-nineteenth century, photography played an instrumental role in the growth of several branches of scientific (and pseudo-scientific) study, including modern social science. Sir Francis Galton (1822–1911), who is best known for developing the science of fingerprinting, was also a pioneer in the use of photography to measure and classify human faces. Galton was a proponent of eugenics—the belief that humanity can be improved through selective breeding and that the propensity for criminality, illness, and other characteristics is inherent in certain types of people. Key to his use of photography was the theory that these propensities can be identified within the facial features. By combining mugshots of certain categories of people (such as smugglers, thieves, "consumptives," and so on), he created composite portraits that he proposed could be used to identify these tendencies. The images were made by layering exposures of a number of faces onto one single plate. Each exposure was allowed only a fraction of the standard time, thus drastically underexposing and deleting any singular features not held in common. This practice, as well as the eugenics movement itself, is now discredited. JG

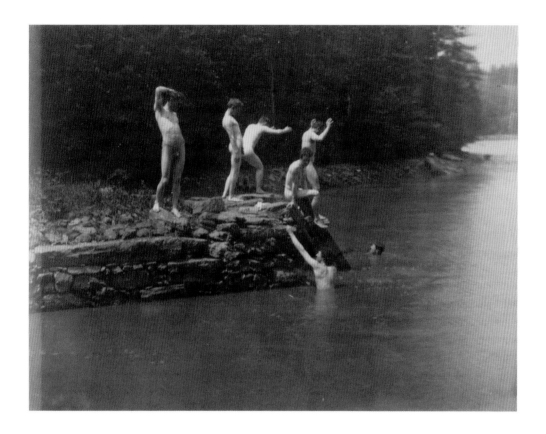

THE SWIMMING HOLE

THOMAS EAKINS

Date 1884
Location Pennsylvania, USA
Format Albumen print

Born in Philadelphia, Thomas Eakins (1844–1916) attended the École des Beaux-Arts in Paris from 1866 until 1870. It was there that as a young artist he first discovered *académies*, photographic nude studies intended for use by students of drawing and painting as an alternative to life models. He introduced them when he began to teach at the Pennsylvania Academy of the Fine Arts in 1873.

Eakins soon began to take photographs of nudes as the basis for his paintings; about half of all the photographs Eakins took are nude studies. Eakins is reputed to have said that a naked woman "is the most beautiful thing there is—except a naked man." His photographs were never intended to be viewed as works of art in themselves.

In 1884, during an outing to Mill Creek, Pennsylvania, Eakins and his students made numerous photographic studies of one another as they bathed. These would eventually be used by Eakins to create what is probably his most famous painting, *The Swimming Hole* (1884–85). The figure standing on the left is Eakins himself.

Eakins was dismissed from his teaching post in 1886 for allowing female students to view a nude male model in their life-drawing classes. CH

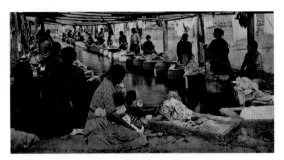

LAVANDERAS (WASHERWOMEN), MEXICO CITY

WILLIAM HENRY JACKSON

Date 1884–85
Location Mexico City, Mexico
Format Photocrom

William Henry Jackson (1843–1942), aka "America's pioneer photographer," was responsible for documenting scenery on the Union Pacific Railroad and other striking landscapes of the western United States. His color photography technique, the Swiss photocrom process, was invented in the mid-1880s and allows black-and-white photographs to be transformed into color lithographs. The advantage of using this process was twofold: Jackson could apply his artistic experience as a colorist to his photographs, and it allowed the mass production of color prints to maximize sales potential.

Jackson also carried his large-format camera to some of the more remote areas of the world and to Mexico, where he recorded the buildings, markets, ranches, and street scenes in Chihuahua, Aguascalientes, San Marcos, and elsewhere. This photo provides an insight into the lives of poor laundrywomen working in squalor in Mexico City, and Jackson captures these women as part of the urban landscape. In the foreground is a woman with her small child, lit in a way that draws attention to her form but which also invites the viewer into the photograph for a closer look. SY

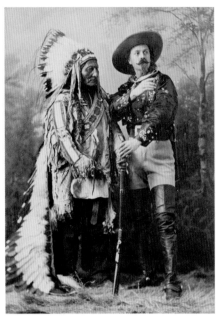

SITTING BULL AND BUFFALO BILL

WILLIAM NOTMAN

Date 1885
Location Montreal, Canada
Format Large format

William Notman (1826–91) was born in Paisley, Scotland, in 1826, and moved to Montreal in the summer of 1856, where he established a successful professional photography studio. He was noted for his innovative techniques in the studio, holding patents for various approaches to recreating snow and winter effects. He also specialized in complex images created from multiple photographs.

In this study of the relationship between two showmen, Buffalo Bill and Chief Sitting Bull, taken during a visit of their famous Wild West review to Montreal, the cowboy's pose looks forced and artificial while his Native American friend seems resigned to the fate of his people in the face of overwhelming European settlement. PL

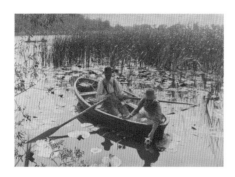

GATHERING WATER-LILIES

PETER HENRY EMERSON

Date 1886
Location Norfolk, UK
Format Platinum print

Peter Henry Emerson (1856–1936) championed a style of photography that he called "naturalistic." In his influential book *Naturalistic Photography for Students of the Art* (1889), he argued that art should imitate nature. Suggesting that nothing in nature is always in sharp focus, he manipulated his camera's depth of field to ensure that the central subject of his composition was in focus while the background and foreground were thrown out of focus. Emerson's views were much debated.

In 1886, Emerson produced a limited-edition portfolio, *Life and Landscape on the Norfolk Broads*, which depicted landscapes and studies of local people at their daily work. Included in this series, *Gathering Water-Lilies* is arguably Emerson's best-known photograph and certainly his most widely reproduced. What, at first glance, appears to be a romantic, idyllic scene is actually an image of a couple at work: the man rows and the woman gathers water-lily flowers to use as bait for fishing. (The flowers were placed in a large bow net that was then sunk to trap tench, a fish common in the vicinity.) Emerson's genius was his ability to take an everyday event with ordinary people going about their daily work routine and transform it into something extraordinarily beautiful. **CH**

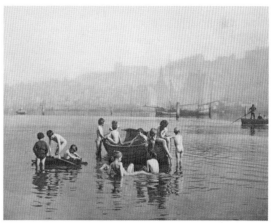

WATER RATS

FRANK MEADOW SUTCLIFFE

Date 1886
Location Whitby, UK
Format Albumen print

Frank Meadow Sutcliffe (1853–1941) spent most of his life as a professional photographer in Whitby, a fishing town in the north of England that was gradually developing into a tourist resort. He earned his living primarily from commercial portraiture, but he also recorded the town and its inhabitants.

Sutcliffe at first used wet collodion plates, switched to dry plates in the 1880s, and then employed snapshot cameras and roll film provided by Kodak. A champion of naturalism, he experimented with differential focus and photographing in mist and fog. Although he embraced the spontaneity that faster photographic plates and "instantaneous" exposures allowed, he occasionally posed his subjects, as in this image.

Sutcliffe later recounted how on one sunny day he spotted a group of young boys truanting from school, paddling in Whitby Harbor. Sensing a photo opportunity, he directed the boys to an empty rowing boat and grouped them carefully, instructing them not to look at the camera. Afterward, he gave each of them one penny. **CH**

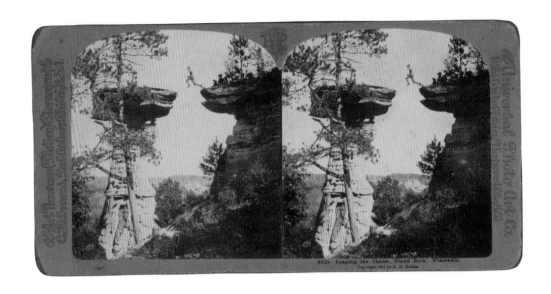

ASHLEY BENNETT LEAPING ACROSS STAND ROCK
IN WISCONSIN DELLS

HENRY HAMILTON BENNETT

Date 1886
Location Wisconsin, USA
Format Glass plate

Henry Hamilton Bennett (1843–1908) was a technical innovator as well as an accomplished artist. After losing the use of his right hand during the Civil War, he used his woodworking skills to develop and make cameras. Preferring to photograph outdoors rather than in the studio, he roamed the hills and forests around Wisconsin Dells, carrying his hand-built wooden camera and portable darkroom. The landscape of the region is marked by deep gorges and sandstone formations, and Bennett

realized that the stereoscopic format was perfect for making the dramatic landscape appear more lifelike and three-dimensional.

Bennett's main technical innovation was the development of a stop-action shutter that enabled him to photograph fast-moving subjects. At the time, moving subjects were always blurred because cameras had no shutter between the lens and the glass plate; they were exposed simply by removing the lens cover for the duration of the exposure and then replacing it. To demonstrate his shutter, Bennett photographed his son leaping between two rock formations in the Dells. Audiences gasped when he displayed the image in public magic lantern shows in Boston in 1890. PL

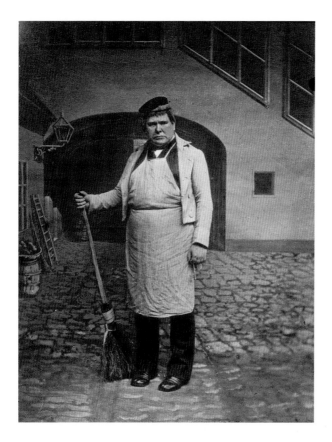

THE CARETAKER

OTTO SCHMIDT

Date 1886
Location Vienna, Austria
Format Hand-colored lantern slide

Very little is known of Otto Schmidt (1849–1920), but this hand-colored lantern slide certainly gives us an insight into how people dressed in nineteenth-century Vienna. As in all good portraits, the posture of the subject speaks volumes, and the full-length figure and his stance give a sense of the dignity of the caretaker profession. In the early days of photography, exposures were very long, due to the low sensitivity of photographic plates, and the caretaker is holding his broom for support.

The magic lantern (*laterna magica*) consists of a small rectangular sheet of glass bearing a painted picture or photograph ("lantern slide"), a projecting lens, and a light source, and is used to project an enlarged image onto an external surface, such as a white wall. A concave mirror behind the light source directs as much of the light as possible through the glass and onward into the lens at the front of the apparatus. Originally, the pictures were hand painted onto the glass using black paint, but soon transparent colors were also used. The main disadvantage of the magic lantern was the weak light source, often a single candle, but the invention of the electric bulb allowed for much larger and brighter projections. **ZG**

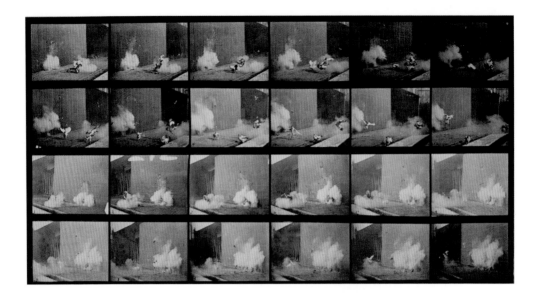

CHICKENS SCARED BY A TORPEDO

EADWEARD MUYBRIDGE

Date 1887 Location Unknown
Format Composite from multiple
glass plates

The 1878 photograph by Eadweard Muybridge (1830–1904) of a galloping horse garnered significant acclaim and inspired him to make further motion studies. In 1882, he quareled with his patron Leland Stanford over the use of his images, resulting in a court case and accusations of plagiarism. The two parted company, and Muybridge sought funding and commercial opportunities to sponsor his work. Henceforth, he undertook increasingly complex arrangements that sometimes employed dozens of cameras triggered by clockwork in order to capture scenes from multiple angles.

After the break with Stanford, Muybridge's studies became more artistically inclined. As well as continuing to document animals in motion, he increasingly photographed people—for example, climbing staircases or pouring water into pots—and in several studies, he stood in as the subject himself, in one case chopping wood while nude. The image above is perhaps one of the strangest motion studies of Muybridge's career and the final plate in his multivolume 1887 publication *Animal Locomotion*. It shows a group of chickens that fly off in different directions after being disturbed by the detonation of an explosive charge. LB

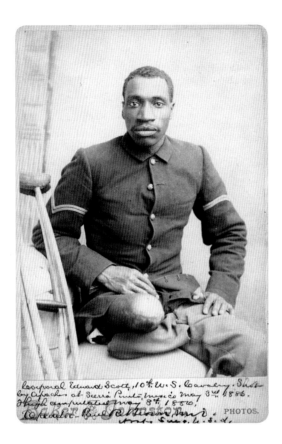

CORPORAL EDWARD SCOTT, US 10TH CAVALRY

BAKER AND JOHNSTON

Date 1887

Location Fort Huachuca, Arizona, USA

Format Glass plate

Corporal Edward Scott was a member of the Buffalo Soldiers, segregated cavalry units composed of African Americans formed after the American Civil War. They were so named by the Native Americans they fought to open up the frontier to the West. Scott was badly wounded in a skirmish with Apache Indians, but his white commanding officer, Lieutenant Powhatan H. Clarke, dragged him to safety. In a letter to his mother, Clarke described how he felt great admiration for the men under his command, noting, "There is not a troop in the US Army that I would trust my life to as quickly as this K troop of ours. I have seen them only once but it was in a place where a stampede would have meant massacre. The firing was at 200 yards from rocks nearly over our heads. No men could have been more determined and cooler than these same darkies were and as for their officers they like them and will risk themselves for them. The wounded Corporal has had to have his leg cut off, the ball that shattered it lodging in the other instep. This man rode seven miles without a groan, remarking to the Captain that he had seen forty men in one fight in a worse fix than he was. Such have I found the colored soldier." PL

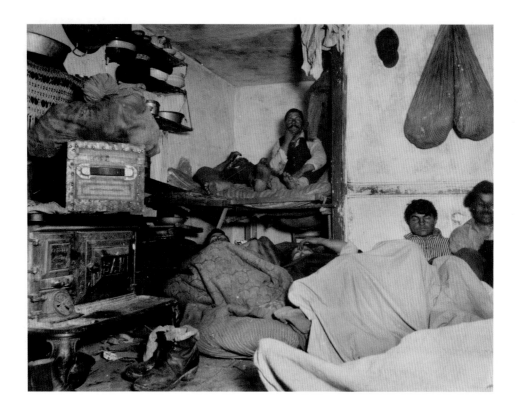

LODGERS IN BAYARD STREET TENEMENT, FIVE CENTS A SPOT

JACOB AUGUST RIIS

Date 1889

Location New York, New York, USA

Format Glass plate

Born in Denmark, Jacob August Riis (1849–1914) emigrated to the United States at age twenty-one years. He arrived at a time of enormous immigration and population growth, particularly in major East Coast cities. After a period as a carpenter and doing odd jobs, Riis became a trainee journalist, later landing a job as a crime reporter on the *New-York Tribune*. This work took him to some of the most impoverished parts of the city. A devout Christian, Riis determined to draw attention to the iniquities.

In 1887, Riis started to experiment with photography as a way to convey the scenes to which he felt unable to do justice in words. In order to cast light on the gloomiest corners of the darkest slums, he employed the newly developed technology of flash lighting, as in this photograph of men sharing a cramped room in a tenement block in Lower Manhattan.

Riis also gave lectures to show the resulting images directly to the public. In 1890, he published a book, *How the Other Half Lives: Studies Among the Tenements of New York*, in which his photos were reproduced in the newly developed halftone. His work helped to inspire social reform, including the Tenement House Law of 1901. **LB**

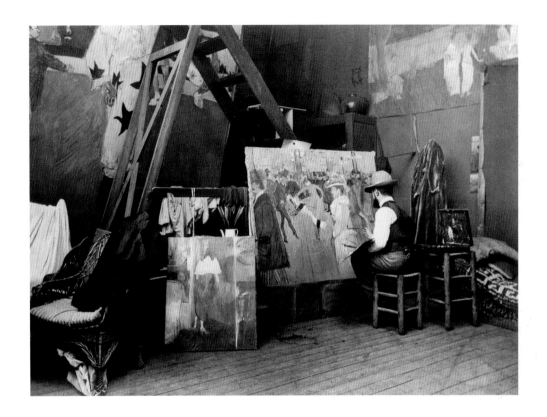

HENRI DE TOULOUSE-LAUTREC PAINTING *LA DANSE AU MOULIN ROUGE*

MAURICE JOYANT

Date 1890
Location France
Format Large format

Maurice Joyant (1864–1930) was an art dealer and amateur photographer who took numerous images of his friend, the artist Henri Toulouse-Lautrec, who apparently never took a single photograph himself. Yet Toulouse-Lautrec very much relied on posters and photographs for inspiration, using them as templates to suggest the compositional ratios, lighting, and scenery of his paintings. Many of his paintings derived directly from photographs taken by his friends. Uniquely for his time, Toulouse-Lautrec operated between the two mediums when painted portraiture was being replaced by that of the silver plates. What he depicted, and how he did so, would have been inconceivable without photography, because the moments he painted clearly reflect the immediacy of a camera's shutter.

From its inception photography was seen as a fundamental challenge to painting, with some even declaring the invention of photography to be the death knell of art. But Toulouse-Lautrec's use of photography as a source for his art was an early sign of the productive coexistence of the two mediums. Just as photographers look to art as inspiration, so do painters look to photographs for unrepeatable situations. **ZG**

THE ONION FIELD

GEORGE DAVISON

Date 1890
Location Mersea Island, UK
Format Photogravure

GEORGE EASTMAN ON BOARD SS *GALLIA*

FREDERICK CHURCH

Date 1890
Location SS *Gallia*
Format Kodak #2 snapshot

George Eastman patented an easy-to-use camera with flexible film on a roll, thereby reducing the cost of photography and making it accessible to everyone. This portrait of Eastman by painter Frederick Church (1826–1900) depicts the inventor with the Kodak #2, introduced in 1889. The company's third camera, it took circular images that the makers claimed meant the operator did not need to worry about holding the camera level. These early Kodaks were known as String-sets because they were armed by pulling a string connected to the shutter mechanism that protruded from the top of the machine. The film was preloaded; once the photographs were exposed, the customer sent the whole camera back to Kodak. There, the film was processed, prints were made, the camera was reloaded with a fresh roll of film, and it was shipped back to the customer. To market the camera, which cost $25, Eastman coined the slogan: "You Press the Button, We Do the Rest." PL

An indefatigable experimentalist, George Davison (1854–1930) was one of the most important figures in the development of pictorial photography at the end of the nineteenth century.

This image, originally titled *An Old Farmstead*, was awarded a medal at the Photographic Society of Great Britain's annual exhibition. To get the desired soft focus, it was taken not with a conventional device but with a pinhole camera. Davison was one of the first to use pinhole photography for pictorial effect.

The Onion Field created enormous interest and controversy. The *British Journal of Photography* thought that it would "probably be the battlefield for the two conflicting sections of photographic art" (those practitioners who championed "straight" photography versus those who explored a more impressionistic aesthetic—often summed up disparagingly as "fuzzy" or "foggy" photography). *The Times* newspaper, however, was unstinting in its praise of Davison's work: "Perhaps no more beautiful landscapes have ever been produced by photographic methods." CH

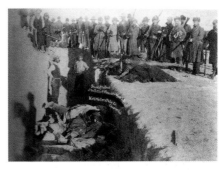

THREE PHOTOS IN A SERIES SHOWING A HYSTERICAL WOMAN YAWNING

JEAN-MARTIN CHARCOT AND ALBERT LONDE

Date c. 1890
Location Paris, France
Format Glass plate

Jean-Martin Charcot (1825–93) was a doctor who trained under Duchenne de Boulogne and became a neurologist at the Pitié-Salpêtrière Hospital in Paris, then the city's largest lunatic asylum for women. He identified and described a series of neurological afflictions, including multiple sclerosis and Parkinson's disease; among his students was Sigmund Freud, the founder of psychoanalysis.

For all his good work, however, some of Charcot's theories were problematic, including his attempts to reintroduce "hysteria" as a medical condition, and his employment of questionable techniques to demonstrate it, such as subjecting patients to hypnosis during public lectures.

In 1878, Charcot hired Albert Londe (1858–1917) as a photographer to document the behavior of his supposedly hysterical patients. Beneath the scientific guise of this project there were subtle photographic manipulations—for example, in the use of artificial lighting, which was sometimes more dramatic than scientific. Beyond his work with Charcot, Londe photographed a range of other subjects using his chrono cameras, and collaborated with Étienne-Jules Marey. **LB**

BURIAL OF THE DEAD OF THE BATTLE OF WOUNDED KNEE

GEORGE TRAGER

Date 1891 Location Wounded Knee Creek, South Dakota, USA
Format Unknown

On December 29, 1890, the 7th Cavalry Regiment of the US Army massacred between 150 and 300 men, women, and children of the Lakota tribe at Wounded Knee Creek in what was the last major armed conflict between the US government and Native Americans. The killing began after the accidental discharge of a rifle by Black Coyote, a deaf Lakota man who did not understand the soldiers' call to disarm. The cavalry used four 336-pound (152kg) rapid-fire mountain guns and mercilessly killed fleeing Lakota in the subsequent hours. It is likely that the massacre was primarily an act of vengeance: in 1876, 268 members of the same cavalry regiment were annihilated by Lakota warriors at the Battle of Little Bighorn in the Montana Territory.

This photograph was taken by George Trager (1861–1948) soon after the massacre. He and his partner, Fred Kuhn, specialized in documenting Native American life and were known as "wigwam photographers." The image of massacre victims lying in a mass grave was erroneously captioned as a depiction of a battle aftermath—foreshadowing the revisionism that has characterized mainstream histories of the colonization of the Americas. **MT**

TRUDE AND I, MASKED, SHORT SKIRTS, 11 P.M., THURSDAY AUG. 6TH, 1891

ALICE AUSTEN

Date 1891
Location New York, New York, USA
Format Glass plate

One of the clues to this photograph's subversiveness is the time it was taken, noted in the title. In 1891 this was not an hour in which young women conventionally donned masks, smoked cigarettes, or photographed themselves in their undergarments. Alice Austen (1866–1952) broke free of the patriarchal confines of Victorian society. She lived with her lover, Gertrude Tate—"Trude" in this picture—until her death, though their families did not allow them to be buried together.

Austen was the first woman on Staten Island, New York, to own a car, and she made use of it to pursue photographic work. She found success as a documentary photographer, taking her practice outside the studio, traveling to nearby states, such as Illinois and Massachusetts, as well as to Europe. Her work photographing the Quarantine Station, through which all immigrants to the United States had to pass, prefigured the photojournalism that would flourish during the next century. Her reach also included street photography and resulted in an 1896 book, *Street Types of New York*.

Austen challenged every aspect of her society, and we are lucky to have a record of her wit, talent, and transgressive spirit. MH

TRIPPERS AT CROMER

PAUL MARTIN

Date 1892
Location Cromer, UK
Format Platinum print

At first, photography was complicated and could be performed only by professionals and wealthy amateurs. In the 1880s, however, technical advances brought increasing speed, mobility, and convenience. Factory-made gelatin "dry" plates obviated the photographers' need to sensitize their own plates. Exposure times were greatly reduced, so "instantaneous" photographs could be taken with handheld cameras. Tripods were no longer essential. One of the earliest exponents of "snapshot"

photography was Paul Martin (1864–1944), a Frenchman who captured late Victorian Britain.

In 1892, Martin bought a Facile hand camera. He modified it by asking a harness maker to make a leather case so that the camera resembled a portmanteau. With his camera tucked unobtrusively under his arm, Martin assembled a collection of candid photographs of daily life, taken without his subjects' knowledge. Martin later wrote: "It is impossible to describe the thrill which taking the first snaps without being noticed gave one."

At the time, some critics thought that Martin was wasting his time on such mundane subjects, but he is now recognized as one of most important pioneers of social documentary photography. CH

NEGATIVE DISCHARGE ON GOLD-COATED PAPER

ALAN ARCHIBALD CAMPBELL-SWINTON

Date 1892
Location Unknown
Format Exposure on gold-plated paper

Alan Archibald Campbell-Swinton (1863–1930) was an electrical engineer who is particularly remembered for his research into the transmission of sound and images, experiments that included work with cathode-ray tubes. He devised the theoretical basis for television several decades before the technology existed to actually build one.

Campbell-Swinton used photography in his research and experiments with electricity and related phenomena. He was credited with making some of the first X-ray images in England just a few months after Wilhelm Conrad Röntgen discovered this form of electromagnetic radiation.

At the end of the nineteenth century, scientists were increasingly turning photography and related methods toward documenting ever more nebulous and invisible processes, experiments that resulted in some remarkable and unique images. The print above is one such example. It shows the effect of introducing an electrical current to the surface of gold-coated photographic paper, with the metal coating reacting to the path of the electrons as the charge dissipates across the paper's surface. LB

THE TERMINAL

ALFRED STIEGLITZ

Date 1893
Location New York, New York, USA
Format Photogravure

Alfred Stieglitz (1864–1936) is a seminal figure not only in the history of photography but in US art and culture in the early twentieth century. Born in Hoboken, New Jersey, to successful German immigrants, Stieglitz was sent to Berlin in 1880, age sixteen, to study mechanical engineering. In 1884, while taking a course given by the eminent chemist Hermann Vogel, Stieglitz discovered that photography was his true passion. He returned to New York in 1890, and the dynamic and bustling city

provided him with very different subject matter to the scenes that he had photographed in Europe.

Until then, pictorial photography had been linked with soft focus and romantic, picturesque subjects, but Stieglitz took to photographing the everyday scenes that he saw in New York. *The Terminal* was taken on Fifth Avenue at the southern end of the Harlem streetcar route. Stieglitz later recalled: "From 1893 to 1895 I often walked the streets of New York downtown, near the East River, taking my hand camera with me. . . . [One day] I found myself in front of the old Post Office. . . . It was extremely cold. Snow lay on the ground. A driver in a rubber coat was watering his steaming car horses." JS

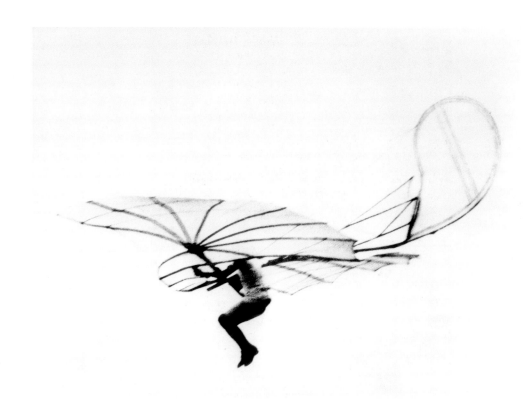

OTTO LILIENTHAL IN FLIGHT WITH "MODEL 93"

OTTOMAR ANSCHÜTZ

Date 1893
Location Berlin, Germany
Format Medium format

Ottomar Anschütz (1846–1907) developed a shutter capable of firing at 1/1,000th of a second to stop motion in fast-moving subjects. His images of storks in flight greatly impressed aviation pioneer Otto Lilienthal, who invited the photographer to record his experiments with gliders.

Between 1893 and 1896, Lilienthal made more than 2,000 flights, amassing a total of five hours' flying time, some of which is captured on film. He was an inspiration to many, perhaps most notably

Wilbur Wright, who stated that "no one equaled him in power to draw new recruits to the cause; no one equaled him in fullness and dearness of understanding of the principles of flight; no one did so much to convince the world of the advantages of curved wing surfaces; and no one did so much to transfer the problem of human flight to the open air where it belonged." And in this Lilienthal was greatly aided by Anschütz, whose photographs Lilienthal used to illustrate his work in awareness-raising public lectures.

On August 9, 1896, Lilienthal lost control of his glider on another of his regular test flights and fell 50 feet (15m) to his death. His last words were reputedly: "Sacrifices must be made." PL

AUBREY BEARDSLEY

FREDERICK H. EVANS

Date 1894
Location London, UK
Format Large format

Although better known for his photographic meditations on medieval architecture, Frederick Henry Evans (1853–1943) was also a skilled portraitist, as this wonderful character study of the young artist Aubrey Beardsley clearly demonstrates. He presents Beardsley in striking profile, like a gargoyle perched on the buttress of a cathedral, his eyes looking down, as if observing life from afar. Evans met the seventeen-year-old Beardsley while working in a bookshop and recommended him as an illustrator to publisher John M. Dent, who was looking for an artist to work on a new edition of Thomas Malory's *Le Morte d'Arthur*, first published in 1485. Beardsley accepted the commission and thus began his meteoric career.

Evans made a pair of portraits of Beardsley in 1894, around the time of the publication of the artist's scandalous and controversial illustrations for the script of Oscar Wilde's play *Salome* and the literary quarterly *The Yellow Book*. Evans purportedly studied Beardsley's face for hours during the portrait session, trying to find the best angle from which to shoot him. Finally, the artist, growing tired of these exertions, relaxed into a more natural pose. PL

X-RAY OF ANGELFISH & SURGEONFISH

EDUARD VALENTA AND JOSEF MARIA EDER

Date 1896

Location Vienna, Austria

Format Photogravure from X-ray

DANCER (ADJUSTING HER SHOULDER STRAP)

EDGAR DEGAS

Date 1895

Location Paris, France

Format Glass plate negative

Known primarily for his paintings and sculptures, French artist Edgar Degas (1834–1917) came to photography late in his career, in 1895. His subjects were street scenes, landscapes, nudes, and, of course, the ballet dancers that appear throughout his work in every medium.

This photograph is one of a series of partially solarized images of dancers. These were negatives found in his studio after his death by his brother René. Its somber mood is created through the use of one light source focused on the subject and of a long exposure time, so that the dancer appears to be coming out of the shadows in a black-and-white relief. More a psychological study than a physical one, this atmospheric image highlights Degas's ability to capture movement and make creative use of lamplight. SY

In late 1895, physicist Wilhelm Conrad Röntgen observed the ability of X-rays to pass through solid objects, and further experimentation with sensitized photographic paper revealed that elements of the interiors of these objects could be recorded photographically. Previously, the only way to observe the internal workings of living organisms had been to cut them open in surgery or during a postmortem, but X-ray photography made it possible to perceive the structures and movements of the body without the need for invasive methods.

Eduard Valenta (1857–1937), a chemist, and Josef Maria Eder (1855–1944), a photographic historian, were among the first to use X-rays to probe the inner structures of fish, reptiles, rats, and the human body. Fifteen of these images were reproduced using the photogravure process and published as a portfolio titled *Experiments in Photography by Means of Röntgen's Rays* in January 1896, just a month after Röntgen announced his discovery. LB

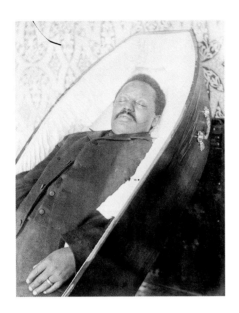

WILLIAM BIGGERSTAFF

JAMES PRESLEY BALL

Date 1896
Location Montana, USA
Format Glass plate

In 1896 prominent African-American photographer James Presley Ball (1825–1904) took three photographs to record the demise of William Biggerstaff, a former slave from Lexington, Kentucky, who was accused of murdering African-American prizefighter Dick Johnson in a fight over a white woman. Despite claiming self-defense, Biggerstaff, found guilty, was sentenced to death. Ball campaigned in vain for clemency.

In the first studio portrait, Biggerstaff looks the epitome of a successful middle-class American. The next image is disturbing: the condemned man is hooded, while a crowd poses for the camera as if for a family portrait. In this, the final frame, Biggerstaff's corpse is carefully arranged in its casket, still wearing the same suit as in the first formal portrait and with his wedding ring visible in the bottom left-hand corner of the shot. PL

THE CRUCIFIXION

FRED HOLLAND DAY

Date 1898
Location Norwood, Massachusetts, USA
Format Platinum print

Fred Holland Day (1864–1933) was a millionaire publisher and aesthete, and a prominent art photographer who courted controversy. In the summer of 1898, he began a series of photographs depicting the life of Christ. His inspiration might have been the Oberammergau Passion Play, which he saw during a trip to Bavaria in 1890. He spent three months making almost 250 studies of *The Betrayal*, *The Crucifixion* (shown here), and *The Resurrection*. Controversially, he cast himself as the model for Christ. Friends and professional actors played the roles of Roman soldiers and onlookers, all dressed in authentic costumes. Day starved himself for several months beforehand in order to appear emaciated, and he even had the Cross made by a Syrian carpenter from specially imported Lebanese cedar. When the pictures were exhibited they were condemned by many as sacrilegious. CH

UNTITLED

JIMMY HARE

Date 1898
Location San Juan, Cuba
Format Gelatin film

James H. (Jimmy) Hare (1856–1946) was one of the earliest photojournalists, and one of the first to realize the potential of the smaller, handheld cameras using the new gelatin film rather than cumbersome glass-plate negatives. He quickly perceived that this new flexibility allowed him to photograph the action of war, rather than just landscapes and portraits. He later remarked: "What I did was to try to obtain pictures of action in the early days of war photography—not just static group scenes." He covered five major wars for *Collier's* magazine, including the Russo-Japanese War, the Mexican Revolution, and World War I. With its emphasis on news, *Collier's* became a leading proponent of the new technology of the halftone news picture, and Hare's dramatic coverage of conflict contributed greatly to the publication's success. His photographs from the decisive Battle of San Juan Hill, in the Spanish-American War, were published over several pages of *Collier's* in the issue of July 31, 1898. In what was one of the earliest attempts to tell a story through photographs, the narrative drive of the article moved from frontline images to ones depicting the aftermath of the fighting and the care of the wounded. PL

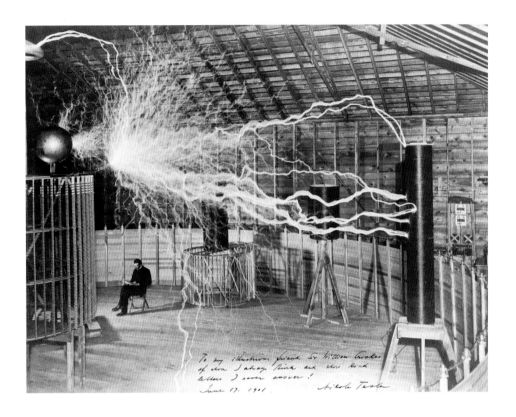

NIKOLA TESLA, WITH HIS EQUIPMENT FOR PRODUCING HIGH-FREQUENCY ALTERNATING CURRENTS

DICKENSON V. ALLEY

Date 1899
Location Colorado Springs, Colorado, USA
Format Unknown

The late nineteenth century was marked by rapid advances in the knowledge and application of electricity and also by the rivalry between two of its most important researchers, Thomas Edison and his former employee Nikola Tesla. A commonly cited example of this was the so-called War of the Currents, a protracted competition between Edison's direct current and the alternating current of which Tesla was an advocate and for which he had patented a number of inventions.

This photograph by Dickenson V. Alley illustrated an article in *The Century Magazine* titled "The Problem of Increasing Human Energy." It shows Tesla reading a book while sitting next to his "magnifying transmitter"—a project that led to the construction of the vast Wardenclyffe Tower in Shoreham, New York, which Tesla hoped would transmit messages and electricity to ships at sea. Here we see the machine throwing off bolts of electricity twenty feet (6m) long, but Tesla remains nonchalant. However, this is trick photography, an image comprised of two exposures. First, the massive electrical bolts were photographed in a darkened room before Tesla was photographed sitting with the machine turned off. LB

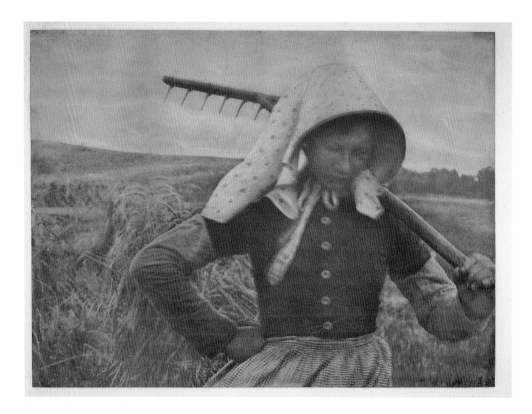

EVENING

THEODOR AND OSKAR HOFMEISTER

Date 1899
Location Northern Germany
Format Gum bichromate print

Born in Hamburg, brothers Theodor (1863–1943) and Oskar (1871–1937) Hofmeister were amateur photographers—Theodore ran a wholesale business and Oskar was a lawyer—who became leading figures in the German pictorialist movement. They produced most of their work jointly; Oskar took the photographs and Theodor made the prints. Theodor was taught gum bichromate printing by Viennese photographer Heinrich Kühn and the brothers produced many large-scale gum prints.

During the late 1890s the brothers produced pictorialist figure studies of peasants working in the farms and villages around Hamburg. Avoiding the sentimentality of their contemporaries, they created moody, realistic studies of rural life. Their work was notable for its creative use of color to reflect the relationship between man and nature.

The Hofmeisters exhibited widely, becoming members of two leading groups of artistic photographers—the Linked Ring Brotherhood in Britain and the Photo-Secession in America. Many photographers traveled to Hamburg to learn from them. The brothers were happy to share their knowledge, and they gained a reputation for helping other aspiring photographers. CH

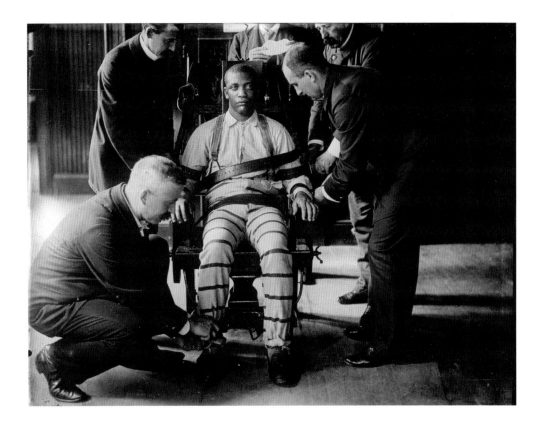

ELECTRIC CHAIR AT SING SING

WILLIAM VAN DER WEYDE

Date 1900
Location Ossining, New York, USA
Format Large format

In this haunting photograph by William van der Weyde (1871–1928), a convict faces death in the electric chair at Sing Sing state prison. First used in 1890, the electric chair became the preferred method of legal execution in the United States and continued to be used until 1972, when the US Supreme Court ruled the method unconstitutional.

The electric chair was invented at Thomas Alva Edison's works in New Jersey in the late 1880s. Edison himself favored the abolition of capital punishment, but thought that, for as long as the sanction remained legal, electrocution would be quicker and less painful than hanging.

The rapid development of handheld cameras, faster films, and commercial photography services facilitated bolder, more journalistic photographs such as this. The moral dilemma of photographing an execution does not seem to have been a restrictive factor at the time—this is not a quick snap, but a considered composition resulting in a print of good quality. It is not known whether the photograph was taken for the prison's records or for publication. The shot was not taken through a two-way mirror: all the participants were aware of the presence of the camera. CJ

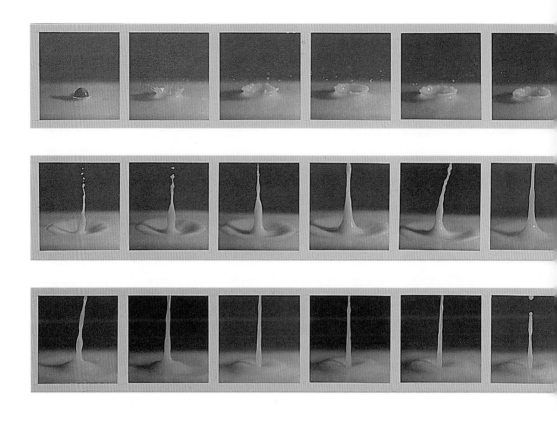

THE LIFE HISTORY OF A SPLASH

ARTHUR CLIVE BANFIELD

Date 1900
Location Unknown
Format Composite

Arthur Clive Banfield (1875–1965) worked in a broad range of styles, including landscape, portraits, and microphotography. He was one of many photographers inspired by the work of late-nineteenth-century chronophotographic pioneers, such as Eadweard Muybridge and Étienne-Jules Marey. Those early photographers relied on relatively crude means to capture their images—

Muybridge employed a series of cameras triggered by timers or wires; Marey utilized a spinning disk in front of the camera lens. The problem with these mechanical techniques was that they restricted the camera's capacity to capture fast movement.

Banfield and his contemporaries developed various ways to overcome that limitation. This series of photographs—depicting the splash created by a small steel ball as it is dropped into a container of milk from a height of five inches (12cm)—was captured using light discharged from a series of Leyden jars (simple devices for storing static electricity).

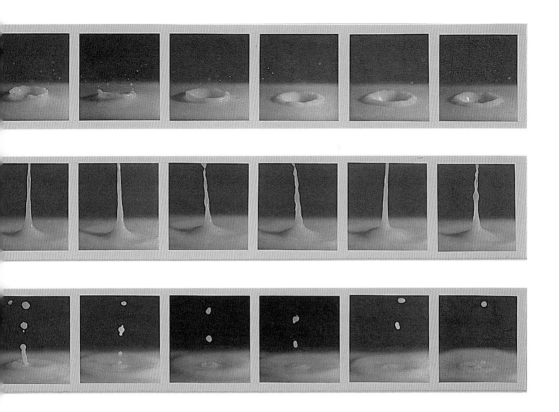

By using a burst of light, rather than relying on natural illumination and a mechanical shutter, Banfield captured phenomena occurring at far greater speeds than had previously been possible, and in so doing anticipated the development of stroboscopic photography by Harold Eugene "Doc" Edgerton, professor of electrical engineering at Massachusetts Institute of Technology.

The Life History of a Splash was of great interest to artists, and of significant use to scientists, who were able to see clearly for the first time a physical occurrence whose exact nature had previously been only a matter of conjecture.

Among the other great images for which Banfield is celebrated are a pair of sixteen-frame stop-motion chronograph sequences of a dog and a cat jumping over a wooden fence—two series that revealed more clearly than ever before the stages of each creature's physical movements, thus doing for these animals what Muybridge had previously done for galloping horses.

Of other aspects of Banfield's biography, little is known: ironically, the life of his splash is better documented than his own. However, his work is a major landmark in the development of photography in the twentieth century. **LB**

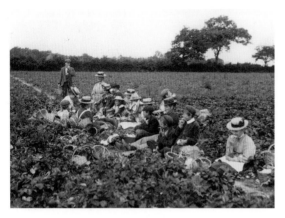

UNTITLED

FRANCES BENJAMIN JOHNSTON

Date 1900
Location Hampton, Virginia, USA
Format Glass plate

STRAWBERRY FARM

F. J. MORTIMER

Date 1900
Location Hampshire, UK
Format Glass plate

Francis James Mortimer (1874–1944) here depicts fruit pickers enjoying a moment of relaxation and camaraderie during a day of harvesting strawberries. His image sensitively captures their smiling faces and relaxed body language, thus providing a wonderful insight into English country life at the start of the twentieth century—what appears a rural idyll from today's perspective.

A founding member of the London Salon of Photography, Mortimer was part of the Linked Ring, a society that promoted photography as art. In his role as editor of *Amateur Photographer* magazine from 1908 until his death, he was committed to pictorialism, frequently producing composite photographs by combining negatives to evoke emotion. During World War I, he reworked some of his negatives to create emotive scenes depicting British navy personnel at sea. Even though the image here is not overtly Pictorialist, happy emotions are clearly visible on the pickers' faces. Whether working in a pictorialist way or not, as an observer of contemporary life Mortimer was among the best photographers ever. GP

Frances Benjamin Johnston (1864–1952) was one of America's first female photojournalists and portrait photographers. In 1900 she was commissioned by the Hampton Institute (now Hampton University)—an educational establishment for African Americans and Native Americans—to document the students in a series of staged tableaux designed to demonstrate their work ethic and virtue. She used a glass-plate camera, which necessitated a long exposure time indoors, so her subjects had to remain motionless for extended periods. The images were an early form of public relations photography—they were used for fundraising for the school, and to promote its educational values. The photographs were displayed at the 1900 Exposition Universelle (International Exhibition) in Paris as part of the "American Negro" exhibit, which was organized by civil rights activist W. E. B. Du Bois and lawyer Thomas Calloway, and intended to present a positive vision of the progress of African Americans since the Civil War (1861–65).

Another of Johnston's claims to fame is that she chanced to take the last photographic portrait of US President William McKinley before he was assassinated in 1901. PL

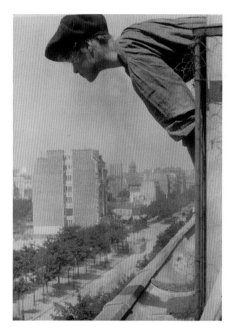

BETA RAYS EMITTED FROM A RADIOACTIVE SUBSTANCE THROUGH SCREENS

ANTOINE-HENRI BECQUEREL

Date 1901
Location Unknown
Format Photogram

GARGOYLE

GERTRUDE KÄSEBIER

Date 1901
Location Paris, France
Format Unknown

Gertrude Käsebier (1852–1934) is best known for images of mothers and children and also of Native American people. Her work was championed by Alfred Stieglitz, who called her "beyond dispute, the leading artistic portrait photographer of the day," and in 1903 he dedicated the first issue of *Camera Work* magazine to her images.

Käsebier founded the Women's Professional Photographers Association of America and was a mentor to many women who became well-known photographers in their own right. This picture brings to mind a portrait of another groundbreaking American photographer, Margaret Bourke-White, pictured by Oscar Graubner in 1934 on top of one of the New York Chrysler Building's steel gargoyles, her camera pointed toward the city below. JG

In 1896, while working on phosphorescence and X-rays, French science professor Antoine-Henri Becquerel (1852–1908) inadvertently discovered radioactivity. He noted that when uranium salts were left on a photographic plate sealed in paper, an energy from the salts penetrated the paper and caused fogging of the plate. He at first suspected that the salts released X-ray-like particles when exposed to an external energy source, such as sunlight, but he subsequently realized that the energy fogging the plates was emitted from the salts themselves, without any external stimulation.

The above image is one of the illustrations from his subsequent learned paper on this subject, "Research into a New Property of Matter" (1903), which set out his key findings on radiation. In the same year, Becquerel was a corecipient of the third Nobel Prize in Physics with fellow radioactivity researchers Marie Skłodowska-Curie and her husband, Pierre Curie. LB

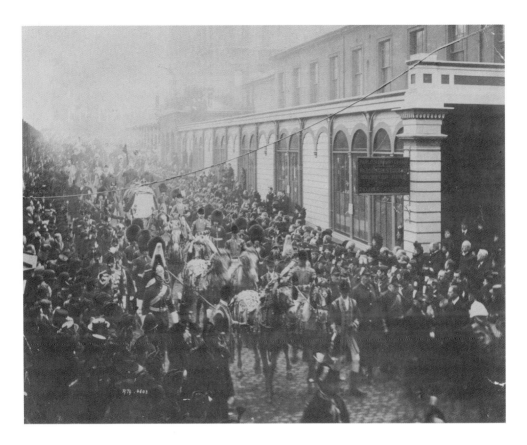

QUEEN VICTORIA'S FUNERAL PROCESSION

UNKNOWN

Date 1901
Location London, UK
Format Glass plate

At her death on January 22, 1901, Queen Victoria had reigned for sixty-three years, longer than any previous British monarch. Her body was brought across the sea from the Isle of Wight, where she had died at her favorite residence, Osborne House. It was then taken by train to London, and thousands of mourners lined the streets to pay their last respects as her funeral cortege passed by on its way to Windsor Castle, where her funeral was held in St. George's Chapel on February 2.

This image, taken by a stringer—a newspaper correspondent not on a fixed salary—shows the procession as it passes through a London street. It is not known who took it, which at the time was not unusual, since jobbing photographers were often not credited for their work.

Shot from a high angle, the photograph shows a gun carriage containing the coffin, pulled by eight white horses. Looking closely, it is possible to make out the furrowed brows of mourners in the crowd. Several photographs of the queen's funeral at its various stages exist, but this one, formerly part of the Topical Press Agency, now in the Hulton Royals Collection at Getty Images, captures the somber mood better than any other. GP

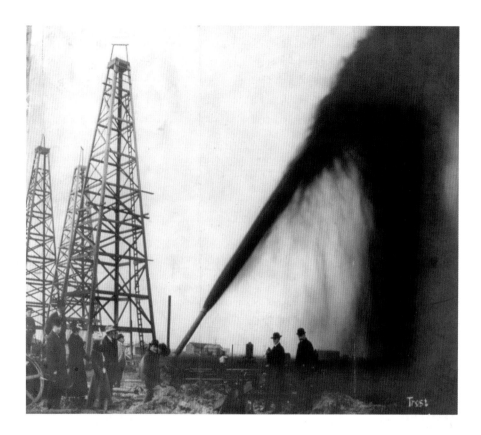

TEXAS OIL GUSH

UNKNOWN

Date 1902
Location Beaumont, Texas, USA
Format Unknown

January 10, 1901, is the most famous date in Texas petroleum history. A Croatian mining engineer, Anthony Francis Lucas, struck oil while drilling a salt dome near Beaumont. Natural gas erupted and was followed by a stream of crude oil and debris spouting 200 feet (60m) into the air. Thousands of barrels of oil gushed out before the well, the Lucas No. 1, subsequently known as Spindletop, could be capped nine days later. It is said that 50,000 spectators came to witness the event.

With that sudden fanfare, the economy of Texas was thrown dramatically into the industrial age. The discovery created a sensation throughout the world and encouraged exploration and drilling in Texas that have continued ever since. Oil deposits were found under much of the state's territory, leading it to become a major force in national politics. Oil became central to the US role in world industrialization, crucially in the development of the nascent automobile industry.

The bystanders in this photograph, taken a year after Lucas's initial success, probably at Spindletop, appear more proprietorial than curious, perhaps anticipating the extraordinary wealth that was waiting for them. CJ

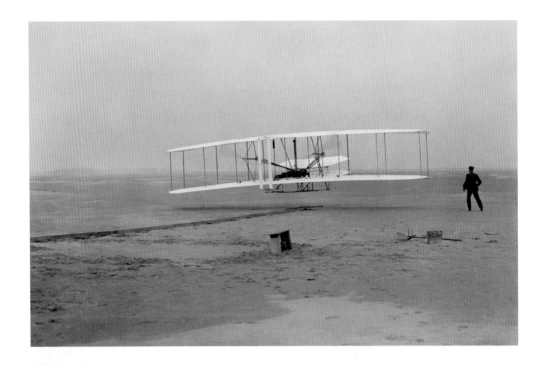

FIRST POWERED FLIGHT BY THE WRIGHT BROTHERS

JOHN T. DANIELS

Date 1903
Location Kitty Hawk, North Carolina, USA
Format Glass plate

At 10:35 a.m. on December 17, 1903, Wilbur and Orville Wright completed the first-ever powered, heavier-than-air flight of an aircraft when their *Wright Flyer I* flew 120 feet (37m) at 6.8 miles per hour (10.9km/h). The plane reached an altitude of 10 feet (3m) and was airborne for twelve seconds, just long enough for John T. Daniels (1873–1948) to grab this historic image from a fixed camera.

The Wright Brothers began their careers by making bicycles, and carried their skills into their experiments in the possibility of flight. From the early 1900s they developed and flew a series of gliders that preceded the innovations of *Wright Flyer I*. Their major breakthrough was in designing controls that could steer the aircraft in flight, and their three-axis control system remains standard on fixed-wing planes today.

Wright Flyer I was built from lightweight spruce covered with muslin fabric, with twin "pusher" propellers hand-carved by the brothers themselves driven by a 12-horsepower (8.9kW) engine. The aircraft weighed 605 pounds (274kg) and had a wingspan of 40.3 feet (12.3m).

Wright Flyer I is now on display in the Smithsonian Museum in Washington, D.C. PL

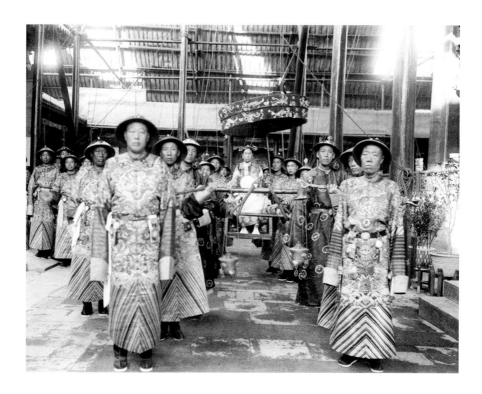

THE EMPRESS DOWAGER CIXI CARRIED IN STATE ON
A PALANQUIN BY PALACE EUNUCHS

UNKNOWN

Date 1903
Location Beijing, China
Format Unknown

Cixi, the empress dowager of China, is seen here being carried by her retinue of eunuchs and courtiers. Cixi entered the imperial court in 1852 as a maid and soon became the "honorable consort" of Emperor Xianfeng. After his death, she held on to the power of the Manchu dynasty by installing her nephew Guangxu as a puppet emperor. This photograph shows the empress insisting on maintaining the imperial tradition. She recognized the need to make a few concessions to modernity,

and she allowed herself to be photographed with her courtiers. Nevertheless, the old ways remain apparent: the ceremonial parasol is held to protect Cixi from the weather, the incense burners are used to purify the air she breathes, and the eunuchs are wearing symbolic robes signifying happiness and prosperity. Cixi herself is wearing curious-looking platform shoes because Manchu women were forbidden to bind their feet yet wished to simulate a teetering gait; Chinese men were said to find unbound feet distasteful.

After Cixi's death in 1911, there followed years of turmoil that led to the emergence of the Chinese Communist Party and Mao Zedong's declaration of the People's Republic of China in 1949. CJ

A SEA OF STEPS

FREDERICK H. EVANS

Date 1903
Location Wells, UK
Format Large format

Originally a bookseller, Frederick Henry Evans (1853–1943) took up photography in 1883. In 1886 he exhibited a series of photomicrographs of shells at the annual exhibition of the Photographic Society in London. He did not, however, confine himself to viewing the world through a microscope. He also began to take landscapes and, more significantly, architectural studies. It was for his architectural photographs—in particular, his studies of cathedrals—that he would become famous. Not content with merely making a record of the building, he would spend weeks at each cathedral, noting the changing effects of light on the dimly lit interiors at various times of day. It was the beauty and symbolism of these places of worship, rather than their architectural or historical importance, that most appealed to Evans. Seeking to convey to viewers his emotional connection to these buildings, he referred to his cathedral photographs as "poems in stone."

In 1903, Evans took what is now undoubtedly his most famous photograph—*A Sea of Steps*. He made various attempts over several years before he succeeded in capturing exactly the effect he wanted in this view of the steps leading up to the Chapter House in Wells Cathedral, Somerset, England. Evans described the result thus:

"The steps now rise steeply before one, and the extraordinary wear in the top portions leading to the corridor is now shown just as it appeals to the eye in the original subject, a veritable sea of steps. The passing over them of hundreds of footsteps … have worn them into a semblance of broken waves, low-beating on a placid shore." **CH**

"Using both a 'straight' approach (not altering his negatives) and pictorial sensitivity to subject and style, Evans's work … continues to move and inspire." J. Paul Getty Museum

MARSHALL WALTER "MAJOR" TAYLOR

UNKNOWN

Date 1903
Location Unknown
Format Unknown

Marshall Walter "Major" Taylor (1878 –1932) was one of the greatest African-American sportsmen and a true unsung hero of cycling. In 1899 he won the 1-mile (1.6km) track sprint world championship in Montreal, Canada, thus becoming only the second African-American athlete to win a world championship in any sport, the first being the Canadian-American boxer George Dixon, who in 1891 won the world featherweight title.

Taylor won his first race at age thirteen in Indianapolis, Indiana, in 1891, and at age fifteen broke the amateur 1-mile (1.6km) track record despite being hooted at by the crowds. He was subsequently banned from the track because of his color. He became known as the "Black Cyclone," and turned professional in 1896 at age eighteen, with one of his biggest fans being US president Theodore Roosevelt.

Taylor faced considerable prejudice and racism throughout his career, particularly when he raced in the southern states of America. He had nails strewn on the road in front of his wheels, freezing water thrown at him, and was even choked unconscious by a fellow rider, who was punished with a meager $50 fine. However, despite all these trials, he wrote in his autobiography that "Life is too short for any man to hold bitterness in his heart." In an extraordinary six-week period in 1899, Taylor broke seven world records at a variety of distances from the quarter-mile (0.4km) to 2 miles (3.2km), including the mile from a standing start in one minute forty-one seconds, a record that stood for twenty-eight years and a time that would still be competitive in track racing today. PL

"[Taylor] became a cycling star not only through natural talent. He also had what one might call a force of dignity."
Tim Hilton

TSAR NICHOLAS II BLESSING A REGIMENT LEAVING
FOR THE RUSSO-JAPANESE WAR

UNKNOWN

Date 1904
Location Russia
Format Unknown

If there is something godlike about Nicholas II in this photograph—standing over a regiment with an authoritative air as he blesses the soldiers below—it is in keeping with what was at the time the commonly held view that God appointed each tsar of Russia, who was known as the "Little Father." As head of the state, the army, and the church, the tsar had supreme authority over the whole empire.

Nicholas is holding up what appears to be a portrait of Jesus Christ, thus further emphasizing his association with the divine. The soldiers kneel respectfully before him.

The men are about to depart for the Russo-Japanese War. The conflict had started on February 8, 1904, when Japan attacked the Russian Pacific naval base at Port Arthur. In essence the conflict arose from both countries' desire for power in Korea and Manchuria, with Japan ultimately victorious when the war ended in September 1905.

This photograph would be powerful enough without any knowledge of the historical context, but it is rendered all the more poignant when we consider that Nicholas was the last tsar of Russia, overthrown and murdered in the Communist Revolution of 1917. GP

FIVE DOGS UNDERGOING EXPERIMENTS ON GASTRIC
SECRETION IN THE LABORATORY OF IVAN PETROVICH PAVLOV

UNKNOWN

Date 1904
Location Moscow, Russia
Format Unknown

Five dogs wait to be tested in the laboratory where Russian physiologist Ivan Pavlov developed his theories of the conditioned reflex. He accustomed his dogs to receiving food after they had heard a bell. Once he had firmly established in the animals' minds that the sound of the bell was the precursor to a bowl of meat, he demonstrated that the noise alone would make them think that they were about to be fed—they would salivate in anticipation even when there was no food to follow.

In the 1990s, some academics cast doubt on whether Pavlov had ever actually used a bell in his experiments, saying that his writings showed that he employed a wide range of other stimuli, including electric shocks, whistles, metronomes, and tuning forks. In spite of these reservations, however, his conclusions were valid, and earned him the 1904 Nobel Prize in Physiology or Medicine. His study of classical conditioning had a huge influence on how humans understand themselves and their learning processes; his work continues to be central to behavior therapy; and he influenced writers of fiction, notably Aldous Huxley in *Brave New World* (1931) and Thomas Pynchon in *Gravity's Rainbow* (1973). CJ

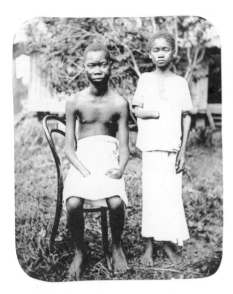

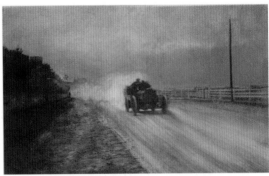

SPEED

ROBERT DEMACHY

Date 1904
Location France
Format Gum bichromate print

Born on the outskirts of Paris, Robert Demachy (1859–1936) came from a wealthy family. He took up photography in the late 1870s, but discovered his métier in the 1890s when he began to use the gum bichromate process, producing heavily manipulated prints that evoke a painterly aesthetic. *Speed* is one of Demachy's finest and best-known works. By extensively manipulating the print, he transcended what he saw as the limitations of direct photography to create a subtle and atmospheric image conveying a sense of speed and movement. In 1904 he began experimenting with oil-based processes and soon abandoned gum in favor of oil printing, which enabled him to create even bolder manipulated images.

Demachy received the unprecedented honor of having no fewer than five one-man shows organized by the Royal Photographic Society in London. At the outbreak of World War I, Demachy was at the height of his fame and was widely regarded as one of the world's most important and influential photographers. And yet, in 1914, suddenly and without any explanation, Demachy gave up photography completely. He never again picked up a camera. CH

CONGO FREE STATE

ALICE SEELEY HARRIS

Date 1904
Location Congo Free State
Format Glass plate

Alice Seeley Harris (1870–1970) and her husband went to the Congo Free State as missionaries for the Congo Balolo Mission. The country was at the time under the personal sovereignty of the Belgian king Leopold II, who presented his activities in the territory as essentially humanitarian. Alice Seeley Harris, however, was appalled by what she witnessed there, discovering a regime of extreme brutality that used mutilation, rape, and murder to coerce the local population into meeting rubber production quotas. The children of rubber workers who failed to meet their targets sometimes had their hands amputated as punishment.

Harris's primary role was as a teacher, but she soon began to photograph the atrocities she saw, in the process producing a remarkable documentary recording of one of the darkest episodes in European imperialism and becoming an early pioneer of human rights photography. LB

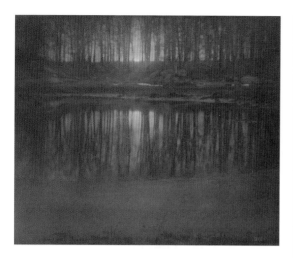

THE POND—MOONLIGHT

EDWARD STEICHEN

Date 1904
Location Mamaroneck, New York, USA
Format Multiple gum bichromate print
over platinum

Edward Steichen (1879–1973) helped to convince the world that photography was a valid art form. This painterly image of soft light coming through trees to reflect on water was the most valuable photograph in the world in 2006, when one of the three existing prints sold at Sotheby's in New York for $2.9 million (£2.2 million). Each of the three is subtly different in tone, due to slightly different processing techniques of the negative.

When the first color process for photography— the autochrome—was developed in 1907, Steichen was quick to add it to his repertoire. He learned to work with gum bichromates in France at the turn of the twentieth century and returned to the United States to master his own techniques.

The Pond—Moonlight was created by putting multiple layers of gum bichromate over an initial platinum print. Each layer could be modified with a brush or sponge to adjust shapes and shadows, making each version of the image unique. CP

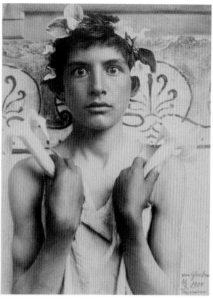

BOY WITH LILIES

WILHELM VON GLOEDEN

Date 1904
Location Taormina, Sicily, Italy
Format Salt print

German-born Wilhelm von Gloeden (1856– 1931) moved to Italy in 1877 to recuperate from tuberculosis. He set up a photographic studio in Taormina, Sicily, and by the 1890s was exhibiting his work internationally. Although he also took landscape photographs, von Gloeden is best known today for his pastoral nude studies, which are notable for their controlled use of lighting and were widely sold as postcards. With subjects often arranged in pseudo-classical poses and incorporating props such as wreaths or amphorae, they have an obvious homoerotic content. He wrote in 1898: "The Greek forms appealed to me, as did the bronze-hued descendants of the ancient Hellenes." In the early 1930s, after his death, Italian fascists destroyed thousands of his negatives, claiming that they were pornographic. CH

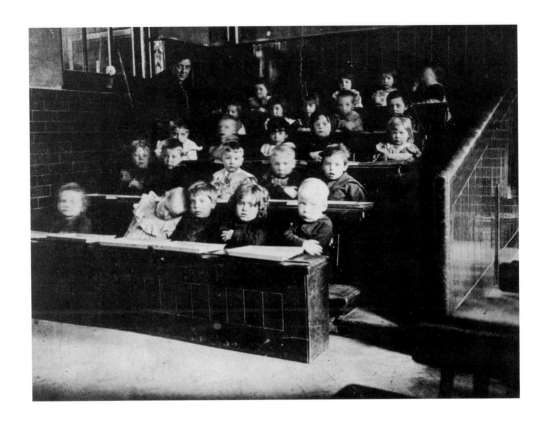

CHILDREN IN A LONDON CLASSROOM

UNKNOWN

Date 1905
Location London, UK
Format Unknown

Conditions in this London classroom were basic and austere, and most of the children have dutifully (and perhaps unnaturally) folded their arms for the photographer, no doubt on the teacher's orders. The ordeal of being photographed seems too much for one child, who has fallen asleep on her classmate's shoulder.

The development of a national public system of education in England and Wales lagged way behind much of Europe and the United States at this time. In 1900, only one child in fifty was educated beyond the age of eleven or twelve years. Against this background, the newly elected Conservative prime minister Arthur Balfour presented the 1902 education bill to the British Parliament, warning that "England is behind all continental rivals in education."

Opponents of the bill feared that the cost of popular education would lose them the support of landowners and industrialists. Most politicians, however, accepted that Britain needed an educated workforce if it was to maintain a dominant position in world trade. The bill was passed, leading to a massive expansion in the building of schools in the years up to the outbreak of World War I. CJ

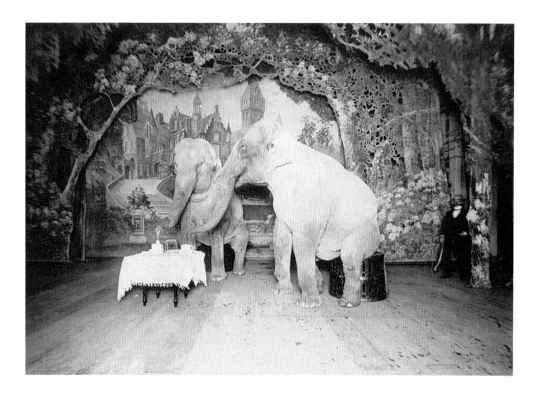

ELEPHANTS TAKING TEA IN PARIS

HARRY C. ELLIS

Date c. 1905
Location Paris, France
Format Unknown

Traveling menageries were hugely popular in the nineteenth century, and a brisk trade in elephants brought over to Europe from Asia and Africa meant that these animals were increasingly used as performers. By the early twentieth century, circuses featuring trained animals were found all over the world.

Harry C. Ellis (1857–1928), an American who moved to France in 1900 and lived there for thirty years, took this photograph at a theater thought to be the Hippodrome de Paris. It depicts a performance involving two elephants trained to sit and appear as if they are having tea. Elephants—intelligent, sentient, but physically imposing and potentially dangerous creatures—are able to use their trunks to pick up and hold objects: in this case what appear to be teaspoons. In the right of the shot is an onlooker, who was presumably involved in taming and training the elephants. He is believed to have been Frank C. Bostock, an Englishman known as the greatest animal trainer of the epoch.

A caption alongside the photograph reads: "To induce delicacy in great beasts was once seen as a major human triumph." GP

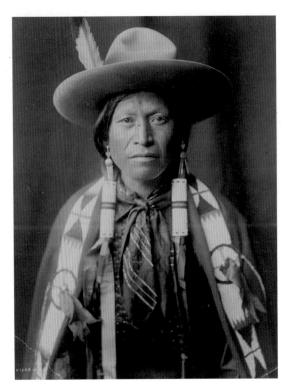

JICARILLA APACHE COWBOY

EDWARD S. CURTIS

Date 1905
Location USA
Format Photogravure

Wisconsin-born Edward Sheriff Curtis (1868–1952) created and compiled what has become renowned as the most comprehensive collection of historical documents on record about the culture and history of the Native American Indian. Over a thirty-year period he took more than 40,000 negatives and made 10,000 wax cylinder recordings of Native American language and music from more than eighty different indigenous cultures. He documented their folklore, traditional foods, clothing, ceremonies, and daily life, and he wrote biographical sketches of the major leaders. This extraordinary archive is wide ranging and in many particulars unique.

On its completion in 1930, the work, titled *The North American Indian*, was published in twenty volumes, each consisting of 300 pages of text and seventy-five hand-pressed photogravures, such as this image of a native of the southwestern United States. Curtis was fully aware of the urgency of his mission, since the pressures of land exploitation were forcing the Native American peoples onto reservations, thus undermining and eroding their traditional ways of life. In the introduction to his first volume in 1907 he wrote:

"The passing of every old man or woman means the passing of some tradition, some knowledge of sacred rites possessed by no other; consequently the information that is to be gathered, for the benefit of future generations, respecting the mode of life of one of the great races of mankind, must be collected at once or the opportunity will be lost for all time. It is this need that has inspired the present task." PL

"Curtis was far ahead of his contemporaries in sensitivity, tolerance and openness to Native American cultures and ways of thinking."

Laurie Lawlor

MORNING

CLARENCE HUDSON WHITE

Date 1905
Location Unknown
Format Large-format view camera

Clarence Hudson White (1871–1925) was a self-taught photographer, but he established the first educational institution that taught photography as an art form in the United States. He became one of the leading lights of the pictorialist movement, with images such as this one that depicted intimate and atmospheric moments of life, in a style demonstrably influenced by artists such as James McNeill Whistler, John Singer Sargent, and the Impressionists, as well as by Art Nouveau and Japanese art.

White's tonal values and soft focus give his images a rich and delicate air, which was apparent in his work even before he left his native Ohio for New York, to which he moved in order to be closer to his friend Alfred Stieglitz. In 1914, White set up the Clarence H. White School of Photography, which became his main preoccupation. The school became very influential, counting among its graduates Margaret Bourke-White, Dorothea Lange, and Paul Outerbridge.

White's teaching methodology was central to the success of the school; he promoted personal vision and style, assigning his students visual problems and encouraging them to photograph concepts and ideas such as "innocence" rather than concentrating on subject matter. He valued experimentation and exploration, stressing that the aspiring photographer had to learn "the capacity to see." He was very egalitarian in his teaching, never creating a competitive atmosphere by comparing one person's work with another's; instead, he treated each student's work on its own terms. **PL**

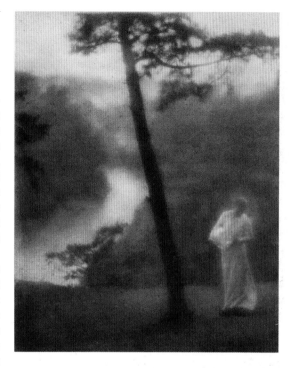

"I do not believe [a photographer] should go with a preconceived idea of what he is going to get. He should be moved by his subject. If he is not, he will become blind to the most beautiful aspects of nature."

Clarence Hudson White

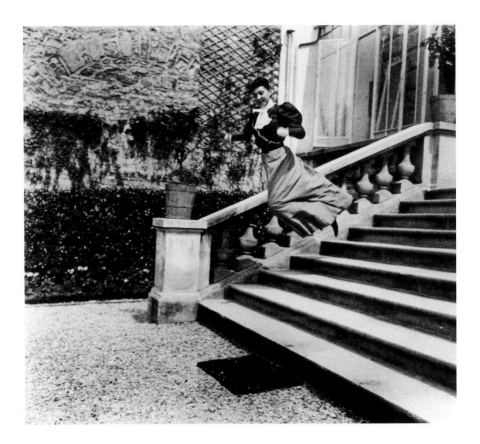

MY COUSIN BICHONNADE

JACQUES-HENRI LARTIGUE

Date 1905
Location Paris, France
Format Gelatin silver print

A well-dressed young woman, Bichonnade, appears suspended in midair, leaping from a flight of stone stairs in her long Edwardian skirt. Bichonnade was a cousin of the photographer, eleven-year-old Jacques-Henri Lartigue (1894–1986). Lartigue received his first large-plate camera at age seven, which he operated standing on a stool. As part of a wealthy French family, with a father who shared his interest in photography, Lartigue had access to all the newest technologies at a time when photography was changing rapidly and cameras were becoming smaller and more portable. He received a Brownie No. 2 camera in 1903, one of the earliest roll-film options.

Flying and action shots were among Lartigue's favorite genres, and the image here highlights the new capabilities of stop-action photography. His capturing of movement sits at a crossroads between an early form of surrealism and an informal, joyful documentation of the everyday realities of his life. Lartigue trained as a painter in 1915–16 and was to consider painting his primary occupation. His photography was not shown publicly until 1963, when the New York Museum of Modern Art put on the first Lartigue solo exhibition. **CP**

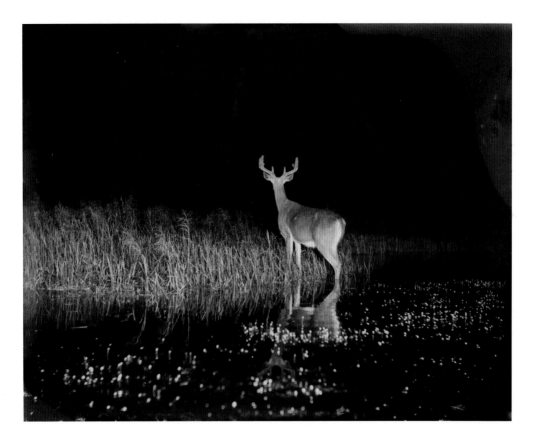

DEER AT NIGHT

GEORGE SHIRAS III

Date 1906
Location Whitefish Lake, Minnesota, USA
Format Glass plate

George Shiras III (1859–1942) was a lawyer, a politician who represented Pennsylvania in the US Congress, and a pioneer of wildlife photography. He campaigned energetically for the establishment of US national parks and was instrumental in drafting the Migratory Bird Bill of 1903. He lobbied effectively for the Olympic National Monument, the Petrified Forest National Monument, and the expansion of Yellowstone National Park. In 1905, his photography came to the attention of *National Geographic* editor

Gil Grosvenor, who published his work in a single, themed issue titled "Hunting Wild Game with Flashlight and Camera." The publication showed a portfolio of seventy-four stunning images of wildlife shot at night.

To make his dramatic images, Shiras used a magnesium flash to light the scenes, describing its explosion as a "blowing moon." He used the skills as a game hunter that he had learned as a child, including using traps to set off remote cameras and the technique of "jacklighting," in which a lamp is placed in the bow of a canoe to catch the attention of the animal, allowing the hunter—or photographer—to train his sights on the two bright beacons of the creature's eyes. PL

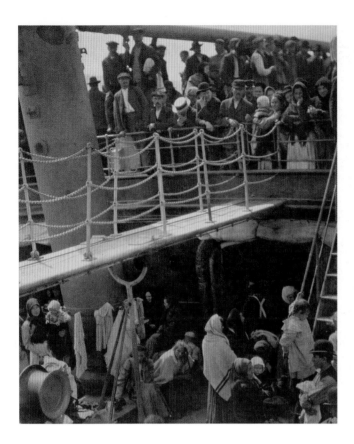

THE STEERAGE

ALFRED STIEGLITZ

Date 1907
Location SS *Kaiser Wilhelm II*, Atlantic Ocean
Format Glass plate

Alfred Stieglitz (1864–1946) was the well-connected curator and editor of *Camera Work* magazine who spent the early years of the twentieth century promoting photography's value as a fine art. He was also a great photographer in his own right. On a voyage to Europe in 1907, he experienced, by his own account, a kind of epiphany that changed and cemented his views. On board the SS *Kaiser Wilhelm II*, he looked down from the upper deck to the steerage filled with lower-class passengers, many

of whom were making the return journey from North America after failing to build new lives. Here was a picture of social inequality, human drama and pathos, but Stieglitz was captivated most of all by its formal perfection: "I stood spellbound for a while. I saw shapes related to one another—a picture of shapes, and underlying it, a new vision that held me: simple people; the feeling of ship, ocean, sky."

What we might now call the documentary value of this picture—the insight it gives into a social reality—is made possible only by its careful formal balancing of geometric elements and details. This is what makes Stieglitz's picture a masterpiece of modernism. JG

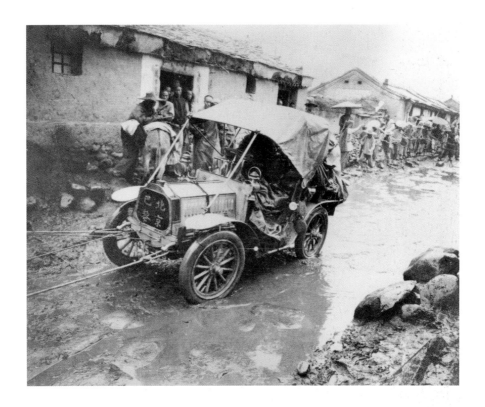

PEKING TO PARIS AUTOMOBILE RACE

UNKNOWN

Date 1907
Location China
Format Unknown

On June 10, 1907, a group of motorists in Peking (Beijing), China, set off on the first Peking to Paris automobile race, in which they undertook a 9,400-mile (15,000km) westbound journey by motorcar across Asia and Europe. Forty entrants answered the call put out by French newspaper *Le Matin* on January 31, 1907. Eventually, five cars set off; four of them completed the distance. The winner was the Italian prince Scipione Borghese, who arrived in the French capital on August 10.

Pioneering French newspaper *L'Illustration* covered the race from start to finish and published a photographic essay that included the image reproduced here.

The drivers had to overcome many challenges along the treacherous route, which took them through Outer Mongolia and across Russia. For the first 5,000 miles (8,000km) there were no roads, and along the way the competitors had to contend with difficult mountain passes, deserts, ravines, swamps, rivers, and extreme temperatures.

This photograph captures the looks of fascination on the faces of Chinese onlookers who most likely had never previously set eyes on an automobile. GP

THE BRASS BOWL

GEORGE H. SEELEY

Date 1907
Location Unknown
Format Large-format gum bichromate print

George H. Seeley (1880–1955) was inspired to become a photographer by meeting the pictorialist Fred Holland Day, and exhibited his first prints to great acclaim at the First American Photographic Salon in New York in 1904. Seeley's photographs were noted for their expressive softness and sophistication, and demonstrated the influence of Symbolist art on his vision. He mostly photographed figures and landscapes, printing to a high standard using the platinum and gum bichromate processes. This delicate study of a young woman gazing into a reflective bowl shows the soft, painterly effect that the gum bichromate process produced. Seeley clearly esteemed himself highly, as he priced his prints at $50, far more than his contemporaries charged.

His work was appreciated by Alfred Stieglitz, who invited him to become the youngest member of the Photo-Secessionists. Stieglitz further championed his work in the pages of his influential magazine *Camera Work*; he featured eighteen photogravures by Seeley in multiple issues in 1906, 1907, and 1910. Gravures were normally produced directly from the photographers' original negatives and were then considered to be original prints. Stieglitz, a renowned perfectionist, personally hand retouched every image intended for the magazine, checking it for dust and scratches. The resulting quality of the gravures was so high that when a set of prints failed to arrive for a Photo-Secession exhibition in Brussels, a selection of pages from the magazine was hung instead, and audiences assumed they were looking at the original photographs. PL

"Mr. Seeley is the new man for whom we are always on the lookout, and his advent among pictorialists will be the sensation of the year." Review of the First American Photographic Salon in New York, 1904

DANISH GYMNAST

UNKNOWN

Date 1908
Location London, UK
Format Unknown

This austere-looking gymnast with a focused expression on her face was a member of the Danish women's gymnastics team that caused a stir during the Olympic Games in London in 1908—the fourth Games of modern times. Although women were allowed to compete in only a handful of competitive events, such as archery, figure skating, and lawn tennis, female athletes from Denmark performed displays outside of the main male-dominated program in July 1908 to great acclaim. These so-called "gymnastic exhibitions" took place in the Great Stadium but were not well attended, as this photograph shows. Nevertheless, the women's performances were widely written about, and newspapers ran photographs of them on their front pages, commenting on their appearance and femininity, praising their agility, and turning the women into celebrities.

The athlete, whose identity is not recorded in the photograph's caption, just as the photographer is not reliably credited, is crouching on a gymnastic pommel horse, poised to make a move or having just competed one. She cuts an imposing figure and embodies strength and resilience as well as the feminine qualities of gracefulness, beauty, and nobility that were then demanded. Indeed, it was the ability of the female athletes to carry out physical activity in a graceful manner that surprised and impressed spectators at the Games. Although it would be another twenty years before women's gymnastics were included in the Games in a competitive way, the presence of the Danish gymnasts in 1908 was an important step toward that goal. GP

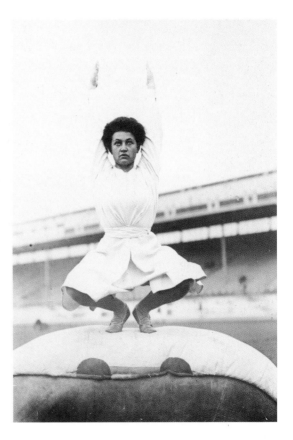

"The Danish ladies have taken the town by storm. We were, all of us, Danes in our welcome of them. I mean, of course, those charming gymnasts at the Stadium."

The Gentlewoman, August 1, 1908

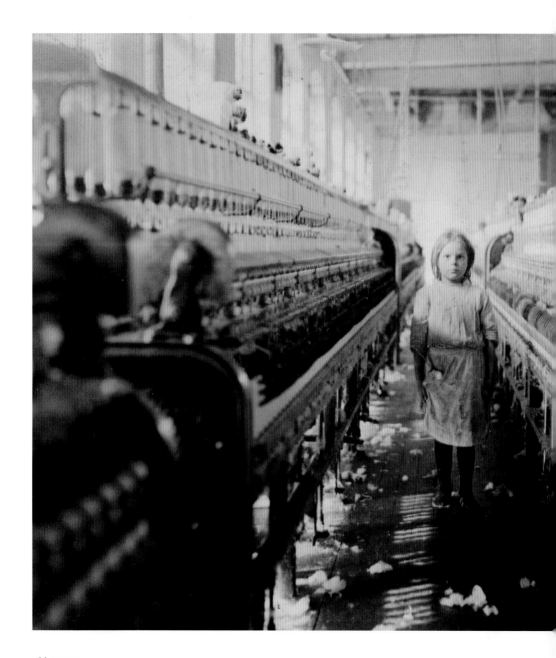

A LITTLE SPINNER IN THE MOLLOHAN MILLS, NEWBERRY, SC

LEWIS HINE

Date 1908
Location Newberry, South Carolina, USA
Format Glass plate

Lewis Hine (1874–1940) studied sociology and then taught the subject in New York City. He encouraged his students to employ photography as part of their studies and led them on field trips to the city's immigration processing hub on Ellis Island, where thousands of people were then arriving daily from Europe. He took hundreds of photographs of these new arrivals.

In 1908, Hine left his teaching post and was commissioned as a photographer for the National Child Labor Committee, a nonprofit organization that campaigned for reform of child labor laws. Over the next decade, Hine undertook extensive documentation of child labor across a range of industries, including cotton production, glass manufacturing, coal mining, and cigar making. The work was dangerous—Hine was frequently threatened by officials at the factories he sought to expose. To avoid confrontation, he employed disguises to gain entry, including masquerading as a fire inspector.

This image is one of a series of photographs that Hine took in a cotton mill run by the Mollohan Manufacturing Company. Hine recounted of the scene that the girl was operating her machines "like a veteran," but when an overseer saw him take her photo he came over "and said in an apologetic tone that was pathetic, 'She just happened in.'" Hine's photographs from this period were published in newspapers and pamphlets and displayed in slideshows and lectures. They are widely credited with helping to bring about a change in child labor laws in the United States. LB

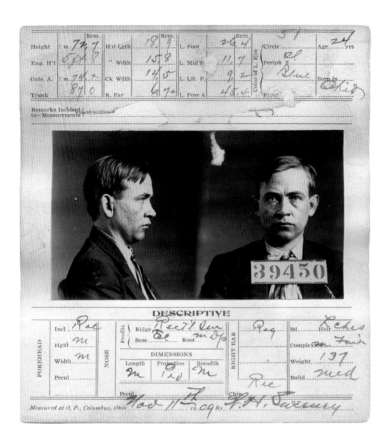

THE BERTILLON SYSTEM

ALPHONSE BERTILLON

Date 1909
Location Paris, France
Format Glass plate

Alphonse Bertillon (1853–1914) began as a clerk in a Paris police headquarters, and in 1882 he became head of its photography department. Dissatisfied with the methods then used to identify criminals, he developed the system that now bears his name, based on the measurements of key parts of the body, in particular the face. This information was collated on cards along with front and profile photographs of each person, resulting in a record system that could be quickly cross-referenced.

The Bertillon system was adopted by police forces worldwide. Such was Bertillon's fame that Arthur Conan Doyle refers to him as the "father of scientific detection" in his novel The Hound of the Baskervilles (1902). Countless criminals were documented using the system; however, the methodology was not perfect, and a number of cases illustrated this, including the widely reported example in 1903 of two unrelated but almost identical men with similar names who were incarcerated in the same prison in the United States. Before long the Bertillon method was partly superseded by fingerprinting, but it is still sometimes used today in conjunction with other more recent technologies. LB

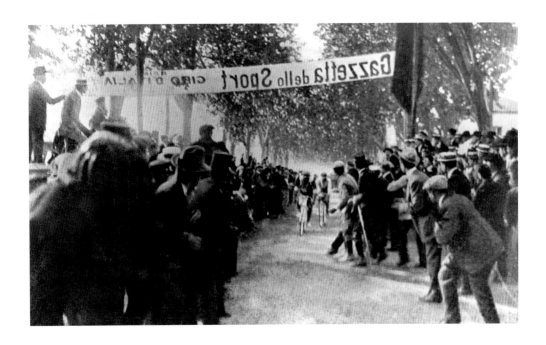

GIOVANNI ROSSIGNOLI TAKES THE SPRINT STAGE IN CHIETI, NAPLES, DURING THE INAUGURAL GIRO D'ITALIA

UNKNOWN

Date 1909
Location Naples, Italy
Format Unknown

The first Giro d'Italia cycling race was organized and sponsored by *La Gazzetta dello Sport* newspaper. It began in Milan and ended there after covering 1,521 miles (2,448km) over eight stages. The riders had to sign in at checkpoints during each stage to prevent cheating, and they were photographed at the beginning and end of each stage so that the judges could compare the images. Despite these precautions, three riders were disqualified for taking a train over part of the course.

The inaugural stage saw 127 riders set off from *La Gazzetta*'s offices in the Piazzale Loreto, but the occasion was cursed by bad weather, which led to numerous mechanical issues and crashes. The first of the latter was a mass pileup that occurred before dawn less than one mile (2km) from the start.

The eventual winner was Luigi Ganna of the Atala team, with fellow Italians Carlo Galetti and Giovanni Rossignoli second and third, respectively. The first prize of 5,325 lire was four times greater than the annual salary of *La Gazzetta*'s editor, but he showed no bitterness, writing in a leader column that: "A glorious event has been deeply inscribed in the annals of sport, to be repeated yearly with growing enthusiasm and love." PL

JACK JOHNSON IN THE RING WITH JAMES JEFFRIES

UNKNOWN

Date 1910
Location USA
Format Unknown

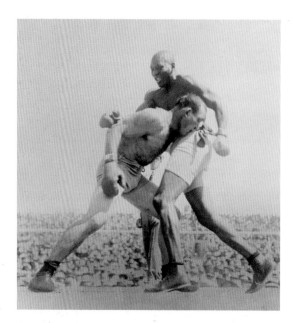

The heavyweight fight between Jack Johnson and Jim Jeffries was one of the most significant in the history of US boxing. Johnson was black and held the crown and was taking on the former champion, Jeffries, who was white and had been undefeated during his reign from 1899 to 1904.

Johnson had antagonized numerous white Americans with his flamboyant lifestyle: he drove fast cars and dated dance-hall girls, all of whom were white. This was at a time when blacks were considered second-class citizens, and interracial relationships were greeted with hostility. The media, boxing promoters, and establishment political forces decided that former champion Jeffries would be their "White Hope." When Jeffries finally agreed to come out of retirement to fight Johnson, he said he was responding to "that portion of the white race that has been looking to me to defend its athletic superiority." There was huge prefight publicity. *The New York Times* wrote: "If the black man wins, thousands and thousands of his ignorant brothers will misinterpret his victory as justifying claims to much more than mere physical equality with their white neighbors."

In retirement, Jeffries had become overweight and unfit, and, despite a rigorous training regime, he lost the fight in the fifteenth round. The result set off some of the worst racial violence in US history. There were riots and deaths, mainly of blacks, in many cities. Johnson was twice indicted and once convicted for transporting women across state lines for immoral purposes. He fled to Europe in 1913 and lived in exile there until 1920. Jeffries's fine reputation was left in tatters. CJ

"I just didn't have it today. Six years ago it would have been different. Now, I guess the public will leave me alone."

Jim Jeffries

MURDER OF MONSIEUR ANDRÉ, BOULEVARD DE LA VILLETTE, PARIS, OCTOBER 3, 1910

ALPHONSE BERTILLON

Date 1910
Location Paris, France
Format Glass plate

While Alphonse Bertillon (1853–1914) is probably best known for developing the pioneering Bertillon system of criminal identification, his innovations were numerous and included developing the forerunner of modern crime scene photography, a technique that he termed "metric photography." Just as he had recognized the potential benefits of photography for identifying criminals, Bertillon reasoned that, if employed correctly, photography could provide a comprehensive record of crime scenes and would include details a written report might miss, since "the eye only sees in each thing that for which it looks." His disciple Rodolphe Reiss went further, suggesting that such images would help to transmit a sense of the violence of an act like a murder far more effectively in court, perhaps even enticing suspects confronted with an image of their wrongdoing to confess.

Like the Bertillon system of identification, metric photography employed a precise and consistent approach. Each crime scene was photographed from several positions, including from directly above using a specialized wide-angle camera pointed downward from a tripod six feet six inches (2m) high. The developed photographs were then mounted on cards with measurements running along the side of the frame, which helped viewers to make adjustments for distortion and perspective and allowed investigators to estimate an object's size accurately. This system, with some alterations, became the basis for forensic photography throughout the twentieth century and foreshadowed the 3D imaging of crime scenes that is often undertaken today. LB

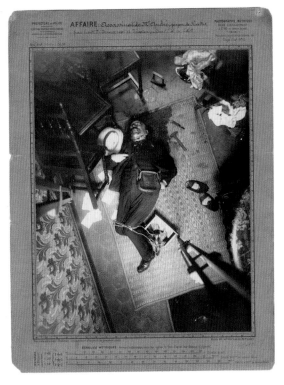

"The image is always in itself an enigma, demanding that we articulate what it really shows." Diane Dufour

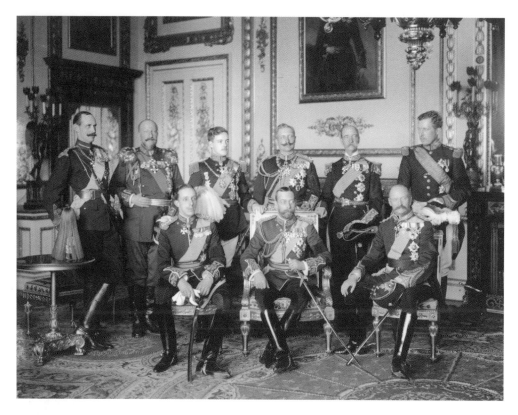

NINE SOVEREIGNS AT WINDSOR FOR THE FUNERAL OF KING EDWARD VII

WILLIAM DOWNEY

Date 1910
Location Windsor Castle, UK
Format Large format

The funeral of King Edward VII on May 20, 1910, brought together an unprecedented number of European royalty, including these sovereigns, who were photographed together in what is probably the only image of nine reigning kings ever taken. The somber event was the last time all of the great European monarchs would meet before World War I. Four would be later deposed, and one assassinated, and just a few years later, Britain and Belgium would be at war with Germany

and Bulgaria. Only five of the nine monarchies represented here are still in existence today. The photograph shows, standing from left to right, King Haakon VII of Norway, King Ferdinand of Bulgaria, King Manuel of Portugal, Kaiser Wilhelm II of the German Empire, King George I of the Hellenes (Greece), and King Albert I of the Belgians (Belgium). Seated from left to right are King Alfonso XIII of Spain, King George V of Great Britain, and King Frederick VIII of Denmark.

The photograph was taken by W. & D. Downey, who were known as "the Queen's Photographers"; the studio had been the semiofficial photographer to the British monarchy since the 1860s and received a Royal Warrant of Appointment in 1879. PL

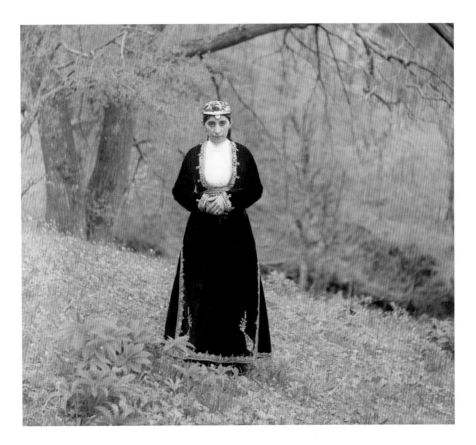

ARMENIAN WOMAN IN NATIONAL COSTUME, ARTVIN

SERGEY MIKHAYLOVICH PROKUDIN-GORSKY

Date 1910
Location Artvin, Turkey
Format Glass plate negative

Sergey Mikhaylovich Prokudin-Gorsky (1863–1944) made a celebrated portrait of the great writer Leo Tolstoy, which gained the attention of Czar Nicholas II and his family in 1909. The czar then sponsored Prokudin-Gorsky to document the Russian Empire in color. Traveling across the county in a railroad car equipped with a custom darkroom, Prokudin-Gorsky photographed the empire on the eve of World War I and the Russian Revolution.

His work documented the emergence of industry and revealed the diversity of the empire's numerous ethnicities, such as this Armenian woman in traditional dress. His aim was to educate the children of Russia about the empire via his "optical color projections."

To make his images, Prokudin-Gorsky used the complex three-color system in which three black-and-white photographs were exposed using red, green, and blue filters successively. The resulting photographs could then either be projected onto a screen through filters of the same color or viewed individually through a chromoscope or photochromoscope that used colored filters to create the final image. PL

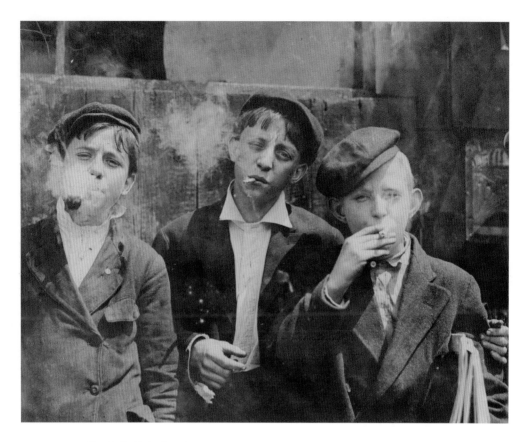

NEWSBOYS SMOKING

LEWIS HINE

Date 1910
Location St. Louis, Missouri, USA
Format Large format

At the end of the nineteenth century and into the twentieth, child labor was common across the United States. Children worked in factories and mines and on farms, fields, and the streets—a consequence of the country's burgeoning industry.

Meager pay, coupled with poor treatment and substandard working conditions, put child labor, many felt, on a par with slavery. The National Child Labor Committee (NCLC) was founded in 1904 and pushed for reform, with Lewis Hine (1874–1940),

a teacher who had a background in sociology, joining its ranks four years later. Driven by the belief that photographs could be used as tools for social change, Hine created around 5,000 images documenting children at work.

Many of his photographs portray working and living conditions where little or no consideration is given to the children's safety or well-being. The widespread dissemination of images such as this, of preadolescents taking a break from work outside a pool hall, persuaded the American public to reconsider its attitudes to child labor. Hine's work helped to inspire the Keating-Owen Child Labor Act of 1916, which sought to restrict the exploitation of young people. **GP**

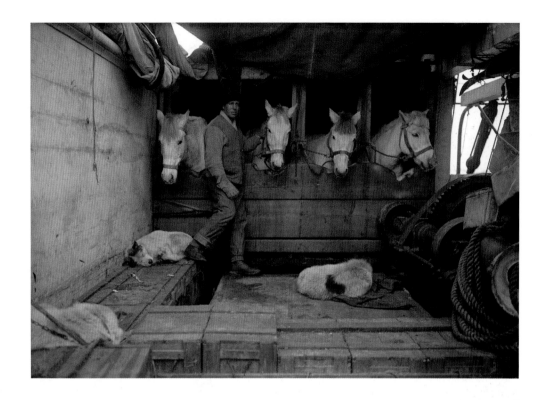

PORTRAIT OF CAPTAIN OATES

HERBERT PONTING

Date 1911
Location SS *Terra Nova*, Antarctica
Format Unknown

Herbert Ponting (1870–1935) was a pioneer of modern polar photography. He accompanied Robert Falcon Scott's expedition to Antarctica and set up a darkroom in the base hut at Cape Evans. He took more than 1,000 photographs of Antarctic landscape and wildlife. He did not, however, accompany the expedition on its trek inland to the South Pole.

This portrait shows Captain Lawrence Oates with some of the nineteen horses he cared for on the expedition ship *Terra Nova*. The animals were intended to haul food and supplies, but Oates, a former cavalry officer, wrote that they were "very old for this sort of job" and "a wretched load of crocks." Oates was right; the ponies could not cope with the freezing conditions. Scott's team struggled to reach the Pole, and there discovered that Roald Amundsen's Norwegian expedition had gotten there first.

Oates was the tragic hero of the doomed return trip from the South Pole. Suffering from appalling frostbite to his feet, and convinced that he was slowing the group's progress, he walked out to his death in a blizzard, uttering his famous last words: "I am just going outside and may be some time." CJ

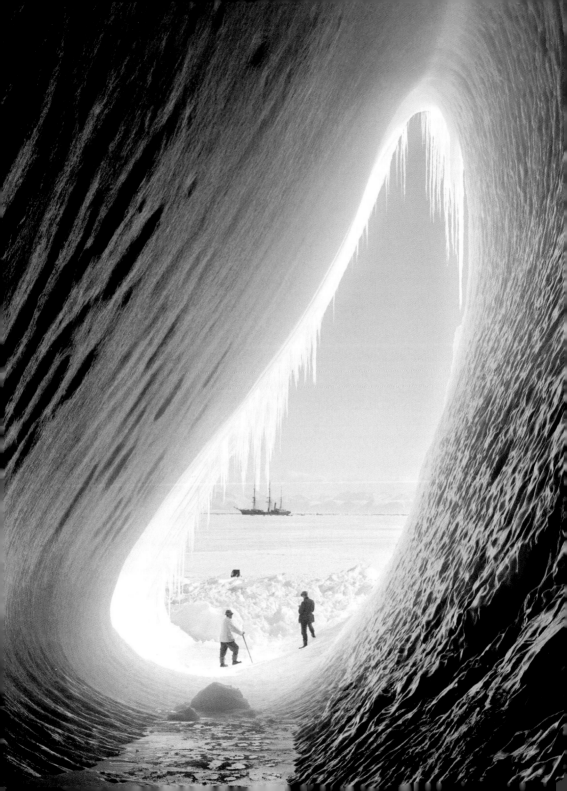

GROTTO IN A BERG, *TERRA NOVA* IN THE DISTANCE

HERBERT PONTING

Date 1911
Location Antarctica
Format Large format

This is one of several photographs taken by Herbert Ponting (1870–1935) from a cave in an iceberg in Antarctica on January 5, 1911. Ponting joined Captain Robert Falcon Scott's British Antarctic expedition in 1910; he was the first professional photographer to accompany the explorers on their journey to the South Pole. Ponting used 7x5-inch (17.8x12.7cm) and 5x4-inch (12.7x10cm) glass plates for his negatives, working in harsh and dangerous conditions to produce images of breathtaking beauty of what was then an alien landscape. *Grotto in a Berg,* Terra Nova *in the Distance* shows two of the explorers in the mouth of the cave, geologist Thomas Griffith Taylor (leaning on his walking stick) and meteorologist Charles Wright. In the distance, shown framed by icicles at the mouth, is their ship *Terra Nova*.

Scott wrote in his diary of Ponting's fascination with the scene: "Ponting has been ravished . . . by a view of the ship seen from a big cave in an iceberg, and wished to get pictures of it. He succeeded in getting some splendid plates. . . . I went to the iceberg with him and agreed that I had rarely seen anything more beautiful than this cave. It was really a sort of crevasse in a tilted berg parallel to the original surface; the strata on either side had bent outwards; through the back the sky could be seen through a screen of beautiful icicles—it looked a royal purple, whether by contrast with the blue of the cavern or whether from optical illusion I do not know. Through the larger entrance could be seen, also partly through icicles, the ship, the Western Mountains, and a lilac sky; a wonderfully beautiful picture." CK

CHINESE REPUBLICAN SOLDIERS

UNKNOWN

Date 1911
Location China
Format Unknown

When the Qing (aka Manchu) dynasty was overthrown in 1911–12, 267 years of imperial rule came to an end, resulting in the birth of the Republic of China. A mutiny in Wuchang, Hubei province, in October 1911 sparked the uprisings in which nationalist Sun Yat-sen seized power and established a provisional republican government at Nanjing. In February 1912, a republican constitution was put in place. Sun Yat-sen became China's provisional president, but later ceded power to military leader Yuan Shikai.

The men pictured in this photograph, which belongs to Roger-Viollet, one of France's oldest photography agencies, are thought to be republican soldiers. They are milling around, waiting for something or someone, and their relaxed, quizzical expressions suggest that this is a moment of downtime. A publishing boom in China that gained momentum in the early twentieth century led to the creation of popular publications that ran photographs, and it is possible that this image appeared in one such periodical. GP

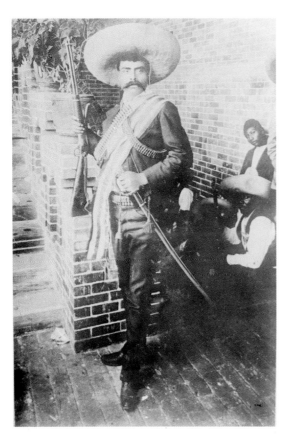

EMILIANO ZAPATA

UNKNOWN

Date 1911
Location Cuernavaca, Mexico
Format Unknown

Although the identity of the photographer behind this image remains a mystery, the subject is one of the most iconic revolutionaries of the twentieth century, General Emiliano Zapata of Mexico. Here he is seen posing in his famous charro outfit—tight-fitting black pants with silver buttons, sombrero, neck scarf, boots, spurs, and a pistol at his side. Note also the rifle, the ceremonial sash across the chest, and—above all—the mustache, which has become Zapata's most memorable attribute in popular culture.

The image was taken at the start of the Mexican Revolution, which would last until 1920. Zapata, who had been raised on a farm, came to understand at an early age how hard it was to exist within the *hacienda* system, where peasants had no entitlement to ownership, and land grabs were common under the dictatorial rule of President Porfirio Díaz. With the revolution, Zapata saw an opportunity to change the economic system in Mexico. Accordingly, he struggled for the rights of the poor *campesinos* (peasant farmers), helping them to reclaim disputed land. His plans were cut short when those who opposed the revolution assassinated him in 1919.

Zapata remains a somewhat controversial figure today, but he is revered by revolutionaries worldwide, particularly in southern Mexico, where the 1994 civil war in Chiapas was led by a group called the Zapatista Army of National Liberation, or the Zapatistas. In the 1980s, the city where this photograph was taken—Cuernavaca, capital of the state of Morelos—renamed one of its municipalities in Zapata's honor. **SY**

"It is better to die on your feet than to live on your knees."

Emiliano Zapata

WOMEN OF THE MEXICAN REVOLUTION

P. FLORES PÉREZ

Date 1911
Location Veracruz, Mexico
Format Unknown

This photograph of Mexican revolutionaries is notable for the line of female *soldaderas*, also known as *adelitas*, posing alongside their male comrades. It is one of few photographs to portray the women who fought during the Mexican Revolution, which lasted from 1910 to 1920. The image was captured by Ponciano Flores Pérez, of whom very little is known except that he took several pictures of this type as a photojournalist during the Revolution. However, he is also known for the images he made of the US invasion of Veracruz in 1914.

It is thought that Pérez may have staged some of his photographs, perhaps to commemorate actual events some time after they occurred. History might suggest that men such as Emiliano Zapata and Pancho Villa were the only heroes of the Mexican Revolution, but the women in this portrait were destined to become popular twentieth-century icons in Mexico as well. Women had little choice but to join the ranks of the military, as they faced certain death if they refused. They were not always treated equally to men, but certainly there were female officers as well as combatants. Although it is difficult to find hard evidence of the fact, it is believed that women such as these were in combat alongside the men.

As Mexico, engaged in a war about agricultural reform and economic rights, hurtled toward modernization, the women grew in the strength of their feminism. Yet a certain vulnerability is seen in their young faces. Posed in their long dresses with their weapons and clearly ready to fight, they express the complexities of being a woman in Mexico in a time of such radical change. **SY**

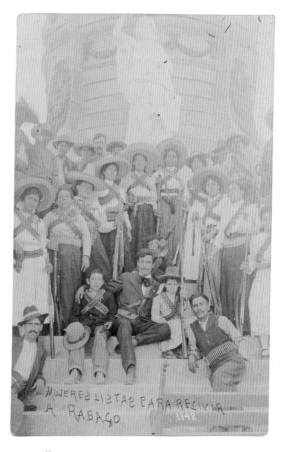

"The difficulties of photographing actual fighting may have led Flores Pérez to direct scenes that would provide visual evidence of opposition . . ."

John Mraz, *Looking for Mexico* (2009)

BRIDLINGTON BEACH

A. H. ROBINSON

Date 1912
Location Bridlington, UK
Format Panoramic

Alfred Hind Robinson (1864–1950) was one of the leading pioneers of panoramic photography in Britain. Between 1903 and 1930, he shot more than 2,000 panoramas using the autotype process, a special form of carbon printing.

Robinson traveled widely all over England, Scotland, and Ireland and also visited some parts of northern Belgium and the southern Netherlands, photographing a host of subjects, including seaside resorts, golf links, castles, abbeys, cathedrals, and coastlines. He produced a remarkable collection of images about the lives of ordinary people at leisure, and many of his photographs were purchased by British railroad companies to decorate the walls of their first-class compartments. Today, some of his best-known works are images of great English sporting venues, notably the All England Lawn Tennis and Croquet Club at Wimbledon, venue for the annual Grand Slam tournament, and Stamford Bridge, the home of Chelsea soccer club, also in London.

Much of Robinson's work was produced on large-format nitrate negative film using a Kodak Panoram No. 4 camera. This was a hand-cranked contraption, covering an angle of 142 degrees, and the traversing speed of the lens could be controlled by manually adjusting the tension of a spring. It could be used horizontally or vertically. Kodak introduced the camera in 1899, and it remained on the market until the 1920s.

Robinson was one of the few photographers who mastered the craft of successful panoramic photography. The field of vision available was much wider than that of the human eye, giving a unique perspective on landscapes and human social activity.

The panoramic image reproduced here is of the beach at Bridlington, a seaside town on the North Sea coast of Yorkshire, England, which was a popular summer vacation spot for more than a century before cheap air fares in the 1960s turned the place into a quaint anachronism.

Although Robinson sold some of his images, he was never a professional, merely an enthusiast. Thus, when he died, the obituary in his local newspaper in Scarborough, Yorkshire, referred only to his work as a magistrate. CJ

WALTER AND EDELTRUDE

HEINRICH KÜHN

Date c. 1912
Location Tyrol, Austria
Format Autochrome

Heinrich Kühn (1866–1944) was one of the most gifted of the European pictorialists. In 1895, with Hugo Henneberg and Hans Watzek, he formed the Trifolium, an experimental group within the Camera Club of Vienna. The grainy, atmospheric images that the group produced owe an obvious debt to both Impressionist and Symbolist painting.

In 1907, Alfred Stieglitz introduced Kühn to the new autochrome color process, which involved coating the plate with a layer of starch grains dyed red, green, and blue, with a layer of emulsion on top. After the plate had been exposed to light, the image was developed into a transparency.

Kühn created hundreds of autochromes at his home near Innsbruck in Austria's Tyrol. His most regular models were his children—Hans, Walter, Lotte, and Edeltrude—and their English nanny. They became adept at taking up the poses he asked for in such a way as to suggest naturalness and even spontaneity, despite needing to keep still for the long exposures. *Walter and Edeltrude* is a beautiful study of a pair of siblings seemingly deep in conversation, and Kühn's artistry is evident in the diagonal composition and harmonized coloring of the image's highlights. JS

THE OCTOPUS

ALVIN LANGDON COBURN

Date 1912
Location New York, New York, USA
Format Large format

A radical photographic experimenter with an extremely wide range of images to his name, Alvin Langdon Coburn (1882–1966) is one of the forgotten heroes of early-twentieth-century photography. He was born in Boston, Massachusetts, and his precocious talent was encouraged by his cousin, the pioneering pictorialist F. Holland Day. Through Day he met many of the leading photographers of the period and—still in his teens—studied with Edward Steichen, Robert Demachy, and Gertrude

Käsebier. In 1902 he opened his New York studio and became part of the group of intellectuals and artists in the orbit of Alfred Stieglitz.

Coburn was among the first photographers to use abstraction in his work, as in the picture shown here. Taken from the top of New York's Metropolitan Tower, looking down at a snow-covered Madison Square, the photograph breaks with conventional ideas of composition by excluding the horizon line: the pathways of the park resemble a living organism or an Art Nouveau design, while the shadow of the tower is darkly ominous. Part of a set of five images, with the collective title *New York from its Pinnacles*, *The Octopus* was exhibited in 1912, the year he moved to the United Kingdom. ER

COUR, 41 RUE BROCA

EUGÈNE ATGET

Date 1912
Location Paris, France
Format Large-format glass plate

The Paris captured by Eugène Atget (1857–1927) is not the Paris of world renown, the rich and elegant city of grand boulevards and the Eiffel Tower. Although two children can be seen in the middle window on the right of this photo, many of Atget's images are devoid of people altogether. Atget systematically documented old Paris, areas of the city that were medieval, warren-like, and quickly disappearing. Yet, despite the paucity of figures, this photo is filled with evidence of daily routines and human life: carpets hung out of two windows to air; a potted plant sitting on a windowsill to the left; and ground-floor windows and doors open to expose various items within.

Despite advances in camera technology during his active years as a photographer, Atget preferred to remain with familiar gear: a simple 8x10-inch (20x25cm) box camera with glass plates on a tripod. In order to achieve the often poetic stillness in his images, Atget ventured forth early each morning to photograph before much of Paris was active. While he labored in relative obscurity for much of his life, his work, particularly his images of shop windows and mannequins, became beloved by the Parisian avant-garde of the 1920s. CP

STRIKING COAL MINERS

UNKNOWN

Date 1912
Location UK
Format Unknown

Coal miners are seen here preparing for the first nationwide strike in the history of their industry in the United Kingdom.

There was said to have been quite a holiday atmosphere at the time, as evidenced by this photograph, since many of the miners would be receiving strike pay from their union dues. The Miners' Federation of Great Britain, the main labor organization representing the coal miners, was seeking to secure a minimum wage from the private coal mine owners who had been reluctant to negotiate.

The strike began in Alfreton, Derbyshire, and quickly spread nationwide. Almost one million miners took part, forcing the Liberal government of prime minister H. H. Asquith to intervene after thirty-seven days and pass the Coal Mines (Minimum Wage) Act.

The strike—according to *The Times* newspaper, "the greatest catastrophe that has threatened the country since the Spanish Armada"—had a major impact on Britain, forcing ships to stay in port because of lack of fuel. CJ

UNTITLED

E. J. BELLOCQ

Date 1912
Location New Orleans, Louisiana, USA
Format Large-format glass plate

Storyville, the red light district of New Orleans, was named after politician Sidney Story, who thought it would improve the city if all the bordellos were in one area. One regular visitor to Storyville was John Ernest Joseph "E. J." Bellocq (1873–1949), scion of an aristocratic Creole family and a keen photographer. At the time he wasn't thought particularly talented (most of his professional work was done for a shipbuilding firm), but unknown to all but a few, one reason for his visits to Storyville was to photograph the prostitutes. The resulting pictures are remarkable for showing the women—some naked, others partially or fully clothed—not as objects of eroticism or pity, but as individuals.

There are women playing cards; one pets a dog; another (in striped stockings) raises a glass of rye—all in the surprisingly homely brothel. Even when, as here, the pose is more conventional, the effect is playful—note the woman's amused smile—rather than erotic. She is masked, and in other images the heads of the sitters have been scratched out, perhaps to conceal their identities.

Bellocq's photographs only became widely known after they were exhibited in 1970 at New York's Museum of Modern Art. JS

LE GRAND PRIX A.C.F.

JACQUES-HENRI LARTIGUE

Date 1913
Location Dieppe, France
Format Large format

Automobiles were a boyish fascination for Jacques-Henri Lartigue (1894–1986), and in 1913 he found himself at the Dieppe Grand Prix with his large-format camera mounted on a tripod, tracking the race cars as they roared around the track at speeds of up to 100 miles per hour (160 kph). Car number six, piloted by the ace driver Croquet, was so fast that Lartigue caught less than half of the vehicle in the frame. But this compositional accident makes for one of the great sporting photographs in history. The hunched driver and his rocket-like car draw the eye irresistibly right, rear wheels transformed into frantic ovoid blurs, while by the same distorting effect spectators and lampposts are rocked backward as if by the force of an explosion.

Lartigue remained largely unknown outside his native France until he was introduced to John Szarkowski, curator of New York's Museum of Modern Art. In 1963, Szarkowski organized a retrospective of Lartigue's work that brought him belated recognition as one of the first photographers to capture the fleeting spontaneity of lived experience. His finest images still look bracingly, thrillingly modern. AD

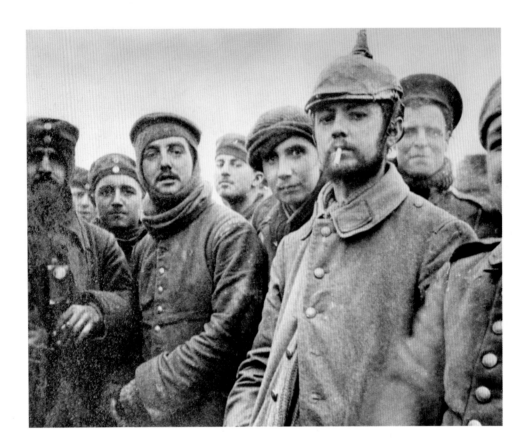

CHRISTMAS TRUCE

UNKNOWN

Date 1914
Location Ploegsteert, Belgium
Format Unknown

This photograph shows British and German soldiers fraternizing during the Christmas Day truce in the first year of World War I.

Although accounts of a universal Yuletide outbreak of peace along the Western Front are greatly exaggerated, there were some isolated gestures of goodwill. In a letter home to his mother, dated December 25, 1914, Captain A. D. Chater of the Second Battalion Gordon Highlanders wrote: "I think I have seen today one of the most extraordinary sights that anyone has ever seen. About ten o'clock this morning I was peeping over the parapet when I saw a German, waving his arms, and presently two of them got out of their trench and came towards ours. We were just going to fire on them when we saw they had no rifles, so one of our men went to meet them and in about two minutes the ground between the two lines of trenches was swarming with men and officers of both sides, shaking hands and wishing each other a happy Christmas."

The high commands on both sides of the conflict were appalled by such behavior. Soldiers defying orders faced court-martial and execution; thereafter it was armed conflict year-round. CJ

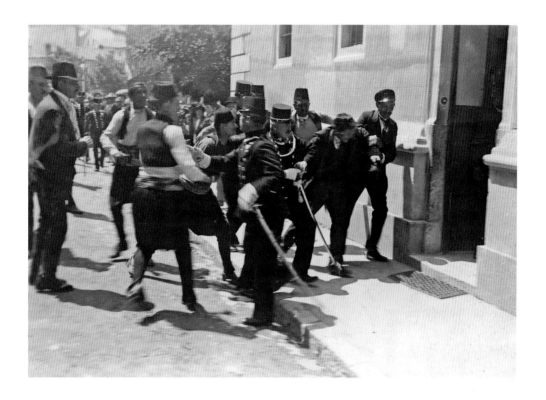

ARREST OF GAVRILO PRINCIP, ASSASSIN
OF ARCHDUKE FRANZ FERDINAND, 1914

UNKNOWN

Date 1914
Location Sarajevo, Bosnia and Herzegovina
Format Unknown

The assassination of Archduke Franz Ferdinand of Austria, heir presumptive to the Austro-Hungarian throne, and his wife, Sophie, Duchess of Hohenberg, was the spark that ignited the conflagration of World War I, which broke out exactly a month later, on July 28, 1914. The assassin, Gavrilo Princip, then aged nineteen, was a member of the Black Hand, a secret society that wanted to break the South Slav provinces away from the empire to form a self-determining Yugoslavia.

This photograph, full of tension and action, has frequently been published as the moment when Princip was arrested after he shot the couple in their open-top car as it drove through the center of Sarajevo. However, despite its continuing popularity as one of the defining images of the momentous event, it is now well established that it is not, in fact, of Princip at all, but rather of an innocent bystander, Ferdinand Behr, who was trying to stop the mob from beating the killer to death. That it is not Princip is evident because this man is clean shaven and Princip had a mustache, but this detail has not stopped the misuse of the image for a hundred years, its drama seemingly outweighing the facts. PL

ENDURANCE AT MIDWINTER

FRANK HURLEY

Date 1915
Location Weddell Sea, Antarctica
Format Large-format glass plate

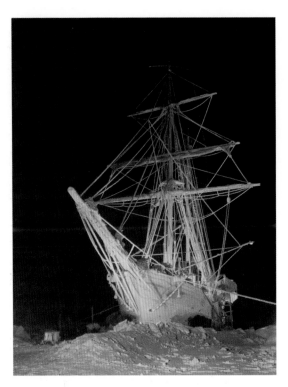

James Francis ("Frank") Hurley (1885–1962) grew up in a suburb of Sydney, Australia, taught himself photography, and established a business selling photographic postcards, often depicting dangerous scenes that required the photographer to put himself in harm's way to capture them. Hurley was recommended by a mutual acquaintance to explorer Douglas Mawson and joined the 1911 Australasian Antarctic Expedition. Returning from this trip in 1914, Hurley almost immediately set out for the Antarctic again as the photographer on Ernest Shackleton's Imperial Trans-Antarctic Expedition, an attempt to make the first land crossing of the continent. The expedition was aborted, however, when its ship, *Endurance*, became permanently stranded in pack ice.

Despite this major setback, Hurley continued his job as photographer, producing a remarkable documentary record of the struggle to survive while awaiting rescue and of the bleak and unforgiving landscape of Antarctica. The image shown here is one of the best known of Hurley's photographs; it shows *Endurance* locked in the pack ice several months before the pressure crushed and sank the ship. Photographed at night and artificially lit, the snow and frost on the boat cause it to resemble a ghost ship. With *Endurance* gone, rescue became a greater imperative, and a small group led by Shackleton set out in a lifeboat on the long journey to South Georgia while the majority of the men waited behind on the pack ice. Finally, three months after he left them, Shackleton returned in August 1916, rescuing the entire party without loss of life. **LB**

"The words, 'Near enough is not good enough,' were scratched into the wood over his [Hurley's] dark room."
The Guardian

AERIAL PHOTOGRAPHY ON THE WESTERN FRONT, 1916

BRITISH ARMY, ROYAL FLYING CORPS, 4 SQUADRON

Date 1916
Location Thiepval, France
Format Unknown (probably glass plate)

Aerial photography had been pioneered using balloons by intrepid innovators such as Gaspard-Félix Tournachon (Nadar) in France and James Black in the United States. While there had been some limited use of balloon photography during the American Civil War, it was not until World War I that aerial photography really came into its own.

In the early stages of the conflict, the method sometimes consisted simply of the pilot or observer photographing out of the side of the aircraft with a small handheld camera; this produced inconsistent and not always satisfactory results. As the war dragged on, cameras and methods were improved and standardized on all sides. In Britain, Group Captain Frederick Laws established the Royal Flying Corps' School of Photography at Farnborough in 1915. He went on to develop a series of purpose-built reconnaissance cameras including the L camera, which was mounted on the underside of an aircraft's fuselage and pointed directly down at the battlefield below.

The image here demonstrates how detailed and accurate aerial photography had become by the middle of the war. It shows German positions in the village of Thiepval, under heavy bombardment by British artillery ahead of the Battle of Thiepval Ridge, a major offensive by the British army during the Battle of the Somme. The high degree of detail was very valuable to strategists at the time, and, subsequently, for historians, these photos have become a way to chart the enormous destruction wrecked by the war on villages like Thiepval, which found themselves caught on the frontlines. LB

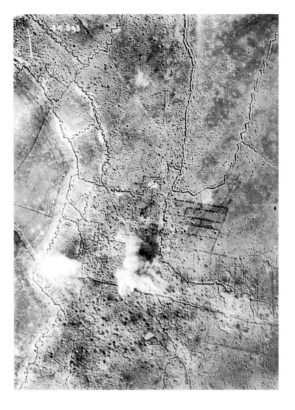

"[In August 1914] the RFC [Royal Flying Corps] began taking aerial photographs and in 1915 J. T. C. Moore-Brabazon of the RFC designed the first efficient aerial camera." *History Today*

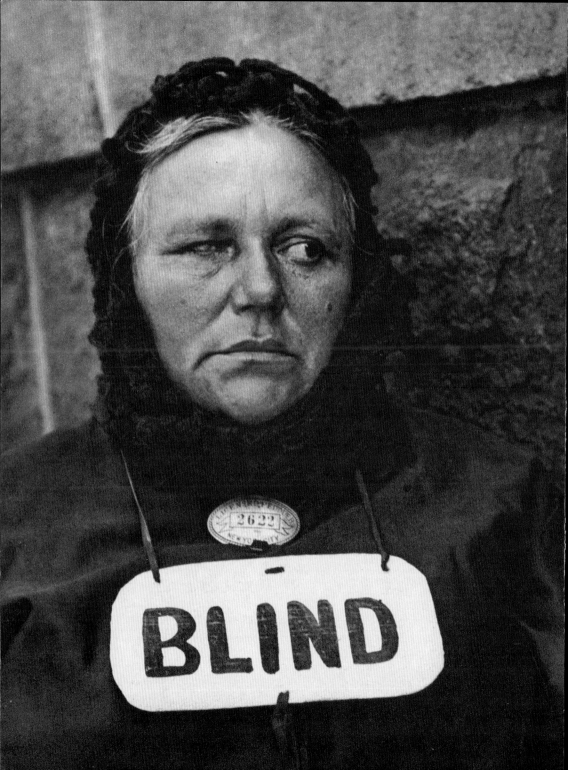

BLIND

PAUL STRAND

Date 1916 Location New York, New York,
USA Format Large-format camera with
trick lens and right-angle mirror

In 1909, American photographer Paul Strand
(1890–1976) completed his studies under the
social reformer and photographer Lewis Hine at
the Ethical Cultural Fieldston School in New York.
Hine introduced Strand to Alfred Stieglitz, founder
of the Photo-Secession group and publisher of
the influential magazine *Camera Work*.

Strand began producing abstract photographs
in 1915 that were notable for their use of shadow,
rhythmic shapes, simplified forms, and artful
composition. The last double edition of *Camera
Work* in 1917 was dedicated to Strand's work, and
included this image of a blind street beggar on
the streets of New York. *Blind* is one of a series of
street photographs Strand took with a handheld
camera fitted with a prismatic lens, which allowed
him to point his camera in one direction while
taking a photograph at a ninety-degree angle.
The decoy lens meant that he was able to take
photographs without his subjects being aware,
because they thought he was photographing
something else—an act that has prompted
ethical debate on the role of photographers
and their relationships with their subjects. In
this case, the subject is also blind, further calling
into question the morality of capturing images
of people unaware. At the time, the photograph
was hailed for its modernism; today, it functions
well as a provocative and poignant piece of
social documentation. *Blind* serves to reveal the
dehumanization of the partially sighted in the
early twentieth century, as this woman has to beg
for a living and wears a placard akin to a dog collar
to advertise her plight. CK

STILL FROM *THE BATTLE OF THE SOMME*

GEOFFREY MALINS

Date 1916
Location France
Format 35mm

The identities of the men in this photograph are
unconfirmed and may never be known, but this act
of human kindness during the Battle of the Somme
will remain etched in history forever. The scene,
which shows a British soldier with a wounded
comrade draped across his shoulders, is a still from
The Battle of the Somme, a film by British official film
cameramen Geoffrey Malins (1886–1940), a former
portrait photographer turned cinematographer,
and John Benjamin ("JB") McDowell. Historians at
London's Imperial War Museum, which has the
film and stills images in its archive, assert that the
scene was filmed on the first day of the battle—
July 1, 1916. It comes from a sequence captioned
"British Tommies rescuing a comrade under shell
fire. (This man died thirty minutes after reaching
the trenches)."

Combining scenes staged outside of the
event alongside footage made in the trenches,
the documentary provides a starkly honest record
of the infamous World War I battle. GP

CHILDREN SCAVENGING RUINS AFTER THE EASTER RISING

UNKNOWN

Date 1916
Location Dublin, Ireland
Format 35 mm

On Easter Monday, April 24, 1916, approximately 1,200 Irish republicans converged at strategic points in downtown Dublin. What came next was a fierce rebellion that reduced areas of the capital to ruins and fueled the country's flame of independence. An estimated 200 buildings were damaged in the process, and the fighting left almost 500 dead, mostly civilians who were caught in crossfire or shot, mistaken as rebels by the British army. The British army was caught off guard, with only 1,268 troops

stationed in the city at the time, but by the end of the week they had gathered a force of 16,000 men. In the short term, the Easter Rising was a failure, but it was a pivotal turning point in the Irish campaign for freedom from British rule.

In this photograph, children scavenge amid heaps of rubble of collapsed buildings in the aftermath of the uprising. Seizing the advantage of the occasion, the young boys collect bits of firewood from the piles. The scene resembles a battleground. It is a significant image because it exposes the damage that was caused by the uprising and serves as a lasting document of a landmark event in Irish history that galvanized a nationalist movement. EC

STRETCHER BEARERS, BATTLE OF PILCKEM RIDGE

JOHN WARWICK BROOKE

Date 1917
Location Boesinghe, Belgium
Format Unknown

John Warwick Brooke was a press photographer on the British *Daily Mirror* newspaper before joining the king's cavalry soon after the outbreak of World War I. He fought as a regular soldier and was awarded the Military Cross before being wounded and invalided out of the army. Returning to his previous profession, he worked for the Topical Press Agency. In 1916 he returned to the Western Front as only the second official British army photographer after Ernest Brooks.

Over the next two years, Brooke produced around 4,000 images. He was present at many major battles, including this, the opening encounter of the Battle of Passchendaele (aka the Third Battle of Ypres).

Pilckem Ridge (July 31–August 2) was successful, but also extremely bloody from the Allied point of view, with as many as 30,000 casualties on the British side alone. The wider Passchendaele offensive cost the lives of as many as 600,000 soldiers on both sides. The name of Passchendaele—a village of no inherent use or strategic significance to the combatants—has since become a byword in many languages for senseless wartime slaughter. LB

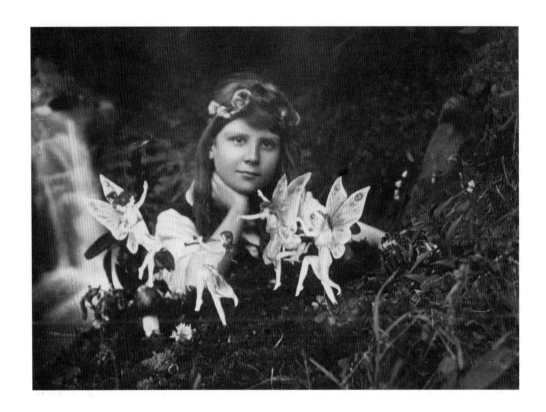

THE COTTINGLEY FAIRIES

ELSIE WRIGHT

Date 1917
Location Cottingley, UK
Format Glass plate

Photographic history has more of its share of hoaxes and hoaxers, but one of the most enduring and influential was perpetrated by two young girls, seemingly on the spur of the moment. In 1917, Frances Griffiths and her cousin Elsie Wright (1901–88) were living in the small village of Cottingley, West Yorkshire. When the two girls were scolded by their mothers for playing near a local stream, they responded that they went there only to see the fairies, and borrowing Elsie's father's camera,

they shortly afterward returned with the image above. Elsie's father dismissed it as a fake, but her mother believed the image was genuine, and in 1919 it and four other similar photographs came to the attention of Edward Gardner, a leading figure in the spiritualist Theosophical Society, who saw them as a potential coup for the movement.

When the photos became public, they divided opinion. Among those who believed that they were genuine was writer Sir Arthur Conan Doyle, creator of Sherlock Holmes. It was not until 1983 that Wright and Griffiths finally revealed that the photographs had indeed been faked. They added that after Doyle said the images were genuine, they felt too embarrassed to reveal the truth. LB

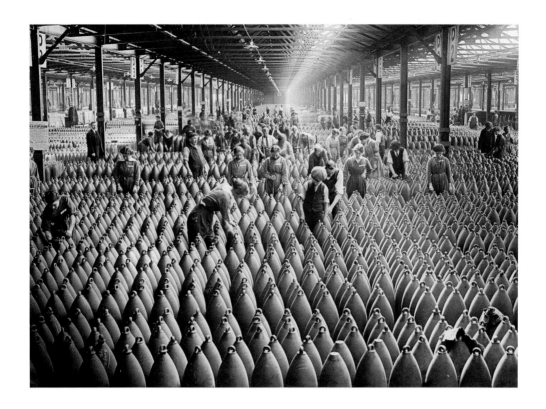

MUNITIONS PRODUCTION ON THE HOME FRONT

HORACE NICHOLLS

Date 1917
Location Chilwell, UK
Format Medium-format plate camera

In 1917, during World War I, photojournalist Horace Nicholls (1867–1941) was appointed home front official photographer by the British government. Sadly, his new position coincided with the death of his own son on the Western Front. Nicholls recorded the process of recruiting and training new soldiers, the huge munitions factories and shipyards, and focused especially on women who had taken on the roles vacated by men who had been sent to the front. His work was part documentary, part morale-boosting propaganda. In this image of one of the largest munitions factories in the country, the serried rows of shells are lined up almost to infinity. The workers have their sleeves rolled up to signify their commitment to the task, while the formally suited foreman makes notes on the volume of the day's production in the corner. The No. 6 National Shell Filling Factory produced more than nineteen million shells during the war, but was the scene of a tragic accident in 1918, when eight tons of TNT exploded, killing 134 people and wounding a further 250. At the end of the war, Nicholls became the first chief photographer for the newly established Imperial War Museum. PL

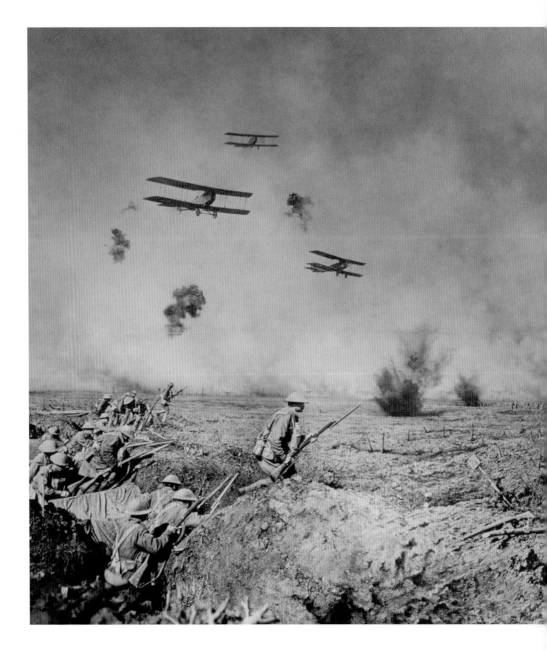

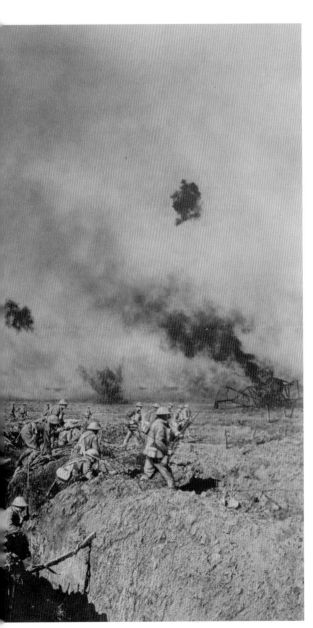

OVER THE TOP

FRANK HURLEY

Date 1917
Location Western Front, Belgium
Format Composite image from glass plates

In August 1914, Australian photographer James Francis ("Frank") Hurley (1885–1962) was marooned in Antarctica with Ernest Shackleton's ultimately unsuccessful Imperial Trans-Antarctic Expedition. Rescued in 1916, he almost immediately joined the Australian Imperial Force, was appointed as an official war photographer, and departed for World War I in Europe. Hurley wrote at length in his diaries about the frustrations of trying to document the conflict using the rudimentary cameras that were then available.

Hurley's ways of overcoming the limitations of his equipment were highly unorthodox: for example, having soldiers stage scenes for him, and sometimes even creating complex composites such as the image reproduced here. Created from as many as twelve separate exposures, this tableau shows an intricate battle scene with Australian troops emerging from trenches while under fire as biplanes swoop overhead. Another aircraft has crash-landed and smolders on the far right of the image.

Hurley justified these measures by arguing that his composites depicted the war more accurately than any single image ever could, but his methods brought him into conflict with Australia's official war historian, Charles Bean. For Bean, Hurley's photographs were fakes that called into question the veracity of the official record of the war. With the relationship between the two men becoming increasingly bitter, Hurley left the Western Front in November 1917 for the Middle East, where he continued to photograph Australian soldiers until the end of the war. LB

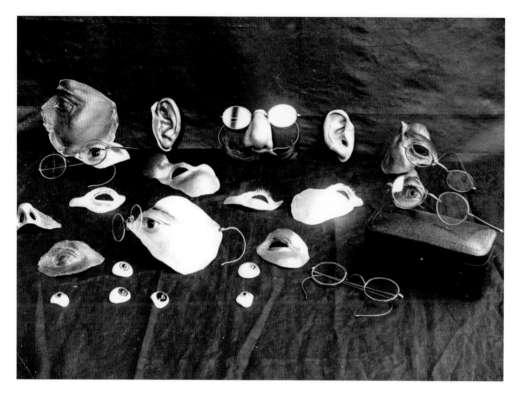

REPAIRING WAR'S RAVAGES: RENOVATING FACIAL
INJURIES. VARIOUS PLATES AND ATTACHMENTS IN
DIFFERENT STAGES OF COMPLETION

HORACE NICHOLLS

Date 1917

Location London, UK

Format Medium-format plate camera

Dubbed "the Tin Noses Shop" by the wounded former British servicemen who were treated there, the Masks for Facial Disfigurement Department was the formal name for the extraordinary facility set up by British sculptor and artist Captain Francis Derwent Wood in 1916.

World War I left a terrible legacy to many of the survivors, with an estimated 60,500 British soldiers suffering head or eye injuries, and 41,000 men having limbs amputated. Dr. Fred Albee, an American surgeon working with the casualties and seeking an explanation for these high numbers, remarked that the soldiers "seemed to think they could pop their heads up over a trench and move quickly enough to dodge the hail of machine-gun bullets." Too old to serve on the frontline himself, Wood used his skills as a professor at the Royal College of Art in London to create lifelike masks from thin sheets of copper, hand-painted and sculpted to match the contours of the wounded soldier's face. Horace Nicholls (1867–1941) made an extensive photographic study of the work of the hospital as part of his duties for the Imperial War Museum, including this disturbing still life with its echoes of surrealism. PL

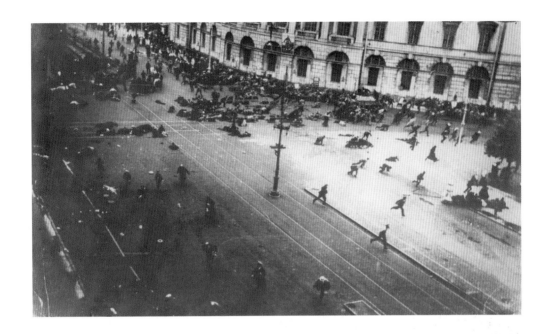

STREET DEMONSTRATION

VIKTOR BULLA

Date 1917
Location St. Petersburg, Russia
Format Unknown

This photograph, taken during the Russian Revolution by Viktor Bulla (1883–1938), offers an insight into the chaos that erupted on the streets of Petrograd (St. Petersburg), when disaffected workers rose against the Russian Provisional Government during the so-called "July Days." Hordes of workers, soldiers, and sailors—some of whom were revolutionary Bolsheviks—took to the streets of the city to protest. Armed clashes broke out, and an estimated 400 people were injured. Bulla, who was working as a documentary filmmaker as well as a photographer at the time, captured the unrest as it unfolded on Nevsky Prospekt, the main street. Shot from a high vantage point—perhaps from the window of a nearby building—this image clearly shows groups of injured people in the background, and in the foreground, protesters dispersing. The Bolsheviks were temporarily halted after the uprising, with Vladimir Lenin forced into hiding and other party members arrested, although their power strengthened again in the months leading up to the October Revolution of that year. Vivid in its depiction of the chaos that ensued, Bulla's photograph is the most famous and telling image of the events of those days in July. GP

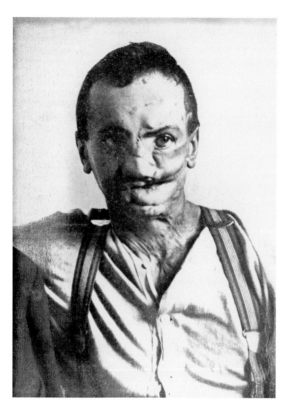

THE HEALTH RESORT
OF THE PROLETARIAN

ORIGINAL PHOTOGRAPHER UNKNOWN, COMPILED BY ERNST FRIEDRICH

Date 1917
Location Unknown
Format Unknown

Ernst Friedrich (1894–1967) was a German pacifist and political radical who quit an apprenticeship as a printer to join the Social Democratic Party and served a prison sentence for military sabotage during World War I. In 1919, he established a meeting place for radical youth and antigovernment artists and traveled throughout Germany giving antiwar lectures. In 1924, Friedrich published *War Against War!*, a collection of nearly 200 photographs drawn from medical and military archives that he hoped would act as unchallengeable proof of the evils of armed conflict.

War Against War! was radical not only in its politics but also in the way it appropriated photographs from a wide variety of official sources and repurposed them to fresh effect. Photographs like this were probably originally produced as part of programs on reconstructive surgery for wounded soldiers, but in Friedrich's hands they became powerful images of the horrendous violence of a modern, industrialized war. The book was also innovative in its design, with captions in four languages (German, French, Dutch, and English), intended to speak to the nationalities who had been most involved in the fighting in Western Europe. The book's effect, however, has often been criticized as being counterproductive. Political activist Susan Sontag, for example, described the book as a form of visual shock therapy and used it to support her assertion that graphic images do little to motivate viewers to challenge the things that caused them. LB

"Friedrich's work represented a breakthrough. Before then, imagery of war had been subject to absolute censorship during conflict and diluted for the sake of 'taste and decency.'" Paul Mason

TSAR AND FAMILY ON ROOF
AS CAPTIVES

UNKNOWN

Date 1918
Location Tobolsk, Russia
Format 35 mm

In 1917 the 300-year Romanov dynasty in Russia was ended by the Bolshevik Revolution, which would create the Soviet Union. The last tsar (emperor) of Russia, Nicholas II, was forced to abdicate on March 15 of that year.

It was originally suggested that Nicholas and his family should be allowed to sail into exile in the United Kingdom, where the king, George V, was the tsar's cousin. However, the Russian revolutionary Workers' and Soldiers' Council opposed this initiative, and the royal family was instead transported to Tobolsk in Western Siberia. There they dwelt for some time in relative comfort and safety, under house arrest in the mansion occupied before the revolution by the provincial governor of the Tyumen Oblast.

It is here that the deposed royal family members are seen sitting on the roof of a conservatory. The image is a haunting one because, not long after it was taken, the communist revolutionaries persuaded the Romanovs that they would be better protected in the neighboring city of Ekaterinburg. The family believed them (not that they had much choice in the matter), but it was there, on the night of July 16–17, 1918, that they were all murdered in the cellar of the house in which they had been confined. Their bodies were burned, cast into an abandoned mine shaft, and then buried unceremoniously in a location that was concealed from the public by a government that feared a tomb would be a rallying point for dissidence. It was not until after the collapse of the Soviet Union that the bodies were given a proper Russian Orthodox interment. EC

"I shall never, under any circumstances, agree to a representative form of government because I consider it harmful to the people whom God has entrusted to my care."

Tsar Nicholas II

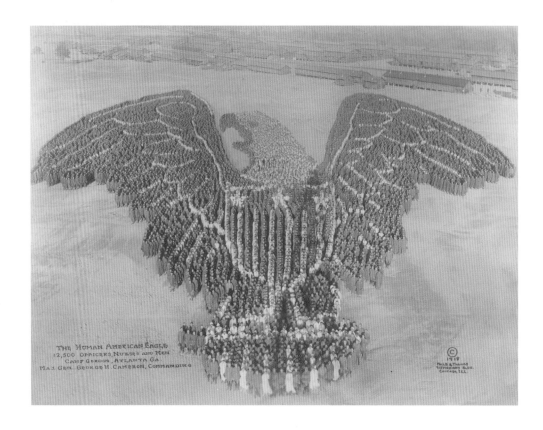

The Human American Eagle
12,500 Officers, Nurses and Men
Camp Gordon, Atlanta Ga.
Maj. Gen. George H. Cameron, Commanding

THE HUMAN AMERICAN EAGLE

ARTHUR MOLE

Date 1918
Location Atlanta, Georgia, USA
Format Large format

With his business partner John D. Thomas, Arthur Samuel Mole (1889–1983) made a series of thirty of these extraordinary "living photographs" during World War I. He arranged tens of thousands of soldiers and their equipment into huge tableaux vivants, the shapes of which could be fully perceived only from the top of a specially erected 80-foot (24m) tower that created the correct perspective to view the composition. Each photograph required a week to prepare, with Mole carefully planning

out the lines of perspective needed to create the illusion and marking out the terrain with tape. He used a megaphone and a system of white flags to signal his instructions to the massed ranks below.

Mole intended to create morale-boosting images to generate feelings of patriotism as the United States entered the global conflict. He visited eighteen US military bases, including this one at Camp Gordon, Atlanta, Georgia, where his arrangement depicting the American eagle comprised 12,500 officers, nurses, and men. Other images included Woodrow Wilson, the Liberty Bell, the Statue of Liberty, the emblem of the YMCA, and the Allied flags. PL

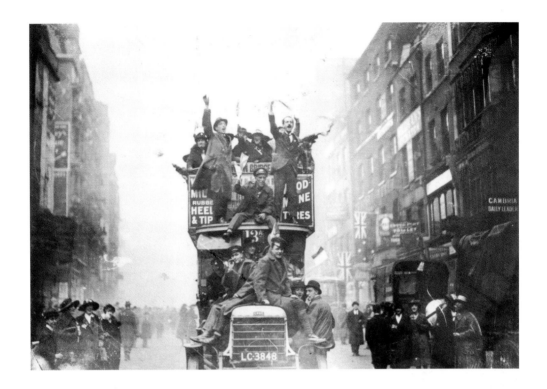

PEACE BUS

UNKNOWN

Date 1918
Location London, UK
Format Unknown

When Britain declared war on Germany after the latter's invasion of Belgium in the summer of 1914, politicians on both sides were publicly optimistic that "it would be all over by Christmas." The Yuletide in question, however, turned out to be more than four years away, and in the intervening period three-quarters of a million Britons were killed and another two million were wounded. In total, World War I claimed seventeen million dead and twenty million wounded.

Under the circumstances it is perhaps not difficult to understand why the armistice that brought an end to the conflict on November 11, 1918, was a cause for massive celebrations throughout the victorious nations.

In London the biggest crowds gathered in the largest public spaces—Trafalgar Square, Piccadilly Circus, and on the Embankment beside the Thames River. But the joy and relief spread across the British capital, as evidenced by this image of jubilant people aboard a red bus on an unidentified city street. Most Britons were keen to believe the politicians' new pledge, that this was "the war to end war"; unfortunately, that was not how events transpired. LB

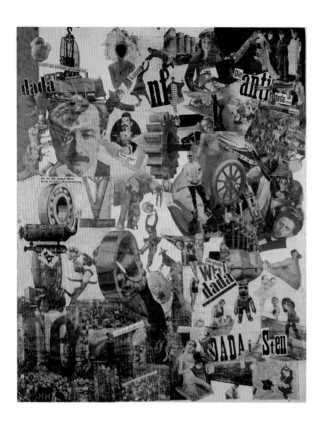

CUT WITH THE KITCHEN KNIFE THROUGH THE LAST WEIMAR BEER-BELLY CULTURAL EPOCH IN GERMANY

HANNAH HÖCH

Date 1919
Location Berlin, Germany
Format Collaged paper prints

Collage artist Hannah Höch (1889–1978) was a prominent member of the Berlin Dada, a circle of artists inspired by the avant-garde movement of the same name. A key tenet of Dadaism was that art should engage with the changes taking place in the world, rather than hold on to older artistic traditions and subject matter.

The demise of the German monarchy in the aftermath of World War I and the establishment of the Weimar Republic led to a period of unprecedented permissiveness in Germany. This in turn led to a flourishing of the press, which had previously been tightly controlled, and a proliferation of mass media, including illustrated magazines. Höch often took these publications as the source material for her collages, collecting editorial and advertising imagery, and building it up into complex assemblages such as this.

This collage suggests that the Weimar Republic is more closely aligned with the forces of conservatism than those of progress, and consequently needs to be cut away. At the same time, and like much of Höch's other work, it makes reference to the significant gender divisions that remained in the art world. LB

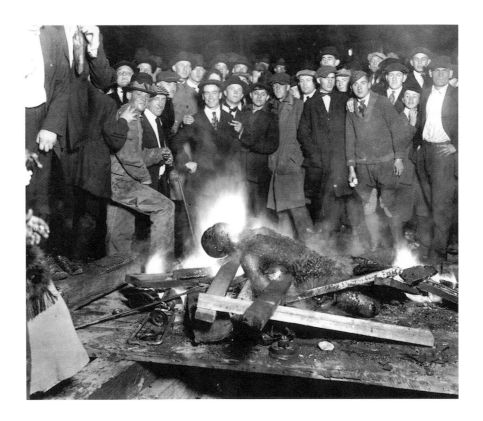

LYNCHING IN NEBRASKA

UNKNOWN

Date 1919
Location Omaha, Nebraska, USA
Format Unknown

In the summer of 1919, a series of race riots broke out in Chicago, Illinois, and several other US cities. In Omaha, Nebraska, a white woman, Agnes Loebeck, claimed that she had been assaulted by a black man whom she identified as Will Brown. Brown was taken into police custody, but an angry mob began firing on the courthouse with looted guns. The crowd set fire to the building and prevented firefighters from putting out the flames. The mayor tried to reason with them but was knocked unconscious and strung up, almost dying before he was rescued. Brown was seized, beaten unconscious, and hung from a lamppost, where his spinning body was riddled with bullets. His body was then burned, and the charred corpse dragged through the city streets.

This distasteful image is a powerful testament to the evil inspired by race hate.

Movie actor Henry Fonda, born and raised in Nebraska, witnessed this lynching from his father's print shop at age fourteen. He later recalled: "It was the most horrendous sight I'd ever seen . . . We locked the plant, went downstairs, and drove home in silence. . . . All I could think of was that young black man dangling at the end of a rope." CJ

ALLIED OFFICERS VIEWING SIGNING OF VERSAILLES TREATY

UNKNOWN

Date 1919
Location Versailles, France
Format Unknown

Sometimes what's happening in the wings can be even more interesting than the action on stage. This photograph is a case in point: the main event—the signing on June 28, 1919, of the peace accord that marked the formal end of World War I—is happening outside the frame, behind the doors in the background. Allied officers, waiting with bated breath, are precariously perched on pieces of furniture, straining to see and hear what is going on inside. The sense of expectation is palpable, but the viewer can only imagine what is going on inside that room. However, a little background knowledge makes this image even more interesting: the Treaty of Versailles was intended to bring an end to global conflict, but it managed to postpone another one for only twenty years.

This image is one of thousands collected by Henry Guttmann, a writer and photography agent, who amassed more than 10,000 historical images to illustrate his articles. GP

A BEGGAR PURSUES KING GEORGE V

UNKNOWN

Date 1920
Location UK
Format Unknown

The remarkable aspect of this photograph to a modern viewer is the absence of police protection or security. King George V arrives at the Derby horse race, and a beggar is able to run alongside the royal landau and hold his cap out under the nose of Prince Henry, one of the king's sons. The royal party does not seem alarmed; the beggar should have perhaps been told that monarchs do not carry money. What comes across as a classic scene of social class confrontation is a little misleading in the context of the times. There were increasing numbers of unemployed war veterans in this period of recession, but George V made great efforts to bring the monarchy closer to the people after the traumas of World War I and regularly appeared at sporting events and on public occasions.

Iconic images such as this often leave the viewer with a sense of unfulfilled curiosity. We wonder what happened to the beggar after this moment. Was he arrested, reprimanded, or ejected from the racecourse? Nowadays, countless pictures taken by members of the public on cell phones would fill in the gaps and provide the answers. CJ

ALCOHOL BEING DESTROYED DURING PROHIBITION

UNKNOWN

Date 1920
Location USA
Format 35 mm

Mid-January 1920 saw the start of Prohibition under the Eighteenth Amendment of the US Constitution, which outlawed the production, sale, and transport of alcohol. The aim of this "noble experiment" was to reduce crime, poverty, and death rates. To emphasize their seriousness of purpose, federal law-enforcement agents made a great show of discarding seized liquor, as in this image of the contents of a barrel of beer being poured down a drain.

Outlawing alcohol was one thing; preventing people from drinking it turned out to be quite another. Prohibition inspired the creation of undercover distilleries and breweries all over the United States. It also led to a huge growth in organized crime; gangsters made huge profits in the liquor business, thanks to the incessant demand for the product. Illegal drinking dens, known as "speakeasies," became widespread. The failure of Prohibition was finally acknowledged during the presidency of Franklin D. Roosevelt, who brought it to an end on December 5, 1933, by repealing the Eighteenth Amendment. EC

LIFE IN A LONDON SLUM

UNKNOWN

Date 1920
Location London, UK
Format Unknown

This photograph—taken in Shadwell, East London, less than one mile from the Bank of England, the focal point of Britain's wealth—is an important social record of an era of extreme privation. An estimated one million people in Britain lived in such extremely poor conditions at the beginning of the 1920s. Throughout World War I, when thousands of working-class men went off to fight in the trenches, British politicians spoke of the need to build "homes fit for heroes," but the cost of victory was so great that it transformed the world's premier power into a debtor nation. The government did little to address the social problems of the postwar era, among the most pressing of which were unemployment and poor housing.

Slum dwellings such as the tenement shown here arose from rapid urbanization in the nineteenth century, combined with significant population growth and an uncontrolled property market. The poorest members of society could afford only the cheapest, most overcrowded, and unhealthiest homes, often in damp basements that never saw real daylight. CJ

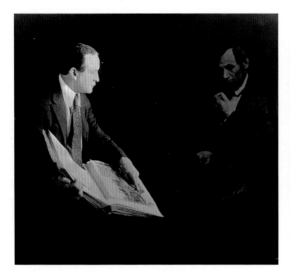

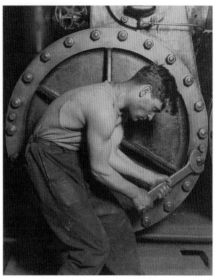

HOUDINI AND THE GHOST OF ABRAHAM LINCOLN

UNKNOWN

Date c. 1920–30
Location Unknown
Format Magic lantern slide

Harry Houdini remains well known for his stunts and escapology, which included being buried alive and locked up underwater. Less well known is that during the 1920s he also undertook a campaign aimed at debunking spiritualists.

In 1924, Houdini published an account of his efforts in *A Magician Amongst Spirits*, one chapter of which focuses on debunking spirit photography and includes sample images of ghostly apparitions. Houdini also lectured extensively on "fraudulent spiritualistic phenomena," using a magic lantern to project photographic glass slides, including the one above. Showing Houdini with US President Abraham Lincoln, who had been assassinated in 1865, the image demonstrated how easy it was to fake a spirit photograph. Here, Houdini was deliberately echoing a famous spirit photograph of Lincoln's widow by William H. Mumler. LB

POWER HOUSE MECHANIC WORKING ON A STEAM PUMP

LEWIS HINE

Date 1920
Location Unknown
Format Large format

Late in life, American sociologist and photographer Lewis Hine (1874–1940) recalled: "There were two things I wanted to do. I wanted to show the things that had to be corrected. I wanted to show the things that had to be appreciated." Throughout the first part of his career he did the former, concerning himself with such social problems as child labor; then around 1920 he changed direction, altering the description of his studio practice from "social photography" to "interpretive photography." This involved moving away from images that exposed worker exploitation to a more optimistic vision that celebrated the industrial laborer as a heroic figure—the power behind the Machine Age. What was common to both phases of Hine's career was his unshakable respect for the dignity of the people he portrayed. JS

TOUR DE FRANCE 1921

UNKNOWN

Date 1921
Location Dalstein, France
Format Unknown

It would be unheard of today during the Tour de France, but in 1921, at the fifteenth edition of the famous cycling race, it was acceptable to have a beer break. Here, Swiss riders Henri Collé and Charles Parel are pictured on a step outside a French tavern, watched by local children. Other customers, or perhaps the proprietors, stand behind them, looking toward the camera. It is a wonderfully natural scene, unposed and full of joie de vivre. The photographer, who was probably working for a newspaper or a magazine, captures the intimacy that defined the tour in its early days.

The tour, which was created in 1903 as a promotional tool by Henri Desgrange, editor of *L'Auto-Velo*, was more than a competitive sporting event. For local people who lived in villages along the route, the three-week race was an annual celebration in which everyone could participate.

Neither of these riders won the overall race, but they were both among the thirty-eight who completed the course: Collé finished seventeenth, Parel twenty-ninth. That year's overall winner was Belgian rider Léon Scieur. GP

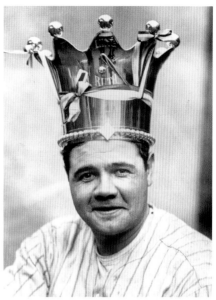

BABE RUTH

GEORGE RINHART

Date 1921
Location USA
Format Unknown

George Herman "Babe" Ruth had an extraordinary athletic career and was one of the most popular US baseball players ever. Ruth's charisma and legendary prowess as a slugger, combined with his reckless lifestyle off the field, meant that he was constantly in the press during the Roaring Twenties. He made up for his excesses, however, by his charitable work, visiting sick children and orphans, and by his later unwavering support for the troops in World War II. This image of him wearing a faintly ridiculous fake crown expresses the larger-than-life persona he cultivated. It was given to him when he was crowned the "King of Swat" in the Yankee clubhouse. The elaborate headgear was made of silver, cost $600, and was more than 1 foot (30cm) high; around the rim is a row of forty-nine engraved miniature baseballs. PL

RAYOGRAPHY "CHAMPS DÉLICIEUX" NO. 04

MAN RAY

Date 1922
Location Paris, France
Format Photogram

Man Ray (1890–1976) was a leader of the Dada and Surrealist movements that burgeoned in Europe in the 1920s. Born Emmanuel Radnitzky to a Jewish family in Philadelphia, he was recognized for his talent while in high school, but he declined a scholarship to architecture school, preferring to study drawing and watercolor painting. In 1913–14 two events secured his future as an artist: his visit to the Armory Show and his first encounter with French avant-garde artist Marcel Duchamp, with whom he would later collaborate on several experimental film projects. In 1915, Man Ray bought a camera to document his drawings and paintings, and soon become interested in photography.

He then followed Duchamp back to Paris, where he became part of a circle of artists who inspired him to continue his experimental work. In 1922, he began his Rayographs, a series of photograms that depict silhouettes of random objects organized on light-sensitive paper, made without the use of a camera or a negative. Depending on the transparency of the object, the shadows of the Rayographs appear lighter or darker, as in this example. They are haunting images that extended the boundaries of the still relatively new medium of photography.

Duchamp said of Man Ray: "It was his achievement to treat the camera as he treated the paintbrush, as a mere instrument at the service of the mind." Other artists later experimented with this "cameraless photography," including Alexander Rodchenko, Imogen Cunningham, and László Moholy-Nagy, but Man Ray's images are still the most widely referred to and recognized. SY

DUBLIN, 1922

UNKNOWN

Date 1922
Location Dublin, Ireland
Format Unknown

These members of the Irish Republican Army (IRA) are patrolling Grafton Street in central Dublin. They are anti-Treaty republicans—also known as IRA Irregulars, or mutineers—who, under the leadership of Éamon de Valera, conducted armed resistance against the newly independent government during the Irish civil war of 1922–23. The signing of the Anglo-Irish Treaty on December 6, 1921, which established the Irish Free State, had led to divisions within the republican movement.

The photograph is a chilling example of how the violent disagreements played out on the streets of Dublin in an everyday context. The men, whose expressions (particularly that of the man at front center) are severe and focused, are pictured walking amid members of the public, who appear to be going about their daily business as best they can. In this way the photographer shows how violence came to define life in the capital at this volatile time. GP

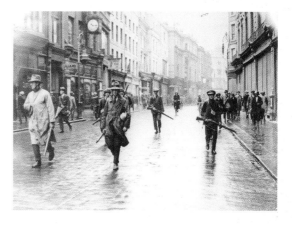

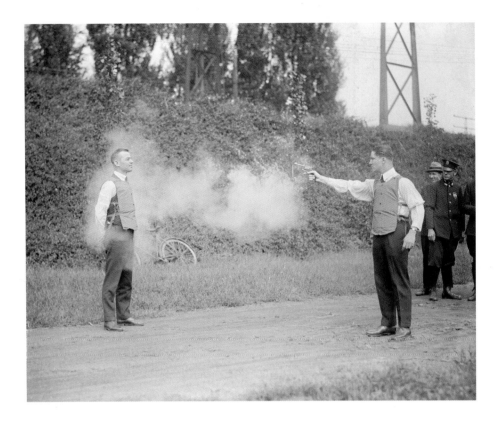

TESTING A BULLETPROOF VEST

UNKNOWN

Date 1923
Location Washington, D.C., USA
Format Unknown

The original caption for this startling image reads: "W. H. Murphy of the Protective Garment Corp. of New York stood less than ten feet [3m] from (Frederick County, Md.) Deputy Sheriff Charles W. Smith in police headquarters Wednesday and let the deputy fire a .38 caliber revolver straight at his chest. When the bullet hit, Murphy never batted an eye. Inventors of the bulletproof vest, which weighs about 11 pounds [5kg], have put it on the market for the protection of police and other officers in emergency cases. The bullet which Deputy Smith fired into the vest Wednesday was presented to him for a souvenir."

The rise of gang violence during the Great Depression of the 1920s and 1930s saw a rapid increase in violent crimes, as gangsters armed themselves with lethal arsenals that included the infamous tommy gun, the weapon of choice of the Mafia. The arms race caught the police off guard, and they looked to bulletproof vests to save officers' lives. However, the gangsters too started to use body armor made from thick layers of cotton padding and cloth that could stop a bullet from a normal pistol, so law enforcement agencies had to adopt the more powerful .357 Magnum round. PL

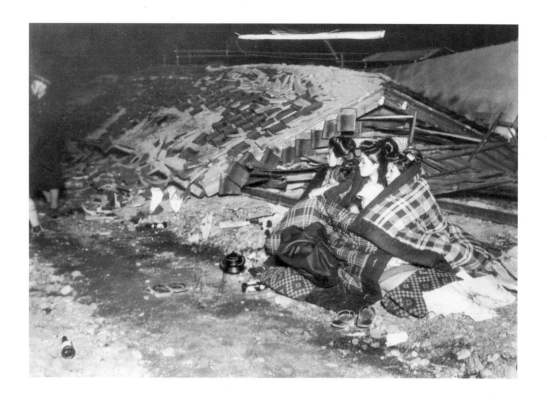

EARTHQUAKE SURVIVORS IN YOKOHAMA

UNKNOWN

Date 1923
Location Yokohama, Japan
Format Unknown

The Great Kantō Earthquake struck at 11:58 a.m. on Saturday, September 1, 1923, just as families were gathering for lunch. The tremor measured 8.2 on the Richter scale; it was followed by a tsunami 35 feet (11m) high and a firestorm caused by overturned cooking stoves, fanned by high winds. The tremors continued for almost five minutes, striking Tokyo most heavily, leaving 60 percent of the city's population homeless and flattening the nearby port of Yokohama. Up to 140,000 people died.

The poignancy of this image of survivors in Yokohama lies in its almost tranquil atmosphere. It is night, and some hours after the earthquake. The three girls seem stoic, if understandably anxious, intent on keeping warm and surviving. Their upright posture gives them an air of dignity, facing an uncertain future by supporting one another. The sandals tucked under the blanket add a curiously domestic note to the scene.

Among those who survived the earthquake was Akira Kurosawa, the future movie director, then aged thirteen years. He recalled: "Through it I learned not only of the extraordinary powers of nature, but of extraordinary things that lie in human hearts." CJ

INGRES' VIOLIN

MAN RAY

Date 1924
Location Paris, France
Format Unknown

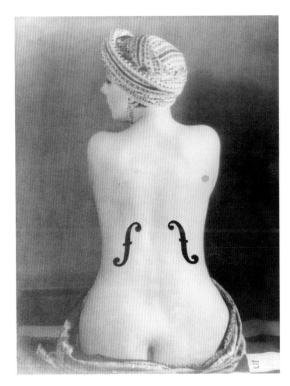

Many Dadaists and Surrealists admired the paintings of Jean-Auguste Dominique Ingres (1780–1867). *Ingres' Violin* is a curious homage to the French Neoclassicist by Man Ray (1890–1976), an influential member of both movements.

In the mid-1920s, Ray produced a series of images inspired by Ingres's paintings of nudes. In this photo, the most famous of that collection, he depicts his favorite model, Kiki de Montparnasse, seated naked from the waist up except for a turban, earrings, and f-holes on her back. Ray based it on Ingres's *The Valpinçhon Bather* (*La Grande Baigneuse*; 1808).

The poet Charles Baudelaire thought this work of Ingres a unique combination of voluptuousness and chastity, and it is this synthesis of sin and virtue that Man Ray sought to reproduce by an unusual method: he first painted the sound holes directly onto a photograph of Kiki and then re-photographed the result in order to achieve this uncanny effect.

Ray once said: "I paint what cannot be photographed, and I photograph what I do not wish to paint." This image reflects that approach and demonstrates his taste for experimentalism and mixed media.

The image is also notable as a typically Dadaist play with meaning and symbolism. The title in French, *Le Violon d'Ingres*, is an idiomatic expression meaning "hobby" and refers to Ingres's favorite recreational activity, playing the violin. Man Ray is thus implying that the subject of this image is his pastime—but is the subject sex or music or both? **SY**

"Nature does not create works of art. It is we, and the faculty of interpretation peculiar to the human mind, that see art." Man Ray

A PHRENOLOGIST'S STUDY OF NATHAN LEOPOLD JR.

UNKNOWN

Date 1924
Location Chicago, Illinois, USA
Format Unknown

In 1924, the United States was gripped by a shocking murder trial. Two wealthy college students, Nathan Freudenthal Leopold Jr. and Richard Albert Loeb, had confessed to the kidnapping and murder of fourteen-year-old Bobby Franks. This murder was the culmination of a series of crimes committed by the pair, who believed that their superior intelligence would allow them to escape the consequences of their criminal actions. The two had spent months plotting the murder of Franks, intending it to be the perfect crime only to then make a series of mistakes, including Leopold losing a distinctive pair of glasses at the murder scene. The two were soon arrested and subsequently confessed, each blaming the other for the murder.

During the subsequent trial, several unofficial phrenological studies were conducted, based on photographs of the two men, and published in newspapers covering the case. Phrenology—later discredited as a pseudoscience—held that a person's character could be determined from the shape of his or her head. These studies were often damning, emphasizing aggression and implying that the behavior of the two men was beyond their control. In view of the fact that both Leopold and Loeb were Jewish, there was detectable racism at play here.

The trial's conclusion was marked by a remarkable twelve-hour closing plea by defense attorney Clarence Darrow, a speech that is widely credited with saving the accused from execution—both men were sentenced to life imprisonment for the murder, plus ninety-nine years for the kidnapping. LB

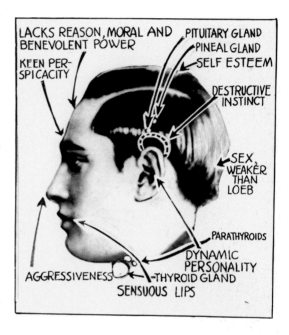

"Phrenology: The science of picking the pocket through the scalp. It consists in locating and exploiting the organ that one is a dupe with." Ambrose Bierce, *The Devil's Dictionary*

THE CONSTRUCTOR

EL LISSITZKY

Date 1924
Location Unknown
Format Photomontage on paper print

El Lissitzky (1890–1941) was a Jew whose work opportunities were limited by anti-Semitism in his native Russia, so he went to Germany and France to study art. Returning home after the 1917 Bolshevik Revolution, he prospered as a radical artist in many fields. As a graphic designer he produced propaganda posters for the new regime. As a painter in collaboration with Kazimir Malevich, he developed the basis for Suprematism, an ultra-abstract movement that focused on simple geometric forms and a narrow palette of colors.

In photography, Lissitzky used photomontage and other experimental techniques, combining multiple images to dramatic effect. This composite self-portrait of Lissitzky is composed of six separate images. Art and design merge in the squared paper backdrop and the compass-holding hand that emerges from Lissitzky's head, while his eye, emerging from the center of the frame, emphasizes the primacy of vision. LB

CRITIC OSIP BRIK

ALEXANDER RODCHENKO

Date 1924
Location Russia
Format Photomontage

Alexander Rodchenko (1891–1956) created this composite image as a cover illustration for the Soviet avant-garde magazine *LEF* (translated as "Leftist Front of the Arts"), of which literary critic Osip Brik was a cofounder. The publication's title appears in Cyrillic script over Brik's right eye; his other eye is clear, perhaps to symbolize his dedicated leftist vision.

Both Rodchenko and Brik are associated with the Russian movement of Constructivism, and Rodchenko used both photography and photomontage to illustrate his ideas about the connection between vision and revolution, centered upon the camera as a new kind of eye. Brik wrote in 1926 that "[t]he task of the cinema and of the camera is not to imitate the human eye, but to see and record what the human eye normally does not see." Rodchenko argued that perceptual habits deaden our vision of the world. By revealing new and unconventional points of view, the camera had the potential to change political points of view, too. As the Stalin regime progressed through the 1930s, the avant-garde vision represented by Rodchenko and Brik became marginalized and eventually persecuted, replaced by the heavily restricted style of Socialist Realism. Meanwhile, Rodchenko had moved from photomontage to photography, expressing his political vision in part through the use of oblique and often dizzying angles that challenged viewers' sense of the world and their position within it. But the photomontage style that he pioneered, exemplified here, persisted and remains part of the unmistakable visual language of the Soviet era. JG

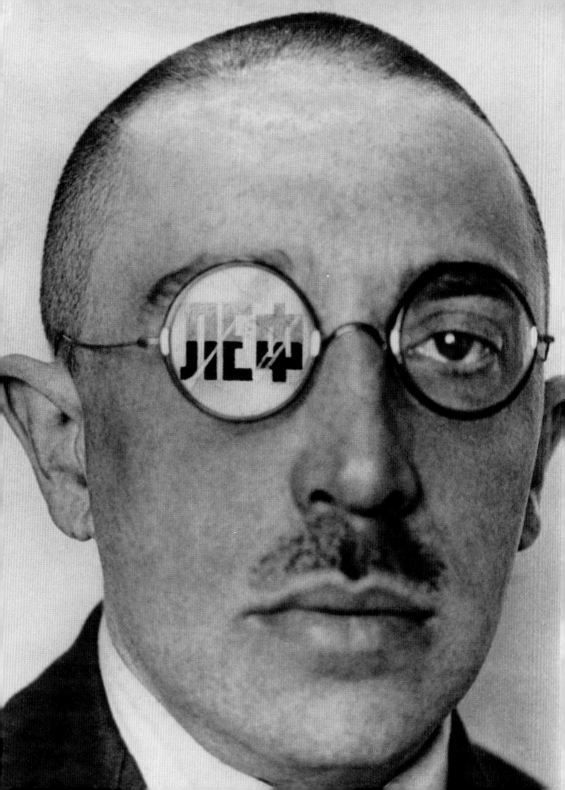

THE PANTHÉON

EUGÈNE ATGET

Date 1924
Location Paris, France
Format Large-format

Of Eugène Atget (1857–1927), US photographer Berenice Abbott wrote: "He [was] an urbanist historian . . . a Balzac of the camera, from whose work we can weave a large tapestry of French civilization." This haunting photograph of the Panthéon was taken by Atget late in his career and reveals his signature style. He used his mechanical and framing techniques to invite the viewer into the composition. He would often rise at dawn, so his cityscapes are often empty, with an almost abandoned appearance.

Because Atget was virtually unknown when he died, we know little of his biography or the context in which he took his photographs. However, one need only look at the nearly 2,000 glass plates and 10,000 prints that he left to acquire a strong sense of the neighborhoods and haunts that intrigued him. He said: "I can truthfully say that I possess all of Vieux Paris," and it would be hard to deny the validity of his claim. SY

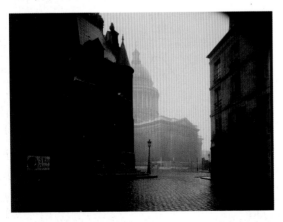

TWO WORKERS SET UP A GIANT ERNEMANN CAMERA

UNKNOWN

Date 1925
Location Berlin, Germany
Format Unknown

In the 1920s and 1930s, blurred boundaries between cinema and photography—technologically as well as artistically—saw artists experiment with both mediums, embracing the overlap. This photograph of a giant model camera embodies the sense of feverish activity that was happening within the film and photography industries. It was taken just before the opening of Kipho (Kino-und Photo Ausstellung), a cinema and photography exhibition and conference that focused on the industry of photography and film and where companies presented their products to visitors in a trade-fair setting. Despite Kipho's relative success in terms of visitors, the event was never held again.

The company responsible for this impressive display is Ernemann, a producer of cameras and movie projectors, which was founded in Dresden by the German entrepreneur, Heinrich Ernemann. By the early twentieth century, thanks to its founder's business acumen, the company was producing small cine cameras for amateurs, SLR cameras, and even its own lenses. The giant model camera pictured appears to boast a replica of the company's Ernostar lens, a famously fast optic due to its large aperture.

In the 1930s, filmmaking was big business, but parallel to this was the commercialization of photography precipitated by the widespread use of 35mm cameras and the expansion of the illustrated press. As this photograph testifies, companies went to great lengths to cash in on the appetite for photography, doing everything in their power to ensure that they remained at the head of the pack. GP

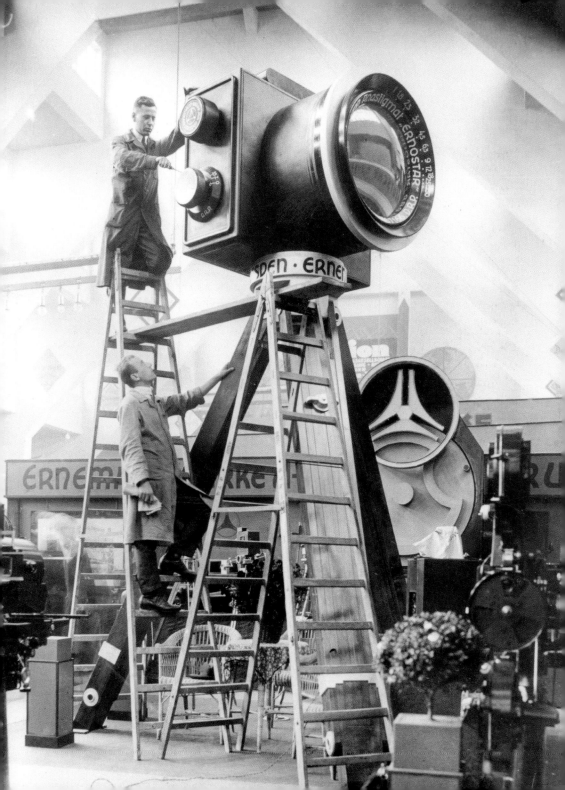

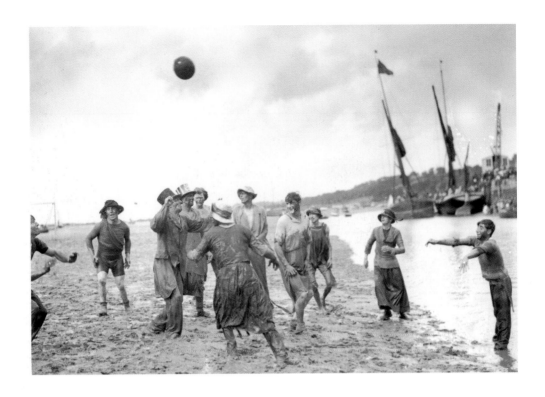

FOOTBALL IN THE MUD

JOHN WARWICK BROOKE

Date 1925
Location Leigh-on-Sea, UK
Format Unknown

This photograph by John Warwick Brooke (1886–1929) shows men and women taking part in a game of soccer at the Leigh-on-Sea Regatta. The so-called "mud football" event still takes place during the annual festivity at the historic old fishing village on the estuary of the Thames River, around 30 miles (48km) east of London.

The village predates the Roman invasion and has a large entry in the Domesday Book of 1086. It was once a busy port, and local fishermen played their part in the Dunkirk rescue operation of 1940. Brooke worked as a press photographer and is best known for the photographs he took during World War I. From 1916 to 1918, he took more than 4,000 photographs documenting the harsh realities of life on the Western Front for the British army. He was one of two official war photographers sent by Britain to the region; the other was Ernest Brooks. After the war, Brooke worked as a freelance stringer for the Topical Press Agency, which operated from 1903 until 1957 and is now part of the Hulton Archive at Getty Images. Brooke may be known for his dramatic war images, but this lighter scene captures something of the essence of Englishness. GP

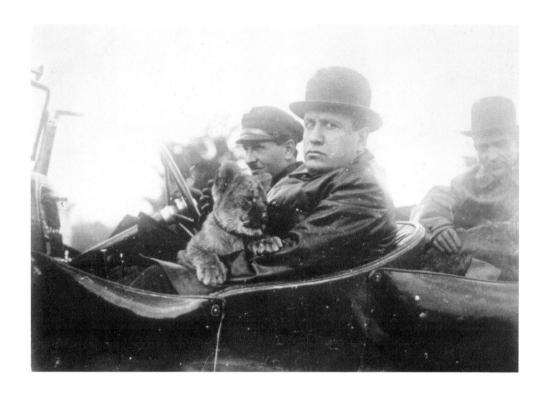

MUSSOLINI WITH PET LION CUB

UNKNOWN

Date 1925
Location Italy
Format Unknown

Benito Mussolini is seen here with his pet lion three years after he seized power in Italy through a coup d'état. The lion cub was a gift from a circus owner; Mussolini kept it in his house for a while before donating it to a zoo, where he would often be photographed inside its cage. Here, Mussolini seems to be challenging both the photographer and the wider public to recognize his strength and authority. The lion cub has been brought along for the ride, no doubt to underline this macho spirit.

Mussolini, a former journalist, made sure that newspapers published what they were told, and his propaganda team gained total control over film production, radio, poster art, sports events, and political rallies. Endless publicity stories of Mussolini's power and achievements were circulated throughout the country. Photography also played an integral role in creating the myth of Il Duce. He was frequently photographed playing sports, including skiing, swimming, and fencing. A famous image of Mussolini in uniform on horseback conveniently airbrushed out a groom holding the reins to steady the animal. Another widely circulated photograph showed him bare chested on sunlit ski slopes near Rome. CJ

FOTOGRAMM

LÁSZLÓ MOHOLY-NAGY

Date c. 1926
Location Dessau, Germany
Format Photographic print

László Moholy-Nagy (1895–1946) studied law before fighting in World War I, during which he was seriously injured. While recuperating he became increasingly interested in art. In 1919, he moved to Vienna, Austria, and then a year later settled in Berlin, Germany. Later, he took a job as an instructor at the Bauhaus school. Combining craft, design, and fine arts, the Bauhaus had an enormous influence in all these fields, employing and producing a whole generation of important artists and designers.

Moholy-Nagy taught and practiced across a broad range of media, experimenting with photography, painting, sculpture, printmaking, and typography. In photography he coined the concept of "the new vision," arguing that photography's importance rested on its ability to perceive the world in ways that the human eye could not.

One example of this innovation was Moholy-Nagy's interest in the photogram, a technique for making cameraless photographs by laying objects on photographic paper and then exposing it to light. Using this technique, he created complex photographic images resonant of the work of Constructivist artists, such as the Russians Kazimir Malevich and Alexander Rodchenko. LB

Self Taken — OCT. 1926.

SELFIE OF HELEN AND ARNOLD HOGG

ARNOLD HOGG

Date 1926
Location Warwickshire, UK
Format 35 mm

Now an indispensable aid for tourists everywhere, the selfie stick is a device that allows camera-phone users to take pictures of themselves, called "selfies." Ever since the stick first appeared, some people have seen it as a clever and useful invention, while others have viewed it with scorn. Whatever their opinions, it looks as though the stick is here to stay.

Historians suggest that the selfie stick was invented in Japan in the 1980s, and again in the early 2000s, this time in Canada. Hiroshi Ueda, who

worked for the camera manufacturer Minolta, was the man behind the first iteration, while Canadian inventor Wayne Fromm independently created the so-called "Quik Pod."

However, it is possible that both were pipped to the post by a man from Rugby in England who may have used something resembling a selfie stick as far back as 1926. In this photograph, Arnold Hogg seems to be holding some kind of selfie stick to make a photograph of himself and his puzzled-looking wife, Helen. The couple's grandson, Alan Cleaver, found the image in an old family album. It is a wonderful example of how a device assumed to be a modern invention may have a much longer history than anyone would have suspected. GP

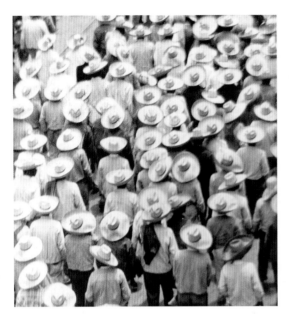

WORKERS' PARADE

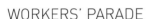

TINA MODOTTI

Date 1926
Location Mexico City, Mexico
Format Large format 5x4

Italian-born Tina Modotti (1896–1942) set up a photo studio in Mexico City with her lover, American photographer Edward Weston. She made Mexican culture and the plight of Mexican workers her primary subject matter. This photograph reflects her passionate desire to record the political movements in the metropolis through an aesthetic sensibility. It shows Mexican laborers, who were held up by the new regime as an ideological ideal of the authentic Mexican but who in reality felt forgotten by the state in the wake of the Mexican Revolution (c. 1910–20).

Modotti's photography career ended in 1930 when she was deported because of her political affiliations with Communists. Her photographs of the social dynamics of Mexico are still regarded as some of the strongest and most striking images from the period. SY

TV DEMONSTRATION

JOHN LOGIE BAIRD

Date 1926
Location London, UK
Format 35 mm

On January 27, 1926, the Scottish engineer and inventor John Logie Baird (1888–1946) gave a successful public demonstration of a television to members of the Royal Institution at his laboratory at 22 Frith Street in Soho, London. This photograph, which shows a face suspended like a death mask in its midst, is an original television image from that demonstration. While the pictures were small, only 3½ x 2 inches (9 x 5 cm), the process was revolutionary. It was the world's first demonstration of true television, as it revealed moving human faces complete with tonal gradients and detail. The audience's reactions of excitement, fear, and awe as the formerly static image began to dance and flicker on the screen can only be imagined. EC

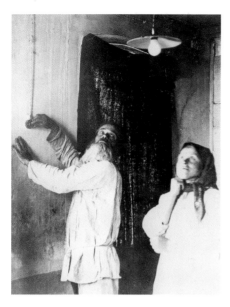

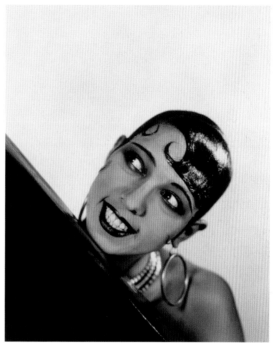

VILLAGE ELECTRIFICATION IN THE SOVIET UNION

ARKADY SHAIKHET

Date 1927
Location Soviet Union
Format Unknown

Arkady Samoilovich Shaikhet (1898–1959) trained as a locksmith's assistant in his native Ukraine, then moved to Moscow in 1918. In 1924, he became a photojournalist for the weekly illustrated magazine *Ogonyok*. While many of his professional rivals concentrated on buildings under construction and the latest machinery, Shaikhet majored in photo-essays about the everyday lives of ordinary people.

Here, a peasant and his wife try out an electric light, brought by a village electrification scheme. Later, Shaikhet collaborated with two other photographers on a picture story about a day in the life of a worker in the Red Proletarian Factory in Moscow. The Soviet propaganda machine was quick to make use of this work and included it in a touring exhibition to Vienna, Prague, and Berlin. CJ

JOSEPHINE BAKER IN PARIS

UNKNOWN

Date 1927
Location Paris, France
Format Unknown

American cabaret artist Josephine Baker radiates the buoyant self-confidence of someone who was quickly accepted and adored in Paris, a city obsessed with American jazz and dance. Baker had spent her youth in poverty in St. Louis, Missouri, before finding success on Broadway in New York. She moved to France to perform in La Revue Nègre at the Théâtre des Champs-Élysées and soon became one of Europe's most popular and highest-paid performers. She caused a sensation in a performance called *La Folie du Jour* when she wore a skirt made of sixteen bananas and little else. She was the first American woman in history to be buried in France with full military honors. CJ

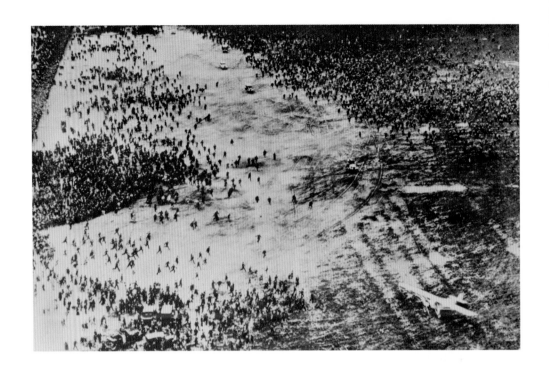

CHARLES LINDBERGH ARRIVES AT CROYDON AIRPORT AFTER HIS RECORD-BREAKING TRANSATLANTIC FLIGHT

UNKNOWN

Date 1927
Location Croydon, UK
Format Unknown

Charles Lindbergh was not the first aviator to fly across the Atlantic (he was, in fact, the nineteenth; the first had been Alcock and Brown in 1919), but he was the first to make it nonstop from New York to Paris, France, and thus won the Orteig Prize for that specific achievement. His celebrity status was assured even before he landed his aircraft, *Spirit of St. Louis*, at Paris–Le Bourget Airport— as he approached in darkness, he was confused by thousands of lights below and thought they

might be from a complex of factories; in fact, they were the headlights of thousands of cars full of spectators who were converging to hail his unprecedented feat.

The above image shows the huge crowds that were drawn to see Lindbergh when he landed at Croydon Airport in England on his way back to the United States. After his record-breaking flight, he took the *Spirit* on a tour of ninety-two US cities, a lap of honor during which he gave 147 speeches and rode 1,290 miles (2,064km) in parades.

Lindbergh's transatlantic heroics raised global interest in aviation and accelerated its development—first as a mail carrier, and later as a mass commercial transportation mode. PL

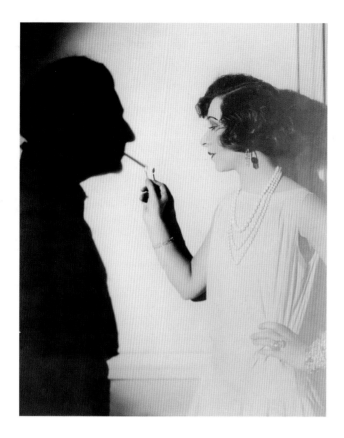

YVONNE PRINTEMPS

FLORENCE VANDAMM

Date 1927
Location New York City, New York, USA
Format Unknown

Florence Vandamm (1883–1966) was a prolific portrait photographer whose career spanned five decades. Opening her first studio in London in 1908, she and her husband, George R. Thomas—known as Tommy Vandamm—went on to run the hugely successful Vandamm Studio in New York. From 1925 to 1950, the duo specialized in photographs of theater productions. Tommy generally shot production photographs after each show's last dress rehearsal, while his wife, who had trained as

a painter, photographed performers in costume or the fashions of the day, as she has done in this photograph of French singer and actress Yvonne Printemps, commissioned by *Vanity Fair*. Printemps is pictured lighting the cigarette of actor Sacha Guitry; she is brightly lit, while Guitry is thrown into silhouette, creating a striking contrast. The tonal balance of the photograph makes it a fine example of Vandamm's considerable technical skill and creativity with the camera.

Florence continued to run the studio when her husband died in 1944, taking on his production photography work. By the time she retired in 1950, she was one of the most successful female commercial photographers of her century. GP

HITLER REHEARSING
A SPEECH

HEINRICH HOFFMANN

Date 1927
Location Germany
Format Unknown

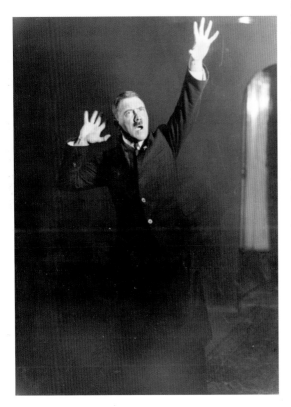

This is one of a set of nine photographs of Adolf Hitler taken by Heinrich Hoffmann (1885–1957) that challenge the myth of Hitler's natural, hypnotic, demagogic skills. He is seen rehearsing supposedly spontaneous gestures while listening to a recording of one of his own speeches, soon after he had written his political manifesto *Mein Kampf*. Hitler asked Hoffmann to take these shots to see what he would look like to his audience, using them to improve his technique. Hitler later demanded that the photographs be destroyed, but the canny Hoffmann deliberately didn't do so.

Hoffmann was a German photographer and magazine publisher. He became Hitler's friend and personal photographer and accompanied the Nazi leader everywhere during his rise to power. Hitler strictly controlled his public image, allowing only Hoffmann to take pictures of him. Hoffmann's photography played a crucial role in Hitler's campaign to present himself and the Nazi Party as a significant mass movement. He photographed a march of 5,000 storm troopers at Weimar in 1926, where Hitler first used the Fascist salute; this was a forerunner to the massive Nuremberg rallies in Hitler's later ascendancy. In 1933, Hoffmann published a book, *The Hitler Nobody Knows*, which also played a significant part in the manipulation of Hitler's public profile.

Hoffmann's photographs were used as postage stamps, postcards, posters, and picture books and, at his suggestion, both he and Hitler received royalties from all uses of Hitler's image, making both men millionaires. After World War II, Hoffmann was imprisoned for profiteering. CJ

"When Hitler objected to a photographic proof, he knew that Hoffmann would not print it." Louis L. Snyder

ELIZABETH ARDEN
ADVERTISEMENT

BARON ADOLF DE MEYER

Date 1927
Location Unknown
Format Large format

This image relates to a series of advertisements shot by Baron Adolf de Meyer (1868–1946) for Elizabeth Arden. The ads appeared in *Harper's Bazaar* during the 1920s, with each image in the series being subtly altered until the woman was completely transformed into a wax mannequin. De Meyer was likely influenced by surrealist photography of the period, which made use of wax mannequins as an expression of the "uncanny."

The images were typical of de Meyer in their use of pictorialist soft-focus photography, sometimes with skillful backlighting, which helped to generate an ethereal vision of femininity. His images conveyed elegance and romance through gauzy layers of silks, satins, and flowers, not to mention jewels, fashion accessories, and masks. What De Meyer supplied were dreamy fantasies that offered escape for the female reader, being far removed from "real-life" concerns of politics and war. In this Arden image, however, such softness finds contrast in the model's studied expression, bandaged head, and slightly sinister mask.

Hired by Condé Nast around 1914, de Meyer became the first staff photographer at American *Vogue*, with Cecil Beaton dubbing him "the Debussy of photography." He famously photographed the Ballets Russes, as well as maintaining a friendship and professional correspondences with Alfred Stieglitz, with his photos appearing in *Camera Work*. Today, de Meyer is remembered equally for his unconventional lifestyle; his mastery of lighting; and his singular, romantic vision of femininity, portrayed—so effectively—through the paraphernalia of fashion. ML

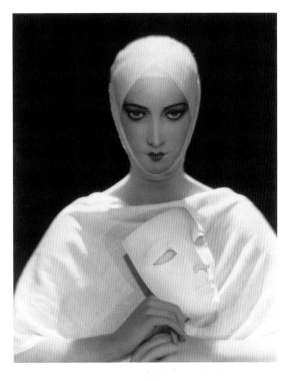

"Few have had greater influence on the picture-making of today than this somewhat affected but true artist." Cecil Beaton

CRISS-CROSSED CONVEYORS, RIVER ROUGE PLANT, FORD MOTOR COMPANY

CHARLES SHEELER

Date 1927
Location Dearborn, Michigan, USA
Format Large format

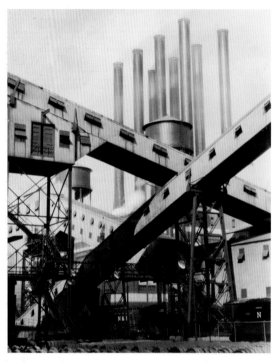

A painter, and later a self-taught professional photographer of architecture and fashion, Charles Sheeler (1883–1965) was a giant of modernism whose imposing artworks across media depict the might of American industry. Creating images that typically pay meticulous attention to detail, Sheeler was fascinated by the differences and overlap between photography and painting. He found beauty in functionality, and—whether working with paint or a camera, in color or black and white—rendered the urban and industrial scenes before him with crisp precision. The results, as this remarkable image taken at Ford's River Rouge Plant attests, were consistently startling and unnerving.

Sheeler, whose careful, considered handling of form led him to be linked with artists of the Precisionist style, who were also committed to working in this way, took this photograph during a six-week-long commission from the motor company ahead of the release of its flagship Model A automobile. Here, the complex, intricate structure of the plant takes center stage in an image that promotes the Ford brand but at the same time points to US industrial prowess. In this way, the towering shapes of the plant become almost a symbol of the country's success. Unsurprisingly, given the image's role as a promotional vehicle, there is nothing modest about it. The inherent power of the photo is intensified by Sheeler's characteristic accentuation of bold lines and stark shadows. Although created for commercial use, the photographs of the River Rouge Plant have come to be seen as artworks in their own right. **GP**

"Beauty of line and proportion through excellence of craftsmanship make the absence of ornament in no way an omission."

Charles Sheeler

AUTOPORTRAIT

CLAUDE CAHUN

Date 1927
Location Paris, France
Format Unknown

Claude Cahun was an alias adopted by Surrealist writer and artist Lucy Schwob (1894–1954), under which she made work that challenged ideas of gender and self-identity in ways that now seem decades ahead of their time. Playful self-portraiture features heavily in her work, and she used complex staging, costume, and makeup; resisted clearly defined gender identification; and adopted a range of imaginative guises.

This composite self-portrait is deliberately confusing. Costume, hairstyle, and makeup make reference to French male homosexual stereotypes of the period, and the result is a layered series of double bluffs: is this a woman dressed as a gay man, or a man dressed as a woman? Portraiture usually reveals insights into the inner life of its subject, but Cahun's approach strives for the opposite effect. It is unsettling because it obscures identity and poses so many questions, including those about the viewer's own subjectivity.

Cahun's resistance to gender norms went far beyond her artwork. In her own life she continually rejected social conventions, especially those associated with the performance of "normal" gender roles. In Paris she worked alongside Man Ray, Salvador Dalí, and André Breton, though, characteristically, she was unwilling to label herself a Surrealist (or even an "artist"). For nearly thirty years after her death, her significance as a Surrealist artist was all but forgotten until her work was rediscovered in the 1980s, at a time when feminist and queer studies were engaging in many of the same questions as those that had preoccupied Cahun herself. JG

"She portrays herself in such androgynous guises that when she wears wigs and frilly dresses, she actually looks like a drag queen."

Will Shank

EURYTHMY, OR JUMP OVER THE BAUHAUS

T. LUX FEININGER

Date c. 1927
Location Dessau, Germany
Format Glass plate

T. Lux Feininger (1910–2011) was born to a German mother and an American father who had lived most of his life in Germany and who in 1919 was one of the first people appointed to a teaching post at the Bauhaus art school by its new master, Walter Gropius. Until shortly after the end of World War I, the school had been the Grand-Ducal Saxon School of Arts and Crafts. Already an influential center for art and design, under Gropius's guidance the institution transformed in name, focus, and even in the architecture of its buildings to become arguably the most important art school of the twentieth century. Originally based in Weimar, the Bauhaus later relocated to Dessau, southwest of Berlin, where Gropius constructed a new modern campus, visible in the background of this image.

From the age of sixteen, Feininger studied at the school, where his tutors included Paul Klee and Wassily Kandinsky and where he was taught in a range of arts, including theater, painting, and jazz. Feininger also became increasingly enamoured with photography, earning the nickname "Lux" (meaning "light") because of his ever-present camera, which he used to document the day-to-day life of the school. While photography was not part of the Bauhaus curriculum at this time, many of the artists teaching at the school experimented with it, including László Moholy-Nagy, who was a neighbor of Feininger's family and whose influence is detectable in the dynamism of the young photographer's images.

After leaving the Bauhaus, Feininger went on to a successful career as a painter, writer, and teacher in his own right. **LB**

"Feininger chronicled daily life at the Bauhaus in images that showed a playful, spontaneous spirit and a keen sense of new formal developments in photography." William Grimes

PASTRY CHEF

AUGUST SANDER

Date 1928
Location Cologne, Germany
Format Large format

In 1910, August Sander (1876–1964) conceived the idea of creating a comprehensive photographic portrait of contemporary society, titled *People of the Twentieth Century*. Sander envisioned that the project would consist of between 500 and 600 images depicting all strands of German society, from the unemployed to a porter, an architect, an innkeeper, a cobbler, and a pharmacist. He organized his portraits into seven groups, according to social types and occupation: "The Farmer," "The Skilled Tradesman," "The Woman," "Classes and Professions," "The Artists," "The City," and "The Last People." Some of the sitters are shown in their places of work, such as this skilled tradesman, the pastry chef, shown at work in uniform in his kitchen with his shiny, round pate mirroring the large steel mixing bowl in his left hand.

The album would prove to be Sander's life's work, and it continued to occupy him until the 1950s. Such was the scale of the task that he first published sixty portraits from the collection in the 1929 book *Face of Our Time*. In the 1930s, Sander fell foul of the authorities, and his work was banned by the Nazi regime in 1936. Worse was to come when his studio and archive were bombed in 1944 during an Allied air raid. However, Sander resumed work, and his son Gunther saw that the collection was finally published in 1980. Images such as *Pastry Chef* work effectively as standalone portraits, but, as part of Sander's more ambitious overall work, they constitute an invaluable social document of the Weimar Republic and German society before World War II. CK

"Nothing is more hateful to me than photography sugar-coated with gimmicks, poses, and false effects." August Sander

UNTITLED

MARTIN MUNKÁSCI

Date 1928
Location Unknown
Format 35 mm

When asked the secret of photographic success, Robert Capa (1913–54) joked: "It's not enough to have talent, you also have to be Hungarian." One of Capa's most brilliant co-patriots was Martin Munkásci, who introduced a new element of immediacy, spontaneity, and movement into photography.

Born in Transylvania into a Jewish family, by the age of eighteen he was working as a photojournalist in Budapest. He soon began specializing in sports event, producing pictures—

such as this one of a goalkeeper—that were innovative for the way they got close to the action, propelling the viewer into the thick of it. In 1928, he moved to Berlin to work for the best of the new illustrated weeklies, *Berliner Illustrirte Zeitung*. A series on the actress and movie maker Leni Riefenstahl featured a now-famous picture of the future Nazi propagandist skiing in a swimsuit.

With the rise of Nazism, Munkásci left for the United States and worked for *Harper's Bazaar*. The magazine wanted him to take fashion pictures and with his very first photo shoot he revolutionized the genre, liberating models from contrived poses in the studio by getting them outside to move about as living, breathing women. JS

LOUISE BROOKS

EUGENE ROBERT RICHEE

Date 1928
Location Unknown
Format Large format

The radiant form of movie actress Louise Brooks is captured here by Eugene Robert Richee (1896–1972). Shot in profile, Brooks epitomizes the elegance of Roaring Twenties' fashion. Her long necklace of pearls droops in a graceful arc through the darkness, and her hair, cropped in the "flapper" style, accentuates her angular features. Brooks, an icon of the silent movie era, was once described by British theater critic Kenneth Tynan as "the most seductive, sexual image of woman ever committed to celluloid," and this bold, ingeniously simple picture captures her on the cusp of the most productive phase of her short-lived career.

Richee was a studio photographer at Paramount Pictures. In the early twentieth century, studios had began to establish their own photography departments, partly to satisfy the growing demand for publicity stills, and partly to keep tight control over their stars' public image. The photographers would idealize the stars, presenting them as awe-inspiringly flawless and glamorous. Louise Brooks happened to be one of Richee's most frequently photographed actresses. Later in his successful career, Richee went on to work for both MGM and Warner Brothers. EC

ALLIUM OSTROWSKIANUM/ DUTCH HYACINTH

KARL BLOSSFELDT

Date 1928
Location Berlin, Germany
Format Large-format glass plate

It is not hard to believe that this arresting fusion of science and symmetry was created by an artist with a background in sculpture. This image and much of the collection of which it is a part became popular with both the Surrealist and the New Objectivity movements. Karl Blossfeldt (1865–1932), a trained sculptor and an amateur botanist, taught at the Kunstgewerbemuseum in Berlin. He ultimately produced a collection of more than 6,000 such images over three decades, which he used as teaching aids for his art and architecture students, particularly in the German winters, when it was hard to find fresh plants and flowers. The warm blacks, rich shades of gray, and feeling of depth in this image are all qualities associated with its photogravure production. In this technique, invented in 1879, an image is transferred onto a metal plate and then etched before being printed. When a photogravure is viewed under a magnifying glass, a honeycomb appearance can be identified; this is the shape of the grid used in the printing process.

Blossfeldt was fascinated by the underlying structures of nature, and pioneered his own method of macrophotography to document flora and plants at up to thirty times their original size. He used long exposure times of between eight and twelve minutes in soft daylight, and large glass negatives, which were easy to retouch and required little enlargement. He meticulously posed and retouched images to create a uniform and aesthetically pleasing collection. His diligent work over thirty years was first published in 1928 in three portfolios titled *Art Forms in Nature*. **CP**

"Blossfeldt has played his part in that great examination of the inventory of perception, which will have an unforeseeable effect on our conception of the world."

Walter Benjamin

BERLIN RADIO TOWER

LÁSZLÓ MOHOLY-NAGY

Date 1928
Location Berlin, Germany
Format Medium format

In the winter of 1928, Hungarian painter and photographer László Moholy-Nagy (1895–1946) left the Bauhaus school in Dessau, Germany, for Berlin at the start of a new phase in his life. Soon after his arrival in the capital city, he climbed to the top of the Funkturm Berlin ("Berlin Radio Tower") carrying his medium-format Ernemann 6x9cm (2.4x3.6-inch) camera. This is one of the images he captured at the summit.

Completed in 1926, the Funkturm Berlin was a feat of engineering to rival the Eiffel Tower. Its base was seven times smaller than that of its French counterpart, and thus allowed Moholy-Nagy an unrestricted view of the ground from its 450-foot-high (137m) summit. His explorations of the world beneath him are typical of his experiments with perspective, scale, and unusual viewpoints. Whereas in Paris he had photographed the Eiffel Tower from below, making striking compositions from its canopy of girders stretched above his head, in Berlin he flattened out the landscape into a complex pattern of shapes and lines from above. The snow added to the graphic nature of the image, with the delicate tracery of the winter trees and the subtle grays of the areas of grass creating a harmonious scene that resembles an abstract Cubist painting. The resulting image is typical of Moholy-Nagy's explorations of the fluidity and portability of the new generation of 35-mm cameras that liberated photographers from the cumbersome limitations of tripod-mounted, large-format cameras and permitted them to explore the world from a host of exciting, fresh viewpoints. PL

"We have—through a hundred years of photography and two decades of film—been enormously enriched . . . We may say that we see the world with entirely different eyes." László Moholy-Nagy

MEUDON

ANDRÉ KERTÉSZ

Date 1928
Location Meudon, France
Format 35 mm

This photograph by André Kertész (1894–1985) has an aura of what André Breton described as "opportune magic," but it is also an artfully constructed collage of diverse elements. Kertész perhaps expressed it best himself: "People often ask, 'How did you do this photograph?' I do not know, the moment came. I know beforehand how it will come out. There are few surprises. You don't see, you feel the image."

The depth of perspective is remarkable, with the suburban street curving back into the dirt path running up to a construction site at the base of the viaduct. The buildings and viaduct follow a number of crisscrossing angles; there are no flat, planar elements. There is no one place to look; the viewer can be drawn, for example, to both the fleeting moment of eye contact with the man in the foreground, carrying his canvas, or to the train in the background, extruding dark smoke.

To achieve such a precise composition was partly luck, but it also required meticulous planning, and there is evidence from Kertész's other negatives that he planned the setting and angle of this shot carefully. It also appears to have been partly inspired by two paintings: Lyonel Feininger's *The Viaduct, Meudon* (1911) and Giorgio de Chirico's *The Soothsayer's Recompense* (1913).

Meudon was taken in the first year that Kertész began working with a Leica, an ideal camera for his improvisational approach and daily street photography. After moving to New York in 1936, Kertész continued as a prolific street photographer, leaving more than 100,000 negatives upon his death. CP

COMPOSITION

JAROMÍR FUNKE

Date 1928
Location Unknown
Format Unknown

Czech photographer Jaromír Funke (1896–1945) experimented with the arrangement of elements in his compositions, and his inventive handling of light led him to produce many important works within the modernist genre.

In this arrangement, Funke focuses on the overlapping shapes created by the shadows of the objects, rather than the objects themselves. Mirrors set at carefully adjusted angles are used to project images from one surface to another. It may not be entirely clear what we are looking at, but we can be certain of Funke's command of the mechanics of photography and his ability to manipulate the medium to artistic effect. GP

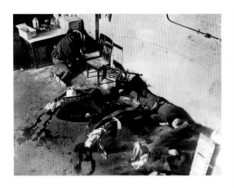

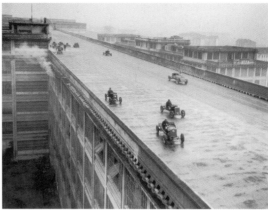

ST. VALENTINE'S DAY MASSACRE

UNKNOWN

Date 1929
Location Chicago, Illinois, USA
Format Unknown

During Prohibition (1920–33), when alcohol was banned in the United States, rival gangs fought for control of the illegal liquor trade. In Chicago, Al Capone vied for supremacy with George "Bugs" Moran. On February 14, 1929, four gunmen dressed as policemen entered a garage belonging to Moran, tricked seven of his men into lining up against a wall, and then shot them all dead in a hail of machine-gun bullets. The gruesome scene of the massacre is here captured by an unknown photographer who is likely to have accompanied or followed the police attending the scene.

Two women witnessed the "policemen" leaving the garage, escorting two casually dressed men as if under arrest; they soon received a letter advising them to "keep [their] mouths shut," and one left town immediately. These murders were never pinned on Capone, who claimed to have been at home in Florida at the time. After the massacre, Capone was dubbed "Public Enemy No. 1" by the press. Though never booked for this crime, he was eventually sentenced to eleven years in prison for tax evasion. He died a reclusive invalid in Florida in 1947. CJ

CARS RACING AROUND THE OVAL TRACK ON THE ROOFTOP OF THE FIAT WORKS IN TURIN

UNKNOWN

Date 1929
Location Turin, Italy
Format 35 mm

The Fiat production line ran from the bottom of the works building to the top, with cars moving through the five floors to emerge onto a banked rooftop track for a lap of testing before they were released for sale to the public. They returned to the street level via a series of spiral ramps.

The factory was featured in Le Corbusier's 1923 manifesto, *Toward an Architecture*, but by the 1970s, manufacturing methods had advanced, and the building was outdated; it ceased production in 1982. It was then remodeled by Renzo Piano into a new public complex with shopping malls, a concert hall, a theater, a hotel, and a convention center. The rooftop track was retained and can still be visited today. It was used during the escape scene in the cult British movie *The Italian Job* (1969), in which Michael Caine led his team of criminals around the track in Mini Coopers. PL

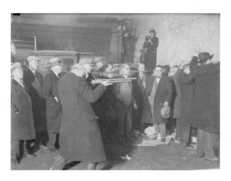

RECREATION OF THE ST. VALENTINE'S DAY MASSACRE

UNKNOWN

Date 1929
Location Chicago, Illinois, USA
Format 35 mm

The events of the St. Valentine's Day Massacre have become immortalized in film as a defining image of the mob; they have been referenced in numerous movies, including Brian De Palma's *Scarface* (1983) and Billy Wilder's *Some like it Hot* (1959). However, as no actual photographs of the moment of the executions exist, these interpretations are likely based on recreations such as the one pictured in this image, showing police investigators restaging the event to help determine what might have taken place on that fateful February morning.

The men playing the roles of the victims can be seen lined up against the wall, as they were in the actual event, while the "killers" take aim with whatever weapons they had to hand. Surrounding this scene, the investigators look on with stern faces, hands shoved in the pockets of their overcoats. The photographers capturing the scene from above are a reminder that this is purely a re-enactment of the crime. The police have made one major error, however: they are using shotguns, not the infamous Thompson machine guns that were later proven to have been used in the crime. EC

THE WALL STREET CRASH

UNKNOWN

Date 1929
Location London, UK
Format Unknown

In 1929, the world's economic system was shaken to its foundations by the Wall Street crash, which heralded the beginning of the Great Depression that saw the Western industrialized nations sink into stagnation for ten years. In just two days in October, the markets lost more than $30 billion— the equivalent in 2017 of more than $400 billion (£325 billion). This image shows how the London subsidiary of one of the main US brokers, St. Phalle Limited, kept its headquarters up-to-date on rapidly tumbling UK stock prices through a headset linked directly to New York.

The recent emergence of rapid long-distance telecommunications meant that purchases and sales previously conducted only as fast as a piece of paper could travel could now be completed instantaneously. As one journalist described the time: "The great buildings were ablaze with lights all night as sleepy clerks fought desperately to get the accounts in shape for the Monday opening. Horrified brokers watched the selling orders accumulate. It wasn't a flood; it was a deluge." PL

BIG TOE, MASCULINE SUBJECT, THIRTY YEARS OLD, *DOCUMENTS*, NO. 6, 1929

JACQUES-ANDRÉ BOIFFARD

Date 1929
Location Unknown
Format Unknown

While enrolled as a medical student, Jacques-André Boiffard (1902–61) met the Surrealist André Breton in 1924. Inspired by their conversation, he quickly decided to suspend his studies and dedicate himself to working with the wonderfully named Bureau of Surrealist Research, initially as a writer but later specializing in photography.

Boiffard worked as an assistant to Man Ray from 1924 to 1929. He then became involved with the circle around the controversial writer Georges Bataille and his new publication *Documents*. Boiffard illustrated several articles for the magazine, including "The Big Toe," written by Bataille, for which he made this disturbing study.

Boiffard's photographs played with scale and viewpoint, transforming everyday objects into strange sculptural forms. By isolating and separating the toe from the rest of the foot, Boiffard elevates a part of the human body that is usually neglected and ignored to the status of a fetish object, drawing on his medical background to give the image a forensic air. The toe looms out of the darkness, like some deformed and exaggerated growth. *Documents* was a unique publication that combined both highbrow intellectualism and lowbrow popular art with ethnography. It claimed that "the most provoking as yet unclassified works of art and certain unusual productions, neglected until now, will be the object of studies as rigorous and scientific as those of archaeologists." After the death of his father in 1935, Boiffard returned to his studies as a doctor and worked for the rest of his life as a radiologist at the Hôpital Saint-Louis in Paris, France. PL

"Every discovery that changes the nature, the destination of an object or of a phenomenon constitutes a surrealist fact."

La Révolution Surréaliste, 1924

BATEKE CHIEF

CASIMIR ZAGOURSKI

Date c. 1929–37
Location Congo
Format Unknown

In this warm black-and-white photograph, the subject, a leader of a Bantu ethnic group of Central Africa, looks away from the camera, allowing the viewer to admire his elaborate feather headdress, seemingly woven directly into his hair. His gaze is inscrutable, but the general style and aim of this image are fairly clear, particularly once one is able to view some of the hundreds of other images that comprise this series, titled *Vanishing Africa*. The photographer, an aristocratic Pole, emigrated from Eastern Europe in 1924 and traveled widely through the Belgian Congo, Congo-Brazzaville, Tanganyika, and what are now Rwanda, Burundi, Kenya, Chad, Cameroon, and the Central African Republic, photographing landscapes, dwellings, peoples, and traditions, which he, like many of his contemporaries, believed were being eroded or eradicated by colonialism.

While Zagourski's photography resembles in many ways the consistent, "objective" approach of early ethnographers to documenting "types," there is a sense of empathy with his subjects, who often gaze directly at the lens.

Although archival records document Zagourski's regular arguments with the Belgian colonial administration, which often did not pay for work it commissioned, his photography was widely viewed and preserved as postcards produced at his shop in Leopoldville. Many collectors aimed to acquire full sets, which comprised hundreds of images. Zagourski also created larger prints and deluxe, embossed portfolios; his work was exhibited and well received at the 1937 World's Fair in Paris. CP

"[His] oeuvre . . . shows how postcards and albums served as important means of distributing ethnographic images." Kevin Mulhearn

A KOMSOMOL YOUTH AT THE WHEEL

ARKADY SHAIKHET

Date 1929
Location Balakhna, Russia
Format Gelatin silver print

Arkady Shaikhet (1898–1959) was born in Ukraine. In 1922, he moved to Moscow, where he worked his way up to become a respected photojournalist, covering some of the decisive events of the early Soviet Union and photographing political and cultural figures, including composer Dmitry Shostakovich.

Now Shaikhet is probably best remembered for his photography documenting the rapid transformation of the Soviet Union during these years, particularly the industrialization of the country and the construction of massive civil engineering projects such as the Moscow–Volga Canal. The canal project reflected the dark side of the Soviet Union: it was constructed using forced labor, and as many as 22,000 prisoners died in the process. Shaikhet and his fellow photographers were enjoined to depict such projects as examples of Soviet progress and achievement.

The Komsomol, the Soviet youth organization, also played a significant role in this industrialization, with its members undertaking "shock construction projects" to help build plants and infrastructure across the Soviet Union. Shaikhet's image of a Komsomol youth at work in the town of Balakhna may have been taken as part of his work for *USSR Under Construction*, a propaganda magazine published between 1930 and 1941. Aimed at foreign audiences, the magazine was designed to show the Soviet Union as progressive, prosperous, and technologically advanced. Shaikhet later documented the Great Patriotic War, including the bitter fighting at Stalingrad (the turning point of the war on the Eastern Front) and the liberation of Kiev in his native Ukraine. **LB**

"Soviet photographers in the 1920s and 1930s created a new mythology, founded on vivid symbols of collective progress, patriotism, and self-sacrifice."

Nailya Alexander Gallery

WOMAN IN SWIMSUIT
SITTING ON A ROCK

FU BINGCHANG

Date 1929
Location China
Format Unknown

In his professional life, Fu Bingchang (1895–1965) was a career civil servant in the Chinese government, but he was also a prolific and talented amateur photographer. His pictures are of great interest today, not only because they offer unique insights into how people led their lives in prewar China, but also because they reveal the internal workings of the Nationalist regime of Chiang Kai-shek.

Fu's interest in the camera was to blossom in the 1920s when, as a young man, he was one of the founders of a photographic society called Jinshi, which in translation means a "scenery club." Along with friends and fellow members of the club he would go on photographic excursions into the countryside. Choosing artistic settings of mountains, lakes, woodland, and picturesquely winding roads, he often pictured his female friends in glamorous poses that seem remarkably modern for the period. The images are striking for the way they challenge the stereotypes of submissive females in Asia with their downcast gazes; there is no doubt that Fu's subjects are presenting themselves directly to the camera as confident, independent women.

As a trusted servant of the Nationalist government, Fu was close to Chiang Kai-shek and was given permission to take a series of intimate photographs of him and his entourage relaxing at the Tangshan Hot Springs, Nanking (Nanjing). He went on to become an important diplomat, serving as the Republic of China's Ambassador to the USSR from 1943 to 1949. While in Moscow he kept a diary that historians now value highly as a record of postwar Chinese diplomacy. PL

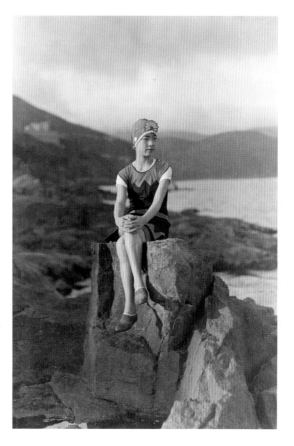

"The images show a society poised between tradition and modernity."

Visualising China website

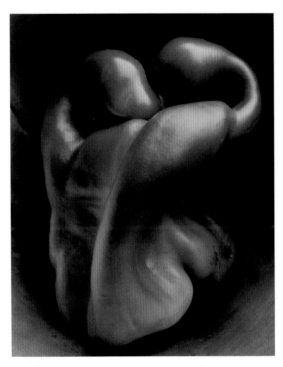

PEPPER NO. 30

EDWARD WESTON

Date 1930
Location Carmel, California, USA
Format 8x10 large-format view camera

This photograph is one of the first, and purest, examples of photographic modernism: it is not "about" a pepper as such; rather, it is a study of light and form, of which Edward Weston (1886–1958) wrote, "It is . . . more than a pepper: abstract, in that it is completely outside subject matter. It has no psychological attributes, no human emotions are aroused: this new pepper takes one beyond the world we know in the conscious mind."

With his commitment to exploring the limitations of photography as a way of seeing and representing the world, Weston was a pioneer. Previously, American and European photographers had been preoccupied with asserting the relationship of photography to painting, often by imitating oils and watercolors in an approach that tended to look to the past rather than the future. Weston challenged this convention, making photographs that looked like nothing that had been seen before. His obsessive studies of this simple pepper (which he photographed and printed many times over) echo both Modernist sculpture and the human body. In 1936, Weston joined the Group f/64, a collective of West Coast photographers named after the smallest aperture in the cameras they used. Their aim was to champion what became known as "straight photography," which they defined in their manifesto as photography "possessing no qualities of technique, composition or idea, derivative of any other art form." Weston applied this approach to a range of subjects: landscapes, nudes, portraits, and still lifes, of which *Pepper No. 30* remains the most famous. **JG**

"Weston pulled off a sort of photographic hat trick: he created artistic and highly evocative images that also manage a near scientific recording of what was in front of the lens."

Digital Photography Review

DIVERS. HORST WITH MODEL, PARIS

GEORGE HOYNINGEN-HUENE

Date 1930
Location Paris, France
Format Large format

Fashion photographer George Hoyningen-Huene (1900–68) was born in St. Petersburg, Russia, to a German father and an American mother. He fled his birthplace because of the Russian Revolution, going first to London before settling in Paris in 1920. He worked for *Harper's Bazaar* and collaborated with Surrealist Man Ray on his fashion pieces. By 1926, he was chief photographer for French *Vogue*, where he became known for his stylish studio work, often inspired by the forms, architecture, and sculpture of Greek antiquity.

Divers. Horst with Model, Paris brings to mind the *scuola metafisica* paintings of Italian artist Giorgio de Chirico, because of its dreamy sense of stillness, bold composition, and dramatic use of geometric shapes and volume. It depicts an attractive, androgynous couple sitting on a diving board, staring out to a horizon between sea and sky, but this is an illusion. Hoyningen-Huene shot the carefully constructed image on the roof of *Vogue*'s Paris studio above the Champs-Élysées. The fact that the photograph is in black and white helped him to produce what is an artful deceit.

Color photography was rare in magazines at the time, and this image was printed in monochrome in the July 5, 1930, US edition of *Vogue*, alongside a necessarily descriptive caption of the Izod beachwear: "Two-piece swimming suit with garnet-red trunks and a mixed red-and-white top of machine-knit alpaca wool, resembling a sweater weave." The feature formed part of a sports issue, and one of the two apparently athletic-looking subjects was Hoyningen-Huene's lover, the early male model Horst P. Horst. CK

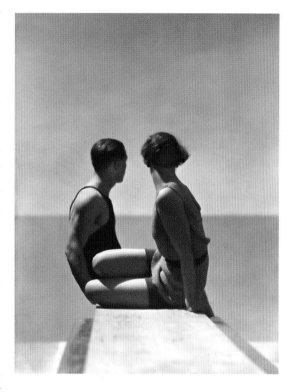

"Necromancy requires a mastery of technique, and George Hoyningen-Huene was one of photography's early practitioners of this art of transformation."

William Meyers

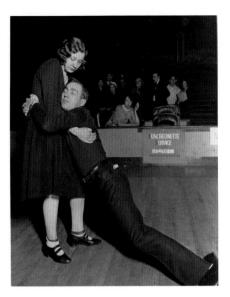

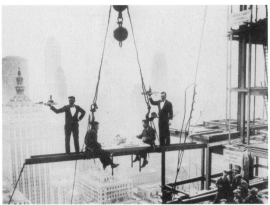

NEW YORK SKYSCRAPERS

UNKNOWN

Date 1930
Location New York City, New York, USA
Format Unknown

Built in 1893, the original Waldorf Astoria hotel on Fifth Avenue in Manhattan was demolished in 1929 to make way for the Empire State Building. This photograph was taken on the upper floors of the replacement skyscraper, then under construction at 301 Park Avenue, between 49th and 50th Streets. Designed by architects Schultze and Weaver and opened in 1931, the finished product is a forty-seven-story Art Deco masterpiece standing 625 feet (190.5m) above the sidewalk.

In this scene, two formally attired waiters serve lunch to a couple of steelworkers straddling a girder high above the city. Clearly a setup, it is one of the earliest of many similar images created partly to shock but mainly to publicize particular businesses taking premises in the tall buildings proliferating throughout Manhattan. Today, the best-known example is that created by Charles C. Ebbets of workmen eating lunch on a steel beam during the construction of 30 Rockefeller Plaza. But Ebbets's photograph was taken two years later than this one, so here we give overdue credit to an unknown earlier photographer. LB

EXHAUSTED MARATHON DANCERS

UNKNOWN

Date 1930
Location USA
Format Unknown

The marathon dancing craze gripped the United States during the Great Depression; it began as an endurance test, and later attracted competitors seeking fame or material reward. In New York in 1923, Alma Cummings danced nonstop for twenty-seven hours with six different partners, then challenged others to break her record. As the competitions became more organized and commercial, cash prizes became a strong incentive at a time of high unemployment, as did the provisions of free food and accommodation for contestants.

The marathons were a popular spectator sport. Rules varied, but among the common requirements were that competitors could not fall asleep and that they should keep moving. These events were not without risk: one man died on the dance floor after eighty-seven hours of nonstop dancing. CJ

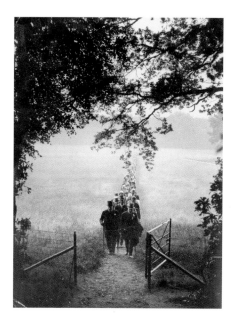

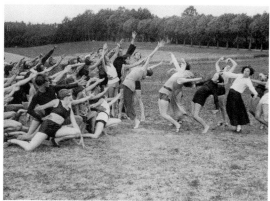

THE LABAN DANCE GROUP AT AN OUTDOOR REHEARSAL FOR *TANNHÄUSER*

FELIX H. MAN

Date 1930
Location Rhineland, Germany
Format 35 mm

RACEGOERS IN FIELD

UNKNOWN

Date 1930
Location Ascot, UK
Format 35 mm

For three centuries, racing at the world-famous racecourse in Ascot has been synonymous with glamour, grandeur, the fashionable elite, and of course, royalty. Known as Royal Ascot when the queen is in attendance, the five-day event every June is as much about socializing as racing.

This photograph by an unknown person (most likely a "stringer," or freelance photographer) shows attendees making their way through a field from the railroad station to the Royal Enclosure at Ascot Heath, near Windsor. Quintessentially English, Royal Ascot continues to draw many visitors, from the privileged and wealthy to ordinary folk. This photograph, with its open, inviting gate and neat line of racegoers framed by foliage, suggests the excitement and sense of expectation felt by racegoers today. **GP**

Felix H. Man (1893–1985) was a precocious talent, making his first photographs at the age of just ten years. During World War I, he photographed his experiences on the Western Front with a Vest Pocket Kodak camera. After the war he joined DePhot (Deutscher Photodienst), one of the first photojournalistic agencies. Using the new 35 mm roll-film cameras, the Ermanox and Leica, Man produced more than 100 photo-essays for the newspapers *Berliner Illustrirte Zeitung* (*BIZ*) and *Münchner Illustrirte Presse* (*MIP*) in the late 1920s and early 1930s, the most successful of which recorded a day in the life of Italian dictator Benito Mussolini. Man's eye for strong compositions is exemplified in this shot of the Laban dance group at an outdoor rehearsal for Richard Wagner's opera *Tannhäuser*.

After falling foul of the Nazi Party in 1934, Man fled to Britain, where he worked for the *Daily Mirror* newspaper and the *Picture Post* magazine. **PL**

PIONEER WITH A BUGLE

ALEXANDER RODCHENKO

Date 1930
Location Soviet Union
Format Gelatin silver print

In this photograph, the soft, puffed-out cheeks of the young Pioneer (Soviet Scout) oppose the smooth, precise curves of the bugle he or she plays. Its creator, Soviet avant-gardist Alexander Rodchenko (1891–1956), is known for his unsettling images of often everyday subjects—buildings, streetscapes, and people—which are often shot close up and at disorienting angles, and embedded with random geometric shapes. Rodchenko used a Leica, a highly popular camera of the day that was portable and allowed street photographers to capture quickly and easily what their eyes saw.

Soon after the 1917 Russian Revolution, photography boomed, with many artists eager to challenge old stereotypes and create "vanguard" images that would push various genres forward into new terrain. Rodchenko turned to photography after denouncing his former medium, painting, as "bourgeois." He believed that new styles of photography had ideological power to help people think in new ways, arguing that "in order to accustom people to seeing from new viewpoints it is essential to take photographs of everyday, familiar objects from absolutely unexpected vantage points and in absolutely unexpected positions." CP

PLUTO DISCOVERY PLATES

CLYDE WILLIAM TOMBAUGH

Date 1930
Location Flagstaff, Arizona, USA
Format Astrograph

The search for another planet began in 1906 when Percival Lowell, founder of the Lowell Observatory in Flagstaff, Arizona, argued that observations of the planet Uranus implied that its orbit was being disrupted by another celestial body in addition to Neptune. He actually recorded two very faint images of a new planet on March 19 and April 7, 1915, but he did not recognize their significance at the time.

After Lowell's death in 1916, the hunt was continued by the director of the observatory, Vesto

Melvin Slipher, who gave the job to the young astronomer Clyde William Tombaugh (1906–97). Tombaugh used a 13-inch (33cm) astrograph at the observatory to photograph the area of the night sky where it was suspected that the celestial body might be. He made pairs of images over a period of time and then used a blink comparator to shift quickly back and forth between them to see if any objects in them had shifted position. After almost a year of observations, on February 18, 1930, Tombaugh spotted a small difference on plates taken on January 23 and 29. Further observations established that the object's orbit took it farther out than Neptune, ruling out a classification as an asteroid; it was duly named as the ninth planet. PL

ANNA MAY WONG

EDWARD STEICHEN

Date 1930
Location New York City, New York, USA
Format Large format

At one time in widespread parlance, to be "Steichenized" was to be photographed and transformed by one of the most important fashion photographers of the twentieth century, American Edward Steichen (1879–1973). Remembered by artists as a founder of the modernist movement of the Photo-Secessionists and of the publication *Camera Work*, Steichen took dramatic and glamorous fashion shots for *Vogue* and *Vanity Fair* that have become some of the most influential and iconic images of the symbols of twentieth-century culture. Among the most famous of the more than 1,000 people who sat for him were Fred Astaire, Audrey Hepburn, and Winston Churchill. Steichen popularized photography and changed the medium forever.

This photograph is of Anna May Wong, remembered as the first Chinese American actress. Wong's career started at age fourteen, when she got a part as an extra in a silent film called *The Red Lantern*. She hid her new career from her Chinese family. Wong went on to play roles in numerous silent films and talkies in Hollywood, although her career was limited because of US laws enforcing racial segregation that prohibited actors from on-screen kisses with people of different ethnicities. She was given more roles in Europe, but there she was often forced to play stereotypical Asian roles. Steichen's dreamy and enigmatic image of Wong is a study in light and design, and recalls the Art Deco style of the era. More importantly, however, it is an homage to the grace and beauty of a woman who became a symbol for Asian American women. SY

THE KING OF THE INDISCREET

ERICH SALOMON

Date 1931
Location Quai d'Orsay, Paris, France
Format 35 mm

The introduction by Ermanox and Leitz of small, handheld cameras that used 35-mm film enabled photographers to capture the rich and famous unawares. Posed portraits taken in studios using heavy, large-format cameras gave way to what German photographer Erich Salomon (1886–1944) called *Bildjournalismus*, or "photojournalism."

Salomon was the master of the candid shot and gained notoriety for his use of an Ermanox with a fast lens and a Leica concealed in an attaché case fitted with levers to trigger the shutter.

This picture shows French statesman Aristide Briand pointing to Salomon, who had gained unauthorized admission to a state dinner and reception at the French Ministry of Foreign Affairs. When Briand caught sight of Salomon he called his colleagues' attention to him, jokingly exclaiming: "*Voilà*! The king of the indiscreet!" The byname was apposite, and so it stuck. CK

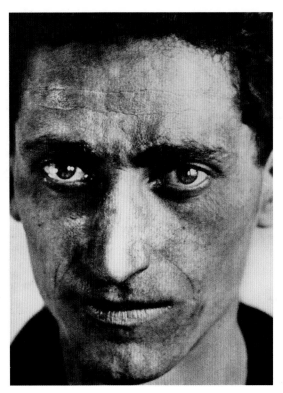

FACTORY WORKER

KATA KÁLMÁN

Date 1931
Location Hungary
Format Large format

Kata Kálmán (1909–78) was part of a group of socially committed and politically active photographers working in Budapest in the 1920s and 1930s, many of whom were associated with the avant-garde magazine *Munka*. Originally a student of modern dance, Kálmán took up photography in around 1930, after some instruction from her husband, critic and cultural historian Iván Hevesy. Her earliest photographs focused almost entirely on work and poverty—city laborers, peasants, hungry children—subjects with obvious left-wing appeal. They show a variety of different approaches, reflecting some of the aesthetic and political debates then current about the nature and purpose of *szociofotó* ("social photography"), which aimed to depict the whole gamut of working-class life, not just the squalid or the abject.

Factory Worker is one of a series depicting workers of both sexes; its close framing, neutral background, and fixed pose indicate that it was probably shot in a studio. The approach here is dispassionate, perhaps deliberately so. A different, more empathetic, approach can be found in *Tiborc*, a photo-book published in 1937, which is Kálmán's most celebrated work. Taking its title from a character in a classic Hungarian novel, the book consists of twenty-four close-up portraits of Hungarian peasants, with short accompanying biographies and an introduction by writer Zsigmond Móricz, whose novels depicted peasant life. Photographed out-of-doors, but with little or no context, that collection focuses on the individuality of each sitter, with an emphasis on dignity and self-sufficiency. **JS**

"The tightly cropped physiognomic gallery . . . engages the conventions of portraiture [and] resists this tradition's visual rhetoric."

Devin Fore

"BABY SAFE INSTRUCTIONS LATER ACT ACCORDINGLY"

UNKNOWN

Date 1932
Location New Jersey, USA
Format 35 mm

On March 1, 1932, Charles Augustus Lindbergh Jr., the twenty-month-old son of aviator Charles Lindbergh and Anne Morrow Lindbergh, was kidnapped from their family home. What followed became one of the most highly publicized police cases of the twentieth century.

This image, of a note written by the kidnapper on a penny postcard, stood as an important and promising clue during the case, along with a series of ransom notes. Scrawled in uneven letters, the handwritten note—reading "baby safe instructions later act accordingly"—was addressed to "Col. Linberg, Princeton, N.J." The words, in capital letters of varying sizes, take on a much more sinister quality when we imagine the killer penning the note. More than two months after Lindbergh Jr.'s disappearance, the decomposing body of the toddler was discovered only a few miles from the Lindbergh home in New Jersey. The killer was eventually identified as Richard Hauptmann, who was duly sentenced to death.

In the wake of the crime, the US Congress passed the Federal Kidnapping Act, often referred to as the Lindbergh Law, which made it a federal crime to transport a kidnapped victim across state lines. The new law enabled state and local law-enforcement officers to pursue kidnappers more effectively. The case also demonstrated that a photograph, as in this example, could be a valuable document of evidence. As a tangible copy of the real thing, it could be reprinted an unlimited number of times without destroying the original evidence; this allowed for the wide dissemination of the handwritten note. **EC**

"This tragedy is such an inextricable part of my story that it cannot be left out of an honest record. Suffering—no matter how multiplied—is always individual."

Anne Morrow Lindbergh

HARLEM

JAMES VAN DER ZEE

Date 1932
Location New York City, New York, USA
Format Unknown

In 1916, James Van Der Zee (1886–1983) and his wife set up a studio in Harlem; it did brisk trade during America's participation in World War I and onward into the 1920s and 1930s. The portraits he took during this period have an aura of glamor; he encouraged his sitters—among them poets, artists, dancers, and others, often lavishly dressed—to adopt poses and expressions derived from celebrities of the day. By combining flowers, furniture, and backdrops, he crafted photographs

in which his subjects came alive. He brought that same glamor-magazine aesthetic to this portrait, photographed outside in the street, in which the pristine automobile, the expensive fur coats of the couple, and their confident expressions place them in an enviable bubble of fashion and privilege.

Van Der Zee was a leading figure of the Harlem Renaissance, a movement that saw African-American culture flourish in the interwar years. His work played an important role in redefining black identity in the United States, and still offers a fascinating and at times sobering portrait of life in Harlem. Van Der Zee fell on hard times in the 1960s and 1970s, but receiving the Living Legend Award in 1978 did much to restore his fortunes. **GP**

BIJOU À PARIS

BRASSAÏ

Date 1932
Location Paris, France
Format 35 mm

Born Gyula Halász, the Hungarian photographer who took the professional name Brassaï (1899–1984) was aptly termed "the Eye of Paris" by novelist Henry Miller. Brassaï produced intimate portraits of all strata of Parisian society, from the prostitutes to the bourgeoisie. He started out as no more than a collector of old postcards and photographs, but in 1929 he bought a Voigtländer camera.

This photograph was taken at one of Brassaï's favorite haunts in Paris, the Bar de la Lune ("Moon Bar"). The subject is La Môme Bijou ("Miss Diamonds"), and this is the image that perhaps best shows his intimacy with his subject matter. Brassaï claimed that in this woman he "had discovered what had to be the queen of Montmartre's nocturnal fauna." She was then living on charity, but according to the rumors Brassaï heard around the bar, she had once been rich and lived a grand life of riding around in carriages and wearing the latest fashions.

For Brassaï, Bijou—with her elegant hat and jewelry, her formal pose for the camera, and her thick makeup applied in an effort to conceal the ravages of the years—was both a nostalgic vision and a dystopic symbol of the present. **SY**

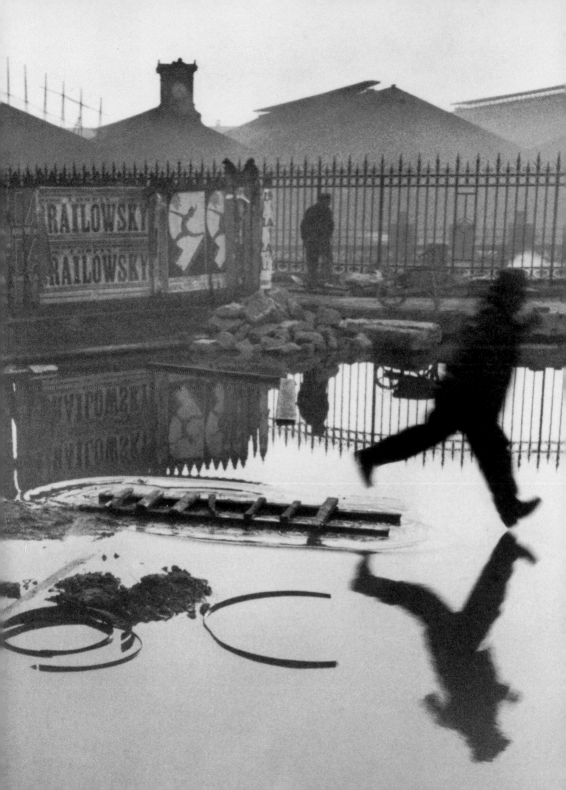

BEHIND THE GARE
ST. LAZARE

HENRI CARTIER-BRESSON

Date 1932
Location Paris, France
Format 35 mm

Henri Cartier-Bresson (1908–2004) studied painting in Paris at a private art school and at the studio of Cubist painter and sculptor André Lhote, where he met several Surrealist artists and became interested in their focus on the subconscious. He completed his studies in painting and literature at the University of Cambridge, and then in 1931 he switched direction to take up photography.

An early adopter of the 35 mm format, Cartier-Bresson acquired his first Leica in 1932 and pioneered street photography. He took many photographs of the streets of the French capital during the 1930s, including *Behind the Gare St. Lazare*, which shows the slightly blurred silhouette of a man running. Although naturalistic in style, the image shows the influence of Surrealism. Cartier-Bresson uses the juxtaposition of the leaping figures on two posters for a circus shown on a wall in the background and the mirrored repetition of the man's movement in his reflection in a large puddle to heighten the effect of the jumping action. Shown next to a small ladder and the curved shapes formed by cast-off building materials, the subject becomes more of an urban acrobat than an ordinary man in a hurry.

Famed for his ability to capture what he called the "decisive moment," uncharacteristically Cartier-Bresson chose to crop this photograph, explaining: "There was a plank fence around some repairs behind the Gare St. Lazare train station. I happened to be peeking through a gap in the fence with my camera at the moment the man jumped. The space between the planks was not entirely wide enough for my lens, which is why the picture is cut off on the left." CK

EMPEROR HIROHITO
INSPECTS GIANT
EAR-TRUMPETS

UNKNOWN

Date 1932
Location Japan
Format Unknown

This intriguing photograph shows Emperor Hirohito of Japan inspecting giant ear-trumpets designed to detect enemy planes.

The massive size of these antiaircraft devices might seem faintly comical to modern viewers familiar with radar detection, but they were state-of-the-art technology at the time. The photographer deliberately accentuated the impressive scale of the machinery rather than the stature of the Emperor.

Japanese military commanders used the Emperor's divinity manipulatively as a device to push through policies that undermined parliamentary liberalism. This process culminated in the second Sino-Japanese War, which began in 1937 when Japan invaded China and escalated with the Japanese attack on the United States at Pearl Harbor in 1941.

Hirohito was said to be unenthusiastic about his country's growing aggression, but nevertheless often appeared in military uniform, as in this picture, giving the impression of his support. CJ

MILLIONS STAND BEHIND ME: THE MEANING OF HITLER'S SALUTE

JOHN HEARTFIELD

Date 1932
Location Berlin, Germany
Format Photomontage

Born Helmut Herzfeld to politically active parents in Berlin, John Heartfield (1891–1968) anglicized his name during World War I as a protest against militarism and anti-British sentiment in Germany. After the war, Heartfield fell in with a small circle of Dadaist artists, including Hannah Hoch and George Grosz. Alongside the latter he helped to develop and popularize a form of collage known as "photomontage," which involved pasting together found photographs to create images with new, often political, meanings. Using this method, Heartfield produced some of his best-known and most influential works, often taking aim at the German establishment and increasingly at Nazi leader Adolf Hitler. From 1930, many of these photomontages were published on the cover of left-wing weekly *Arbeiter Illustrirte Zeitung*.

Heartfield had a particular talent for taking the pompous symbolism and rhetoric of Nazism and making both appear ridiculous. In his photomontage *Millions Stand Behind Me*, Heartfield suggests that Hitler was financed by a number of major businessmen, some of whom shared Nazi ideology, while others saw the right-wing group as a possible solution to the labor problems created by left-wing organizations like the German Communist Party. The caption reads: "Little man asks for great gifts."

Like other critics of Hitler, Heartfield was in increasing danger as the Nazi regime cemented its power over the country. In 1933, he fled Germany for Czechoslovakia, and then moved to England, where he remained until he returned to East Germany after World War II. **LB**

"John Heartfield is one of the most important European artists. He works in a field that he created himself."

Bertolt Brecht

NIGHTVIEW, NEW YORK

BERENICE ABBOTT

Date 1932
Location New York City, New York, USA
Format Large format

In 1917, Berenice Abbott (1898–1991) enrolled at Ohio State University with the aim of becoming a journalist, but she soon abandoned her studies and moved to New York, where she focused on sculpture. There, she met artist Marcel Duchamp, who introduced her to Surrealist photographer Man Ray. She then moved to Europe and became Ray's studio assistant, and through him became familiar with the work of pioneering French photographer Eugène Atget, who documented urban life in Paris. By the time Atget died in 1927, Abbott had set up her own studio specializing in portraiture, and she acquired his archive. Two years later she returned to New York. She began photographing the city, and her work evolved into the series *Changing New York*. Her interest in sculpture, and in Atget's street photography, is evident in her documentation of the forms of the fast-changing metropolis, and of its evolving streetscapes, diverse population, and thrusting skyline.

Abbott planned in advance to photograph *Nightview, New York* between 4:30 p.m. and 5 p.m. on December 20, 1934 (as this was the day of the year when it gets dark the earliest), shooting from an upper floor of the Empire State Building. She exposed the negative for fifteen minutes without blurring. Subtitled "New York at night, Empire State Building, 350 Fifth Avenue, West Side, 34th and 33rd streets," the photograph shows Manhattan's modernity in all its glory: bright lights, ziggurat-like skyscrapers, and busy streets. Although the rectangular shapes of the buildings and windows suggest Cubism, the tiny square pinpricks of light also recall mosaics and stained-glass windows. CK

"The world doesn't like independent women. Why, I don't know, but I don't care." Berenice Abbott

JAMES CAGNEY

IMOGEN CUNNINGHAM

Date 1932
Location Unknown
Format 35 mm

Imogen Cunningham (1883–1976) was among the most important American photographers of the twentieth century, with her work exploring a wide range of subjects, including landscapes, botanicals and plants, nudes, and portraits. She developed her interest in photography, and her technical skills, working in the studio of Edward Curtis before studying in Germany. She then opened her own photography studio in 1910, one of the first owned by a female in the United States. In 1913 she published *Photography as a Profession for Women*, encouraging other women to join her as professionals. She had great success as a portrait photographer in the 1930s, capturing a range of celebrities, including dancer Martha Graham and actors Spencer Tracy and Cary Grant.

In this powerful study of James Cagney for *Vanity Fair* magazine, Cunningham displayed her characteristic use of strong light and deep shadows. The image attests the effectiveness of a stripped-down approach—as she herself said: "I turn people into human beings by not making them into gods." She later remarked that "the thing that's fascinating about portraiture is that nobody is alike. I am never satisfied staying in one spot. But I can always stay with people because they really are different."

In 1932, Cunningham was one of the founders of the influential Group f/64, along with Ansel Adams and Edward Weston. The latter wrote of her: "She uses her medium, photography, with honesty—no tricks, no evasion: a clean-cut presentation of the thing itself, the life of whatever is seen through her lens." PL

"[Cunningham] said she preferred shooting ugly men because they were the least likely to complain about the results." William Meyers

A GAS-MASKED RIDER
AND HORSE

UNKNOWN

Date 1932
Location Oranienburg, Germany
Format Unknown

This eerie photograph of a horse and rider moving through smoke, both wearing gas masks, was taken during a propagandist publicity shoot in a studio at Oranienburg, near Berlin, in the year in which the Nazis became the largest single party in Germany. They did not yet have sufficient Parliamentary seats to form a government, but that would change in March 1933, when Adolf Hitler became Chancellor and immediately set about dismantling German democracy, suppressing dissent, liquidating opponents and rivals, rearming, and accelerating the descent into World War II.

Gas attacks had first been deployed on a large scale during World War I at the Second Battle of Ypres, on April 22, 1915, when the Germans attacked French troops with chlorine gas. The chemical caused many chronic injuries but few deaths—it made victims cough, and the more they coughed, the less they could ingest. Above all, gas was unreliable as a weapon: the wind could carry it in any direction, and thus, it could be as dangerous to attackers as it was to the enemy. Nevertheless, it was used by both sides and greatly feared, not only by soldiers but also by the civilian population. At the start of the second global conflict, the British government handed out 38 million gas masks to its citizens, in anticipation of an attack that would never come.

This image was intended to remind the German people of external threats, and thus encourage them to rally behind their strong new leader, who claimed (falsely, it was later proved) to have endured a British gas attack during the Battle of Courtrai (September 1918). CJ

"We were subjected for several hours to a heavy bombardment with gas bombs. A few hours later my . . . eyes were like glowing coals, and all was darkness around me."

Adolf Hitler, *Mein Kampf*

CAT AND ME

WANDA WULZ

Date 1932
Location Trieste, Italy
Format Gelatin silver print

Wanda Wulz (1903–84) was the daughter and granddaughter of portrait photographers, and for many decades her family had run a successful professional portrait studio in Trieste, Italy, where she was born. She and her sister Marion took over the studio in 1928, when their father died. The pair continued to take traditional portraits but also began to experiment with the camera, posing for each other and working collaboratively to create portraits that were playful and expressive.

Wulz then became acquainted with futurism, a genre that embraced dynamism, energy, and all that was new and exciting. The movement had existed since 1909, when intellectual Filippo Tommaso Marinetti published his influential manifesto, but by 1914 it had run its course. A second wave of futurism, with a strong focus on the mechanical, occurred in the 1920s, and it is with this wave that Wulz became associated. Most famous is this composite cat print, which she made by combining a negative of the family's cat with one of her own face. This and other experiments caught Marinetti's attention, and he invited Wulz to exhibit her work in 1932 in the National Exhibition of Futurist Photography, Rome. **GP**

DENMARK. COPENHAGEN. NOVEMBER 27, 1932.
LEON TROTSKY LECTURING

ROBERT CAPA

Date 1932
Location Copenhagen, Denmark
Format 35 mm

Endre Friedmann (1913–54) was born to a Jewish family in Budapest, but emigrated at age eighteen to escape the anti-Semitic climate of interwar Hungary. Initially intending to become a writer, but later becoming a photographer, he worked in Berlin and Paris, where he changed his name to Robert Capa.

In 1932, Capa was working in a relatively lowly job in the darkrooms at Delphot, a Berlin photo agency. In desperate need of a photographer to cover a speech by Russian Revolutionary leader Leon Trotsky in Copenhagen, but without any of their usual photographers available, the agency gave Capa his first break and dispatched him to document the speech.

Trotsky had recently lost a power struggle with Joseph Stalin to succeed Vladimir Lenin as leader of the Soviet Union, and he was now in exile. He was renowned for his blazing speeches and rhetorical energy, and Capa's photographs seem to capture this intensity. The negative of the image shown here was subsequently damaged, leading to a series of marks and fissures on its surface. These heighten the emotional intensity of Trotsky's grimacing face and claw-like hands. LB

THE FIRST ROUND

PIERRE DUBREUIL

Date 1932
Location Brussels, Belgium
Format Large-format glass plate

Pierre Dubreuil (1872–1944) was a modernist pioneer whose innovative approaches and concepts were initially celebrated and widely critiqued throughout his native France and farther afield in the English-speaking world. They were then almost forgotten for half a century until they were rediscovered in the 1980s by American photographer and collector Tom Jacobson.

Dubreuil was both a technical and an aesthetic master of photography. He experimented with a variety of printing techniques—including platinum, carbon, and gum bichromate—until, in 1904, he began using the Rawlins oil process (oil pigment painting), which gave him greater control over the tones of the final print. He also extensively used the diapositive process to produce slides from his original glass-plate negatives, which could then be used to make additional prints of the highest quality. He convincingly argued: "Why should the inspiration that exudes from an artist's manipulation of the hairs of a brush be any different from that of the artist who bends at will the rays of light?"

The First Round is a concentrated study of the determination of a boxer. Only two vintage prints of this widely exhibited photograph are known to exist, and one of them sold for $314,500 (£257,000) at auction in 2011.

Dubreuil suffered a series of personal and financial setbacks in the 1930 and 1940s, which led him to sell his archive to the Gevaert photographic company in Belgium, but tragically, the factory was totally destroyed during World War II, and all his negatives were lost. **PL**

"Dubreuil's work . . . combines a wispy, Whistlerian aestheticism with a modernist bent for machinery, overall pattern, and abstraction." Andy Grundberg

HUMANLY IMPOSSIBLE
(SELF-PORTRAIT)

HERBERT BAYER

Date 1932
Location Berlin, Germany
Format Photomontage

In addition to being an innovative and accomplished photographer, Herbert Bayer (1900–85) worked across a whole range of creative practices, including graphic design, painting, sculpture, art direction, interior design, and architecture.

Bayer was the last surviving member of the Bauhaus movement, which he joined as a young student in 1921. He studied with László Moholy-Nagy, who inspired Bayer's avant-garde experiments in photography and typography.

After leaving the Bauhaus in 1928, Bayer became art director of German *Vogue* magazine and of Dorland Studio, a Berlin-based international advertising agency. The image reproduced here is part of *Mensch und Traum* ("*Man and Dream*"), a series of eleven surrealist photomontages. Here, Bayer blew up the original print of himself looking into a mirror and painted over the photograph to cover up the arm from which the slice (in reality a bath sponge) would appear to have been removed. Next, he airbrushed the print to smooth out any imperfections that might reveal the artifice of the montage and then rephotographed the original print twice more, each generation of print disguising his handiwork even further until he achieved a seamless effect.

The completed work is at once humorous and disturbing, with the sculptural form of the creator's body intentionally referencing both classical art and the amputee soldiers of World War I, who were still much in evidence throughout Europe. Bayer's disquieting self-portrait offered something of an antidote to the cult of the body expressed by the rise of Fascism and Nazism in Germany. PL

"Bayer's work challenged a lot of previous perspectives, in design theories and in just changing the perspective in his work. He often did work that would mess with your mind."

Carnegie Mellon School of Design

EARLY FLOODLIT RUGBY

R. WESLEY

Date 1933
Location UK
Format 35 mm

In this dramatic image, captured in 1933, rugby players crowd together to form a scrum on a dark field. In a scrum the team packs closely together with heads facing down, in an attempt to gain possession of the ball in a restart of play. The floodlight shines through the players' legs in refracted beams and pierces the engulfing dark. The effect is strong and moody, the more so because we cannot see clearly what is going on within the scrum. The player standing to the side provides a scale by which to measure the others.

The first recorded floodlit rugby match took place in the UK's industrial north, when on October 22, 1878, Broughton played against Swinton. This paved the way for a craze of "illuminated matches," but in 1933, the Rugby Football Union prohibited floodlit rugby for gate money, claiming it was "not in the interests of the game." Things began to change in the 1950s, however, when the Harlequins and Cardiff put on popular annual evening matches at Cardiff's White City Stadium. Today, major international matches in the southern hemisphere are often staged as night games. **EC**

JOSEPH GOEBBELS

ALFRED EISENSTAEDT

Date 1933
Location Geneva, Switzerland
Format 35 mm

Pioneering photojournalist Alfred Eisenstaedt (1898–1995) said that his aim was always "to find and catch the storytelling moment," and in this chilling photograph of Nazi propaganda minister Joseph Goebbels, he certainly does that.

Eisenstaedt, a German Jew who emigrated to the United States in 1935, took this photograph in the garden of the Carlton Hotel, Geneva, during a League of Nations conference. Behind Goebbels is his private secretary, Walter Naumann, and to the left of the frame Hitler's interpreter, Paul Schmidt.

Eisenstaedt recalled how the look on Goebbels's face changed as he approached. "[H]e looked at me with hateful eyes and waited for me to wither. But I didn't wither." **GP**

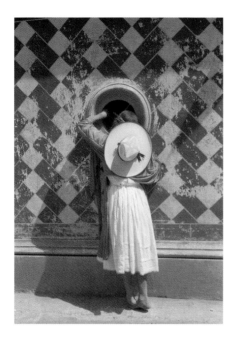

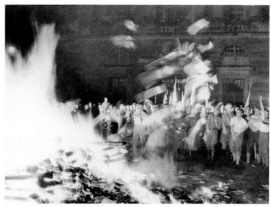

BOOK BURNING

UNKNOWN

Date 1933
Location Berlin, Germany
Format Unknown

DAUGHTER OF THE DANCERS

MANUEL ÁLVAREZ BRAVO

Date 1933
Location Mexico City, Mexico
Format 35 mm

Manuel Álvarez Bravo (1902–2002) was a key figure in the Mexican renaissance. Among his influences were Tina Modotti and Edward Weston, although he departed from the latter's formal style and straddled a bridge between realism and surrealism.

Here, we see the influence of both these movements. The girl, in a traditional white dress and hat, is on her toes, peering into a dark portal. Her garb is a reference to folkloric dancing, but is it also a reference to the Mexican search to understand the nation's past? Only she knows what is inside. As in other Álvarez Bravo images, there are layered symbolic references. The aged tile wall and the tentative pose of the girl with her awkward footing echo representations of the female form in indigenous art from the region. **SY**

The scene depicted here shows Fascist students, encouraged by soldiers and police, burning hundreds of copies of books condemned by the Nazis. This purge of literature, ordered by Hitler's propaganda minister Joseph Goebbels, took place in the Opernplatz ("opera square") in Berlin. An estimated crowd of 40,000 gathered here to watch books by writers deemed "degenerates," such as Walter Benjamin, Bertolt Brecht, Sigmund Freud, and Thomas Mann, go up in flames. Similar events took place simultaneously in university towns across Germany as part of an extensive Nazi campaign that sought to ignite a new "Aryan" spirit, free from what Hitler and his followers regarded as the scourge of intellectualism.

The photographer, who was probably a freelance stringer for newspapers and magazines, perfectly captures the atmosphere of hate. The fluttering, blurred pages dance in the flames like ominous specters, adding to the symbolism of the scene. As the Nazis recognized, the burning of books is a powerful and symbolic act of oppression, destruction, and control. **GP**

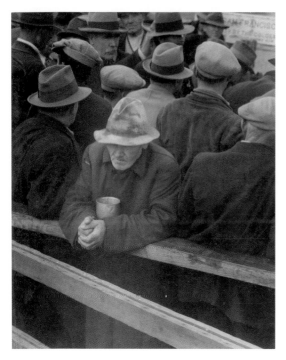

WHITE ANGEL BREAD LINE, SAN FRANCISCO

DOROTHEA LANGE

Date 1933
Location San Francisco, California, USA
Format Gelatin silver print

By 1929, the year of the Wall Street crash, Dorothea Lange (1895–1965) had been running a portrait studio in San Francisco for about ten years. But as the economic downturn worsened and her roster of clients diminished, she became increasingly aware of the growing numbers of unemployed and destitute people on the streets. Sometime during the winter of 1933, Lange made her first foray into socially aware photography, the type for which she would become famous. Her destination was the nearby waterfront, where a well-off widow, Mrs. Lois Wilson—the "White Angel" referred to in her photograph's title—was running a soup kitchen with money provided by donations.

In the line for food, Lange spotted an old man resting against a wooden barrier who seemed isolated from those around him. She took several exposures of the same scene, but it is the one shown here—shot from a raised viewpoint—that has become one of the defining images of the Depression era. It is a photograph that works on many levels. The man's battered hat, torn coat, and grizzled beard single him out as more down-and-out than the rest. The way his hands are clasped against the cold, and the fact that his eyes cannot be seen, gives him an archetypal quality: an individual down on his luck, seemingly lost in his own thoughts.

It was through work like this that Lange came to the attention of Roy Stryker; in 1935, he hired her as one of the photographers of the Resettlement Administration (later the Farm Security Administration), a federal agency set up to combat and document rural poverty. JS

"It came to me that what I had to do was to take pictures and concentrate on people, only people, all kinds of people, people who paid me and people who didn't."

Dorothea Lange

PRINCESS ELIZABETH
AND PRINCESS MARGARET

UNKNOWN

Date 1933
Location Windsor, UK
Format Cigarette card

This picture of the two English princesses, Elizabeth (right) and Margaret Rose, standing in front of Y Bwthyn Bach ("The Little House") was originally printed on a cigarette card. These collectibles were first issued by tobacco manufacturers as a practical effort to stiffen cigarette packaging. While at first the cards centered on advertising, they swiftly changed to lithograph pictures and artworks encompassing a vast range of subjects, to the extent that the cards became known as "the working man's encyclopedia." However, in early 1940, the production of such cards ground to a halt due to wartime restrictions. Later, because of the high cost of materials after World War II, cigarette cards were discontinued. Since then, the cards have become nostalgic collectors' items, and their appeal has transcended their modest beginnings.

The Little House—a straw-thatched cottage on the grounds of Windsor Castle—was presented to the young princesses in 1932 on Elizabeth's sixth birthday. Furnished inside and out—and equipped with running water, electricity, and miniature telephones—The Little House was constructed in the style of the charming cottages typical of the Welsh hillsides. It was originally presented to the princesses' parents, the Duke and Duchess of York, during a ceremony in Cardiff, Wales, before it was re-erected in the Royal Lodge gardens.

When this photograph was taken, the older girl thought that her grandfather, King George V, would be succeeded by her uncle Edward VIII. But when Edward abdicated the throne, her father became king, and on his death in 1952, she succeeded him as Queen Elizabeth II. EC

WILLS'S CIGARETTES

THE PRINCESSES AND
THEIR MINIATURE HOUSE

"The most glamorous Wendy House ever." Princess Beatrice

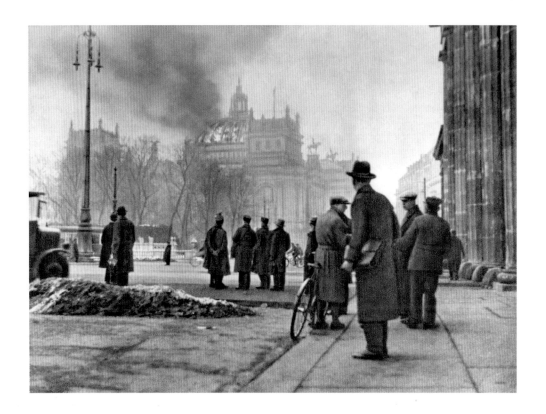

THE REICHSTAG FIRE

UNKNOWN

Date 1933
Location Berlin, Germany
Format Unknown

Late in the evening of February 27, 1933, the German parliament building was engulfed in flames. The fire was blamed at the time on an unemployed Dutch bricklayer, Marinus van der Lubbe, who was associated with the Communist Party. He was arrested at the scene, charged and convicted of the arson attack, and executed in 1934. However, there is some controversy about whether he acted alone or whether Nazi sympathizers were also involved in the attack. Whatever the truth, the fire was a major political coup for the Nazi Party, whose leader, Adolf Hitler, had been sworn in as Chancellor of Germany on January 30. He used the fire as a pretext to issue the Reichstag Fire Decree, suspending civil liberties and establishing his control over German society. *Time* magazine described how the fire came during "a campaign of unparalleled violence and bitterness" by the Nazis and reduced the building to "a glowing hodge-podge of incandescent girders."

To enhance its propaganda value, this image was retouched to add smoke and flames to the cupola of the building, making it much more dramatic. In fact, by the time the original image was taken on the morning after the blaze, the fires had all been put out. PL

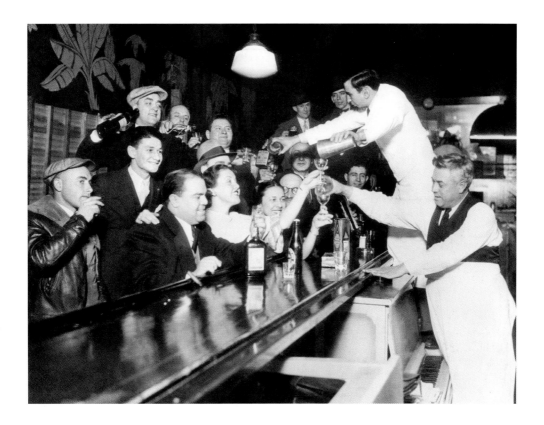

THE NIGHT THEY ENDED PROHIBITION

UNKNOWN

Date 1933
Location USA
Format 35 mm

If these people look happy, there is a good reason why. They are toasting the end of Prohibition, a law that from 1920 made liquor illegal in the United States. Thirteen years later, the ban, which came into force under the Eighteenth Amendment, was repealed. There is not one unsmiling face in the house, and the elation is palpable. It is possible that this was a speakeasy, an illicit establishment that sold liquor, or it could be an ordinary bar that stocked up in anticipation of the change in the law.

Prohibitionists believed that, after initial resistance, Americans would soon find that life was better without alcohol. They were mistaken. People went to extraordinary lengths to keep drinking—both home brewing and bootlegging became widespread practices, and criminal gangs profited from servicing a demand that could not be satisfied legally. Liquor was smuggled into the United States overland from Canada and Mexico, and also by sea from the Bahamas and Cuba, among other places.

The news of the repeal of Prohibition was met with much jubilation, as this photograph shows, and the public could once again enjoy their liquor in public places without guilt. GP

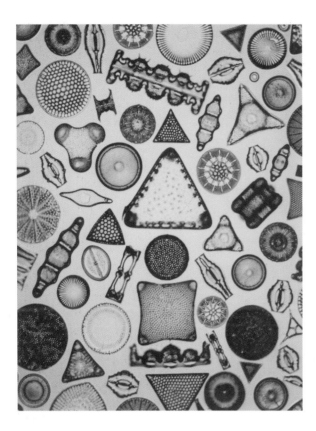

THE ARCHETYPE OF INDIVIDUALITY

CARL STRÜWE

Date 1933
Location Bielefeld, Germany
Format Unknown, probably medium format

Carl Strüwe (1898–1988) trained in lithography before fighting in World War I. After the war, he continued to study graphic design, and eventually made this his profession. From 1924, he became increasingly interested in photography, producing a series of accomplished but relatively conventional images of Italian architecture and sculpture. In 1926, he began to experiment with microphotography, initially by photographing directly into the eyepiece of a standard microscope. Intrigued by the results,

he began to produce a series of unconventional photographs that twisted natural forms and structures into remarkable, almost abstract, images.

While microphotography had become a well-established practice employed by early pioneers such as William Henry Fox Talbot, Strüwe's photographs were among the first to transcend the scientific purpose of these techniques in order to create something more akin to art.

Strüwe came to worldwide attention with the publication in 1955 of his book *Forms of the Microcosmos*. His work was later included in other significant books, including György Kepes's *The New Landscape* (1959), and a series of solo exhibitions in the United States. LB

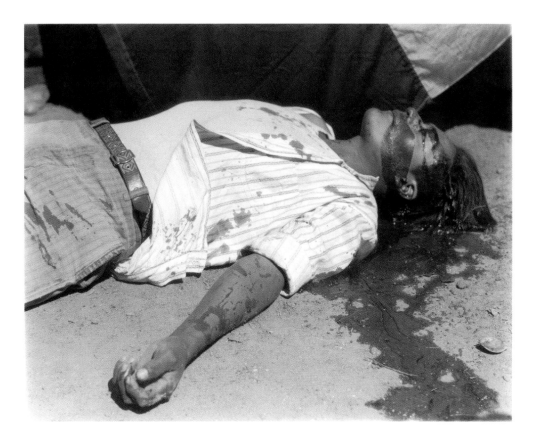

STRIKING WORKER ASSASSINATED, OAXACA

MANUEL ÁLVAREZ BRAVO

Date 1934
Location Tehuantepec, Oaxaca, Mexico
Format 35 mm

Picking up his camera in the 1920s in the wake of the Mexican Revolution (c. 1910–1920), Manuel Álvarez Bravo (1902–2002) changed the way in which the world saw his country and influenced the art of photography throughout Latin America. Although it is often noted that Álvarez Bravo was influenced by American photographer Edward Weston, French photographer Henri Cartier-Bresson said that the two could not be compared because "Manuel is the real artist."

This artistry is evident in this photograph of a young man murdered while striking at a local factory. Álvarez Bravo was working in Tehuantepec when he heard what he thought were fireworks nearby. On arrival at the scene he found the young leader of the workers at the local sugar mill sprawled lifeless in front of him. He took this iconic photograph of the dead man, eyes open, national flag as a background, with his hand extended, seemingly reaching toward the viewer in a pose reminiscent of the style of the Mexican muralists.

Although this photo is less subtle than Álvarez Bravo's *The Daughter of the Dancers* (1933) and *Public Thirst* (1933), it remains his most famous work for its immediacy, drama, and political significance. SY

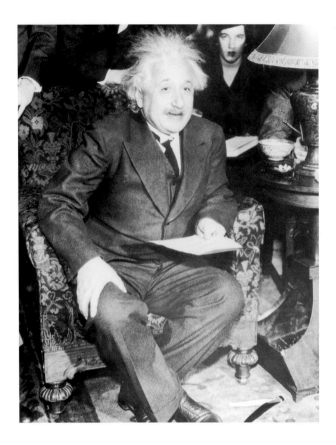

EINSTEIN TALKS TO JOURNALISTS

UNKNOWN

Date 1934

Location Pittsburgh, Pennsylvania, USA

Format 35 mm

Albert Einstein was at the Carnegie Institute of Technology (since 1967, Carnegie Mellon University) for a meeting of the American Association for the Advancement of Science. By this point he was already one of the world's most famous men, having been awarded the 1922 Nobel Prize for Physics. However, this day's appointment was a significant event in Einstein's career, not only because the lecture he was scheduled to deliver was touted as his "first important speech in the United States"—he would address a crowded auditorium on his mass-equivalency theorem, which explained the theory of special relativity—but also because it would be the first time that he had addressed a formal gathering in English rather than his native German.

Almost any image of the great scientist would be of historical interest, but this photograph is particularly striking because it captures the look for which Einstein is best known—the shock of wild, seemingly electrified hair, the graying mustache, and the sloping eyebrows. It was taken during a press conference with journalists, who surrounded him like acolytes and hung on his every word. **EC**

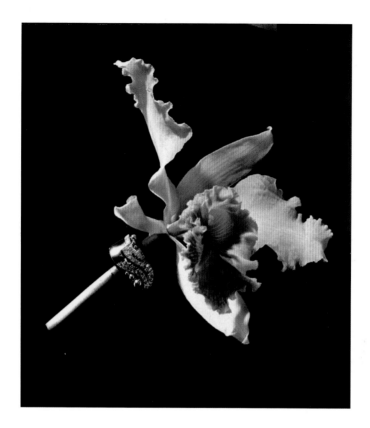

STILL LIFE

LUSHA NELSON

Date 1934
Location USA
Format Large format

This picture for *Vogue* typifies the fine art image that the magazine was at this time striving to project. Pictured against a dark backdrop, the flower is held in a diamond-and-platinum clip. The simple composition and subtle lighting demonstrate the use of traditional photography techniques, reminiscent of Edward Weston's vegetable and flower studies, and presage Robert Mapplethorpe's still lifes. The texture of the petals has the quality of deep-water coral, accentuated against the darkness.

The diamond clip becomes almost a natural feature of the flower, adding to its perfection—the straightness of the stem, the petals without the hint of a blemish. The product being advertised, in this case the clip, is no longer the focal point. The photographer uses the flower to represent femininity and the female form, connoting both beauty and purity in a way that complements the diamond clip, and vice versa.

Lusha Nelson (1907–38) was a Latvian American who brought an elevated degree of sophistication and elegance to his commissions for high-end fashion magazines—*Vanity Fair* and *Esquire*, as well as *Vogue*. He shone brightly but all too briefly in the photographic firmament. EC

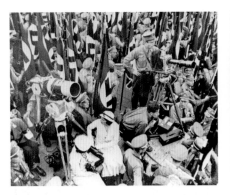

LENI RIEFENSTAHL SHOOTING *TRIUMPH OF THE WILL*

UNKNOWN

Date 1934
Location Nuremberg, Germany
Format Unknown

Remembered as the notorious creator of Nazi propaganda movies, Leni Riefenstahl (1902–2003), began her career as a dancer and actress, and starred in a succession of successful movies in the late 1920s and early 1930s. She turned to movie making in the early 1930s and, after meeting Adolf Hitler, directed a propaganda film for the ascendant Nazi party titled *The Victory of Faith* (1933), which celebrated the first National Socialist Party Congress after Hitler came to power.

The following year Riefenstahl would direct the first of two movies that would make her famous: *Triumph of the Will* (1935), the making of which this photograph depicts. Riefenstahl is pictured in the bottom middle of the frame in white. The movie, for which Riefenstahl reportedly had an unlimited budget, numerous cameras, and a crew of more than 100, was commissioned by Hitler, who was an unofficial producer. A technically and conceptually brilliant piece of work, *Triumph of the Will* is still considered to be one of the most effective propaganda films of all time. GP

BREAKFAST ROOM, BELLE GROVE PLANTATION

WALKER EVANS

Date 1935
Location White Chapel, Louisiana, USA
Format Large format

Walker Evans (1903–75) traveled to Louisiana to work on a commission for Gifford Cochran, a wealthy carpet manufacturer. Cochran wanted Evans to photograph the antebellum architecture of the Deep South for a proposed book.

Built by slaves between 1852 and 1857, Belle Grove is one of the largest mansions in the area. With seventy-five rooms over several floors, the building is one of the grandest plantation homes ever constructed. However, by the time Evans visited, it had been abandoned for a decade. This photograph, showing an unfurnished room with Corinthian columns, pilasters, and ceiling molding typical of Classical Revival architecture, captures the decay and elegance of the formerly magnificent building. Although the title refers to the Breakfast Room, the image shows the derelict drawing room. The temple-like opulence is still apparent, but it has faded, while the closed shutters symbolize the passing of an epoch. CK

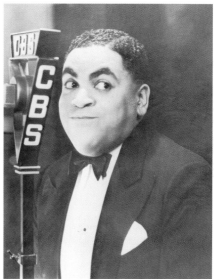

FATS AT CBS

UNKNOWN

Date 1935
Location USA
Format Unknown

Thomas "Fats" Waller was an exuberant American jazz musician famous for his humor and his "stride" style of playing piano. Here, he is seen at the height of his fame in a photo that captures his extrovert personality and his sheer delight in performing. The use of flash accentuates his impressive size and his magnetic showmanship.

Waller learned to play piano at age six, later also learning organ, double bass, and violin. He left school at fifteen and became an organist at the Lincoln Theater in Harlem, New York. Before long, he made his recording debut and began to cowrite a string of hits, including "Squeeze Me" and "Ain't Misbehavin'."

In his later career, Waller rather tired of the irreverent comic persona that his fans had come to expect, and sought to be taken seriously as an artist. He died in 1943 at the age of thirty-nine. CJ

PETER LORRE

LUSHA NELSON

Date 1935
Location Unknown
Format 35 mm

In this theatrical image, actor Peter Lorre poses against a wall in the film adaptation of Fyodor Dostoyevsky's novel *Crime and Punishment* (1935), directed by Josef von Sternberg. Cornered by six accusing fingers, Lorre, who plays the role of protagonist Raskolnikov, wears a mask of dismay as he realizes he has been captured for his crimes.

Lorre was an Austro Hungarian who fled the Nazis in 1933, and in London, landed a major role in Alfred Hitchcock's first version of *The Man Who Knew Too Much* (1934).

Latvian American Lusha Nelson (1907–38) photographed commercially, but was also well known for his documentation of social issues. EC

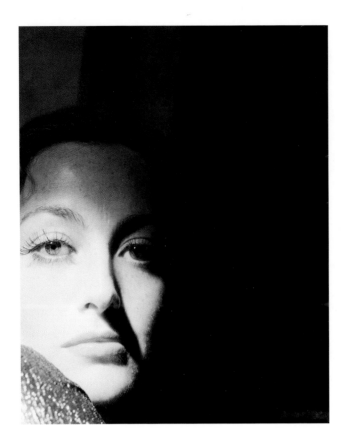

JOAN CRAWFORD, PROMOTION IMAGE FOR *I LIVE MY LIFE*

GEORGE HURRELL

Date 1935
Location Hollywood, California, USA
Format Unknown

Hollywood portrait photographer George Hurrell (1904–92) saw the creation of glamor, mystique, and physical perfection as simply part of his job. He joined MGM in 1930, in an era when film stars were seen as remote and godlike beings. In this promotional picture for the movie *I Live My Life* (1935), Joan Crawford is presented in these terms, projecting an allure that is startling and enticing.

Hurrell was a master of studio lighting and once said, "The critical question is not where is the light, but where are the shadows?" Crawford's face emerges out of those shadows, her eyes sharpened with a catch light, her seductive mouth wonderfully present. In fact, almost two-thirds of the image lies in darkness, drawing the eye constantly back to the eyes and mouth, divided by the deep shadow line of the nose.

It is interesting that the smooth perfection of Crawford's skin belies the fact that she had a face full of freckles. Hurrell liked his sitters to wear little makeup when being photographed, as this left the field open for his spectacular retouching techniques on the negative. Glamorization, he claimed, was something every photographer aimed for. ER

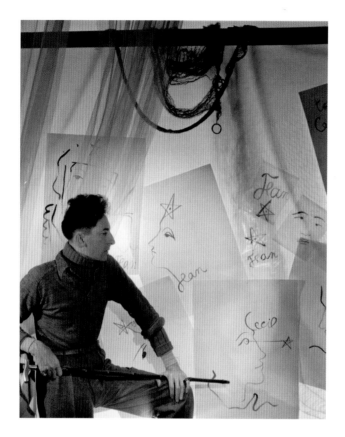

JEAN COCTEAU

CECIL BEATON

Date 1935
Location Unknown
Format Medium format

The most celebrated British portrait photographer of the twentieth century, Cecil Beaton (1904–80) made pictorial studies of numerous high-profile figures, and thus fed the world's apparently insatiable appetite for images of celebrities. He had a gift for making his subjects look beautiful—or even more beautiful—under his lens. He examined his sitters with a harsh eye and then disguised any imperfections through subtle lighting and posing, making them ooze elegance and glamor.

In this portrait, French writer and artist Jean Cocteau sits against a curtain covered in illustrations, mostly sketches of profiles that reflect the side of Cocteau's own face. Also visible in the composition are an array of illustrated five-pointed stars, and the names "Jean" and "Cecil." A radiant theatrical light shines through the curtain, giving the image a kind of ethereal quality while also echoing Beaton's work on stage sets.

Among the many other famous figures photographed by Beaton were Winston Churchill, Salvador Dalí, Marlene Dietrich, Greta Garbo, Audrey Hepburn, David Hockney, Mick Jagger, Grace Kelly, Elizabeth Taylor, Frank Sinatra, and Mae West. **EC**

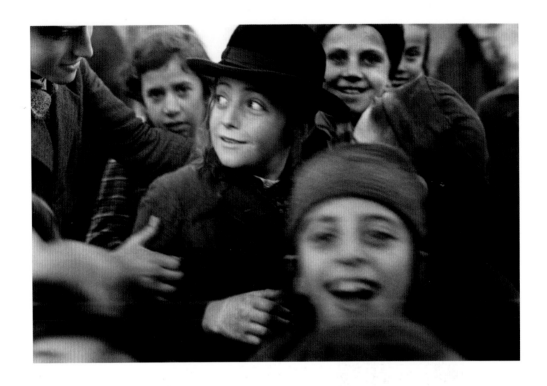

JEWISH SCHOOLCHILDREN

ROMAN VISHNIAC

Date 1935
Location Mukacevo, Ukraine
Format 35 mm

Russian photographer Roman Vishniac (1897–1990) regarded his stark images of prewar Jewish life in Eastern Europe as fleeting. Prophetically, he said that he took these moving photos of a specific moment in history to "preserve—in pictures, at least—a world that might soon cease to exist."

From 1935 to 1938, Vishniac, who spoke Yiddish, traveled across Eastern Europe, from the Baltic Sea to the Carpathian Mountains, in search of the Jewish shtetls and ghettos of Poland, Ukraine,

and Romania. It was a risky enterprise. In the mid-1930s, traveling as a documentary photographer in this part of Europe was dangerous because of censorship laws. Vishniac often suffered arrest and the confiscation of his camera. Yet he carried on with the project, producing thousands of images.

This tightly cropped shot of schoolchildren was taken in the city of Mukacevo, Ukraine. Jews from all over the region would go there to study. Using only a portion of the full frame of the original, Vishniac captures the joy on the faces of the young boys, but also emphasizes the importance of religion by focusing on the dress of the child in the center. In 1944, the last of the community would be deported to Auschwitz. SY

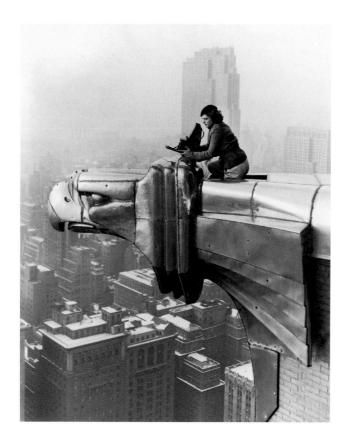

MARGARET BOURKE-WHITE ATOP THE CHRYSLER BUILDING

OSCAR GRAUBNER

Date 1935
Location New York City, New York, USA
Format Unknown

Working for *Fortune* and *Life* magazines, Margaret Bourke-White (1904–71), the subject of this dizzying image, was one of history's greatest, most adventurous photographers. She was, as *Time* magazine reports, *Life*'s first female staff photographer and shot the magazine's first cover, in 1936; she was the first Western photographer permitted to enter the Soviet Union, where she was given unprecedented access; and she was the first female photographer to cover combat

zones in World War II. She is perhaps best known for her superb photography of industrial and architectural subjects.

In this photograph, taken by her darkroom assistant, Oscar Graubner (1897-1977), Bourke-White is perched high up on an eagle gargoyle of the Chrysler Building, the construction of which she was commissioned to photograph; she later took up a studio space in the building. The gargoyle's stern expression seems to express her own steely resolve to photograph the skyscrapers far below. With this image, the little-known Graubner captured an icon of photography in her prime, and in so doing created a homage befitting her colossal talents and achievements. GP

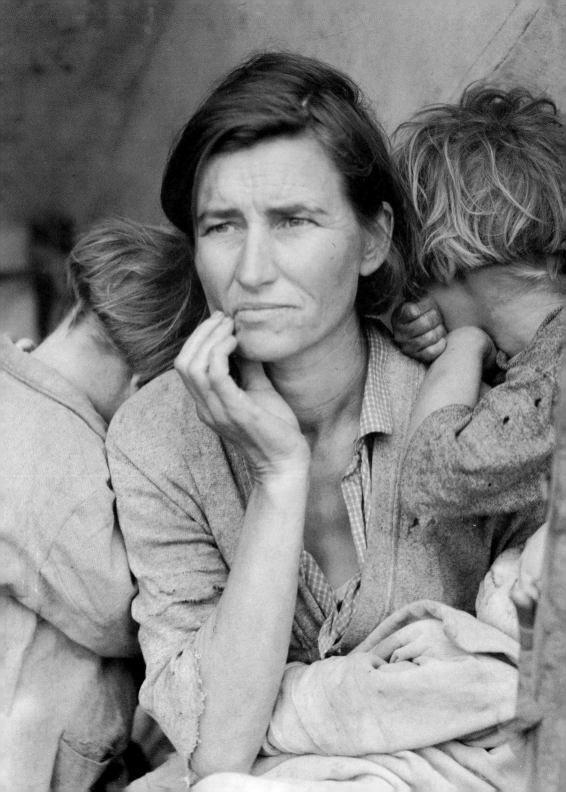

MIGRANT MOTHER

DOROTHEA LANGE

Date 1936
Location Nipomo, California, USA
Format Large format

It was February 1936, and Dorothea Lange (1895–1965) was on her way home from an assignment for the Resettlement Administration (RA), an agency helping to relocate poor rural workers, when she stopped off at a pea picker's camp at Nipomo, California. In an interview twenty-four years later, she recalled seeing a "hungry and desperate" woman and approaching her. "She told me her age, that she was thirty-two. She said that they had been living on frozen vegetables from the surrounding fields.... There she sat in that lean-to tent with her children huddled around her." The woman's name was Florence Owens Thompson, and Lange took six photographs of her, two of which appeared the following month in a *San Francisco News* feature that demanded help for the people in the camp.

The last photo of the series, known as *Migrant Mother*, has come to symbolize the struggles of the poorest and most dispossessed people of the Great Depression. Lange had been a portrait photographer, and many of her most effective Depression-era images focus on individuals. The power of *Migrant Mother* comes from the way its conflicting elements—motherhood, fortitude, anxiety, poverty, beauty—are melded into a coherent aesthetic whole. Lange's boss, Roy Stryker, thought it an outstanding picture and that "she [Lange] never surpassed it." The only person unimpressed was Florence Owens Thompson, who felt exploited and misrepresented, and that a chance ten-minute encounter with a photographer had turned her image into a national icon with no discernible benefit to her or her family. JS

GENERAL FRANCO TAKES THE OATH AS HEAD OF STATE

UNKNOWN

Date 1936
Location Burgos, Spain
Format 35 mm

With his arm in the air in an authoritative salute, and adopting a commanding stance, General Francisco Franco takes the oath of office upon being declared the head of state in Spain. In this ceremonial scene, supporters cheer, and some raise their arms too.

Franco led a military rebellion of right-wing insurgents who overthrew the left-wing Republican government and established a Nationalist regime in its place. His appointment was the culmination of an uprising that had lasted for several months. Long-term instability and deep political divisions within the country had contributed to the disintegration of the political system, allowing the rebels to seize power.

Following Franco's appointment, a bloody civil war ensued, which lasted for three years and saw Republicans and their supporters fight to end Fascism and restore democracy. But they were defeated, and Franco remained in power until his death in 1975. GP

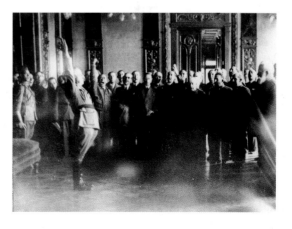

JESSE OWENS AT THE BERLIN OLYMPICS

ANTHONY CAMERANO

Date 1936
Location Berlin, Germany
Format Gelatin silver print

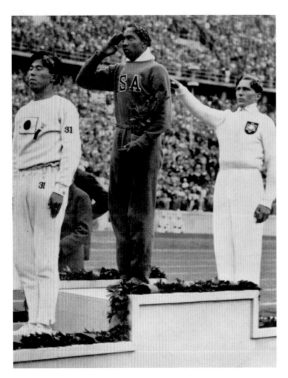

"It took a lot of courage for him to befriend me in front of Hitler. You can melt down all the medals and cups I have and they wouldn't be a plating on the twenty-four karat friendship that I felt for Luz Long at that moment."

Jesse Owens

At the 1936 Berlin Olympics, African-American athlete Jessie Owens won four gold medals, infuriating Adolf Hitler, the führer of Germany, who envisaged the games as an opportunity to prove the superiority of the "Aryan" race over all others. US photographer Anthony Camerano (1909–73) captured the moment when German athlete Carl Ludwig (Luz) Long—tall, blond, and blue-eyed—stood to accept his medal for the long jump. Long, who came second to Owens, gave a diplomatic Nazi salute but was also the first to congratulate Owens on his victory, no doubt adding to Hitler's displeasure. In contrast, Owens's US salute seems to defy the Fascist culture of the German hosts.

Owens was quick to credit Long with giving him invaluable technical advice, but the pair never saw each other again after the Olympics, as Long was killed in combat in World War II.

In his early career, Owens broke three world records at a college meeting but was denied an athletics scholarship because he was black. Then in Berlin, throngs of Berliners, intrigued by Owens, followed him enthusiastically around the city. Returning home, he was given a hero's parade in Manhattan but still had to use the side door of the Waldorf Astoria hotel because of his skin color. He retired from athletics after the 1936 Olympics and spoke out about the lack of opportunities for black athletes in the United States. He died of lung cancer, in 1980, aged sixty-six, having earlier filed for bankruptcy and faced prosecution for tax evasion. The city of Berlin later named a street after him, and in 1990, President Bush posthumously awarded him the Congressional Gold Medal. CJ

NUDE
(CHARIS, SANTA MONICA)

EDWARD WESTON

Date 1936
Location Santa Monica, California, USA
Format Large format

This beautiful image of the sinuous forms of the female body marked a turning point in Edward Weston's (1886–1958) exploration of the nude. Previously, he had worked mostly with elements of the figure—arms, legs, torsos—but in this photograph of his assistant, lover, and muse, Charis Wilson, he expanded his vision to encompass the whole form. Shot on the sun terrace of the modest house in Santa Monica that he shared with Wilson and his three sons, Weston chiseled a sculptural form out of the hard Californian light—a study in the textures of skin and the blackness of dark shadow. Shooting with his usual 8 x 10 Ansco view camera with a Zeiss 21 cm lens, he exposed just a single sheet of film of the scene.

Wilson later recalled, "I sat in the bedroom doorway with the room in a shadow behind me. Even then the light was almost overpoweringly bright. When I ducked my head to avoid looking at it, Edward said 'Just keep it that way.' He was never happy with the shadow on my right arm, and I was never happy with the crooked hair part and the bobby pins. But when I see the picture unexpectedly, I remember most vividly Edward examining the print with a magnifying glass to decide if the few visible pubic hairs would prevent him from shipping it through the mails."

Weston took hundreds of portraits of Wilson—both clothed and unclothed—over the course of their relationship, but this particular image went on to become one of the photographer's most admired and celebrated works. A print made personally by him sold at auction for $260,000 in 2003. **PL**

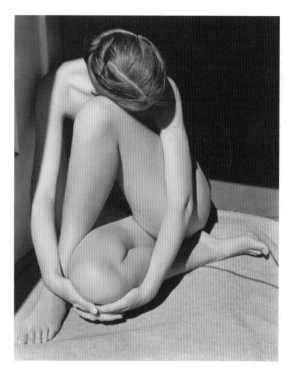

"The camera should be used for a recording of life, for rendering the very substance and quintessence of the thing itself, whether it be polished steel or palpitating flesh." Edward Weston

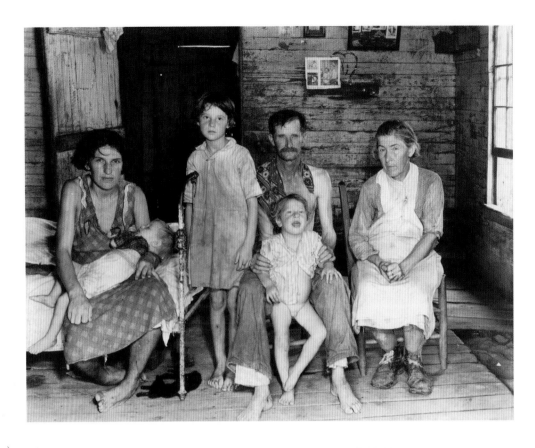

SHARECROPPER'S FAMILY, HALE COUNTY, ALABAMA

WALKER EVANS

Date 1936
Location Hale County, Alabama, USA
Format Large format

In June 1936, Walker Evans (1903–75) and writer James Agee were sent by *Fortune* magazine to find a willing family of Southern sharecroppers whose life they were to document. As a photographer for the federal Resettlement Administration, Evans had been doing similar work over the previous year, recording the impact on ordinary people of the Great Depression. Evans and Agee found three families in Hale County, Alabama, willing to be involved, and spent several weeks with them. The

photograph here shows Bud Fields and his family. Everyone is barefoot, except the grandmother whose battered boots are falling apart. The sitters seem to be waiting patiently for Evans to finish.

When, on their return, *Fortune* rejected their material, the two men published it in book form. *Let Us Now Praise Famous Men* (1941) opened with thirty-one of Evans's photographs, followed with 500 pages of Agee's prose. The writing is angry, passionate, and poetic; the photographs, by contrast, achieve their power through austerity and directness. No captions were included. Everything Evans selected testifies to the poverty and hardship that the sharecroppers endured, but does so quietly and without sensationalism. **JS**

SVETLANA STALIN SITS ON BERIA'S KNEE

UNKNOWN

Date 1936
Location Soviet Union
Format 35 mm

This photo offers a rare glimpse into the private life of Joseph Stalin, Soviet dictator (1924–53). The young girl in the foreground is his only daughter, Svetlana, then aged nine or ten years, who sits on the knee of the man she called Uncle Lara, but who is known to history as Lavrenty Beria, head of the dreaded NKVD (secret police). Stalin himself sits on the wicker sofa in the background, with a pipe hanging from his mouth, apparently engrossed in affairs of state. Partly obscured by Beria, another man sits wearing

a pair of headphones—this is Stalin's friend Nestor Lakoba, a leader of the Abkhazia region of the Soviet Union.

To anyone lacking knowledge of its historical context, this appears to be a photograph of three evidently busy men in a garden setting. With it, however, we see two mass murderers who were responsible for the deaths of an estimated more than one million people. Among their victims was Lakoba, who by the end of the year would be murdered, with Stalin's blessing, by poison administered to him at a dinner with Beria.

As a child, Svetlana was close to her father; it was only after his death that she began to learn the truth about him. EC

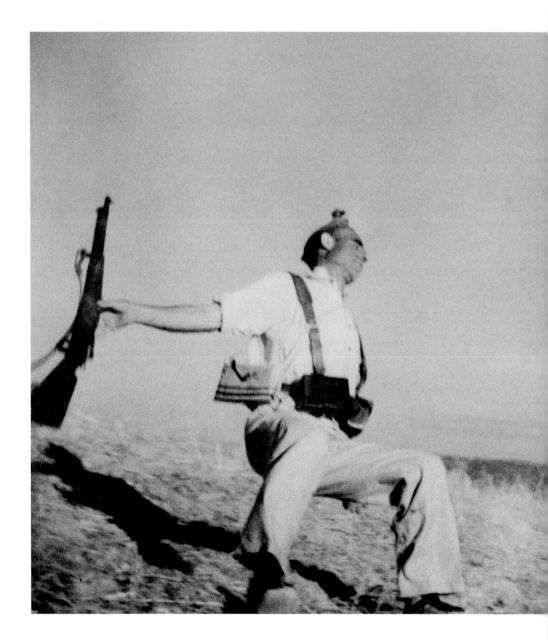

LOYALIST MILITIAMAN AT THE MOMENT OF DEATH, CERRO MURIANO, SEPTEMBER 5, 1936

ROBERT CAPA

Date 1936
Location Cerro Muriano, Spain
Format 35 mm

Having established his fine reputation as a photographer in Germany and France, Robert Capa (1913–54) relocated to Spain in 1936 to cover the Spanish Civil War (1936–39). Working alongside his partner Gerda Taro and colleague David Seymour, Capa produced some of the most iconic images of this conflict. In September of that year, he took the photograph shown here, which has become an iconic image of the Civil War, and indeed perhaps of all wars. It shows a militiaman loyal to the anti-Fascist Republicans apparently caught at the moment of being fatally struck by an enemy bullet. The photograph was published soon after in the French illustrated magazine *Vu* and later in other publications, including *Life* magazine.

Almost from the moment of its very first publication, questions were raised about whether the photograph might have been staged or miscaptioned, a debate that has persisted to this day. Academics and researchers have since suggested that this image was actually taken 30 miles (48 km) from the location Capa claimed, well away from any fighting, while others have questioned whether the soldier was, in fact, killed at another location. There have also been suggestions that Gerda Taro was the real photographer. Normally an ardent self-promoter, Capa was conspicuously silent about the circumstances surrounding the capture of this image, although he stated in a 1947 interview that he had been in a trench and had taken the photograph by holding the camera above his head without even looking. **LB**

SIR OSWALD MOSLEY'S BLACKSHIRT PARADE

UNKNOWN

Date 1936
Location London, UK
Format Unknown

CLASS (HIGH DIVER MARJORIE GESTRING, 1936 OLYMPICS CHAMPION)

JOHN GUTMANN

Date 1936
Location Oakland, California, USA
Format Gelatin silver print

German-born John Gutmann (1905–98) had an eye for the obscure and an ability to catch fleeting moments in telling ways. A trained painter and teacher who studied under the Expressionist artist Otto Mueller, Gutmann was never averse to taking photographs from unusual angles—looking up or down at his subjects, which included people and all manner of street scenes, from a stack of cars on an elevator to graffiti-covered walls.

The somewhat surreal photograph reproduced here shows springboard diver Marjorie Gestring in action at a US national diving competition. By stripping back the scene to its most essential elements, Gutmann produced a photograph that was modernist in its straightforward, unfussy, and clear depiction of the subject. **GP**

Mosley was a Socialist who lost patience with parliamentary democracy and formed the British Union of Fascists (Blackshirts) in 1932 after meeting, and being impressed by, Benito Mussolini. Mosley's movement rapidly became anti-Semitic and pro-Hitler. The Blackshirts staged demonstrations in poor and predominantly Jewish areas of London's East End. Party membership grew to 30,000 by 1934, but declined after the British government banned private armies and political uniforms.

This photograph captures Mosley's vainglory and self-importance. The bystanders seem both curious and apprehensive.

British Socialist politician Jennie Lee said that Mosley "had a fatal flaw in his character: an overwhelming arrogance and an unshakeable conviction that he was born to rule drove him on to the criminal folly of donning a black shirt and surrounding himself with a band of bullyboys, and so becoming a pathetic imitation of Hitler, doomed to political impotence for the rest of his life." **CJ**

REPUBLICAN MILITIAWOMAN TRAINING ON THE BEACH, OUTSIDE BARCELONA

GERDA TARO

Date 1936
Location Barcelona, Spain
Format Medium format

Gerda Taro (1910–36) was the *nom de guerre* of Gerta Pohorylle, a German Jewish woman who teamed up with photojournalist Endre Friedmann, a Hungarian Jewish man; they marketed their photographs as the work of a fake American photographer, "Robert Capa." The ruse was soon discovered, but their images were so good that Friedmann became Capa; Gerta adopted the identity of Gerda Taro, after Japanese artist Tarō Okamoto.

Capa and Taro traveled together to cover the Spanish Civil War (1936–39). Here, a Republican militiawoman is training on the beach in Barcelona, her high heels and flared pants contrasting with the stark silhouette of her pistol.

Not long after Taro took this photograph she was killed while covering the Battle of Brunete. PL

HARROW SPEECH DAY

J. A. HAMPTON

Date 1936
Location Harrow School, UK
Format 35 mm

J. A. Hampton covered a wide range of sports and daily life situations in a career that spanned more than three decades, from the 1920s to the late 1950s, including a period as an official military photographer while serving as a second lieutenant in the British Royal Navy throughout World War II.

Hampton had an unerring knack of finding unusual viewpoints and dramatic moments. The photograph reproduced here also displays Hampton's ability to find patterns and shapes in the world around him, with the line of the boys' straw hats leading the viewer's eye around the image. The youths are taking part in one of the roll calls that are held in each house three times a day at Harrow School, founded in 1572. PL

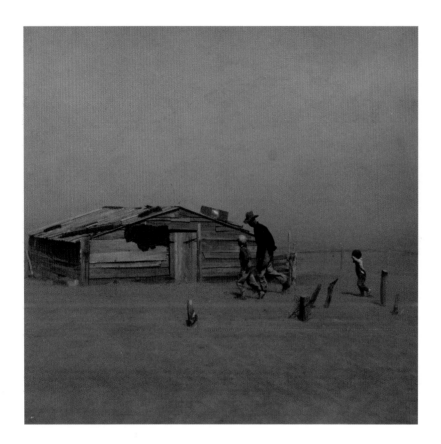

FLEEING A DUST STORM

ARTHUR ROTHSTEIN

Date 1936
Location Cimarron County, Oklahoma, USA
Format 35 mm

Albert Rothstein (1915–85), working for Roy Stryker and the information division of the Resettlement Administration (RA), took this picture showing the devastation caused by terrible droughts that turned the topsoil of America's Great Plains to dust, to be whipped up into great storms by high winds. Cimarron County in the northwest of Oklahoma was very badly affected, prompting many "Okies" to abandon their homes and head for California. But Arthur Coble, the man depicted striding past

a ramshackle hut with his young sons, Milton and Darrel, was staying put and braving it out.

The images commissioned by the RA were ultimately intended to justify the interventionist policies of the US government's New Deal. They were meant to be truthful, but like the equally celebrated *Migrant Mother* by Dorothea Lange, *Fleeing a Dust Storm* has generated controversy, not least because of contradictory accounts by Rothstein about whether scenes like this were staged and, if so, to what extent. For some, these questions undermine the picture's veracity as documentary photography; for others, the image retains the power to communicate the harsh reality endured by the dust bowl farmers. JS

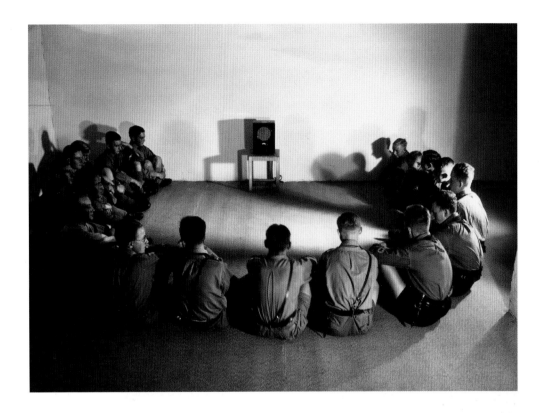

HITLER YOUTH

UNKNOWN

Date c. 1936
Location Unknown
Format Unknown

Scenes such as this became commonplace in Nazi Germany after 1933, the founding year of the Hitler Youth, which was open to all "pure Aryan" German males over the age of thirteen years and whose membership rose within a year to more than two million.

The network was an important part of Hitler's strategy for spreading Nazi principles. By 1936, all those eligible (every applicant was screened to ensure that he was of Aryan descent) were expected to join. Meetings, or "home evenings," were held once a week in disused buildings, cellars, and barns across the country; their aim was to entrench the attendees' ideas about race and politics.

During these sessions, led by boys only slightly older than those attending, members would learn and recite slogans, read propagandistic material, and, as depicted here, listen to radio broadcasts devised especially for the Hitler Youth. In a photograph that illustrates the efficacy of radio broadcasts as a propaganda vehicle, the boys sit in an otherwise empty room, transfixed. The radio is one of the official Nazi sets known as People's Receivers—radios that could be tuned only to Nazi Party-approved stations. GP

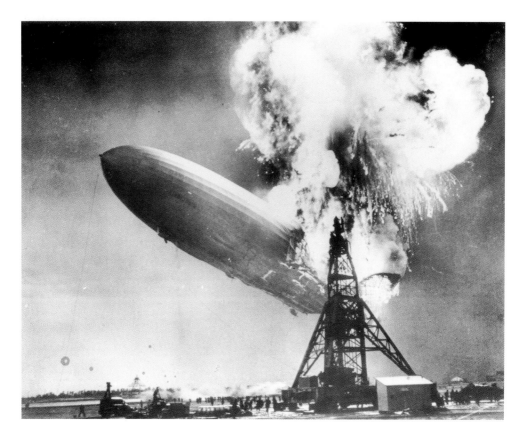

THE *HINDENBURG* ZEPPELIN DISASTER

SAM SHERE

Date 1937
Location Lakehurst, New Jersey, USA
Format Unknown

The largest Zeppelin airship ever built, *Hindenburg*, arrived from Germany at Lakehurst, New Jersey, after its twentieth transatlantic flight in the early evening. More than twenty photographers were watching the event when the airship exploded on May 6, 1937—a spark or electrical charge probably set off the huge amount of hydrogen gas on board. Within five minutes, thirty-five of the ninety-seven passengers on board were dead or dying. Twenty-seven of them died when they jumped from the ship as it floated 200 feet (61m) above ground. Sixty-two passengers stayed on board and survived, avoiding the toxic fumes. Some photographers exposed only one side of their two-sheet film holders, fearing that they might make double exposures by mistake. This image by Sam Shere (1905–82) stands out from the rest because it conveys an eerie sense of doom as the massive structure of the ship slides inexorably to earth behind the silhouette of the mooring tower.

In a famous emotional radio broadcast, American reporter Herbert Morrison described the scene: "It's a terrific crash, ladies and gentlemen. It's smoke, and it's in flames now; and the frame is crashing to the ground ... Oh, the humanity!" CJ

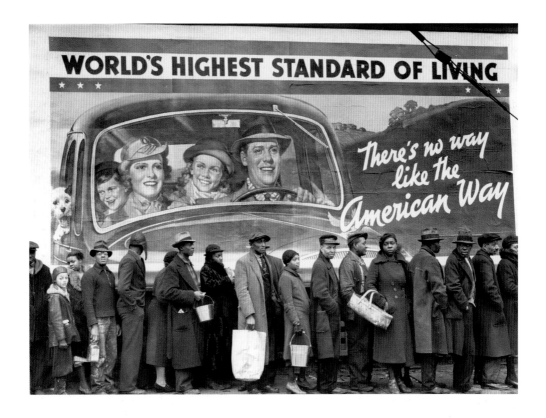

THE LOUISVILLE FLOOD

MARGARET BOURKE-WHITE

Date 1937
Location Louisville, Kentucky, USA
Format Large format

When *Life* was refashioned as a weekly pictorial news magazine in 1936, its new proprietor, Henry Luce, stated that the mission of its contributors was "to see life; to see the world; to eyewitness great events." Among the first staff photographers he hired was Margaret Bourke-White (1904–71), an already experienced photojournalist. The following January she was sent to cover one of the worst disasters in recent US history, the Ohio River flood. One of the cities most badly affected was Louisville,

Kentucky; around ninety of its citizens drowned and approximately 200,000 had to be evacuated.

The feature covering the disaster, which appeared in the February 15, 1937, issue of *Life*, used just a handful of the hundreds of photographs that Bourke-White had shot. Of these, one in particular stood out. A line of weary-looking African Americans wait patiently for food at a flood relief agency; above them a huge poster, produced by the National Association of Manufacturers, shows an idealized white nuclear family enjoying a drive in their automobile. As an illustration of the yawning chasm between the American dream and American reality, Bourke-White's photograph could hardly be more powerful or effective. JS

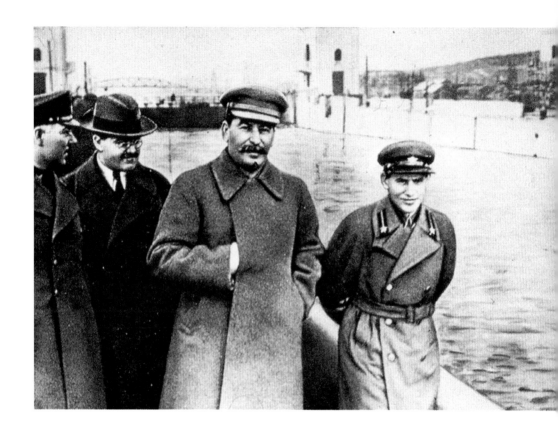

STALIN AND YEZHOV

UNKNOWN

Date 1937
Location Moscow–Volga Canal, Russia
Format Unknown, probably 35 mm

In 1927, Joseph Stalin became supreme leader of the Soviet Union and forced his chief rival, Leon Trotsky, into exile. He then set about eliminating Trotsky's supporters, and anyone else who ever had been, or conceivably could become, a threat. Soon, no one was above suspicion, and since the penalty for almost any perceived form of political or ideological deviancy was summary execution,

more and more people denounced one another in order to avoid being denounced themselves.

Thus, what began as a method of consolidating power quickly began to manifest itself in a form that could be regarded as paranoiac—a relatively small initiative to neutralize political opposition grew into the Great Purge, during which as many as five million people were arrested and as many as one million were murdered. The Purge was most intense in 1937–38, a period sometimes known in Russian as *yezhovshchina* ("the times of Yezhov") for Nikolai Yezhov, People's Commissar for State Security and head of the secret police (NKVD).

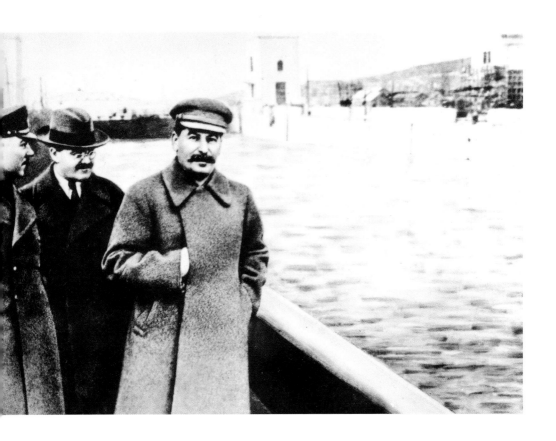

In the genuine, unretouched original version of this image on the left, Yezhov appears with Stalin visiting the Moscow–Volga Canal, then under construction predominantly by forced convict and slave labor. Despite his role as the main agent of the purges, Yezhov himself was not too big to fail: Stalin decided that the Great Purge had run its course and wanted a new man at the helm of the NKVD. Yezhov's star fell quickly: he was transferred from state security—first to internal affairs and shortly thereafter to the Department for Water Transport. The writing was on the wall; Yezhov was denounced as an enemy of the state, secretly tried, and executed in February 1940. His successor as chief of the secret police was his former deputy, Lavrenty Beria, whom Yezhov had spared from an identical fate only two years earlier.

The elimination of Yezhov had to be kept from the public gaze—no show trial for him, as there had been for many of his high-ranking contemporaries, because he knew where too many of the bodies were buried, both metaphorically and literally. So his death was kept secret; gradually, his name was expunged from official documents and, as here, from photographs—the image on the right has been retouched to render him an "unperson." LB

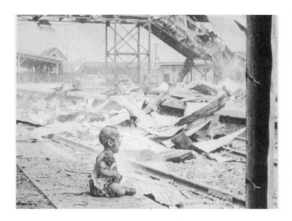

LONE BABY CRYING AFTER BOMBING OF SHANGHAI RAILROAD STATION

H. S. WONG

Date 1937
Location Shanghai, China
Format 35 mm

H. S. "Newsreel" Wong (1900–81) captured this image on his Leica moments after a Japanese air attack on Shanghai South Railroad Station, during the Second Sino-Japanese War (1937–45). The disturbing scene of a lone baby sitting up crying amid the carnage became symbolic of Japanese wartime atrocities in China. Shooting on the ground for newsreel, Wong often had to put himself in danger in order to get a photo. The Japanese government hated him for exposing the brutality of their attacks and put a bounty of $50,000 on his head. After receiving death threats from Japanese nationalists, he was forced to relocate to Hong Kong.

This image first appeared in *Life* magazine on October 4, 1937. Wong never discovered the identity or gender of the child, but he knew its mother was lying dead nearby. On the facing page in the *Life* spread, the baby was pictured on a stretcher receiving medical care. These photographs helped to fire up anti-Japanese sentiments in the West; the Japanese, however, denounced them as fakes. EC

WESTERN FASHIONS AND HAIRSTYLES, PEKING

UNKNOWN

Date 1937
Location Beijing, China
Format Unknown

There is something very contemporary about this photograph. It could almost be from the pages of a modern fashion magazine. It is a fascinating record of women's fashion in China during the 1930s.

Young Chinese went abroad to study and brought the fashions of the West back with them. As hemlines rose in Paris, they did in China too. The push by Chinese women for greater freedoms and equality extended to the clothes that they wore, and this photograph captures the changing mood of the era. The three women marching down a Beijing street are wearing contemporary versions of traditional Chinese *cheongsams* or *qipaos*. With their hair up and heels on, and flaunting the daring slit up the sides of their skirts, they epitomize the modern, forward-thinking Chinese woman. GP

PORTRAIT OF THE KENNEDY FAMILY

FABIAN BACHRACH

Date 1937
Location Bronxville, New York, USA
Format Unknown

There is surely not another family in American history more famous than the Kennedys. Here, they are pictured in their living room by Fabian Bachrach (1917–2010). The head of the family, Joseph P. Kennedy, to the far left, and his wife, Rose, on the right, are pictured with their nine children. The scene seems stiff, as is sometimes the case with official portraits, and the smiles appear forced. John F. Kennedy, standing at the back on the left, struggles to allow a slight smile to form.

The photograph was taken before tragedy struck the family on more than one occasion. The death of Joseph P. Kennedy, Jr. (seated, far right) in 1944 began a catalog of misfortunes. Kathleen (seated on the right) was killed in a plane crash in 1948; John F. Kennedy was assassinated in 1963, three years after his election as US president; Robert F. Kennedy (standing at the back of the picture with his elbow resting on the mantelpiece) was assassinated in 1968, shortly after he had won the California Democratic primary. John F. Kennedy, Jr., his wife, and his sister-in-law were killed in a plane crash in 1999. Some have taken all this as evidence of "the curse of the Kennedys." GP

WASHING IN ROAD BETWEEN TERRACED HOUSING

HUMPHREY SPENDER

Date 1937–38
Location Ashington, UK
Format 35 mm

Humphrey Spender (1910–2005) was inspired to take up photography as a form of social activism. He was one of the first British photographers to use a rangefinder camera and 35 mm film, so he was able to capture candid pictures of life in action rather than the carefully posed compositions required by heavy, large-format cameras. He became famous for his images of the Jarrow Marches of the unemployed from Tyneside to London in 1936 that were published in the Socialist journal *Left Review*. A year later he joined the Mass Observation movement, a large-scale investigation, founded in the northern industrial town of Bolton, into the habits and customs of people in Britain. Volunteers kept diaries and responded to questionnaires known as "directives," and photographers, including Spender, documented life in the communities.

Spender felt that the best way to achieve his goal was by photographing people unobserved, so he used a Contax Zeiss miniature camera, because its near-silent shutter release made it suitable for catching people unawares. Within a year, he had taken almost 1,000 pictures, including this one. CK

THE GOOD REPUTATION, SLEEPING

MANUEL ÁLVAREZ BRAVO

Date 1938–39
Location Mexico City, Mexico
Format Unknown

Asked by his friend the French Surrealist André Breton for a photograph for an exhibition catalog, Manuel Álvarez Bravo (1902–2002) produced this remarkable image—a bandaged, seminude model apparently sunning herself against a backdrop of cacti and a heavily textured wall. By carefully clothing his female model, who lies prone with the light softly enveloping her body, Álvarez Bravo elegantly draws attention to the woman's pubic area as the central focus of the photograph. He

seems to taunt the viewer whose eye is drawn directly to the taboo region.

Yet what does it mean? Influences on Álvarez Bravo's work cannot be ignored in this image, including his interest in European modernist movements and in the Mexican Day of the Dead. The photograph has been interpreted in several ways: with the model as a muse soaking up the sun; or as a woman who is wrapped in the bandages of bondage, pointing to women's lack of freedom in the world. Others insist that it is a play on a Mexican proverb, which says that if you "earn a good reputation, then rest on your laurels." Either way, it is imbued with mystery and serves the Surrealist intention. SY

FRANK SINATRA

UNKNOWN

Date 1938

Location New Jersey, USA

Format Police mug shots

Frank Sinatra's alleged links to the criminal underworld have been pored over for decades. Although the Italian-American singer and movie star always denied being involved in any Mob-related activity, he was arrested in 1938 on sex charges. Dated November 27, 1938, these uncredited police mug shots show the then twenty-three-year-old in the Bergen County Sheriff's Office, New Jersey. Sinatra had been charged with "seduction" after a woman complained he had seduced her on the promise of marriage. When it turned out that the woman was already married, the charge was changed to "adultery" and later dropped altogether.

Here, the young singer, whose career was just getting off the ground, is reduced to the level of a petty criminal. Shot in flat light against a dull background and hastily composed, the front- and side-view photographs are not intended to be flattering; they are simply photographic records of a person taken for identification purposes. Even so, with Sinatra fixing his gaze to the camera, and even in profile, the blue-eyed performer's good looks and charisma shine through, ironically making these ordinary mug shots at least as memorable as many of his more famous portraits. GP

JEWISH REFUGEES

UNKNOWN

Date 1938

Location Harwich, UK

Format 35 mm

By the early 1930s, the threat posed by the growing strength of the Nazi Party in Germany to the Jewish people living in Europe was already becoming very apparent. In 1933, the World Jewish Relief Fund—named The Central British Fund for German Jewry at the time—was started with the purpose of securing the safety of Jews living in both Germany and Austria. Of foremost concern was the safety of Jewish children, and in 1938 frantic efforts were being made to separate them from their families and send them to sympathetic countries that would protect them from anti-Semitism.

The *Kindertransport* ("children's transport") program took place during the nine months prior to the outbreak of World War II. The first *Kindertransport* train departed from Berlin on December 1, 1938. The following day, 196 children arrived in Harwich, England; many of them would never see their families again.

In this photograph, a British policeman escorts a young refugee from Vienna, Austria, who has arrived at Harwich on December 12 on the steamer *Prague*, en route to Pakefield Holiday Camp in Lowestoft. In all, 502 Viennese children arrived on the steamer, most of whom where Jewish. EC

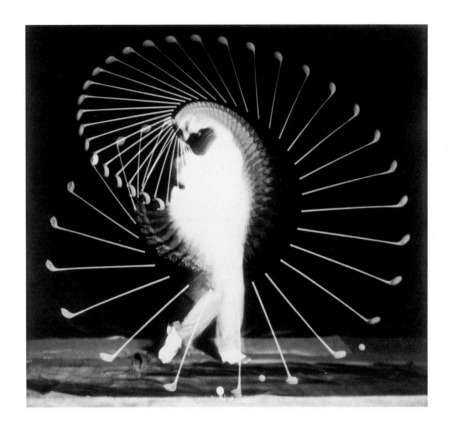

GOLFER

HAROLD EDGERTON

Date 1938
Location Cambridge, Massachusetts, USA
Format Unknown

Working at General Electric, Harold Edgerton (1903–90) specialized in the use of high-speed stroboscopic photography to document the phenomena he was researching. While the images that resulted were often visually similar to the pioneering work of French scientist Étienne-Jules Marey, Edgerton's use of strobing light sources allowed him to record action occurring at a far greater speed than a mechanical camera could. His *Milk Drop Coronet* (1934) is an early example.

From 1937, Edgerton increasingly collaborated with Albanian-American photographer Gjon Mili, whose high-speed studio photography of dancers, sportsmen, and celebrities had been published extensively in the nonscientific press. Throughout the 1930s and 1940s, the two men produced a series of striking images documenting a range of phenomena, from the motions of machines and people, as in the image reproduced here, to bullets speeding through the air. Edgerton's photographs became aesthetically more sophisticated over time, with later examples including his well-known *Bullet Through Apple* (1964), an image that generated great interest among a wide, nonspecialist audience. **LB**

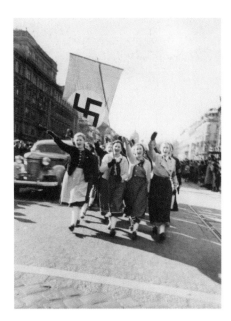

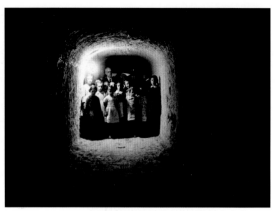

CHILDREN TAKE REFUGE IN UNDERGROUND SHELTERS TO ESCAPE THE BOMBINGS

DAVID "CHIM" SEYMOUR

Date 1938
Location Minorca, Spain
Format 35 mm

David Seymour (1911–56) became known as "CHIM," a variation of his original surname; he was born Dawid Szymin in Warsaw. He photographed the Spanish Civil War (1936–39) alongside Robert Capa (with whom he would later found the Magnum agency). In this image, the children are lit dramatically by a single light and outlined by the gaping shadow of the tunnel. The mood is generally somber (although one child in the second row does appear to be smiling). The group, framed as they are, appear remote and still, at the mercy of the war that surrounds them.

Ten years later, CHIM documented the plight of the millions of children displaced after World War II for his UNICEF-commissioned project *Children of War*. This photograph foreshadows his great sensitivity to and sympathy for the innocents drawn into the consequences of war and violence, a preoccupation that remained with him throughout his life. AZ

AUSTRIAN GIRLS SALUTE HITLER

MAX EHLERT

Date 1938
Location Vienna, Austria
Format 35 mm

Austria was officially annexed on March 12, 1938, by the Third Reich. "Anschluss" became the Nazi propaganda term used to refer to the annexation, and many Austrians responded enthusiastically. Here, Austrian members of the BDM (*Bund Deutscher Mädel*, or League of German Girls) in Vienna show their support of the Anschluss by marching, singing, and giving the Nazi salute.

The photographer, Max Ehlert (1904–79), is known to have worn the Nazi uniform, which enabled him to photograph from a perspective many were not used to seeing. He must have been trusted as a supporter of the Nazi cause because the authorities would not have allowed him to roam freely and continue his work as a correspondent otherwise. EC

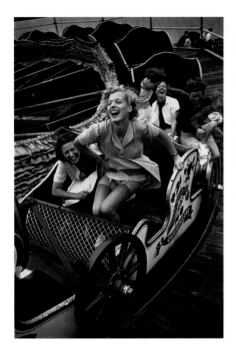

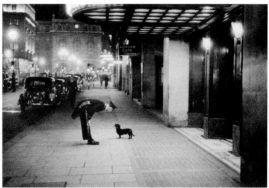

THE COMMISSIONAIRE'S DOG

KURT HUTTON

Date 1938
Location London, UK
Format 35 mm

Kurt Hutton (1893–1960) was born Kurt Hübschmann in Germany but anglicized his name when he emigrated to the United Kingdom in 1934 to escape Nazism. He began his career working for the DePhot agency in Germany, alongside Felix Man, who also fled to London along with the famed editor Stefan Lorant. Hutton initially worked for *Weekly Illustrated*, but he joined the staff of *Picture Post* when Lorant recruited him and Man in 1938 to be two of its chief photographers. Hutton and Man were among the pioneers of the new 35 mm roll-film Leica cameras in Britain, and they used these discreet cameras to shoot photo-essays about everyday life across a range of subjects. This charming image demonstrates the ability of the new cameras to capture scenes in low light and near darkness. It was used originally to illustrate a story titled "In the Heart of the Empire."

Hutton was best known for his portraits of the famous, including novelists Graham Greene and Evelyn Waugh, and actor Kenneth More. He spent his later life in the village of Aldeburgh, where he photographed the annual arts festival established there by composer Benjamin Britten. **PL**

CARE FREE

KURT HUTTON

Date 1938
Location Southend-on-Sea, UK
Format 35 mm

Kurt Hutton (1893–1960) made this energetic image, originally captioned "Crisis forgotten. War scares blown away," for *Picture Post*, which at its peak sold 1.7 million copies a week. In 1945, the magazine's owner, Sir Edward Hulton, recognized the historical value of his photographic archive and accordingly established the Hulton Press Library. He invited Charles H. Gibbs-Smith from the Victoria and Albert Museum to catalog the collection using a complex set of keywords that became the world's first indexing system for pictures. After *Picture Post* closed in 1957, Hulton sold the library to the BBC, which in turn sold it in 1996 to Getty Images for $10.5 million (£8.6 million). Getty's archive is now the world's largest photo collection, with 80 million images. **PL**

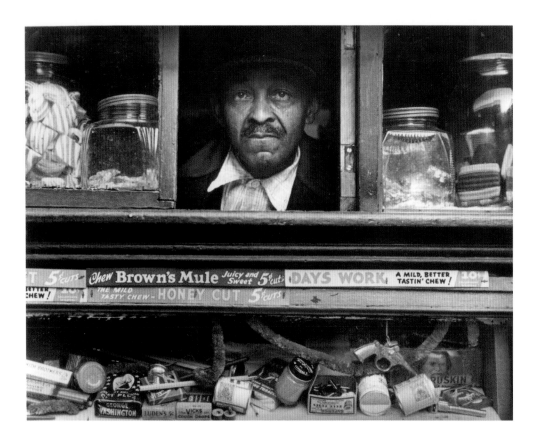

HARLEM MERCHANT, NEW YORK CITY

MORRIS ENGEL

Date 1938

Location New York, New York, USA

Format 35 mm

This photograph by Brooklyn-born Morris Engel (1918–2005) shows a man staring out of the service window of a small Harlem store. His gaze seems fixed ambivalently on the photographer, his face cleverly framed by the window. Surrounding the man are the wares of the shop—a toy gun, chewing tobacco, cough drops, jars of candy. The image was taken toward the end of the Great Depression, throughout which the world economy was in profound recession.

In 1936, Engel joined the Photo League, a cooperative formed in New York that promoted the use of documentary photography as a tool for social change; in 1939, he had his first exhibition. Two years later he joined the US Navy as a combat photographer. After World War II he directed the 1953 film *Little Fugitive*, which was shot entirely on a handheld 35mm camera.

Through his experimental techniques, Engel was a driving force in the independent film movement. French director François Truffaut cited Engel as a major influence for his classic *The 400 Blows* (1959). This image is one of his personal works, in which he focused specifically on 10th Street in Manhattan, New York, where he lived. EC

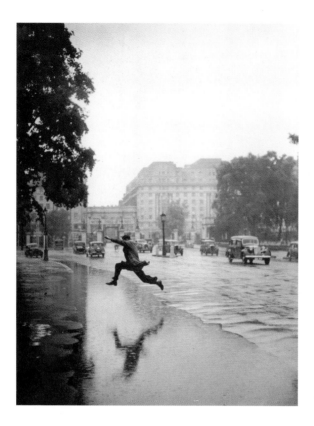

LEAP OF FAITH

J. A. HAMPTON

Date 1939
Location Hyde Park, London, UK
Format 35 mm

Although the shutter of a camera freezes a moment in time, the photograph retains a temporal aspect, still able to suggest what might occur in the future and echo what has happened in the past.

With his characteristic eye for a telling moment and composition, English photographer J. A. Hampton has captured this man in mid flight, fully extended in an athletic pose that belies his trench coat and hat, as he attempts the seemingly impossible feat of leaping across a huge puddle in the street. The viewer can only hope that he will reach the far side safely, although the implication is that the man is unlikely to succeed in his valiant efforts to stay dry. Real moments such as this, pregnant with possibility, are essential to the genre of street photography, and the image is a testament to the quick eye and reflexes of the photographer. The image has a timeless quality, despite the presence of vehicles dating it to the 1930s, as dodging a flood is as familiar a challenge today as it was then. In good hands, a camera transforms the everyday and ordinary by choreographing the world into compositions of heightened tension, and J. A. Hampton was one of the unsung masters of that craft. PL

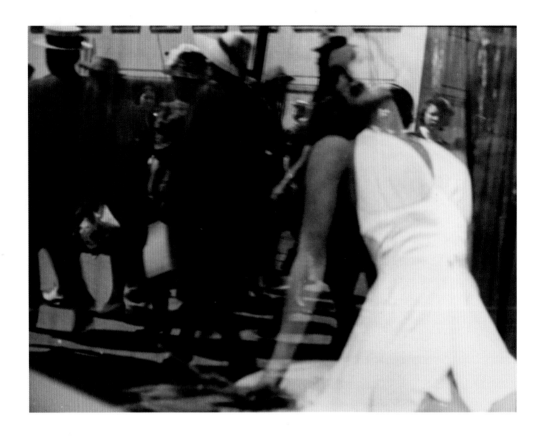

REFLECTIONS, NEW YORK

LISETTE MODEL

Date 1939
Location New York, New York, USA
Format 35 mm

"The so-called great photographers or great artists … don't think so much about themselves. It is what they have to say that is important." Lisette Model (1901–83) was true to her own words. Born into a Jewish family in Vienna, Austria, she found her first inspiration in avant-garde music when she studied under the iconoclastic composer Arnold Schönberg. Eventually moving away from music to drawing and painting, Model finally settled on photography, moving to France and coming to public attention

with her unsettling images of material culture taken on the Côte d'Azur in the 1930s.

After emigrating to the United States in 1937, she freelanced for magazines, such as *Harper's Bazaar* and *Ladies' Home Journal*, which appreciated her unusual, sometimes ruthless, visions of America. Her *Reflections* series, created two years after she arrived, is a pessimistic examination of New Yorkers through plate-glass windows; it is almost as if Model was a spy. Her filmic, flattened, and mostly unbecoming street portraits anticipate the film noir aesthetic of the 1940s. As in those shadowy detective movies of the underbelly of society, Model's portraits of life between the wars are a sharp social criticism of urban America. **SY**

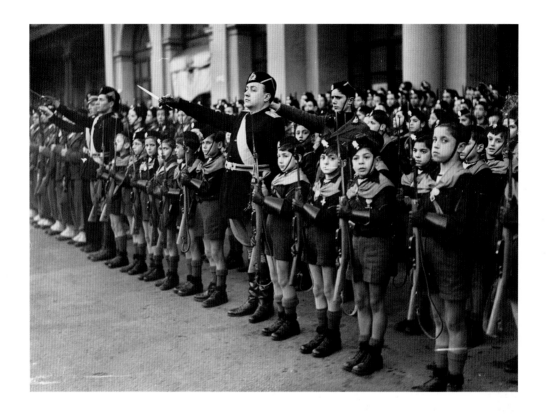

ITALIAN BLACKSHIRTS WELCOME CHAMBERLAIN

UNKNOWN

Date 1939
Location Rome, Italy
Format 35 mm

Here, young Italian Blackshirts in Rome welcome the arrival of British Prime Minister Neville Chamberlain for a meeting with Italian dictator Benito Mussolini in January 1939. Three and a half months after the signing of the Munich Agreement—involving Italy, France, Nazi Germany, and Britain—which gave way to Adolf Hitler's annexation of portions of Czechoslovakia, Chamberlain and British foreign secretary Lord Halifax visited the Italian capital to engage with Mussolini, wanting to find a way to

appease the Italians and maintain the peace. The image was taken at a time of escalating tensions in the lead-up to World War II.

The Chamberlain–Halifax visit was the final effort to bring Italy into the Allied sphere before war broke out eight months later. Our gaze falls on the stony faces of the young Blackshirts—children seen as the Fascists of the future, armed and ready to fight. Organized in impeccable lines, the boys appear stiff and uncomfortable holding the guns, yet they obey the orders of the adults who appear among them with their arms extended in a Roman salute. There is something vulnerable about their shorts and socks pulled high, which contrasts sharply with the guns in their hands. EC

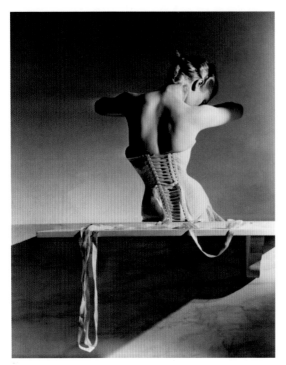

MAINBOCHER CORSET

HORST P. HORST

Date 1939
Location Paris, France
Format Large format

German-born Horst P. Horst (1906–99) moved in 1930 to Paris, where he worked as a male model alongside his mentor and lover, fashion photographer George Hoyningen-Huene. In 1931, Horst began to photograph for French *Vogue*, working for the magazine until 1939, when he left for the United States just weeks before the outbreak of World War II. This is the last photograph Horst took in Paris; he sailed for New York later the same day. It shows an unknown model wearing a back-lacing pink corset made by Detolle for Mainbocher and was published in French *Vogue* in December of that year.

Horst had many influences, but three in particular are prominent in this image: Bauhaus design; Surrealism, as practiced by Man Ray and Salvador Dalí; and classical Greek sculpture. These inspirations are reflected in the clean lines of composition, in the use of spotlights and reflectors to create the deep shadows, in the brilliant highlights of an otherworldly space in which the subject almost seems to float, and in the appearance of the figure as a statue resting on a faux marble balustrade. Yet the most powerful and sensual element of this image is entirely original: the tangled ribbons in the foreground, which seductively invite the viewer to take hold of them, tie up the wasp-waisted corset, and possess the drooping, puppetlike model in a manner suggestive of sexual bondage. The provocative tone is perhaps the main reason why this carefully composed photograph has become an iconic image recognized for its eroticism as much as for its sophistication and formal felicity. CK

"This photograph helped establish Horst as *Vogue*'s leading fashion photographer in an era when technical advancements in image-making were slow."

Aesthetica magazine

SAVOY BALLROOM, HARLEM

CORNELL CAPA

Date 1939
Location New York, New York, USA
Format 35 mm

Hungarian photographer Cornell Capa (1918–2008) has been overshadowed by his famous elder brother, war photographer Robert Capa, but he was an important figure in his own right. Cornell worked as a staffer for *Life* magazine from 1946 and was to become a member and subsequent president of the Magnum Photos agency after his brother's untimely death in 1954. Later in life he coined the description "concerned photographer" to distinguish those who demonstrated a humanitarian impetus to use photography as a means to educate and change the world, rather than merely create a record. Cornell Capa became a notable curator of, and advocate for, documentary photography, and he founded the International Center of Photography in New York in 1974 especially to promote "concerned photography."

This image comes from one of Capa's earliest magazine assignments, to cover the Lindy Hop craze, a dance movement based on swing jazz that originated in the African-American community of Harlem, New York. In 1939, Capa photographed the craze at its height in Harlem's Savoy Ballroom, where dancers would perform to entertain with increasingly athletic dance moves. The series of photographs he took capture the energy of the dancers and, to our eyes, look surprisingly modern, as they prefigure the postwar growth of youth movements based on musical affiliation.

Working for pictorial magazines, Capa went on to photograph an eclectic range of subjects, including the Six-Day War (1967) in Israel, Perón's Argentina, the USSR, and, in a memorable story, the first 100 days of the Kennedy presidency. NG

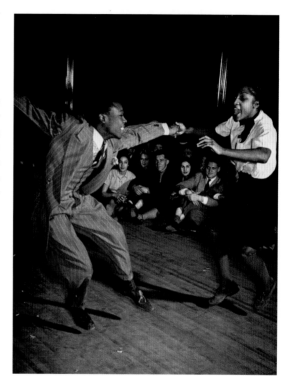

"Isolated images are not the most representative of my work. What I do best are probably groups of interrelated pictures which tell a story." Cornell Capa

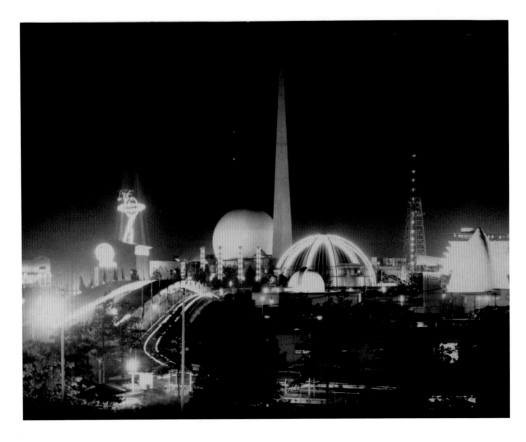

VIEW OF THE WORLD'S FAIR

UNKNOWN

Date 1939
Location New York City, New York, USA
Format Unknown

Glittering and glowing like the Land of Oz, this majestic, shimmering scene is actually the World's Fair of 1939–40, advertised as the "World of Tomorrow." While past expos in other international cities had focused on technological innovation, the historic New York fair, which took place on the site of Flushing Meadows–Corona Park in Queens, promised visitors an experience of a futuristic world. Opening on April 30, 1939 and running for eighteen months, the fair welcomed more than 40 million

people, inviting them to view and engage with all kinds of strange displays and activities. There was a talking robot 7-feet (2.1-m) tall, a time capsule, and a huge, sprawling model city.

Jutting sharply out of the ground was the Trylon obelisk, the fair's centerpiece, and alongside that was a domelike construction, the Perisphere, which housed the main auditorium. Both the 610-foot (190-m) Trylon and the eighteen-storey Perisphere were designed by architects Wallace Harrison and André Fouilhoux. Many striking color photographs were taken both inside and outside of the fair, but this dramatic black-and-white image epitomizes the wonder, mystique, and sheer delight of the strange event. GP

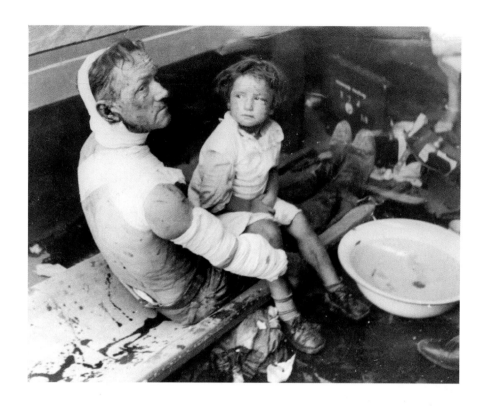

INJURED FAMILY

UNKNOWN

Date 1939
Location Warsaw, Poland
Format 35 mm

The photograph may be in black and white, but there is no denying the bloodstains on the stretcher. This Polish man and his young daughter were injured during a German air raid on Warsaw in 1939. They are pictured together on a stretcher in a first-aid station, their glazed expressions betray the shock they must have been feeling, and, despite turning slightly to acknowledge the photographer's presence, the man makes little attempt to respond. The tight framing, which cuts out any other activity, compels the viewer to focus solely on the father and daughter, and their relationship. This is a quiet, intimate moment, but not a peaceful, happy one. We do not know who else these people might have lost, but at least they have survived the bombing.

Hitler's bombing raids on Warsaw began at six a.m. on September 1 and continued until September 27, when Poland finally surrendered. It is unknown who took this image, or how the photographer—probably working for a newspaper—came to be at the first-aid station, or what brief was being followed. But this unhappy scene survives as a stark reminder of the human cost of Hitler's attack on Poland, and indeed of the prolonged terrible conflict that followed. GP

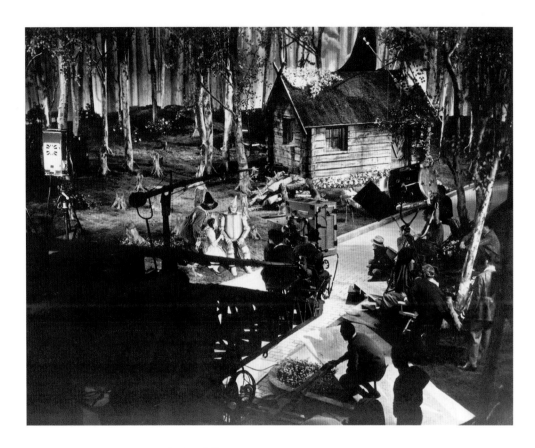

FILMING *THE WIZARD OF OZ*

UNKNOWN

Date 1939
Location Culver City, California, USA
Format Unknown

Still photography plays a central role in conveying the sense of wonder, fun, and drama in the film industry. Photographers document behind-the-scenes action, and thereby provide insights into how the magic of movies actually happens.

This studio shot of the filming of *The Wizard of Oz* reveals the complexity of the production and the range of people involved off camera. This movie was particularly stressful, since no fewer than four directors were involved. Victor Fleming was in charge for most of the production, but he replaced Richard Thorpe and George Cukor, and was himself replaced by King Vidor. The shoot lasted more than six months and was MGM's most expensive production to date. The film used the new Technicolor process, which required daylight-bright lighting that raised temperatures on set above 100°F (38°C). The actors had to be at the studio at four or five a.m. for makeup and costume fitting, often not leaving until seven or eight p.m. Most of the principal cast were banned from eating in the studio's commissary because of their costumes, with the witch makeup worn by Margaret Hamilton preventing her from eating solid food, so she lived on liquids. PL

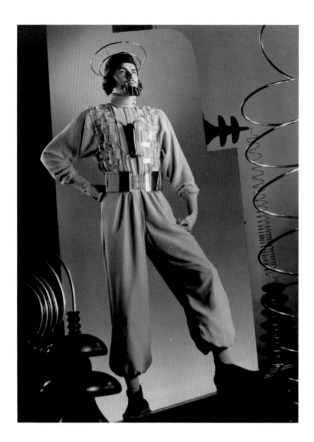

VOGUE 1939

ANTON BRUEHL

Date 1939
Location New York, New York, USA
Format 35 mm

Born in Australia to German parents, Anton Bruehl (1900–82) emigrated to the United States in 1919. He started out as a student of engineering, but soon turned his attention to photography, and sold some of his early work to *Vogue*. Inspired by this success, he set up a studio on 47th Street in New York. He never loooked back: magazine commissions always remained a major part of his business.

In this black-and-white photograph from the February 1939 issue of *Vogue*, a male model is pictured wearing a futuristic gray jumpsuit, a metal antenna-like hat, and a wide metal belt with pockets, all created by American modernist industrial designer Gilbert Rohde. The image contains multiple elements that all compete for our attention at once—the springs and metal pipes echoing the style of the model's outfit. The model, standing defiantly on a sloping platform, looks out of the frame, reflecting the forward-looking vision that Bruehl evidently had in mind when taking the photograph. Flicking through the pages of fashion magazines in the 1930s, it was quite unusual to find photographs of men, so Bruehl's image is all the more remarkable an exception to the norm. EC

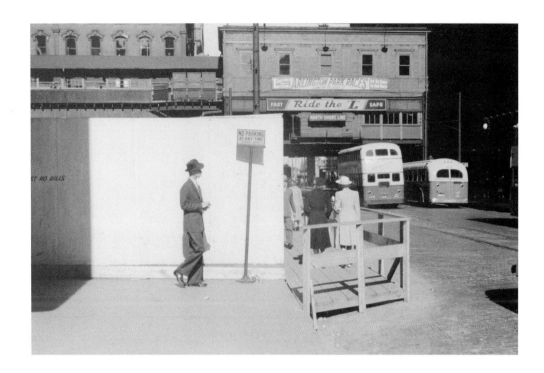

CLARK STREET, CHICAGO, ILLINOIS

JOHN VACHON

Date 1940

Location Chicago, Illinois, USA

Format 35 mm

As a chronicler of everyday life in 1940s' North America, John Vachon (1914–75) was one of the finest photographers of his generation.

Vachon first wanted to be a writer, but in 1936 he came into contact with Roy Stryker, who was involved in a major documentary photography project that was produced by the Farm Security Administration under the New Deal. Its aim was to record the economic and social impact of the Great Depression on the US Midwest and South.

Stryker needed a junior clerk, so he hired the young Vachon to write captions and organize the files. Before long Vachon picked up a camera himself. With support and encouragement from photographers Ben Shahn and Walker Evans, Vachon developed his own approach. He traveled to Nebraska, in particular the city of Omaha, and spent time in Chicago, where he made this photograph. The smartly dressed man is placed perfectly against the white backdrop, contrasting with his surroundings as other passersby move around in the distance. The compositional balance and use of light and shadow make the image—a fine example of classic street photography—immensely satisfying to behold. **GP**

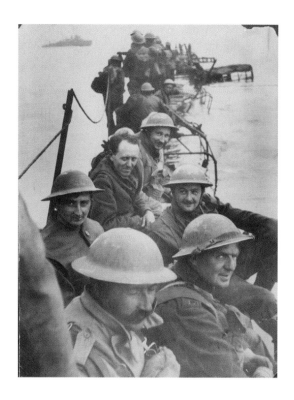

OFFICERS OF THE ROYAL ULSTER RIFLES AWAITING EVACUATION AT BRAY-DUNES NEAR DUNKIRK, MAY 1940

MAJOR H. E. N. BREDIN

Date 1940
Location Bray-Dunes, France
Format Unknown

This image captures the relief on the faces of British soldiers who have just been delivered from the clutches of the advancing German army. It is part of the Imperial War Museum collection, which attributes it to Major Humphrey Edgar Nicholson Bredin (1916–2005), who commanded a company of the Royal Ulster Rifles (RUR) in World War II. RUR soldiers were among the last to depart Dunkirk, having been part of the rearguard that held off the enemy to allow Allied troops to make their escape.

The evacuation of Dunkirk, which was given the code name Operation Dynamo, saw more than 300,000 soldiers saved during the period of approximately one week in May and June 1940. When the German army cut off Belgian, British, and French troops along the English Channel coast, the decision was made to retreat. An official emergency call for assistance brought out a vast fleet of rescue craft that carried the troops to safety. Known as "little ships," they were, in fact, of all shapes and sizes, from tiny motor boats to great passenger steamers, such as the vessel for which the men shown here were bound—a ferry that normally worked the Irish Sea crossing between Liverpool and the Isle of Man. GP

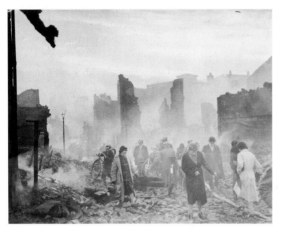

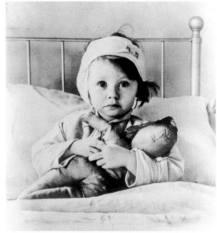

THE RUINS OF EARL STREET

UNKNOWN

Date 1940
Location Coventry, UK
Format Unknown

The German Luftwaffe's ten-hour bombing raid on Coventry, which began in the evening of November 14, 1940, killed more than 500 people and reduced most of the city's buildings, including its famous fourteenth-century Gothic cathedral, to rubble. The Nazis targeted this city because it was the location of many of Britain's most important heavy industries. This image of the downtown area captures some of the damage, which represented a severe blow to British wartime morale. Eyewitnesses reported that survivors wandered around the streets not knowing what to do or where to go as bodies lay strewn all around them.

Some sources have since claimed that British Prime Minister Winston Churchill knew that an attack on Coventry was imminent because the Allies had recently cracked the Enigma codes used by the Nazis to communicate intelligence, but he chose not to act. However, the current consensus among historians is that, although the British knew that a heavy bombing raid would occur, they did not know where the attackers would strike. **GP**

VICTIM OF THE BLITZ

CECIL BEATON

Date 1940
Location London, UK
Format Medium format

Cecil Beaton (1904–80) is best known for his society portraits and fashion photographs and for his work as an Oscar-winning costume and set designer. He worked regularly for *Vanity Fair* and *Vogue* and later became the unofficial court photographer of the British royal family, shooting Queen Elizabeth II's coronation portrait. However, he also produced an extraordinary series of images as an official war photographer for the British government during World War II. He was commissioned in 1940 by the British Ministry of Information as a war artist to create positive images for propaganda purposes to boost morale. His images of the desert campaign are studies in the surreal landscape of war. One of his most effective images was this powerful study of a three-year-old casualty of the German Blitz bombing of London, Eileen Dunne, with her head bandaged and cuddling her doll. Published as the cover of *Life* magazine in September 1940, while the United States was still neutral, it increased US public support for the British. **PL**

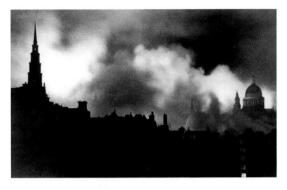
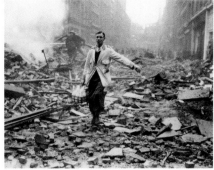

ST. PAUL'S DURING A BLITZ AIR RAID ON LONDON

UNKNOWN

Date 1940
Location London, UK
Format 35 mm

During the Battle of Britain, the German Luftwaffe launched a campaign of heavy nighttime air raids on London. On October 9, 1940, the dome of St. Paul's Cathedral was pierced by a Nazi bomb, leaving the high altar in ruins. It was one of the few occasions in World War II that the structure of the building was even slightly damaged.

The first cathedral on this site was built in 604 CE and later demolished when England reverted briefly to paganism. A second edifice was then erected, but destroyed in 1087 by fire. The third St. Paul's, consecrated in 1240, survived until the 1660s, but had meanwhile fallen into such disrepair that the Church of England commissioned Sir Christopher Wren to restore it. Restoration became complete reconstruction after the whole cathedral was razed to the ground in the Great Fire of London in 1666.

Wren's magnificent cupola, completed in 1710, is therefore the fourth St. Paul's Cathedral. In the light of the history of churches on this site, it is amazing that it survived the Luftwaffe campaign almost unscathed. But it did, and its proud standing among the surrounding bomb damage was a powerful symbol of British resistance to Hitler. ZG

DELIVERY AFTER A RAID

FRED MORLEY

Date 1940
Location London, UK
Format Unknown

This photograph was taken on the morning of October 9, 1940, after a German air raid on London during the Blitz; it shows the aftermath of the thirty-second successive night of bombing of the British capital. A milk delivery man nonchalantly picks his way through the rubble, with a crate in one hand and a pint bottle in his pocket. The implicit message is that normal life continued uninterrupted; the nation was undeterred; its people were being fed. The photograph is a highly effective piece of propaganda at a time when British censors, in an effort to prevent panic among civilians, were blocking the publication of photographs that depicted the devastation wrought by German bombs. The blocking would also mask the impact of raids to enemy eyes, and deny them knowledge of the locations where bombs had hit.

In the event, the photograph was staged. Fox Photos' press photographer Fred Morley (1925–2013) wanted to show the damage without eroding morale, so he posed his assistant in a borrowed white coat with a crate of milk bottles against a backdrop of firefighters at work. The censors recognized the photograph's propaganda value and it was published the next day. CK

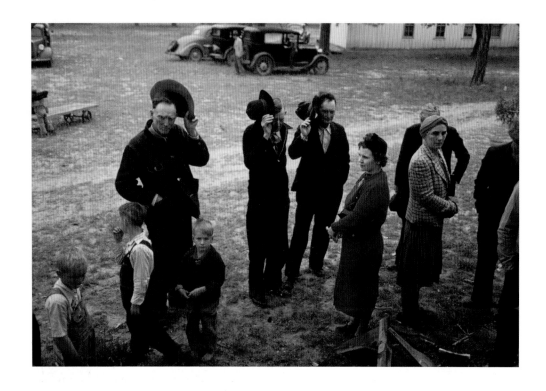

SAYING GRACE BEFORE THE BARBEQUE DINNER AT THE PIE TOWN, NEW MEXICO FAIR

RUSSELL LEE

Date 1940
Location Pie Town, New Mexico, USA
Format 35 mm

From the children waiting expectantly, to the three men raising their hats simultaneously and the women lost in thought, this photograph seamlessly brings together all its elements to present a candid slice of rural life in 1940s' New Mexico. Its photographer, Russell Lee (1903–86), had been sent to Pie Town, Catron County, to document everyday life. He was on assignment for the Farm Security Administration (FSA), a New Deal agency that worked to combat poverty in rural parts of the United States. The FSA hired photographers such as Lee in a promotional capacity to convince people that there was a need for the support provided by its programs. Together, FSA photographers created a phenomenal body of work comprising more than 160,000 images—an unsurpassed visual record of US life at the time. Lee alone took 600 photographs, many shot on Kodachrome film, which was noted for its vibrant and rich colors. He recorded everything, from families eating dinner to men at work, and locals at the annual New Mexico Fair. Shot before color photography became commonplace, Lee's images burst from the page, bringing out every nuance of the scene with uncanny realism. **GP**

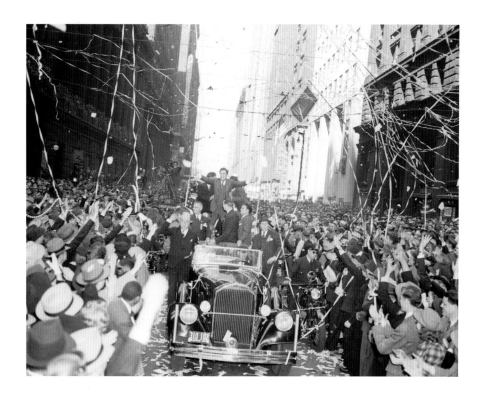

WENDELL WILLKIE, REPUBLICAN PRESIDENTIAL CANDIDATE, PARADES THROUGH HIS HOMETOWN, ELWOOD, INDIANA

UNKNOWN

Date 1940

Location Elwood, Indiana, USA

Format 35 mm

In the center of this image is Wendell Willkie, who is making his way through his hometown to accept the Republican nomination for the US presidency. A former Democrat who had switched to the Republican Party only a year previously, Willkie won the nomination on the sixth ballot and was attempting to oust incumbent President Franklin D. Roosevelt.

When the campaign went into full swing, the publisher and avid Republican supporter Henry Luce reportedly instructed all staffers and freelances on his magazines—*Time*, *Life*, and *Fortune*—to maximize favorable coverage of Willkie's campaign and thereby turn the candidate into a celebrity.

This photograph did what it was intended to do: make Willkie look like a movie star surrounded by adoring fans. Luce's initiative was impressive, but ultimately unsuccessful. In the event, although Willkie received a respectable 44.8 percent of the popular vote (22 million votes), Roosevelt was triumphant, amassing 27 million votes and securing a record third term in office. Willkie briefly ran for president again four years later, but failed again; he died in late 1944. GP

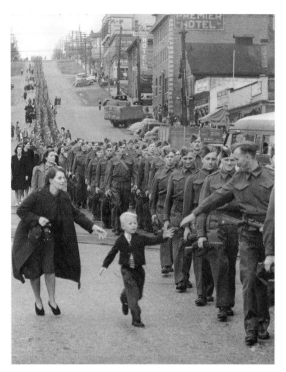

WAIT FOR ME, DADDY

CLAUDE P. "DETT" DETTLOFF

Date 1940
Location Vancouver, Canada
Format 35 mm

This poignant photograph came to symbolize the human cost to families of a war effort. Claude P. "Dett" Dettloff (1899–1978) was an American who moved to Canada in 1936 to take up the post of chief photographer for the Vancouver newspaper *The Province*. As the military mobilized at the start of World War II, Dettloff attended a parade to see off the troops from the British Columbia Regiment and captured the moment when a small child, Warren "Whitey" Bernard, ran away from his mother to bid a final farewell to his father, Private Jack Bernard. The image became hugely popular, and Whitey became a mascot for the war. As he later explained: "Not long after, the authorities asked me to join the victory bond drives in nearby war plants. Everyone would be given half an hour off, a group would perform the songs of the day, and at the end they would wheel out a huge copy of this picture. I would come out in my blazer and short pants (that my mother insisted I wear) and make a speech along the lines of, 'Buy a bond today and bring my daddy home.'"

Jack Bernard survived the conflict. The image began to circulate widely again in the 1960s as part of the Remembrance Day commemorations, and was enshrined in a specially commissioned bronze statue unveiled in New Westminster in Vancouver in October 2014. It was also used on Canadian postage stamps and $2 coins. Bernard recalled that during the unveiling of the statue he was "overwhelmed by the emotion this photograph evokes. As one of the veterans present said, 'It's not about war, and blood and guts, and guns. It's about the families that get left behind.'" **PL**

"The picture went everywhere. ... It was a full page in *Life*, it was in *Liberty* and *Time* and *Newsweek* and the *Reader's Digest* and the *Encyclopaedia Britannica Yearbook* and in newspapers everywhere."

Warren "Whitey" Bernard

ORSON WELLES

W. EUGENE SMITH

Date 1941
Location United States
Format 35 mm

W. Eugene Smith (1918–78) captured this image of US actor, director, writer, and producer Orson Welles emerging from a cab beneath a brightly lit theater marquee displaying his name and the title of his film in sparkling lights. The photograph was taken on May 1, 1941, when Welles, who was just twenty-five at the time, released *Citizen Kane*, his first feature movie. The movie was very well received, being lauded for its cinematography, music, and narrative structure, all of which were then highly innovative. Its story, following the life and legacy of Charles Foster Kane, a character played by Welles himself, was loosely based on that of US newspaper magnate William Randolph Hearst.

The image gains resonance because it shows the famous director arriving at the premiere of his movie, not in a glossy limousine as would happen today, but rather stepping out of a taxi in which the prices are painted on the side in cents, as a regular man in the street would have done. He steps out coolly, with a cigar clenched between his teeth and a look of slight irritation on his face, possibly at the sight of the cameramen who no doubt were awaiting his arrival at the curbside. Welles's crouching form is echoed by the display above the marquee behind him, which shows a figure rising and getting larger in sequence, raising its arms in an increasingly triumphal pose. The display coincidentally reflects Welles's rising fame and adds to the multiple layers of meaning in the image. The photograph marks a momentous occasion considering the grand success of *Citizen Kane*, which now has the reputation of being one of the greatest movies of all time. EC

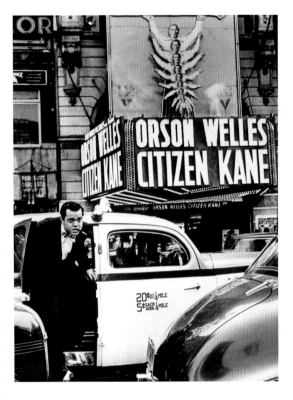

"I am constantly torn between the attitude of the conscientious journalist who is a recorder and interpreter of the facts and of the creative artist who often is necessarily at poetic odds with the literal facts."

W. Eugene Smith

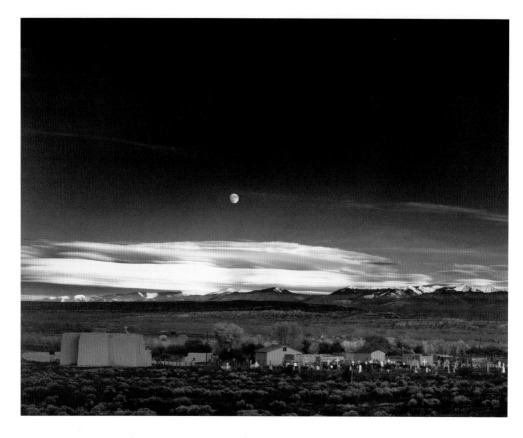

MOONRISE, HERNANDEZ, NEW MEXICO

ANSEL ADAMS

Date 1941
Location Hernandez, New Mexico, USA
Format Gelatin silver print, large format

Ansel Adams (1902–84) was a founding member of the influential Group f/64, a collective of San Francisco-based photographers that was formed in 1932 to promote straight photography at a time when pictorialism was the dominant form. By the time he took the image reproduced here, he was already known for his skill in shooting landscapes of superb tonal quality. Yet even a photographer of Adams's caliber sometimes relied on luck. He came across this location by chance while driving. Realizing that the moon setting over the snow-covered mountains would make a dramatic backdrop to the village of Hernandez, he slammed on the brakes. In the rush to get the shot, he could not find his light meter. So he set the exposure to one second at f/32, based on the known luminosity of the moon. The resulting image is a tour de force. The tombstones glisten in the moonlight; the shapes of the crosses stretch across the scene in thin bands of brilliant white, echoed by those of the snowcapped peaks and soft clouds.

As much as this is a shot of a landscape, it is also a meditation on life, death, heaven, and earth. Edward Steichen selected *Moonrise* for publication in the *US Camera* 1943 annual. CK

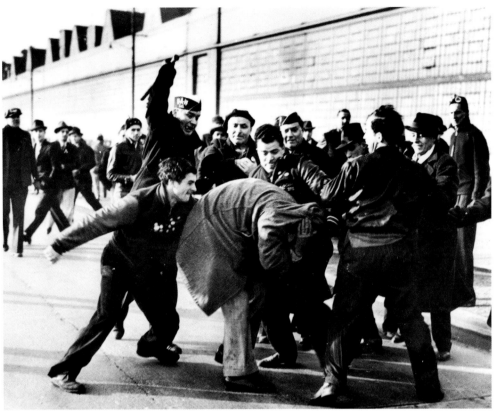

FORD STRIKERS RIOT

MILTON BROOKS

Date 1941
Location Detroit, Michigan, USA
Format 35 mm

Strikers attack a "scab" on April 3, 1941, as he tries to cross the picket line at the Ford Motor Company's River Rouge plant in Dearborn, a suburb of Detroit, Michigan. Only a couple of days earlier, the company had purportedly fired at least one and possibly more of its employees, thereby sparking a walkout by most of the workforce. Strikers were protesting this and Ford's refusal to recognize the United Automobile Workers (UAW) labor union. Previous strike action in the 1930s had led

to General Motors and Chrysler signing contracts with the UAW, but Ford had refused to allow union representation. The owner eventually relented, which led to formal recognition of the UAW by Ford. A contract was signed in June 1941.

Milton Brooks (1901–56), a photographer with *The Detroit News*, was present during the action and watched events unfold. As the scuffles between strikers and a strikebreaker intensified, Brooks was poised, ready to take a photograph that not only captures an important moment in Ford's history but is also a universal record of the potential power of strike action. On the strength of this image, in 1942, Brooks became the first recipient of a Pulitzer Prize for Photography. **GP**

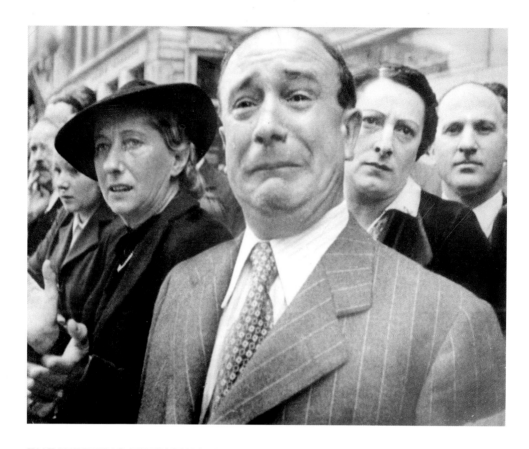

THE WEEPING FRENCHMAN

UNKNOWN

Date 1941
Location Marseille, France
Format 35 mm

It happened more quickly than anyone could have predicted. On May 10, 1940, German forces attacked France via the Low Countries, and within a few weeks the French government capitulated. People could do nothing but watch in disbelief as their freedom was snatched away from them.

The national outpouring of grief after the surrender has over time come to be represented by this single photograph of one man, subsequently named as Jerôme Barzetti, weeping as he watches

French regimental flags being marched through Marseille on their way to Africa, out of Nazi reach.

In the United States, *Life* magazine published the photograph in its issue of March 3, 1941. Footage of Barzetti and other onlookers was also recorded and shown in various newsreel bulletins throughout World War II. It also appears in Frank Capra's *Divide and Conquer* (1943), one of seven US propaganda films commissioned under the overall title *Why We Fight* to justify American involvement in the conflict. Barzetti appears toward the end of that movie as the narrator utters the words, "the people weep as their glory departs." The image may in fact have originated as a still extracted from motion picture footage. GP

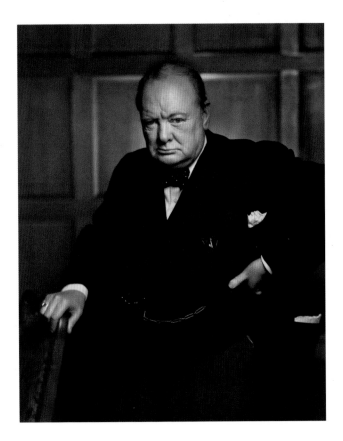

WINSTON CHURCHILL

YOUSUF KARSH

Date 1941
Location Ottawa, Canada
Format Large format

Armenian-born Canadian Yousuf Karsh (1908–2002) was an official portrait photographer for the Canadian government. He took this powerful character study after Churchill addressed the Canadian House of Commons on December 30, 1941, during World War II. When it came to the sitting afterward in an anteroom, Churchill was angry because he had not been not told that he would be photographed, and he told Karsh: "You have two minutes. And that's it, two minutes."

The wartime leader then lit one of his famous cigars. Karsh asked him to remove it, but Churchill refused. Claiming that he needed to get a lighting level, Karsh walked up to Churchill and snatched the cigar from his mouth. As Karsh walked back to his camera, he clicked his camera remote, capturing Churchill's glowering indignation. Karsh later said: "By the time I got back to my camera, he looked so belligerent he could have devoured me. It was at that instant I took the photograph. The silence was deafening. Then Mr. Churchill, smiling benignly, said, 'You may take another one.' He walked toward me, shook my hand and said, 'You can even make a roaring lion stand still to be photographed.'" CK

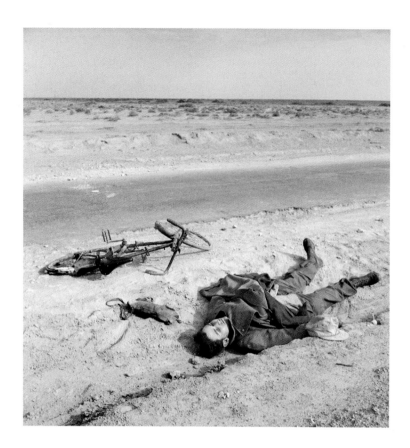

A DEAD GERMAN SOLDIER

GEORGE RODGER

Date 1941
Location Western Desert, Egypt
Format Medium format

George Rodger (1908–95) grew up in England and Scotland before eventually working for the BBC as a photographer. At the start of World War II, Rodger documented the destruction caused by the air raids of the London Blitz. This led to a job as a war correspondent for *Life*, which in turn opened up opportunities for him to document the conflict overseas. By his own account, Rodger's coverage took him to sixty-two countries during the war. He photographed numerous battlefronts, including the fierce fighting in northeast Africa resulting from the Allies' Western Desert Campaign. Part of the wider war in North Africa, this campaign dragged on for more than three years, with skirmishes of Axis and Allied forces taking place over vast expanses of largely empty desert, punctuated by larger battles and sieges in key locations like the city of Tobruk.

As a haunting image of the cost of war, this one is especially poignant because the dead Wehrmacht soldier appears so peaceful, as if he simply lay down for a nap beside his bicycle. Rodger used a 35mm Leica camera, but he also employed a medium-format 6x6cm (2½x2½-in)-square-format Rolleiflex camera to make more contemplative images, such as this one. LB

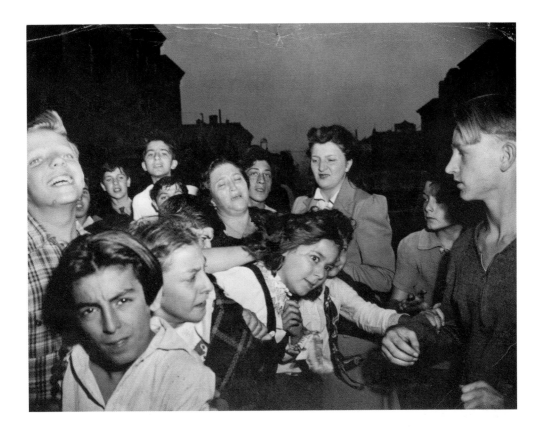

THE FIRST MURDER

WEEGEE

Date 1941
Location Brooklyn, New York, USA
Format Large-format view camera

Weegee (1899–1968) was born Usher Fellig in Ukraine. In 1910, his family emigrated to the United States, where he anglicized his first name to "Arthur." As a freelance photographer for tabloids such as the *Daily News* and *PM Daily*, Weegee documented New York life: crowds on Coney Island; Easter Sunday in Harlem; lovers at the theater. But he was best known for his shots of death, destruction, and criminals: automobile accidents, suicides, drownings, burning buildings, hoodlums under arrest, the bloody

corpses of gangsters killed in gangland executions, and grieving relatives. He was able to capture such images because in 1938 he became the first private citizen to receive a permit for a shortwave radio to monitor police communications. He drove around with his Speed Graphic camera around his neck. His nose for a story was so good that he often arrived at crime scenes before the police, which earned him his nickname Weegee, after the ouija board.

His first book, *Naked City* (1945), contains *The First Murder*, with the caption: "A woman relative cried . . . but neighborhood dead-end kids enjoyed the show when a small-time racketeer was shot and killed." On the facing page of *Naked City*, the bloody body is shown lying in the street. CK

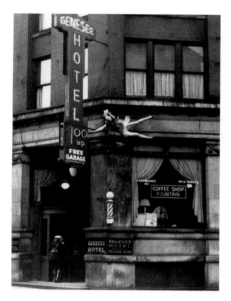

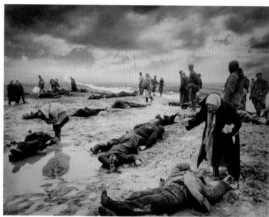

GRIEF, OR SEARCHING FOR LOVED ONES AT KERCH

DMITRI BALTERMANTS

Date 1942
Location Kerch, Ukraine
Format 35 mm

SUICIDE, BUFFALO

I. RUSSELL SORGI

Date 1942
Location Buffalo, New York, USA
Format Large format

Photography's ability to freeze time is among its most powerful, challenging attributes. I. Russell Sorgi's harrowing image of a woman jumping to her death from the eighth story of a hotel in Buffalo, New York, is a poignant example of how this phenomenon can unfold. The woman—Mary Margaret Miller—was a thirty-five-year-old divorcée from Chicago, Illinois, who had checked into the Genesee Hotel earlier the same day. Sorgi, a photographer with the *Courier Express* newspaper, reached the scene just as police were arriving.

The May 18, 1942, issue of *Life* magazine ran Sorgi's photograph alongside a short text describing the events in the moments leading up to Miller's jump. According to the article, Miller perched on a ledge for twenty minutes before lowering herself over it and letting go, plummeting to her death. GP

Dmitri Baltermants (1912–90) was born in Warsaw when Poland was part of the Russian Empire. In 1915 his family relocated to Moscow, following his father, who served in the tsar's army and was killed in World War I. As a young man, Baltermants worked a series of jobs, including as a cinema mechanic, before training to teach math at a military academy. By 1939 he was back in Poland, and photographed the Soviet invasion in 1939, although none of those images is known to have survived. When Germany invaded the Soviet Union in June 1941, Baltermants covered the fighting for the Soviet daily *Izvestia*.

The Germans committed numerous atrocities, and Baltermants documented the aftermath of a massacre in the village of Kerch. With its scattered bodies, darkened skies, and isolated clusters of survivors, *Grief* is a powerful image of war. Like many Soviet photographers of the time, Baltermants had few misgivings about staging photographs, and it has subsequently been suggested that this image is a composite of several frames. LB

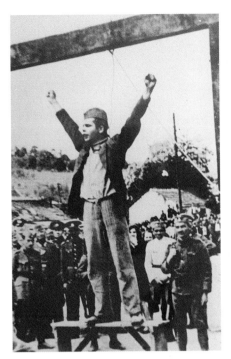

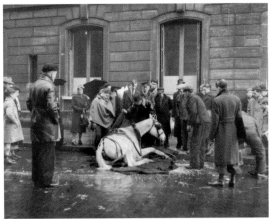

THE FALLEN HORSE

ROBERT DOISNEAU

Date 1942
Location Paris, France
Format Medium format

Robert Doisneau (1912–94) studied lithography before turning to photography. As a young man, he became fascinated by the everyday events he saw on the streets. His observations are often playful and surreal, but never unkind. He had a keen but gentle eye and captured unguarded moments.

After the occupation of France in World War II, he joined the resistance as a photographer and forger of documents. The picture here, of a horse fallen in the street and surrounded by a watching crowd, is Doisneau's metaphor for France at the time. The horse is seemingly dying, and none of the onlookers is doing anything to help, except for one man who attempts to alleviate its suffering by drawing a blanket over it. Yet in spite of its parlous state, the animal seems to glow with radiance, refusing to relinquish life.

In the postwar period, Doisneau worked in advertising, also undertaking fashion work for magazines including French *Vogue*, but his heart was still with street photography, which he continued to practice assiduously. ER

MOMENTS BEFORE EXECUTION

SLOBODANKA VASIĆ

Date 1942
Location Valjevo, Serbia
Format Unknown

Twenty-six-year-old Croatian Stjepan Filipović yells the partisan slogan, "Death to fascism, freedom to the people," moments before he is hanged by the German army and their collaborators. When World War II started, Filipović joined the resistance movement and became commander of a partisan battalion in the Valjevo area of Serbia. He was captured in 1942 by Četniks (Serbian Nazi collaborators) and handed over to the Gestapo. He was tortured and sentenced to death by hanging. Slobodanka Vasić (born 1925), at the time an apprentice to a local photographer, made around twenty exposures of this execution. ZG

AMERICAN GOTHIC

GORDON PARKS

Date 1942
Location Washington, D.C., USA
Format 35 mm

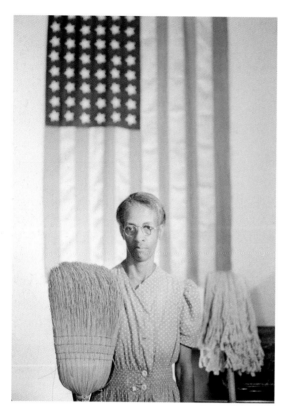

In 1942, African-American photographer Gordon Parks (1912–2006) began working for the Farm Security Administration (FSA) in Washington, D.C. There, he faced the everyday racism that was then prevalent in the nation's capital, and had to enter restaurants and theaters through the back door. Parks encountered Ella Watson cleaning floors in the FSA building and made this powerful study of her, mop in hand, contrasted against the US flag. He recalled: "It's the first professional image I ever made, created on my first day in Washington." Parks interviewed Watson, recounting how "she had struggled alone after her mother had died and her father had been killed by a lynch mob. She had gone through high school, married and become pregnant. Her husband was accidentally shot to death two days before their daughter was born. By the time the daughter was eighteen, she [the daughter] had given birth to two illegitimate children, dying two weeks after the second child's birth. What's more, the first child had been stricken with paralysis a year before its mother died."

Parks showed the photograph to the chief of the FSA, Roy Stryker, who oversaw the team of photographers working for the agency, including Dorothea Lange, Walker Evans, and Carl Mydans. Parks remembered that Stryker had told him that he had "gotten the right idea but was going to get all the FSA photographers fired, that my image of Ella was 'an indictment of America.'" The image was, however, published on the front page of *The Washington Post* and became a symbol of the oppression of minorities. It was named *American Gothic* after the 1930 painting by Grant Wood. **PL**

"While most people have at least an intellectual understanding of the ugly inequities that endured in the post-Reconstruction South, Parks's images drive home the point with an emotional jolt." *Art in America*

THREE DEAD AMERICANS
ON THE BEACH AT BUNA

GEORGE A. STROCK

Date c. 1942–43
Location Buna, New Guinea
Format Unknown (probably medium format)

Having studied photography in high school in Los Angeles, California, and then worked in a variety of photography-related jobs, George A. Strock (1911–77) joined first the *Los Angeles Times* and then in 1940, *Life* magazine, which dispatched him two years later to cover World War II in the Pacific. He was with US troops during the pivotal Battle of Buna-Gona in New Guinea in late 1942. The magazine published nearly all of Strock's photographs, apart from those that showed dead American soldiers—these were withheld by the US Office of Censorship. This instigated a struggle for editorial control between *Life* and the US government, which had blocked publication because of fears of undermining public morale.

Strock and *Life* found a sympathetic supporter in Elmer Davis, director of the Office of War Information, who convinced US President Franklin D. Roosevelt to repeal the ban on images of dead soldiers, albeit with restrictions on revealing the victims' faces or other identifying information.

This photograph showing three dead US soldiers and a destroyed landing craft finally appeared in print in September 1943, nearly a year after it was taken, alongside an editorial that set out *Life's* justification for reproducing it. This was an important victory for the freedom of the press to report and depict the course of the war. The debate about the rights and wrongs of showing the most extreme consequences of armed conflict has continued ever since, and has most recently resurfaced over press and television depictions of dead American and British soldiers during military actions in Iraq and Afghanistan. **LB**

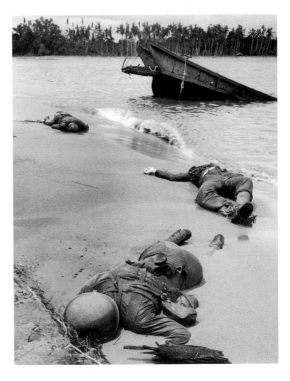

"When I took pictures,
I wanted to bring the viewer
into the scene." George A. Strock

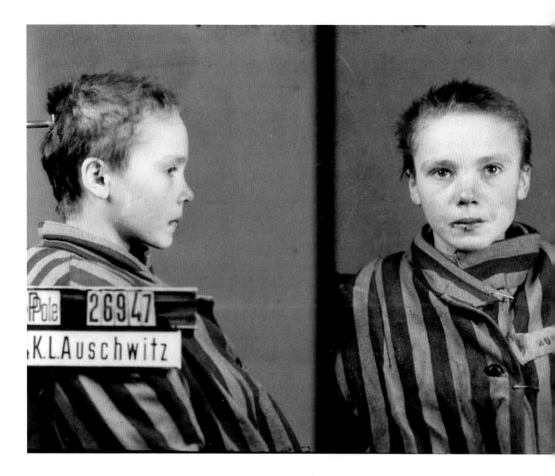

CZESŁAWA KWOKA

WILHELM BRASSE

Date c. 1942–43
Location Auschwitz, Poland
Format Unknown

Wilhelm Brasse (1917–2012) was born in Poland and trained as a portrait photographer in Żywiec at a studio owned by his aunt. In 1939, Nazi Germany invaded Poland at the start of World War II. Being of part-Austrian descent, Brasse came under pressure to join the German army. He refused, and attempted to escape to Hungary, but was captured at the frontier and deported in 1940 to the newly opened Auschwitz concentration camp. Because of his photographic experience and his ability to speak German, Brasse was one of several photographers assigned to the camp's photographic identification unit, which created ID photographs of new prisoners.

During the war, Brasse and the other photographers working at the camp are estimated to have produced as many as 200,000 photographs. While intended to be for the benefit of the camp authorities, they today act as a remarkable record of the people who passed through Auschwitz and in most cases died there.

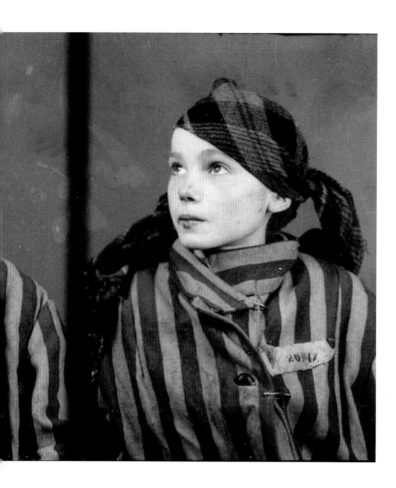

Despite working in unimaginable conditions, Brasse's training as a photographer is apparent throughout his work, and many of his images retain a surprising beauty, as is evident in these of Czesława Kwoka, a Polish Catholic who died at the camp in 1943 at age fourteen. Despite their aesthetic value, these portraits leave little doubt about the brutality in the camps, and prisoners often show clear signs of malnutrition and ill treatment.

After the war, Brasse returned home and attempted to resume his career, but found himself so traumatized by his experiences that he abandoned photography altogether. Although he continued to own a modest camera, he claimed never again to have taken a photograph of anyone or anything ever again. Instead, he ran a modest local business that made casings for sausages.

In 2006 *The Portraitist*, a television documentary about Brasse's life and work, directed by Ireneusz Dobrowolski, was broadcast to great acclaim in Poland and was later shown in many other countries. In the following year, Theresa Senato Edwards and Lori Schreiner produced a mixed-media artwork based on the images shown here, titled *Painting Czesława Kwoka*. **LB**

THE CRITIC

WEEGEE

Date 1943

Location New York, New York, USA

Format Unknown

Usher (later Arthur) Fellig (1899–1968), or Weegee as he was known, was the ace of New York City's tabloid photographers. Conscious of his reputation, he stamped his pictures "Weegee the Famous." By using a miniature darkroom in the back of his automobile to develop his film, he frequently managed to be first to deliver his prints to the newspapers.

Although many of his photographs appeared spontaneous, this image was deliberately staged. On the opening night of the Metropolitan Opera House's sixtieth season, Weegee co-opted a famous regular drinker from Sammy's, a bar he frequented in the Bowery. He plied the woman on the far right with cheap wine and coaxed her to participate in this photograph with two of New York's most famous high-society benefactors, Mrs. George W. Kavanaugh and Lady Decies. Weegee's trademark explosive flash gives a floodlit effect, establishing a stark and symbolic contrast between the smartly dressed rich women and the grubby poor woman in the shadows. Acme Newspictures ran the photograph with the caption: "She is aghast at the quantity of diamonds in evidence . . . but the bejeweled ladies are aware only of Weegee's clicking camera." CJ

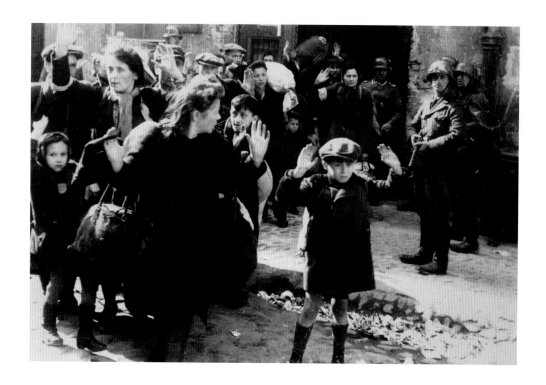

THERE IS NO JEWISH RESIDENTIAL DISTRICT
IN WARSAW ANYMORE

UNKNOWN

Date 1943
Location Warsaw, Poland
Format 35 mm

Looking at this photograph of Jews being forced from Poland's Warsaw ghetto by Nazi soldiers, one can assume that all must have died either immediately or shortly thereafter in concentration camps. But the young boy with his hands in the air survived—or so it is believed. His name is understood to be Tsvi C. Nussbaum, who went on to become a physicist in the United States. Decades after this photograph was taken, Nussbaum came forward claiming he was the boy. It is thought that

the photograph, which has come to symbolize the collective suffering of Jewish people during the Holocaust, was taken around the time of the Warsaw ghetto uprising (April 19–May 16, 1943).

Perhaps surprisingly, not everyone was delighted by Nussbaum's claim; some believed that it diminished the photograph's emotional impact and usefulness.

This photograph is sometimes attributed to SS General Jürgen Stroop, who was in charge of the ghetto at the time of the uprising. Although there is no certainty about this attribution, the chilling title of the image is the same as that of the report that Stroop subsequently produced for his commanding officer, Heinrich Himmler. GP

FROM *ONE DAY OF WAR, RUSSIA—1943*

UNKNOWN

Date 1943
Location Unknown
Format Unknown

In the heat of battle at the height of what the Russians call the Great Patriotic War (1941–45)—their campaign in World War II to drive the Nazi invaders out of their motherland—a female nurse slides into a trench to tend to a wounded soldier.

The role of women in the second global conflict is often downplayed or overlooked altogether, but in the Soviet armed forces, thousands of them fought alongside their male counterparts. They were pilots and tank commanders, as well as nurses on the frontline.

This image is a still from *One Day of War, Russia—1943*, part of *The March of Time*, an American short documentary series produced by the editors of *Life* and *Time* magazines. The movie features scenes filmed by 160 Soviet cameramen on a single day of fighting. This woman appears for a brief instant about seventeen minutes in.

Although almost nothing is known about this photograph—who took it, where and when, or the identity of the subject—it has nevertheless become internationally famous as a symbol, not only of the Soviet struggle against Hitler, but also of feminism. GP

BOY WITH FINGER IN HIS MOUTH IN A MOVIE THEATER, NEW YORK

WEEGEE

Date c. 1943
Location New York, New York, USA
Format Large format

The artist known as Weegee (1899–1968) was born Usher Fellig in Ukraine. After emigrating to the United States, he worked as a press photographer in New York. Many of his photographs are unflinching depictions of the aftermath of criminality, violence, and accidents, but are often also commentaries on the people who gather to revel in these spectacles.

Fellig was self-taught; his photographs were visceral, and his reputation is sometimes one of a glorified paparazzo or an ambulance chaser. However, such appraisals fail to account for his wider interest in the lives of ordinary people. They also fail to recognize his creativity.

This image is part of a series taken in the darkness of a New York cinema. Knowing that the auditorium would be pitch black, but to avoid disturbing the action and interactions taking place in the darkened space, Weegee used infrared film and flashbulbs to photograph people unawares. LB

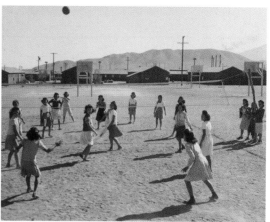

MANZANAR RELOCATION CENTER, CALIFORNIA

ANSEL ADAMS

Date 1943
Location California, USA
Format 35 mm

FROM AMERICAN *VOGUE*, MARCH 1943

JOHN RAWLINGS

Date 1943
Location Unknown
Format Unknown

John Rawlings (1912–70) began his career as a shop window dresser in New York City in the early 1930s. He bought a Leica and started photographing his aristocratic clients. His images somehow landed on the desk of the editor in chief of *Vogue*, Edna Woolman Chase, who hired him in 1936. He thus joined the likes of Cecil Beaton, Horst P. Horst, Irving Penn, and George Hoyningen-Huene. After just one year as an apprentice, Rawlings was promoted to first assistant and had his first photograph published in the September 15, 1942, issue of *Vogue*.

This glamorous, high-concept shot is timeless, and has been reappropriated by modern photographers such as Tim Walker. Rawlings went on to shoot more than 200 *Vogue* and *Glamour* covers and amassed more than 30,000 images in the Condé Nast archive. LH

In the wake of the Japanese attack on Pearl Harbor in 1941, President Franklin D. Roosevelt ordered the mass detention of Japanese-Americans on the US west coast. More than 110,000 were forcibly removed from their homes in California, southern Arizona, western Washington, and Oregon. Manzanar, one of ten "relocation centers," was located in California's Owens Valley; the camp spread over 6,200 acres (2,500 ha) and contained thirty-six residential barracks.

The renowned photographer Ansel Adams (1902–84) visited Manzanar in 1943 to capture life in the camp. While the bulk of his images from Manzanar are portraits, he also recorded scenes of daily life, sports and leisure activities including baseball and volleyball, and people at work. It is often said that Adams's images are more optimistic than those of photographer Dorothea Lange, who had visited the previous year. However, Adams claimed that his aim was to show the internees' ability to cope with the situation. EC

RICHARD ATTENBOROUGH IN *BRIGHTON ROCK*

FELIX H. MAN

Date 1943
Location London, UK
Format 35 mm

After being forced by the rise of Nazism to leave Germany in 1934, Felix H. Man (1893–1985) worked in London for the *Daily Mirror* using the nickname "Lensman" and then joined *Picture Post* magazine, newly founded by a fellow European émigré, Stefan Lorant. Almost all of the images in the initial launch issue of 1938 were taken by Man, and he had a knack of finding the stories as well as the pictures.

Although labeled a "friendly alien" at the outbreak of World War II, and so limited to

photographing only civilian subjects, Man produced a wide range of portraits and images of fashion and daily life. The second editor of *Picture Post*, Tom Hopkinson, attributed Man's success as a photojournalist to an extraordinary photographic memory; an ability to previsualize a situation; a capacity for intense concentration; economy of effort; and, above all, "the patience and resourcefulness of a practiced angler."

Man's observational skills are demonstrated in this study of a young Richard Attenborough playing the sociopathic gang leader Pinkie in a stage dramatization of Graham Greene's novel *Brighton Rock*. Attenborough later reprised his breakthrough role in the 1947 movie version. PL

BERLIN, 1943

WOLF STRACHE

Date 1943

Location Berlin, Germany

Format 35 mm

This work by Wolf Strache (1910–2001)—a German press photographer during World War II who created images that were in keeping with the spirit of Nazi propaganda—epitomizes civilians' attempts to carry on as best they could. It has become his most famous photograph because of its graphicness and starkness and because it depicts human resolve in the face of adversity.

Captions explain that the woman is walking down Kurfürstendamm, a famous street in Berlin, after a heavy British raid. There is a strange sense of normalcy here, but the situation is, of course, anything but normal. It is almost as though the woman is oblivious to the devastation around her, although that is unlikely given the extent of the destruction. No other people are visible, and a sense of uneasy calm and quiet engulfs the scene. In the background a sign advertises a film, *Reise in die Vergangenheit* (*Trip to the Past*). Dominating the frame, the sign bears down heavily on the woman, the words adding poignancy. The image demonstrates Strache's skill in using photography to glorify Germany, and its message is clear: the German people are resilient and will not succumb to the enemy. GP

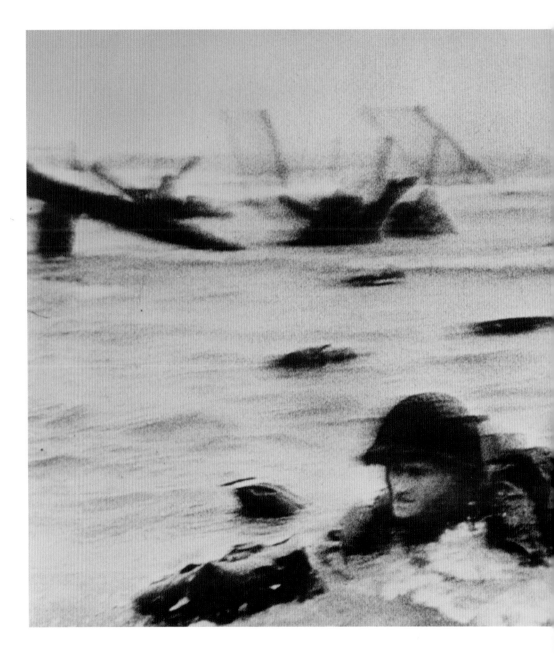

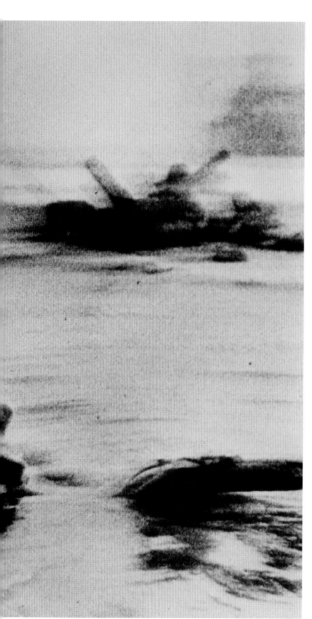

AMERICAN SOLDIERS LANDING ON OMAHA BEACH, D-DAY, JUNE 6, 1944

ROBERT CAPA

Date 1944
Location Normandy, France
Format 35 mm

When World War II broke out, Hungarian-born war photographer Robert Capa (1913–54) was in the United States and technically an enemy alien. He was already an experienced combat photographer, having covered the Spanish Civil War (1936–39) and the early part of the Second Sino-Japanese War (1937–45). He went on to report on conflicts throughout the European theater as the Allies' only enemy alien photographer. He was assigned to cover the Allied invasion of Europe, codenamed Operation Overlord. On D-day, June 6, 1944, he accompanied Company E of the 16th Regiment of the 1st Infantry Division of the US Army as they landed on Omaha Beach on the southern shore of the English Channel.

Capa took with him two Contax II cameras mounted with 50mm lenses and several rolls of spare film. He stood in the stern of a landing craft and then swam ashore to take photos of the troops arriving. He shot 106 photographs during the first few hours of the battle, including this one, which shows a GI crawling toward the beach carrying his waterproofed rifle in his right hand, ready for action. It was a dangerous assignment, and Capa was lucky to survive. The grainy image is blurred. Capa confessed that his hands were trembling and his body was shaking as he came under heavy machine-gun fire and was surrounded by smoke, noise, and Allied casualties. The photographer's courageous effort was worth it. This was one of five photographs published in *Life* magazine on June 19: the vision of the GI's steely resolve in the face of the enemy was an uplifting piece of propaganda for the Allies as they attacked the Nazis on a new battlefront. CK

THE SKULL OF A JAPANESE SOLDIER, SENT BY AN AMERICAN SOLDIER TO HIS GIRLFRIEND

RALPH CRANE

Date 1944

Location Phoenix, Arizona, USA

Format Unknown

There were atrocities on both sides during World War II in the Pacific. Among the most barbarous practices was the taking of trophies, often human body parts, by Americans from dead Japanese soldiers. American aviator Charles Lindbergh toured the Pacific in 1944 and noted in his diaries that such practices were widespread, to the extent that when he returned to the United States he was asked by customs officers if he had any human bones in his luggage.

Ralph Crane (1913–88) was a German who emigrated as a young man to the United States and established himself as a skilled photographer, later earning a staff job on *Life* magazine. In May 1944, *Life* sent him to photograph Natalie Nickerson with the Japanese skull that her boyfriend, a lieutenant in the US Navy, had sent home. The skull was signed by her boyfriend and thirteen of his comrades and inscribed: "This is a good Jap—a dead one picked up on the New Guinea beach."

Publication caused an outcry in the United States, and the military thereafter attempted to stop further trophy taking of this nature. In Japan, the photo was used as propaganda to underscore American brutality. LB

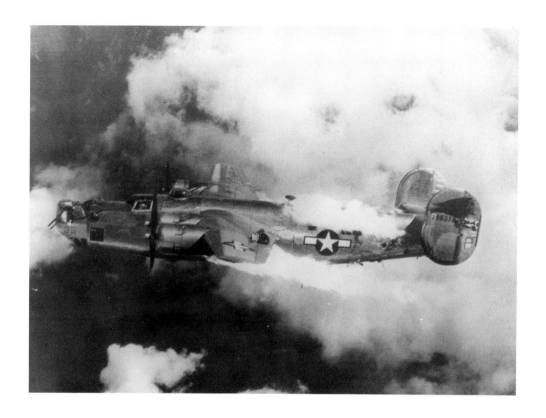

US AIR FORCE B-24 LIBERATOR BOMBER GOES DOWN IN FLAMES IN A RAID OVER AUSTRIA

L. S. STOUTSENBERGER

Date 1944
Location (Above) Türnitz, Austria
Format Unknown

The B-24 Liberator was the mainstay of the Allied bombing effort in World War II, serving in every branch of the US Armed Forces. Almost 19,000 aircraft of this type were built. Each Liberator carried a crew of eleven and a payload of up to 8,000 pounds (3,600kg) of bombs. One of the most famous Liberator pilots was Hollywood film star James Stewart, who commanded the 703rd Bomb Squadron, 445th Bombardment Group, flying out of RAF Tibenham in Norfolk, England.

This B-24H-30-FO Liberator, attached to the 725th Bomb Squadron, 451st Bombardment Group, and 15th US Air Force, was on a daylight bombing raid on August 23, 1944, when it was attacked by German Luftwaffe FW-190 fighter planes in the sky over Austria. The aircraft quickly burst into flames and went out of control, and all ten crew members were killed in action.

US Air Force Staff Sergeant L. S. Stoutsenberger was flying in another bomber when he made this image. Although there was nothing he could do to help his doomed comrades, he later recalled that he "felt guilty, helplessly snapping a death picture while the men were burning inside. It happened so fast they didn't have much of a chance." PL

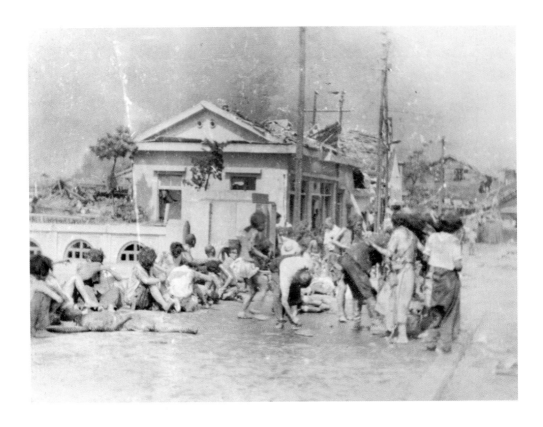

HIROSHIMA THE DAY THE A-BOMB WAS DROPPED

YOSHIKO MATSUSHIGE

Date 1945
Location Hiroshima, Japan
Format Unknown

When the United States dropped an atomic bomb on Hiroshima on August 6, 1945, photojournalist Yoshiko Matsushige (1913–2005) set out to record the immediate effects of the blast. Confronted by terrible scenes, he could scarcely bring himself to press the shutter, and in the next ten hours he took only seven pictures: "I could not endure taking any more pictures that day. It was too heartbreaking," he said. He was unable to develop the film for twenty days, finally doing it in the open air at night, using

a stream to rinse the negatives. Only five images came out—the only ones from the city on that fateful day. In this image, the standing survivors are treating burns with cooking oil on Miyuki Bridge.

The US military confiscated these images under the rule that "Nothing shall be printed which might, directly or by inference, disturb public tranquility." But Matsushige held on to the negatives, and when martial law ended in April 1952, the magazine *Asahi Gurafu* published his photographs in a special edition, titled "First Exposé of A-Bomb Damage," of which 700,000 copies sold out. Later in life, Matsushige said: "Sometimes I think I should have gathered my courage and taken more photos, but at other times I feel I did all I could do." CJ

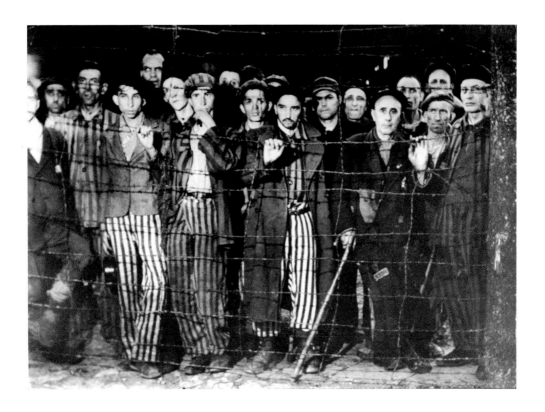

THE LIBERATION OF BUCHENWALD

MARGARET BOURKE-WHITE

Date 1945
Location Buchenwald, Germany
Format 35 mm

As the first-ever female war correspondent for the US Air Force, Margaret Bourke-White (1904–71) accompanied the US Third Army during the spring of 1945 as it made its way across Germany during the last months of World War II. She chronicled the liberation of the Buchenwald concentration camp in April with haunting photos such as this, which shows a group of emaciated survivors dressed in the striped uniforms of prisoners, as if they were caged animals in a zoo.

Bourke-White later wrote of that day: "Using the camera was almost a relief; it interposed a slight barrier between myself and the white horror in front of me. . . . I longed for it to disappear, because while it was there I was reminded that men actually had done this thing—men with arms and legs and eyes and hearts not so very unlike our own. And it made me ashamed to be a member of the human race."

Although many of Bourke-White's images of Nazi barbarity were printed in the May 7, 1945, edition of *Life* magazine, the photograph reproduced here was not. It was first published in the magazine's December 26, 1960, special double-issue, *25 Years of Life*. CK

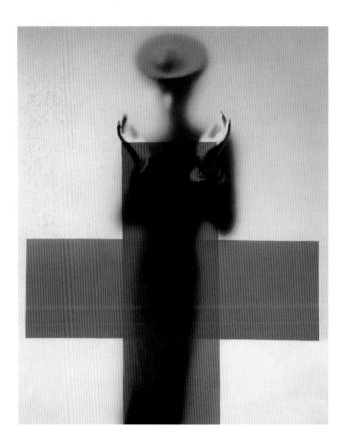

DO YOUR PART FOR THE RED CROSS

ERWIN BLUMENFELD

Date 1945
Location New York, New York, USA
Format Unknown

As *Vogue* covers go, this one, showing a blurred model behind translucent glass overlaid with a bold red cross, is among the most iconic. Created by German photographer Erwin Blumenfeld (1897–1969), the image graced the March 15 issue in 1945 and formed a key part of the magazine's efforts to raise awareness and funds for the Red Cross, particularly its work with prisoners of war. It is bold and graphic, but at the same time hauntingly poetic. There is something almost ghostlike about

the elegantly dressed woman, her raised arms positioned in a figurative call to action, her head tilted slightly forward. Her face is hazy, but there is no doubt that she is directing her gaze at the viewer.

Blumenfeld fled his native Germany during World War II and had been living in the United States for four years when he took this photograph. After securing a contract with *Vogue*, he went on to produce many more striking covers and fashion articles for this magazine and one of its greatest rivals, *Harper's Bazaar*. Keen to be regarded as an artist, Blumenfeld drew on twentieth-century avant-garde art movements such as Dadaism and Expressionism, often embracing an experimental, surrealist approach. **GP**

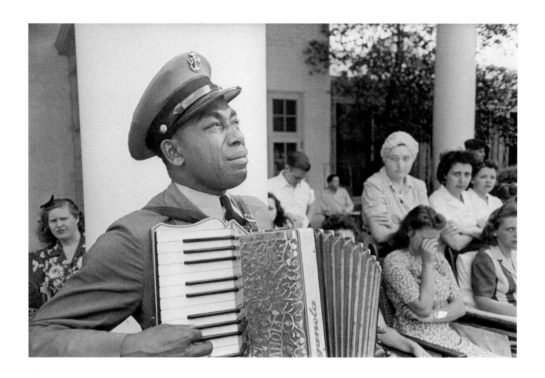

FDR FUNERAL 1945

ED CLARK

Date 1945
Location Warm Springs, Georgia, USA
Format 35 mm

During a career spanning more than forty years, and beginning as a darkroom apprentice while still in high school, Ed Clark (1911–2000) created some of *Life* magazine's most iconic photos. He photographed subjects ranging from studies of agricultural labor to portraits of Hollywood celebrities. He was the darling of both Democrat and Republican presidents, a thing almost unimaginable in the polarized and stage-managed climate of contemporary US politics, and all the more extraordinary because Clark produced a large body of challenging work concerned with racial injustice in the education system.

In this photograph tears stream down the face of accordion player Graham Jackson at the funeral of President Franklin D. Roosevelt (FDR). He plays outside the polio clinic in Warm Springs, where Roosevelt stayed in 1921, after contracting the disease. The photograph can be read as a symbol of the great popularity FDR enjoyed with black voters, the result of his pursuit of socially progressive policies throughout his four terms as president. He implemented the New Deal, a raft of policies that laid the foundations for social security and workers' rights in the United States. **MT**

WHITE DEATH

TONY VACCARO

Date 1945
Location Ottré, Belgium
Format 35 mm

In this stark photograph by Italian-American Tony Vaccaro (born 1922), the pure white background is disrupted by a black outline. With his rifle nearby, a helmeted soldier lies dead in the snow; only a small portion of his body is visible. The clear, elegant composition is infused with empathy yet is unflinching in its portrayal of the brutal consequences of war, in this case the Battle of the Bulge, which took place on the Belgium– Luxembourg border between December 1944 and January 1945. Vaccaro later discovered that this was the body of his friend Private Henry Tannenbaum.

Vaccaro joined the army in World War II and on June 6, 1944—D-day—found himself landing on Omaha Beach in northern France. Determined to photograph as well as to fight, he brought along a 35 mm Argus C3 camera. During his 272 days in the conflict, Vaccaro processed his films inside colleagues' helmets, hanging his negatives on tree branches to dry. The resulting images provide an intimate portrait of war from an ordinary soldier's perspective that epitomizes classic, humane photojournalism. Vaccaro never flinched from graphic depictions of death and violence, claiming, "I felt the world had to see it." **CP**

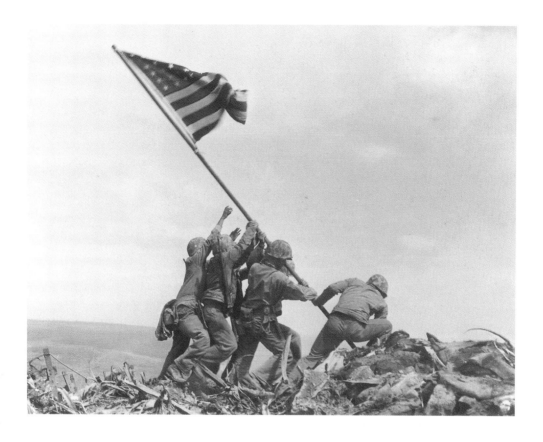

RAISING THE FLAG ON IWO JIMA

JOE ROSENTHAL

Date 1945
Location Iwo Jima, Japan
Format Large format

Joe Rosenthal (1911–2006) dabbled in photography as a hobby, later working as a reporter and photojournalist in San Francisco, California. At the outbreak of World War II, he was initially rejected for a role as a US Army photographer because of his poor eyesight, so he joined Associated Press, which in 1944 sent him to cover the Pacific campaign.

Iwo Jima was the first of the Japanese home islands to be targeted for invasion by US forces, and in anticipation of this it had been heavily fortified

with a network of bunkers and 21,000 Japanese soldiers. The invasion began on February 19, 1945. Four days later a combat patrol of US Marines reached the summit of Mount Suribachi, an imposing volcanic peak overlooking the island. Attaching a flag to an old water pipe, they raised it and were photographed for *Leatherneck* magazine by Staff Sergeant Louis R. Lowery.

Rosenthal arrived later the same day, as a second, larger flag was about to be raised in place of the first, which had been removed as a war trophy. His photograph became an instant classic, but controversy would also dog the image with a string of accusations, now refuted, that Rosenthal had staged the scene. LB

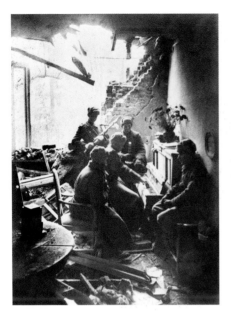

IN THE WAVES

RUTH BERNHARD

Date 1945
Location Santa Monica, California, USA
Format Unknown

TCHAIKOVSKY, GERMANY

DMITRI BALTERMANTS

Date 1945
Location Germany
Format 35 mm

Soviet photojournalist Dmitri Baltermants (1912–90) was a master at finding moments that summed up conflict—not only the actual fighting, but also the behind-the-scenes moments of surreal humor and pathos. This poignant image shows a group of Red Army soldiers enjoying a moment of calm during the fighting in Germany in the last days of World War II. The composition is powerful, with the light falling from the blown-out wall's edge, illuminating the soldiers and highlighting the hand of the piano player as it dances across the keyboard. The vase of flowers still standing on the piano is a reminder of the destruction of normal life, and the clock in the left-hand corner is a metaphor for the passage of time. The title alludes to Tchaikovsky's *1812 Overture*, composed to celebrate Russia's victory over the French led by Napoléon Bonaparte. PL

Ruth Bernhard (1905–2006) was a leading proponent of the photographic study of the female form. In the late 1920s, she became involved in New York lesbian subculture and befriended photographer Berenice Abbott and her lover, the critic Elizabeth McCausland. She met influential photographer Edward Weston by chance on the beach at Santa Monica in 1935, and the encounter changed her perspective on photography and inspired her to move to California. In 1953, Bernhard became part of the West Coast photography circle in San Francisco, with Ansel Adams and Imogen Cunningham.

Her work, typified by this semiabstract study of water flowing over the body of a young woman, explored how the human form can combine graphic structure with sensual tone. Bernhard often used tight viewpoints and crops to accentuate and highlight the contours and shapes of the body, stating that: "My aim is to transform the complexities of the figure into harmonies of simplified forms revealing the innate reality, the life force, the spirit, the inherent symbolism and the underlying remarkable structure—to isolate and give emphasis to form with the greatest clarity." PL

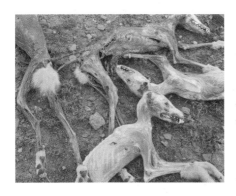

COYOTES

FREDERICK SOMMER

Date 1945
Location Arizona, USA
Format Large format

Frederick Sommer (1905–99) worked across a range of media—including drawing, sculpture, and collage—but photography was central to his practice, and he explored form and structure in works that had an abstract quality but were still related to the material world.

Born in Italy, Sommer studied for an architecture degree in the United States, becoming a naturalized citizen in 1939. He moved to Arizona in 1931 and began a lifelong obsession with exploring the harsh beauty of the desert landscape. In the late 1930s, he began to experiment with a large-format, 10x8 view camera, making still lifes of found objects, including chicken entrails and bones, and what he called "horizonless landscapes," in which he cropped tightly into the terrain of the desert to create images with an intense sense of place.

In this study Sommer focused on the desiccated corpses of a pack of coyotes, bleached almost white by the harsh desert sun. The image resonates with the themes of Sommer's work, with the sense of death preserved by nature. As he explained: "Climatic conditions in the West give things time to decay and come apart slowly. They beautifully exchange characteristics from one to another." PL

TRINITY SITE EXPLOSION, 0.016 SECONDS AFTER DETONATION

BERLYN BRIXNER

Date 1945
Location Alamogordo, New Mexico, USA
Format Still from 16 mm film

On July 16, 1945, the first successful test of a nuclear weapon took place at the Trinity site in New Mexico. Berlyn Brixner (1911–2009) was the chief photographer for what was known as the Manhattan Project. Documenting the detonation was a significant photographic challenge. It was expected to start with a flash of light ten times brighter than the sun, but this was theoretical, and it was difficult to anticipate exactly what would happen. Brixner's response was to employ banks of ultra-high-speed movie cameras filming the test site from various angles and distances. These included the first Fastax cameras, which used rotating prisms to record as many as 10,000 frames per second. In some cases Brixner's cameras were thought to have gone through 100 feet (30m) of film in little more than a second, and this single test produced vast amounts of photographic material. The resulting still and moving pictures of the detonation are remarkable images that echo earlier motion studies by Eadweard Muybridge. LB

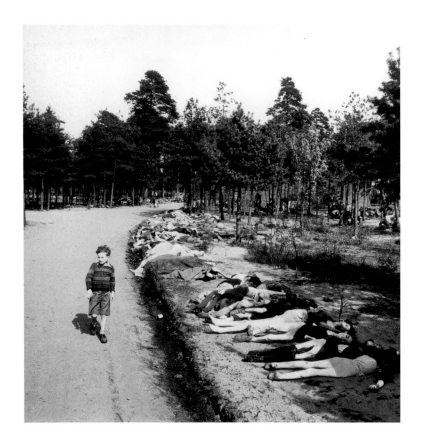

A YOUNG BOY WALKS PAST CORPSES AT BERGEN-BELSEN

GEORGE RODGER

Date 1945
Location Bergen, Germany
Format Medium format

On April 15, 1945, the British 11th Armoured Division came upon horrific scenes as they liberated the Bergen-Belsen concentration camp in northern Germany. The soldiers found around 60,000 prisoners in the camp, mostly half-starved, and another 13,000 corpses lying around unburied. George Rodger (1908–95), a British photographer who accompanied the army, was on assignment for *Life* magazine when he took this image. The simplicity of the scene belies its brutality: the young boy appears to stroll past the array of corpses in a matter-of-fact way, and yet his gaze is turned away from the terrible scene. The almost-empty road stretching out behind him accentuates the piles of bodies laid out along the verge.

Rodger's notes from the day record: "Dead lying by the side of one of the roads in the camp. They die like this in the thousands.... When they became so weak they could no longer walk they just lay down and died." He recalled later how appalled he was to realize that he had spent his time in the camp looking for graphically pleasing compositions. He decided to quit working as a war correspondent and instead traveled in Africa and the Middle East, photographing wildlife and people. CJ

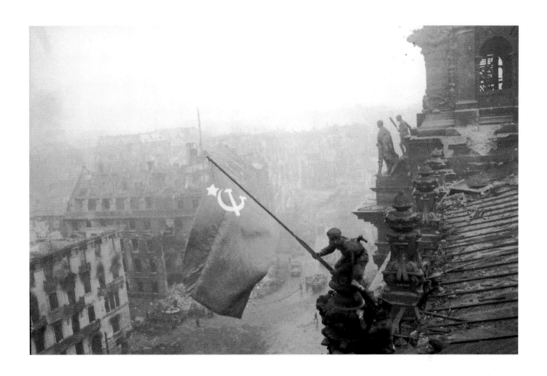

RAISING A FLAG OVER THE REICHSTAG

YEVGENY KHALDEI

Date 1945
Location Berlin, Germany
Format 35 mm

The Battle of Berlin began in mid-April 1945 and marked the final stage of World War II in Europe. With Berlin in ruins and German defenders heavily entrenched, the Soviet Red Army was forced to fight street by street to capture individual buildings. Of these, the Reichstag parliament building was considered one of the most symbolic. The building had been closed since an arson attack in 1933, which had helped to consolidate Hitler's rise to power; the interior was a ruin fortified by German

soldiers. After heavy fighting, the building was finally captured by May 1.

On May 2, Yevgeny Khaldei (1917–97) recorded two soldiers hoisting a Soviet flag over the edge of the Reichstag building. The official line was that the soldiers (Meliton Kantaria, a Georgian, and Mikhail Yegorov, a Russian) had been specially chosen for the job. Other accounts hold that the soldier hoisting the flag was Ukrainian but that this was later covered up. Khaldei in turn claimed he asked two soldiers who happened to be passing. When the image was later published in the Soviet Union, the two watches on the arm of one of the soldiers were airbrushed out to avoid suggestions of looting by the Soviet conquerors. LB

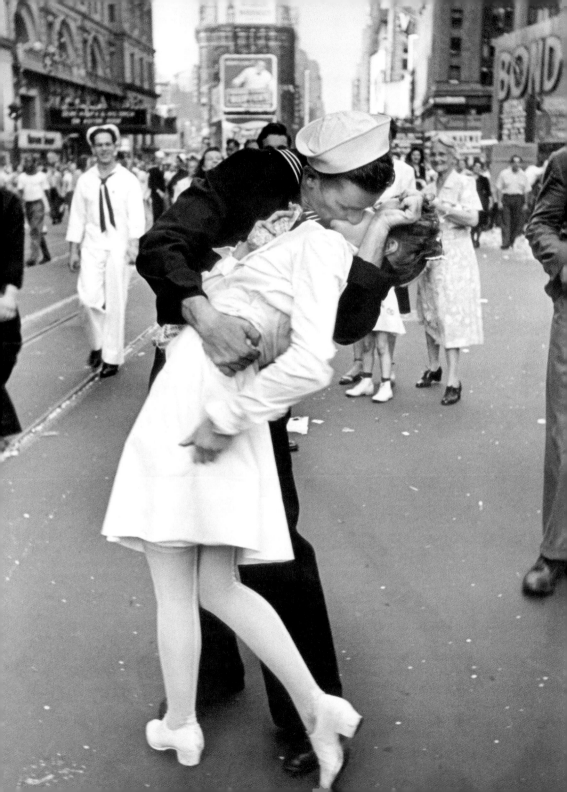

V-J DAY IN TIMES SQUARE

ALFRED EISENSTAEDT

Date 1945
Location New York, New York, USA
Format 35 mm

After fighting for the German army during World War I and working briefly as a belt salesman, Alfred Eisenstaedt (1898–1995) turned to a career in photography from 1928, working for Associated Press in Germany. He rapidly established himself as a skilled press photographer, and scored a number of significant scoops. He was an early adopter of the new compact 35 mm Leica camera, which gave him a flexibility that other photographers lacked. With the rise of the anti-Semitic Nazi Party in Germany, life became increasingly difficult for Eisenstaedt, who was Jewish, and in 1935 he and his family emigrated to the United States, where he continued his career working for *Life* magazine throughout World War II.

On August 14, 1945, the Japanese empire surrendered, marking the close of the campaign in the Pacific and the end of the war. As in other countries, the news was greeted with spontaneous revels in the streets of many cities, including in New York. Eisenstaedt was out in the city documenting the celebrations for *Life* and found himself in Times Square, where he took the most famous photograph of his career of a sailor kissing a nurse. The exact circumstances of the taking of this shot remain unclear; some have suggested it was staged and others that it was entirely spontaneous, with even Eisenstaedt describing the sequence of events differently in subsequent interviews. Whatever the ambiguities over its creation, the photograph was published a week later in *Life* and became iconic, encapsulating the celebratory mood of the moment and the sense that, now that the war was over, normal life could resume. LB

IDENTIFICATION OF GESTAPO INFORMER

HENRI CARTIER-BRESSON

Date 1945
Location Paris, France
Format 35 mm

This image by Henri Cartier-Bresson (1908–2004) shows a crowd of French people, including former concentration camp inmates and resistance fighters, observing the identification of a former Gestapo informer in newly liberated France. The photograph is centered on the informer, with head bowed and fist clenched, while another woman jubilantly presents her to representatives of the interim government. On the table in front of the official are documents with clear Nazi insignia.

The depth of field allows us to read the faces of all the subjects in the image. Most of them have curious expressions on their faces, but the man on the far left, dressed in concentration camp uniform, is carefully following the process, his hand on his hip, a sign of anticipation and, perhaps, indignation. In a single frame we have a victim, an accuser, and the accused in a flawlessly composed arrangement. Nothing is extraneous here; no element distracts the viewer from the judicial arraignment. ZG

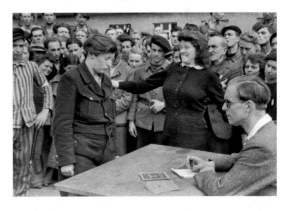

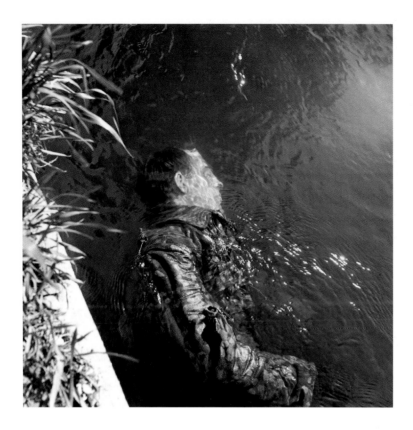

DEAD SS PRISON GUARD FLOATING IN CANAL

LEE MILLER

Date 1945
Location Dachau, Germany
Format 6x6 medium format

Lee Miller (1907–77) was the only female combat photographer in Europe during World War II. The assignment that took the greatest toll on her was documenting the horrors of the Holocaust when Buchenwald and Dachau concentration camps were liberated in April 1945. She said later: "I could never get the stench of Dachau out of my nostrils."

Miller's picture of a dead SS prison guard plays with the viewer's predilections. The man looks at peace in his watery grave, and his camouflaged uniform is almost invisible in the water, only hinting that he was a soldier. The photograph shows the canal bank and the body at a strange angle, perhaps because this was the only way in which Miller could capture her subject while looking down, or perhaps because she is hinting that all may not be as it initially appears.

However, when the image is considered along with the caption, it acquires a different meaning. The corpse is that of a man implicated in genocide, and Miller's sense of anger and disgust at the mass murder she witnessed becomes palpable. She photographed several guards who had been killed by soldiers or prisoners in acts that could be considered revenge or justice. CK

GERMAN PRISONERS OF WAR ARE FORCED TO WATCH AN ATROCITY FILM ON GERMAN CONCENTRATION CAMPS

UNKNOWN

Date 1945
Location Germany
Format Unknown

As Allied armies pushed deeper into Europe at the close of World War II, they found evidence of atrocities committed during the German occupation. This culminated in the discovery of the concentration camps, starting with Majdanek in Poland, which was liberated by the Soviet army in July 1944. In anticipation of future trials for war crimes, the camps were extensively filmed and photographed, and the resulting imagery was a central part of the prosecution's case at

the Nuremberg trials. This image shows German prisoners being forced to watch an atrocity film. Their reactions range from staring blankly ahead at the screen to shielding their faces with their hands and conveying signs of distress.

As well as prosecuting senior figures in the Nazi leadership, the Allies also instituted a program of denazification in Germany, which included publicizing the concentration camps to German soldiers and civilians with the intention of creating a sense of collective guilt and responsibility for what had occurred. Denazification continued until 1951, when the program was canceled by the West German government. Its effectiveness remains a matter of debate. LB

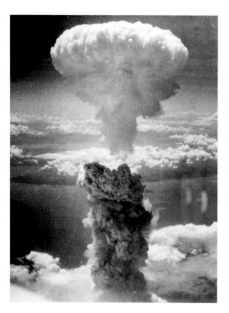

THE SHADOW OF A HANDLE
ON A GASOMETER

UNKNOWN

Date 1945
Location Hiroshima, Japan
Format Unknown

The United States had been developing an atomic bomb since the early 1940s, and in July 1945 it set off a device in the New Mexico desert. Believing this new weapon to be the answer to victory in Japan, on August 6 the US Air Force dropped an atomic bomb on Hiroshima, instantly killing more than 70,000 people and severely injuring many thousands more. Just three days later, a second bomb was dropped on Nagasaki, killing tens of thousands. In addition to the monumental devastation inflicted on people and land, the blasts caused the strange phenomenon known as "nuclear shadows": not shadows in the true sense, but rather the ghostlike marks on the ground or walls, formed as a result of thermal radiation, which bleached the surfaces it came into contact with. Any object or human present would have prevented the surface from being bleached, as is the case here. On the left of the photograph is the handle of a gasometer, its imprint on the right. There is something especially striking about this "shadow" image, which looks like it could be an example of a modernist photograph, were the horrific reality not known. **GP**

MUSHROOM CLOUD
OVER NAGASAKI

UNKNOWN

Date 1945
Location Nagasaki, Japan
Format Unknown

At 11:02 a.m. local time on August 9, 1945, the 'Fat man' atomic bomb was dropped from a B-29 Superfortress codenamed Bockscar, exploding at an altitude of about 1,650 feet (500 m) over the Japanese city of Nagasaki. The explosion killed an estimated 35,000–40,000 people immediately; the final total of fatalities, including those affected by longterm illnesses including cancer, was between 60,000 and 80,000. Ironically the city of Kokura was the original target, but when the B-29 arrived the aiming point was obscured by smoke and clouds from a previous firebombing raid, and the crew moved on to the secondary target, Nagasaki. Such aerial shots as this of the enormous mushroom clouds over both Hiroshima and Nagasaki attest to the incomprehensible scale of a nuclear attack. **PL**

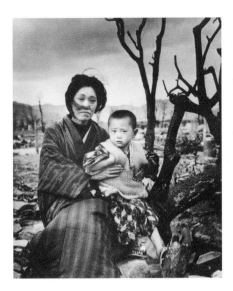

GÖRING WITH LAWYER AT THE NUREMBERG TRIALS

YEVGENY KHALDEI

Date 1946
Location Nuremberg, Germany
Format Unknown

MOTHER AND CHILD, HIROSHIMA, 1945

ALFRED EISENSTAEDT

Date 1945
Location Hiroshima, Japan
Format 35 mm

In this haunting image, a traditionally dressed Japanese woman holds her young son in the foreground of a scene of destruction. In many ways this is a classic Madonna-and-child composition: both subjects make direct eye contact with the viewer, increasing the image's already considerable impact. Photojournalist Alfred Eisenstaedt (1898–1995) described its creation thus: "When I asked the woman if I could take her picture, she bowed deeply and posed for me. Her expression was one of bewilderment, anguish, and resignation. . . . All I could do, after I had taken the picture, was bow very deeply before her." This powerful moment of contact happened in December 1945, four months after a nuclear bomb had been dropped on Hiroshima. The streets had been cleared of rubble, but the city remained a barren wasteland in which these two were trying to survive. **CP**

The Nuremberg trials revealed the true extent of Nazi crimes and atrocities during World War II. Hermann Göring, former head of the Luftwaffe (German Air Force), is shown here talking to his lawyer, Dr. Otto Stahmer, closely watched by a military guard. The prison guards nicknamed Göring "Fat Stuff," and he always tried to assume a jocular manner when in public earshot. He quickly became the informal leader and spokesman of the other twenty-three defendants, adopting a clever, mocking but evasive tone during cross-examination. His line of defense was that everything he and his codefendants had done was out of patriotism for their country. He finally met his match in the experienced British barrister Sir David Maxwell Fyfe and was found guilty of crimes against humanity, including genocide. Göring was sentenced to death but managed to commit suicide less than three hours before he was due to be hanged. Despite being under constant surveillance, he slipped a vial of cyanide into his mouth and crushed it with his teeth. **CJ**

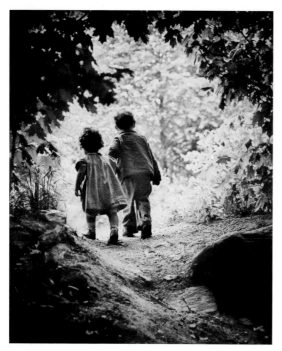

THE WALK TO
PARADISE GARDEN

W. EUGENE SMITH

Date 1946
Location Westchester County, New York, USA
Format 35 mm

Although to modern eyes this image of two children in a wood may seem sentimental, when the viewer realizes that the photographer is US photojournalist William Eugene Smith (1918–78), it takes on another resonance. Smith worked as a war photographer in the South Pacific during World War II. He suffered serious injuries as a result of shrapnel from a grenade and underwent thirty-two operations over two years before returning to work at *Life* magazine. Smith's wounds were not just physical, however. He returned home with the horrors he had witnessed on the battlefields of Okinawa and Iwo Jima in Japan in his mind, and he was unsure he could ever take another photograph. This shot helped to convince him that he could, and set him on the path to rehabilitation.

This photo was taken while he was out walking with his young son and daughter, and he described the moment thus: "While I followed my children into the undergrowth and the group of taller trees—how they were delighted at every little discovery!—and observed them, I suddenly realized that at this moment, in spite of everything, in spite of all the wars and all I had gone through that day, I wanted to sing a sonnet to life . . . I knew the photograph, though not perfect, and however unimportant to the world, had been held. . . . I was aware that mentally, spiritually, even physically, I had taken a first good stride away from those past two wasted and stifled years." Despite Smith's reservations, the image's depiction of innocence and hope struck a chord. In 1955, it appeared in the landmark exhibition *The Family of Man* at New York's Museum of Modern Art. **CK**

"What use is having great depth of field, if there is not an adequate depth of feeling?"

W. Eugene Smith

SINGER AT THE CAFÉ METROPOLE, NEW YORK CITY

LISETTE MODEL

Date 1946
Location New York, New York, USA
Format Unknown

Lisette Model (née Stern, later Seybert, 1901–83) told her students: "The thing that shocks me and which I really try to change is the lukewarmness, the indifference, the kind of taking pictures that really doesn't matter.... It is what they [the pictures] say that is important." And her students, such as Robert Frank and Diane Arbus, who would later become more famous than their teacher, closely followed her advice.

One of the outstanding portraitists of the mid-twentieth century, Model found her first inspirations growing up in Vienna, Austria, where she studied music for a time under revolutionary composer Arnold Schönberg. When she later took up photography, she found herself attracted to subjects who challenged the aesthetics of beauty—often they were grotesque, freakish, and on the margins of society.

Her sense for the unusual helped her to find work when she moved to New York City in 1937 after marrying Evsa Model. She began to freelance for several publications, including *Harper's Bazaar* and *Ladies' Home Journal*, while at the same she was an active member of the leftist group the New York Photo League.

The photograph reproduced here of a woman in a black sleeveless dress, holding a microphone and singing, was taken in the Café Metropole at 7th Avenue and 48th Street, New York. It is a stark portrait that encapsulates the subject's high energy and Model's penchant for capturing "exaggerated 'types'" that were "characterized by their high contrast, deep shadows, often drastic cropping, and unusual perspectives." SY

"Model's photographic contribution surely has to do with her role in introducing a European sense of humanist tolerance into the absurd polarities of postwar civilization." William Wilson

JEWISH REFUGEES AWAITING DEPORTATION FROM PALESTINE

CORNELIUS RYAN

Date 1946
Location Haifa, Israel
Format Unknown

This poignant photograph was taken by Irish photojournalist Cornelius Ryan (1920–74)—author of *The Longest Day* (1959)—who was then stationed in Jerusalem as bureau chief for British newspaper *The Daily Telegraph*. It shows two Polish Jewish refugees—a brother and sister, survivors of a German concentration camp—who had been denied permission to remain in Palestine in 1946. The refugee pair were shipped back to Cyprus by the British authorities. What became of them after this is not known, although in 1976, Ryan's widow, Kathryn, attempted to track down the children via the Jewish Agency. The sadness of the girl's expression reflects not only disappointed hopes but also an awareness of further struggles to come.

Scenes like this were replicated all over Europe at the end of World War II, as millions of "displaced persons" were living under guard behind barbed wire fences, often in squalid conditions. European Jews began to organize underground networks, seeking to move Jewish refugees to Palestine by ship from ports along the Mediterranean coast. The British government, then responsible for administrating Palestine, opposed this kind of mass immigration; they were concerned about the existing Arab population and turned back more than half of the 142 voyages made. As many as 50,000 Jews who failed to get into Palestine ended up once more in internment camps.

The power of this image is its ability to raise our curiosity about the unknown narrative. It persuades us to think beyond the photograph's content and wonder about the capacity of politics to sweep aside individual human beings. **CJ**

"I should like to discover that these children, who struggled so hard to find freedom and a new home, realized their goal. If they did not, the story is equally poignant." Kathryn Ryan

VOGUE FASHION SHOOT

FRANCES MCLAUGHLIN-GILL

Date 1946
Location Unknown
Format 35 mm

In 1943, at the age of twenty-four, Frances McLaughlin-Gill (1919–2014) was the first female fashion photographer to enter into a contract with *Vogue*. As a young photographer, she not only epitomized the magazine's young, female market, but also her work stood in sharp contrast to the formality of fashion photography at the time.

McLaughlin-Gill was raised in Connecticut alongside her identical twin, Kathryn Abbe, who also became a photographer. In 1941, following her graduation from the Pratt Institute, McLaughlin-Gill emerged as a finalist for *Vogue*'s Prix de Paris talent contest. Her relationship with the magazine was forged after her mentor, photographer Tony Frissel, introduced her to *Vogue* art director Alexander Liberman. Condé Nast archive director Shawn Waldron says Liberman was "immediately taken with Franny's youthful irreverence, directness, and spontaneity." She went on to produce some of the most powerful images to appear in the pages of American *Vogue* during the 1940s and 1950s. In 1948, McLaughlin-Gill married photographer Leslie Gill, but it was only after his sudden death ten years later that she adopted the hyphenated name by which she is now known.

In this image for *Vogue*, models Sally Parsons and Mrs George Carey Jr. are pictured in a stable wearing stylish evening dresses. Standing on either side of a horse, their elegance is at odds with the stable setting. Fashion shots of the day typically showed sitters looking directly at the camera, but McLaughlin-Gill achieved a more natural look by capturing the women off-guard with their eyes averted away from the lens. **EC**

"I preferred to cast models who could act, and my favorites all had the ability to improvise within a situation that I had created."

Frances McLaughlin-Gill

ELDERLY GERMAN CITIZENS REBUILDING DRESDEN

FRED RAMAGE

Date 1946
Location Dresden, Germany
Format 35 mm

Early in 1945, Allied forces launched concerted aerial attacks on Dresden. The first raid on the night of February 13 virtually flattened the city, but the British and US Air Forces were unrelenting—they returned the next night. Over the course of the action, almost 1,300 heavy bombers dropped a total of more than 3,900 tons (4,000 tonnes) of incendiary devices and explosives. The confirmed death toll was around 25,000, but in view of the fact that at the time the downtown area around the railroad station was full of refugees from the Soviet Red Army advancing from the east, the figure may have been much higher.

When British photographer Fred Ramage (1900–81) arrived in Dresden the following year, World War II was over, but the city was still largely as the US and British air forces had left it; volunteers were still clearing the damage. The bleakness of the scene is clearly visible; the residents appear to carry out their work in sad and stoical silence.

The two elderly volunteers are identified in the original caption as Gustav and Alma Piltz. A dark cloud seems to hover overhead, deepening the gloom. However, the picture also captures the spirit of the people as they rebuild their city. EC

THE FIRST PHOTOGRAPH FROM SPACE

CLYDE HOLLIDAY

Date 1946
Location Outer space
Format 35 mm

The launch of the Soviet Sputnik satellite in 1957 is often cited as the start of the space age, but human-made objects had been launched out of Earth's atmosphere at least a decade before this. The first was probably a German A-4 rocket, test-launched in 1944 when the V-2 rocket was being developed. After the war, captured V-2 rockets, and many of the scientists who had made them, were sent to the United States as part of a covert program to deny German technical expertise to the Soviet Union.

Tests of the V-2 continued at White Sands Missile Range in New Mexico. On October 24, 1946, a movie camera developed by engineer Clyde Holliday (1912–82) was mounted into a modified nose cone on one of the rockets. It was set to take a new frame every second and a half. Until this point the highest-taken photograph of the Earth had been from the Explorer II balloon, which was flown in 1935 to a height of 13 miles (21km). This modified V-2 rocket reached a height of around 65 miles (105km), producing in the process the first grainy black-and-white photographs that—as Holliday wrote in *National Geographic* in 1950—"show how our Earth would look to visitors from another planet coming in on a spaceship." LB

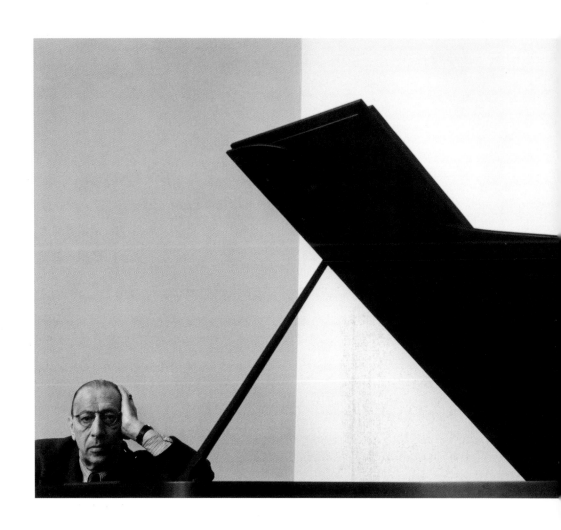

IGOR STRAVINSKY

ARNOLD NEWMAN

Date 1946
Location New York, New York, USA
Format Large format

Arnold Newman (1918–2006) got his big break in 1941, when Beaumont Newhall of the Museum of Modern Art and Alfred Stieglitz both spotted his work. Two exhibitions followed in New York, one at the A.D. Gallery, the other, "Artists Through the Camera," at the Brooklyn Museum.

Artists, literary figures, and musicians became Newman's forte, and his work was noted for bringing a new approach to portraiture. It is often referred to as "environmental portraiture," whereby the sitter's normal surroundings—whether home or work—help to define who they are. Newman disliked the term, thinking it diminished the important psychological dimension of his work.

This famous portrait of Stravinsky seated at his piano reveals another aspect of Newman's photography—its strong sense of design: what critic John Szarkowski called its "enforced deliberation, precise framing, exact description."

The original contact sheets for the shoot show Newman experimenting with the basic idea of composer-plus-piano. But the pictures he selected are by no means the most obvious, their success as images being largely based on the way they are cropped. Out go the piano's legs and most of Stravinsky; angles are adjusted so that the body of the piano forms a thin supporting line over which the lid towers; the background tonal shift from gray to white no longer looks like the corner of a room. For Newman it was "a symbolic portrait." He added: "I designed the whole picture around my concept of Stravinsky: the harshness, the beauty...all of which reflect and express the same strength and beauty of his music." JS

CURIOUS ONLOOKERS WATCH STARS DURING SENATE HEARING

UNKNOWN

Date 1947
Location Washington, D.C., USA
Format 35 mm

Here, Humphrey Bogart, Evelyn Keyes, and Lauren Bacall are captured during a visit to Washington to protest against the Communist witch-hunt in Hollywood. The trio are shown in conversation while a crowd of onlookers peer in through the window behind. Their starstruck expressions betray a mixture of emotions, which have been frozen by the light of the photographer's flash. The Hollywood blacklist, as it became known, was a campaign pitched against producers, screenwriters,

actors, and other industry professionals who were suspected to be Communists. The US Congress House Un-American Activities Committee (HUAC) was introduced in 1938 to eliminate Communist sympathizers. Senator Joe McCarthy launched an investigation into all those suspected, which resulted in many losing their jobs.

The first Hollywood blacklist came after ten writers and directors were cited for contempt of Congress for refusing to testify to HUAC. They became known as the Hollywood Ten, and Bogart, Keyes, and Bacall joined the Committee for the First Amendment in support of them. The protest was unsuccessful, however, and their actions led to the media labeling them closet Communists. EC

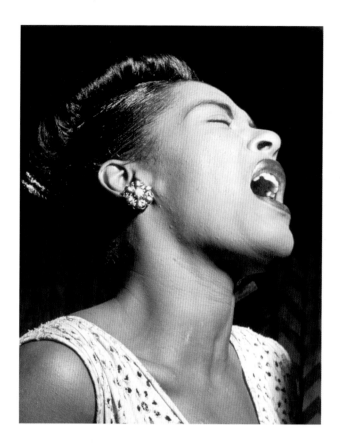

BILLIE HOLIDAY, DOWNBEAT CLUB, NEW YORK, NY

WILLIAM P. GOTTLIEB

Date 1947

Location New York City, New York, USA

Format 35 mm

Although originally a writer, William P. Gottlieb (1917–2006) created one of the most important visual records of the golden age of jazz, what he termed "those jumping years from the late 1930s through the 1940s." Gottlieb took up photography while writing at *The Washington Post*, where house photographers taught him to take the pictures he needed to accompany his music stories.

Gottlieb came to jazz as a fan, and his affection and admiration for the artists he photographed is evident in his work. This photograph of Billie Holiday was taken near the end of the peak period of her career: she seems to glow with an intensity that could be borne as much from pain as from joy. The qualities Gottlieb ascribed to her voice, "haunting, anguished," are visible here: our eyes alight on her neck, before moving up to her mouth, as if mirroring the journey of her voice, taking in her closed eyes as we do so. The image is more poignant in the light of the knowledge that, soon after, Holiday would lose her license to perform after being busted on drug charges, and rumors of her unreliability and declining vocal power would overtake her reputation as one of jazz's most masterful voices. RF

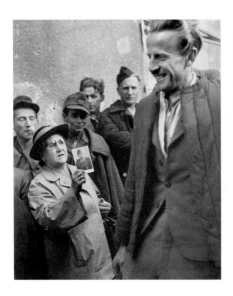

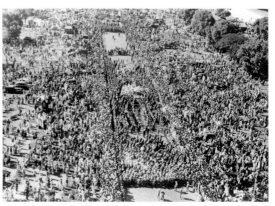

FUNERAL PROCESSION: MAHATMA GANDHI

UNKNOWN

Date 1948
Location New Delhi, India
Format 35 mm

Mahatma Gandhi led campaigns of nonviolent civil disobedience and political negotiations that sought, and in 1947 achieved, Indian independence from Britain. After independence, Gandhi was assassinated by a Hindu nationalist who saw a nonviolent and dialogic approach to politics during a period of widespread violence as appeasement of the political demands of Muslims.

Here, we see Gandhi's funeral parade, in which a crowd of one million lined a 5-mile (8km) route along the bank of the Yamuna River. The army truck bearing Gandhi's body took five hours to make the journey because of incursions by the throngs of people who struggled for a close-up view. Air force planes dropped petals, and after Gandhi's body was cremated, his ashes were left on the riverbank for three days to allow public grieving.

Gandhi said that he would welcome death by assassination if it played a role in creating harmony between Hindus, Muslims, and Sikhs. His teachings have inspired many other leaders, including Martin Luther King Jr. and Nelson Mandela. MT

RETURNING PRISONERS OF WAR

ERNST HAAS

Date 1947
Location Vienna, Austria
Format 35mm

This image cuts through all the rhetoric about the human cost of war. It was taken at Vienna's Southern Railway Station, where Ernst Haas (1921–86) witnessed the emotional scenes as the first 600 Austrian prisoners of war returned from Eastern Europe after World War II. An elderly woman, perhaps a mother, searches for a lost relative, perhaps a son, among the survivors. Her expression combines anticipation, grief, and anxiety. Haas concentrates on the relationship between the woman and the smiling man, who does not even notice her questioning gaze. The image conveys both hope and confidence in the future and the sense of dislocation and loss that so many families experienced during and after the war. Haas himself preferred to align his photos with music rather than politics: "They communicate themselves immediately, without any interpretation." CJ

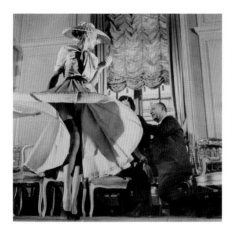

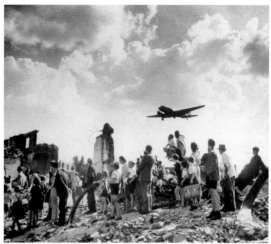

CHRISTIAN DIOR WITH WOMAN MODELING DRESS AND STOCKINGS

UNKNOWN

Date 1948
Location Paris, France
Format Medium format

For many people living in the countries that participated in World War II, life in the immediate aftermath was gray, drab, and depressing. Rationing continued and there seemed little to celebrate.

However, the twin industries of movie making and fashion led the way in restoring people's enjoyment of life and sense of fun. In the vanguard was French designer Christian Dior and what was dubbed by the American fashion press as his "New Look." Revealed in February 1947, his dresses had sloped shoulders, nipped waists, and full skirts using yards of fabric—a direct riposte to the austere style of dress of wartime France.

In 1948, stockings were highlighted for the first time. The hose, which either continued the color scheme of the dress from hem to ankles or afforded a direct contrast, ranged in shades from tender peach to ink black. Here, Dior looks on as a model swirls the skirt of a light blue crepe dress to reveal her sheer navy blue stockings. RF

BERLIN BLOCKADE AND AIRLIFT

WALTER SANDERS

Date 1948
Location Berlin, Germany
Format Unknown

Flying low overhead, the airplane pictured would have brought relief to the besieged Berliners below. The year is 1948, and postwar Berlin had been divided into zones, with the West controlled by British, US, and French forces, and the East under Soviet control. Relations between the occupying countries became strained as disagreements about Germany's future intensified. On June 24, the Soviets blocked roads and railroad lines leading into West Berlin in a standoff that would last almost a year. The United States and Britain responded by airlifting supplies to the Berliners who were cut off. Walter Sanders, who had been born in Germany but left for the United States when Hitler came to power in 1933, was at the time a photographer for *Life* magazine. He captured the impressive sight of a C-47 flying over residents standing amid rubble in Berlin, their heads tilted upward. The image remains a definitive photograph of the blockade. GP

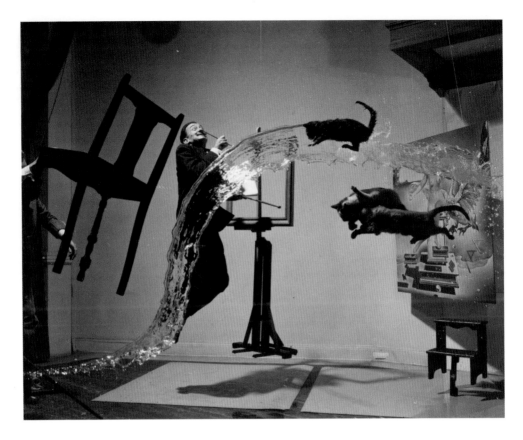

DALÍ ATOMICUS

PHILIPPE HALSMAN

Date 1948
Location New York, New York, USA
Format Unknown

After emigrating to the United States from his native Russia, Philippe Halsman (1906–79) photographed some of the most celebrated artists, movie stars, and politicians of the mid-twentieth century. His tightly cropped, sharply focused portraits were full of warmth and humor. He often asked his subjects to jump, explaining, "When you ask a person to jump, his attention is mostly directed toward the act of jumping and the mask falls so that the real person appears."

This photograph is inspired by Salvador Dalí's painting *Leda Atomica* (1949), which appears in the right of the frame. "Trying to create an image that does not exist, except in one's imagination, is often an elating game. I particularly enjoy this game when I play it with Salvador Dalí. We were like two accomplices," said Halsman. To take the shot in his studio, he suspended an easel, two paintings, and a stepladder from wires. His wife held up a chair to the left of the camera, he got one assistant to toss a pail of water, and two others to throw cats borrowed from a butcher and a neighbor. It took twenty-eight attempts to get the final photograph. When the image was published, Halsman received many vociferous complaints from cat lovers. **CJ**

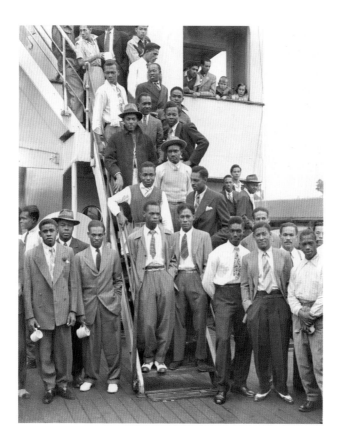

JAMAICANS DISEMBARKING *EMPIRE WINDRUSH*

UNKNOWN

Date 1948
Location Tilbury, UK
Format 35 mm

On June 22, 1948, the SS *Empire Windrush* sailed into Tilbury, on the estuary of the Thames River to the east of London, carrying 490 men and 2 women from Jamaica. At this time, only three years after the end of World War II, which had depleted the male working-age population of Britain, an immigration policy was in place allowing free passage for any colonial subject from one part of the British empire to another. It was a watershed moment that marked the beginning of modern, multicultural Britain.

This photograph from that day in 1948 shows a group of passengers as they disembark the ship. They appear smartly dressed and sophisticated, and while there is an understandable air of apprehension about what might await them (the stiffly posed young man in the oversize suit, in the far left foreground, exemplifies this in an especially poignant way), the facial expressions and body language in general convey self-assurance and a readiness to participate in a new life. Consider the gaze of the man standing halfway up the stairs, in the hat and dark coat, with upturned collar. He looks squarely into the camera lens, and by extension, squarely at the viewer, asserting his presence with confidence. **JG**

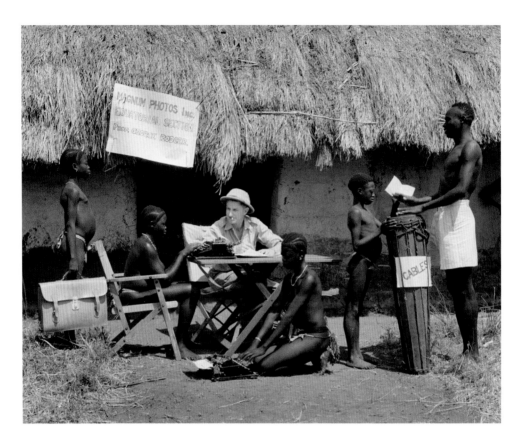

CHRISTMAS CARD FROM MAGNUM'S EQUATORIAL OFFICE

GEORGE RODGER

Date 1948
Location Sudan
Format 35 mm

George Rodger (1908–95) was one of the founding members of Magnum Photos. Acclaimed for his photographs of the London Blitz (1940–41), and for documenting the horrors of the Bergen-Belsen concentration camp, he was traumatized by his experience of "looking for nice compositions" of the dead. After World War II, he sought out a project that would help him to recover from the experience, and embarked on a fifteen-month journey through the Middle East and Africa.

To modern sensibilities this image from a colonial past might appear problematic; it is, in fact, a playful image of self-deprecating humor. A staged self-portrait of Rodger at a fictional equatorial office of Magnum, it may be best described as an elaborate in-joke. While enduring the privations of the road, Rodger sent it as a Christmas card to the New York and Paris offices of Magnum and it can be seen as a gentle dig at his colleagues in more comfortable surroundings. With Rodger's white skin, cigarette, and safari clothing contrasting with the native Sudanese, the tone is ironic; he portrays himself as a news hack abroad, fully aware that he is reliant on these people in order to survive in a remote and often dangerous location. NG

LIGHTS OVER LA

CONSTANTIN JOFFÉ

Date 1949
Location Los Angeles, California, USA
Format 35 mm

This photograph was taken by Constantin Joffé (1910–92), whose *Vogue* fashion portraits were noted for their inventive use of color, perspective, and light. Born in Russia, Joffe moved to France in his early years. In World War II he signed up to the Volunteer French Foreign Legion; he was eventually captured and held in a concentration camp.

In this image of 1949, a stylishly dressed couple to the far right of the frame are overlooking the city of Los Angeles, which appears to stretch interminably into a sheath of mist on the horizon. Lights dot the hills below, whose shapes contrast with the bright illumination of the city. A faint arc of light hovers over the scene, and the sky above is starless, the city appearing to have drained it of starlight. From their elevated vantage point, the couple stand close together and seem wrapped in a moment of solitude and peace as they look out in wonder, far removed from the hustle of the city below. Their silhouettes stand like statues in the encompassing darkness and the rock on which they stand appears bathed in moonlight. The photographer's use of the vertical emphasizes the height of the mountains, and it is almost as if the couple are suspended in space. EC

ELEANOR, CHICAGO

HARRY CALLAHAN

Date 1949
Location Chicago, Illinois, USA
Format Large format

American Harry Callahan (1912–99) is best known as a street photographer, but he grouped his work according to three themes that he described in 1975 as "Nature, Buildings, and People." What links all three are the photographs of his wife and muse, Eleanor Knapp. Callahan met her in 1933 and photographed her repeatedly for more than fifty years of their sixty-three-year marriage. She became his most photographed subject, appearing nude and clothed in snowy landscapes, on beaches, at home, in cityscapes, and in interior spaces.

Here, Eleanor emerges from the waters of Lake Michigan in Chicago. With her eyes shut and her long, wavy hair trailing into the water, she evokes the idealized women of Pre-Raphaelite paintings and goddesses of myth, along with art's most famous image of a watery naked female beauty, Sandro Botticelli's painting *The Birth of Venus* (1482–85). Eleanor's milky-white skin suggests the cool marble of classical sculpture as Callahan uses his skill to create visual poetry.

Callahan's returns to the same subject indicate the special bond between photographer and subject, as well as suggesting the course of their marital relationship. He photographs a woman as she ages, so that the viewer can observe how the curves of her torso, the fine lines of her skin, and the folds of her flesh change over time. Yet Callahan's interest in photographing his wife nude was not simply a romantic gesture—it was also the result of his interest in figure studies and technical experimentation. He often photographed his daughter, Barbara, too. His pictures of Eleanor are an anthology of romantic odes. CK

"If you choose your subject selectively—intensively—the camera can write poetry."

Harry Callahan

THE WRESTLERS

GEORGE RODGER

Date 1949
Location Kordofan, Sudan
Format 35 mm

George Rodger (1908–95) reported in all the major war zones during World War II for *Life* magazine. He covered more than eighteen war campaigns, but most famously, he was one of the first people to enter the Bergen-Belsen concentration camp in 1945. He found the experience so harrowing that he gave up war photography. He left *Life*, and in 1947 cofounded the Magnum Photos agency with Robert Capa, Henri Cartier-Bresson, and David "CHIM" Seymour. The agency was a cooperative that allowed photographers to gain independence from magazines and pursue their own projects.

In an effort to escape Europe and the horrors of the war and its aftermath, Rodger traveled throughout the Middle East, India, and Africa, taking pictures of people and wildlife for Magnum. From 1948 to 1949, he and his wife, Jinx, undertook a 28,000-mile (45,000km) cross-Africa expedition by road, from Cape Town to Cairo, in order "to get away where the world was clean." It was during this trip that he shot *The Wrestlers* in Kordofan, in southern Sudan. The photograph shows the ash-covered victor of a Nuba wrestling match being carried on the shoulders of his opponent. The expressions of the two muscular men reveal their status: one looks proud and triumphant as he gazes at the camera, while the other's furrowed brow reveals his reluctance to have his defeat forever recorded. *National Geographic* published the photograph in 1952.

The image inspired German photographer and filmmaker Leni Riefenstahl to go to Sudan in the early 1960s and the 1970s to photograph the indigenous Nuba tribes for her color portraits. CK

"You must feel an affinity for what you are photographing. You must be part of it, and yet remain sufficiently detached to see it objectively."

George Rodger

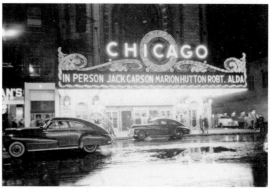

FIRST AERIAL PHOTOGRAPH OF LOS ALAMOS

UNKNOWN

Date 1949
Location Los Alamos, New Mexico, USA
Format Unknown

Trees dot the landscape like daubs of paint, and if it were not for the glimpse of the aircraft from which the photograph was taken, the scene could pass for a painting. But this is a photograph, and it shows the "atomic city" of Los Alamos in New Mexico where atomic bombs were developed as part of the Manhattan Project in World War II. The remoteness of Los Alamos appealed to the US Government, and its identity was kept a closely guarded secret. Scientists, engineers, and their families lived there and were sworn to absolute secrecy.

After bombs were dropped on Hiroshima and Nagasaki in Japan in 1945, the truth about Los Alamos—that it was the site of a classified research laboratory, responsible for developing atomic weapons—emerged. So too did photographs of the city, including this one apparently taken for *The Denver Post* by the Los Alamos Scientific Laboratory, as it was then called. Old housing developments are seen alongside new ones and the newly completed civic center. It is difficult to make out the details, but what is easily apparent is the sheer scale of the site. Los Alamos has since become an extremely wealthy city. **GP**

PEOPLE ARRIVING AT A CHICAGO THEATER

STANLEY KUBRICK

Date 1949
Location Chicago, Illinois, USA
Format 35 mm

Before Stanley Kubrick (1928–99) found fame as a movie director, he was a press photographer in his native New York. In 1945, he sold a photograph marking the recent death of US President Franklin D. Roosevelt to *Look* magazine, which hired him in the following year. While some of his colleagues recalled him as introverted and awkward—unusual characteristics for a press photographer—he showed a strong photographic eye and a knack for constructing engaging, atmospheric stories.

In 1949, *Look* sent Kubrick to shoot a series on Chicago titled *Chicago City of Contrasts*. In a short period of time he photographed a wide cross-section of the city's populace, from steelworkers to wrestlers, from stockbrokers to the poor of its rundown South Side. Many of his images were taken at night and made creative use of shadows and silhouettes in a style reminiscent of Hollywood film noir. Kubrick's attention to narrative, light, and composition served him well in his movie career, and he returned to the subject of one of his earlier photo-essays in his directorial debut, the boxing documentary *Day of the Fight* (1951). **LB**

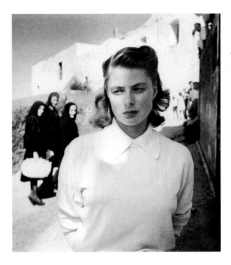

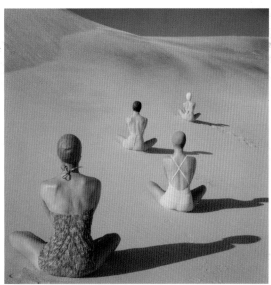

INGRID BERGMAN, *STROMBOLI*

GORDON PARKS

Date 1949
Location Stromboli, Italy
Format 35 mm

A couple of years before this image was taken, Ingrid Bergman had written to Roberto Rossellini, expressing a deep admiration for his Neorealist films, which led Rossellini to cast her in *Stromboli* (1950). While working on the film in Italy, director and star began an affair; Bergman left her husband and child, thus causing a scandal. Gordon Parks (1912–2006) was sent by *Life* magazine to cover the story. Rossellini was reluctant to engage with the press, but Bergman was aware of Parks's reputation as a photographer who could be trusted. After Parks refrained from taking a photograph of the couple in an embrace off set, Bergman gave him unguarded access. This haunting image was taken while out on a walk. Parks recalled how the three women, "clad in black, and resembling ominous birds ... stared at her with curiosity. Aware of their presence, Ingrid waited for them to leave. I allowed my camera to record this sardonic moment." EC

SWIMSUITS IN THE SAND

CLIFFORD COFFIN

Date 1949
Location Los Angeles, California, USA
Format Medium format

This painterly image was shot by Clifford Coffin (1913–72) for the June 1949 issue of American *Vogue*. Tending toward the surreal, it presents repetition of form through angular bodies and colored swimming caps, in a trail toward the horizon.

Coffin was an immensely prolific postwar fashion photographer, and this striking composition is typical of his work. He was known to be a perfectionist, directing every detail of the work, including models' makeup and clothes, as well as the location. His fastidious attention to detail meant very little was left to chance. Coffin pioneered the use of ring-flash lighting: wrapping a circular bulb around the camera lens allowed light to flow from all directions, thus minimizing the distortion of shadow. This worked well for fashion, highlighting shiny fabrics and makeup while detracting from creases and blemishes. ML

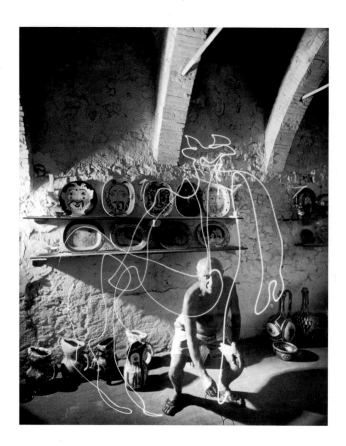

PICASSO

GJON MILI

Date 1949
Location Vallauris, France
Format Unknown

This photograph is part of a series taken by Albanian-American photographer Gjon Mili (1904–84) for *Life* magazine at Pablo Picasso's studio in the south of France. Known as "light drawings," they have an interesting background story. Before they began the session, Mili, an artist in his own right, showed Picasso images of Carol Lynne, an ice-skater who had attached lights to the tips of her boots and then been photographed dancing on ice in the dark, with the lights creating a sinuous pattern

that followed her moves. Picasso was enraptured by what he saw, and permitted Mili to attempt to do the same, but with the act of drawing.

To achieve the effect, Mili used stroboscopic instruments that capture a series of actions in a single image. Picasso used a penlight to draw his well-known centaurs and other images. Mili left the shutters in the studio slightly open, to let in some natural light, and then used a photoflash technique, in which Picasso appears to be frozen behind a drawing that looks to have been made on a glass plate but that is, in reality, merely the captured light. Working in the air, Picasso sketched, not knowing what he had done until Mili developed the powerful and haunting images. **SY**

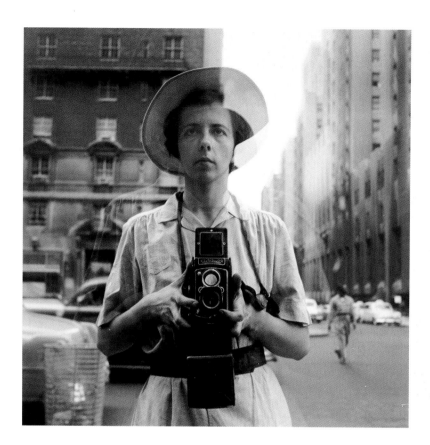

SELF-PORTRAIT

VIVIAN MAIER

Date c. 1950
Location New York, New York, USA
Format 35 mm

"A riddle, wrapped in a mystery, inside an enigma." Although Winston Churchill said this in another context, it is a fitting assessment of the secrecy surrounding the biography of Vivian Maier (1926–2009). Celebrated in a global traveling exhibition and a 2013 film about her life, Maier's work, like that of many great artists, was only fully appreciated posthumously.

She might never have been discovered at all had it not been for historian John Maloof, who in 2007, while working on a preservation project about Chicago, bought an unopened box of negatives for a few hundred dollars, hoping that it might contain some material for his research. When he opened it, he discovered thousands of negatives of Maier's work. He then learned that not even her closest friends had any idea about this aspect of her life—she had strenuously hidden her extraordinary talent.

In this self-portrait, Maier is holding her beloved Rolleiflex camera as she stares glumly at her own reflection. Much of her work is this kind of stark portraiture, and most of her subjects were poor urban dwellers, showing a different side of life in the mid-twentieth-century United States. **SY**

DRUM MAJOR AND BOYS

ALFRED EISENSTAEDT

Date 1950
Location Ann Arbor, Michigan, USA
Format 35 mm

Early one morning in the fall of 1950, German American photographer Alfred Eisenstaedt (1898–1995) was on assignment for *Life* magazine, covering the University of Michigan's nationally famous marching band, when he spotted the school drum major rehearsing on one of the college lawns. The image he took, one he claimed was completely spontaneous and unstaged, shows the drum major—a man named Dick Smith—exuberantly marching across the grass like a Dr. Seuss character, head thrown back and right leg thrust impossibly high, while seven children follow joyously in tow, their heads tilted toward the sun.

Eisenstaedt was out wandering around the campus when he came across the drum major marching alone. Some kids were playing at a distance but when they noticed the drum major, they instantly ran out and began to mimic him. The editor David Friend called this photo Eisenstaedt's "ode to joy"—a picture that encapsulates the buoyancy and carefree nature of youth. Other critics have likened it to the Pied Piper of Hamelin without the sense of menace—there is nothing here but happiness and exultation in existence.

Regarded as one of the twentieth century's finest and most prolific photographers, Eisenstaedt was known for capturing the essence of a story in a single image. He fled Nazi Germany in the 1930s, emigrated to the United States, and worked there for *Life*, producing more than 2,500 photo-stories and 90 covers for the magazine. He remained a regular contributor from *Life*'s debut in 1936 until it eventually ceased publication as a weekly in 1972. EC

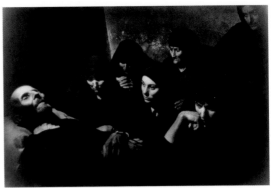

THE WAKE, SPANISH VILLAGE

FRIDA KAHLO

W. EUGENE SMITH

GISÈLE FREUND

Date 1950
Location Deleitosa, Spain
Format 35 mm

Date 1950
Location Mexico City, Mexico
Format 35 mm

This image of Mexican painter Frida Kahlo was created two years before her death in 1952. Kahlo was aged only eighteen years when, in 1925, she was in a bus that was hit by a trolley car; an iron handrail pierced her abdomen so deeply that she never completely recovered.

Photographer Gisèle Freund (1912–94) was a Jew and a socialist who fled Hitler's Germany in 1933 for Paris, France. There, she documented portraits of her friends, who included Henri Matisse, Jean Cocteau, and Simone de Beauvoir. In 1948, Freund was hired by Magnum Photos to be their Latin American contributor, and in 1950 she traveled to Mexico, where she became friends with Kahlo and muralist Diego Rivera.

Freund's intimate relationship with Kahlo is evident in this photograph, which was taken in the Casa Azul (Blue House) in Coyoacán, Mexico City. Kahlo had recently had several operations and was confined to a wheelchair and her bed. Freund's tender photograph reveals the grace and beauty of Kahlo's world, rather than its pain. SY

After recovering from wounds sustained in World War II, American photographer William Eugene Smith (1918–78) went to Spain, where he documented daily life in the village of Deleitosa in Extramadura, halfway between Madrid and the Portuguese border. His work was published in *Life* magazine in April 1951. Alongside images of the harsh landscape, Smith captures all the rhythms of rural daily life and the importance of the Catholic Church to the villagers, with pictures of a baptism, first communion, and the wake shown here.

The deep shadows, strong highlights, and kneeling women in this image recall the religious paintings and chiaroscuro of painter Francisco de Zurbarán (1598–1664), sometimes known as "the Spanish Caravaggio." It could almost be a canvas from the Spanish golden age, as Smith echoes great artworks and elevates the status of the humble mourners.

Smith also depicts poverty and a village that appeared medieval at a time when Francisco Franco's Fascist dictatorship was widely deplored. Smith's images of Deleitosa have come to symbolize the shortcomings of the regime. CK

SUSPECTED COMMUNISTS UNDER ARREST IN SOUTH KOREA

BERT HARDY

Date 1950
Location Pusan, South Korea
Format 35 mm

Outside Pusan railroad station during the Korean War (1950–53), reporter James Cameron and photographer Bert Hardy (1913–95) found sixty men, aged between fourteen and seventy years, suspected of opposing South Korean dictator Syngman Rhee and supporting Communist North Korea. The prisoners were tied up and had no idea what would happen to them; their guards were beating them randomly with rifle butts.

Prisoners on both sides were treated brutally, but little evidence of South Korean atrocities appeared in the Western press. Cameron and Hardy produced a hard-hitting story for *Picture Post* that called on the United Nations to intervene to prevent the maltreatment of Communist suspects. The proprietor of the British magazine, Edward Hulton, pulled the report, believing it would undermine the war effort. Editor Tom Hopkinson resigned in protest; the story was never published. **CJ**

KOREAN SOLDIERS CAPTURE SNIPER

STANLEY TRETICK

Date 1950
Location Korea
Format 35 mm

There are few images that better exemplify the unique role of photography in allowing the viewer to feel part of the scene. No other medium can be simultaneously a documentary record and a rallying cry, both objective and subjective. Here, a captured North Korean sniper looks not to his captors for salvation or leniency, but to the documenter of his plight, photojournalist Stanley Tretick (1921–99). Tretick trained as a photographer in the US Marine Corps and served in the Pacific during World War II. He later covered the Korean War (1950–53) for Acme and United Press International. His war experience allowed him to forge a bond with fellow veteran John F. Kennedy. Tretick's intimate photo-essay of Kennedy with his children was published in the days after the president's assassination in 1963. **MT**

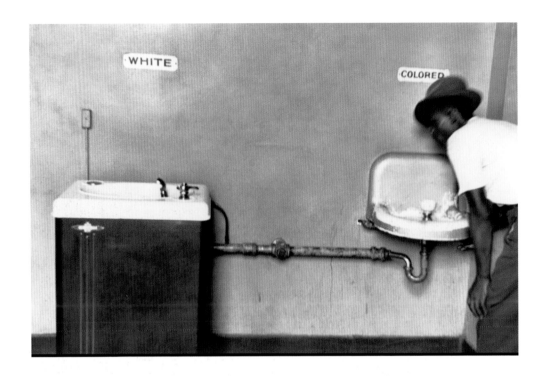

NORTH CAROLINA, USA

ELLIOTT ERWITT

Date 1950
Location North Carolina, USA
Format 35 mm

Two separate taps; one for whites and one for blacks. "The same pipe, the same water, but one is cooled and the other not. One tap is modern, the other old and worn out," said Elliott Erwitt (born 1928) of the shot. The image is a striking visual representation of the injustice of racial segregation. While the photograph highlights the juxtaposition between the two water fountains, our attention is also drawn to the man's face; we are challenged to guess at what he might be thinking.

Taken by a then twenty-two-year-old Erwitt, the image also depicts a world on the brink of social change. Following the Civil War, everywhere from cinemas, elevators, hotels, and prisons had separate areas for whites and blacks. Yet resistance was growing, embodied by the Civil Rights Movement, which, between 1954 and 1968, fought to abolish the segregation of African Americans and other ethnic minorities. The Civil Rights Act of 1964 ended segregation in public places and marked a significant step forward in the struggle for equal rights. Erwitt's image played a part in that success, and is a demonstration of the power of photography to bring about change by opening people's eyes to what is right in front of them. EC

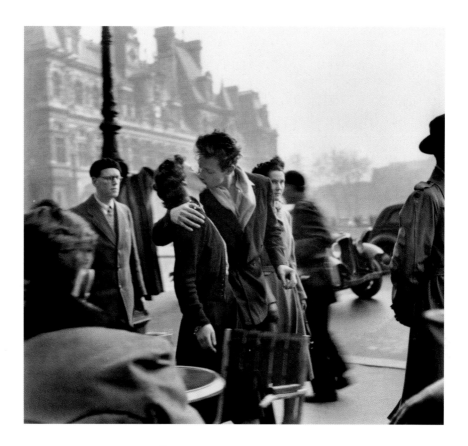

THE KISS AT THE HÔTEL DE VILLE

ROBERT DOISNEAU

Date c. 1950
Location Paris, France
Format 35 mm

The Kiss at the Hôtel de Ville depicts a young couple in a passionate embrace outside the city hall in Paris. It is one of a series of photographs that Robert Doisneau (1912–94) produced on the theme of lovers in the French capital in the springtime and which appeared in *Life* magazine in June 1950.

Although the monochromic photograph, with its slightly blurry background, appears as if reportage, the iconic image was staged; Doisneau paid two actors to pose for him. While the picture

fulfills the brief inasmuch as it evokes a Paris steeped in romance, Doisneau uses the symbols and codes of street photography to conjure up a fantasy in what is a highly effective piece of tourist public-relations material.

On closer inspection, some signs of subterfuge become apparent. On what looks like a cold day, where passersby are wearing hats, the lovers at the center of the image are conveniently bareheaded, so their kiss is obvious to all. Even more suspiciously, the viewpoint is from a seat in a café, with an unobstructed line of sight, and it was unlikely a couple would stop to kiss right in front of the photographer. The picture has become a lesson in the nature of photographic artifice. CK

THE PHOTOJOURNALIST

ANDREAS FEININGER

Date 1951
Location New York, New York, USA
Format Large format

Andreas Feininger (1906–99) was born in Paris, the son of the painter Lyonel Feininger. He grew up in Germany, and in the 1920s attended the Bauhaus school of art and design, where Lyonel taught alongside architect and furniture designer Marcel Breuer and artist Josef Albers. Andreas studied cabinetmaking and architecture but developed an interest in photography. After he graduated with a degree in architecture, he left Germany for Sweden in 1933 and then emigrated to the United States, where he worked as a freelance photographer in New York.

In 1951, *Life* held a competition for young photographers. Feininger, now a staffer on the magazine, was commissioned to photograph the winner, Dennis Stock. The result was this image, which shows Stock holding a Leica SM camera vertically to his face, his eyes suggested by the shape of the TEWE viewfinder and lens. Although this is a portrait, Stock's face is barely visible. He has become a symbol—part man, part camera—and an example of the new breed of photojournalists who were the lifeblood of popular picture magazines like *Life* and *Look*, capturing images of celebrities and news events. Feininger's use of geometric shapes, strong light, and shadow reflects the clean, modernist lines of the Bauhaus.

Stock proved a worthy victor. He became a successful documentary photographer and went on to join the highly respected Magnum Photos agency. Feininger's photograph became so strongly identified with the concept of a photojournalist that *Life* used it for the cover of the book *Life Photographers: What They Saw* (1999). **CK**

"I look at objects of nature primarily with the eye of the structural engineer who is fascinated by the inter-relationship of function and form." Andreas Feininger

ALBERT EINSTEIN

ARTHUR SASSE

Date 1951
Location Princeton, New Jersey, USA
Format 35 mm

This comical image of the great Albert Einstein shows the lighter side of the genius. Einstein was returning home from a party to celebrate his seventy-second birthday at Princeton University, where he had spent most of his scientific career after fleeing Hitler's Germany for the United States in the 1930s. He was leaving the venue together with Dr. Frank Aydelotte, the former head of the Institute for Advanced Study, when they were besieged by photographers. As they prepared to drive away, Arthur Sasse (1908–73), working for United Press International, called out to Einstein, "Ya, Professor, smile for your birthday picture, ya?" to which Einstein promptly pushed out his tongue, possibly little suspecting that the photographer would be fast enough to capture the moment. Sasse had quick reflexes, however, and got the shot.

Publication of this image was not a foregone conclusion: editors worried that printing such an image might seem disrespectful to the great scientist. They could not have been more wrong: when eventually it did appear, it became the most popular image of the originator of the theory of special relativity and was an important early step toward popularizing science and making it accessible to lay audiences.

Einstein himself loved the image and ordered nine prints of a cropped version that showed only his face, one of which he signed for a reporter who had been at the scene. The original print sold at auction on June 19, 2009, for $74,324 (£59,843), a record for an Einstein picture. The photograph quickly became a universal symbol of the character of the original "nutty professor." **PL**

"This gesture you will like, because it is aimed at all of humanity. A civilian can afford to do what no diplomat would dare." Albert Einstein

AMERICAN GIRL IN ITALY

RUTH ORKIN

Date 1951
Location Florence, Italy
Format 35 mm

Freelance photographer Ruth Orkin (1921–85) was in Florence between assignments when she met fellow American woman Jinx Allen. Together they dreamed up a scheme for a photoshoot.

This image, one of the resulting photos, shows an all-too-common experience for a young woman traveling alone. Jinx, with her shawl held tight across her chest and a look of distress mingled with resolution, runs the gauntlet of leering, catcalling men. One of them rubs his groin as she passes.

Except that's not how the two women viewed it. Orkin had seen the reaction as Jinx walked down the street and asked her to do it again so that she could shoot it from a better angle. The other pictures are even more set up, with Jinx cheesily acting the role of tourist having a good time. She even rides down the street with the scooter driver. As Jinx (real name Ninalee Craig) later said of the picture: "It's not a symbol of harassment. It's a symbol of a woman having an absolutely wonderful time! I was admired, but personally I don't see anything wrong with an appreciative whistle." The photos appeared in *Cosmopolitan* magazine the following September, as part of a feature titled "Don't Be Afraid to Travel Alone." JS

CHELSEA PARTY

BERT HARDY

Date 1952
Location London, UK
Format Unknown

Bert Hardy (1913–95) did most of his best work for *Picture Post*, a highly successful photo-led weekly news magazine founded in the United Kingdom in 1938. Assignments were extremely diverse, covering topics from the London Blitz during World War II and the Korean War (1950–53) to fashion on the French Riviera.

Hardy is probably best known for his photo-essays about working-class life—in Liverpool, the then-impoverished Gorbals area of Glasgow, and the Elephant and Castle district of London. All these stories celebrate the ways in which the human spirit survives in the face of poverty and conflict, and reflect the prevailing liberal ethos of the publication that commissioned them. In 1955, no fewer than three of Hardy's pictures were included in Edward Steichen's celebrated *The Family of Man* exhibition in New York.

The image reproduced here is typical of Hardy's raw but tender style. Inexplicably, the central couple are dancing in a state of semi-undress, and the man's beer bottle suggests that both might be the worse for drink. No one else is paying any attention to them, but their snatched moment of happiness together is unmistakable. ER

MONROE, GAYNOR, CURTIS, & DEREK AT THE FPAH AWARDS

LOOMIS DEAN

Date 1952
Location Santa Monica, California, USA
Format 35 mm

Loomis Dean (1917–2005) landed his first photography job in 1938 with Ringling Bros. and Barnum & Bailey Circus, where he acted as both advance man and photographer. In 1947, he joined *Life* magazine and went on to photograph countless celebrity figures, including Ernest Hemingway, Elvis Presley, and Noel Coward.

In this spontaneous image, Dean caught actors Marilyn Monroe, Mitzi Gaynor, Tony Curtis, and John Derek as they waited for a photo shoot to begin at the Foreign Press Association of Hollywood's First Annual International Film Festival in January, 1952. Marilyn Monroe, perhaps the most renowned sex symbol of the 1950s, had just signed a contract with Fox.

Dean had a low-key manner that put his subjects at ease. While redolent of the sleek glamor of the movie world, his photograph presents the actors in an unusually candid light. While they are displaying the seemingly effortless elegance that has earned them their reputations as screen idols, they do not seem to be communicating or enjoying the moment. This is an image of movie stars enduring the tedium of waiting, and of lives fixated under the spotlight. EC

SPANISH RIDING SCHOOL

HANS HAMMARSKIÖLD

Date 1952
Location Sweden
Format 35 mm

The work of Sweden's Hans Hammarskiöld (1925–2012) encompassed still life, fashion, urban street scenes, nature, and portraiture, including atmospheric depictions of famous artists and dancers, and his own family. In the early 1950s, he traveled to the United States, where he met photographer Edward Steichen, who later supported his work.

Hammarskiöld, who in the mid-1950s worked for British *Vogue*, also made evocative portraits of Swedish royals, including Crown Princess Victoria and Prince Vilhelm. In 1952, he photographed inside the Hovstallet (Royal Mews) in Stockholm, where the royal horses are trained and kept. He created this image of a Lipizzaner stallion performing a capriole, in which the horse leaps into the air with front legs toward its chest and hind legs kicking out behind. Lipizzaners are associated with the Spanish Riding School in Vienna, an institution that teaches haute école (classical dressage). The "Spanish" reference comes from the breed of horse, which originated in the Iberian peninsula in the sixteenth century.

In a photo that shows immense technical skill, Hammarskiöld captures the horse at the precise moment its four legs are in the air, framing the creature against the arches in the background. **GP**

HARROW AND WEALDSTONE
TRAIN CRASH

GEORGE PHILIPS

Date 1952
Location London, UK
Format Unknown

An unnamed priest stands traumatized amid the wreckage after a three-train collision at Harrow and Wealdstone station on the outskirts of London during the morning rush hour on October 8, 1952. The death toll reached 112, and 340 other people were injured, 88 of them seriously. An overnight express train from Perth, Scotland, crashed at high speed into the rear of a local passenger train sitting in the station. The wreckage blocked adjacent lines, and within seconds it was struck by a double-headed express train traveling north at 60mph (97km/h).

A combination of poor weather (patchy fog that reduced visibility), misread signals, and inadequate equipment led to a disaster that remains the worst peacetime rail crash in the United Kingdom. The casualty figures would have been higher still had it not been for the swift intervention of passing troops of the United States Air Force, who rushed to the scene to help.

A subsequent British government report on the causes of the accident found that the driver of the Perth train had missed one caution signal and two danger signals before colliding with the local train. The accident accelerated the introduction of the Automatic Warning System that alerted drivers visually and audibly if they had overlooked an adverse signal.

Many press photographers recorded the scene, but George Philips was the only one who skillfully accentuated the chaos of the crash by cropping tightly into the wreckage, and conveyed a sense of scale by focusing on the priest, who seems dwarfed by the twisted metal. CJ

"The Americans did magnificent work, and their organization was first class."

Dr. R. Tudor Edwards, eyewitness

FRANCIS BACON

JOHN DEAKIN

Date 1952
Location London, UK
Format Medium format

John Deakin (1912–72) began his career as a painter, but often also experimented with photography. During World War II he served in the British Army Film Unit as a photographer, documenting clashes such as the Second Battle of El Alamein in 1942. After the war, he drifted away from painting, finding occasional work as a photographer with British *Vogue*. During this time he discovered his true vocation as a portraitist, producing sharply incisive photographs of some of the leading figures of the day, which were direct and unflattering in a way quite untypical of the time. However Deakin's relationship with his employers was complicated by his spiky personality and excessive drinking; *Vogue* fired him in 1954. He then eked out a living as a photographer for a number of other titles and attempted to re-establish himself as a painter, but with limited success.

During this period Deakin was also establishing himself as the unofficial chronicler of the artists in London's Soho district, among whose number were such prominent figures as Lucian Freud, Frank Auerbach, and Eduardo Paolozzi. Perhaps Deakin's most productive and complex relationship was with Francis Bacon. Deakin photographed and painted the artist repeatedly, and Bacon frequently commissioned Deakin to produce photographs for him to paint from.

The two men's interactions were always stormy, and it was only after Deakin's death that Bacon discovered that he had been listed as his friend's next of kin, meaning that he was required to identify the body. Bacon later remarked that "it was the last dirty trick he played on me." **LB**

"[Deakin was] an evil genius . . . a vicious little drunk of such inventive malice that it's surprising he didn't choke on his own venom." George Melly

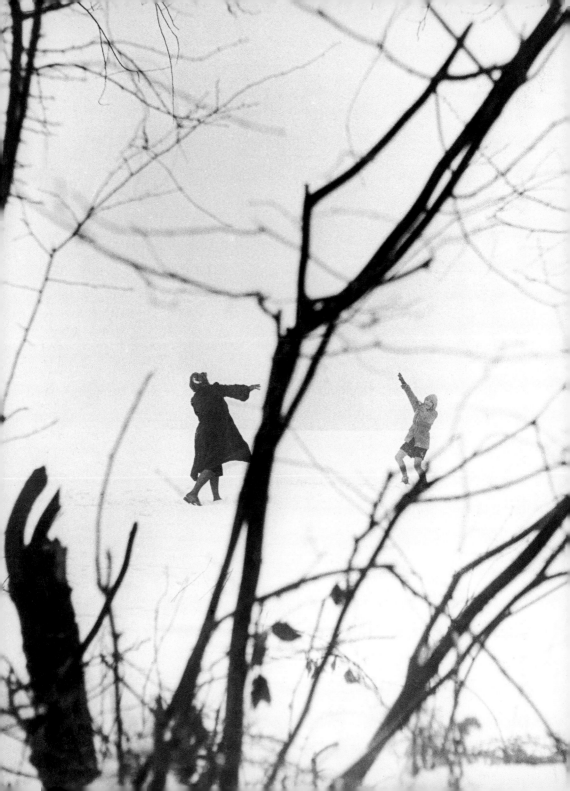

MARIE-ANNE AND VINCENT IN THE SNOW

WILLY RONIS

Date 1952
Location Paris, France
Format Medium format

Humanist photography is a term sometimes applied to those mid-twentieth-century photographers whose subjects were ordinary people and everyday lives, viewed sympathetically. It is particularly associated with French photographers, including those who appeared in the New York exhibition *Five French Photographers* in 1953. Willy Ronis (1910–2009) was one of the five, along with Brassaï, Henri Cartier-Bresson, Robert Doisneau, and Izis.

Born in Paris in 1910 to Jewish refugees, the young Ronis's first passion was music, but when his photographer father became ill in 1932, he had to take over the business. He often remarked on the way his early training in music influenced his photographic work, comparing the way different planes interacted in a pictorial composition to the different lines of music in a fugue.

While Ronis's early work focused on social unrest and the rise of the leftist Popular Front, he went on to become a highly successful photojournalist and was the first French photographer to work for *Life* magazine. He traveled little, preferring to photograph his local Paris streets with a light and tender touch that won him a reputation as one of the great romantic photographers who helped to define postwar France. This enchanting photograph of his wife, Marie-Anne, and his son, Vincent, cavorting in a snow-filled landscape, epitomizes all the qualities that Ronis brought to his art. There is no horizon—simply a view through the screen of almost leafless trees to the distant figures, silhouetted in the landscape. It is a moment of simple joy and beauty, in line with Ronis's idea of finding pleasure in the everyday. **ER**

VULTURES OF THE BATTLEFIELD

WERNER BISCHOF

Date 1952
Location Kaesong, North Korea
Format 35 mm

Werner Bischof (1916–54) studied photography under Hans Finsler at the School for Arts and Crafts in Zurich, Switzerland, and soon became known for his sophisticated compositions of light and shadow.

In the early 1950s, he traveled on assignments to India, Japan, Korea, Hong Kong, and Southeast Asia. The image shown here depicts a pack of press photographers covering the Korean War (1950–53). Bischof turned his camera on the group, so that the photographers became the photographed. The tight crop and composition suggest chaos, showing the men squashed together. As they jostle to get a shot, they appear in a scrum of twisted limbs and cameras.

Bischof was renowned above all for his ethical approach, his sense of social responsibility, and his aversion to the sensationalist aspect of being a photojournalist. The title of this picture leaves no doubt about the disdain he felt for members of his profession who made their living out of the pain and misery of others. **CK**

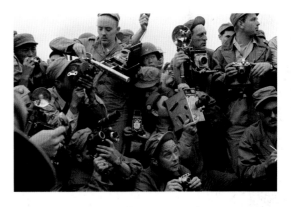

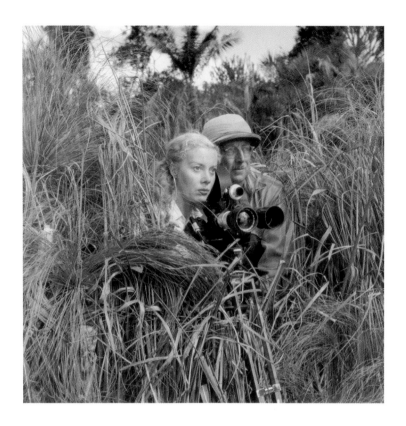

ARMAND DENIS AND WIFE IN JUNGLE GRASS

THURSTON HOPKINS

Date 1952
Location Western Uganda
Format Medium format

Originally trained as a graphic artist, Thurston Hopkins (1913–2014) turned to photography in the mid-1930s, later claiming that his experience in black-and-white illustration helped him as a photographer. He started out in Fleet Street but disliked the ruthlessness of the press. As an RAF photographer during World War II, he acquired his first Leica. He worked for *Picture Post* from 1950 until the magazine's demise in 1957; during this period, he married fellow photographer Grace Robertson.

Many of Hopkins's photographs depicted ordinary working people, but he was also a great chronicler of high society. And while he is best known for his numerous photo-essays on social inequality, he also had a keen eye for the comic, as seen in this image of wildlife filmmakers Michaela and Armand Denis, taken while they were on location in Africa. In an attempt to get closer to their subject without being noticed, the husband-and-wife team are seen filming from an artificial reed bank on a raft.

Hopkins evidently delights in the artificiality of the situation, capturing the couple, in their apparently intense concentration, appearing ludicrously unnatural among the reeds. ER

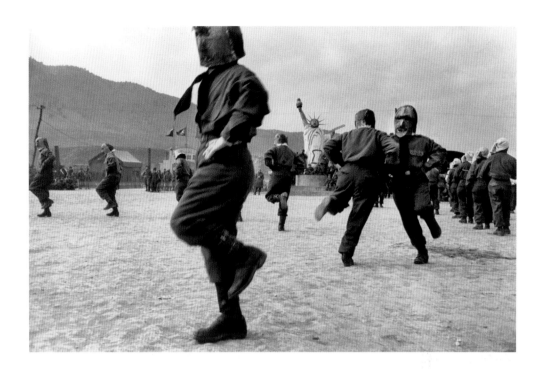

INTERNMENT CAMP FOR NORTH KOREAN PRISONERS OF WAR

WERNER BISCHOF

Date 1952
Location Koje-do Island, South Korea
Format 35 mm

This image was taken for *Life* magazine during the Korean War (1950–53). Chinese prisoners in a United Nations camp are seen taking part in a festival celebration, wearing US uniforms and pink face masks in front of a homemade Statue of Liberty.

Werner Bischof (1916–54), an early member of the Magnum Photos agency, also recorded violence and political intrigue among the mixed populations of this camp, which was made up of 110,000 North Koreans, 38,000 displaced civilians, and 21,000 Chinese. However, none of his combative images appeared in *Life*, which took a staunchly unwavering pro-American line throughout the Cold War. The photographer complained: "It is difficult to take pictures and to hold onto your humanity, and subsequently have your best pictures discarded by the censors."

There is a mocking aspect to this image, which was glossed over in the rather anodyne text that accompanied it. The image therefore raises questions of propaganda and journalistic control in the reporting of war that are still relevant today.

Two years later, Bischof was killed in a road accident while on another assignment in the Peruvian Andes. NG

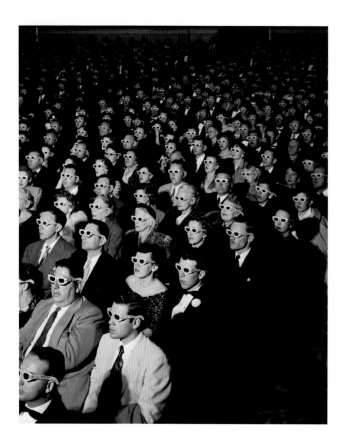

BWANA DEVIL, THE FIRST COLOR 3-D MOTION PICTURE

J. R. EYERMAN

Date 1952

Location Hollywood, California, USA

Format 35 mm

This image has been reproduced countless times and, as the world's dependency on screens grows, is perhaps more pertinent and chilling to look at than ever. J. R. Eyerman (1906–85) took the startling photograph on November 26, 1952, at the opening night of *Bwana Devil*, the first color 3-D motion picture requiring special 3-D glasses. Eyerman worked as a staff photographer for *Life* magazine and the photograph was published in its issue of December 15, 1952, along with a lively

text explaining how two projectors with Polaroid filters were used to create the 3-D effect. The movie was not hugely scintillating, the article concedes, adding, "the audience itself looked more startling than anything on the screen."

The striking appearance of the moviegoers led to a crop from the photograph (flipped from left to right) being used on the cover of Marxist theorist Guy Debord's seminal work, *The Society of the Spectacle* (1967), in its English edition of 1983. In this famous and eerily prophetic book, the author sets out his highly critical view of a capitalist-driven and image-saturated world in which "the spectacle"—in the form of advertising, television, and movies—takes control of our lives. **GP**

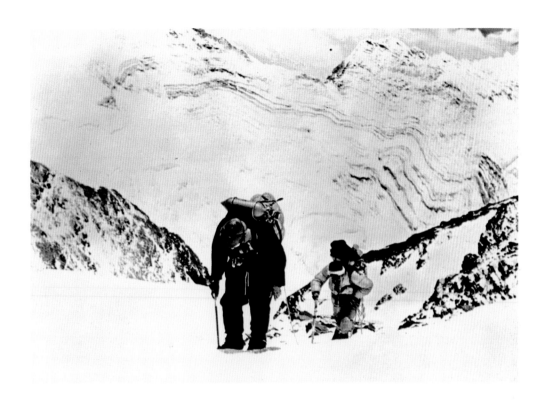

EDMUND HILLARY AND SHERPA TENZING NORGAY CLIMB MOUNT EVEREST

UNKNOWN

Date 1953
Location Mount Everest, Nepal
Format 35 mm

On May 29, 1953, Nepalese Sherpa Tenzing Norgay and New Zealander Edmund Hillary (above) became the first climbers known to have reached the summit of Mount Everest: at 29,028 feet (8,848m), the highest point on Earth.

They were members of the ninth British expedition to Everest, led by John Hunt, which included 362 porters, twenty Sherpa guides, and 10,000 pounds (4,536kg) of baggage to support a team of ten climbers. The expedition established

its base camp in March 1953, but it took them until May 26 to reach their final camp on the South Col of Everest at 25,900 feet (7,890m).

Hillary and Tenzing set out on May 28 to attempt the final push to the top. The New Zealander led the pair up the final major obstacle of the climb, a 40-foot (12m) rock face later dubbed the "Hillary Step." At the time, neither man wanted to say who had reached the summit first, although Tenzing finally conceded in his autobiography that it had been Hillary. After spending just fifteen minutes at the top to take photographs, they began the descent to base camp, where Hillary greeted a colleague with the words: "Well, George, we knocked the bastard off." PL

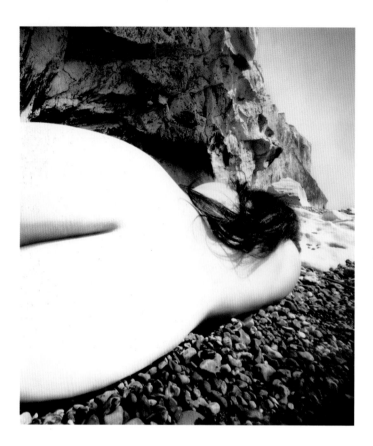

NUDE, EAST SUSSEX COAST, APRIL 1953

BILL BRANDT

Date 1953
Location East Sussex, UK
Format Medium format

Born in Hamburg but a resident in Britain for much of his life, Bill Brandt (1904–83) is widely regarded as one of the greatest and most individual of British photographers. In 1929 a trip to Paris proved a crucial turning point. Working in the studio of Man Ray, Brandt came into direct contact with many avant-garde artists. Surrealism was a major influence, as were photographers Eugène Atget and Brassaï. Brandt moved permanently to Britain in 1934, where he was a regular contributor to the

new picture-led magazines *Lilliput* and *Picture Post*. His work was unusual in that shots were set up, and he favored extreme tonal contrasts in the finished pictures. Whenever necessary, these would be cropped to achieve the results he wanted.

In the postwar years, Brandt concentrated on portraits and nudes. The latter are his most obviously surrealist works. In some the figure is placed in a claustrophobic domestic interior; in others, like this one, the woman (or an isolated part of her) becomes an element within a landscape. The wide-angle lens of his Hasselblad camera distorts and dehumanizes the body, making it resemble the biomorphic sculpture of Hans Arp or Henry Moore. The effect is oddly disconcerting. JS

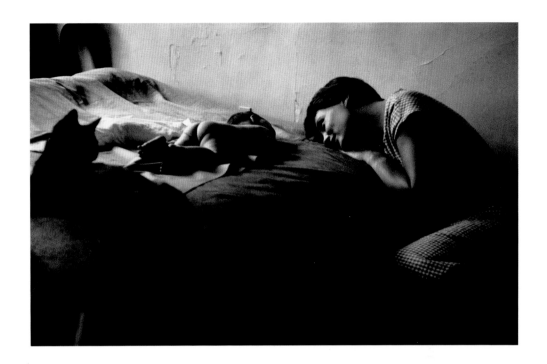

NEW YORK CITY, 1953

ELLIOTT ERWITT

Date 1953
Location New York, New York, USA
Format 35 mm

A highly successful American documentary and commercial photographer, Elliott Erwitt (born 1928) has always considered himself an amateur for whom photography was a hobby before it became a career. Many of his witty, often surreal, juxtapositions are taken on an ad hoc basis around other commissions.

Famed for his casual approach to finding subjects, Erwitt has said: "You can find pictures anywhere. It's simply a matter of noticing things and organizing them. You just have to care about what's around you and have a concern with humanity and the human comedy."

As a delicate domestic portrait, this image feels different from much of Erwitt's other work. This intimate moment captures his Dutch first wife, Lucienne Van Kan, and newborn child Ellen on a bed, a simple image of maternal love. It was taken in the year Erwitt joined the Magnum Photos agency in New York, to which he had recently relocated with his family after having been stationed in France as a photographer in the US Army. Erwitt covered the entire pregnancy and birth, and the series is widely regarded as some of his finest and most sensitive work. **NG**

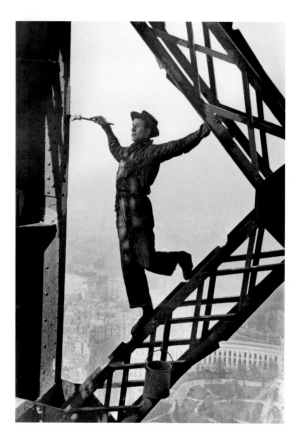

THE PAINTER OF THE EIFFEL TOWER

MARC RIBOUD

Date 1953
Location Paris, France
Format 35 mm

Marc Riboud (1923–2016) received his first camera on his fourteenth birthday. He developed a passion for photography, but only decided to turn professional in 1952, at age twenty-nine. Heading for Paris, he came into contact with two of the founders of the Magnum Photos agency, Henri Cartier-Bresson and Robert Capa.

Early travels took Riboud to India, via Turkey, Afghanistan, and Iran, and he made frequent visits to China throughout his career. He worked mostly in black and white, pointing his camera at ordinary, unknown people. His work has a kinship with the humanist photography of contemporaries such as Édouard Boubat, Willy Ronis, and Robert Doisneau, although his reach is more global and his pictures often have a more political edge than theirs.

The Painter of the Eiffel Tower launched Riboud's career. Having climbed to the top of the tower, he was overcome by vertigo, almost unable to watch whenever the painter—nicknamed Zazou—dipped his brush into his paint pot. With a viewfinder that turned the image upside down, he managed to frame the perfect shot: Zazou, with the city spread out behind him, stands poised like a dancer, simultaneously comical and elegant. **JS**

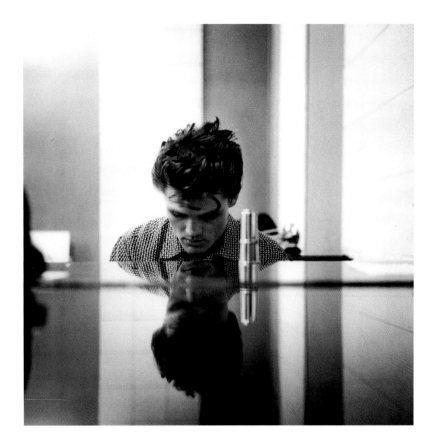

CHET BAKER, LOS ANGELES, 1954

WILLIAM CLAXTON

Date 1954
Location Los Angeles, California, USA
Format Medium format

We cannot see his hands, but we know that he is playing; that where we see perfect stillness, there are notes coming alive at his touch. His immersion is so complete—he's seemingly unaware of his tumbling hair, his bee-stung lips, and the camera, quietly observing—that we seem to catch a glimpse of the place from where his tender playing flowed.

Chet Baker was not a pianist but a jazz trumpeter and vocalist, the "James Dean of Jazz," so called as much for his enigmatic cool as for his boyish good looks. A charismatic performer sensitive to the nuance of his instruments, Baker is best known for the rendition of "My Funny Valentine" that he recorded while with the Gerry Mulligan Quartet. He was also addicted to drugs, a habit that would lead to multiple incarcerations, comebacks, and ultimately his tragic death in 1988 at the age of fifty-eight years.

William Claxton (1927–2008), a photographer with a passion for West Coast cool jazz, chronicled the young Baker in dozens of images during the 1950s, a series that has become iconic. This photograph, which Claxton nicknamed "Young Beethoven," caught a throwaway moment during a pause in a studio photo session. RF

[UNTITLED] FROM *LOVE ON THE LEFT BANK*

ED VAN DER ELSKEN

Date 1954
Location Paris, France
Format 35 mm

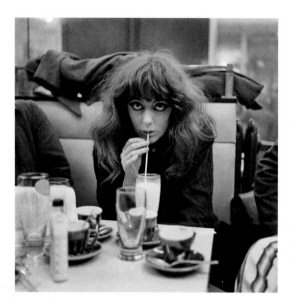

This photograph shows the capacity of the camera—in the right hands—to capture the essence of style. Ed van der Elsken (1925–90) was a Dutch photographer who made his mark along the famous Rive Gauche (Left Bank) in Paris. He frequented the cafés of the Odéon district, which borders the more celebrated Saint-Germain-des-Prés, and saw within them a cast of characters whose existential angst, passionate love affairs, and bohemian way of life all mirrored photography itself, in the sense that both they and it seemed to live for the moment. Van der Elsken was among the first visual artists to understand the potency of disaffected youth, as though he could sense the seeds of *les événements*—the student unrest of 1968—being germinated here.

Unusually, van der Elsken chose to tell this story via a photo-book with a fictional text. His central character was Ann, who was, in fact, an Australian dancer, Vali Myers. Her kohl eyeliner, heavy fringe, and dead-eyed stare would come to define left-bank bohemian chic. This hugely desirable exotic dancer is the unattainable love interest of a Mexican, Manuel, from whose persepective the text is written.

Published in 1954, *Love on the Left Bank* is a feat of exemplary reportage, which helped to cement "grittiness" as an essential stylistic trope of photojournalism throughout the second half of the twentieth century. Yet van der Elsken, by incorporating fictional text and characters, also expanded the possibilities for documentary photography. A facsimile edition of the original text was published by Dewi Lewis in 2002. **MH**

"I report on young, rebellious scum with pleasure . . .
I rejoice in everything. Love. Courage. Beauty. Also blood, sweat and tears. Keep your eyes open." Ed van der Elsken

GUN 1, NEW YORK

WILLIAM KLEIN

Date 1954
Location New York, New York, USA
Format 35 mm

In this dramatic, grainy action shot, one young boy jams a gun directly at the camera and viewer, his face distorted into a mobster grimace, the mouth of the gun blurred by sudden movement. American photographer William Klein (born 1928) described the moment of the shot in order to dispel some of the uncertainty that it may otherwise have caused:

"It's fake violence, a parody," he said. "I asked the boy to point the gun at me and then look tough. He did, and then we both laughed.... [I see it] as a double self-portrait. I was both the street kid trying to look tough, and the timid, good little boy on the right."

Klein returned to his native New York after studying painting in postwar Paris; he brought back with him dramatically new ideas about what constituted a good photograph. He used a secondhand camera purchased from Henri Cartier-Bresson, but his photographic philosophy was the polar opposite of that of the French master, whose aim was almost invariably to observe without interfering. Klein plunged into crowds and street life with maximal intervention, no interest in objectivity, and a sense of risk and experimentation to see what was possible with his camera. Using a wide-angle lens as standard, and high-speed film so that he could shoot in all light conditions, Klein embraced blurring, graininess, high contrast, and uncomfortably close perspectives. Critics claimed that he denigrated New York by depicting the city as a slum; Klein responded that anyone who thought that did not really know the New York of that time, in all its vibrancy and grittiness. CP

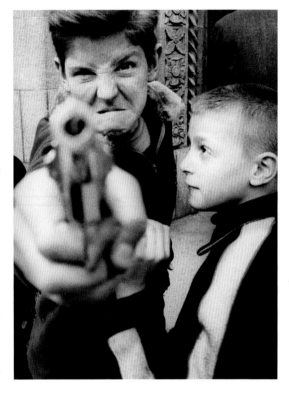

"I photograph what I see in front of me, I move in close to see better and use a wide-angle lens to get as much as possible in the frame." William Klein

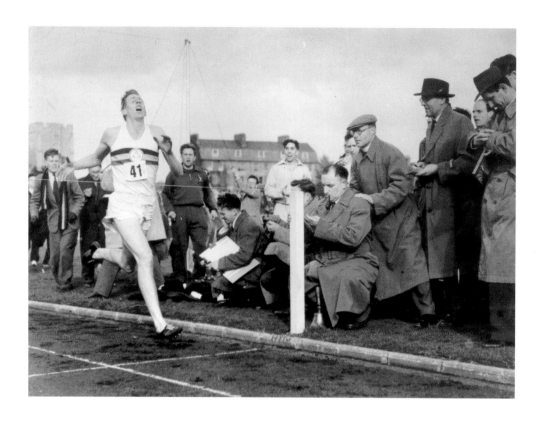

ROGER BANNISTER BREAKS THE FOUR-MINUTE MILE

NORMAN POTTER

Date 1954
Location Oxford, UK
Format 35 mm

His face says it all: exertion and exhaustion rolled into one triumphant moment that made history as English athlete Roger Bannister became the first recorded person to run a mile in less than 4 minutes—3 minutes 59.4 seconds to be precise. "I leapt at the tape like a man taking his last desperate spring to save himself from a chasm that threatens to engulf him," Bannister recounted in a memoir. "[It] had become rather like an Everest—a challenge to the human spirit. It was a barrier that seemed to defy all attempts to break it." But break it he did in front of 3,000 spectators at the Iffley Road track in Oxford, UK—a track he had helped to build while an undergraduate at Oxford University.

The twenty-five-year-old medical student had carefully researched the mechanics of running and had long had his sights set on what was considered to be the ultimate prize in athletics. Two friends, Christopher Chataway and Christopher Brasher, ran with him, serving as pacemakers. Central Press Photos photographer Norman Potter captured the exact moment Bannister's foot crossed the finishing line, immortalizing the runner, but it was not until many years later that he was officially credited for the photograph. GP

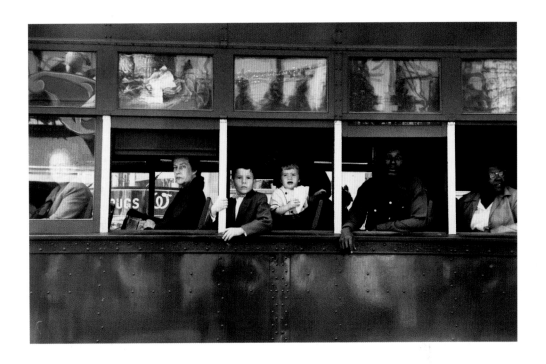

TROLLEY—NEW ORLEANS

ROBERT FRANK

Date 1955
Location New Orleans, Louisiana, USA
Format 35 mm

Robert Frank (born 1924) emigrated to the United States from Switzerland in 1947. This photograph shows people riding a trolley car in New Orleans. Later in 1955, in Montgomery, Alabama, African American Rosa Parks disobeyed a bus driver's order to give up her seat to a white passenger. Her refusal sparked a year-long bus boycott and became a milestone in the civil rights movement.

Frank's image captured the mood of the time. The trolley car's window frames juxtapose the individuals to form a series of vignettes and separate the passengers, just as race laws separated whites and blacks on public transportation in the Deep South.

The man to the left is partially obscured by a reflection, as if hiding; the woman in the fur collar appears disdainful; the children seem well dressed and privileged; the tall man looks confined by the window frame; and the bespectacled woman looks behind her as if distracted. There is no sense of unity among them. They are isolated.

The picture took on even greater significance when Frank chose it for the cover of *The Americans* (1958), his controversial book that documented social inequality in the United States. CK

"BIRDMAN" ALFRED HUBER, AUSTRIAN TENNIS PLAYER, FLYING AFTER A BALL HIT BY OPPONENT G. L. WARD OF GREAT BRITAIN

REG BURKETT

Date 1955
Location London, UK
Format 35 mm

Austrian tennis player Alfred "Freddie" Huber caused a stir during his first-round match at the Wimbledon tennis championships by diving to return the ball before such acrobatics became the norm. The Austrian was even mentioned in *Life* magazine—in the July 4 issue of that year—in an article headlined "Austrian Acrobat Enlivens Tourney."

Reg Burkett, a press photographer with Keystone Press Agency, caught Huber in the midst one of these dives during his match against British player Geoffrey Ward. Huber is pictured mid-dive, frozen in the air as he goes in for a backhand return, mouth open wide and legs jutting out at awkward angles. Spectators in the background look on expectantly. It is not known if Huber won this particular point, but he won the match in five sets. GP

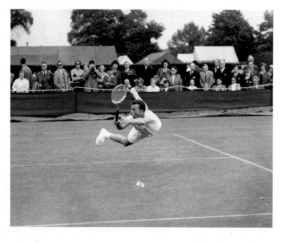

JAMES DEAN, HAUNTED TIMES SQUARE [PRINTING MARK-UP SHEET]

DENNIS STOCK

Date 1955
Location New York, New York, USA
Format 35 mm

This is a printing mark-up sheet from the Magnum agency archive of an image of James Dean taken in 1955, only months before the actor's death in an automobile accident. Taken by Dennis Stock (1928–2010), who befriended the actor—photographing him in Hollywood, Indiana, and New York City—the picture became iconic and was one of the most highly reproduced images of the postwar period. One of its merits is its apparent naturalness. Stock recalled: "I wasn't interested in a lot of the poses Jimmy took. They were artificial, so I let him go through a lot of nonsense until he relaxed and became spontaneous."

Pablo Inirio, Magnum's master darkroom printer, has printed the image many times, and of it he has said: "it's not an easy print! He's a little bit under-exposed, and you want to have just enough information so he's still kind of moody. Even though it's kind of a rainy, cloudy day, the sky is kind of overexposed a little bit, so you kind of have to bring that down, you want to keep the contrast snappy . . . I have my notes and I follow them as much as I can."

The heavily annotated mark-up sheet shows the great amount of precise and thoughtful work that goes into creating a finished print. The image itself is uncomplicated: James Dean walks across a foggy Times Square, collar up, smoking a cigarette; but even so, there are many elements to consider when printing the image, burning detail in at some points, dodging it at others. Here, we see the final image broken into its constituent parts almost mathematically, a peek behind photography's stage door. AZ

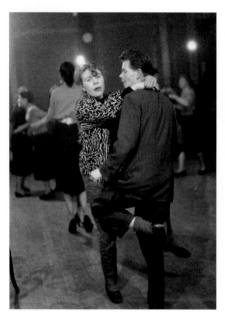

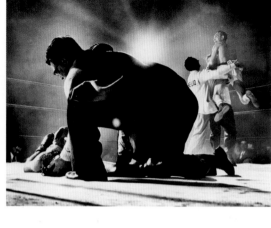

THE JITTERBUG

KURT HUTTON

Date 1955
Location Newcastle upon Tyne, UK
Format 35 mm

Kurt Hutton (1893–1960) will be best remembered for his depictions of working-class British youth culture. Those candid images, often taken in places of relaxation, were in stark contrast to the reverential posed portraits of the famous and noteworthy that dominated magazine photography at the time.

This photograph, taken at the Club Martinique nightspot, depicts a couple dancing the jitterbug, a style of dancing that was already passé at this time. The man is a teddy boy, part of the first British teen subculture. "Teds" wore Edwardian-style clothes in order to distinguish themselves from American rock 'n' roll culture. The postwar period saw the growth in the West of tribal self-definition via clothes, a development that created lucrative new markets for commerce. MT

UNTITLED

HY PESKIN

Date 1955
Location Boston, Massachusetts, USA
Format Unknown

Hyman "Hy" Peskin (1915–2005) began his career as a sportswriter, switching to photography only when he realized that he could make more money that way. He changed sports photography forever by getting out of the restrictive press area and shooting from the sidelines, climbing up onto roofs to get unusual angles on the action. He asserted that "anticipation is the key word in the coverage of all sports."

Peskin was the first staff photographer hired by *Sports Illustrated*, and by the end of his career forty of his images had appeared on the cover of the weekly magazine. He also undertook freelance assignments for *Time*, *Life*, and *Look*.

This dramatic action shot was taken at the 1955 welterweight world title fight, in which Carmen Basilio knocked out reigning champion Tony DeMarco in the twelfth round. *Sports Illustrated* remarked that the black-and-white image walked "the line between reportage and film noir." It was later cited as one of the influences for the fight scenes in Sylvester Stallone's movie *Rocky* (1976). PL

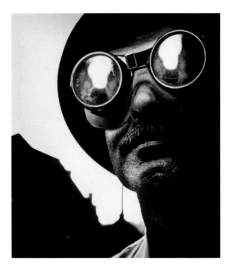

DEVIL GOGGLES

W. EUGENE SMITH

Date 1955–56
Location Pittsburgh, Pennsylvania, USA
Format 35 mm

W. Eugene Smith (1918–78) was already a legend when he accepted a commission for a book commemorating Pittsburgh's bicentennial. He was known for his obsessive editorial control of his images, and his difficult personality. The Pittsburgh project was his most successful and his most miserable period; he referred to it as both a "debacle" and "the finest set of photographs I have ever produced." Originally hired to shoot for three weeks and produce one hundred photos, Smith stayed in Pittsburgh for more than a year and took around 17,000 images.

Here, a steelworker has his individuality hidden by a hard hat and goggles that reflect flames. Industrial hell images such as this sit jarringly with pictures of parkland and shining skyscrapers. A central theme of the essay was the contrasts between hope and despair, wealth and poverty, nature and industry, and beauty and squalor. Smith sought both to comfort and to disturb. **CP**

SOUNDS OF SILENCE

JOHN DRYSDALE

Date 1955
Location London, UK
Format Unknown

At first glance, the pair in this photograph look as though they are being forced at gunpoint to hold their arms in the air. The figures are in fact customers listening to pop releases in newly installed special sound-isolating booths at the HMV record and gramophone shop on Oxford Street in London. Signs on the wall indicate that only records at 78 rpm could be played.

The humor here is typical of John Drysdale's work, but he is best known for his heartfelt and humorous images of children and animals. He worked with Norman Parkinson at Vogue Studios, and assisted Cecil Beaton when he photographed the Coronation of Queen Elizabeth II, before forging a successful career in advertising, reportage, and industrial photography. Drysdale's body of work is full of cleverly seen moments that remind us of photography's deceptive and sometimes sorely overlooked playful side. **GP**

HOT SHOT EASTBOUND

O. WINSTON LINK

Date 1956
Location Iaeger, West Virginia, USA
Format Large format

O. Winston Link (1914–2001) documented steam locomotive railroading with sound recordings and photographs. His passion focused on the Norfolk and Western Railway as he recorded the last days of the steam era.

Link was also a pioneering night photographer. Many of his pictures of railroads were shot at night, thus adding to their nostalgic atmosphere. He said of his preference: "I can't move the Sun—and it's always in the wrong place—and I can't even move the tracks, so I had to create my own environment through lighting."

This photograph is a fusion of both his interests. It shows a steam train passing a drive-in movie theater and was used in his book *Steam, Steel & Stars* (1987). It is typical of Link's photographs, all of which were meticulously planned. It was taken on a hot night when the Iaeger drive-in was showing a movie about the Korean War (1950–53), *Battle Taxi* (1955). Link used two exposures on separate sheets of film—one for the image on the movie screen, the other for the surroundings.

The last Norfolk and Western steam locomotive was taken out of service in May 1960. Link's project was at an end. **CK**

FIR TREES IN WINTER

ALBERT RENGER-PATZSCH

Date 1956
Location Nuremberg (?), Germany
Format Large format

Albert Renger-Patzsch (1897–1966) came to the fore as a photographer in the 1920s with industrial and technical subjects depicted with exacting precision and great attention to form and surface. A member of the New Objectivity movement, he advocated a realistic, documentary style, and believed that photographers should capture the "essence of the object" with optical sharpness, not darkroom manipulation. He sought to distance himself from the experimental, artistic efforts of the avant-garde

and concentrated on producing sober imagery that celebrated advances in technology and the rational aspects of progress.

In the 1950s, Renger-Patzsch's attention shifted to landscapes and architecture. *Fir Trees in Winter* is typical of his output: a tightly framed viewpoint from an unusual perspective. The framing of the image accentuates the verticality of the trees; the snowy corridors between them and the patterns of repeating shapes suggest their uniformity. The picture is in keeping with Renger-Patzsch's stated aims in *Die Welt ist Schön* (*The World is Beautiful*, 1928)—to encourage the viewer to "look at things from a new vantage point" and to take increased "joy" in seeing the world anew. CK

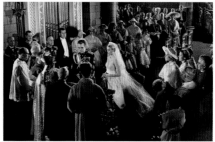

GRACE KELLY'S WEDDING

UNKNOWN

Date 1956
Location Monaco
Format 35 mm

MILLION DOLLAR QUARTET

UNKNOWN

Date 1956
Location Tennessee, USA
Format 35 mm

When four rock 'n' roll legends came together to record an impromptu jam session on December 4, 1956, the results were always going to be memorable. The so-called Million Dollar Quartet recording session saw Jerry Lee Lewis, Carl Perkins, Elvis Presley, and Johnny Cash record an album at Sam Phillips's Sun Studios in Memphis, Tennessee, including hits "Blue Suede Shoes," "That's All Right," and "Great Balls of Fire." It was the first and only time all four musicians would play and record together.

The session seems to have come about by chance. Perkins, who had recently found success with his song "Blue Suede Shoes," was in Phillips's studio to record new material, and Phillips drafted in Lewis to play piano. Presley and Cash dropped by at various points that day and joined in the jam. Reporter Bob Johnson wrote an article about the session, which was published with this image in the *Memphis Press-Scimitar* the following day under the headline "Million Dollar Quartet." "I never had a better time than yesterday afternoon It was what you might call a barrel-house of fun . . . the joint was really rocking before they got thru." **GP**

Screen goddess, siren, style icon, divine beauty—Grace Kelly captured the hearts and imaginations of the public and media during her life, and continues to enthral today. She was the ultimate star of the 1950s, appearing in movies such as *Dial M for Murder, High Noon, Rear Window*, and *To Catch a Thief*.

In 1955 she met Prince Rainier III of Monaco in the French Riviera and on April 19, 1956 the couple married in what the press called "The Wedding of the Century." Following a civil ceremony the day before, Bishop Gilles Barthe conducted a religious service in St. Nicholas Cathedral, watched live on television by an estimated 30 million people. The wedding was, says biographer Robert Lacey, "the first modern event to generate media overkill."

After the wedding, Kelly became Her Serene Highness Princess Grace of Monaco and retired from acting, the Prince purportedly banning screenings of her movies in Monaco and dissuading her from accepting future roles. Many photographs were taken of the highly anticipated wedding, but this one in particular brilliantly captures the solemnity, majesty, and spectacle of the occasion. With onlookers gathered all around, there is something cinematic about the scene—the moment when a star became a princess and was elevated to the ultimate starring role. **GP**

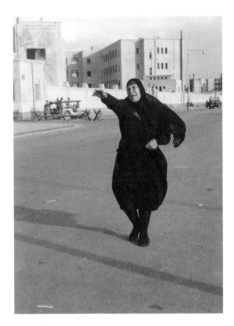

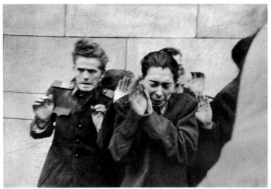

HUNGARIAN REVOLUTION

JOHN SADOVY

Date 1956
Location Budapest, Hungary
Format 35 mm

As the bullets rang out, John Sadovy (1928–2013) was there to capture the drama that unfolded. In what has been described as his most famous sequence of images, the *Life* magazine photographer captured the moment Soviet-controlled security policemen were gunned down in Budapest by rebels during the Hungarian Revolution of 1956. This photograph was typical of the Czech photographer's approach: to use a wide-angle lens with his 35 mm camera and get as close as possible to the action.

Sadovy was one of a handful of photojournalists who gained access to Hungary during this political upheaval. *Life* magazine published this photograph along with many other graphic images by Sadovy in its November 12, 1956, issue. In an editorial that ran alongside the photographs, Sadovy (with journalist Timothy Foote) vividly described what they had witnessed: "Six young officers came out . . . I was 3 feet [1m] from that group. Suddenly one began to fold. They must have been real close to his ribs when they fired. They all went down like corn that had been cut. . . . And when they were on the ground the rebels were still loading lead into them." **GP**

ARAB WOMAN PROTESTS AT SUEZ INVASION

UNKNOWN

Date 1956
Location Port Said, Egypt
Format 35 mm

An Arab woman laments the occupation of her home city by Anglo-French troops. The eerily empty streets give added strength to her lone protest. In July 1956, Egypt unilaterally nationalized the Suez Canal. Britain and France were furious because the canal was a vital lifeline for oil supplies to the West. Israeli forces invaded the Sinai Peninsula after escalating tensions with Egypt; Britain and France had prior knowledge of this intervention and landed airborne troops to take control of the canal. The United States and the Soviet Union forced a halt to the Anglo-French operation, and a UN peacekeeping force arrived to stabilize the region. The Suez crisis showed that Britain and France were no longer world powers that could do as they pleased. **CJ**

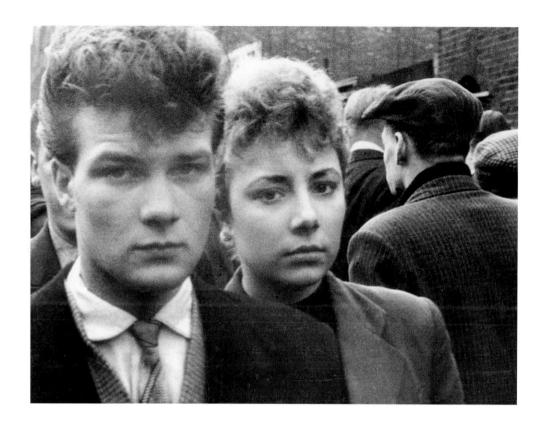

TEDDY BOY AND GIRL, PETTICOAT LANE

ROGER MAYNE

Date 1957
Location London, UK
Format 35 mm

The brash, confrontational gaze that this young couple give the photographer is the epitome of the teddy boy ethos. By the 1960s, the concept of the street as a space where people went to display themselves in a self-conscious way was well established, but in this photograph the uniqueness of the "teds" is emphasized by the surrounding throng of commuters dressed in the conventional clothing of the time. Unabashed in its appropriation of Edwardian-style dress,

teddy-boy style represented perhaps the first widespread British working-class subculture, and certainly the first specifically teenage one.

Roger Mayne (1929–2014) photographed streets in deprived areas of London, most famously Southam Street, Notting Hill, which he documented for five years (1956–60).

Rather than use the streets as a canvas onto which he consciously projected a particular way of seeing, Mayne captured moments that seemed to transcend the deprivation that surrounded them. By the mid-1960s, Southam Street had been demolished and its residents relocated. The teddy boys had gone, too, replaced by a host of other groups, including, for a time, mods and rockers. **MT**

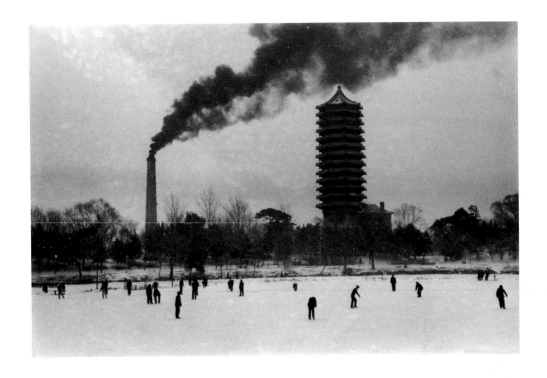

BEIJING, 1957

MARC RIBOUD

Date 1957
Location Beijing, China
Format 35 mm

Marc Riboud (1923–2016) was able to render real life with a poetic sensibility that was uniquely his. His photographs, beautifully composed and perfectly constructed, seem almost plucked from the air. His mentor Henri Cartier-Bresson once told him that "good photography" is dependent on "good geometry," and that advice seems to have stuck.

Riboud traveled much of the world with his camera, but one country always drew him back: China. As one of the first Westerners to photograph in Communist China, he first arrived there in the late 1950s and often returned over the course of the next three decades. Whether it was ice skaters on a frozen canal or workers leaving a factory at the end of the day, Riboud produced images that not only recorded humanity but celebrated it, too. "I have always been more sensitive to the beauty of the world than to violence and monsters," he once said. In the foreword to his book *Visions of China* (1980), one of more than thirty books he published in his lifetime, he wrote: "The best way to discover China is perhaps to use one's eyes. Intense attention to detail and to the moment, here even more than elsewhere, can lead to knowledge and understanding." GP

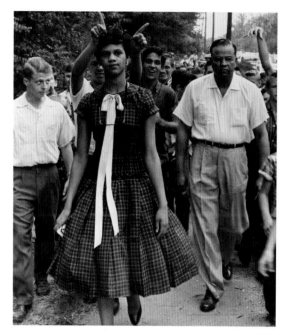

DOROTHY COUNTS

DOUGLAS MARTIN

Date 1957
Location Charlotte, North Carolina, USA
Format 35 mm

At the age of fifteen, Dorothy Counts became one of the first African-American students to attend the newly desegregated Harry Harding High School in North Carolina.

The desegregation of schools began after the 1954 *Brown v. Board of Education of Topeka* case, in which the US Supreme Court declared that state laws establishing separate schools for black and white students were unconstitutional. In 1957, forty black students applied for transfers to all-white schools, including Dorothy Counts and four others in her district.

In this photograph by Douglas Martin, Counts is pictured striding to school on the first day of the semester surrounded by a sea of white students mocking and jeering at her. It is a painful image to look at, as we feel her sense of alienation in the crowd; however, it is also a hugely powerful one as Counts manages to maintain her outward composure. Her posture is one of courage and resilience as she towers above the rest with a resolute expression. Walking a pace behind her is Dr. Edwin Tompkins, a family friend and a professor at a nearby college for black students.

After four days of severe harassment, the police warned Counts that they could not guarantee her safety. Her family withdrew her from that school, but they were not discouraged and subsequently sent her to an integrated school in Philadelphia.

This photograph emerged as a World Press Photo of the Year in 1957, not only for the reason that it captured a historic event, but also because it summarized the raging racial tensions of the time in a single telling image. **EC**

"I remember the words of my father that morning: 'You can do anything you want to do, and no one can stand in your way.'" Dorothy Counts-Scoggins

THE NYLON STOCKING TEST

MAURICE BROOMFIELD

Date 1957
Location Pontypool, UK
Format Large format

Maurice Broomfield (1916–2010) was a prolific photographer of British postwar industry, starting his career in the 1950s and working extensively until the 1980s. Broomfield left school at age fifteen and began working on the assembly line at Rolls-Royce in Derby while taking night classes at the local art school, where he began experimenting with photography. Influenced by the theatricality of industry, Broomfield employed innovative lighting techniques and unusual angles to shoot his subjects on large-format film—factories, industrial processes, and, most crucially, the workers.

In this photograph, reminiscent of the work of Man Ray, a researcher at British Nylon Spinners tests the strength of synthetic fibers for women's stockings. Broomfield, who, even in the tenth decade of his life was able to provide anecdotes for almost every image he shot, said of this photograph: "Although wartime restrictions on stockings were over, a pair of fine nylons was still a welcome gift. This laboratory tested nylon thread—its strength and appearance of the stocking on a shapely leg. The strength was acknowledged by a motoring organization: 'In the event of a fan breakage a nylon stocking makes a good temporary replacement.' At least it would get you home."

The archive of Broomfield's work on British industry is now housed in the Victoria and Albert Museum in London. Yet his contribution to photography is yet to receive the recognition it deserves. Broomfield ceased taking photographs in the 1980s and turned to drawing and painting, which he pursued until his death. **LH**

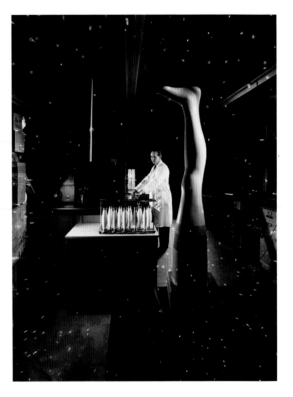

"I love lighting. It changes everything. It creates moods; it's like a painting material."
Maurice Broomfield

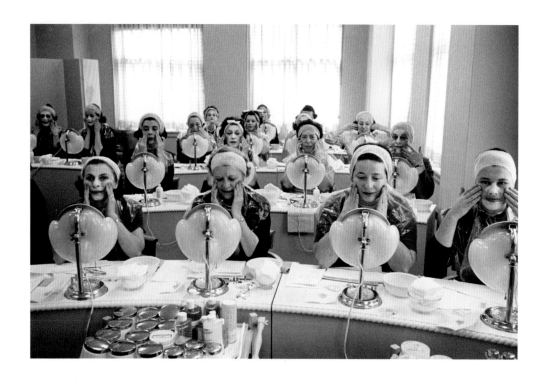

BEAUTY CLASS AT THE HELENA RUBENSTEIN STUDIO

INGE MORATH

Date 1958
Location New York, New York, USA
Format 35 mm

Inge Morath (1923–2002) grew up during World War II and was drafted late in the conflict to work alongside Ukrainian prisoners of war in a factory in the Tempelhof area of Berlin, Germany. When the factory was bombed by Soviet aircraft, she escaped to her native Austria. When the war ended, she worked as a journalist and translator and became friends with photojournalist Ernst Haas, with whom she collaborated on *Heute*, an illustrated magazine published by the Office of War Information in Munich. Their feature articles caught the attention of Robert Capa, who in 1949 invited them both to join the newly founded Magnum Photos agency. Morath began as an editor at the Magnum office and cited her close study of the contact sheets of Henri Cartier-Bresson as a major inspiration, recalling that "I think that in studying his way of photographing I learned how to photograph myself, before I ever took a camera into my hand."

Morath brought intimacy, sensitivity, and, perhaps above all, charm to her work, of which this photo is a typical example. She met playwright Arthur Miller while photographing his estranged wife, Marilyn Monroe, on the set of *The Misfits*; she and Miller married soon after his divorce. PL

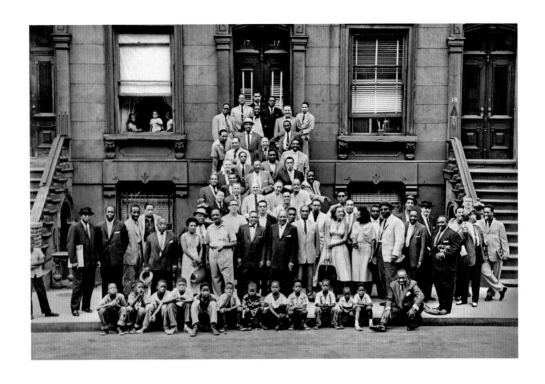

A GREAT DAY IN HARLEM

ART KANE

Date 1958
Location New York City, New York, USA
Format Unknown

It was 10:00 a.m. on August 12, 1958, in Harlem, New York City, and Art Kane (1925–95) was about to take the photograph that would make his name. Kane, an art director who was building his reputation as a photographer, had been commissioned by *Esquire* magazine to photograph a group of jazz musicians for a feature celebrating its view of the golden age of jazz. This was not just any group of jazz musicians; seated in front of a brownstone on East 126th Street were fifty-seven of the very best—

including Dizzy Gillespie, Thelonious Monk, Count Basie, Charles Mingus, and Sonny Rollins—who happened to be available and were willing to make an appearance. It was a mammoth undertaking, and, so the story goes, Kane and his team were struggling to organize the group. Local children also got involved in the shot, which did not help matters, but, despite the chaos, Kane came away with this photograph, immortalized as *A Great Day in Harlem*. The photograph appeared in *Esquire's* issue of January 1959 and was the inspiration for a documentary movie of the same name by Jean Bach, made in 1994. Other photographs using a similar approach include Gordon Parks's *A Great Day in Hip-Hop*, shot forty years after Kane's original. **GP**

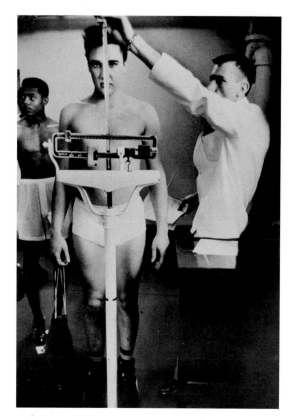

ELVIS PRESLEY
ARMY MEDICAL

DON CRAVENS

Date 1958
Location Memphis, Tennessee, USA
Format 35 mm

In 1958, Elvis Presley, already well on the way to global stardom, took a partial break from the music business to enlist in the US Army, in which he served until 1960. Despite offers from various other branches of the armed forces to join their ranks (the US Navy and Special Services, for example, were intent on securing the star for their respective rosters and did what they could to entice him), the twenty-three-year-old decided to enlist as an ordinary soldier. He reported for duty on March 24, 1958, and was stationed for a time at Fort Hood in Texas, as well as being posted to Germany.

Press photographer Don Cravens (1921–2013) captured a series of candid, intimate images as the singer prepared to be taken into the army. Here, we see Presley undergoing a preinduction medical exam at Kennedy Veterans Hospital in Memphis, Tennessee, standing in his underwear, having his weight and height checked—he was half an inch over 6 feet (1.84m) tall.

Looking straight into the camera with a concentrated expression on his face, Presley looks not a bit like a superstar, but instead appears to be an ordinary young man—by no means an average soldier, of course, but pictured without his elaborate stage costumes and guitar, he could still seem like the boy next door.

Presley kept his music career going to a degree during his time in the army, continuing to record and release songs, and even achieving chart success. Cravens later gave up press photography and became a real estate broker in Los Angeles, California, but he continued to earn royalties from images such as this. **GP**

"I never tried to be these people's friends. I always kept a professional attitude. They respected that."

Don Cravens

GB. ENGLAND. LONDON.
THE CITY. 1958–1959

SERGIO LARRAIN

Date 1958–59
Location London, UK
Format 35 mm

Magnum photographer Sergio Larrain (1931–2012) was born in Santiago, Chile. He initally studied music, before taking up photography in 1949. After studying at the University of California and the University of Michigan in the United States, Larrain worked as a freelance photographer in Europe and the Middle East. In 1958 he was awarded a grant from the British Council that enabled him to produce a series of images of London.

In this photograph, Larrain captures the dark figures—near-silhouettes—of top-hatted London gentlemen striding along. He uses dramatic contrast to emphasize the shapes and graphic of the image, and the viewer's eyes are drawn in the direction of the men as they walk. Larrain noted many British stereotypes without resorting to cliché: here, the hands clasped behind the back are a staple gesture of restrained British politesse.

Larrain often found frames within the frame of his camera, and this is particularly symbolic in his London work: his views, captured through the windows of doorways, buses, and trains, suggest his status as a visitor, a traveler, and an outsider observing the symbols and tropes of London life. In this image, the word "OUT," painted onto the glass of the door through which his camera gazes, emphasizes this sense of inside vs. outside. Larrain and his lens are peering out into a society that he is interrogating and observing, but it is a society of which he is not fully a part.

Larrain's work was featured in "Strange and Familiar," Martin Parr's exhibition of photography at the Barbican, London, in 2016. AZ

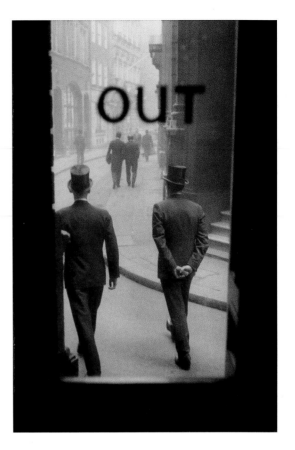

"A good image is created by a state of grace."

Sergio Larrain

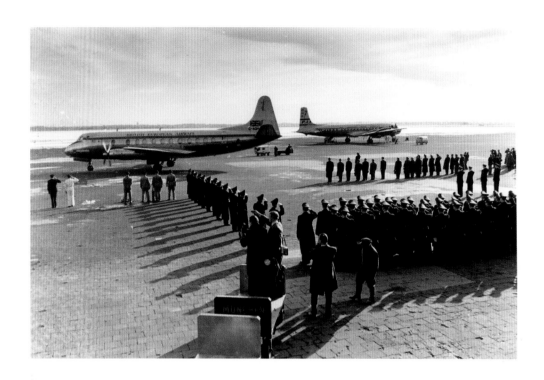

AFTERMATH OF MANCHESTER UNITED'S MUNICH AIR CRASH

UNKNOWN

Date 1958
Location Munich, Germany
Format 35 mm

During a snowstorm on February 6, 1958, the BEA charter flight taking the Manchester United Football Club team back from a European Cup game against Red Star Belgrade crashed on takeoff at Munich Airport. Of the forty-four passengers and crew, twenty-three were killed immediately or died shortly after from their injuries. In this poignant image, taken after the accident, a West German police guard of honor salutes as an aircraft carrying the survivors prepares to leave for Manchester.

Nicknamed the "Busby Babes" after their manager, Matt Busby, the team had drawn 3–3 with Red Star, sending them through to the semifinals of the Cup. Returning, their Ambassador aircaft lacked the range to fly nonstop back to England from Yugoslavia, so it stopped in Munich to refuel. After that, engine problems caused the pilots, James Thain and Kenneth Rayment, to abandon the takeoff twice. As the weather worsened, the pilots decided to make a final attempt to get home on schedule. The plane, unable to gain enough speed to lift off, plowed into a deep layer of slushy snow that had built up at the end of the runway. The ill-fated aircraft had skidded through the airport fence and into a nearby house. PL

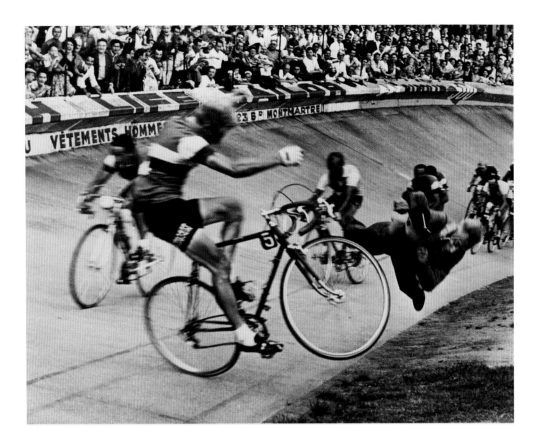

FINAL STAGE OF THE TOUR DE FRANCE

UNKNOWN

Date 1958
Location Paris, France
Format 35 mm

This dramatic shot captures both the energy and the danger of cycle racing. French rider André Darrigade had already won five stages of the 1958 Tour de France and was leading the final stage, which finished in the velodrome at the Parc des Princes, Paris, when he crashed into Constant Wouters, the *secrétaire-général* of the stadium, who was on the track trying to stop photographers obstructing the race. Despite broken ribs and a cracked skull, Darrigade was able to get back on his bike after the end of the race to take a lap of honor, but the seventy-year-old Wouters was seriously injured and died eleven days later.

Veteran racing cyclist Raphaël Géminiani called Darrigade "the greatest French sprinter of all time" and added: "The mold has been broken. But he wasn't just a sprinter. He was an *animateur* who could start decisive breaks; he destroyed the image of sprinters who just sit on wheels."

There was no secret or trick to Darrigade's approach. His tactics were simple—he began his sprint a long way from the line, then led from the front all the way home. He challenged others to pass him, but none could do so; his preeminence made him wildly popular with the fans. PL

RITUAL BRANCH

MINOR WHITE

Date 1958
Location New York, New York, USA
Format 35 mm

Minor White (1908–76) studied botany and aesthetics before he became a photographer, and his interest in both fields is evident throughout his oeuvre. He wielded enormous influence on photography as an art form as editor of *Aperture* quarterly magazine for twenty years and as a teacher at the California School of Fine Arts. He was interested in Eastern philosophies and encouraged his readers and students to engage with the meditative and symbolic qualities

of photographs, regarding them like poems that viewers can connect with emotionally. He promoted the concept of photographs that simulate the experience of a Zen Buddhist *koan*, or riddle, and tried to encourage the act of looking.

Taken on December 8, 1958, *Ritual Branch* is a picture of frost on a window. It is typical of White's carefully composed pictures that are cropped to remove any context. This extreme close-up thus becomes an abstract work that celebrates light, shade, and texture. Although evidently organic in nature, it is not immediately evident what the object photographed is, and the viewer is left to ponder patterns and forms that suggest the puzzle and the complexity of life itself. **CK**

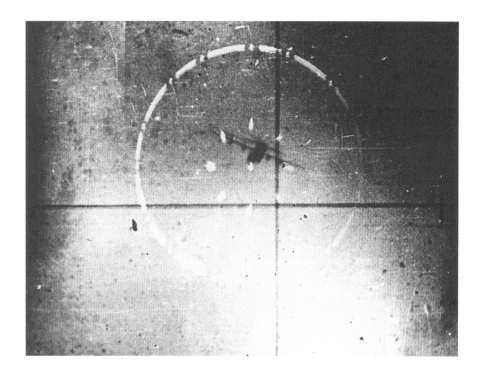

THE LAST MOMENTS OF A US AIR FORCE RECON C-130 HERCULES IN GUN CAMERA OF THE SOVIET MIG-17. 1958

UNKNOWN

Date 1958
Location Near Yerevan, Armenia
Format Unknown, probably 16 mm

In the interwar period, military technicians developed a hybrid of gun and camera. The earliest such creation was probably an adapted version of a Lewis automatic rifle, altered to take photographs rather than fire bullets. Later gun-camera systems integrated directly into aircraft were designed to do both. By creating a camera with the same perspective as an aircraft's gun, it was possible to measure tactical effectiveness and to train pilots and gunners to be more effective in combat.

The product also had intelligence uses, making it possible to study the performance of enemy aircraft. Following World War II, and in the absence of modern special effects, some of the gun-camera footage thus obtained was recycled into the action scenes of war films, with audiences seldom aware that they were watching a blend of fact and fiction.

The image above is a still taken by a gun camera mounted on a Soviet fighter jet flown by a pilot identified only as "Lieutenant Kucheryaev." In a little-known Cold War episode, a US reconnaissance aircraft strayed into Soviet airspace. Fighter planes were scrambled to intercept it, and it was shot down with the loss of all its crew. LB

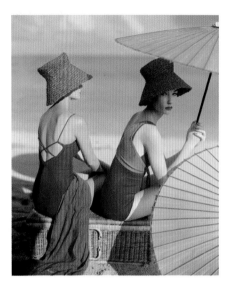

UNDER PARASOLS
VOGUE

LOUISE DAHL-WOLFE

Date 1959
Location Unknown
Format 35 mm

A pioneer of the "New American Look" in such magazines as *Vogue* and *Harper's Bazaar* after World War II, Louise Dahl-Wolfe (1895–1989) exerted an influence that cannot be overstated. In the words of photographer Richard Avedon, "[s]he was the bar we all measured ourselves against." She was among the first to shoot in natural light, using color film on location, and she stoked the postwar interest in air travel by shooting models who seemed at ease wherever they happened to be.

In this evocative, Japan-inspired set piece, published in *Vogue* on January 15, 1959, Dahl-Wolfe arranges her twinned models and props to create a perfect visual confection of shapes and colors. The unusual reds and pinks of the bathing suits, hats, and parasols are beautifully offset by the hues of the sand and the sea, suggesting a world that is timeless, idealized, and seductive. **RF**

BROOKLYN GANG. CONEY ISLAND. KATHY FIXING HER HAIR IN A CIGARETTE MACHINE MIRROR

BRUCE DAVIDSON

Date 1959
Location Coney Island, New York, USA
Format 35 mm

This is one of the *Brooklyn Gang* series of almost seventy photographs that Bruce Davidson (born 1933) took in the summer of 1959. He had read about teenage gangs in New York and contacted a social worker with the intention of finding a gang he could observe and document. Aged twenty-five years, Davidson was not much older than his adolescent subjects, and he later said: "[They] were about sixteen. I could easily have been taken for one of them."

Davidson spent every day that summer with the members of a teenage gang known as the Jokers, photographing them with his Leica. This picture shows some of the youngsters on a day trip to a Coney Island bathhouse. A girl, Kathy, is fixing her hair using the mirrored panel of a cigarette machine. Her male friend rolls up a sleeve. They seem modeled on film stars, Brooklyn's answer to Brigitte Bardot and James Dean. **CK**

FIDEL CASTRO RIDING INTO HAVANA

BURT GLINN

Date 1959
Location Havana, Cuba
Format 35 mm

The story goes that Burt Glinn (1925–2008) was at a New Year's Eve party in New York City when conversation turned to the impending fall of the Batista regime in Cuba. Borrowing money, Glinn got the first plane out and was in Havana at 7 a.m. the following morning. Over the next ten days, he covered unfolding events on the streets, documenting Fidel Castro's triumphant entry into Havana and striking up an unusual friendship with the new Cuban leader. In this picture he turned political turmoil to his advantage, capturing the energy and joy of the moment while maintaining control of the composition. Castro and the jeep in which he is traveling are almost obscured by the crowd and armed soldier escorts.

Most of the images from this shoot were unpublished for many years. Finally they were collected into a book, *Havana: The Revolutionary Moment*, in 2002, not long after Glinn had been reunited with the Cuban leader again in his office, where they reminisced about the glories of the Cuban Revolution. NG

NIKITA KHRUSHCHEV IN FRONT OF THE LINCOLN MEMORIAL

BURT GLINN

Date 1959
Location Washington, D.C., USA
Format 35 mm

Burt Glinn (1925–2008) was one of the first crop of Magnum agency photographers, alongside Eve Arnold and Dennis Stock.

This iconic image of the back of the head of Soviet premier Nikita Khrushchev was captured by chance. Having failed to get the correct press accreditation for the shoot, Glinn missed the crucial position in the front row of photographers. Finding himself at the back, he managed to make the best of a less-than-ideal situation and created a photograph whose originality lies partly in its divergence from the norm. NG

ROOFSCAPE, WHITBY

EDWIN SMITH

Date 1959
Location Whitby, UK
Format Large format

Britain has a wonderfully rich architectural heritage, but during the twentieth century much of it was lost through a combination of warfare, neglect, philistinism, bad planning, and weak legislation. In the fight to reverse this trend, photography has played a key role, not only in documenting the loss of buildings and bolstering the arguments for preservation, but also by raising public awareness.

Edwin Smith (1912–71) was one of Britain's finest architectural and topographical photographers, whose work reflected an emotional response to the buildings he loved. After studying at the Architectural Association, London, he worked as a draftsman, turning to photography only in 1935. In the 1950s, he and his wife, the writer Olive Cook, collaborated on a series of books that included *English Parish Churches* (1952) and *English Cottages and Farmhouses* (1954). The couple had a shared vision, which was essentially nostalgic and at odds with the modernizing spirit of the times. Smith's photographs are mostly in black and white: they rarely include figures, and their even tonality exudes an air of calmness and tranquillity. He even rejected modern equipment, preferring to use half-plate and quarter-plate cameras.

Smith's photographs often feel elegiac, a mournful homage to a lost way of life. This Whitby roofscape picture seems more celebratory, however. Framed between chimneys, the view takes in the northern port as it is illuminated by the early morning sun. There is a painterly feel for texture and atmosphere, the smoke diffusing the light and creating the sense of a human presence—of a day about to begin. **JS**

"In a shorter time than we care to think, these photographs, which now portray a living present, will merely record a vanished past."

Olive Cook

AFTER VAN DONGEN

NORMAN PARKINSON

Date 1959
Location London, UK
Format Unknown

After van Dongen is a typically whimsical image from celebrated British fashion photographer Norman Parkinson (1913–90). It shows model Adele Collins wearing a red velvet toque by Otto Lucas and a flannel suit by Bazaar.

The image was Parkinson's homage to Dutch artist Kees van Dongen's painting *The Corn Poppy* (1919). The Fauvist painter's sensual portrait is of a girl wearing a gray jacket and a red hat against a mustard-colored background. The subject in the painting has bright-red lips with large, exaggerated eyes looking sideways beyond the picture frame. Likewise, Parkinson's picture portrays Collins's pale face using daring soft focus to accentuate her kohl-rimmed eyes looking askance, and scarlet red lips that match her hat. Parkinson departs from the portrait that inspired him by photographing his model against a heavily textured but worn backdrop of brocade.

Parkinson was known for his crisp black-and-white photography, stylish storytelling, and use of exotic locations. What distinguishes *After van Dongen* is its focus on color; because the headdress is out of focus, the model's makeup is all the more striking to the viewer. Parkinson was conveying a look, using his camera to splash colors and shapes as artfully as a painter with a paintbrush.

The photograph was published in the November 1959 edition of British *Vogue*. Parkinson evidently felt some pride in it, because he selected a variant of the image for the cover of the catalog accompanying his 1981 solo exhibition at the National Portrait Gallery in London. **CK**

"[Parkinson] always called them 'snaps,' he didn't make a big deal of it. But photography didn't have a value at that point, it wasn't really considered art, it was a job—an extremely nice job."
Grace Coddington

THE KITCHEN DEBATE

ELLIOTT ERWITT

Date 1959
Location Moscow, Russia
Format 35 mm

In late 1958, an agreement was signed between the USSR and the United States to promote greater cultural exchange. Two trade exhibitions were arranged for 1959: a USSR exhibition in New York, and a US exhibition in Moscow. The aim was to showcase the culture, technical advancements, and economies of each nation.

However, during the grand opening ceremony of the American National Exhibition in Moscow on July 24, Vice President Richard Nixon and Soviet leader Nikita Khrushchev launched into a heated debate on capitalism and communism. Their disagreement became known as the "kitchen debate" because it took place in a mock kitchen set up for the fair. In this image taken by Elliott Erwitt (born 1928), Nixon jabs an accusing finger at the impassive Soviet leader's chest; while Khrushchev maintains his composure, Nixon looks enraged, his jaw jutting out in anger. One of the most famous episodes of the Cold War, the "kitchen debate" made front-page news the following day. EC

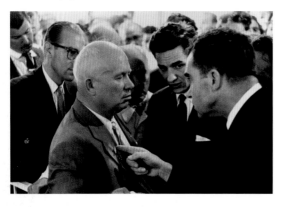

YOUNG MAN WITH A FLOWER

SEYDOU KEÏTA

Date 1959
Location Mali
Format 35 mm

One of the greatest photographers of the twentieth century, and one of the principal evangelists of the medium in Africa, Seydou Keïta (1921–2001) lived in Bamako, Mali. His career in photography began in 1948 when he opened a portrait studio in the city. As he began to establish his style, word spread of his extraordinarily original portraits, and clients flocked to pose for him. The self-taught photographer had a gift for capturing his sitters' personalities, usually in just a single shot—for economic reasons—and always in daylight. Today, his collection of portraits has the additional role of providing an enduring document of the people of Mali in the second half of the twentieth century.

Keïta was always willing to photograph his subjects exactly as they chose to be depicted. The sitters would often choose to don European dress or bring European accessories into the shot—such things were popular in Africa in the 1960s and 1970s. In *Young Man with a Flower*, Keïta's subject, wearing a white suit jacket and wide-rimmed glasses, is the epitome of fashion. He sits perfectly composed, while his gaze reveals a rapport between photographer and subject.

Keïta, whose work was little known in Europe and North America until the 1990s, remarked of his practice: "It's easy to take a photo, but what really made a difference was that I always knew how to find the right position, and I never was wrong. Their head slightly turned, a serious face, the position of the hands . . . I was capable of making someone look really good. The photos were always very good. That's why I always say that it's a real art." LH

JOHN WAYNE ON THE SET OF
THE ALAMO

DENNIS STOCK

Date 1959
Location USA
Format 35 mm

The star of more than 100 Hollywood movies, John Wayne epitomized American machismo as he fought to uphold the right in almost all his screen appearances, particularly those set in the Wild West. Off set, however, he struggled to live up to his image. "The guy you see on the screen isn't really me," he once said. "I'm Duke Morrison, and I never was and never will be a film personality like John Wayne. I know him well. I'm one of his closest students. I have to be. I make a living out of him."

This image shows Wayne on the set of *The Alamo* (1960), which he directed and starred in as Davy Crockett. Taken by Dennis Stock (1928–2010), it reveals the gap between the illusions on the silver screen and some of the banal realities from which they are created. The magnificent horse that would appear in the finished movie is being carried by a prop man without much effort because it is not made from flesh and blood but of papier-mâché.

Stock was famous for his intimate portraits, not only of movie stars, but also of hippies and motorcycle gangs. **EC**

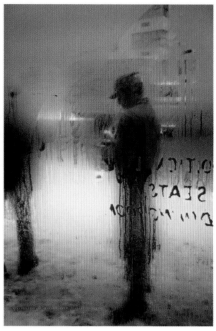

SNOW

SAUL LEITER

Date 1960
Location New York, New York, USA
Format 35 mm

Saul Leiter (1923–2013) was a photographer's photographer, who dedicated his life to the medium, not for want of fame but simply through the desire to create. He was loosely part of the New York school of photographers in the 1940s, a group that included the better-known Diane Arbus and Robert Frank, but he remained largely under the radar, by choice, until late in his career. Leiter began as a painter, but photography soon became equally important to him and he showed a unique eye for color. The image pictured here, like most of Leiter's work of the 1950s and 1960s, is the result of him roaming the streets of New York in search of light, shapes, and colors; beauty emerges when these come together in a single image. **LH**

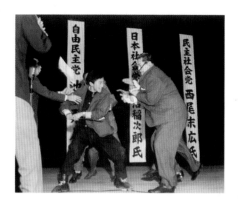

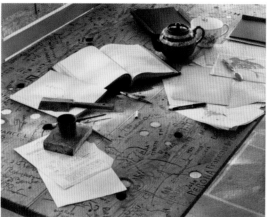

ASSASSINATION OF SOCIALIST PARTY CHAIRMAN IN JAPAN

YASUSHI NAGAO

Date 1960
Location Tokyo, Japan
Format 35 mm

This image was taken during a televised election debate between the incumbent Japanese Prime Minister, Hayato Ikeda, and the Socialist Party chairman, Inejiro Asanuma. Asanuma criticized the government for its mutual defense treaty with the United States, and right-wing students began to heckle him. Suddenly, Otoya Yamaguchi, the seventeen-year-old son of a Self-Defense Force colonel, forced his way through a police cordon and plunged his sword into Asanuma. He chose to use a *wakizashi*, a traditional samurai sword that meant he would have to get close to his victim and stab him with conviction. He is seen here being restrained from attempting a second blow. Yamaguchi was a member of an ultranationalist right-wing group that sought to rid Japan of Western influence.

Yasushi Nagao (1930–2009) was the only photographer present to catch the moment of the assassination, using the last frame in his camera. The frantic body language of all the participants adds a chilling element to the scene. The image won Nagao the 1961 Pulitzer Prize as well as the 1960 World Press Photo of the Year Award. CJ

THE DESK WHERE *THE LITTLE PRINCE* WAS WRITTEN

ANDRÉ KERTÉSZ

Date 1960
Location Connecticut, USA
Format 35 mm

This beautiful image of the desk where Antoine de Saint-Exupéry began *The Little Prince* is deeply resonant of the imaginative work of the mind. Saint-Exupéry wrote the novel in New York, where he had fled after the fall of France in 1940, spending time at the studio at 3 East 52nd Street of fellow exile, French painter Bernard Lamotte. The table is inscribed by the circle of friends around Lamotte, as well as a boyish figure of the prince carved into the wood by Saint-Exupéry himself.

André Kertész (1894–1985) took this evocative photograph while working on a story on Lamotte for *House and Garden*. The painter was at that time living in rural Connecticut.

Kertész photographed hundreds of famous homes and locations for the magazine, which published more than 3,000 of his images. However, he complained that the deal restricted his artistic freedom, and in 1961 he quit. His work then gained the international recognition it deserved. PL

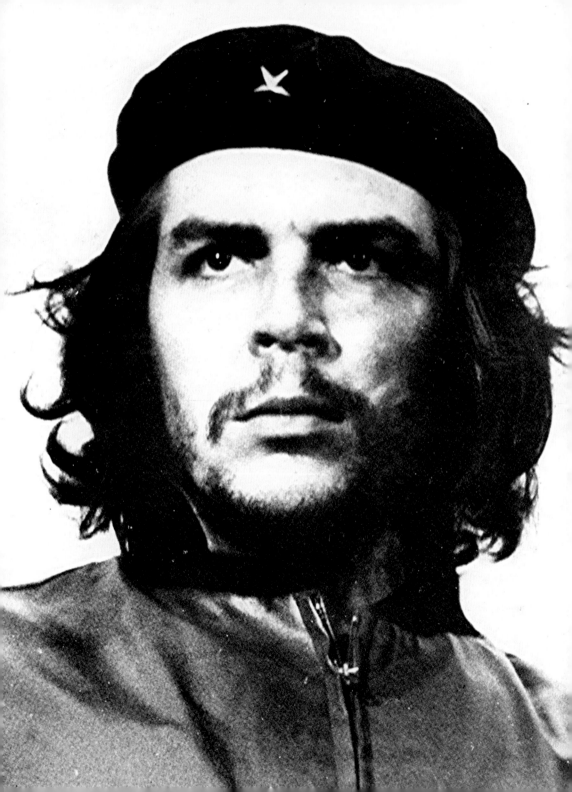

GUERRILLERO HEROICO
(HEROIC GUERRILLA FIGHTER)

ALBERTO KORDA

Date 1960
Location Havana, Cuba
Format 35 mm

Until 1959, Cuban photographer Alberto Diaz Guttierez (1928–2001) had been a fashion photographer with his own studio in Havana. He took the name "Korda" in homage to Hungarian movie directors Alexander and Zoltan. But all that changed almost overnight when he gave up his old life, befriended the new leader of Cuba, Fidel Castro, and became one of the principal photographers of the Cuban Revolution. He took many photographs of Castro and his second in command, Argentine Ernesto "Che" Guevara.

Korda captured this image of Guevara with what he called an "implacable" expression while they were attending a memorial service for victims of a mysterious explosion on the French freighter *La Coubre* as it was docked in Havana Harbor on March 4, 1960, which killed seventy-five people. Although Korda printed the photograph and hung it on the wall of his studio in quiet admiration, it received little notice until it found its way into *Paris Match* in 1967, the same year in which Guevara was assassinated by the Bolivian army while fighting for the poor in the Latin American country.

Since then, the image has been reproduced on almost every surface known to humankind, including tattoos, T-shirts, posters, and billboards. This has happened so many times and in so many different circumstances that one museum curator has described it as the most reproduced photograph in history. In the true spirit of Marxism, Korda never asked for royalties for the image and believed that his photograph was meant to be shared freely throughout the world, as long as it was for the "right" reasons. SY

EAGLES AT GIANTS

JOHN G. ZIMMERMAN

Date 1960
Location New York, New York, USA
Format 35 mm

John G. Zimmerman (1927–2002) was the staff photographer at *Sports Illustrated* magazine from 1956 to 1963. During his tenure he changed the shape of sports photography through technological innovations, from electronic lighting to remote-controlled cameras.

This iconic photograph shows Philadelphia Eagles' linebacker Chuck Bednarik after his tackle of New York Giants' fullback Frank Gifford at Yankee Stadium on November 20, 1960. Bednarik knocked out Gifford, who is shown lying on the ground before being stretchered off the field. He had fractured a vertebra in his neck, and his football career appeared at an end, but in 1962 he did return to playing. Zimmerman's image shows Bednarik pumping his arms, apparently enjoying the fact that his opponent lies supine and unconscious. Bednarik denied taunting Gifford, insisting he was merely celebrating the Eagles having recovered Gifford's fumble, virtually guaranteeing a victory that would take them to that season's championship. The truth of the story is still being debated. CK

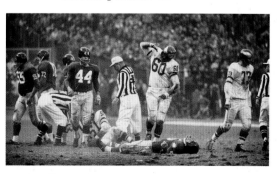

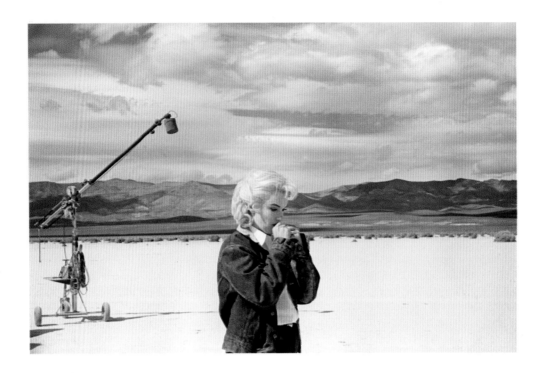

MARILYN MONROE ON THE SET OF *THE MISFITS*

EVE ARNOLD

Date 1960
Location Nevada, USA
Format 35 mm

The story goes that when Eve Arnold (1912–2012) met Marilyn Monroe, the star approached the photographer, congratulating her on her portraits of Marlene Dietrich. Playfully, Monroe asked, "If you could do that well with Marlene, can you imagine what you can do with me?" Arnold and Monroe spent the best part of a decade finding out. It really was a collaboration: Monroe posed while Arnold pressed the shutter, but Arnold later said that Monroe was "in total control . . . she manipulated

everything—me, the camera." The result was a detailed, ever-changing portrait of a capricious and highly self-aware subject, as well as a sensitive reappraisal of the most photographed celebrity of the mid-twentieth century.

Arnold took this image on the set of the 1961 movie *The Misfits*. Written by Arthur Miller, it was an infamously troubled project, given that Miller's marriage to Monroe was falling apart and both were drinking heavily, as was the director, John Huston. With an anxious Monroe framed against, and isolated by, the emptiness of the desert landscape, a solitary microphone standing stark and accusing, the photograph communicates a great deal about the loneliness of fame. AD

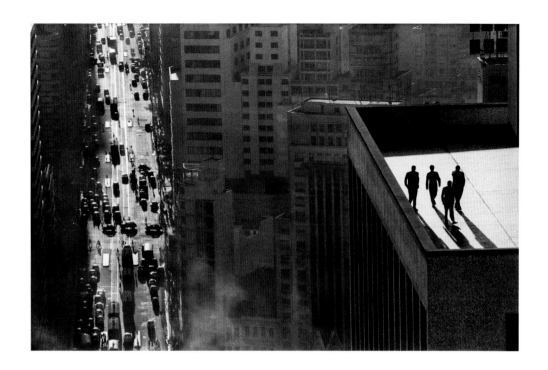

MEN ON A ROOFTOP

RENÉ BURRI

Date 1960
Location São Paulo, Brazil
Format 35 mm

René Burri (1933–2014) joined the prestigious Magnum Photos in 1955 and worked internationally as a photojournalist for a wide variety of magazines. While on assignment for *Praline* magazine on a story about the Brazilian city São Paulo, Burri was on the lookout for a different perspective on the city when he came across this stunning vista. He recounted, "I went up there out of curiosity. I remember taking the elevator to the roof. Buildings weren't guarded in those days; they didn't have guardians as they have now. It was a question of getting to the top and knocking on the door . . . I walked out onto the terrace and at that moment those guys came from nowhere and I shot five images." The image compresses the perspective of the city, contrasting the silhouetted businessmen dramatically against the teeming street below, suggesting that these "masters of the universe" are controlling the world from above. Ironically, Burri's use of a telephoto lens broke one of the unwritten rules of Magnum, as he explained: "Cartier-Bresson limited us to lenses from 35mm to 90mm . . . The lens I used was 180mm—I never told him! At that point I broke loose from my mentor. I killed my mentor!" PL

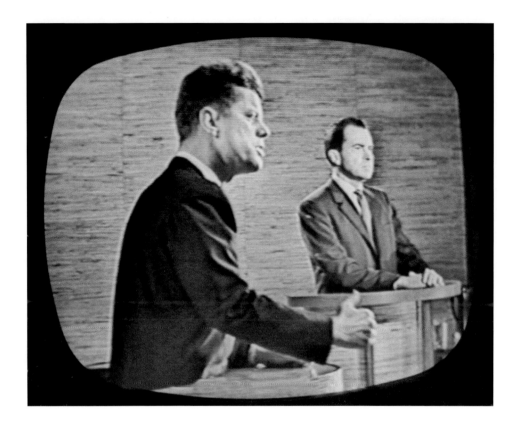

NIXON VS KENNEDY TV DEBATE

PAUL SCHUTZER

Date 1960

Location Chicago, USA

Format 35 mm

On September 26, 1960, over 70 million viewers tuned in to watch the first ever nationally televised presidential debate. In the sixty-minute broadcast, Democratic Senator John F. Kennedy dueled against Republican Vice President Richard Nixon. Until then, Kennedy was a little-known senator from Massachusetts, but by the end of the day he had become a star. The televised debate was a pivotal turning point for political campaigns. Up until that point, people rarely got the chance to see the candidates, they could only read about them. Now people could see the candidates' every movement and gesture. On screen, Nixon appeared pale and disheveled after a recent hospitalization, but Kennedy was alert and camera ready. Television certainly played a major role in his victory.

Life photographer Paul Schutzer (1930–67) began taking pictures after spotting a broken camera in a waste bin in Brooklyn, New York. He studied to be a painter and a lawyer before finding his real passion in photography. Working as a photojournalist, Schutzer frequently accepted risky assignments. Tragically, he died aged thirty-seven in the Negev Desert when the Israeli half-track he was traveling in was hit by a 57-mm Egyptian shell. EC

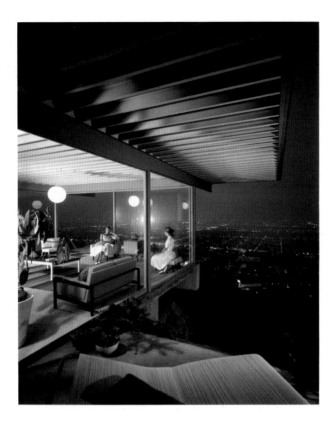

CASE STUDY HOUSE #22

JULIUS SHULMAN

Date 1960
Location Los Angeles, California, USA
Format Large format

The skillful compositions and intuitive sense of architectural space demonstrated in the photography of Julius Shulman (1910–2009) have come to define our perception of the spare beauty of mid-twentieth-century Californian modernism. Shulman photographed iconic buildings designed by acclaimed architects—including Frank Lloyd Wright, Pierre Koenig, Charles Eames, Richard Neutra, and Raphael Soriano—and imbued them with a vision of the age.

Shulman's photographs contextualized the structures within their surrounding landscapes, while his clarity of vision and precise compositions still retained a strong sense of human presence, even when there were no people to be seen. The image reproduced here, perhaps his most widely acclaimed photograph, is of the Stahl House, a modernist-style home with floor-to-ceiling glass walls, designed by Koenig in the Hollywood Hills area of Los Angeles. Constructed in 1959 as part of the Case Study Houses program, the building has since been used as a symbol of Los Angeles in fashion shoots, movies, and advertising campaigns, and was declared a Historic–Cultural Monument in 1999. PL

SUE LYONS AS LOLITA

BERT STERN

Date c. 1960
Location USA
Format 35 mm

Bert Stern (1929–2013) was raised in Brooklyn, New York. Dropping out of school, he worked in the mail room at *Look* magazine before becoming an art director at *Mayfair*. Drafted into the US Army during the Korean War (1950–53), he served in a photography unit. In the early 1960s he undertook a series of highly paid commissions and shoots with some of the biggest stars of the era.

While at *Look*, Stern had become friendly with Stanley Kubrick, who was then a photojournalist but later moved into cinema. In 1960, Kubrick was established in Hollywood, working on an adaptation of Vladimir Nabokov's novel *Lolita*, which explores the obsessive relationship between a middle-aged man and young girl, played in the film by Sue Lyons. Stern produced a series of photographs of Lyons on set: some were published shortly afterward in *Look*; others were used for publicity. Kubrick's movie caused a great furor on its release, despite the fact that the director had changed Lolita's age from twelve to sixteen. **LB**

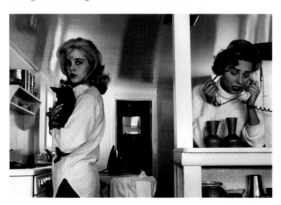

DAVID BAILEY AND VERUSCHKA, *VOGUE*, 1961

BERT STERN

Date 1961
Location New York, New York, USA
Format Unknown

Five years before Michelangelo Antonioni's movie *Blow-Up* (1966) disseminated the myth of the glamorous photographer—with his luxurious lifestyle and parade of beautiful models—Bert Stern (1929–2013) took this photograph of German model Veruschka von Lehndorff and British fashion photographer David Bailey. Although Bailey was the inspiration for the photographer–protagonist of the movie, Stern was already establishing himself with his evocative imagery (of stars such as Elizabeth Taylor and Audrey Hepburn) and his own flamboyant lifestyle. (Veruschka subsequently had a five-minute appearance in *Blow-Up*, which catapulted her to fame and supermodel status.)

Stern started out in advertising and changed the face of that industry in 1955 with his campaign for Smirnoff vodka, which was shot in the imaginative and romantic style of fashion photography. His photoshoots for fashion magazines and advertising clients became happenings: account executives, writers, businessmen, and hangers-on would come to the set to watch him work. He infused fashion photography with an energy that reflected his world, and the vitality and playfulness of the 1960s shines through all he did.

Here, Veruschka commands our attention with her eyes as her statuesque body dances above Bailey who, camera in hand, lies beneath the model, seeming to capture her every move. Bailey's position in the shot in fact mimics one of Stern's preferred photoshoot techniques. Stern could have been photographing himself in this memorable double portrait of hip photographer and beautiful fashion model. **RF**

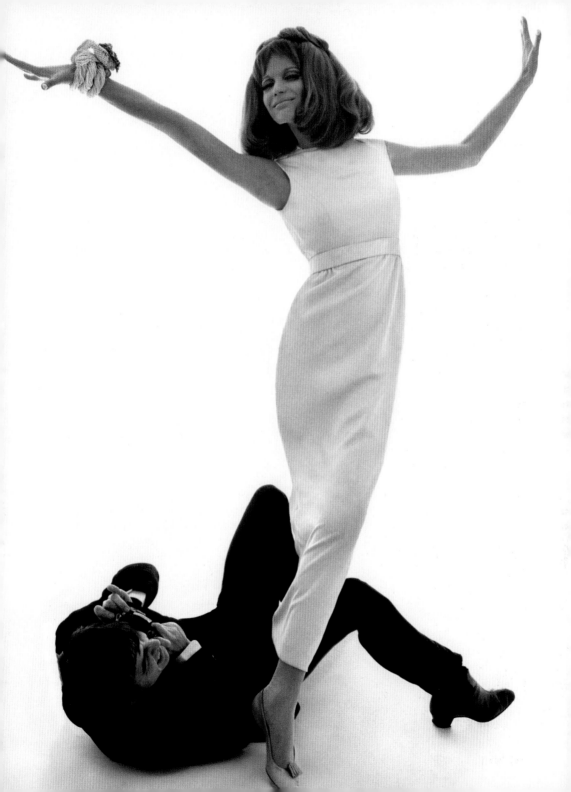

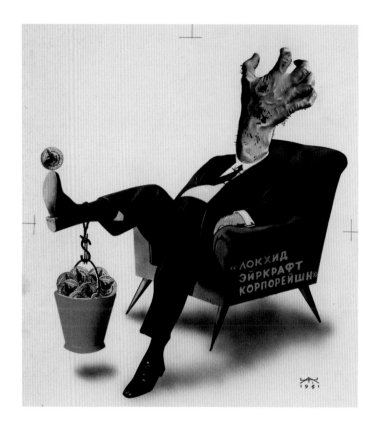

LOCKHEED AIRCRAFT CORPORATION

ALEXANDER ZHITOMIRSKY

Date 1961
Location Moscow, Russia
Format Unknown

The technique of photomontage, which had been pioneered in the early twentieth century by such artists as John Heartfield (1891–1968) and Alexander Rodchenko (1891–1956), enjoyed extensive use in the Soviet Union as a medium of political propaganda. But few Soviet artists since Rodchenko used the medium as effectively as Alexander Zhitomirsky (1907–93). After studying art, Zhitomirsky worked as a poster designer and illustrator for magazines, and then as a caricaturist and art director. During

World War II he produced propaganda to support the Soviet war effort, including magazines aimed at German soldiers. After the war, he became the art director for *Soviet Union Magazine*, a post he held until shortly before his death.

Zhitomirsky employed various photomontage techniques during his career. The image shown here is typical of Zhitomirsky's work of the Cold War period (1947–91). It depicts the Lockheed Aircraft Corporation, a major American military contractor, as a bloated businessman with a corpselike hand for a head, balancing a bucket of dollar coins emblazoned with an American eagle on one leg. Made in 1961 at the height of the Vietnam War, its subtext of war profiteering cannot be missed. **LB**

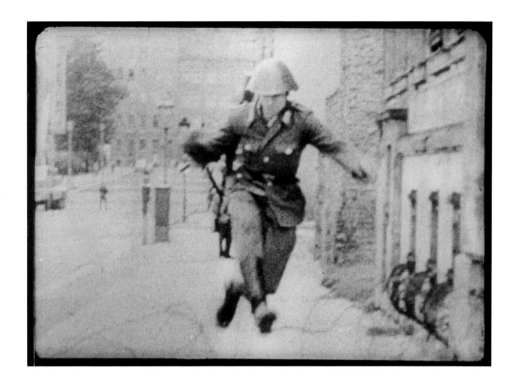

CONRAD SCHUMANN JUMPING A BARBED-WIRE FENCE DURING CONSTRUCTION OF THE BERLIN WALL

UNKNOWN

Date 1961
Location Berlin, Germany
Format 35 mm

Construction of the Berlin Wall began on August 13, 1961, encircling West Berlin in a ring of barbed wire and barricades. Two days later, nineteen-year-old East German soldier Conrad Schumann made his extraordinary break for freedom, as captured in this historic image. Schumann was sent to patrol the new border at the corner of Ruppiner Strasse and Bernauer Strasse, when he seized his chance to escape. Encouraged by the crowds on the West German side, Schumann vaulted over the wire and

was picked up by a waiting police car. "My nerves were at breaking point," he remembered. "I was very afraid. I took off, jumped, and into the car . . . in three, four seconds it was all over."

Several photographers captured the moment, and it became an enduring symbol of Cold War repression. For Schumann, however, it became a heavy burden. Despite building a new life in the West, he suffered from depression and in 1998 he committed suicide. The initial barbed wire barrier was quickly reinforced into a concrete wall with landmines and a wide no-man's-land, to provide a clear line of sight for the soldiers guarding the barrier, who were given orders to shoot at anyone trying to flee East Germany. PL

SELF-PORTRAIT

JOSIP BROZ TITO

Date 1961
Location Brijuni, Croatia
Format 35 mm

The personality cult of Josip Broz Tito (1892–1980)—first president and founding father of the Socialist Federal Republic of Yugoslavia—pervaded every corner of the state. The Croatian—an anti-Nazi partisan in World War II—was celebrated in parades and honored as a liberator and a unifier. Cities, streets, and public buildings were named for him, and his portrait was printed on banknotes and hung in private houses, schools, and company premises. He had an entourage of personal photographers who documented his every move, celebrating state visits to foreign countries as well as domestic events. Tito kept many of the resulting images for his own private collection, amassing 708 boxes of around 132,000 photos, which are kept by the Museum of Yugoslav History in Belgrade, Serbia. He himself was also a keen amateur photographer.

This self-portrait in the sunroom of his summer residence on Brijuni island was shot with his favorite Leica camera. The image is surprisingly complex, with its repetitive use of vertical and horizontal lines and foliage, reminiscent of the seminal self-portraits by Lee Friedlander. Tito's casual attire and portly belly offer a refreshing antidote to the public image of the president of the people. **PL**

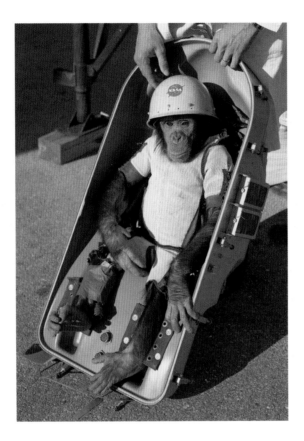

HAM THE CHIMP

NASA

Date 1961
Location Florida, USA
Format 35 mm

"Poyekhali!" ("We have lift-off!"): Russian cosmonaut Yuri Gagarin struck a confident tone as he launched into outer space, making history as the first human to do so. He was not the first hominid in space, though. That accolade went three months earlier to Ham the Chimp, pictured here.

Ham was captured in Cameroon in 1957 and taken to Miami Rare Bird Farm in Florida. Two years later, he was bought by the US Air Force and taken to Holloman Air Force Base in New Mexico to join thirty-nine other chimpanzees on a special training course established by the National Aeronautics and Space Administration (NASA) as part of Project Mercury—the program to put a human into space.

Ham had great publicity value and became something of a celebrity. This photograph, which shows him just before his flight into space from Cape Canaveral, Florida, aboard Mercury Redstone 2, was not released until after the mission was successfully completed. In fact, NASA did not even name him Ham—an acronym for "Holloman Aerospace Medical"—until his safe return, wary of negative public reaction if the mission did not go as planned. Until then he was known simply as Number Sixty-Five. RSH

EICHMANN IN PRISON

UNKNOWN

Date 1961
Location Nazareth, Israel
Format 35 mm

This photo shows Adolf Eichmann taking exercise near Nazareth while awaiting trial in Israel for war crimes. Eichmann was a Nazi SS officer during World War II who played a key role in the deportation of Jews to extermination camps in German-occupied Eastern Europe. At the end of the war, he fled to Argentina using a laissez-passer issued by the Red Cross. He lived in Argentina using a false identity, but in 1960 he was abducted by Mossad (Israeli intelligence), smuggled out of the country, and taken to Israel. During his trial in Jerusalem, Eichmann tried to present himself as a self-effacing technocrat of the German state, merely obeying orders. The prosecutors, however, produced documents signed by him showing his role in the mass extermination of Jews. Found guilty, Eichmann was hanged on May 31, 1962. **CJ**

MELTED BOTTLE, NAGASAKI, 1961

SHOMEI TOMATSU

Date 1961
Location Nagasaki, Japan
Format Medium format

This abstract image is disturbing on initial viewing. Muscular and organic, in grainy black and white, the subject resembles a skinned animal. From the caption we learn that it is in fact a bottle melted and distorted by heat radiation. It is one of the best-known photographs by Shomei Tomatsu (1930–2012), taken on a trip to Nagasaki in 1961 to document the city's recovery from the 1945 atomic bomb. Tomatsu was concerned that many of his compatriots were pushing this trauma aside as the nation strove to rebuild itself. The *Nagasaki* series records the effects of the bomb on objects such as this bottle, but also on people. Influenced by Surrealism, Tomatsu shot at unusual angles using stark shadow and light. **CP**

ORDEAL BY ROSES
(*BA-RA-KEI*) #15

EIKOH HOSOE

Date 1961
Location Tokyo, Japan
Format Large format

WALES

PHILIP JONES GRIFFITHS

Date 1961
Location Pant-y-Wean, Wales, UK
Format 35 mm

Philip Jones Griffiths (1936–2008) is best known for his coverage of the Vietnam War (1954–75, but his photos of his native Wales have an enduring resonance. This image—one of the "decisive moments" postulated by Henri Cartier-Bresson, who had first inspired Jones Griffiths—was taken in Pant-y-Wean, which was voted the most beautiful village in South Wales in the 1930s, but by the 1960s had long since been obliterated by opencast mining. The scene almost resembles a war ground, and the decline of the landscape seems reflected in the bleak overcast sky. The original caption read: "This young boy epitomizes our Welsh ambivalent love for both rugby and music. . . . When I asked what he was doing, he replied, 'My mother gave it to me to mend.'" EC

This image belongs to a series by Japanese avant-garde photographer and moviemaker Eikoh Hosoe (born 1933). Inspired by and modeled on the writer Yukio Mishima, the work is a dark and erotic exploration of the male body, life, and death.

Hosoe and Mishima were brought together when a portrait was commissioned for the cover of one of Mishima's books. The relationship between photographer and subject developed over the course of ten visits to the writer's home, and from this a creative collaboration—Hosoe called it a "subjective documentary"—emerged. It was Mishima's wish that he himself should be viewed as merely the work's subject, but the reality is that his own imagination and dark, theatrical performance are key to it. The Baroque interior and objects in Mishima's house are also important, reflecting Hosoe's belief that a person's possessions express their soul. Part of the work's significance, and of its radical impact as a whole, lies in its deliberate departure from the traditional Japanese aesthetic values of purity and understatement. JG

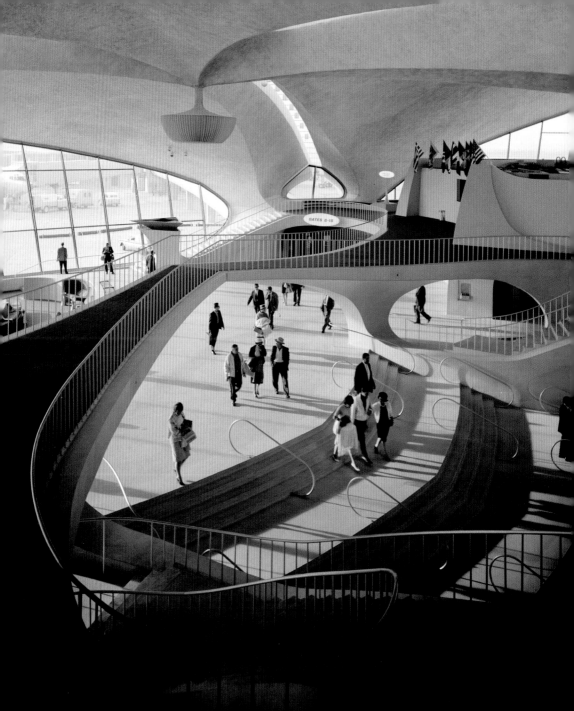

TWA TERMINAL AT JOHN F. KENNEDY AIRPORT (THEN IDLEWILD AIRPORT)

EZRA STOLLER

Date 1962
Location New York, New York, USA
Format Large format

Such was the esteem in which photographer Ezra Stoller (1915–2004) was held by the architectural community that his name was used as a verb; to have a building "Stollerized" was regarded as a great honor. Over his lengthy career Stoller documented more than 3,500 projects, producing more than 60,000 images of buildings and their architectural features. His compositions were sparse, clean, and elegant, and he stripped the spaces down to their essentials. Working with his trademark large-format 8x10 Deardorff or Sinar camera, he would often stay on location for days to get the perfect combination of framing and light, distilling the vision of the architect in question into a single image.

Stoller's influential photographs became virtually synonymous with the rise of modernist architecture, and his clients are a roll call of the movement's leading proponents, including Frank Lloyd Wright, Paul Rudolph, Marcel Breuer, I. M. Pei, Gordon Bunshaft, Richard Meier, Ludwig Mies van der Rohe, and Eero Saarinen. The last designed the iconic TWA (Trans World Airlines) terminal at New York's Idlewild (now John F. Kennedy) Airport, which is pictured here. Robert A. M. Stern described this structure as "the Grand Central of the jet age" (a reference to the historic and beautiful train station in Manhattan), and it was one of the first air terminals to have enclosed passenger jetways, baggage carousels, electronic schedule boards, and satellite gates away from the main terminal. The building was closed on the collapse of TWA in 2001, but in 2016 construction work began to turn it into a hotel. PL

FANS RUSH TO BUY TICKETS FOR FOOTBALL

TONY EYLES

Date 1962
Location London, UK
Format 35 mm

This black-and-white image, captured in October 1962 by Tony Eyles, shows policemen trying to contain a crowd rushing to the White Hart Lane box office of London team Tottenham Hotspur to buy tickets for their game against Glasgow Rangers in the second round of the European Cup Winners' Cup. Although the photograph was taken with a fast shutter speed, there is still some blurring, and a sense of movement and urgency is conveyed as the swarm surges forward. In the background stands a billboard advertisement for Guards cigarettes and Stock 84 brandy—the kind of advertising that has since become illegal in the United Kingdom.

The unruly crowd scene is exuberant, capturing the fans of the nation's best-loved sport, but there is an ominous note. Contemporary viewers are inevitably reminded of tragedies of the recent past, such as the Hillsborough disaster of April 1989, when a crowd surge crushed packed fans against barriers at the Football Association Cup semifinal between Liverpool and Nottingham Forest, and ninety-six people lost their lives. EC

UNTITLED (FROM *LA JETÉE*)

CHRIS MARKER

Date 1962
Location Paris, France
Format Movie still

A woman seen at an airport becomes a lifelong obsession for the narrator of the short movie *La Jetée* (*The Jetty*) by Chris Marker (1921–2012). She also becomes a vector of memory, enabling the movie's hero to return to the past in order to be with her forever. This icon of the cinema is included here because the movie is created almost entirely from still photographs. The narrator begins: "This is the story of a man, marked by an image from his childhood." From there, the viewer is taken

on a journey over twenty-nine minutes to a postapocalyptic Paris, where the trauma began.

The female face is described as a "unique image of peacetime" that happened to be inscribed on the protagonist's retina moments before (he later realizes) he saw someone die for the first time, at the start of World War III. The haunting face of the remembered woman from Paris Orly Airport turns out to be a signpost on the inevitable circular journey to his own death. Marker uses the power of the photographic image to capture life at the moment it becomes history. The still photograph, with its ability to freeze time, and its mutability when mixed with music and voiceover, made it an excellent vehicle for this task. MH

STANDARD, AMARILLO, TEXAS

PHILLIPS 66, FLAGSTAFF, ARIZONA
(FROM *TWENTYSIX GASOLINE STATIONS*)

ED RUSCHA

Date 1962
Location Arizona, USA
Format Self-published photo-book

Twentysix Gasoline Stations—from which this photograph comes—is an iconic photo-book. In a deadpan, factual style, Ed Ruscha (born 1937) documented each of the gasoline stations lining the route from his home in Los Angeles to that of his parents in Oklahoma City, arranging them in a carefully designed but cheaply reproduced format, initially in an edition of 400 numbered copies (and later in two unnumbered editions). The lack of emotion or subjectivity in the pictures is an important statement, in strong contrast with other photographers of the time who were concerned with having social messages or making statements about the world.

This represents a different kind of photographic seeing, in which the camera is a mute machine, perfectly suited to recording the mass-produced homogeneity of the modern industrialized world. In spite of also being well known as a painter, Ruscha revealed in 2008: "Although I was painting pictures at that time, I felt that the books were more advanced as a concept than the individual paintings I had been doing." His use of the self-published book format was completely new and remains hugely influential. JG

CZECHOSLOVAKIA

JOSEF KOUDELKA

Date 1962
Location Czechoslovakia
Format 35 mm

Josef Koudelka (b. 1938) studied at the Czech Technical University in Prague before staging his first photographic exhibition. His first paid assignments were for the Czech theater magazine *Divaldo*, in 1961. Later, as in-house photographer of Prague's avant-garde Theater Behind the Gate, founded in 1965, Koudelka produced compelling, stylish, and unique images of its productions. In 1967 he gave up his parallel career in aeronautical engineering in favor of full-time photography.

This high-contrast photograph, which depicts two abstract shapes suspended on a pale background, was taken in 1962, during Koudelka's earliest phase as a theater photographer. The figures—one standing, one reclining—seem to melt upon the pale surface, like drops of ink on wet paper. The image is remarkable in its simplicity and, despite its distortion, captures the expressive body postures of the two figures admirably: the tall and domineering pose of the male figure on the left, and the distinctly feminine pose on the right. The image demonstrates Koudelka's bold and experimental approach to photography at this early time. It exemplifies the beginning of an extraordinary and highly eventful career. EC

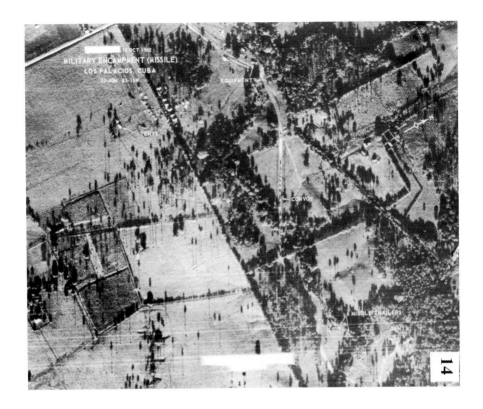

MILITARY ENCAMPMENT (MISSILE)
LOS PALACIOS, CUBA
22 JUN 93-15M

EQUIPMENT

TENTS

CONVOY

MISSILE TRAILERS

14

U-2 PHOTOGRAPH OF FIRST INTERMEDIATE-RANGE BALLISTIC MISSILE SITE FOUND UNDER CONSTRUCTION

CIA

Date 1962
Location Los Palacios, Cuba
Format Unknown

At the end of World War II, it became clear that any future global conflict could be between the United States and the Soviet Union. At that time the US military had little information about the layout or military facilities of the Soviet Union, and was still often relying on aerial photographs taken years earlier by the German air force. With the Soviet Union deploying sophisticated anti-aircraft defenses, it was hard to acquire new overhead images. This problem, and an atmosphere of

competition between the US Air Force and the Central Intelligence Agency (CIA), led the latter to develop the Lockheed U-2, an ultra-high-altitude reconnaissance aircraft designed to fly higher than enemy missiles or fighter aircraft could reach.

In 1962, the U-2 played a key role in the Cuban missile crisis, when images taken by the aircraft revealed Soviet forces building intermediate-range ballistic missile sites on the Caribbean island— only 110 miles (177km) from the coast of Florida. The resulting standoff brought the world to the brink of nuclear conflict but is credited with ultimately leading to a more stable relationship between the two superpowers, including the installation of a telephone hotline for direct communication. LB

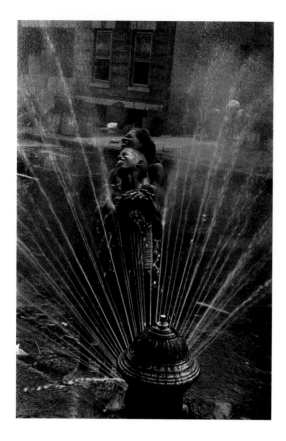

HARLEM

LEONARD FREED

Date 1963
Location Harlem, New York, USA
Format 35 mm

Many of the greatest photographs capture a split second in time in which everything comes together to make a perfect image. Often these photos look effortless, but they usually require endless patience and quick reflexes. This energetic and liberating image by Magnum photographer Leonard Freed (1929–2006) captures the joy of a woman and child as cold water gushes from a fire hydrant on a hot day in Harlem. Freed's composition is faultless; he has framed the pair as they break into the streams

of water, creating a fanlike effect that leads the eye directly to their heads, which are thrown back in laughter and sheer enjoyment.

The son of working class Jewish immigrants, Freed grew up in Brooklyn and began taking photographs in 1953 on a trip to Europe. In 1954 he returned to the United States, where he studied in Alexei Brodovitch's famous "design laboratory." His first major body of work saw him return to his family's roots in Europe and in 1965 he published *Made in Germany*. He felt that photography was a means of personal self expression, maintaining that it "is about who you are. It's the seeking of truth in relation to yourself. And seeking truth becomes a habit." PL

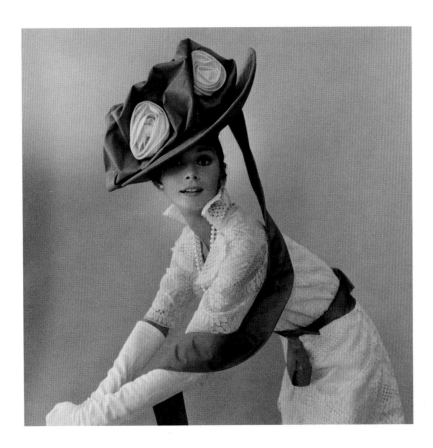

AUDREY HEPBURN, *MY FAIR LADY*

CECIL BEATON

Date 1963
Location Hollywood, California, USA
Format Medium format

Fashion photographer and society portraitist Cecil Beaton (1904–80) took this photograph of actress Audrey Hepburn for the December 1, 1963, edition of *Vogue* magazine. It captures Hepburn, as Eliza Doolittle, during the filming of George Cukor's musical *My Fair Lady* (1964). The movie is based on George Bernard Shaw's play *Pygmalion* (1913). Eliza is a Cockney flower girl who takes elocution lessons from phonetics professor Henry Higgins so that she can pass herself off as a lady.

This elegant photograph marks a high point in Beaton's illustrious career: he had created the costumes and also worked on the art direction for the movie version of *My Fair Lady*, earning one Academy Award for Costume Design and sharing another Oscar for Art Direction. By the time Beaton took this shot, he had known Hepburn for more than a decade, and his image portrays her svelte beauty. However, he was not simply photographing a sitter; he was also showing off his own Edwardian costume design, and his picture emphasizes the sweep of the romantic curves of Hepburn's hat and the lavish detail on the bodice of her gown as much as Hepburn's gamine charm. CK

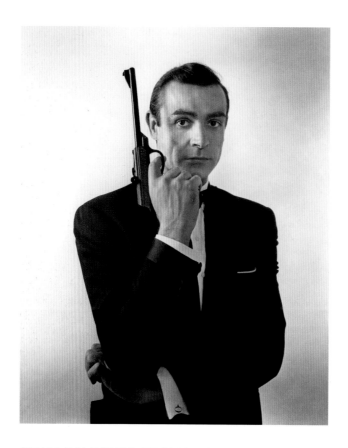

SEAN CONNERY, *FROM RUSSIA WITH LOVE*

DAVID HURN

Date 1963
Location London, UK
Format 35 mm

As stories behind the making of photographs go, the tale about the pistol in this iconic image of Sean Connery as James Bond in the movie version of Ian Fleming's novel *From Russia with Love* is among the most remarkable and humorous.

Magnum agency photographer David Hurn (born 1934), who took the picture, which was used on publicity posters around the world, recounted how it came to be that his own air pistol was used for the shoot. Members of the film production team were assembled in Hurn's photography studio, ready for the shoot to begin, but they had forgotten to bring a gun for Connery to pose with. Thinking on his feet, Hurn, who used to do target practice as a hobby, reassured publicist Tom Carlile that all would be well because he had a Walther air pistol that he could lend them. The designers could cut the pistol to its correct length in postproduction, Hurn said, and besides, since Bond used a Walther PPK in the film, no one would know the difference. And he was right. Only one newspaper picked up on the detail, the photographer recalled, which was all the more incredible since the design team had forgotten to amend the length of the pistol. GP

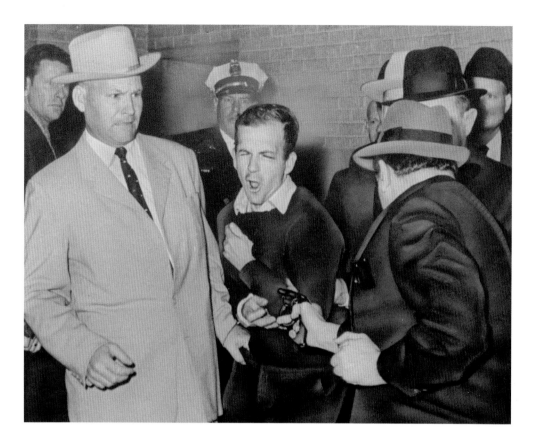

SHOOTING OF LEE HARVEY OSWALD

BOB JACKSON

Date 1963
Location Dallas, Texas, USA
Format 35 mm

On November 24, 1963, *Dallas Times Herald* photographer Bob Jackson (born 1934) was sent to capture the transfer of Lee Harvey Oswald— alleged assassin of President John F. Kennedy—to the county jail. With his Nikon S3 35 mm camera, Jackson captured the murder of Oswald by Jack Ruby, who sprang out with a pistol in the basement of Dallas police station, just as Oswald emerged.

Two days earlier, Jackson's career had been jeopardized when he failed to document one of the most significant events in US history: the assassination of JFK as he was motorcaded through the city. He had been in the process of reloading his camera just as the shots were fired. But in this atoning photograph, Jackson captures the horror and drama of the moment—something that rival photographer Ira Jefferson "Jack" Beers failed to do in his image, taken just six-tenths of a second before. As Ruby fired his shot, Jackson— this time prepared—tripped his shutter. In the photo Oswald's face is contorted in pain as the bullet hits. His killer, a Dallas nightclub owner, later told police that he was hell-bent on avenging the president's death. Jackson's iconic image succeeds in telling us the full story in a single frame. EC

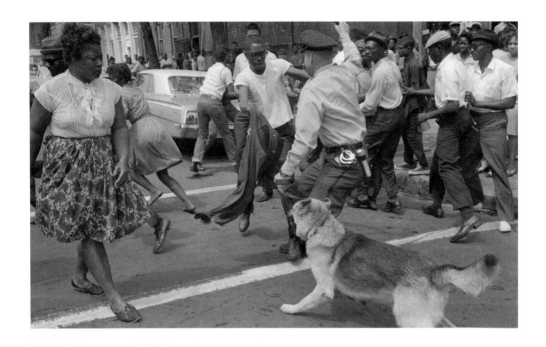

POLICEMEN USE DOGS DURING CIVIL
RIGHTS DEMONSTRATIONS

CHARLES MOORE

Date 1963

Location Birmingham, Alabama, USA

Format Unknown

From 1958 to 1965, photographer Charles Moore (1931–2010) captured tumultuous events during the rise of the civil rights movement in the United States. This picture of policemen with dogs calmly attacking civil rights protesters in Birmingham, Alabama, was published in *Life* magazine and led to a national outcry. Politicians duly took note: the historian and former adviser to President John F. Kennedy, Arthur M. Schlesinger, Jr., commented later that Moore's photographs "transform the national mood and make legislation not just necessary . . . but possible."

Moore followed civil rights leader Martin Luther King, Jr., as he preached, prayed, and marched, and was the only photographer present in 1958 when King was arrested for obstruction in Montgomery, Alabama. He covered the police violence during the civil rights march from Selma, Alabama, in 1965; when asked about it years later, he said: "I fight with my camera. I would rather . . . have that be my weapon than my fists any day." Referring to the impact of some of his more disturbing images, he commented that he was haunted by the power of the photograph to show much more than the eye could see in the heat of the moment. CJ

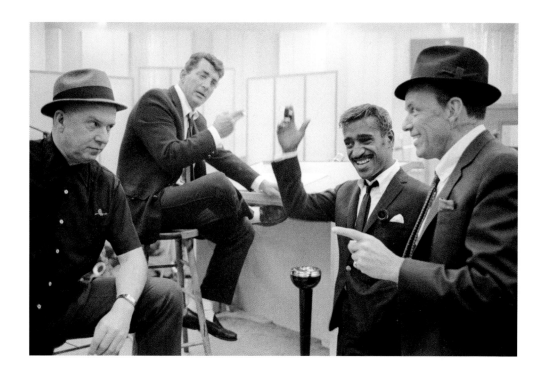

FRANK SINATRA, SAMMY DAVIS JR., AND DEAN MARTIN AT A RECORDING SESSION FOR *COME BLOW YOUR HORN*

GJON MILI

Date 1963

Location California, USA

Format 35 mm

A recording studio in California, 1963. Frank Sinatra stands in profile but there is no mistaking the megawatt smile on his face. Dean Martin shares the joke, chuckling on a high stool in the background, cigarette loose in his fingers, as does Sammy Davis Jr., who stands between them, hand to his ear, face alive with laughter. A fleeting moment distilled, this image is dynamic with gesture: an open palm, a swinging foot, laugh lines creasing cheeks. In some ways it serves as the perfect illustration

of what Jean-Paul Sartre called this particular photographer's intent to "catch you alive."

Having moved from Albania to the United States in 1923 to train as an engineer, Gjon Mili (1904–84) developed his hobby of photography through devising equipment to better capture movement. His desire for photographic sharpness led him to create synchronizers and photoflash lamps through which, in his words, "time could truly be made to stand still." Mili left engineering to become a photojournalist at *Life* magazine in 1934. During this time he shot many leading figures from science and the arts to politics. This image shows the Rat Pack recording music to accompany the 1963 comedy *Come Blow Your Horn*. RF

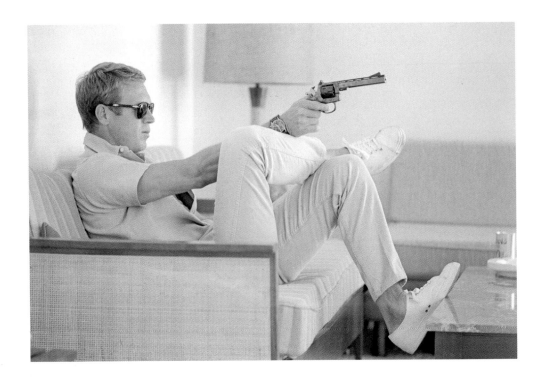

STEVE MCQUEEN TAKES AIM

JOHN DOMINIS

Date 1963
Location Palm Springs, California, USA
Format 35 mm

In 1963, *Life* magazine sent photographer John Dominis (1921–2015) to California to hang out with thirty-three-year-old actor Steve McQueen. Labeled "the King of Cool," McQueen came to fame in *The Magnificent Seven* (1960), and his next big feature, *The Great Escape*, was scheduled for imminent release. *Life* wanted to photograph the star's life away from the spotlight, and Dominis spent three weeks with McQueen at his Palm Springs bungalow. Forty rolls of film later, he emerged with an impressive

selection of images of McQueen riding motorbikes, working out, and shooting guns in the desert with his then-wife, Neile Adams.

In this photo, McQueen practices his aim before heading out for a shooting session in the desert. Sunk back into the sofa, eyes straight ahead, the star seems oblivious to the photographer's presence. It was a remarkable achievement for Dominis to gain such intimate access to McQueen's private life, as the actor was known to be touchy when it came to photographers. One thing that undoubtedly helped form an initial rapport between the two was the fact that star and photographer had a common interest in automobiles, and the pair ended up racing each other in the Mojave Desert. **EC**

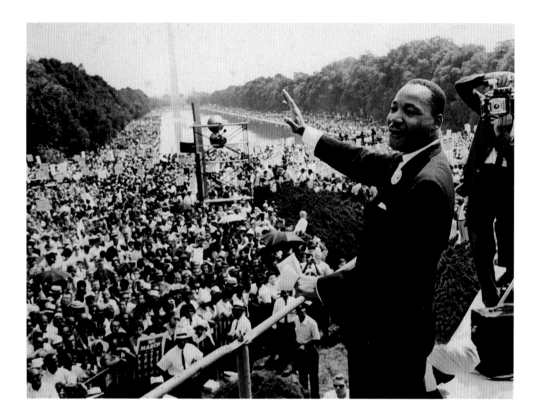

THE BLACK MARCH IN WASHINGTON
FOR JOBS AND FREEDOM

UNKNOWN

Date 1963
Location Washington, D.C., USA
Format 35 mm

Martin Luther King Jr. is seen here addressing the demonstration of some 250,000 people who joined together to march from the Washington Monument to the Lincoln Memorial. The Black March on Washington for Jobs and Freedom, on Wednesday August 28, 1963, was the biggest rally the city had ever seen, bringing together civil rights and religious groups, as well as thousands of ordinary citizens, black and white. It is seen as a turning point in the US civil rights movement,

which led to the Civil Rights Act of 1964 and the Voting Rights Act of 1965. Although slavery had long since ended, the Jim Crow laws meant Southern black Americans still faced racial segregation. The marchers called for effective civil rights legislation, a $2-an-hour minimum wage, and investment in jobs. King gave his historic "I Have a Dream" speech, an electrifying cry for racial justice, to the crowds below, which included celebrities Paul Newman, Sammy Davis Jr., Sidney Poitier, Charlton Heston, and Marlon Brando. As well as being significant in its own right, the march was one of the first live televised protests. The presence of an abundance of cameras, still and movie, helped to give the already momentous action even greater punch. RSH

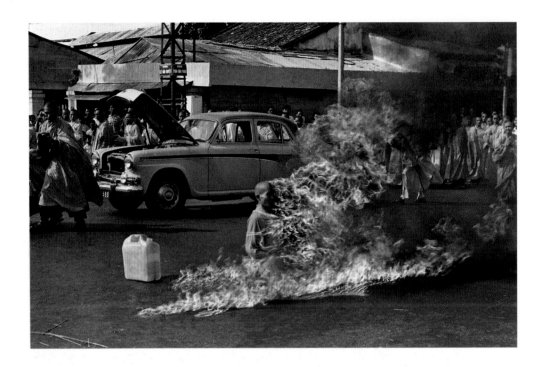

THE BURNING MONK

MALCOLM BROWNE

Date 1963
Location Saigon, Vietnam
Format 35 mm

As a universal symbol of protest, the harrowing image of burning Buddhist monk Thích Quang Duc endures to this day. A photographer with Associated Press, Malcolm Browne (1931–2012) had been based in Saigon, South Vietnam, since November 1961. He took the photo on June 11, 1963, after receiving a phone call the night before from a Buddhist monk telling him that something was going to happen. In predominantly Buddhist South Vietnam, tensions had been building under the repressive regime of Catholic Ngo Dinh Diem. Just a month earlier, soldiers had opened fire on a group of Buddhists, killing nine of them. Quang Duc's self-immolation was carried out to protest against the reported persecution of Buddhists.

In 2011, Browne told *Time* that other foreign correspondents had received calls but were "bored with that threat . . . and tended to ignore it." Browne was the only Western correspondent at the scene, he said. He recounted that he used a cheap Japanese Petri camera and shot ten rolls of film. Interestingly, the photograph here was not the one that was widely published. That image was a later one by Browne, showing Quang Duc's blackened face, his features barely distinguishable. GP

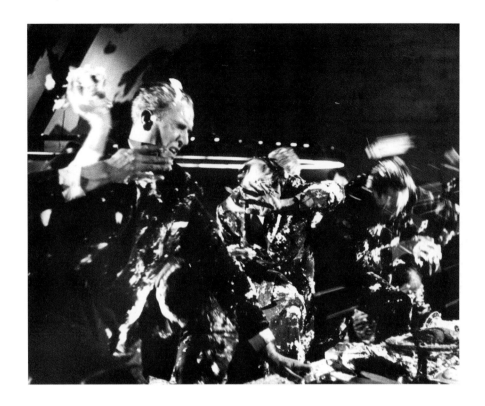

DR. STRANGELOVE

WEEGEE

Date 1963
Location Shepperton, UK
Format 35 mm

Weegee was the pseudonym of Arthur (Usher) Fellig (1899–1968), the press photographer who established his reputation with grim images of New York's underbelly shot during the 1930s and 1940s. In particular, his gruesome pictures of accident and crime scenes won plaudits when he published his book *Naked City* in 1945. After selling the movie rights, he moved to Hollywood to work as technical adviser on the movie. Weegee spent five years in Tinseltown before returning to New York.

He later worked in Europe as a consultant on photographic effects for Stanley Kubrick's *Dr. Strangelove, or: How I Learned to Stop Worrying and Love the Bomb* (1964). This Cold War comedy depicts a scenario in which political maneuvering and the lunacy of a US Air Force general lead to the launch of a nuclear bomb. Weegee took photos on set; this one depicts a custard-pie fight that was intended for the finale but ended up on the cutting-room floor. Set in a war room, it involved the Soviet ambassador throwing a custard pie at the US general. Yet, the Ukrainian-born Weegee's lasting influence on the movie is in the accent Peter Sellers employed for mad scientist Dr. Strangelove, which the actor modeled on that of Weegee. **CK**

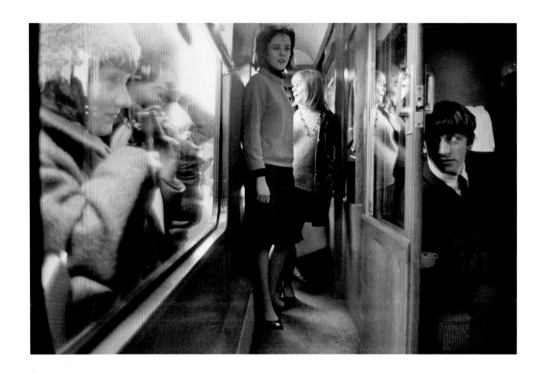

RINGO STARR DURING FILMING OF *A HARD DAY'S NIGHT*

DAVID HURN

Date 1964

Location UK

Format 35 mm

Filmed at the peak of Beatlemania, *A Hard Day's Night* was shot in black-and-white in a cinéma vérité style and followed the Fab Four as they dealt with the pressures of fame. Much of it was shot on a moving train, as this image shows. The movie's unusual title came from one of Ringo Starr's characteristic malapropisms, as he recalled: "We went to do a job, and we'd worked all day and we happened to work all night. I came up still thinking it was day, I suppose, and I said, 'It's been a hard day ...'

and I looked around and saw it was dark so I said, '... night!' So we came to 'A Hard Day's Night.'"

The influential movie inspired The Monkees' TV show, pop videos, and many other movies. Magnum photographer David Hurn (born 1934) followed the filming for weeks, capturing behind-the-scenes moments and shooting in his trademark documentary style, leavened with humor and humanity. He noted "the extraordinary effect the band had on the public. You couldn't go out in a car with them and stop; if you stopped, the car was totally bombarded." Hurn captures the complex relationship between star and fans in this perfectly observed moment, with the highlight of Ringo's eye the key to the photograph's success. PL

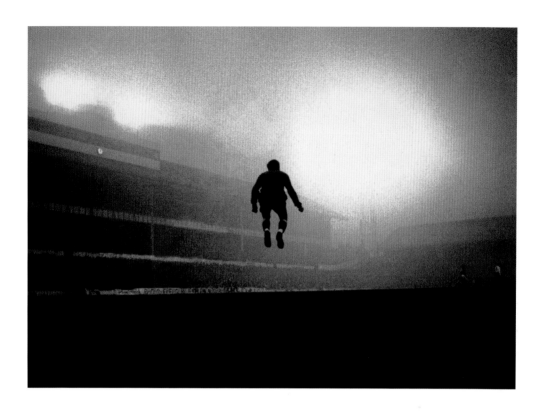

SPURS GOALKEEPER JOHN HOLLOWBREAD
LEAPS INTO THE AIR

GERRY CRANHAM

Date 1964
Location London, UK
Format 35 mm

This beautiful, mysterious image shows goalkeeper John Hollowbread jumping in the fog to gain a better view of his team scoring. He was playing for London soccer team Tottenham Hotspur, and the image was taken by Gerry Cranham (born 1929). Sports events were frequently subject to such foggy conditions at this time. Smog had become a major hazard in Britain in the 1950s; the Great Smog of 1952 claimed some 4,000 lives and led to the passage into law of the Clean Air Act of 1956.

Nevertheless, on December 6, 1962, choking fog spread across Britain, causing many deaths.

Cranham made the most of the poor conditions to produce this eerie image; Hollowbread seems to float, isolated in a surreal, hazy world. The scene resonates with a sense of silence, reflecting the way that fog can dampen sound. In a predigital era, Cranham's skill was remarkable. He would have noticed that the goalkeeper was backlit by the floodlights when he jumped and so would probably appear as a black silhouette against the gray-and-white background in the subsequent print. Sports photographers are not often seen as artists, but this image lasts beyond its immediate press use and would grace any gallery wall. CJ

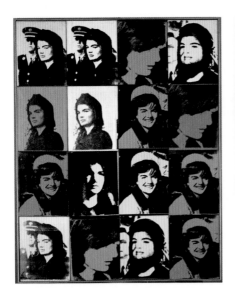

AMERICAN LEGION CONVENTION, DALLAS

GARRY WINOGRAND

Date 1964
Location Dallas, Texas, USA
Format 35 mm

SIXTEEN JACKIES, 1964

ANDY WARHOL

Date 1964
Location New York, New York, USA
Format Unknown

US President John F. Kennedy was assassinated on November 22, 1963, in Dallas, Texas. The media spectacle that this event turned into was pivotal in Pop Artist Andy Warhol's career. He was transfixed by the images that emerged of the president's widow, Jackie Kennedy. He began cropping and printing them onto colored backgrounds, creating around 300 paintings of her over a period of several months. Warhol had already begun using his silk-screen printing technique, but the artworks he made of Jackie were groundbreaking, not least because they used found photographs. The sixteen panels comprise a narrative sequence, chronicling the week of Kennedy's death, from a smiling Jackie to her veiled funeral appearance. The repetition of almost identical imagery is symbolic. As Warhol once said, "Isn't life a series of images that change as they repeat themselves?" JG

This image by Garry Winogrand (1928–84) shows a legless beggar in the street alongside attendees at an American Legion convention. The beggar's stare is unsettling; it feels accusatory, and is filled with pain. To see an amputee on the sidewalk of a wealthy country is surprising; what is more odd is the fact that passersby seem to ignore him. Winogrand served in the US Air Force just after World War II, and then turned to street photography, saying of his choice: "You could say that I study photography and it's true. But, in reality, it is America that I study." Given Winogrand's military background, his picture seems even more poignant, and his shot reflects his personal emotions and viewpoint of war. His sharp eye is keen to show the tragic results of war in the shape of the shuffling beggar alongside members of the American Legion—the nation's largest wartime veterans' organization. While they appear to celebrate and honor military conflict, the man at their feet—possibly himself a veteran—does not, and he lives with the brutal hardship of disability every day. CK

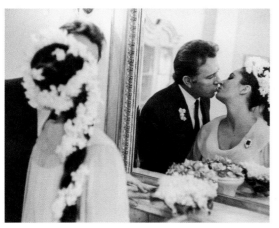

TONKIN GULF INCIDENT, AUGUST 1964

US NAVY

Date 1964
Location Gulf of Tonkin, off Vietnam
Format Unknown

TAYLOR–BURTON WEDDING

WILLIAM LOVELACE

Date 1964
Location Montreal, Canada
Format 35 mm

This would be a wonderfully romantic moment to capture for any newlyweds. But the fact that Richard Burton and Elizabeth Taylor comprised one of the most famous couples in the world adds a whole new level of interest and intrigue to the image. William Lovelace (1924–2003), working for the *Daily Express*, caught the moment when the groom's lips are about to touch his bride's, reflected in a gilded mirror that suggests the unreal nature of their lives in the media spotlight. After the ceremony Lovelace joked: "Richard was so drunk that I kissed the bride before he did."

Lovelace covered a vast range of stories in his forty-year career, including the first flight of Concorde in 1969, the war for independence in Bangladesh in 1972, and the arrest of the Great Train Robber, Ronnie Biggs, in Rio de Janeiro in 1974.

Burton and Taylor were married after a four-year romance that started when they met on the set of the movie *Cleopatra*. At the time, Taylor was still married to Eddie Fisher, her fourth husband, but she divorced him to marry Burton. **PL**

At first glance this grainy photograph may not reveal much, but the tiny black dots on the horizon are North Vietnamese torpedo boats making their way at high speed toward the USS *Maddox* (DD-731) during the Vietnam War (1954–75). Credited only as an "Official US Navy Photograph from the collections of the Naval Historical Center," the image was taken on August 2, 1964, from the *Maddox*, which was on an intelligence-gathering patrol. Upon sighting the three approaching vessels, the *Maddox* reportedly fired warning shots, and the North Vietnamese responded by launching torpedoes and opening fire, although there is controversy over who fired first. No US personnel were hurt, but there are thought to have been casualties on the North Vietnamese side.

The photo is important because it represents a significant moment in the conflict. Following the incident, the US Congress approved the Gulf of Tonkin Resolution, which outlined terms for increased US involvement in the Vietnam War. A second attack involving the North Vietnamese was said to have occurred in the same area a few days later, but what were believed by the National Security Agency to be North Vietnamese torpedo boats were, in fact, false radar images. **GP**

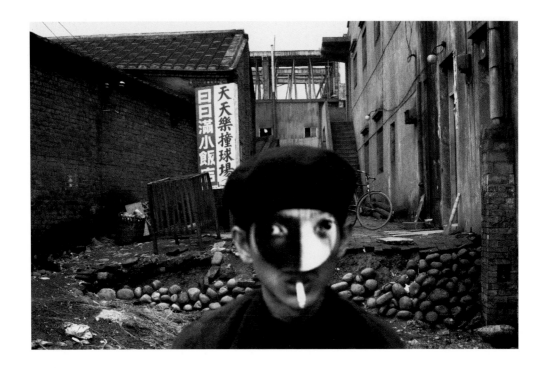

SINCHUNG, TAIWAN

CHAO-TANG CHANG

Date 1964
Location Taiwan
Format 35 mm

Odd, unsettling, surreal: these are words that might be used to describe the work of Chao-Tang Chang (born 1943). A photographer since 1959, when he picked up a camera as a student, and active during the White Terror period 1949–87) in Taiwan, Chang spent decades recording life in his home country, not as a documentary photographer might, but as a person fascinated by the world around him. Often shooting from low angles, in part due to the design of the twin-lens reflex camera he used,

Chang had a knack for capturing the absurd in the everyday. Many of his pictures have a surreal quality: bodies are sometimes without heads, or blurred, and subjects are photographed from strange angles with elements organized in unusual ways.

In this image from 1964, Chang throws his subject, who looks to be a young boy, out of focus, placing the focus instead on the background. It is a bold approach that serves to unsettle the viewer, who is confronted by a subject he or she cannot see properly. There is nowhere else to look but at him. By photographing his subject up close, Chang creates the impression that we as viewers are present in the scene; just as the boy is invading our space, we are invading his. **GP**

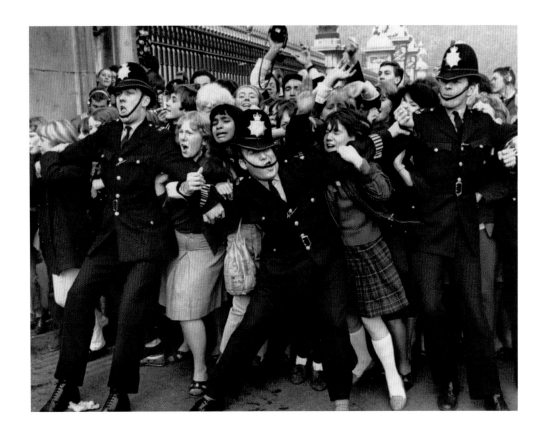

BEATLEMANIA

UNKNOWN

Date 1965
Location London, UK
Format 35 mm

In the tumultuous climate of social, political, and cultural changes that characterized the West in the 1960s, teenagers were determined to throw off the constraints that they believed had stifled previous generations. Music responded by becoming increasingly loud and more electrified, recording technology was evolving rapidly, and the innocent love songs of past decades were giving way to challenging lyrics that for teens seemed to offer hope, salvation, and acceptance. The Beatles were born amid this chaos, providing the distraction that many youths were desperately searching for. The term "Beatlemania" refers to the frenzy of the Beatles' fans, especially the young girls, who were discovering the emotional release of wild adulation within the safety of their peer group.

This shot was taken outside Buckingham Palace, London, on October 26, 1965, the day the Fab Four were each awarded the MBE (Member of the Order of the British Empire) by Queen Elizabeth II. The police, struggling to keep back the pressing crowd of girls, can barely prevent their helmets from slipping off in the chaos, while the crazed, almost agonized, fans push against their outstretched arms. EC

ONKEL RUDI (UNCLE RUDI)

GERHARD RICHTER

Date 1965
Location Unknown
Format Unknown

Over his career as a painter, Gerhard Richter (born 1932) adopted a striking array of different styles. This work originates from a period in which he was concerned with the relationship between photography and painting, and between memory and visual images. It shows a smiling yet self-conscious man posing in full Wehrmacht uniform, whom the title tells us is the artist's uncle. Already this suggests a range of intriguing contradictions. Unlike many of Richter's paintings, it is small in scale, reminiscent of the intimate family snapshot upon which it is based. He painted it in exquisitely realist detail and then drew a dry brush across the surface of the paint. The result is very much like the blur of camera shake or faulty photographic printing: a perfect metaphor for the inadequacy of photographic memory. It is a deliberately flawed reproduction of a photograph that is itself loaded with ambiguity: it tells us nothing about Richter's relationship with his uncle, and in this sense is very much aligned with the artist's enduring attitude to visual imagery. (In fact, Rudi, the artist's mother's younger brother, was killed fighting shortly after the original photograph was taken.)

Growing up in Germany with direct experience of the Nazi and Socialist regimes, and deeply affected by the role of images in both cases, Richter spent his working life resisting an easy relationship between images and meaning. The real message of this picture is about mediation and the many layers through which we experience the things we see. Even though it is an oil painting, it provokes many questions about photography's social and political impacts. **JG**

"Sometimes the real meaning these images have for me only becomes apparent later."

Gerhard Richter

ONE RIDE WITH
YANKEE PAPA 13

LARRY BURROWS

Date 1965
Location Vietnam
Format 35 mm

Larry Burrows (1926–71) was undoubtedly one of the finest war photographers to emerge from the Vietnam War. In early 1965, when US President Johnson sent several US Army and Marine divisions to Vietnam, Burrows decided to do a month-long study of a military unit and was allowed to join the US Marines' Medium Helicopter Squadron 163. Helicopters were a relatively new tool of war, and he flew in a UH-34D, codenamed Yankee Papa 13.

During a mission, the crew went to the aid of another Huey, Yankee Papa 3, disabled in a landing zone. Its copilot, Lieutenant James Magel, helped a wounded crewman to dash to Yankee Papa 13 but was himself hit and badly wounded by enemy machine-gun fire. Once airborne, Yankee Papa 13's door gunner, Lance C. Farley, gave first aid to the two survivors, but Lieutenant Magel died shortly afterward. The photograph shows Farley's distressed reaction to his comrade's death.

Burrows later described his feelings about taking the image: "It's not easy to photograph a man dying in the arms of a fellow countryman ... Was I simply capitalizing on other men's grief? I concluded that what I was doing would penetrate the hearts of those at home who are simply too indifferent." When he received a critical letter from Magel's mother, Burrows replied, explaining that he understood what a shock it must have been to see the photograph—his own family lived in fear of seeing a similar story about him. Six years later, when Burrows himself went missing, presumed dead, after a helicopter crash, Mrs. Magel wrote a moving letter of sympathy to the Burrows family. CJ

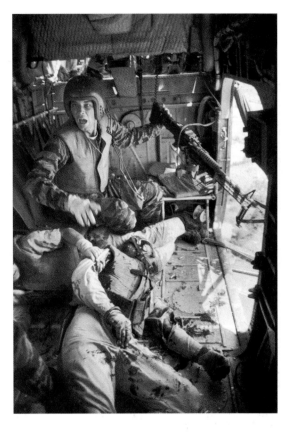

"You can't photograph bullets flying through the air, so it must be the wounded, or people running with ammunition, and the expressions on their faces."

Larry Burrows

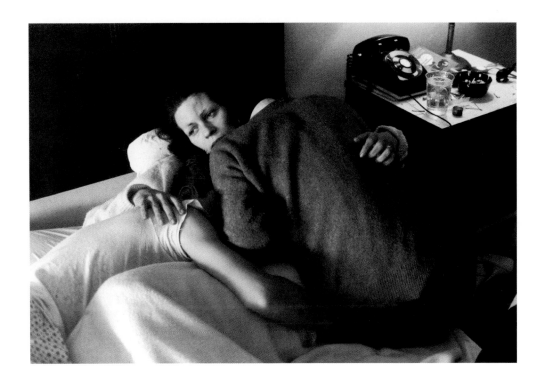

"WE ARE ANIMALS IN A WORLD NO ONE KNOWS"

BILL EPPRIDGE

Date 1965

Location New York, New York, USA

Format 35 mm

This image is from a gritty, seminal photo-essay published by *Life* magazine in February 1965—a real-life tale of two New York City heroin addicts living in Needle Park on Manhattan's Upper West Side. The photographs taken by Bill Eppridge (1938–2013) were paired with text by editor James Mills, and together, they traced the lives of Karen and Johnny and what they had to do in order to sustain their addiction—she worked as a prostitute in the Midwest; he looted cars in New York. The

pair described themselves as "animals in a world no one knows." This image shows Karen with her arms wrapped around John and his addicted brother, Bro. Showing them lying hopelessly in bed, the scene mirrors the grip the drug had over their lives. It would be a very different scene if Karen's face was not lined with anxiety and exhaustion, and if the bedside table was not littered with drug paraphernalia.

Eppridge spent three months living with the couple, and although he was faced with moral dilemmas and was often placed in illegal situations, he and Mills succeeded in creating a deeply moving piece of reportage spotlighting an issue to which many turned a blind eye. **EC**

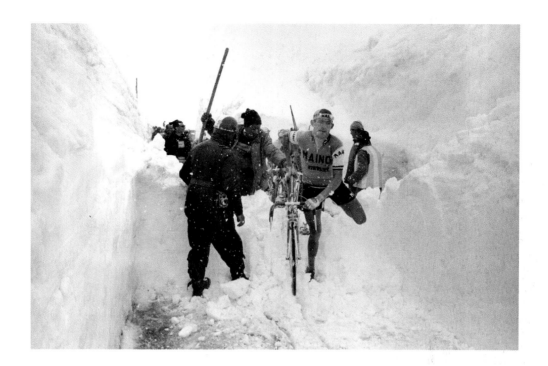

ALDO MOSER AT THE GIRO D'ITALIA, STELVIO 1965

GIORGIO LOTTI

Date 1965
Location Stelvio Pass, Italy
Format 35 mm

The Stelvio Pass in the Italian Alps is one of the most famous and difficult mountain climbs in the world and a mecca for cyclists who take on the challenge of its epic forty-eight hairpin bends that ascend 6,138 feet (1,871m) to an elevation of 9,045 feet (2,757m) at the top. It has featured several times in the Giro d'Italia cycle race since its first appearance in 1954, and is the highest point ever in the race.

In 1965, the Cima Coppi categorization was introduced as a special award for the rider who won the Stelvio stage on the highest summit finish of the race each year. It was named in honor of legendary Italian cyclist Fausto Coppi, winner of five Giros and three mountain classification titles during his career. However, bad weather in 1965 meant that the summit finish had to be moved from the top to lower down the pass.

The race is held in late May and early June, when the mountains are still often covered in snow, and this dramatic image by Giorgio Lotti (born 1937) shows Aldo Moser of the Maino team struggling to make his way through the difficult conditions. Moser finished in twenty-second place overall at the end of the race. In all, Moser raced the Giro a total of sixteen times. PL

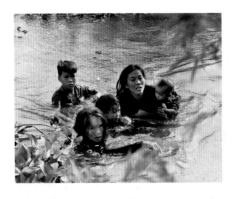

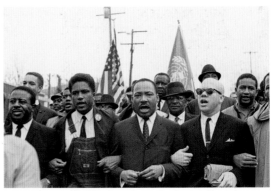

A MOTHER AND HER CHILDREN WADE ACROSS A RIVER TO ESCAPE US BOMBING

KYOICHI SAWADA

Date 1965
Location Loc Thuong, Vietnam
Format 35 mm

Kyoichi Sawada (1936–70) joined the Tokyo bureau of United Press International (UPI) in 1961. At the time Japanese news media focused on domestic affairs, and while Sawada pleaded to be sent to cover the war in Vietnam, he was denied permission to travel. In 1965, he used his vacation entitlement to go to Vietnam alone. The strength of his images convinced UPI to station him in Saigon. Sawada landed the Pulitzer Prize in 1965, and this photo was awarded World Press Photo of the Year. The woman and her children had been driven from their home by the US Air Force, who suspected that their village was a covert camp for the Communist Vietcong. Marines rounded up suspects and evacuated the villagers before bombing the village from the air to eradicate snipers. In 1970, Sawada turned his attention to Cambodia, and in October of that year he took Frank Frosch, UPI's Phnom Penh bureau chief, to an outpost of the Cambodian army. Their car was captured by the Khmer Rouge, who shot them both dead. Sawada was posthumously awarded the Robert Capa Gold Medal. LH

DR. MARTIN LUTHER KING JR. LEADS THE MARCH TO THE STATE CAPITOL IN MONTGOMERY, ALABAMA

JAMES "SPIDER" MARTIN

Date 1965
Location Montgomery, Alabama, USA
Format 35 mm

James "Spider" Martin (1939–2003) was one of the foremost chroniclers of the US civil rights movement. He caught the moment when Alabama state troopers violently attacked the first Selma-to-Montgomery march in spring 1965. Dr. Martin Luther King Jr., cited him as a major force in securing the rights of African Americans, saying: "Spider . . . we could have protested forever, but if it weren't for guys like you, it would have been for nothing. The whole world saw your pictures."

This potent study of solidarity shows Dr. King leading 25,000 demonstrators to the state capitol in Montgomery. Later, King addressed them: "There never was a moment in American history more honorable and more inspiring than the pilgrimage of clergymen and laymen of every race and faith pouring into Selma to face danger at the side of its embattled Negroes." Soon after, on August 6, US President Johnson signed the Voting Rights Act of 1965, outlawing racial discrimination in elections. PL

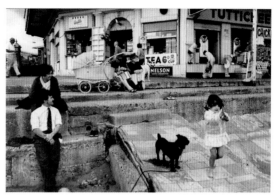

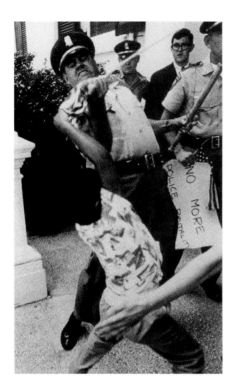

RAMSGATE

TONY RAY-JONES

Date 1965
Location Ramsgate, UK
Format 35 mm

British-born Tony Ray-Jones (1941–72) went to the United States, where he studied graphic design. He spent a year in New York, frequenting the Design Laboratory of Alexey Brodovitch, and met street photographers, including Joel Meyerowitz and Garry Winogrand. Ray-Jones then turned to photography and took to the streets with a Leica.

He returned to Britain in 1965, the year he took this image in the coastal town of Ramsgate. It captures the fun of seaside holidays during the 1960s. It appears quintessentially English, with the hoardings advertising the price of a cup of tea and Wall's ice cream, and an arcade populated by racks of postcards. It is clearly a cool day: the young girl, though barefoot, wears a wool cardigan; the man on the left, leaning against a wall, may have his sleeves rolled up, but he is still wearing a tie; the woman behind him is wrapped up in a blanket. People are relaxing as best they can in the dingy environs. An album of Ray-Jones's seaside images formed part of *A Day Off: An English Journal* (1974), which was published posthumously. His sense of irony, wry humor, and subject matter have influenced photographers such as Martin Parr. **CK**

POLICEMAN RIPS FLAG FROM YOUNG BOY

MATT HERRON

Date 1965
Location Jackson, Mississippi, USA
Format Unknown

This image from the US civil rights era shows white policeman Hughie Kohler ripping a US flag from young black boy, Anthony Quinn, during a protest against the election of five Congressmen from districts where blacks were not allowed to vote. According to photographer Matt Herron (born 1931), as Kohler tried to take the flag, the boy's mother said, "Anthony, don't let that man take your flag." Kohler went mad, yanking the boy off his feet. At this time, the US flag was a potent symbol of the demand for racial integration. Kohler's obituary said that he had regretted the incident "for the rest of his life." **CJ**

HUMAN FETUS AT EIGHTEEN WEEKS

LENNART NILSSON

Date 1965
Location Unknown
Format Unknown

He showed the world something it had never seen: life inside the womb, from the moment of conception until birth. In groundbreaking images, published as a sixteen-page photo-essay in *Life* magazine, Swedish photographer and scientist Lennart Nilsson (born 1922) showed the development of human life in great detail.

Nilsson had been forging a career as a photographer since his teens, but as the 1950s got under way his experiments with techniques gathered pace, driven by his curiosity and a desire to record the unseen photographically. As he said: "I am driven by a desire to illustrate vital processes that concern us all to the highest degree yet are invisible—to make them visible."

Using scanning electron microscopes and endoscopic cameras with macro- and wide-angled lenses, Nilsson shot embryos and fetuses at various stages of development, including this image of a fetus appearing to suck its thumb. In 1965, Nilsson published a book of his pioneering work, *A Child Is Born*, the culmination of twelve years' work. His images not only broke new medical ground, but also helped to fuel discussions around the moment when life begins. GP

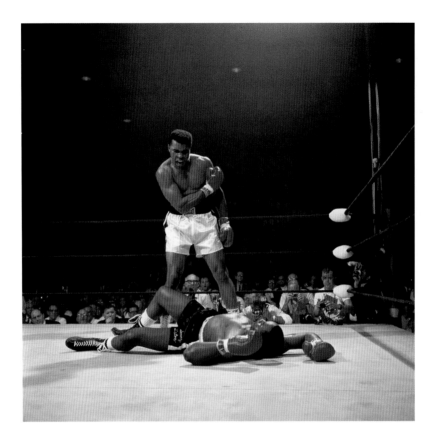

MUHAMMAD ALI VS. SONNY LISTON

NEIL LEIFER

Date 1965
Location Lewiston, Maine, USA
Format Medium format

This elegantly composed photo by Neil Leifer (born 1942) of Muhammad Ali's first-round knockout of Sonny Liston in their second fight for the world heavyweight boxing title began its existence in relative obscurity. It was a similar shot, taken by Associated Press's John Rooney, that appeared on page one of many newspapers the next day and won Best Sports Photo in the World Press Photo Awards, despite being in black and white and a rectangular format that cut closely above Ali's head.

As it had been commissioned for *Sports Illustrated*, Leifer's photo could appear only in that magazine.

Leifer had worked with electricians to position flash units above the ring, but these needed time to recharge, and unlike other photographers at the ringside, Leifer had to pick his shots carefully. Herb Scharfman of *Sports Illustrated* had had first choice of a position by the judges, but at the key moment it was Leifer who was lucky with his seat when Liston was felled by Ali's "phantom punch" right in front of him, one minute and forty-four seconds into the first round. Leifer's Ektachrome film, combined with blue-tinged cigar smoke through the powerful lighting, his position, and his good instinct resulted in a memorable shot. CP

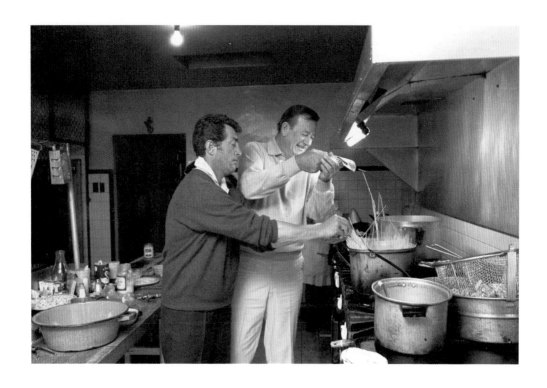

DEAN MARTIN AND JOHN WAYNE IN THE KITCHEN

PIERLUIGI PRATURLON

Date 1966
Location Italy
Format 35 mm

American actors Dean Martin (1917–95) and John Wayne (1907–79) are pictured here cooking spaghetti during a break from filming *The Sons of Katie Elder*. As Wayne pours oil into the large pot of boiling water with a look of glee, Martin keeps well clear to avoid being splashed. The scene was captured by Pierluigi Praturlon (1924–99), who famously immortalized the glory days of Italian cinema with his camera as he roamed movie sets and gained unrivaled access to the stars.

After a few years as a photo-reporter, Praturlon established himself in 1949 as Italy's top film-set photographer, working on many of the great movies that emerged from the Cinecittà studio. Although he was often described as a paparazzo, Praturlon was different in that he built direct, friendly relationships with actors and movie directors. Frank Sinatra consulted him on which tapestries he should hang in his private jet, and Sophia Loren asked him to be her personal photographer. In addition, a fluent grasp of English landed him numerous commissions throughout Europe with US production companies. Praturlon was a photographer with a journalistic perspective on the glamorous world he inhabited. **EC**

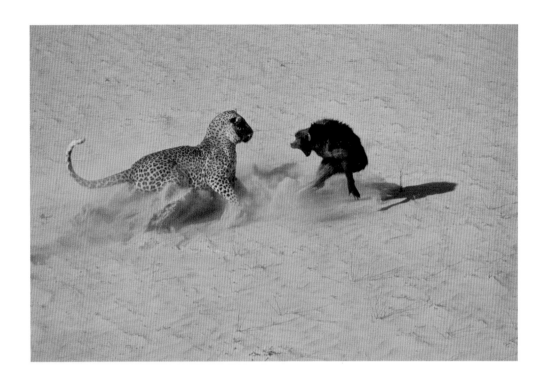

A LEOPARD ABOUT TO KILL A BABOON

JOHN DOMINIS

Date 1966
Location Botswana, Africa
Format Unknown

While John Dominis (1921–2013) was photographing wild cats for *Life* magazine, he found a hunter in Botswana who had a captive leopard. This creature was not tame and had attacked the hunter's daughter shortly before Dominis arrived. The plan was to let the leopard loose in an area where there were many antelope, but a large population of baboons was also living there. Dominis described what took place: "[The hunter] put the leopard in the back of the truck, and we went out into the desert. He would release the leopard, and most of the time the leopard would chase the baboons and they would run off and climb trees . . . But for some reason one baboon . . . turned and faced the leopard, and the leopard killed it."

Dominis was later criticized for "faking" the picture, but as he pointed out, attitudes were different in the 1960s. The behavior of the two animals involved was spontaneous, so perhaps "facilitating" the confrontation is a more apt charge to level. Photographically, it is a remarkable moment depicting a struggle between unequal foes. Contemporary wildlife photographers spend weeks anticipating and capturing such moments as authentic, rather than human-made, events. **CJ**

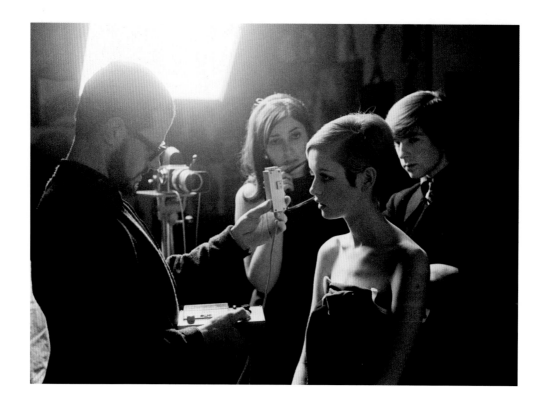

TWIGGY AT A PHOTOSHOOT

BURT GLINN

Date 1966
Location London, UK
Format 35 mm

This behind-the-scenes image by Burt Glinn (1925–2008) shows Barry Lategan (born 1935) checking the lighting before photographing Twiggy. Lategan is credited with discovering the iconic 1960s model and taking the photograph that launched her career. Celebrity hairdresser Leonard Lewis came across schoolgirl Lesley Hornby in his salon in Mayfair, London, and called Lategan, insisting that he take some headshots of her. Lewis hung the finished photograph in his salon, where it was spotted by journalist Deirdre McSharry, who declared Twiggy "the Face of '66." Twiggy became the world's first supermodel at just sixteen years old.

Twiggy worked with the leading photographers of her time, including Ronald Traeger, Bert Stern, and Helmut Newton. Her gaze in photographs was often direct—both startled and insouciant—with eyelashes painted on to emphasize her doll-like qualities. Her boyish crop was mirrored in her androgynous frame, which lent itself well to the geometric styles of the 1960s.

Twiggy has expressed her gratitude to Lategan, stating: "Barry made that shy little girl believe that the lens was her friend and taught her just to be natural, to work with the lens." ML

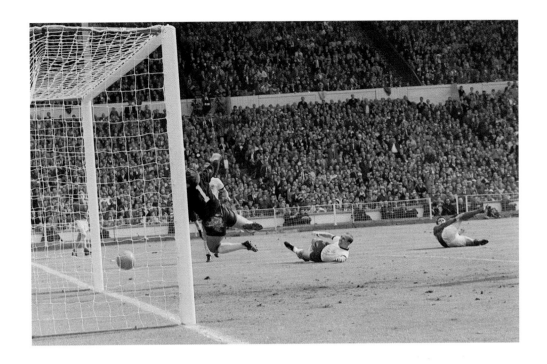

GEOFF HURST SCORES THE THIRD GOAL
IN THE 1966 WORLD CUP FINAL

UNKNOWN

Date 1966

Location London, UK

Format 35 mm

The 1966 soccer World Cup Final between England and West Germany at London's Wembley Stadium hinged on this controversial goal in extra time by Geoff Hurst that put the home side ahead 3–2. The game had been finely balanced in normal time, with an early goal putting West Germany ahead after twelve minutes. Hurst leveled the score four minutes later, and in the seventy-eighth minute England took the lead through Martin Peters. With only one of the normal ninety minutes remaining,

Wolfgang Weber equalized for West Germany. Extra time was thus required. In the ninety-eighth minute, Hurst fired a volley toward the goal, beating goalkeeper Hans Tilkowski. This dramatic image shows the moment when the ball hit the crossbar and bounced down before Weber headed it out for a corner as Hurst falls to the pitch. The Germans appealed, claiming that the ball had not crossed the line, but they were overruled by Swiss referee Gottfried Dienst after consultation with the linesman, Tofiq Bahramov, an Azeri from the Soviet Union. None of the still or motion pictures shows conclusively whether or not it was a goal. At the end of extra time, Hurst completed a hat-trick, making the final score England 4, West Germany 2. PL

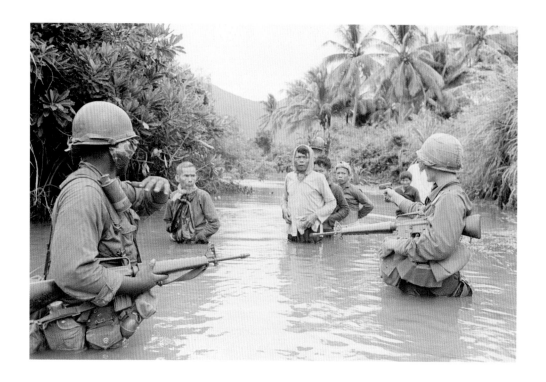

US TROOPS MOVE VIETCONG SUSPECTS ACROSS RIVER

UNKNOWN

Date 1966
Location Vietnam
Format 35 mm

In this image, US 1st Cavalry troops are pictured moving suspected Vietcong Communist fighters across a river south of Bong Son in South Vietnam. The picture was taken in October 1966 during Operation Irving—a clearing operation in the central coastal province of Binh Dinh. The mainly civilian farmers in this heavily populated area had been advised by the Americans to stay put in their villages and to leave only if conflict erupted, and then in the direction of the US soldiers. These suspects were rounded up by the soldiers during a sweep of a village that the Vietcong had been using as a base.

The viewer's eyes are immediately drawn to two things. First: the handgun held by the trooper on the right of the frame. He is evidently in command of the situation. Next, our vision travels left of the gun to the central, hooded suspect's face. His eyes betray a visible mix of fear and distrust, which is echoed in the faces of the other suspects. Looking from behind the soldiers, we cannot see their faces. The menacing forms of their rifles are unsettling, but it is the small handgun that transfixes the eyes of the suspects as they wade through the water, their faces filled with dread. **EC**

THE KRAY TWINS AT HOME

UNKNOWN

Date 1966
Location London, UK
Format 35 mm

Ronnie and Reggie Kray, known as the Kray Twins, gained notoriety for building an underground empire of organized crime in the East End of London during the 1950s and 1960s. They were involved in robberies, arson, protection rackets, brutal assaults, and the infamous murders of Jack "the Hat" McVitie and George Cornell. As nightclub owners in the West End, they were also on Swinging London's celebrity circuit and were photographed on many occasions by fashion photographer David Bailey.

In this uncredited photograph, taken inside their home, the Kray Twins are pictured after being questioned by police regarding the murder of George Cornell, who had been shot in the Blind Beggar public house in Whitechapel in the East End. They are both dressed smartly, and Ronnie has his shirt unbuttoned in a display of macho confidence. Their unease, however, is apparent in the way they hold themselves—their slightly dazed expressions and their rigidly held teacups. The unease derives from the presence and probing interrogation of the police, but, shot from a low-angle perspective, the Kray Twins still possess some of the powerful aura that they commanded as London's most dangerous men. EC

CROSSING THE OHIO

DANNY LYON

Date 1966
Location Louisville, Kentucky, USA
Format 35 mm

Danny Lyon (born 1942) helped to redefine photojournalism because he became involved with his subjects rather than remaining an objective observer. He has specialized in photographing those existing on the edges of society as well as those involved in changing it. In late 1965, Lyon documented the nascent civil rights movement in the southern United States and decided that his next project would focus on bikers. He bought a motorcycle and joined the Chicago Outlaws motorcycle club. He later said of the decision: "They were outsiders and I was drawn to outsiders. From my involvement in the civil rights struggle, I knew the best way to get good pictures was to get involved. I was a participant who also happened to be a photographer." His book, *The Bikeriders* (1968), consists of interviews with gang members and images, including this iconic one of a leatherclad biker crossing the Ohio River, which brought the counterculture to public attention. It has come to epitomize the idea of the open road and free spirit popularized by the Beat Generation. CK

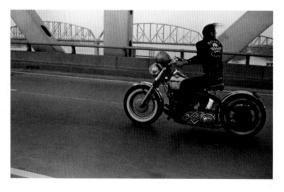

ON THE SET OF *BLOW-UP*

TAZIO SECCHIAROLI

Date 1966
Location London, UK
Format 35 mm

Possibly the most famous film to feature photography in a prominent way, *Blow-Up* depicts the hedonism and energy of London's fashion and art scenes in the 1960s. At the center of the film is Thomas, a fashion photographer played by David Hemmings, who believes that he has witnessed a murder when he spots what he thinks is a gunman in the bushes in one of his photographs. Thomas enlarges the negative in his darkroom to try to ascertain what might have happened, but is unable to come to any conclusions. In this way, Michelangelo Antonioni's cult classic—the Italian director's first English-language film—seems to call into question photography's legitimacy as evidence: the closer Thomas looks, the less he is able to see and know.

Antonioni commissioned British photographer Arthur Evans to take production stills that were used for promotional purposes, but other photographers, including Italian paparazzo Tazio Secchiaroli (1925–98), also captured moments from the Oscar-nominated film, such as this one featuring model Veruschka von Lehndorff and Hemmings.

The photographer towers over and almost preys on von Lehndorff, her arms outstretched, and writers have commented on how the image reflects the trend for photographers of the day to leave their tripods behind when shooting and to get closer to their subjects. Indeed, fashion photographers of the time, including David Bailey, Terence Donovan, and Brian Duffy, from whom Antonioni drew inspiration, were granted star status and commanded considerable power over their subjects. GP

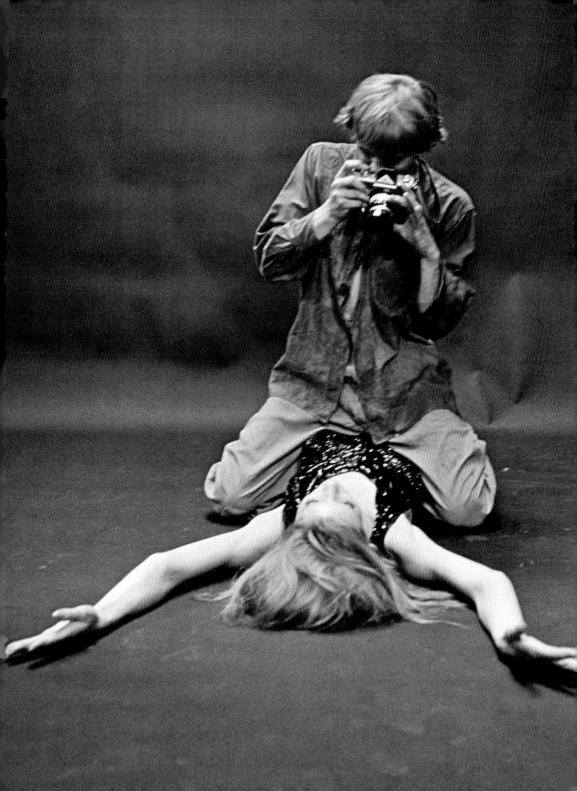

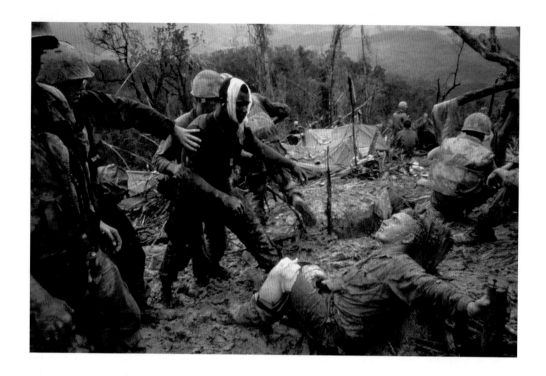

REACHING OUT

LARRY BURROWS

Date 1966
Location Vietnam
Format 35 mm

Larry Burrows (1926–71) was one of the greatest war photographers of all time, and this image is often considered to be one of the finest from the Vietnam War. It was taken on Hill 484 in the aftermath of a firefight with the North Vietnamese enemy. An injured US Marine—Gunnery Sergeant Jeremiah Purdie (with bandaged head)—is making his way to a rescue helicopter. The scene is one of utter desolation—cloying mud; blasted tree stumps, bandages, and bloody wounds; exhaustion

and postconflict numbness. In the middle of this nightmarish scene, Purdie, hit by shrapnel in the knee and behind his ear, finds time to reach out toward his injured and shell-shocked colleague in a human gesture of concern amid the chaos.

Burrows was on assignment for *Life* magazine but, strangely, this epic picture was not published at the time. It finally appeared five years later in a tribute to Burrows after his death in a helicopter crash. *Life*'s managing editor, Ralph Graves, then wrote: "[Burrows] had deep passions, and the deepest was to make people confront the reality of the war, not look away from it. He was more concerned with people than with issues, and he had great sympathy for those who suffered." CJ

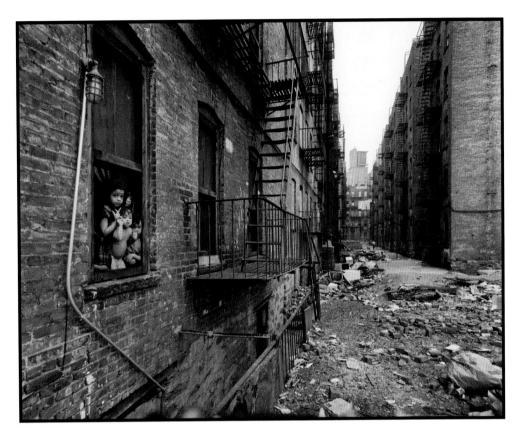

CHILDREN LOOKING OUT THEIR WINDOW INTO THE ALLEY

BRUCE DAVIDSON

Date 1966
Location New York, New York, USA
Format Large format

Begun in 1966, *East 100th Street* was a two-year photography project undertaken by Bruce Davidson (born 1933) on a poverty-stricken housing block in East Harlem, New York City. Davidson, a member of the Magnum agency, was already known for his chronicle of a group of New York teenagers—*Brooklyn Gang* (1959)—and for coverage of the civil rights movement. His assignments placed him among radical new practitioners such as Diane Arbus and Lee Friedlander.

Published in 1970, *East 100th Street* was an unflinching document of ghetto life, notable for both intimate interior shots showing the daily lives of the inhabitants and grim images of the external environment. This particular image depicts a group of children pressed against a window screen overlooking a trash-strewn back alley. One child looks out with expectation toward the photographer. But far from being negative or detached, *East 100th Street* powerfully explores people's humanity and resilience. Davidson has commented: "I start off as an outsider, usually photographing other outsiders, then, at some point, I step over a line and become an insider. I don't do detached observation." NG

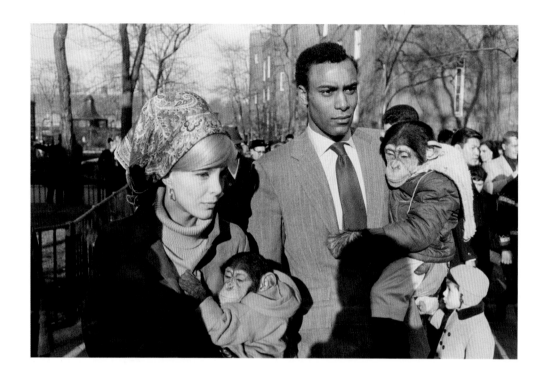

COUPLE IN CENTRAL PARK ZOO

GARRY WINOGRAND

Date 1967
Location New York, New York, USA
Format 35 mm

Tod Papageorge, a young photographer working with Garry Winogrand (1928–84) in Central Park Zoo when this bizarre moment was captured, recalls Winogrand shoving him out of the way to photograph it. Winogrand, an experienced street photographer, was a master of framing and would likely have been hopeful, but not completely sure, of whether the interpretative possibilities he sensed in the moment would be conveyed in his resulting image, taken on a Leica with a wide-angle lens. As he said himself, "I photograph to find out what something will look like photographed."

This photograph unsettled by provoking viewers to acknowledge, and thereby feel somewhat complicit in, unpalatable social and political views on the outcomes of miscegenation in the very year in which the US Supreme Court had overturned state laws banning interracial marriage. The image still disturbs today. It also has a surreal quality that is characteristic of much of Winogrand's work, particularly in his incongruous juxtapositions of people and animals.

Much of Winogrand's later work on the streets of New York explored the experiences of women as objects of predominantly male gazes. CP

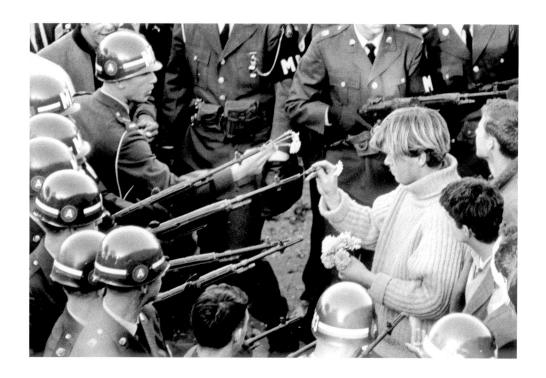

FLOWER POWER

BERNIE BOSTON

Date 1967
Location Washington, D.C., USA
Format 35 mm

This picture was originally shot for *The Washington Star* by Bernie Boston (1933–2008). It was taken on October 21, 1967, when an estimated 50,000 people had just reached the Pentagon in the US capital as part of a nationwide demonstration against the war in Vietnam.

Boston, poised on top of a wall, was about to shoot one of the most iconic photos of the era. As the crowd swirled beneath him, his eyes fell upon a protestor with a bunch of flowers in his hand. Static amid the ensuing chaos, and penned in tightly by police, this man was then spotted placing carnations into the barrels of the military policemen's rifles. From the wall, Boston clicked his shutter and captured a moment.

Perhaps surprisingly, at least with the benefit of hindsight, when Boston returned to the *Star* offices his editor failed to see the significance of this image, so it was put aside. It was only when Boston began to enter the image into a series of competitions that it garnered recognition. Later nominated for the 1967 Pulitzer Prize, this photograph became one of the defining images of the era, a stand-alone symbol of the Flower Power peace movement. EC

A WEEKEND WITH H.R.H. THE DUKE AND THE DUCHESS OF WINDSOR

PATRICK LICHFIELD

Date 1967
Location Paris, France
Format 35 mm

Lord Lichfield (1939–2005), the 5th Earl of Lichfield—known professionally as Patrick Lichfield—used his noble connections to gain unprecedented access to the British royal family. In 1967, he was summoned by the famous editor of American *Vogue*, Diana Vreeland, to a mysterious meeting at the Hôtel de Crillon, Paris, where he found a handwritten note from her with one question: "Who is the best-dressed man in the world?" His reply, that of course it was the Duke of Windsor, secured him the assignment to photograph the former King and his consort, Wallis Simpson, for whom the Duke had abdicated the throne in 1936. The couple had been living at Le Moulin de la Tuilerie, their home outside of Paris, since the 1950s, and Litchfield captured a series of intimate moments with them for the *Vogue* feature, which was published in November 1967. Lichfield recalled that, "desperate to raise a smile, and lacking a ladder to fall off, I put my foot through a cane garden chair instead, and guaranteed myself at least one good shot." PL

LIGHT TRAP FOR HENRY MOORE, NO. 1

BRUCE NAUMAN

Date 1967
Location San Francisco, California, USA
Format Unknown

The photograph reproduced on the facing page is one of a pair from a series of works that American conceptual artist Bruce Nauman (born 1941) made in affectionate homage to British sculptor Henry Moore. It was created by twirling a flashlight in a darkened room and recording the trail of light by means of a slow shutter speed. The resulting image evokes a seated human form that appears to have been "trapped" within the flashlight's spiral of light.

Nauman is one of a group of artists who came to prominence in the 1960s and 1970s by working across a broad range of media, including drawing, video, sculpture, sound, photography, and live performance. They used photography in ways that did not necessarily bear any relation to the priorities of photographers who had gone before, but sought instead to use the form pragmatically, as another means at their disposal to explore their general preoccupations. In this case, Nauman, who made the image at a time when he was concerned principally with sculpture, said that he had "tried to make . . . drawing three-dimensional."

We might say that he was using the properties of photography as another way of thinking about sculptural space. The work also exemplifies an important theme that was being explored by other artists during this period, concerning the connection between photography and performance: where is "artwork" located? Is it in the performance of an action itself, or in the photographic recording of that performance? Or partly in both? Performance is a recurring theme in Nauman's work, often involving the actions of his own body. JG

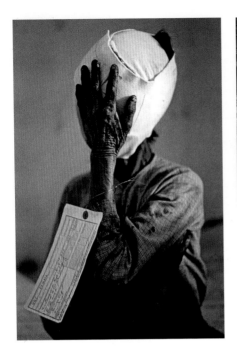

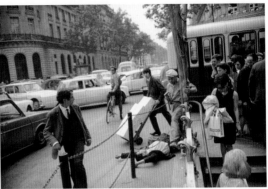

PARIS, FRANCE

JOEL MEYEROWITZ

Date 1967
Location Paris, France
Format 35 mm

Photographers have been making pictures of street scenes ever since the medium was invented, but the idea of "street" as an independent genre emerged in the 1960s, pioneered by a group of young Americans, including Lee Friedlander, Garry Winogrand, Tod Papageorge, and Joel Meyerowitz (born 1938). They knew one another, worked in New York around the same time, and discussed their shared objectives. The new aesthetic captured the energy of New York—all its buzz and randomness. Meyerowitz has described it as "tough" photography: "It was something made out of your guts, out of your instinct, and it was unwieldy in some way."

Paris, France is classic Meyerowitz. There is no obvious place where the viewer's gaze should focus: the viewpoint is skewed, the action dissipated, the spaces between the figures as important as the figures themselves. Tension abounds—between the different reactions to the incident, between movement and stillness. If it is not clear what has happened, that's what Meyerowitz intended. "A photograph," he said, "allows such contradictions to exist in everyday life; more than that, it encourages them." JS

VIETNAM

PHILIP JONES GRIFFITHS

Date 1967
Location Quang Ngai, South Vietnam
Format 35 mm

In *Vietnam, Inc.* (1971), Philip Jones Griffiths (1936–2008) published 266 black-and-white photographs of the US involvement in the war there. This image, taken at a Quaker amputee center in the village of Quang Ngai, shows an elderly woman. Wounded, she has a bandage around her head. Covered by her hand, her face is not visible. A paper tag with her details hangs from her wrist, as if she was cataloged. In a caption, Griffiths wrote: "This woman was tagged, probably by a sympathetic corpsman, with the designation VNC (Vietnamese civilian). This was unusual. Wounded civilians were normally tagged VCS (Vietcong suspect) and all dead peasants were posthumously elevated to the rank of VCC (Vietcong confirmed)." CK

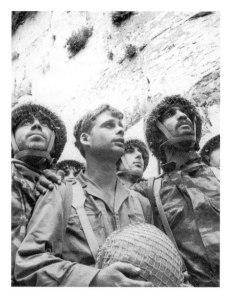

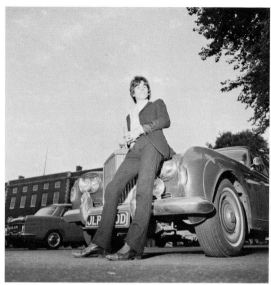

JERUSALEM

DAVID RUBINGER

Date 1967
Location Jerusalem, Israel
Format 35 mm

Taken from a low angle, this image by David Rubinger (1924–2017) shows a group of Israeli paratroopers following the recapture of the Western Wall in Jerusalem. The Six-Day War, which erupted between Israel and its Arab neighbors in June 1967, resulted in Israel gaining occupation of new territory including the Gaza Strip, the Sinai, Jerusalem, the West Bank, and the Golan Heights. The symbolic image captures the hope and triumph, but also the apprehension, of the soldiers and the nation they stand for.

Rubinger, a former refugee from Nazi Germany, is best known for his work as *Time-Life*'s chief Middle East photographer. He covered all of Israel's wars and was given unrestricted access to government leaders. Shimon Peres, the late Israeli politician, once described him as being "the photographer of the nation in the making." EC

KEITH RICHARDS RELEASED ON BAIL

NORMAN POTTER

Date 1967
Location Surrey, UK
Format 35 mm

Norman Potter (born 1932), a photographer with agency Contact Press Photos, here captures a rather smug-looking Keith Richards, lead guitarist of the Rolling Stones, posing in front of a Bentley. Richards had found himself on the wrong side of the law after police raided his home during a party on February 12, 1967. They had removed various tablets and substances, and Richards was "charged with allowing his house to be used for the purpose of smoking cannabis." Both Richards and fellow Stone Mick Jagger pleaded not guilty and were released on bail, but at Chichester Crown Court in June that year both were fined and given jail sentences—one year for Richards and three months for Jagger. The charges were eventually overturned, but Richards ended up spending one night in HM Prison Wormwood Scrubs, London. GP

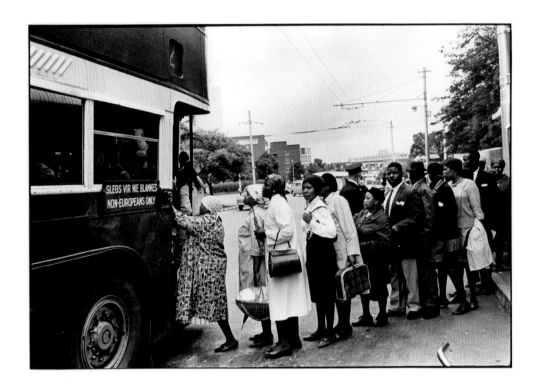

UNTITLED

ERNEST COLE

Date *c.* 1967
Location South Africa
Format 35 mm

This is one of many images taken by black photographer Ernest Cole (1940–90) that focus on transportation systems as one of many forms of daily segregation endured by nonwhites under apartheid in South Africa.

Cole worked hard to become a photojournalist; by 1958, at age eighteen, he had acquired his own Nikon rangefinder cameras and was working as a production assistant at *Drum* magazine. He became increasingly politicized by the inequalities

he faced daily while shooting for magazines and newspapers. He trained himself to work quickly and without a flash to avoid official notice. He would risk much to get a good photo, including getting himself arrested to shoot in black prisons and concealing his camera in a sandwich bag with a hole cut out for the lens.

Cole was forced into exile to the United States after refusing to identify to the South African police the township gangsters he was following for a story. He struggled to adapt to life in America, which he found in many ways as racist as his homeland. He died poor and homeless just one week after Nelson Mandela walked free from prison in South Africa. CP

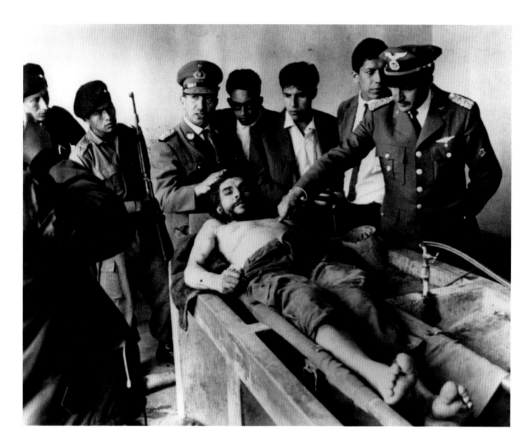

CHE GUEVARA

FREDDY ALBORTA

Date 1967
Location Vallegrande, Bolivia
Format 35 mm

"I had the impression that I was photographing a Christ" is how Freddy Alborta (1932–2005) described the experience of photographing the cadaver of Marxist revolutionary Ernesto "Che" Guevara when it was first displayed to journalists by the Bolivian army that had killed him.

Che—famous for helping Communists under Fidel Castro to overthrow the Batista regime in Cuba in 1959—was in Bolivia in 1967, fighting for the rights of the oppressed, when he was captured. When the Bolivian army could get no information from the Communist leader, they assassinated him. Then, afraid that revolutionaries of the world would think that Che's death was faked, they transported his body by strapping it to the skids of a helicopter and flying him to the town of Vallegrande. There, he was displayed in a large sink in a laundry room, shirtless and shoeless, surrounded by his killers.

In later life, Alborta contributed to documentary films about Che but devoted most of his time to photographic studies of native Andean peoples. Many of his studies were commissioned by Bolivian newspapers and the international agencies United Press International and Associated Press. SY

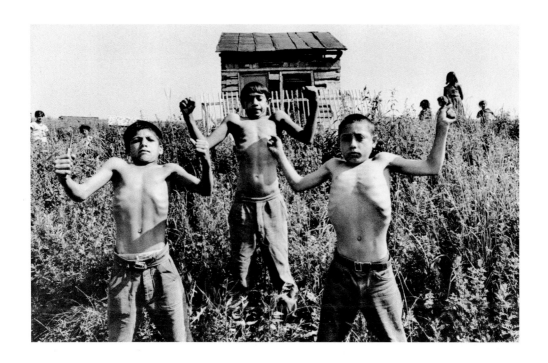

SLOVAKIA. ZEHRA. 1967. GYPSIES

JOSEF KOUDELKA

Date 1967
Location Zehra, Slovakia
Format 35 mm

Josef Koudelka (born 1938) spent much of his early career documenting the vanishing way of life of Europe's Roma population, especially those living in Slovakia, then part of Communist Czechoslovakia. Although the Roma have lived in Europe for hundreds of years, they regularly encounter prejudice and persecution. Koudelka immersed himself so thoroughly in the various communities he visited that he seems to have been fully accepted by them and allowed access to every aspect of their existence. The result was *Gitans: La Fin du Voyage* (*Gypsies: The End of the Journey*, 1975), a book of sixty black-and-white photographs.

There are some formal portraits here, but the main focus is on groups of people and the dynamic interaction between them; the use of a 25mm wide-angle lens provided a panoramic sweep to many of the compositions. This photograph of a trio of young boys posing as tough guys exudes a bizarre energy. The three are clearly showing off for the camera. The bemused spectators kept at a distance in the background reinforce the sense that this is a setup—perhaps by the boys themselves— as does the almost comical arrangement of the figures. JS

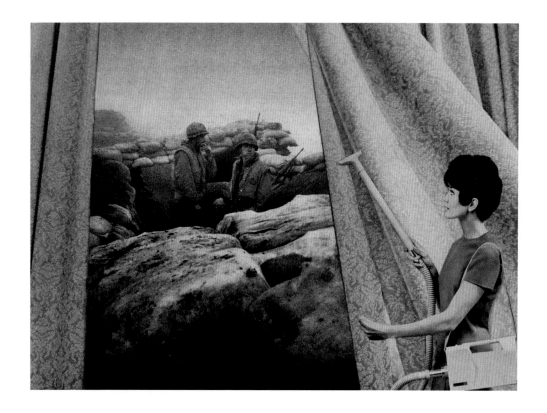

CLEANING THE DRAPES, FROM THE SERIES
HOUSE BEAUTIFUL: BRINGING THE WAR HOME

MARTHA ROSLER

Date c. 1967–72
Location Unknown
Format Photomontage

House Beautiful: Bringing the War Home is a series of twenty images that Martha Rosler created during the US engagement in Vietnam, a conflict known as "the living-room war" because of its ubiquity on televisions in homes across the nation.

Rosler uses a collage technique, combining photographs of American casualties taken from *Life* magazine with commercial images from *House Beautiful* magazine. As an antiwar activist, Rosler felt frustrated that "the images we saw were always

very far away, in a place we couldn't imagine," and her solution was to play on the theme of "the living-room war" by bringing the violence into idealized versions of this space. The work fits into a long tradition of artists appropriating photographs to create montages that gain force from the dramatic juxtaposition of imagery. But Rosler's point is not that these two different types of photographs are alien to one another; rather, it is that they belong together. As an artist Rosler has worked across various media and is also well known for her writing, which has critiqued the use of documentary practices in photography that emphasize the gaps between classes and de-emphasize the agency of relatively disempowered groups. JG

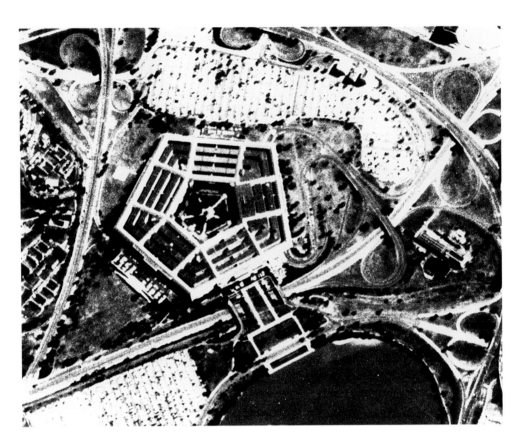

KH1 CORONA IMAGE OF THE PENTAGON

UNITED STATES AIR FORCE

Date 1967
Location Washington, D.C., USA
Format Detail from panorama

Aerial reconnaissance photography played a huge role in the early stages of the Cold War, but the acquisition of the images put pilots and aircraft at great risk. In 1960, a US Lockheed U-2 spy plane was shot down over the Soviet Union; in 1962, the same type of aircraft was downed during the Cuban Missile Crisis.

In 1956, the United States Air Force and the Central Intelligence Agency (CIA) began to develop satellites that would photograph Earth

from orbit in high resolution using two panoramic cameras that, when combined, would create a stereoscopic image. The exposed film would then be returned to Earth in re-entry vehicles that would be captured in midair by specially adapted aircraft.

This program, codenamed Corona, began returning usable imagery in 1960. It spawned a slew of follow-on satellites, including a Soviet equivalent system known as *Zenit*. Engineering advances developed during the Corona program proved critical to subsequent civilian space missions. In 1995, the Corona program was declassified by presidential order, and the public was finally allowed to see images like this. **LB**

KENYAN STUNTMAN JACKIE PAUL

C. WOODS

Date 1968
Location Weymouth, UK
Format 35 mm

Lying on one board bristling with nails would seem to be bad enough, but here, in a newspaper photograph by stringer C. Woods, Kenyan stuntman Jackie Paul is sandwiched between two of them. In a staged event in Weymouth, he looks calm and collected as 24-stone (152.5-kg) publican Richard Robinson adds his weight to the upper board. Members of the crowd look on with concerned and puzzled expressions on their faces. To the uninitiated, it seems unthinkable that a human could endure such a stunt without serious injury. Surely the nails would pierce the skin?

In fact, it is possible to do the stunt safely. Because the force applied is distributed equally across the nails, there is not enough pressure for any single nail to pierce the body. A later image from the same day shows Paul standing with barely any marks on his body. On other (separate) occasions, he lay on a bed of nails and bore the weight of three women and a Rolls Royce.

As impressive as his achievements are, humans have been lying on beds of nails for hundreds of years, for healing purposes and in meditation. Yet the act's value as a spectacle is undeniable and it remains firmly in the stunt repertoire. GP

THE FALLEN ANGEL

DUANE MICHALS

Date 1968 **Location** New York, New York,
USA **Format** 35 mm, frame-by-frame
sequential images

In the early 1960s, self-taught photographer Duane
Michals (born 1932) carried out commissions for
a range of leading magazines, including *Esquire*,
Mademoiselle, and *Vogue*. In 1966, he turned
from commercial work to explore more creative
projects, staging his own scenarios and creating
richly imaginative photo sequences that draw on
fantasy and philosophy.

This series of eight gelatin silver prints forms
a narrative. They show a man and a woman in a
brightly lit room, a stage set for Michals's cinematic
serial imagery. A partially dressed woman is lying
asleep on a bed while a naked man wears a pair
of faux wings, as if he were an angel looking down
on her. He moves downward and kisses her. The
angel seduces the woman. Afterward, the angel
loses his wings and appears in ordinary clothes.
He seems to be ashamed and leaves the scene
hurriedly in what could be a modern-day version
of Anglo-Swiss artist Henry Fuseli's oil painting *The
Nightmare* (1781).

Throughout his long career, Michals repeatedly dealt with themes of guilt, power, sex, and transgression, and invariably treated them with great positivity and brio. Assemblages such as *The Fallen Angel*, with their posed theatricality, helped to free photography from the shackles of documentation and realism, and foreshadowed the work of artists such as Cindy Sherman and Carrie Mae Weems.

Michals's use of sequential imagery was regarded as almost subversive by some of his contemporaries because of its lack of attention to composition. Rather, Michals chose to pursue his desire for storytelling, and to portray feelings and the inner world of his imagination. He has said of his "undocumentary" art: "Doing sequences was liberating. It liberated me from the decisive moment." (Henri Cartier-Bresson had claimed that there was always a decisive moment; Duane Michals set out to demonstrate that this generalization was false.)

Among a host of remarkable commissions, Michals photographed the 1968 Olympics for the government of the host nation, Mexico, and created the artwork for the cover of *Synchronicity*, the 1983 album by The Police. **CK**

ASSASSINATION OF ROBERT KENNEDY

BILL EPPRIDGE

Date 1968
Location Los Angeles, California, USA
Format 35 mm

Shortly after midnight on June 5, 1968, during the campaign season for the 1968 presidential election, Robert F. Kennedy was passing through the kitchen of the Ambassador Hotel in Los Angeles when he was gunned down by Sirhan Bishara Sirhan, a Jerusalem-born Palestinian Christian, who was said to have targeted the Democratic candidate because of his support for Israel.

This image, captured moments after the shooting by *Life* photographer Bill Eppridge (1938–2013), is one of the best-known photographs of that night. It is also one of the most haunting signature images of the 1960s. It demonstrates the immediacy of great photojournalism, freezing the precise moment when busboy Juan Romero leaned down to comfort the victim. Kennedy had been shaking hands with Romero as he was shot, and the shock is still visible in his face. According to reports, Kennedy asked Romero, "Is everybody safe, OK?" And Romero responded, "Yes, yes everything is going to be OK," before placing a rosary in his hand. About twenty-six hours following the shooting, Kennedy died at just forty-two years of age.

In Eppridge's chilling image, Kennedy lies in a pool of his own blood on the concrete floor with his arm outstretched. Although Eppridge hardly had time to consider artistic elements at such a tragic moment, the drama and intensity of the image and the lighting are undeniable. In fact, it bears a striking resemblance to paintings by the Old Masters, with the light beaming down and illuminating Kennedy's supine form, which seems to float suspended in the darkness. **EC**

"I think what makes a picture is a moment that is completely spontaneous and natural and unaffected by the photographer." Bill Eppridge

WARSAW PACT TANKS
INVADE PRAGUE

JOSEF KOUDELKA

Date 1968
Location Prague, Czechoslovakia
Format 35 mm

On August 21, 1968, tanks from four Warsaw Pact countries rolled into Prague, the capital of what was then Czechoslovakia. Their mission was to crush what became known as the "Prague Spring," a brief period of liberal reform led by Communist Party leader Alexander Dubček, which was also an attempt to loosen the Soviet Union's tight grip on the country. Dubček told the Czechoslovak army to offer no resistance; instead, the citizens of Prague took to the streets to protest. Thousands of people surrounded the tanks on a daily basis, cajoling, arguing, and pleading with the troops to leave. Across the country more than 100 people were killed and many more injured.

Josef Koudelka (born 1938), who up to that point had been working as a theater photographer and documenting European Gypsy communities, joined the Prague crowds in order to record the trauma of the invasion. During the following week he took more than 5,000 photographs, shot on his simple Exakta Varex camera using rolls of cinema film. "I used to have to run home to reload, always thinking I was missing something," he recalled. The results are incredibly immediate, conveying the emotional intensity of those days—the anger and defiance of the Prague residents, and the confusion of the young occupying soldiers.

Smuggled out of Prague to the Magnum agency—where the staff found it difficult to believe that all the images had been taken by a single photographer—the pictures were published anonymously to protect Koudelka and his family from reprisals. It was another sixteen years before he was able to acknowledge that they were his. JS

"Koudelka has . . . achieved semi-mythic status as a photographer . . . he is the last of the great hard-bitten romantics of twentieth-century reportage."

Sean O'Hagan

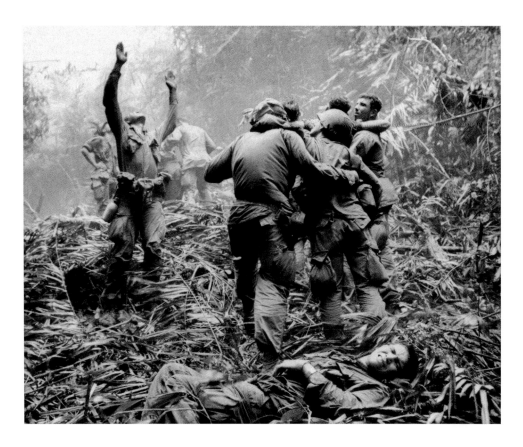

US PARATROOPER GUIDES IN A HELICOPTER IN VIETNAM

ARTHUR GREENSPON

Date 1968
Location South Vietnam
Format 35 mm

With no experience of war photography, Arthur Greenspon (born 1931) wanted to find out the "truth" about what was going on in Vietnam. He bought a one-way ticket to Saigon and survived on his wits as a freelancer, learning from the more seasoned journalists and photographers there.

This photograph was taken on a day during the Battle of Hué in 1968, when Greenspon accompanied a patrol with the US 101st Airborne Company near the city. A paratrooper signals in a medical evacuation helicopter, and there is a visceral sense of an event unfolding but, as in many of the best war pictures, there is no actual fighting going on. This is an aftermath picture, full of tension and anxiety. The layered composition reinforces the narrative: the paratrooper wildly gesticulating to the heavens could be calling on a deity to stop the madness; his comrades struggle to support their wounded colleagues; in the foreground, the pain in a wounded man's face underlines this as a scene out of hell. The presence of the unseen, descending helicopter is palpable. The weather was appalling, and when Greenspon saw the helicopter coming in, he could take only three frames before his camera jammed. *CJ*

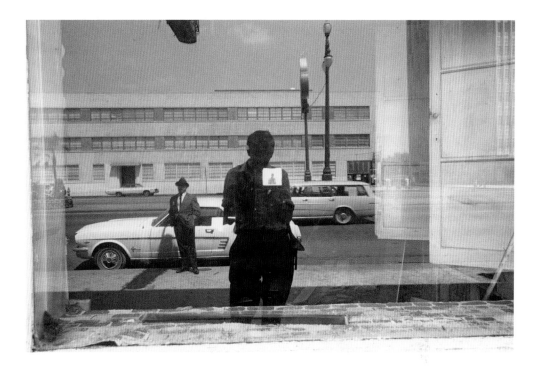

NEW ORLEANS, LOUISIANA

LEE FRIEDLANDER

Date 1968
Location New Orleans, Louisiana, USA
Format 35 mm

Along with Diane Arbus and Garry Winogrand, Lee Friedlander (born 1934) participated in the groundbreaking exhibition *New Documents* at the New York Museum of Modern Art in 1967. The trio revolutionized street photography. Whereas Arbus and Winogrand were interested in social commentary, Friedlander was more concerned with the act of taking a photograph itself and the act of viewing. He often incorporated mirrors or windows into his pictures—the reflections disrupt and disturb,

confusing the spatial sense. Here, he stands in front of a plate-glass window taking a picture of the man and the street behind him, as well as of a small picture inside the store. He also includes himself in the shape of his silhouette reflected in the store window. His indistinct self-portrait is located in the center of the image, just where a viewer might stand to look at the picture, so that the picture plane appears as a mirror to the viewer in the real world, collapsing the sense of distance. Friedlander's break with convention highlights the artifice of the work. Although he is documenting a moment, he illustrates how an image changes according to the perception of the viewer—that which appears fixed is open to interpretation. CK

PORTRAIT OF DIANE ARBUS

ROZ KELLY

Date 1968
Location New York, New York, USA
Format 35 mm

This photograph is a rare portrait of the famously shy photographer Diane Arbus (1923–71). Though the Arbus estate is insistent that her images—typically of marginalized people on the edge of society—should be protected from interpretation, the mystery of Diane Arbus has provided an endless fascination to writers. Moreover, the style in which she photographed—nakedly exposing her subjects, rendering them perhaps more "freakish" than they were—brings to center stage the ethics of photographing marginalized subjects. Her detractors claim that her pictures dehumanize subjects who are already objectified in society, and indeed her contact sheets reveal that she chose pictures that emphasized her subjects' strangeness. Admirers believe her to be right to refuse the facile impulse to say that "these people are just like us."

Roz Kelly (born 1943) shows Arbus holding her trademark Rolleiflex camera and refusing to meet her eye. For Arbus, the whole of life was circumscribed either by trauma or by the fear of it. Her search for people born with trauma—giants, dwarfs, transvestites, swingers—has been described as a quest for moments in which she felt at home in a world where she was otherwise unhappy. Arbus suffered from depression and committed suicide at the age of forty-eight. **MT**

MAY '68, PARIS

GILLES CARON

Date 1968
Location Paris, France
Format 35 mm

Gilles Caron (1939–70) is remembered as one of France's premier photojournalists. He made his name as a fashion and advertising photographer before turning to journalism. Traveling the world while working for several different agencies, he covered conflicts such as the Six-Day War in Israel in 1967, Biafra in 1968, and Northern Ireland in 1969.

His most memorable images were taken during the tumultuous month of May 1968 in his native France. This black-and-white action shot shows a university student running from the police in central Paris during the social upheaval as students demanded a change in the status quo. After months of conflict the Paris University of Nanterre was shut down, and students rose to protest the crackdown on their civil liberties. It was a social revolution. There were demonstrations, general strikes, and occupations of factories and universities throughout the country. Much of the action took place in the Latin Quarter of Paris, around the Sorbonne University. Students and workers battled police armed with tear gas and batons for months until, to quell the unrest, President Charles de Gaulle promised new elections. **SY**

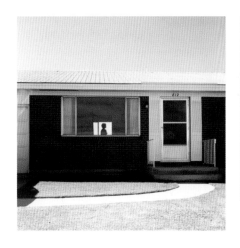

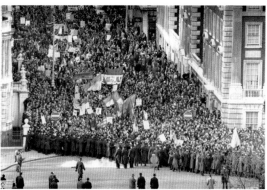

GROSVENOR SQUARE RIOT

UNKNOWN

Date 1968
Location London, UK
Format 35 mm

COLORADO SPRINGS

ROBERT ADAMS

Date 1968
Location Colorado Springs, Colorado, USA
Format Medium format

Robert Adams (born 1937) is known for his photographs of the landscape of the American West, particularly California, Oregon, and his home state of Colorado. He spurns a romantic vision of the vast outdoors in favor of suburban sprawl.

This image is part of a series that features homes, gardens, and storefronts. It shows the silhouette of a woman inside a house on a small lot. Adams has shot the image head on, and his composition emphasizes the harsh, geometric shapes of the architecture. The house lacks a warm welcome; rather, the figure appears imprisoned within a cube—she looks alone and even isolated. The vertical and horizontal lines, and the spartan aesthetic of the dwelling, lack character as Adams forces the viewer to dwell on the emotional price of uniformity and conformity. Form follows function here, but at the expense of a natural, organic beauty.

Adams was one of several artists whose work changed the direction of landscape photography in the late twentieth century, with a focus on what became known as the New Topographics. **CK**

For much of 1968, a wave of political protests disrupted life in many cities of North America and Europe. Mainly but not exclusively involving the young, this unrest had many different causes, among them objections to capitalism, consumerism, racism, and traditionalism in nearly all its forms.

One of the most contentious issues was the involvement of the United States in the Vietnam War—many Americans objected to the draft and challenged the US government's stated belief that if Vietnam were allowed to become Communist, the whole of Southeast Asia would follow. People in many other noncombatant nations shared similar misgivings, and marched in solidarity with antiwar campaigners in the United States.

In London these demonstrations degenerated into violent clashes as an estimated 10,000 protestors converged on the US embassy in Grosvenor Square. Stones, firecrackers, and smoke bombs were thrown by marchers; mounted police and police with batons intervened. In total, an estimated eighty-six people were injured and 200 arrested in the protest, which took place on Sunday, March 17, 1968. **EC**

MY LAI: A GROUP OF SOUTH VIETNAMESE WOMEN AND CHILDREN, COWERING. MINUTES LATER THEY WERE ALL DEAD

RON HAEBERLE

Date 1968
Location My Lai, Vietnam
Format 35 mm

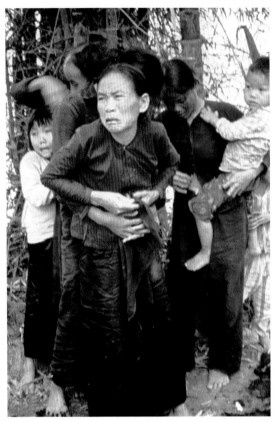

US Army photographer Ron Haeberle (born 1940) took numerous images of Charlie Company's infamous visit to My Lai, during which they burned the hamlet and tortured, raped, and murdered between 350 and 500 of its inhabitants. Most of his photos show lifeless bodies strewn on the ground, but this one shows the villagers as living, feeling victims of atrocity.

Haeberle and Jay Roberts, a journalist with Charlie Company, described a sexual assault on the woman holding the child, just before this photo was taken; the older woman in the foreground attempted to fight off the American troops as they perpetrated it. The soldiers stopped as Haeberle and the journalist approached, then killed this group as they turned away.

The US Army tried to hush up the events at My Lai, but the following year a soldier who had not been there at the time heard about the incident and wrote about it to US President Richard Nixon, the Pentagon, the State Department, and other prominent organizations and individuals. Finally, the truth began to emerge.

Although the subsequent Peers Report on the massacre confirms that rapes and sexual assaults occurred at My Lai, these crimes were not visually documented and have remained unprosecuted.

Haeberle's photographs, first published in the *Cleveland Plain Dealer* in November 1969 and later in *Life* magazine, were crucial visual evidence of a story few in the United States wanted to believe. Haeberle carried two cameras—one army-issued and one personal, which allowed him to create his own record of the atrocity. **CP**

"No one believed it . . the executive editor . . . wasn't sure if we should go with it. Almost simultaneously, this kid comes forward with these pictures." Mike Roberts, *Cleveland Plain Dealer*

BLACK POWER SALUTE ON OLYMPIC MEDAL STAND

NEIL LEIFER

Date 1968
Location Mexico City, Mexico
Format 35 mm

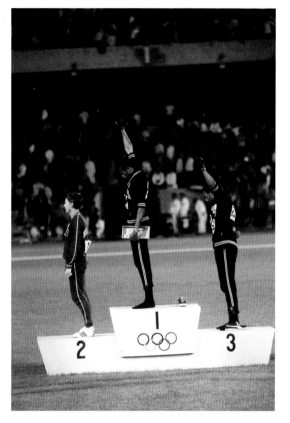

At the 1968 Mexico Olympics, US athletes Tommie Smith and John Carlos made history. As the American national anthem played out, Smith (center) and Carlos (right), who had won gold and bronze in the 200-meter race respectively, raised black-gloved fists in peaceful protest. It was an act of resistance and defiance at a time of immense social and political change in the United States and internationally. The civil rights movement was active, Martin Luther King, Jr., had been assassinated that year, and race riots were occurring.

With human rights badges on their jackets (silver medalist Peter Norman of Australia also wore one), Smith and Carlos made their salute to protest racial discrimination in the United States and to call for equality. The crowd fell silent, and then the booing and catcalling began. An immediate backlash saw the US media and sporting establishment criticize the athletes, and their families received death threats. Neil Leifer (born 1942), at the time a photographer for *Sports Illustrated*, among other titles, captured this moment for posterity.

Smith was reported to have said that the gesture represented Black Power in America, but later in his autobiography, *Silent Gesture* (2008), he wrote that it "was not the Black Power movement. ... It was the Olympic Project for Human Rights. It was more than civil rights; that's why it was called human rights."

Leifer's iconic image—a record of a symbolic moment in sporting and, indeed, twentieth-century history—resonates now as it did then, among those fighting for equality and justice. **GP**

"What separates the top photographers from the run-of-the-mill photographers is that when you get lucky a good photographer doesn't miss." Neil Leifer

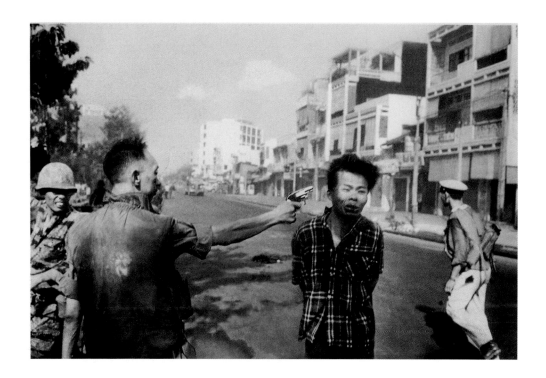

SAIGON EXECUTION

EDDIE ADAMS

Date 1968
Location Saigon (Ho Chi Minh City), Vietnam
Format Unknown

Eddie Adams (1933–2004) won the 1969 Pulitzer Prize for this image, but its success made him uncomfortable. The Vietnam War was uniquely uncensored, and Adams was able to move around freely as an Associated Press photographer. On the second day of the 1968 Tet Offensive, he and some colleagues came upon a man being dragged from a building by South Vietnamese police. Brigadier General Nguyen Ngoc Loan appeared with a pistol and raised it. Adams expected that he would threaten and interrogate the prisoner. Instead, less than a second later, his 35 mm, wide-angle lens camera recorded the moment of death for the captive, Nguyen Van Lem. Adams described it as a "reflex" photo, taken with no time for thoughtful framing, and regardless of how the effect was achieved, it remains a deeply affecting image.

Having served as a combat photographer in the Korean War (1950–53), Adams empathized with the fighting forces. Widely used by the antiwar movement to illustrate the brutality of conflict, this photo contributed to General Nguyen becoming a persecuted man for the rest of his life, something that Adams thought unfair given the daily brutalities of the war that he had witnessed on both sides. **CP**

ROBERT KENNEDY FUNERAL TRAIN

PAUL FUSCO

Date 1968
Location USA
Format 35 mm

After Robert F. Kennedy was assassinated in Los Angeles in June 1968, his body was flown to New York City and then taken by train to Washington, D.C. The route was lined with mourners. Paul Fusco (born 1953) was one of the journalists traveling on the train and, positioning his lens out of the window, photographed people along the trackside.

Fusco was a staff photographer at *Look* magazine. He later recalled that he had not expected the huge numbers of spectators and

that he had felt compelled to photograph them for the entire eight hours of the journey, which he has described as "a constant flood of emotion."

He shot the series on color Kodachrome and, although initially concerned about the slow shutter speed coupled with the moving train and moving people, he was amazed by the results. He said: "The motion that appears in a lot of the photographs, for me, emphasized the breaking up of the world, the breaking up of society, emotionally. Everyone's there; America came out to mourn, to weep, to show their respect and love for a leader, someone they believed in, someone who promised a better future. And they saw hope pass by in a train." LH

EARTHRISE

WILLIAM ANDERS

Date 1968
Location Outer space
Format Medium format

This image, taken from Apollo 8, the first manned spacecraft to orbit the Moon, shows Earth as it appears from space. Many professional photographers applied to go on this mission, but the National Aeronautics and Space Administration (NASA) decided to leave the pictorial record in the hands of its own staff.

Astronaut William Anders (born 1933) took this groundbreaking color photograph—previously, only black-and-white images of the Earth, taken by robotic cameras, had been seen by the general public. He used a highly modified Hasselblad that had a simple sighting ring, rather than the standard reflex viewfinder, and was loaded with a 70 mm film magazine containing special Ektachrome film pioneered by Kodak. Anders later wrote: "We'd come 240,000 miles [386,000km] to see the Moon, and it was the Earth that was really worth looking at." The contrast between the barren, rugged surface of the satellite and the delicate beauty of the floating Earth is one of the qualities that make this image so memorable.

The emotional impact of *Earthrise* cannot be overstated; it has been called the most influential environmental photograph ever taken. Former US Vice President Al Gore said that it "was credited with awakening the modern version of the environmental movement." Within eighteen months of Earth's inhabitants seeing what their planet looked like from without, many governments around the world passed legislation to encourage cleaner air and water and to coordinate environmental protection policies, including protection for endangered species. CJ

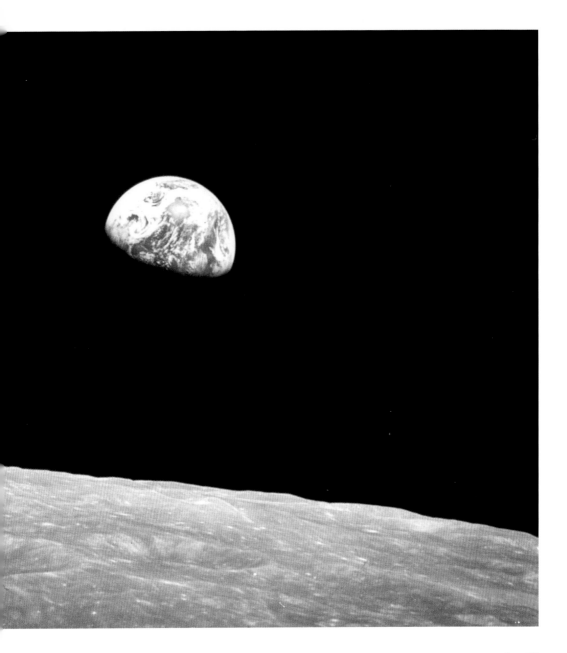

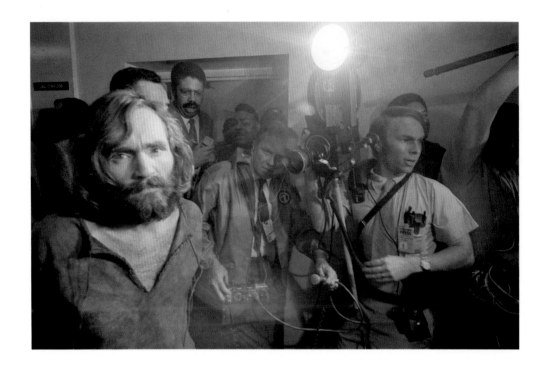

CHARLES MANSON ARRESTED

UNKNOWN

Date 1969
Location Los Angeles, California, USA
Format 35 mm

"I'm already dead, have been all my life. I've spent twenty-three years in tombs that you built." These are the words of Charles Manson, whose disciples carried out some of the most notorious murders of the late twentieth century.

In the late 1960s, Manson, an ex-felon living in southern California, formed a quasi-cult made up mostly of troubled and rebellious young women. Manson believed that the world would end in an apocalyptic race war. Having decided that he would have to start this conflict himself, he encouraged his followers to go on a killing spree in Los Angeles in the summer of 1969. The most infamous of the slayings was that of actress Sharon Tate, the pregnant wife of film director Roman Polanski, whom they brutally murdered along with her house guests on August 9, 1969.

This photo was taken later in August 1969, when Manson was arrested along with members of his group. He went to court in 1970, and at first, he conducted his own defense, but, unable to control himself in the courtroom, he was assigned an attorney to oversee his case. Manson infamously carved an X on his forehead to protest the denial of his right to defend himself. **SY**

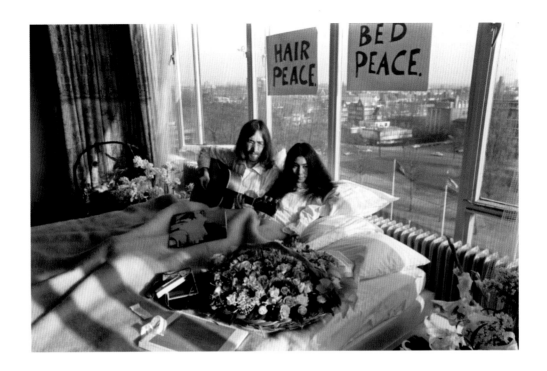

JOHN LENNON AND YOKO ONO IN THEIR "BED-IN"

UNKNOWN

Date 1969
Location Amsterdam, The Netherlands
Format 35 mm

It was an act made in the name of peace that captured the world's imagination. In March 1969, musician John Lennon and his new wife, artist Yoko Ono, staged a "bed-in" in the presidential suite at the Hilton Hotel, Amsterdam, to protest violence, and in particular, the Vietnam War. The newlyweds, who had been married for only five days after tying the knot in Gibraltar on March 20, spent a week in their hotel room bed, inviting television crews to witness their unusual protest. Film footage shows

a media frenzy, with one reporter asking the pair: "Is there not a more positive way of demonstrating in favor of peace than sitting in bed?" To which Lennon replies: "What's more positive?" Later the musician jovially remarks: "We're those famous freaks." The stunt, which can be viewed as a piece of performance art, was meant to be lighthearted and humorous, but the message—that everyone has a responsibility to promote peace—was a serious one. The couple, wearing pajamas, decorated the room with signs drawn by hand that read: "Hair Peace" and "Bed Peace." Two months later the pair held another bed-in at the Queen Elizabeth Hotel in Montreal, Canada, where they recorded the single *Give Peace a Chance.* GP

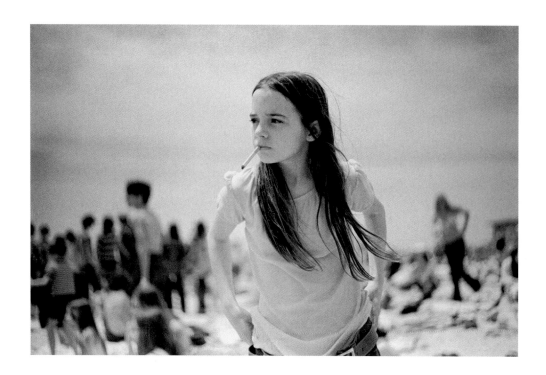

PRISCILLA, 1969 (FROM THE SERIES *ALMOST GROWN*)

JOSEPH SZABO

Date 1969
Location New York, New York, USA
Format 35 mm

On Jones Beach, New York, with a cigarette nonchalantly held between her lips, and a hard expression on her face, the girl seems older than her years. The tomboyish, casual gesture of hoisting up her oversized jeans could almost be mistaken for drawing a set of guns from their holsters. Focused on something in the distance, she seems to be searching for something on the horizon and appears totally unaware of the camera. The shallow depth of field that sends the backdrop into a myopic haze—in which dark figures stir—creates a moody atmosphere where a slight wind tugs at the girl's hair and an overcast sky gives a noticeable weight to the image.

Best known for his pictures of American teens, Joseph Szabo (born 1944) tried in his images to capture the nuances of adolescence. This particular image—which was included in his first book, *Almost Grown* (1978)—was also used as a cover for rock band Dinosaur Jr.'s 1991 album *Green Mind*. In Szabo's book, the image is accompanied by a poem by Jill Newman that begins: "I know it hurts / all the pain / rips your heart apart." The Jones Beach mystery girl remains one of Szabo's most famous images. **EC**

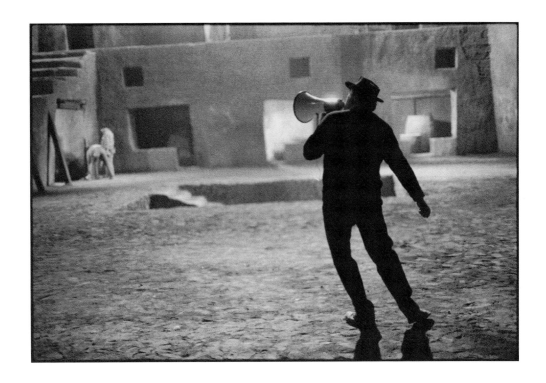

FEDERICO FELLINI ON THE SET OF *SATYRICON*

MARY ELLEN MARK

Date 1969
Location Italy
Format 35 mm

Known for powerful black-and-white documentary work, Mary Ellen Mark (1940–2015) was a prolific photographer, covering a vast range of subject matter, including production stills. In 1969, she worked on the set of Federico Fellini's *Satyricon*. Once asked how she set up a shot, she replied: "The subject gives you the best idea how to make a photograph. So I just wait for something to happen." That philosophy is in evidence here: the powerful, backlit figure in the foreground dominates the

scene, with his megaphone pointed at the two tiny figures in the corner of the set.

Small subtleties reinforce the message: Fellini's swaying body is full of vigor and seems to dance; the light bouncing off the megaphone gives it an almost supernatural quality; and Fellini's body is the only truly black thing in the picture, everything else being shades of gray.

Mark's work had a major influence on many photographers, and she was highly respected in her lifetime. In 2014, she received the Lifetime Achievement in Photography Award from George Eastman House, and the Outstanding Contribution to Photography Award from the Sony World Photography Organization. ER

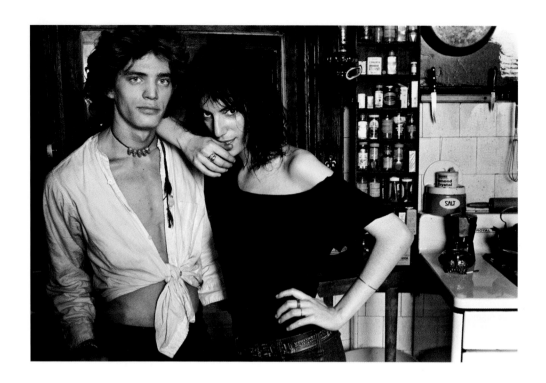

ROBERT MAPPLETHORPE AND PATTI SMITH

NORMAN SEEFF

Date 1969
Location New York City, New York, USA
Format 35 mm

When South African Norman Seeff (born 1939) took this photograph of Robert Mapplethorpe and Patti Smith, he had been in New York for just a year. Born in Johannesburg, Seeff had relocated to the United States in search of an outlet for his creativity (he had studied both science and art). Mapplethorpe, who was himself at the start of a career in photography, and Smith, a poet and musician, had only met in 1967, but struck up a deep friendship that would be remembered for its intensity and immortalized

in Smith's book, *Just Kids* (2010). Seeff, who had been photographing people he came across in Manhattan, recounts in an interview with Artnet how he had met Smith and then Mapplethorpe before moving to the Chelsea Hotel where the pair lived and worked. "This picture was taken at a friend's apartment [where] they had a studio, and they let me use it," he recalled. "This was after a photo session we did; we were just hanging out." Perhaps this explains the photograph's informal air. Seeff certainly captured the closeness of the friends, whose love for one another emanates from the picture. Seeff's time in New York arguably laid the foundations for his future career within photography and as a movie maker. **GP**

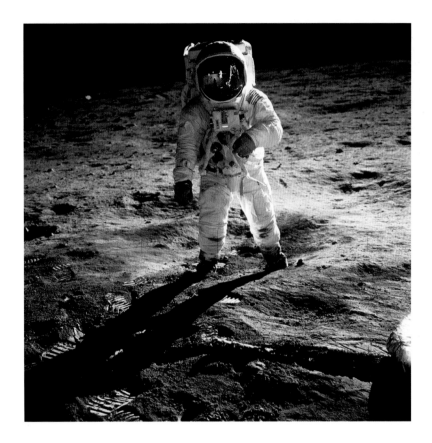

BUZZ ALDRIN ON THE MOON

NEIL ARMSTRONG

Date 1969

Location Outer space

Format 70 mm lunar surface camera

This groundbreaking picture was taken by Apollo 11 mission commander Neil Armstrong (1930–2012) on July 20, 1969. It shows his fellow astronaut, lunar module pilot Edwin E. "Buzz" Aldrin, Jr., walking on the surface of the Moon in the Sea of Tranquillity region during the first lunar landing mission. Note the reflection of Armstrong in Aldrin's visor, and the bootprints in the lunar soil. The gold-colored object on the right of the image is the leg of the lunar landing module *Eagle*.

Eight years previously, US President John F. Kennedy had set his nation the goal of landing a man on the Moon. This photograph is one of a series of images taken on the lunar surface that celebrate the supreme technological advances made by the United States. Among these were the two specially adapted Hasselblad cameras that accompanied the lunar module. Both were built around a 500EL body. The one used for this image was called the Extravehicular Camera, for use outside the module. It had anodized surfaces to prevent overheating, a reseau plate, and a wide, Planar 60 mm f/2.8 lens. The camera was loaded with 70 mm film specially designed for the mission by scientists at Kodak. CK

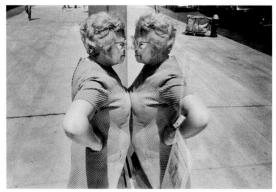

WOMAN LOOKING AT HERSELF IN STORE WINDOW

RICHARD KALVAR

Date 1969
Location New York, New York, USA
Format 35 mm

YUCATÁN MIRROR DISPLACEMENTS (1–9)

ROBERT SMITHSON

Date 1969
Location Yucatán, Mexico
Format Unknown

Robert Smithson (1938–73) installed 12-inch-square (29x29cm) mirrors on a range of sites near Mayan ruins. Within the mirrors, the landscape was reflected, refracted, and "displaced" in a commentary on temporality and location.

Smithson is best known for his monumental "earthwork" *Spiral Jetty* (1970), located in Utah's Salt Lake. Along with photography, writing was also an important aspect of his practice. The *Yucatán Mirror* series was made to accompany an essay in *Artforum International Magazine*, in which he recounts how he believed that the Aztec deity Tezcatlipoca had spoken to him on his journey through Mexico, urging him to throw away his guidebooks and make work that collapsed the gulf of time between the present and the ancient past: "'All those guide books are of no use,' said Tezcatlipoca. 'You must travel at random, just like the first Mayans; you risk getting lost in the thickets, but that is the only way to make art.'" JG

Richard Kalvar (born 1944) consistently uses certain visual tropes—doubling, reflection, and strange juxtapositions—to render the world otherwise: a man's head is replaced by a dog's; a couple walk into the jaws of a crocodile; a disembodied leg pokes out of a hedge; and here, a woman appears to regard herself in a shop window. Yet of course, she is not doing so. She is standing as close as possible to the glass to view the displays without the sun's glare. The thing in front of us is no longer the thing that was photographed: "It's a scene, it's almost a play," Kalvar remarks.

He credits growing up in a permissive and prosperous era, the 1960s, for allowing him the freedom to produce gently playful images without worrying about their marketability. Distinguishing himself from humanist photographers such as Walker Evans, he describes his work as "reacting to" the world rather than "showing" something. In a sense the things he shows did not really happen. Yet they also did. His images are both believable and absurd, creating a playful tension between different interpretations. MT

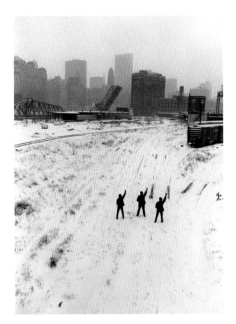

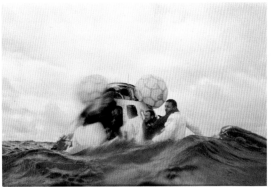

APOLLO 13 ASTRONAUTS AWAIT RECOVERY

NASA

Date 1970
Location Pacific Ocean, off American Samoa
Format 35 mm

It could have ended in tragedy. On April 17, 1970, the astronauts of the stricken Apollo 13 mission returned safely to Earth after an ordeal lasting several days. The spacecraft made a successful splashdown in the South Pacific.

James A. Lovell, John L. ("Jack") Swigert, and Fred W. Haise had been headed to the Moon in what was intended as the third manned lunar landing. But after only fifty-six hours the crew was forced to abandon its mission. An electrical failure had caused an oxygen tank to explode, severely damaging the service module, which provided electrical power to the command module where the crew and equipment were housed. Both oxygen tanks failed, and there was a loss of power. As Lovell famously told Mission Control: "Houston, we've had a problem." Fortunately, the crew was able to use the lunar module as a "lifeboat."

Millions of people around the world watched on television as news networks broadcast constant live coverage. A routine mission had turned into one of the most famous incidents in the history of space travel. GP

USA. ILLINOIS. CHICAGO. 1969. BLACK PANTHERS PROTESTING.

HIROJI KUBOTA

Date 1969
Location Chicago, Illinois, USA
Format 35 mm

Born in Japan in 1939, Hiroji Kubota moved to the United States in 1962. He became fascinated with the Black Panther Party, a revolutionary black nationalist and socialist organization started in 1966, and spent time documenting their activities in Chicago. Describing how he came to make this iconic image of resistance, Kubota recalled that he had been photographing the men indoors at the Chicago Public Hall when "it started snowing, so we went outside and I took this. I didn't give them any instructions—they just went down there and saluted, never asking me anything about myself, or what I might be doing the picture for. They pretty much ignored me." PL

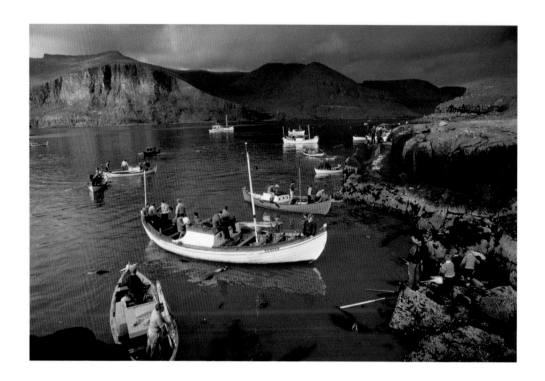

WHALING IN THE FAROE ISLANDS

ADAM WOOLFITT

Date 1970
Location Tindhólmur, Faroe Islands
Format 35 mm

When first published in *National Geographic*, this disturbing image by Adam Woolfitt (born 1938) immediately became controversial. It shows the aftermath of the slaughter of a pod of long-finned pilot whales on the shores of the remote, uninhabited Faroe island of Tindhólmur. The image is surreal, with the dark, storm-laden skies and the rocky coastline and cliffs framing a sea of blood in a scene as if from Dante's *Inferno* or a painting by Bruegel. This has been a Faroese tradition since the time of the earliest Norse settlements and is explicitly sanctioned in the Sheep Letter, a royal decree of 1298. The slaughter is still regulated by the Faroese authorities and carried out under strict rules. Called *grindadráp*, the hunts are noncommercial and are organized on a community level. Each year, mainly in summer, approximately 800 long-finned pilot whales and some Atlantic white-sided dolphins are slaughtered. When a pod is sighted near the coast, the islanders sail out to drive the whales onto the shoreline, where they kill them with special whaling knives. Whale meat is considered by the Faroese as a vital part of their food culture and history. Animal rights groups condemn the harvest as cruel and unnecessary. **PL**

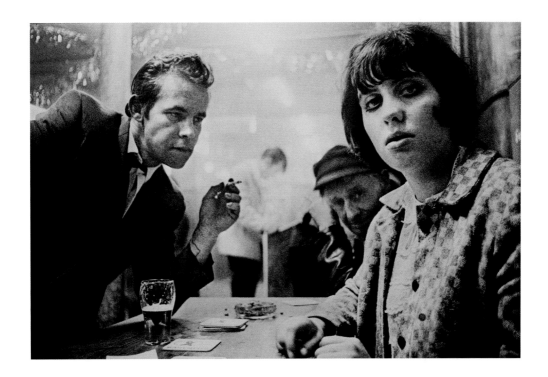

LILLY, ROSE, AND SCAR

ANDERS PETERSEN

Date 1970
Location Hamburg, Germany
Format 35 mm

Anders Petersen (born 1944) studied photography under Christer Strömholm in Stockholm. In 1967, he visited Hamburg, Germany, where he started to take photographs at the Café Lehmitz. Petersen took pictures of the bar's regulars for the next three years. Among the clientele were prostitutes, drug addicts, circus performers, transvestites, and drunks. For Petersen, they became like a family. He held his first solo show at the bar in 1970, which consisted of some 350 photographs nailed to the wall, and told viewers that if they saw a picture of themselves, they could take it down and keep it—after a few days the walls were empty.

This image shows some of the bar's late-night customers. The woman was known as "Lilly"; the man on the left was known as "Rose," because of a tattoo on his chest; and the man behind Lilly is a sword-swallower, "Scar." Petersen said of this picture: "I took hundreds of photographs . . . but this one is special. I like these three characters and they are being themselves."

In 1978, Petersen published a photo-book, *Café Lehmitz*, dedicated to the pictures he took at the bar, which is regarded as a seminal work of European photography. CK

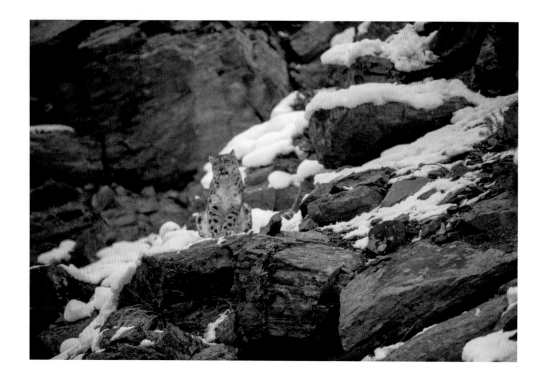

SNOW LEOPARD

DR. GEORGE SCHALLER

Date 1970
Location Hindu Kush, Pakistan
Format 35 mm

Dr. George Schaller (born 1933) is an American naturalist who has devoted his life to preserving the world's most endangered animals, including mountain gorillas, Tibetan antelope, wild yak, jaguars, giant pandas, lions, and tigers. For more than fifty years, Schaller trekked through the remote mountains of Pakistan, Afghanistan, China, Nepal, Tibet, and India, researching and studying the elusive snow leopard, and became one of only two Westerners to see the creature

in Nepal between 1950 and 1978. Schaller has been particularly concerned with understanding how snow leopards interact with humans and with countering threats to their survival. In 1973, his expedition to Dolpo, Tibet, was recorded by Peter Matthiessen in his book *The Snow Leopard*. More recently, Schaller has worked extensively in China, home to 50 percent of the estimated 3,000 remaining snow leopards in the wild.

Schaller described the encounter shown here thus: "I spotted the snow leopard on a rocky slope high in the Hindu Kush mountains of northern Pakistan on a December day in 1970. She had a kill, a domestic goat, and at the entrance to a rock cleft nearby were her two small cubs." PL

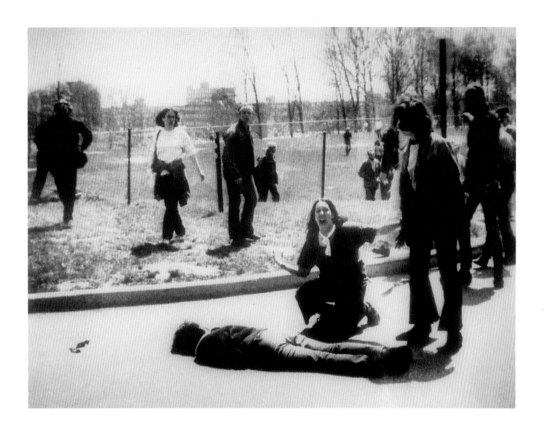

SHOOTING AT KENT STATE UNIVERSITY

JOHN PAUL FILO

Date 1970
Location Kent, Ohio, USA
Format Unknown

On April 30, 1970, US President Richard M. Nixon announced that the United States was to invade Cambodia (where he claimed, inaccurately, were "the headquarters of the entire communist military operation in South Vietnam"), and that 150,000 additional soldiers would be drafted to bolster the Vietnam War effort. In response, massive protests broke out across the country. At Kent State University, students set fire to a building. The Governor of Ohio ordered 900 National Guardsmen

to the campus. On May 4, twenty-eight guardsmen opened fire on a crowd of students, killing four of them and wounding nine.

John Paul Filo (born 1948) was a photography student at Kent State taking pictures for the school yearbook when he captured this iconic image that later won a Pulitzer Prize. It shows Mary Ann Vecchio, age fourteen, crying over the body of Jeffrey Miller. Filo recalled: "I didn't react visually. This girl came up and knelt over the body and let out a god-awful scream that made me click the camera."

The image shown here is the original photograph. The fence post above Vecchio's head is airbrushed out of most reproductions. CJ

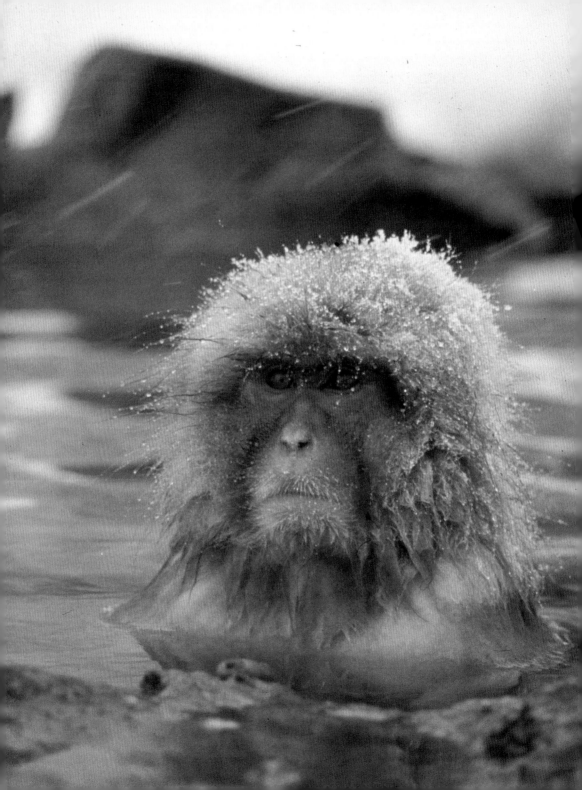

APE IN WATER

CO RENTMEESTER

Date 1970
Location Japan
Format 35 mm

Originally shot for the cover of *Life* magazine's issue of January 30, 1970, this image shows a snow monkey bathing in a hot spring during a blizzard in the Japanese Alps. Using a shallow depth of field, Jakobus Willem "Co" Rentmeester (born 1936) captures the blur of snowflakes soaring past while simultaneously highlighting the detail on the monkey's poised head. The creature is caught in a moment of its own, motionless yet surrounded by movement. The lens picks up on the snowflakes clinging to its shaggy mane, the pinkish tone of its skin, and the striking humanness of its face as it bathes in the water to warm up.

Rentmeester rowed for the Dutch Olympic team in Rome in 1960, then moved to the United States, where he took a course in photography at the Art Center College for Design in Los Angeles, California. Upon graduating, he began working as a freelance photographer for *Life*, gaining immediate recognition for his images of the Watts Riots of 1965, before eventually becoming a staff photographer the following year. He then covered the Vietnam War, and his image of a US tank commander won the World Press Photo of the Year Award in 1967 (this was the first color photo to receive this accolade). His wartime career was ended by a Vietcong sniper, but as soon as he recovered from his wound, he photographed a range of stories for several major publications. In 1972, his photo of Olympic gold medalist swimmer Mark Spitz won first prize in World Press Photo's sports category. As an advertising photographer, Rentmeester worked on campaigns for Marlboro, Nike Air, and other leading brands. **EC**

RECRUITS UNDER LIVE FIRE CRAWL BELOW BARBED WIRE AT PARRIS ISLAND

THOMAS HOEPKER

Date 1970
Location South Carolina, USA
Format 35 mm

In 1970, photojournalist Thomas Hoepker (born 1936) visited Parris Island, a training site for US Marine Corps recruits. Among the images he took there we see a recruit driven to breakdown by drill sergeants; a drill instructor reprimanding a marine; and marines shouting "Yes, sir!" to their seniors. In this image, recruits crawl under barbed wire while live fire is directed on top of them. Their desperate and extreme expressions—in particular, the recruit on the right of the frame appears to be screaming out in agony—suggest that they are in a war zone.

The image is all the more disturbing when we learn that it was shot at a training site. With the use of live ammunition, it shows how terrifyingly close the training is to real conflict. Marines first came to Parris Island in 1891, but it was not until 1915 that the site was turned over to the US Marine Corps. During the Vietnam War, more than 200,000 recruits trained at Parris Island. Today, around 20,000 are thought to embark on the rigorous twelve-week training program each year. **GP**

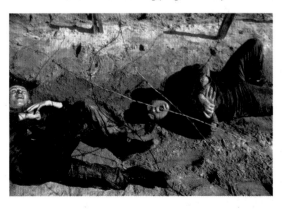

PVC GARDENER

UNKNOWN

Date 1970
Location London, UK
Format 35 mm

Clad from head to toe in a weird-looking PVC suit, gardener Sophia Pienkos looks more like someone from a sci-fi movie than a horticultural worker. She is pictured here tending plants in the historic Palm House at the Royal Botanical Gardens in Kew, London. The bizarre outfit she is wearing is designed to protect her from the toxic sprays she is using. The protective headgear was essential to prevent the inhalation of pesticides, and the elbow-length gloves prevented chemicals from coming into contact with her skin. While those who work with pesticides in the twenty-first century continue to wear protective clothing, the outfits are not as outlandish as they were back then.

As well as being humorous in its own right, the photograph gives a glimpse inside the famous glasshouse as it was in the 1970s. Designed and constructed in the nineteenth century to house exotic plants being brought from far afield, the Palm House is made from 16,000 panes of glass held in place by a structure of wrought iron arches. It was the first time that wrought iron had been used on that scale without having to rely on supporting columns. The technique was also applied in the construction of ships' hulls. **GP**

HARLEM KISS

JILL FREEDMAN

Date 1970
Location New York City, New York, USA
Format 35 mm

This spontaneous image shows a couple kissing in a New York street; the woman in white heels and a large, fur-trimmed coat is swept up in the man's arms. They are seemingly oblivious to the men watching and smirking behind. In the 1970s, New York was in the grip of an economic crisis; the streets were rampant with crime, poverty, and violence. Yet self-taught documentary photographer Jill Freedman (born 1939) recalls how she used to love taking her Leica M4 into the streets during those times of gloom to record daily life as it unraveled before her on the sidewalks.

Born in Pittsburgh, Freedman moved to New York in 1964. Experimenting with a friend's camera, she soon discovered her vocation. Setting up a darkroom in a cheap apartment above Sullivan Street Playhouse, she made the place her base for twenty-four years. Freedman is known for her fearlessness. After documenting the protest encampment named "Resurrection City," she lived in a beat-up Volkswagen bus traveling with the Clyde Beatty-Cole Brothers Circus. In 1975, she photographed firefighters in the Bronx and Harlem; later, following the NYPD, she exposed the darker side of the city's Lower East Side. **EC**

STRAY DOG

DAIDŌ MORIYAMA

Date 1971
Location Misawa, Japan
Format 35 mm

HITCHCOCK PROMOTING *FRENZY*

UNKNOWN

Date 1971
Location London, UK
Format 35 mm

At first glance, the figure floating on the Thames River looks like Alfred Hitchcock. But look again, and you will see it is not the movie director at all, but a dummy. The likeness is nonetheless uncanny.

The image was used in the publicity campaign to promote *Frenzy*, Hitchcock's penultimate movie and the one with the most graphic violence. Based on the novel *Goodbye Piccadilly, Farewell Leicester Square* (1966) by Arthur La Bern, the movie tells the story of a serial killer on the loose in London who strangles his victims with a necktie. At the center of the narrative is ex-Royal Air Force pilot Richard Blaney (Jon Finch), who, after discovering that his ex-wife has been murdered, is wrongly suspected of killing her and of being the necktie murderer.

It is perhaps not surprising that Hitchcock, many of whose macabre films feature flashes of black humor, should have overseen the creation of a promotional still in a similar vein. If the key to a successful publicity drive is to create impact and intrigue, then Hitchcock's image of his dead self, floating on the Thames, where the film begins, surely ticks all the boxes. **GP**

On a US military base in Japan in 1971, Daidō Moriyama (born 1938) came upon a stray dog. He crouched down and photographed the animal at eye level in bright sunlight in his characteristic, grainy black-and-white style. Before long, the image became an icon within Moriyama's striking and often unsettling portrayal of postwar Japanese society. Although it was an unpremeditated chance encounter, the symbolic value of the image has been much discussed. Unlike in the West, there is no tradition in Japanese culture of romanticizing the outsider, the rebel, or the renegade. Instead, a stray dog epitomizes a kind of threatening nonconformity that tends to evoke suspicion. Yet Moriyama's image is celebrated both inside and outside Japan. It is much reproduced, and prints of it are held in many public and private art collections internationally. He even titled his 2004 memoir *Memories of a Dog*.

In the late 1960s Moriyama was one of a group of photographers responsible for the hugely influential *Provoke* magazine, which aimed to present cutting-edge images underpinned by a radical political agenda. This postwar period was a profoundly unsettling time in Japan. Moriyama sought to confront the darkness of the recent past and to help to forge a new future. **JG**

DEMONSTRATION AGAINST NARITA AIRPORT AND THE VIETNAM WAR

BRUNO BARBEY

Date 1971
Location Tokyo, Japan
Format 35 mm

In the 1960s, plans were made to build a new international airport to support the burgeoning economic growth of Japan. It was to be the largest public works program in Japanese history—and the most contested. The chosen site was located in Chiba Prefecture, covering agricultural land occupied by both smallholders and the Imperial Household. The farmers rebelled, and their bitter protest movement expanded to include many Leftist activists; it continues to this day, despite the airport itself having been completed in 1978. The state's occupation of this land was seen in the same context as other fraught political issues of the time, including the Vietnam War, which became included in the movement's passionate protests.

In 1971, Bruno Barbey (born 1941) photographed this Zengakuren student federation demonstration, in which a snakelike formation of protestors collides with riot police and other obstacles. With the group's long flagpoles and red flags lowered like spears or jousting lances, and their white helmets contrasting against the police's dark riot gear, the impression is of a medieval battle scene, good pitted against evil, painted from above. JG

THE MINEHEAD HOBBY HORSE

HOMER SYKES

Date 1971
Location Minehead, UK
Format 35 mm

Photographer Homer Sykes (born 1949) is one of the leading documentarians of the British way of life. In particular, he has focused his attention on the eccentricities and oddities of English customs, ranging from working-class rituals to the pastimes of the wealthy nobility.

In the early 1970s, while still a student of photography at the London College of Printing, he began a long-term project exploring the folklores and celebrations of English towns and villages. In this charming image, a young boy in the Somerset town of Minehead confronts the Sailors Horse on May Day, when, according to tradition, the hobby horse walks to Whitecross, to the west of the town, and bows three times to the sun at dawn.

Sykes has described how he forgot about the photograph for the first publication of his book, *Once a Year: Some Traditional British Customs* (1977), but came across it when he was preparing the reissue of 2016. His work is marked by a gentle wit and a strong aesthetic; he has said that "composition has always been very important to me. I like space and visual formality." PL

EZRA POUND

HENRI CARTIER-BRESSON

Date 1971
Location Venice, Italy
Format 35 mm

In addition to being celebrated for his street photography and photojournalism, Henri Cartier-Bresson (1908–2004) was a noted portrait photographer, and he continued to capture images of people long after 1968, the year he abandoned other forms of photography. He shot many noted luminaries from the arts and culture, including painter Henri Matisse, novelist and philosopher Albert Camus, and fashion designer Coco Chanel, as well as a host of politicians and private individuals with no particular claim to fame. He worked mainly on commission, but he also took photographs of friends and strangers who interested him.

The study shown here of Ezra Pound was made less than a year before the controversial American modernist poet's death in 1971 at age eighty-seven. Cartier-Bresson's wife, Martine Franck, was present at the shoot, and she reported "a tremendous, heavy silence … Pound didn't say a word. He just seemed to condemn the world with his eyes. We were there for about twenty minutes. I stayed to one side. I huddled in a corner. Henri took seven pictures."

Shot at eye level, this photograph diminishes the frailty of the seated elderly Pound and, unlike the other low-contrast images taken during the same sitting, catches the subject in a strong light that adds drama to his introspective stare, shadows the eyes, and increases intensity by deepening the features.

This photograph has become a defining portrait, not only of Ezra Pound, but of also old age in general. NG

"I am completely and have always been uninterested in the photographic process. I like the smallest camera possible, not those huge reflex cameras with all sorts of gadgets." Henri Cartier-Bresson

CLINT EASTWOOD IN
DIRTY HARRY

UNKNOWN

Date **1971**
Location **Unknown**
Format **35 mm**

On December 22, 1971, the eponymous first installment of the action thriller series *Dirty Harry* was released by Warner Bros. In the title role was American actor and filmmaker Clint Eastwood. There were to be four sequels: *Magnum Force* (1973), *The Enforcer* (1976), *Sudden Impact* (1983), and *The Dead Pool* (1988), but none was to grab the moviegoing public as much as the original movie.

In this uncredited publicity portrait, Eastwood gives the photographer a hard stare from behind the looming barrel of Inspector "Dirty" Harry Callahan's famous Magnum .44 revolver, which he describes in the movie as "the most powerful handgun in the world," one that "would blow your head clean off." Eastwood did not have to dig deep to give his new character credibility. In previous roles, particularly in Spaghetti Westerns such as *A Fistful of Dollars* (1964), *For a Few Dollars More* (1965), and *The Good, the Bad and the Ugly* (1966), he had already made his name synonymous with guns, masculinity, and violence.

Produced and directed by Don Siegel, *Dirty Harry* was hugely successful and inspired a whole new genre of police films. Eastwood's take on San Francisco cop "Dirty" Harry is arguably among his most memorable roles. The plot was based on the true-life case of the "Zodiac Killer," a serial murderer who operated in northern California in the late 1960s and early 1970s, and whose identity was never discovered. In *Dirty Harry* it is down to Inspector Callahan to track down the psychopath.

Eastwood was to direct *Sudden Impact*, the movie's third sequel, and it was recognized for being the darkest and most violent of them all. **EC**

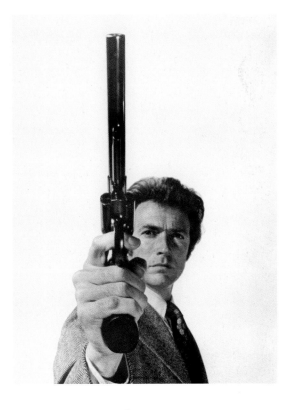

"I have a very strict gun control policy: if there's a gun around, I want to be in control of it." Clint Eastwood

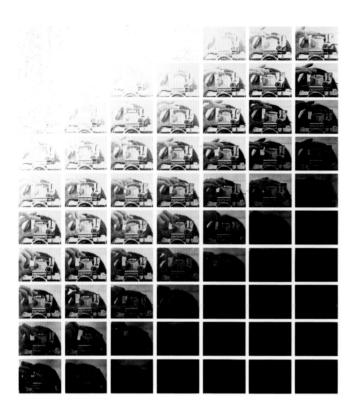

CAMERA RECORDING ITS OWN CONDITION
(7 APERTURES, 10 SPEEDS, 2 MIRRORS)

JOHN HILLIARD

Date 1971
Location UK
Format Photographic prints

The work of John Hilliard (born 1945) explores the nature and limitations of the photographic medium. This image is an example of his use of photographic apparatus as a subject. He pointed his 35 mm SLR camera at a mirror and took photographs at each possible combination of aperture and shutter-speed setting, his own fingers visible in each frame. The resulting grid of seventy pictures reveals a single diagonal row of "correctly" exposed images, with the alternative extremes at the top left and bottom right corners. It is a systematic attempt to document one aspect of photography's "own condition," behind which is the premise that this is, in fact, what every photograph inevitably does.

Hilliard is interested in the inadequacy of the single photographic image as an objective record, hence his tendency to work in series such as this. With photography as both the subject and the medium, his work can be seen as an extension of the earlier modernist commitment to distill photography to its purest specificity. In Hilliard's case, however, this seems to be an entirely reflexive critique—not representation of the world at large, but documentation for its own sake. JG

WHAT MAKES JACKIE RUN? CENTRAL PARK, NEW YORK CITY, OCTOBER 4, 1971

RON GALELLA

Date 1971
Location New York, New York, USA
Format 35 mm

Artist Andy Warhol said that his idea of a good picture is "one that's in focus and of a famous person doing something unfamous," which might explain why Ron Galella (born 1931) was his favorite photographer. Dubbed "the King of the Paparazzi," Galella made his name shooting the famous whether they liked it or not. Actor Marlon Brando once knocked out five of his teeth when he got too close, and Jackie Onassis had a restraining order put in place to compel him to keep his distance.

It is for his photographs of Onassis that Galella is best known. He once mused, "Why did I have an obsession with Jackie? I've analyzed it. I had no girlfriend. She was my girlfriend in a way." And so his lens caught her incidentally, drawing close as she crossed the street, wind whipping her hair around her face, or here, as she runs through Central Park. She took to running away to distract Galella from her children whenever he tried to photograph them, and it is telling of his fixation that he kept clicking the shutter as she fled. We could read into this image the futility of an icon like Onassis trying to flee the trappings of her celebrity, or see the pathos of a woman trying to evade intrusion by a man who would not leave her alone. RF

BENGALI SOLDIERS ABUSE PRISONERS

PENNY TWEEDIE

Date 1971
Location East Pakistan (now Bangladesh)
Format 35 mm

During the Bangladesh War of Independence from Pakistan in 1971, soldiers of the Mukti Bahini, the Bengali guerrilla army, held a victory celebration and started to attack and kill terrified prisoners in full view of international journalists and photographers. Some photojournalists felt that this grisly event was being organized for their benefit; Magnum's Marc Riboud talked of it being "an invitation to a massacre." British photographer Penny Tweedie (1940–2011) agreed; after taking a few pictures, she and Riboud walked away in disgust, realizing what was about to happen. Her photograph shows one of the young prisoners being abused and manhandled. Other photographers chose to stay on and witness the actual killings, feeling they had a duty to tell the story. Horst Faas of Associated Press and French photojournalist Michel Laurent jointly won the 1972 Pulitzer Prize for their photographs of the massacre. Tweedie was subsequently accused on British television of being a coward for leaving the scene. She responded: "It was a gut reaction on my part. I did what I felt was right at the time. If all the photographers had walked away, would they still have killed the prisoners? I still don't know the answer to that." CJ

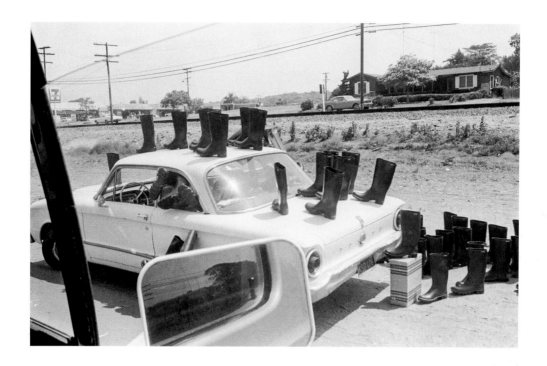

100 BOOTS ON THE ROAD FROM THE SERIES *100 BOOTS*

ELEANOR ANTIN

Date 1971
Location Leucadia, California, USA
Format Postcard

100 Boots is an amalgam by Eleanor Antin (born 1935) of photography, performance, and "mail art." It features fifty pairs of rubber boots, which together became a character whose adventures she created and documented. "We took 100 Boots down to the beach to look at the sea," she wrote. "We took him to the market, the bank, and the church. He seemed to be a good suburbanite. . . . Later he reappeared in a meadow, hanging out with the cows . . . and 100 Boots was on his way to his next adventure."

The boots were photographed by fellow artist Philip Steinmetz in fifty-one different scenarios, and the resulting images printed onto 1,000 postcards, which Antin sent to artists and art-world professionals all over the United States over a period of three years. Thus, *100 Boots* became a small part of the ordinary lives of hundreds of people, rather than a gallery exhibit of expensive prints to be bought and sold on the art market.

Antin's project raises questions about the nature of art: whether the true work lies in the sculptural "performance" of the boots as a single character, in the performance of the artist arranging the boots, in the photographer's images of the boots, in the postcards, or in the act of mailing them. JG

MARK SPITZ

CO RENTMEESTER

Date 1972
Location USA
Format 35 mm

Dutchman Co Rentmeester (born 1936) originally planned to enter the lumber business in California, but subsequently decided to pursue a photographic career. As a former Olympic rower, he had a natural interest in sports, and this image of US Olympic swimmer Mark Spitz is one of his finest. The photograph, taken during a training session, demonstrates perfect control: Spitz's eyes are wide open; no splash or wave is hiding his face. It would have been almost impossible to achieve such a clean image in a competitive situation. Rentmeester entered the pool himself and stood very close to the lane in which Spitz was swimming. He used a Hulcher camera, an adapted movie camera that allowed him to shoot at thirty to forty frames per second while nevertheless maintaining a sharp image. The effect is extraordinarily intimate: we feel we are immersed in the water alongside Spitz, experiencing his intense concentration.

The world has gotten used to seeing US competitor Michael Phelps dominating Olympic swimming competitions, but in the 1972 Munich Olympics, it was twenty-two-year-old Spitz who walked away with seven gold medals, setting world records in each event. **CJ**

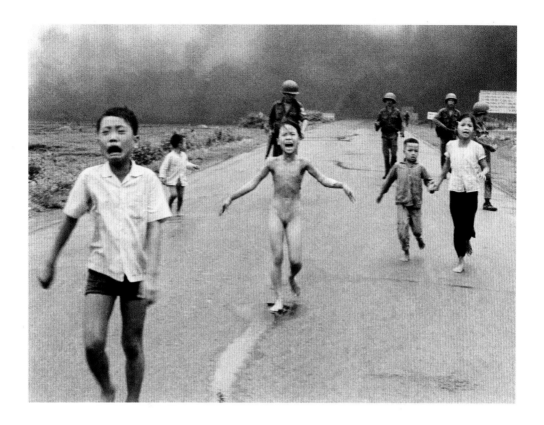

THE NAPALM GIRL

NICK UT

Date 1972
Location Trang Bang, South Vietnam
Format 35 mm

Vietnamese photographer Huynh Cong "Nick" Ut (born 1951) joined Associated Press (AP) in 1966 after his older brother, Huynh Thanh My, also an AP photographer, was killed in combat. On June 8, 1972, Nick witnessed South Vietnamese aircraft dropping napalm on a village near Saigon. He then captured the above image of screaming children fleeing away in terror from a backdrop of billowing smoke. The girl at the center of the photograph, nine-year-old Phan Thi Kim Phuc, had torn off

her clothes to survive the attack. She was badly burned. After taking the picture, Ut rushed her and the other children to a Saigon hospital, which saved her life.

Western newspapers were at first reluctant to run this photo because it featured full-frontal nudity, but they soon decided that it was too important to ban. US President Richard M. Nixon wondered if the image had somehow been "fixed." The picture won every major photographic award in 1973, including the World Press Photo Award and the Pulitzer Prize. Nick Ut continued to work for AP as a photojournalist until he retired in 2016. He remained in regular contact with Kim Phuc, who made a new life for herself in Canada. CK

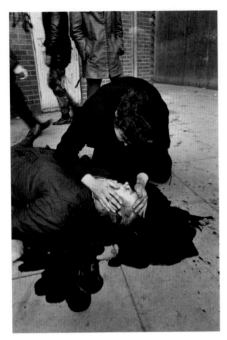

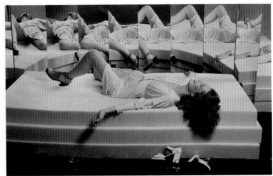

CHARLES JOURDAN ADVERTISEMENT, SPRING 1972

GUY BOURDIN

Date 1972
Location Unknown
Format Unknown

There is something manic about this Charles Jourdan advertisement. The model lies sprawled, laughing, on what looks like a bed but could also be a platform or an altar. What could be a moment of careless drunken revelry—witness the overturned champagne coupe, the neck of a bottle just visible in the reflection—could also be sinister. A second pair of shoes lies discarded: where is the woman who wore them? And although she seems to be alone, the articulated mirror wall shows us many women, slicing the model into small sections— her fingers gripping the edge of the mattress, her naked shin—making us voyeurs as we peer up her skirt while her eyes are closed.

Guy Bourdin (1928–91) remains unparalleled in the unsettling power of his fashion images. His work with shoe label Charles Jourdan brought him wide acclaim and he shot campaign images for them over twenty-two years. The resulting collection of photographs is as shocking as it is playful, and simultaneously painterly, dreamlike, and provocative. **RF**

BLOODY SUNDAY

GILLES PERESS

Date 1972
Location Derry/Londonderry, UK
Format 35 mm

On January 30, 1972, British troops in Northern Ireland opened fire on predominantly Catholic civil rights protestors, killing thirteen of them. What became known as Bloody Sunday was witnessed and recorded by Magnum photographer Gilles Peress (born 1946). One of those killed was Barney McGuigan, pictured here moments after being shot. Peress later spoke of his overwhelming emotions. "I know that at one point I was shooting and crying at the same time. I think it must've been when I saw Barney McGuigan dead. . . . He was alone. Then a priest arrived and started to give him the Last Rites. . . . I remember that I didn't want to intrude too much, but that at the same time I felt this obligation to shoot, to document." **LH**

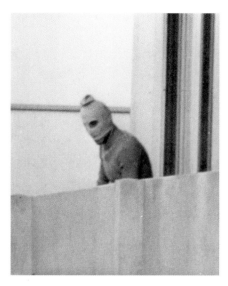

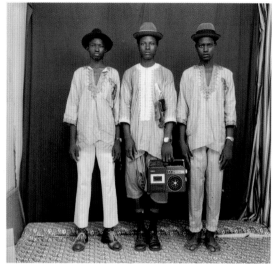

HOSTAGES MURDERED AT THE 1972 MUNICH OLYMPICS

KURT STRUMPF

Date 1972
Location Munich, Germany
Format 35 mm

Two weeks into the 1972 Munich Olympics, eight heavily armed members of the Palestinian militant group Black September ambushed eleven Israeli Olympic team members, killing two and taking the remaining nine hostage. This grainy picture, shot at long range by Associated Press photographer Kurt Strumpf, depicts one of the eight kidnappers on the Israeli athletes' balcony.

Black September named the operation "Ikrit and Biram" after two Palestinian Christian villages whose residents had been expelled in 1948 by the Israeli army. They demanded the release of 234 prisoners in Israel, along with Red Army Faction founders Andreas Baader and Ulrike Meinhof in Germany. After a botched rescue attempt, six Israeli coaches, five Israeli athletes, five of the eight terrorists, and a policeman were left dead. RSH

YOUNG FULANI SHEPHERDS (*LES JEUNES BERGERS PEULS*)

MALICK SIDIBÉ

Date 1972
Location Bamako, Mali
Format Medium format

When Mali gained independence from France in 1960, Malick Sidibé (1936–2016) documented his nation's newfound freedom. In 1962, he opened a photography studio in Bamako, where young and old came for portrait shots and passport photos. He shot this picture there, and its title reveals that the three young men are of Fulani, or Peul, ethnicity. The title also states that they are shepherds, which is one of the traditional occupations for the Fulani, a nomadic people. However, the clash between old and new is evident in the young men's attire as they sport watches, and homburgs rather than traditional straw hats, and one of them wears fashionable two-tone shoes with heels. The man in the center proudly carries a radio, indicating that the group are able to listen to the latest music. CK

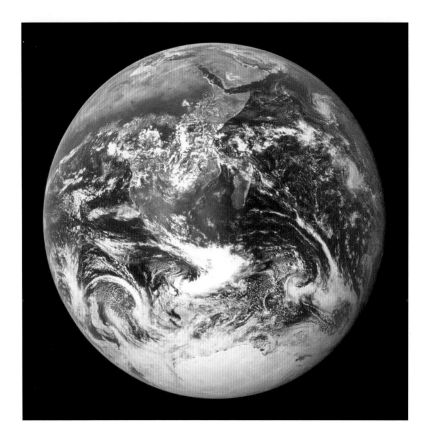

THE BLUE MARBLE

THE CREW OF APOLLO 17

Date 1972
Location Outer space
Format Medium format

Launched at night on December 7, 1972, Apollo 17 was the final mission of the Apollo program, which three years previously had successfully landed the first man on the moon. Around five hours after launch, as the spacecraft prepared to leave Earth's orbit, one of the astronauts took this photograph of the receding planet—a pale, luminous sphere, with the landmass of Africa just visible beneath the swirling cloud, and the whole orb surrounded by the deep empty black of space.

While similar photographs of Earth fully illuminated had been taken during several previous Apollo missions, *The Blue Marble* happened to coincide with an upsurge in environmental awareness. The campaigning organizations Greenpeace and Friends of the Earth were both founded in 1969, and the United Nations held its first significant conference on environmental issues in 1972. This growing movement needed a universal icon; *The Blue Marble* appeared at precisely the right moment and was adopted without hesitation. The photograph is credited to all three members of the Apollo 17 crew: Eugene Cernan (born 1934), Ronald Evans (1933–90), and Harrison "Jack" Schmitt (born 1935). LB

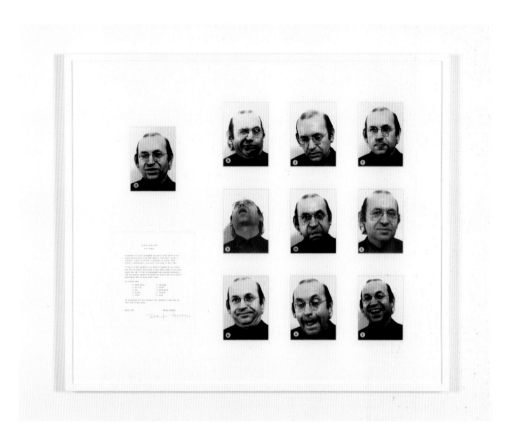

VARIABLE PIECE #101

DOUGLAS HUEBLER

Date 1973
Location Unknown
Format Photographic prints

In 1969, Douglas Huebler (1924–97) famously said: "The world is full of objects, more or less interesting; I do not wish to add any more." Subsequently, he made a range of "rule-based" works that he named "variable pieces"; they involved meticulous documentation and systems that depended on the participation of the subjects. For *Variable Piece #101* (1973), Huebler took ten photographs of conceptual artist Bernd Becher. Just before he took each photograph, Huebler asked Becher

to make himself "look like," in order, a priest, a criminal, a lover, an old man, a policeman, an artist, "Bernd Becher," a philosopher, a spy, and a "nice guy." Two months later, Huebler sent Becher the ten prints, but now numbered as shown here, and asked him to pair each photograph with its "correct" verbal identity. Becher responded: 1. Bernd Becher; 2. Nice Guy; 3. Spy; 4. Old Man; 5. Artist; 2 (sic). Policeman; 7. Priest; 8. Philosopher; 9. Criminal; 10. Lover. But what is missing from Huebler's "variable piece" is the original order of the photographs; further, different printed versions of the work, each giving a subtly different running order, exist. Clearly, interpreting a facial expression correctly is not as simple as it might appear. **JG**

PLANK PIECE I–II

CHARLES RAY

Date 1973
Location Iowa City, Iowa, USA
Format 35 mm

Plank Piece I–II by American conceptualist Charles Ray (born 1953) is sculpture recorded by photography. In the 1970s, many artists were investigating the possibilities of performance, but this work is different, because here the artist incorporates himself within the work—not as a performer but, as he puts it, as "a sculptural element": his body functions as a static object whose physical properties he wants to explore on the same terms as those of the wooden plank that suspends it and

pins it to the wall. These experiments were part of Ray's investigation of the work of other sculptors who had influenced him in their use of balance, tension, and binding, most importantly Anthony Caro and Richard Serra.

Since such "sculptures" cannot be permanent, photographs of them must be the artwork. This reflects Ray's commitment to "think sculpturally rather than to think about sculpture." In other words a finished object is not the point; more important is the process of experimentation and discovery. Photography is a useful medium for sculptors, because it enables them to make ephemeral forms as enduring as bronze, wood, or fiberglass. **JG**

DAVID BOWIE PERFORMS LIVE IN LONDON

GIJSBERT HANEKROOT

Date 1973
Location London, UK
Format 35 mm

Image savvy and endlessly creative, musician David Bowie crafted trailblazing persona after persona. There was Major Tom, Aladdin Sane, the Thin White Duke, and, of course, Ziggy Stardust. This picture, taken in May 1973 at a gig in Earl's Court, London, shows Bowie in full Stardust mode. Photographers could not get enough of the gender-bending glamrock character with theatrical performances and flamboyant, otherworldly costumes befitting the cosmic traveler he claimed to be.

Here, light cascades gloriously down the tightly cropped frame, bouncing off Bowie's tinted hair, the shining circle on his forehead, his silvery skin, sparkling, heavily kohl-framed eyes (one pupil permanently dilated), shimmering lips, and the glossy material of his clothes.

Bowie retired this glam-rock alter ego not long after this picture was taken. But there would be myriad more reinventions to come, in both his music and his appearance, right up until his death in January 2016. Gijsbert Hanekroot (born 1945), the Dutch photographer behind this picture, began his career as a rock photographer in 1969 and shot Bowie many times, culminating in his photo-book *David Bowie: The Seventies* (2016). RSH

THROWING THREE BALLS IN THE AIR TO GET
A STRAIGHT LINE (BEST OF THIRTY-SIX ATTEMPTS)
(DETAIL FROM THE ARTIST'S BOOK)

JOHN BALDESSARI

Date 1973 Location Unknown
Format Portfolio of fourteen
photolithographs, 35 mm

This photograph by John Baldessari (born 1931) is the record of a game. The artist set himself a challenge, and this image shows one of the fourteen out of thirty-six attempts (thirty-six being the number of exposures on a typical roll of 35 mm film) that he presented in a limited-edition book. Despite its simplicity and humor, the series reflects Baldessari's interest in language, semantics, games, and rule-based methodologies for creating artworks. Other related works include *Throwing*

Three Balls in the Air to Get an Equilateral Triangle (1973) and *Throwing Four Balls in the Air to Get a Square* (1974): all structured attempts at achieving an arbitrary goal, resulting in photographs that have a simple compositional beauty.

Influenced by the visual and literary work of the Dada and Surrealist movements of the early twentieth century, Baldessari is known for his irreverent approach to conceptualism, which he often uses to critique the unwritten rules of the art world. "I guess a lot of it's just lashing out," he said, "because I didn't know how to be an artist, and all this time spent alone in the dark in these studios and importing my culture and constant questions. I'd say, 'Well, why is this art? Why isn't that art?'" JG

UNTITLED, FROM THE SERIES *THE PARK*

KOHEI YOSHIYUKI

Date 1973
Location Tokyo, Japan
Format 35 mm

Kohei Yoshiyuki (born 1946) was working as a commercial photographer when he happened one night upon a very odd scene in a park in Shinjuku, Tokyo. He saw a couple copulating on the ground while several people stood nearby, silently watching, hidden from view. After realizing that this was a regular occurrence in Tokyo parks, Yoshiyuki became fascinated by the sordid, nightly performances and felt compelled to bring them to the attention of a wider public.

After visiting the park for six months without photographing, to gain the trust of the voyeurs, Yoshiyuki began shooting with a small 35 mm camera and a Kodak infrared flash. The grainy, snapshot-like images were never about the couple, but about the people watching them, slowly inching forward and sometimes joining in.

The Park was first exhibited at the Komai Gallery in Tokyo in 1979. The photographs were displayed in the dark, and visitors were given flashlights, to make them feel complicit in the acts. The controversy surrounding the show meant that this work was largely hidden from the public until 2007, when it was published as a book and exhibited worldwide. **LH**

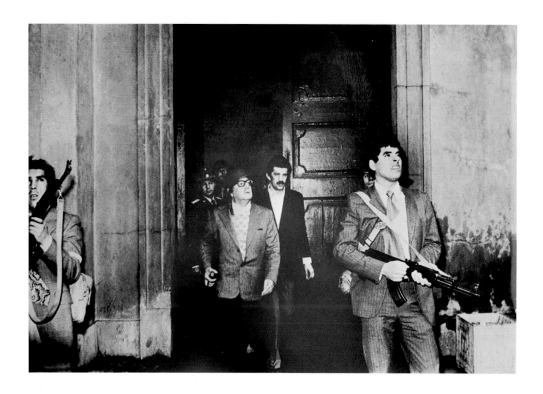

ALLENDE'S LAST STAND

LUIS ORLANDO "CHICO" LAGOS VÁSQUEZ

Date 1973
Location Santiago, Chile
Format 35 mm

This photograph, taken on September 11, 1973, is believed to be the last public sighting of Salvador Allende, the democratically elected Marxist president of Chile, before he died in suspicious circumstances during the coup d'état in which power was seized by the military under the leadership of General Augusto Pinochet.

Here, we see Allende (center) leaving La Moneda, the presidential palace, wearing a helmet and carrying a Soviet weapon that was supposedly given to him by Cuban leader Fidel Castro. On this day he gave his final radio speech, in which he proclaimed his love for Chile and talked about himself in the past tense. Allende was reported to have committed suicide, but many insist that he was assassinated. The authorship of this image was concealed for many years, but we now know the identity of the man behind the lens: Luis Orlando Lagos Vásquez (1913–2007), official photographer of La Moneda Palace. It is probable that, for as long as Pinochet's junta remained in power, Lagos regarded his anonymity as a factor in his survival, and indeed the truth about this image was not uncovered until after his death. SY

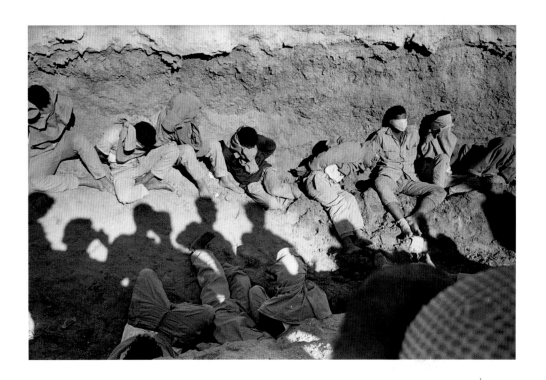

ISRAEL. 1973. EGYPTIAN PRISONERS OF WAR.

MICHA BAR-AM

Date 1973
Location Israel
Format 35 mm

Magnum photographer Micha Bar-Am (born 1930) is known for his coverage of Israel. This image was taken during the Yom Kippur War of October 1973, when Israel suffered heavy losses despite achieving military victory. It depicts bound and blindfolded Egyptian prisoners of war in a dugout trench. It is striking that although twenty-one people appear in the picture—twelve POWs, and the shadows of nine onlookers, including Bar-Am, holding the camera—not one pair of eyes can be seen.

Bar-Am's image creates a narrative of power and dominance. The viewer feels a basic human sympathy for the helpless shapes of the captives, stripped as they are of sight and mobility, and is implicitly grouped with the shadowy onlookers.

Note the pattern from the varied lines across the frame: at the top of the image, the rim of the trench, followed by the figures of the prisoners, lined underneath by the jutting shadows, and finally reaching the near edge of the trench and the partially visible body of one of the photographer's standing companions. This aesthetic effect of layering draws the eye down through the frame in a series of stages, decelerating analysis of the picture and its various implications. AZ

UNTITLED (GREENWOOD, MISSISSIPPI) 1973

WILLIAM EGGLESTON

Date 1973
Location Greenwood, Mississippi, USA
Format 35 mm

William Eggleston (born 1939) was one of a new generation of photographers who began to experiment with color for its own sake. Color photography was increasingly popular after World War II as technology improved and became more affordable. It was widely used in commercial photography to glorify objects of desire in advertisements. Alongside such carefully considered imagery, Eggleston's pictures of everyday objects may have seemed like artless snapshots, but when printed as rich, lush, dye transfers, his photographs of the ordinary became extraordinary: their jewel-like colors gave commonplace items a precious quality and made viewers look at their surroundings with fresh eyes. Eggleston's images summed up the consumer society and suburban landscape of the United States in the late 1960s and 1970s: its hope, its innocence, and, in pictures like this, even its sense of menace and desolation. The blood-red surfaces, white plastic lines, and bare light fixture make a mundane room resemble a torture chamber.

The seventy-five prints exhibited by Eggleston at New York's Museum of Modern Art in 1976 are now regarded as crucial in establishing the central role of color in a photograph's content. **CK**

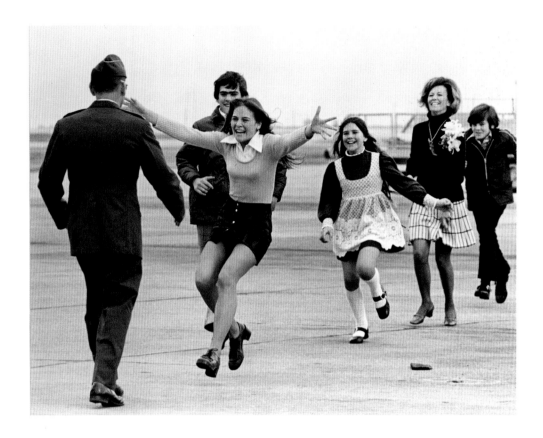

BURST OF JOY

SAL VEDER

Date 1973
Location California, USA
Format 35 mm

This historic photograph of returning US prisoner-of-war and fighter pilot Lt. Col. Robert L. Stirm being greeted by his family has been reproduced countless times. Stirm was shot down over Hanoi in 1967 and then imprisoned in North Vietnam. The image, taken on March 17, 1973 by Associated Press photographer Slava (Sal) Veder (born 1926) at Travis Air Force Base in Fairfield, California, depicts Stirm's daughter Lorrie running toward her father, followed by his wife and his other children.

Veder was one of two AP photographers assigned to the scene, and has recounted how he and several others were shooting from a pen. Veder had been photographing the gathered crowd when he saw movement out of the corner of his eye and fired off a few frames. "This family came out of nowhere, got out of their car, and dashed for the soldier," he told the *Guardian* newspaper in 2015. "You could tell, even at a distance, what they were feeling . . . There was a surge of emotion from the crowd, too." The photograph, which won Veder a Pulitzer Prize in 1974, has come to represent all troops returning from Vietnam. It remains, said *Smithsonian Magazine* in 2005, "the quintessential homecoming photograph of the time." GP

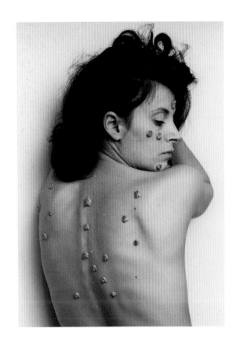

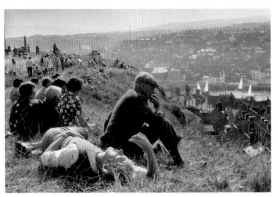

WHITBY

IAN BERRY

Date 1974
Location Whitby, UK
Format 35 mm

English photographer Ian Berry (born 1934) made his reputation in South Africa at the *Daily Mail* newspaper and *Drum* magazine. He was the only photographer to document the massacre at Sharpeville in 1960.

He later won a grant to document life in his native country. He said of the project: "England is the easiest country in the world in which to take photographs—in the way people react or rather do not react in the photographer's presence." He traveled all over England, photographing the rich and poor at work and at play, and the result was *The English*, which was published as a book in 1978.

This picture, part of that series, shows crowds on a sunny Sunday afternoon on a hill overlooking Whitby, a fishing port and popular holiday destination. All the people enjoying the view seem oblivious to Berry, who explained his working method thus: "I don't set up anything—never do—I just get into situations. My feeling is that I grab the moment, if the subjects see me I smile; if they want to talk I talk. More often than not they tried to pretend they hadn't seen me and went on their way." CK

S.O.S. STARIFICATION OBJECT SERIES

HANNAH WILKE

Date 1974–82
Location New York, New York, USA
Format Unknown

Hannah Wilke (1940–93) used photography, performance, sculpture, and film to explore gender, sexuality, and feminism. Her photography attracted criticism from conservatives for her use of vaginal imagery and from feminists for the idealized way in which she displayed her own body.

Her *S.O.S. Starification Object Series* merged self-portraiture and sculpture in order to address ideas about beauty. She posed in various degrees of dress, adopting the poses of advertising models. Her torso and face are dotted with small pieces of chewing gum shaped like vulvas, but which in the final black-and-white photographs more closely resemble small scars across her body. LB

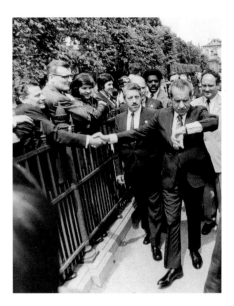

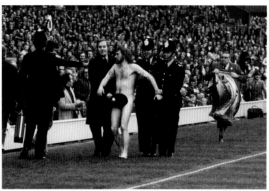

STREAKER IS ARRESTED

TONY DUFFY

Date 1974
Location Twickenham, UK
Format 35 mm

NIXON CHECKS WATCH ON WALKABOUT

HORST FAAS

Date 1974
Location Brussels, Belgium
Format 35 mm

Horst Faas (1933–2012) was a German photojournalist best known for his work during the Vietnam War. Along with photographing the conflict himself, he was in charge of recruiting and training a team of freelance photographers. Two iconic photographs to emerge from Faas's tutelage were Nick Ut's image of a Vietnamese girl fleeing napalm bombing, and Eddie Adams's image of a Vietcong suspect being executed on the streets of Saigon.

In this unusually comical image, US President Richard M. Nixon greets supporters on a visit to Brussels to attend a North Atlantic Council meeting. Faas managed to capture the exact moment when Nixon glances at his watch while haphazardly shaking hands with one of his admirers—his mind is clearly on other things. **LH**

Humorous photographs seldom achieve iconic status, but this image, taken during an England vs. France rugby match, is an outstanding exception.

During the half-time break in the game, Michael O'Brien, an Australian accountant, dashed naked in full view of 53,000 spectators. He did it for a bet. Most of the press photographers had gone off for a cup of tea, but those who remained were suddenly confronted by a highly newsworthy spectacle—however, in 1974, no newspaper was going to publish a full-frontal male nude, so they had to wait for someone or something to cover at least a part of the streaker's modesty.

Then police constable Bruce Perry intervened. He took off his helmet and used it to conceal O'Brien's genitals. Later, the officer explained: "I feared he would be mobbed, or that other people would follow suit. I felt embarrassed so I covered him up as best I could... It was a cold day—he had nothing to be proud of."

O'Brien was subsequently fined £10 ($12.50), the exact amount he had won in the bet. He also lost his job as a result of his actions, but later became a successful stockbroker. **CJ**

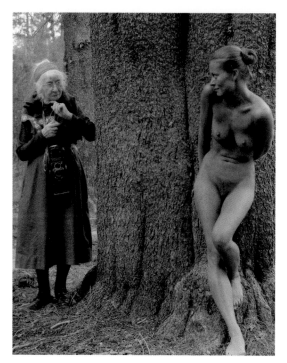

IMOGEN AND TWINKA
AT YOSEMITE

JUDY DATER

Date 1974 **Location** Yosemite National Park, California, USA
Format Unknown

The two women smile nervously at each other: model Twinka Thiebaud leans against a weathered tree, as playful as a nymph; Imogen Cunningham, herself a celebrated photographer, and here aged ninety-one, appears to be on the verge of offering instruction.

This is an image of contrasts: between age and youth; between dark clothing and bronzed nudity; and between the momentary human presence and the timeless ancient forest. It also reveals the interest of photographer Judy Dater (born 1941) in feminine mystique.

Cunningham was long established as a consummate exponent of photography. She had acquired her first camera in 1901, when she was aged eighteen, thereby initiating a lifelong career during which she pursued her dual interests in botany and portraiture. Her careful and precise observation of detail was reflected in the name she gave to the coterie she founded—Group f/64, after a large-format camera's smallest aperture—which included Ansel Adams, Edward Weston, and Sonya Noskowiak.

Cunningham and Dater met in the mid-1960s, at one of the former's photography workshops, and remained friends until Cunningham's death in 1976. Cunningham encouraged Dater to put into practice her theory that the naked female form could and should be depicted photographically without objectifying or demeaning the subject. As a measure of Dater's success in achieving this goal, *Imogen and Twinka at Yosemite* became the first adult full-frontal nude photograph ever published in *Life* magazine. **RF**

"By poking fun at popular stereotypes of women's roles... Dater was able to confront the dilemmas of the modern woman at the same time she was critically clarifying her own identity."

Donna Stein

PATTY HEARST
SURVEILLANCE

SURVEILLANCE CAMERA

Date 1974
Location San Francisco, California, USA
Format Surveillance camera still

On February 4, 1974, nineteen-year-old newspaper heiress Patty Hearst was abducted from her apartment in Berkeley, California, and dragged into the trunk of a car. Her abductors revealed themselves to be from a radical left-wing group, which called itself the Symbionese Liberation Army (SLA), led by ex-con Donald DeFreeze, who later declared they were holding Hearst as a "prisoner of war." While they used her to demand ransom money from the Hearst family to feed all California's needy and hungry, this image, captured the following month by a surveillance camera, put a completely new spin on the developing mystery.

The image of Patty Hearst holding an M1 carbine surfaced in April 1974 and showed her looking like a confident, dark-haired assassin—a stark contrast to the image of an abducted heiress. The surveillance cameras captured her partaking in a San Francisco bank robbery. Hearst, adopting the name "Tania," later declared that she had joined the SLA of her own accord, and the CCTV imprint of her collaborating with her kidnappers further deepened the mystery, which became one of the biggest news stories of the 1970s. One version of events painted Hearst as a captive of the SLA—tied up, raped, and forced to partake in armed bank robberies. In the other narrative Tania appeared to be a blossoming SLA revolutionary, joining forces with her kidnappers. Hearst was eventually captured by police in September 1975 and sentenced to seven years in prison for armed robbery. She served just twenty-one months before her sentence was commuted by US President Jimmy Carter. **EC**

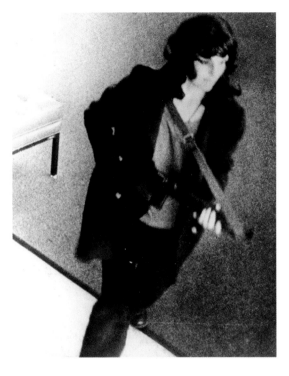

"I had been, you know, held in the closet for two months and, you know, abused in all manner of ways. I was very good at doing what I was told." Patty Hearst

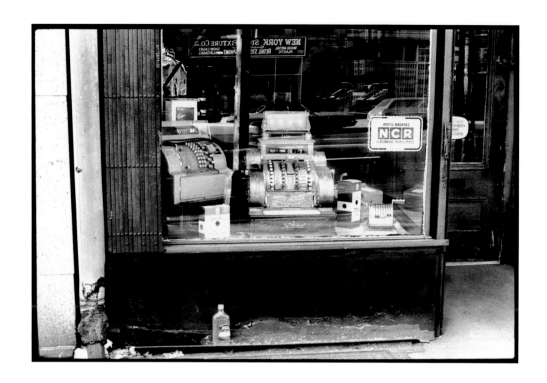

THE BOWERY IN TWO INADEQUATE DESCRIPTIVE SYSTEMS

MARTHA ROSLER

Date 1974–75
Location New York, New York, USA
Format 35 mm composite

The Bowery in two inadequate descriptive systems is an artwork composed of twenty-four black panels with twenty-one images of New York's Bowery—a neighborhood notorious in the 1970s for down-and-outs and drunks—and three blank spaces paired with twenty-four photographs of text.

Although somewhat characteristic of the photo-text experiments of the period, this work has an additional critical dimension. Its main subject is poverty, but it is also about the limitations of documentary photography. By choosing to avoid the usual representational strategy of photographing "victims" (here, only traces, such as empty bottles, are visible), Martha Rosler combines views of unpopulated urban locations with printed text, both of which—as she acknowledges in the title of the work—fail to convey the whole problem, and thus make the viewer aware of the inadequacy of photography and text, separately or together, in conveying the full complexity of an important social issue.

```
stewed

boiled

potted

corned

pickled

preserved

canned

fried to the hat
```

One of Rosler's points is that in order to address this subject adequately, it is necessary to step outside the documentary form and move into the realm of art. *The Bowery in two inadequate descriptive systems* is about social inequality and urban degeneration—a conceptual artwork that must be viewed and interpreted quite differently from a documentary.

Rosler's preoccupation in her later work has been thought by some commentators to have changed from poverty to feminism, but she herself dismisses such suggestions, saying: "Feminism is a central angle in all my work; it does not replace or supplant other considerations. Feminism is a world view, or a great factor in such a perspective."

That her photography can be so greatly misinterpreted spurs her on to express another of her abiding preoccupations: that the best critics today are bloggers, whose words are unlikely to be read by more than a few dozen people. Conventional taste, in Rosler's view, is determined excessively and undesirably by the curators and benefactors of museums and galleries. Consequently, the only art that is likely to see the light of day is that which can safely be forecast to make money—another damper on true creativity. JG

HENRI CARTIER-BRESSON WITH HIS DAUGHTER MÉLANIE

MARTINE FRANCK

Date 1974
Location Vaucluse, Provence, France
Format 35 mm

There are few photographs of Henri Cartier-Bresson. The immensely influential photographer who helped to define street photography, and who became known as the "father" of photojournalism, was himself seldom photographed. This may be regarded as ironic for one famed for his penetrating portraits of others. Even when he received an honorary doctorate from the University of Oxford in the United Kingdom in 1975, he obscured his face with a sheet of paper to avoid onlookers' lenses. This reticence was partly due to natural reserve, but it was also important for professional reasons—street photographers need anonymity, and Cartier-Bresson was a master of the unobtrusive photograph, with even the chrome of his Leica blacked out with tape to help him remain inconspicuous, the essential ingredient of his modus operandi.

Of the photographs of Cartier-Bresson that do exist, most were taken by his wife and fellow Magnum photographer, Martine Franck (1938–2012), whom he married in 1970. This image is one of the most intimate. It shows a happy family moment with his young daughter, Mélanie, sitting on his shoulders. Whether by accident or design, she covers his face. It was taken several years after Cartier-Bresson had stopped practicing as a photojournalist and returned to drawing and painting, which he had studied before picking up a camera. Nevertheless, there is still a Leica around his neck—evidently, although he had set out on a new path to challenge himself in different creative media, he never fully abandoned the instrument with which he had made his name. **NG**

"What I most like about photography is the moment you can't anticipate: you have to be constantly watching for it, ready to welcome the unexpected." Martine Franck

PORTSMOUTH: JOHN PAYNE, AGED TWELVE, WITH TWO FRIENDS AND HIS PIGEON

DANIEL MEADOWS

Date 1974
Location Portsmouth, UK
Format Medium format

This photograph by Daniel Meadows (born 1952) of boys presenting Chequer the pigeon to the camera is remarkable for the way it captures their very particular sense of pride mixed with bravado. Chequer belongs to John Payne, the protagonist in the center of this photograph, who is joined in the portrait by two of his friends. The built environment of the working-class housing estate visible behind them has a somewhat bleak and uninspiring look, but there is a sense that, in their comradeship, enthusiasms, and resilience, their shared lives are colorful, meaningful, and fulfilled.

Meadows took the image in Portsmouth, England, in 1974, while he was traveling around the UK with the Free Photographic Omnibus, his double-decker mobile studio. Previously, Meadows had been running a low-budget photography studio in an old barbers' shop in Manchester, but, inspired to travel further afield to make photographs, he set off around England in his double-decker bus in 1973. He ended up being on the road for more than a year, visiting some twenty towns and making portraits of people he met. The resulting body of work captures Britain at a time of enormous social change, brought by deindustralization, Thatcherism, and miners' strikes. This image offers an insight into what life was like at the time and was included in a traveling exhibition titled *No Such Thing As Society*, which explored British life from 1967 to 1987. The title was designed to question a statement made by Prime Minister Margaret Thatcher: "Society? There is no such thing. There are individual men and women and there are families." **GP**

"[Meadows' images] could have been taken in another century, so little can we recognize of our contemporary world."

Val Williams, curator

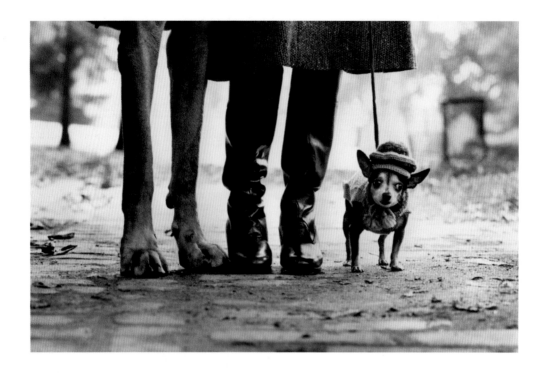

FELIX, GLADYS AND ROVER

ELLIOTT ERWITT

Date 1974
Location New York, New York, USA
Format 35 mm

French-born US photographer Elliott Erwitt (born 1928) excels at taking what appear to be unguarded, black-and-white studies of people and animals. He is best known for his quirky pictures of dogs, which have featured in four photo-books: *Son of Bitch* (1974), *Dog Dogs* (1998), *Woof* (2005), and *Elliott Erwitt's Dogs* (2008).

Felix, Gladys and Rover is typical of his work, with its realistic feel, sense of the absurd, and playful wit. It shows a cobbled path in what appears to be a park in the fall. Contrary to expectation, only one pair of legs belongs to a human—the Gladys of the title, who wears shiny boots and a coat. Her companions are Felix, a Great Dane, and a chihuahua, the only one of the trio visible in its entirety, clad in a woolly hat and coat.

The perspective of the photograph is unusual in that Erwitt has taken the shot at ground level, allowing the chihuahua to gaze directly at the viewer. The photographer has cropped the image so that two of the subjects in the photograph are only partially visible. He has played with scale to emphasize how small the chihuahua is, while the diminutive dog's outfit anthropomorphizes it. In effect, the image is a portrait of the chihuahua. **CK**

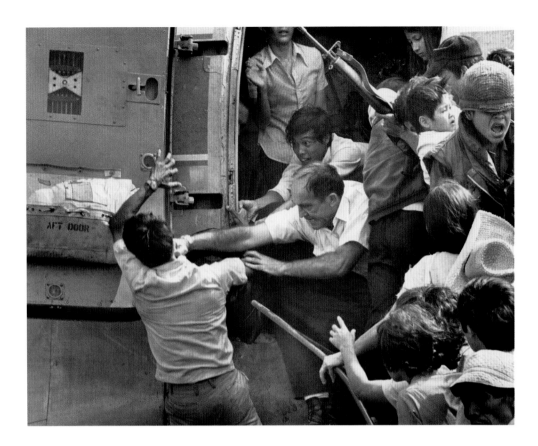

HELICOPTER EVACUATION OF THE US EMBASSY, SAIGON

UNKNOWN

Date 1975
Location Saigon, Vietnam
Format 35 mm

This photograph captures the desperation of American and South Vietnamese civilians at the imminent arrival of North Vietnamese troops in Saigon. An American official punches a Vietnamese man who is attempting to board the already full transport aircraft.

In April 1975, Communist troops began their final assault on Saigon. With the airport destroyed by shelling, helicopter evacuation from the US embassy remained the only escape route

for American administrators and Vietnamese associated with the government. Although the US response to the fall of Saigon—"Operation Frequent Wind"—included the largest helicopter evacuation in history, moving more than 7,000 people to safety, flights could not operate quickly enough to evacuate all designated people. At 4 a.m. on April 30, US President Gerald Ford issued the order that the remaining aircraft were to be used only for US citizens. The doors of the embassy were bolted, and teargas was used to prevent Vietnamese from entering the building. At 11 a.m., North Vietnamese tanks smashed the gates of the presidential palace and raised their flags. This signaled the reunification of Vietnam. MT

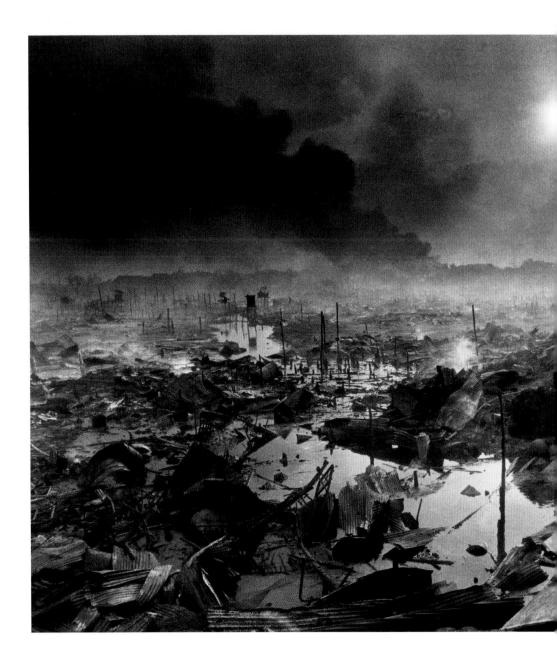

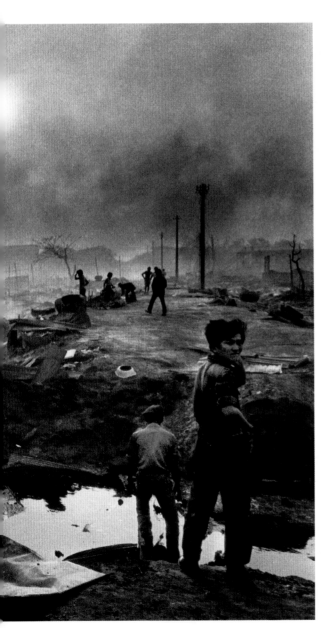

PHNOM PENH DEVASTATED

CHRISTINE SPENGLER

Date 1975
Location Phnom Penh, Cambodia
Format 35 mm

This extraordinary, apocalyptic image is a fine example of the photojournalism of Christine Spengler (born 1945). It shows the almost surreal destruction of Phnom Penh, the capital of Cambodia, as Khmer Rouge Communist forces seized political power. Spengler is one of a small band of female war photographers to receive international recognition, having reported on many major conflicts, including those in Northern Ireland, Vietnam, Lebanon, Afghanistan, and Iraq.

Her preferred approach is to emphasize the suffering rather than the causative brutality, and to this end she concentrates whenever possible on the innocent victims—often, but not invariably, the women and children.

After the Khmer Rouge victory shown here, the leader of the insurgents, Pol Pot, became head of state—his title was "Brother Number One." He enforced a wholesale march of up to three million inhabitants out of Phnom Penh into the countryside, seeking to take the country back to "Year Zero" by means of a peasant revolution. Many old, sick, and young people died by the roadside on this journey; survivors were placed in agricultural communes and forced into hard labor, working up to seventeen hours a day. These former urban dwellers died in their thousands from diseases such as dysentery, malnutrition, and malaria; others were taken away and murdered by Khmer Rouge guards. By the time the Vietnamese Army overthrew Pol Pot in 1979, an estimated two million Cambodians had been killed by execution, starvation, or exhaustion under the dictator's tyrannical regime. CJ

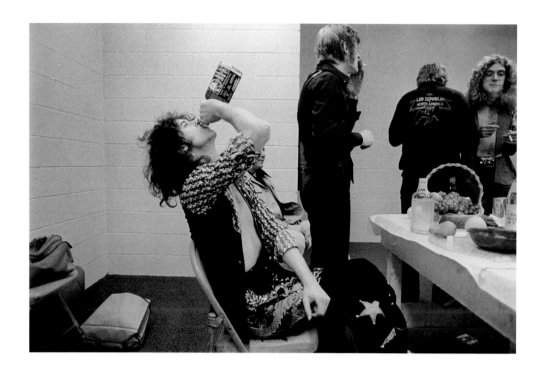

JIMMY PAGE / JACK DANIELS

NEAL PRESTON

Date 1975
Location Indianapolis, Indiana, USA
Format 35 mm

In this striking image by Neal Preston (born 1952), guitarist Jimmy Page of English rock band Led Zeppelin empties Jack Daniels whiskey down his throat while backstage in Indianapolis during the band's US tour in 1975. Other band members and a security guard are in the frame, too, but Page is undoubtedly the main focus. Preston, who had been hired as the band's official tour photographer, was on the road with Led Zeppelin documenting what was happening both on and off stage.

Describing the moment he made this picture, Preston recounted how he was sitting a short distance away from Page, and, happening to turn his head, he noticed the musician lifting the bottle to his mouth. He had a loaded Nikon 35-mm camera with a 24-mm lens on his lap and as the bottle hit its peak height, he turned, focused the camera, and shot a single frame. It was, he says, a moment where the stars aligned, adding: "when those moments happen, you have to be prepared." The shot was one of many Preston took of the band during that tour and over the years, but it is an image that has endured because, as some have suggested, it so brilliantly conveys the excess of rock and roll bands in the 1970s. **GP**

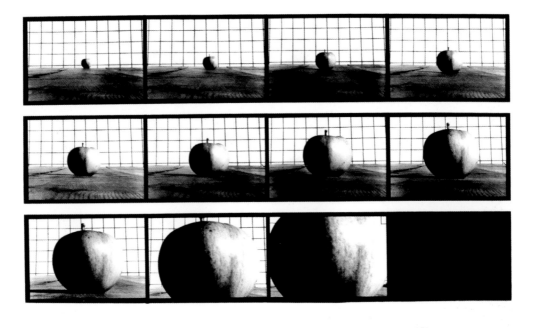

APPLE ADVANCING [VAR. "NORTHERN SPY"]

HOLLIS FRAMPTON
AND MARION FALLER

Date 1975
Location Unknown
Format Unknown

Eadweard Muybridge's locomotion studies of animals and humans had a profound impact on the visual arts—they are explicitly referenced in the title of Marcel Duchamp's painting *Nude Descending a Staircase (No. 2)* (1913), and a preoccupation with time and motion is also evident in paintings by Francis Bacon.

One of the most amusing homages to be paid to Muybridge was produced by the American husband-and-wife duo of Hollis Frampton (1936–84) and Marion Faller (1941–2014), who employed his serial approach to photography to produce an absurd series of motion studies of fruit and vegetables, which appear to move and transform before the camera. Frampton was an avant-garde artist, filmmaker, and pioneer of digital art; Faller was a documentary photographer. In their Muybridge-inspired collaboration, they produced a work of art that makes sharp observations about the limitations of documentary photography and film, and the fact that what occurs outside the frame and outside of the moment that a photograph is taken can often be as important as what the photograph itself shows. **LB**

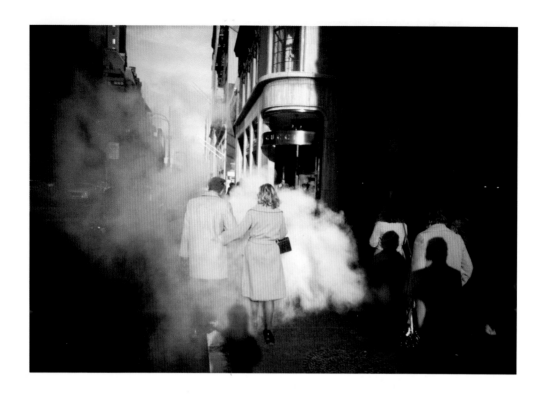

CAMEL COATS, NEW YORK CITY

JOEL MEYEROWITZ

Date 1975
Location New York, New York, USA
Format Large format

Joel Meyerowitz (born 1938) began photographing in 1962 after a chance encounter with Robert Frank. He left his job as an art director at an advertising agency and took to the sidewalks of New York with a 35 mm camera. From the mid-1960s, he became a staunch advocate of color photography, and in 1972 he abandoned black and white altogether. His advocacy of color photography as fine art influenced a generation of photographers who studied under him at Cooper Union in New York.

This photograph taken in Manhattan shows a couple wearing camel coats, surrounded by steam rising from the street as they walk toward a yellow-colored building. The couple at the center of the image are echoed by two other people on the right who are also wearing yellow coats. On the backs of the figures on the right are the shadows of another couple. Meyerowitz transforms New York into a yellow city, a destination from a fairy tale. He later said of his picture: "Photographers learn to accept the gifts that come their way, because surely life produces moments crazier than we can conceive. Just as the duo in camel coats disappear into the steam, a similar pair of coats enters the frame bearing a twin set of heads." CK

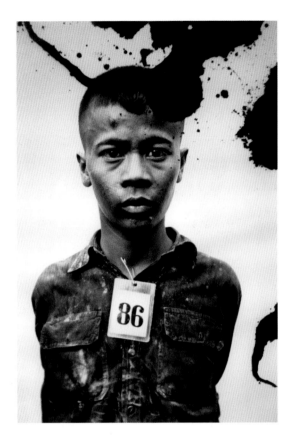

VICTIMS OF THE KHMER ROUGE

NHEM EIN

Date c. 1975–79
Location Phnom Penh, Cambodia
Format Unknown

Between 1975 and 1979, Pol Pot's murderous regime in Cambodia killed an estimated 14,000 inmates at the Tuol Sleng prison, known as S-21, in Phnom Penh. Confessions were forced out of the prisoners using torture; they were taken outside the city, made to dig their own graves, and shot or had their skulls smashed. Interviewed later, one of the executioners said: "What else could I do? If I'd refused to kill the prisoners, I would have been killed myself."

The members of the Khmer Rouge running S-21 were meticulous bureaucrats who kept a written record as well as a photograph of every prisoner, including copies of their "confessions." After the overthrow of Pol Pot's regime, the American Photography Archives Group helped to salvage some 6,000 negatives of the haunting portraits of the victims, and the prints are housed at the former prison, now a museum, commemorating the horrors inflicted in Cambodia.

The Associated Press agency later interviewed Nhem Ein (born 1959), the photographer who took 10,000 of these portraits. He said that he knew that the people he was photographing were doomed to die, but he was too frightened to protest. **CJ**

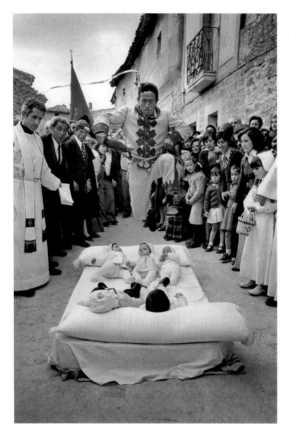

EL COLACHO, CASTRILLO DE MURCIA, SPAIN, 1975

CRISTINA GARCÍA RODERO

Date 1975
Location Castrillo de Murcia, Spain
Format 35 mm

Cristina García Rodero (born 1949) spent twenty years traveling around her native Spain, seeking out and photographing the country's most unusual celebrations, religious ceremonies, and occult traditions. Her images of pagans and Christians performing acts of devotion, in public and in private, capture how rituals and the spiritual can transform the mundane into the mysterious. In this image, El Colacho, aka the devil incarnate, leaps over babies to rid them of original sin during a religious ritual in Murcia.

Rodero's project, shot from 1974 to 1989, is an important anthropological document, but it is also something more spiritual. As she explained: "I tried to photograph the mysterious, true and magical soul of popular Spain in all its passion, love, humor, tenderness, rage, pain, in all its truth; and the fullest and most intense moments in the lives of these characters are as simple as they are irresistible, with all their inner strength."

In 1989, the work was published as *España oculta*, which won that year's Book of the Year Award at Arles's Festival of Photography and the prestigious W. Eugene Smith Foundation Prize. Rodero became a full member of the Magnum Photos agency in 2009, and continued with the theme of ritual, producing bodies of work and books on Haiti, India, and Venezuela, all places where people have a deeply ingrained relationship with the occult.

Rodero shoots in color for sensuality and happiness, but for her faith-themed works she uses black and white because it is less distracting, and, as she puts it, "so different from reality." LH

"Her approach to these events is not a simple observation of expressive and photogenic sceneries, it is a sociological investigation of humanity from a sensible and informed eye." Suzanne Cohen

SCHOOLBOY SHOT
IN SOWETO

SAM NZIMA

Date 1976
Location Soweto, South Africa
Format 35 mm

Eighteen-year-old Mbuyisa Makhubo carries the body of twelve-year-old Hector Pieterson after South African police opened fire on schoolchildren in the township of Soweto. Alongside runs the dead boy's sister, Antoinette. Pupils in local schools had joined a peaceful march to protest the introduction of compulsory tuition in Afrikaans, seen as the language of the oppressor, in their overcrowded, underfunded schools. Sam Nzima's photograph appeared around the world, provoking outrage at police brutality and the racism of the apartheid government.

Mbuyisa's sister later spoke of the consequences of that day for him: "He was disturbed, distressed. He was harassed all the time by police and journalists. Eventually he said, 'I have to go,' and I packed him a small bag and he left for the border, to Botswana. He wrote for a while but after five years, the letters stopped. We never saw him again."

In 1996, photographer Masana Samuel ("Sam") Nzima (born 1934) gave evidence about the Soweto shootings to the post-apartheid Truth and Reconciliation Commission in South Africa. He described how he saw a senior police officer pull out a pistol and fire indiscriminately into the crowd of students after a minimal warning to disperse. He later spoke of how his famous photograph influenced his subsequent life: "Because of that picture . . . I was a victim of the police harassment. I was therefore compelled to leave my job as a journalist to hide in the Eastern Transvaal . . . Because I had stuck to journalism I was going to be shot or locked up in jail." CJ

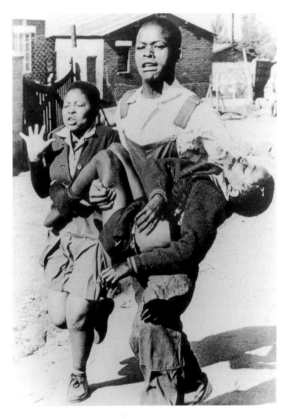

"There were no rubber bullets back then. It was live ammunition. When they pull out the gun, you must know that you are dead." Sam Nzima

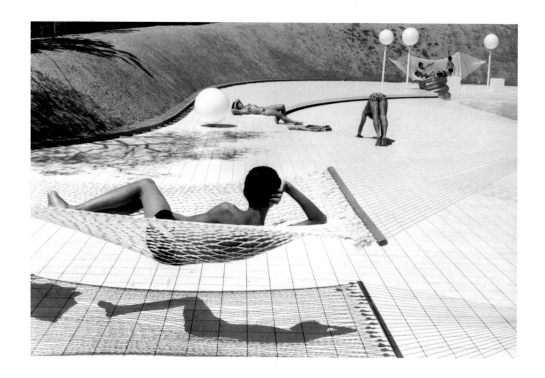

POOL DESIGNED BY ALAIN CAPEILLERES

MARTINE FRANCK

Date 1976
Location Provence, France
Format 35 mm

This photograph represents an almost impossibly perfect synchrony of objects and tones, which is made all the more remarkable by the fact that it was not staged. Upon seeing these bathers, Martine Franck (1938–2012) rushed over while changing the roll in her 35 mm Leica and captured a classic decisive moment. The intersecting lines of the tiled floor and hammock string, the luscious curves in the distance, the mirroring of the boy and his shadow, and the multitude of different bodies—all present a harmonious discord that pleasurably satisfies the eye's desire to travel.

The quality and breadth of Franck's work—ranging from portraiture of the metropolitan elite to extensive studies of cultures far from her native France—led her to become one of the first female photographers admitted to Magnum in 1980. She challenged the male dominance of documentary photography both by producing work of equal or higher stature and through acts that insisted upon the singularity of her work: in 1970, she canceled her first solo show when she found out that London's Institute of Contemporary Arts had used her husband's name—Henri Cartier-Bresson—on the invitations to the opening. MT

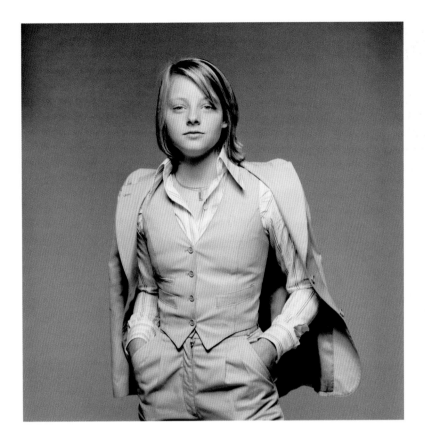

JODIE FOSTER

TERRY O'NEILL

Date 1976
Location London, UK
Format Medium format

Dylan Jones, editor of *GQ* magazine, remarked that the work of Terry O'Neill (born 1934) can "seem casual: he captures what's there, not what might be," but this photograph of Jodie Foster, taken when the actress was in London to promote the movie *Bugsy Malone*, captures both. Here, we see a child on the threshold of maturity. The fit of her three-piece suit is immaculate, and she stands with steady gaze, hands in pockets; she is at ease. Yet her jacket seems moments from slipping off her left shoulder, her forelock is falling childishly over her soft face, and her wire necklace sits off her neck, a little too big for her.

This image is typical O'Neill: influenced by reportage but focusing on celebrities, his portraits offer a glimpse of the person behind the studio image. Originally wanting to be a jazz drummer, O'Neill took a job in the photographic unit at London Heathrow Airport, in the hope of graduating to flight attendant and getting to New York. He took a photograph of someone he thought was a random traveler asleep in the departure lounge, but it turned out to be British Home Secretary R. A. Butler; he sold the image and kick-started a career in photojournalism. **RF**

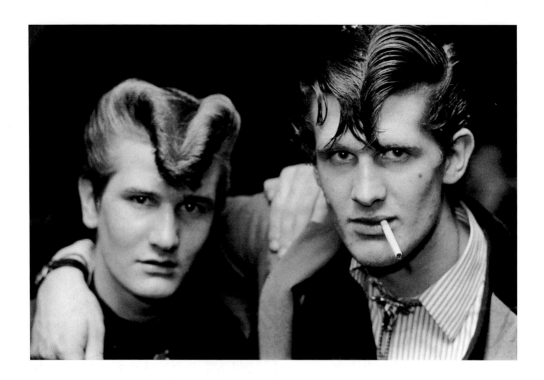

RED DEER, CROYDON 1976

CHRIS STEELE-PERKINS

Date 1976
Location Croydon, UK
Format 35 mm

The original teddy boys were part of the youthful counterculture that emerged in Britain after World War II and are often regarded as part of the vanguard of teenage rebellion. Their name derived from a shortened form of "Edward" and referred to their sartorial code: frock coats and quiffs in the style that was fashionable during the reign of King Edward VII (1901–10).

In the 1960s, subsequent waves of fashion— mods, rockers, hippies, skinheads—outmoded the teddy boys, but the style experienced a revival in the mid-1970s, and it is this that Chris Steele-Perkins (born 1947) chronicled in his photo-book *The Teds* (1979).

The above image—the cover of the book— was taken in the Red Deer, a public house in Croydon, south London, which was one of the mustering points for new-wave teds who hung out there in large numbers to dance, drink, smoke, and, not infrequently, fight.

Steele-Perkins's work is documentary that takes the viewer beyond the dress code to reveal insights into the psychological and social elements of the teds—as he puts it: "small worlds which have the whole world in them." **NG**

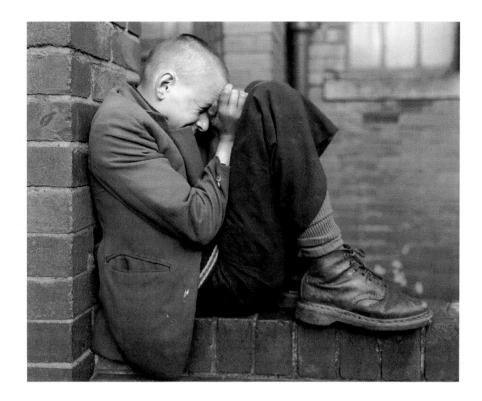

YOUTH ON WALL

CHRIS KILLIP

Date 1976
Location Jarrow, UK
Format Large format

In 1970, Chris Killip (born 1946) used a large-format camera to photograph the people, architecture, and landscape of his native Isle of Man, with a focus on documenting the disappearing traditional Manx lifestyle. However, this project underwent a hiatus when he won a two-year fellowship to photograph communities in and around Newcastle-upon-Tyne in northeast England, and to document the effect on the region of the decline of shipbuilding, mining, and the steel industries.

Moving images such as *Youth on Wall* reek of despair and frustration. The young man's cropped hair, oversize jacket, baggy pants, and large laced boots were fashionable—this is plainly a youngster who cares about his appearance. Yet, seeing him seated on a brick wall with his head on his hands, the viewer wonders what his future holds. His compressed body shape and bare head suggest the fetal position.

Killip's picture captures the loss of purpose and hope that many people in Britain felt in the second half of the 1970s and the early 1980s, particularly the working class in areas affected by deindustrialization. It appeared in his photo-book *In Flagrante* (1988). CK

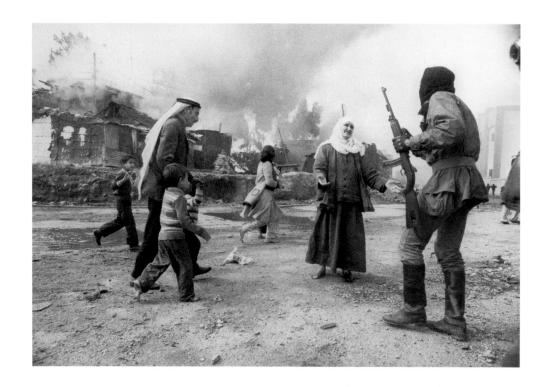

PALESTINIAN REFUGEES FLEE FROM CHRISTIAN MILITIA

FRANÇOISE DEMULDER

Date 1976
Location Beirut, Lebanon
Format 35 mm

With this image, Françoise Demulder (1947–2008) became the first woman to win the World Press Photo of the Year Award, twenty years after the prize was inaugurated. It was taken in La Quarantaine, a Palestinian district of Beirut; it shows a Palestinian woman pleading with a Phalangist Christian militiaman. The Phalangists had massacred many hundreds of the Palestinian residents and set fire to their homes in reprisal for the murder of four of their own. Demulder managed to courier her film to

her Paris agency, Gamma, via Damascus, but it was not published until Demulder herself returned to France and pointed out its significance. As she said, "From then on, it was no longer good Christians and wicked Palestinians, and the Phalangists never forgave me." She later recounted in a TV interview that only the young woman and her child seen in the background survived, the militiaman having killed himself in a game of Russian roulette.

The bravery of the woman confronting the fighter contrasts with the body language of the man who seems desperate to avoid eye contact and to shepherd the children to safety. The young boy at the far left has learned the precaution of raising his arms at the sight of a gunman. **CJ**

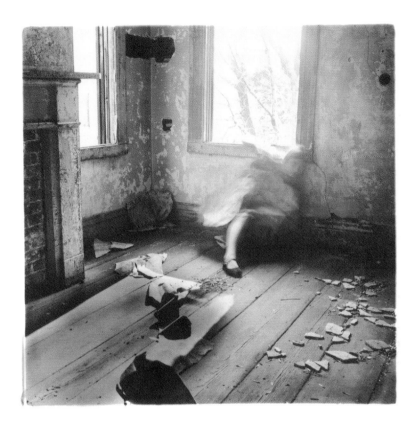

HOUSE #3

FRANCESCA WOODMAN

Date 1976
Location Providence, Rhode Island, USA
Format Medium format

The work of Francesca Woodman (1958–81) is very different from much of US art photography of the 1970s, which was dominated by conceptualism. Woodman was influenced by Surrealists, Symbolists, and Gothic fiction, although her style remains unique. The work for which she is best known was made while she was still a teenager, studying at the Rhode Island School of Design. She showed extraordinary talent from a very early age, and died very young, leaving a substantial body of work. This photograph is one of many made in an abandoned house in which she herself is the model. She cowers beneath a window in a decaying room, made indistinct by long exposure time and what appears to be a shield of paper covering her body. Only her right foot is clearly visible.

Woodman took her own life in 1981 at age twenty-two, and much has been made of how her work may or may not have been an outward expression of inner despair. In this picture she does appear to be haunted, fearful, and longing to disappear. Woodman's work is seen as an exploration of gender, self, and the body in space. Feminist readings of it emphasize the significance of the domestic interior as alien and prisonlike. JG

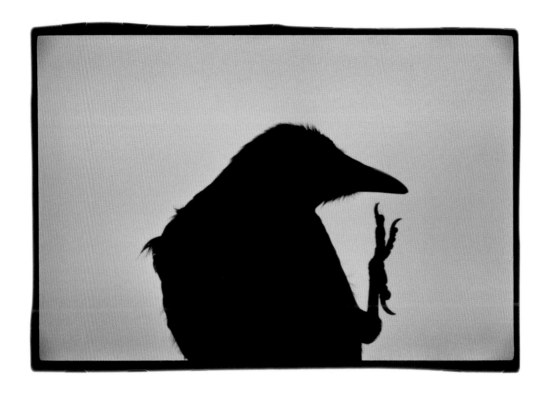

FROM *SOLITUDE OF RAVENS*

MASAHISA FUKASE

Date 1976
Location Japan
Format 35 mm

This image is part of the series made between 1975 and 1982 by Masahisa Fukase (1934–2012) after his wife and muse, Yōko, had left him. Following the divorce, Fukase turned his lens on the ravens he would see gathering at railroad stations on his way home to Hokkaido, shooting always in grainy monochrome. Captivated by their loneliness and dark, brooding nature, the more he photographed the birds, the deeper his obsession became. He wrote in 1982 that he himself had "become a raven."

The visual narrative of the series focuses on the anthropomorphic form of the raven, and this becomes a recurring motif—a symbol of the photographer's own solitude and inner turmoil. In Japanese mythology ravens are seen as harbingers of dark times, yet in this picture series they become synonymous with lost love and heartbreak.

In this close-crop of a solitary raven, we see just its silhouette against an overcast sky. The detail of its raised claw and feathery head are visible, but its eyes are not. Its loneliness is manifest.

This was Fukase's last work before he died in 2012, after having been in a coma for almost twenty years. At the hospital, Yōko would visit Fukase twice a month, but he did not know she was there. **EC**

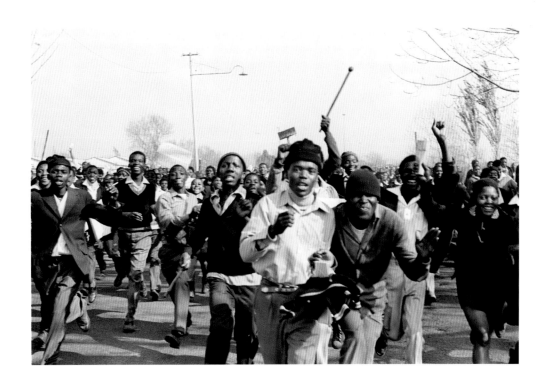

THE YOUNG LIONS

PETER MAGUBANE

Date 1976
Location Soweto, South Africa
Format 35 mm

The Soweto uprising of 1976 was a key moment in the struggle against apartheid. Reacting against an increasingly degraded black educational system, thousands of mostly secondary school students began a peaceful demonstration on the streets of Soweto township. When police opened fire on the marchers, killing about twenty-three of them, the students retaliated by setting fire to cars and administrative buildings. The incident triggered widespread violence across South Africa and

helped to galvanize support for exiled resistance movements, such as the African National Congress (ANC). It also prompted international outrage at the brutality of the police and renewed calls for increased sanctions against the apartheid regime.

Peter Magubane (born 1932) was there on the first day of the uprising and took many of the photographs that brought the story to the world. As a black photographer he was able to mix easily with the demonstrators, but he later recalled how "the young lions," as he called them, at first objected to him photographing them but were persuaded by his argument that a struggle without documentation was less powerful than one with it. JS

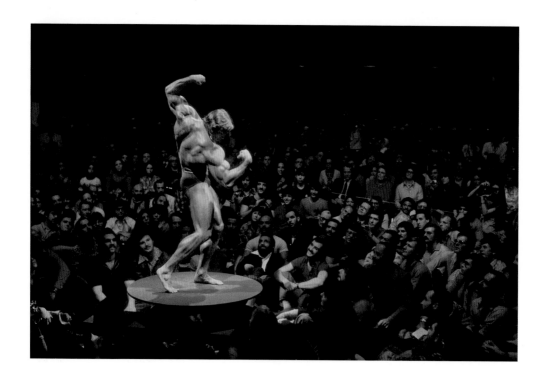

ARNOLD SCHWARZENEGGER

ELLIOTT ERWITT

Date 1976
Location New York City, New York, USA
Format 35 mm

On February 25, 1976, the prestigious Whitney Museum in New York hosted a highly unusual exhibit: *Articulate Muscle, The Male Body in Art*. The event, inspired by former weightlifter Charles Gaines' photo-essay *Pumping Iron: The Art and Sport of Bodybuilding* (1974), saw Frank Zane, Ed Coney, and Arnold Schwarzenegger posing nearly naked on rotating turntables, presented to the audience as "living objects of art." The event was attended by 2,500 people, which exceeded the expectations

of many, as well as a panel made up of prominent artists, art historians, and writers. According to *Sports Illustrated*, after they had showed off their sculptured physiques the bodybuilders were discussed by the panel, "not in athletic terms, but as artists living inside their own creations."

In this image by advertising and documentary photographer Elliott Erwitt (born 1928), Schwarzenegger appears in skintight briefs, looking Herculean in the dramatic spotlight. Surrounding him, the faces of the audience gaze up, mesmerized by Schwarzenegger's hologramlike form. Interestingly, very few women are visible in the audience, although more women compete in bodybuilding contests today. **EC**

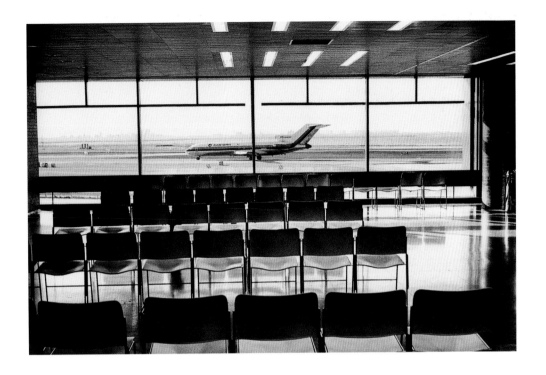

FLIGHTS OF FANCY FROM *US 77*

VICTOR BURGIN

Date 1977
Location USA
Format 35 mm

In 1977, British photographer Victor Burgin (born 1941) embarked on a US road trip with a 35 mm camera, following in the footsteps of many great photographic chroniclers of American culture. He had in mind the work of Robert Frank, but his own American odyssey produced very different results.

The series *US 77* combines black-and-white photographs with text, as part of Burgin's ongoing exploration of the interplay between words and images. The work is in some ways reminiscent of commercial magazines, but unlike them, in which the meaning is always clear, Burgin's text is oblique and enigmatic. *Flights of Fancy* shows what appears to be an airport departure lounge with strip lighting and rows of empty chairs, and a passenger jet visible through the wall of glass beyond. In the top left corner, the text begins: "Inessa Armand wanted to write a book about free love. Lenin wrote her a letter. It concluded: 'The issue is not what you subjectively want it to mean, the issue is the objective logic of class relations in matters of love.'"

Marxism, semiotics, and feminist theory are all strong influences on Burgin, who is hugely influential as one of the first conceptual artists. JG

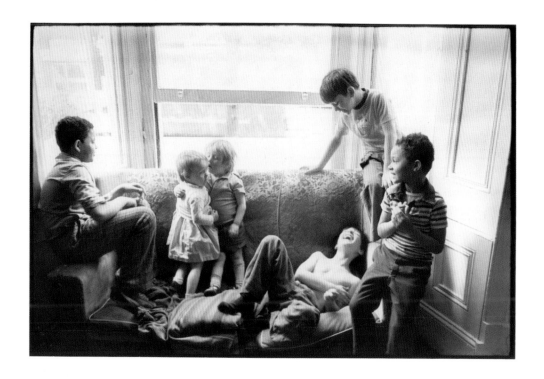

CHILDREN IN BATTERED WOMEN'S AID III

MARKÉTA LUSKAČOVÁ

Date 1977
Location London, UK
Format 35 mm

This photograph is from a series taken in the world's first women's refuge in London. Chiswick Women's Aid (now the Refuge charity) was opened by Erin Pizzey in 1971. Women and their children could go to the center and be "offered tea, sympathy, and a safe place to stay."

In this image light pours in through an open window, illuminating a scene of kids on a settee. The boy lying on the sofa has his head thrown back, laughing, and the others look on at the tiny ones kissing. The scene has innocent charm, but it also documents a point in history when people were beginning to open up about important issues and tackle certain stigmas and taboos.

Markéta Luskačová (born 1944), originally from Prague, went to the United Kingdom in 1975. She was known for her illuminating photographs of London markets and her emotionally intense series based on the city's homeless people. Throughout the 1970s and 1980s, Communist censorship in Czechoslovakia tried to conceal Luskačová's international reputation: her works were banned in her home country. Her impressive humanistic oeuvre puts her among the best photographers to have come out of Central Europe. EC

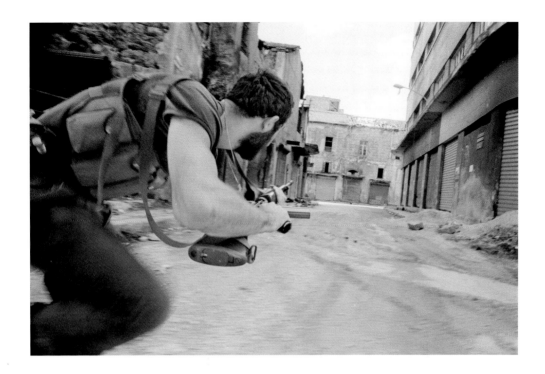

GUNMAN IN BEIRUT

RAYMOND DEPARDON

Date 1978
Location Beirut, Lebanon
Format 35 mm

Photographer and filmmaker Raymond Depardon (born 1942) was self-taught and began taking photographs at age twelve on his family's farm. By 1966, he was living in Paris, had cofounded the Gamma photographic agency, and was reporting from all around the world. In 1978, the year he joined Magnum Photos, he spent time covering the Lebanon civil war.

Depardon had first photographed Beirut on a trip to Lebanon in 1965. By the time he returned in 1978, the city had completely changed. The images he shot during that time are in both color and black and white, depicting everything from weddings and days at the beach to bullet-ridden, ruined buildings, and men wielding guns in broad daylight in the street. This image is one of a series that record his time shadowing a sniper from the Christian Phalange political party. Like much of Depardon's still photography, the image is tightly framed and almost filmic.

In the 1980s, Depardon turned his attention from combat zones to New York City, where he made a celebrated collection of black-and-white street photographs, many of which were shot without his subjects' knowledge. LH

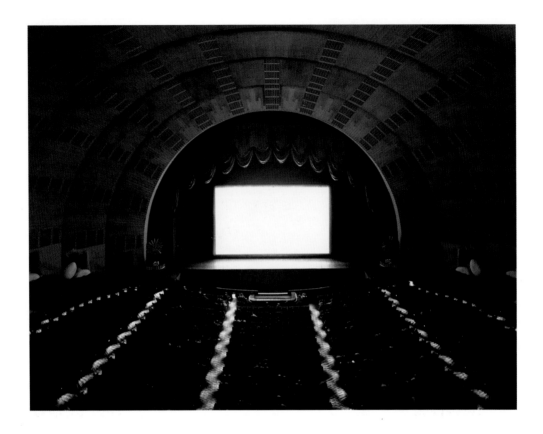

RADIO CITY MUSIC HALL

HIROSHI SUGIMOTO

Date 1978
Location New York, New York, USA
Format Large format

The idea behind the long-running *Theatres* series by Hiroshi Sugimoto (born 1948) is simple but striking: using a 4x5 camera and tripod, he makes a single exposure lasting for the whole length of a movie. In every image the result is a white screen, saturated with light, framed by the seating and architectural details of the cinema space. Often these are ornate and beautiful period buildings. Sometimes—at outdoor drive-in venues—the background is the sky, in which the long exposure

time also registers the "movement" of stars and lingering jet streams. Sugimoto wrote: "Suppose you shoot a whole movie in a single frame? And the answer: You get a shining screen. Immediately I sprang into action, experimenting toward realizing this vision. Dressed up as a tourist, I walked into a cheap cinema in the East Village with a large-format camera. As soon as the movie started, I fixed the shutter at a wide-open aperture, and two hours later when the movie finished, I clicked the shutter closed. That evening, I developed the film, and the vision exploded behind my eyes."

The pure absence of the white screen signifies the presence of both action and light: the two principal ingredients of cinematic experience. **JG**

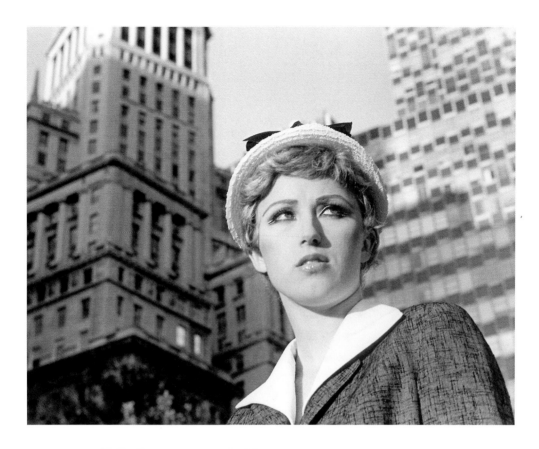

UNTITLED FILM STILL #21

CINDY SHERMAN

Date 1978
Location Unknown
Format Unknown

In her 1977–80 series *Untitled Film Stills*, Cindy Sherman (born 1954) created sixty-nine scenes in which she assumed the role of a movie heroine whom, because of the meticulous makeup, costume, lighting, and set design, we feel we have seen before. In fact, very few images in the series make direct reference to existing films. Rather, the work derives its power from the force of feminine stereotypes that have proliferated in American postwar cinema so extensively that they have become part of a shared cultural imagination: the femme fatale, the bombshell, the housewife, the murder victim, the ingenue, and, here, the ambitious but uncertain career girl, into whose expression we can read any number of imagined plotlines. The image is a complex and ambiguous fiction, with Sherman performing the role of an actress performing the role of a character who has never existed but seems somehow familiar. In the language of Hollywood cinema, this kind of shot—the close framing of a beautiful woman—typically signals that an act of violence is about to take place. Or maybe she is just concentrating, about to cross a busy street. There is no right answer. Sherman's series is celebrated as a work of feminist art. JG

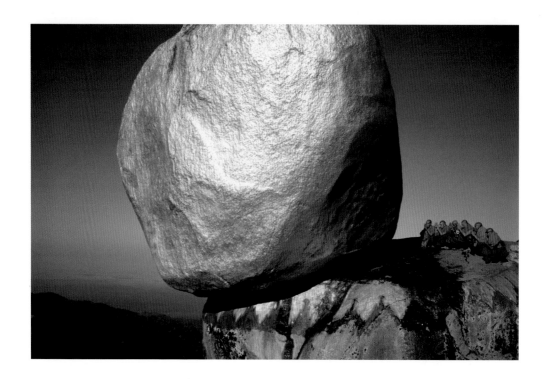

THE GOLDEN ROCK AT SHWE PYI DAW (THE "GOLDEN COUNTRY"), THE BUDDHIST HOLY PLACE, KYAIKTIYO, BURMA

HIROJI KUBOTA

Date 1978
Location Myanmar (formerly Burma)
Format 35 mm

Every year during pilgrimage season, from March to November, Buddhist pilgrims travel to the Golden Rock or Kyaiktiyo Pagoda in Myanmar. At this holy site, a pagoda, 25 feet (7.6 m) tall, stands on a granite boulder covered in gold leaf, itself perched precariously atop a hill. A strand of Buddha's hair is believed to lie beneath the boulder. Hoping to secure good fortune, pilgrims light candles and chant at the foot of the boulder, and males are invited to paste gold leaf onto the rock.

Hiroji Kubota (born 1939) met Magnum photographers René Burri, Burt Glinn, and Elliott Erwitt when they visited Japan in the early 1960s. He graduated from Waseda University with a degree in political science, but decided that photography was to be his vocation. Moving to the United States, he won commissions as a freelance from numerous publications. As a Magnum associate he was in Vietnam during the fall of Phnom Penh and Saigon, and later in Korea. In 1979, he began a 1,000-day tour of China (after many years spent requesting permission to do so), taking in excess of 200,000 photographs. He has since continued to fulfill his lifelong commitment to photographing the life and cultures of Asia. GP

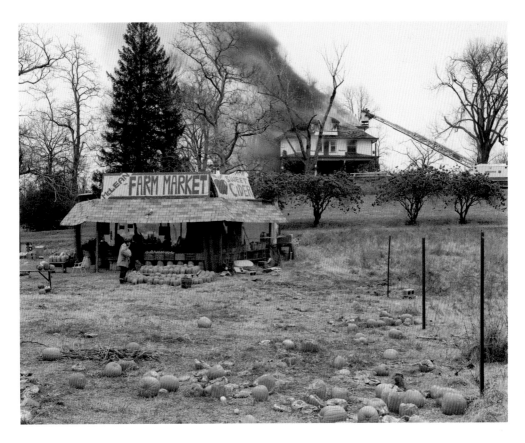

MCLEAN, VIRGINIA, DECEMBER 1978

JOEL STERNFELD

Date 1978

Location McLean, Virginia, USA

Format Large format

Joel Sternfeld (born 1944) is considered one of the pioneers of color photography in the United States, along with the likes of William Eggleston and Stephen Shore. Following closely in the footsteps of Walker Evans, Sternfeld grasped American identity through photographing the most ordinary people and places. From 1979 to 1983, he traveled around the country with his large-format camera, capturing the rich, multilayered images that would form his series and book *American Prospects* (1987).

This image of a firefighter, perusing a pumpkin stand while the house behind him is engulfed in flames, is one of Sternfeld's iconic works—it was included in *Life* magazine's *The Best of Life: Favorite Photographs 1978–1991*. It has also caused controversy. In his customary style, Sternfeld captioned the photo simply with the place and date, rather than informing the viewer that this was a fire training exercise, and that the man in the foreground was just taking a break.

Ambiguity always appealed to Sternfeld. As he said: "Photography has always been capable of manipulation . . . Any time you put a frame to the world, it's an interpretation. . . . You take thirty-five degrees out of 360 degrees and call it a photo." LH

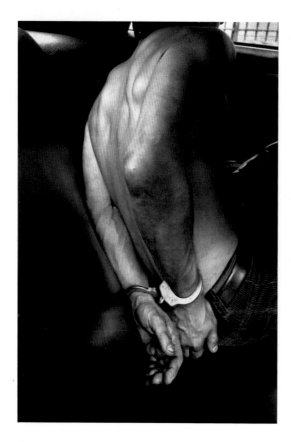

"HANDCUFFED," NEW YORK CITY

LEONARD FREED

Date 1978
Location New York City, New York, USA
Format 35 mm

After making his name in documenting the US civil rights movement, Magnum photographer Leonard Freed (1929–2006) embarked in 1972 on a long-term project documenting the New York City Police Department, originally as a commission for the British *Sunday Times* newspaper. The images were initially controversial when published with a negative article, but Freed said that the newspaper "wanted blood and gore, but I was more interested in who the police were . . . I wanted to get involved

in their lives." This remained his watchword over the next seven years, during which he covered murders, drug busts, and protests (this portrait of an unidentified half-naked man under arrest is perhaps his most famous single image) but also captured the kinder side of police work. He maintained a professional and evenhanded approach, and he was sympathetic to the police officers, who he saw as doing a difficult job in a tough city. "They are not psychiatrists, they are not lawyers, they are not doctors. . . . They are blue-collar workers," he later remarked.

The 100-plus images he published as *Police Work* in 1980 became an exemplar of long-form documentary photographic storytelling. NG

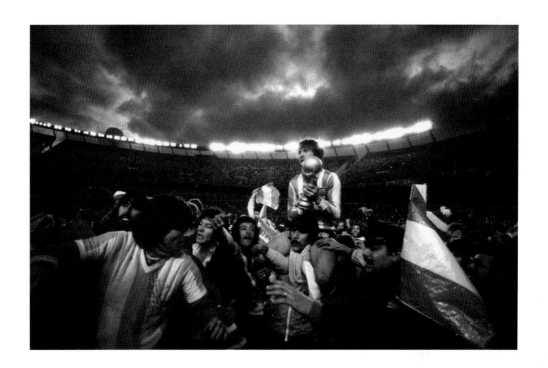

ARGENTINA WINS THE 1978 WORLD CUP

UNKNOWN

Date 1978
Location Buenos Aires, Argentina
Format 35 mm

In the 1978 World Cup soccer final—held at the River Plate club's home ground, Estadio Monumental, in Buenos Aires—Argentina defeated the Netherlands 3–1 after extra time. Victory in this match secured the host nation's first tournament triumph.

The competition was not without controversy, coming just two years after a military coup in Argentina and in the middle of an oppressive crackdown on internal political opposition. International concern led several countries, including the Netherlands, to debate publicly whether to boycott the tournament in order to make clear their objections to the human rights abuses reportedly taking place.

The final itself was also contentious, with the Dutch team accusing the hosts of delaying the start of the game to increase the tension among the hostile Buenos Aires crowd, and the seeming favoritism of the Italian referee toward the Argentines during the match. Such was the Dutch players' anger that they refused to attend the post-match press conferences. The above photograph sums up the emotion and drama of the event, with its dramatic yet harmonious color palette of blues and whites under a stormy evening sky. PL

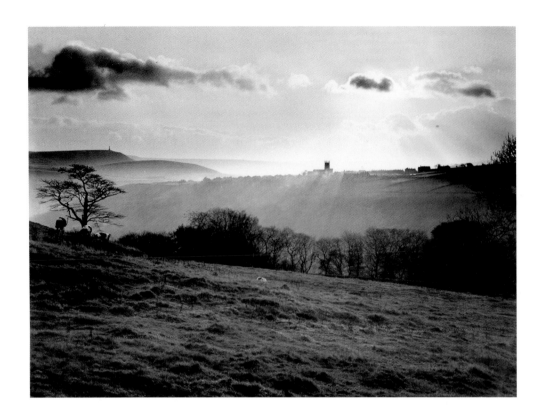

HEPTONSTALL, WEST YORKSHIRE

FAY GODWIN

Date 1979
Location Yorkshire, UK
Format 35 mm

Fay Godwin (1931–2005) taught herself to be a highly competent photographer, taking portraits of many leading writers. But she really came into her own with her black-and-white landscape images, gradually establishing her reputation with a series of books and accompanying exhibitions. In 1979, she collaborated with poet Ted Hughes on *Remains of Elmet*, which combined Godwin's richly atmospheric photographs of West Yorkshire's bleak Calder Valley with Hughes's elegiac poems about the area in which he grew up. The image here, which was used for the cover of one edition of the book, reveals Godwin's fascination with the mutability of the landscape and humankind's complex relationship with the natural world. The sun dominates the image, bursting through the sky behind the distant village of Heptonstall, where Hughes's parents had their home.

Much of Godwin's work was permeated by a sense of loneliness and desolation, but she objected to being described as a Romantic photographer: "I hate it. It sounds slushy and my work is not slushy. I'm a documentary photographer, my work is about reality, but that shouldn't mean I can't be creative." ER

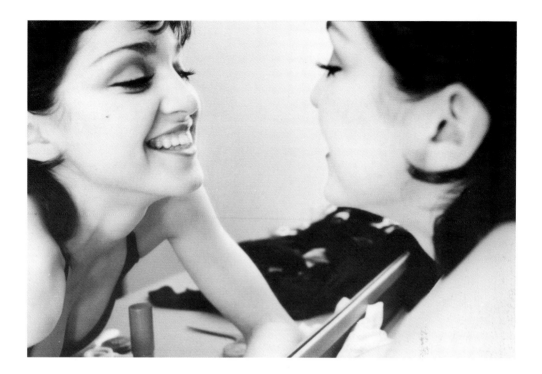

MADONNA

MICHAEL MCDONNELL

Date 1979
Location New York City, New York, USA
Format 35 mm

When fashion photographer Michael McDonnell ran into a young Madonna in a hallway in his building, he was instantly mesmerized and asked if he could photograph her. Dressed in full black with ripped jeans and untamed hair, "she had a little attitude," McDonnell recalls. The two collaborated on a number of photoshoots over the next eight months, and this is one of the earliest professional images of Madonna. The future star had just moved to New York City to study dance.

Madonna Louise Ciccone was born in 1958 in Bay City, Michigan. As a teen, she was known for her excellent performance in school, and equally for her rebelliousness. Upon graduating high school early, she won a dance scholarship to study at the University of Michigan; in 1978, after winning another scholarship with the Alvin Ailey Dance Theater, she made the decision to drop out and relocated to New York City. There, she performed in a number of dance troupes and worked odd jobs. In the year this photo was taken, Madonna traveled to France to perform as a showgirl, and it was around this time that her career began to take off. Here we see Madonna radiant with youth and optimism, just on the cusp of stardom. EC

MAFIA ASSASSINATION

FRANK CASTORAL

Date 1979
Location Bushwick, New York, USA
Format 35 mm

Carmine Galante worked his way up through the Mafia the hard way. He first established his reputation by doing the bidding of others—he was reputed to have murdered the editor of an anti-Facist US newspaper in order to please Italian dictator Benito Mussolini. The next stage in his career path was to eliminate other hoods who stood between him and supreme power within New York's Cosa Nostra. Eight of the Gambino family are believed to have been killed by Galante or on his orders.

As the 1970s drew to a close, Galante seemed invincible, but he had a fatal flaw: greed. He didn't want any other gang or family to have a share in the illegal narcotics trade, and the criminals he was trying to deal out got together and decided that he had to be removed.

On July 12, 1979, Galante went out for lunch on the patio at Joe and Mary's Italian-American Restaurant in Brooklyn. He had just finished eating when three masked men walked up to his table and shot him and his chief bodyguard, Leonard Coppola, dead at point-blank range.

When the police were alerted of the crime, their radio messages were overheard by *Daily News* photographer Frank Castoral, who made it to the restaurant before any other reporter. The crime scene was already sealed off, but Castoral managed to climb onto the roof of the family home above the restaurant and get this shot from the high vantage point. The structure of the photograph culminates with the telling detail of the cigar in the corner of Galante's mouth. Galante was also known as "the Cigar." ZG

"No one will ever kill me. They wouldn't dare." Carmine Galante

NUESTRA SEÑORA DE LAS IGUANAS ("OUR LADY OF THE IGUANAS")

GRACIELA ITURBIDE

Date 1979
Location Juchitán, Oaxaca, Mexico
Format Medium format

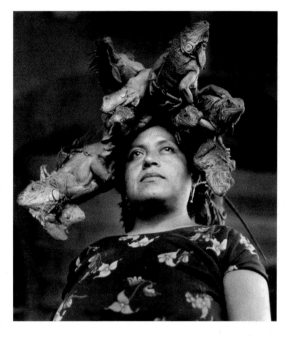

Tina Modotti photographed them, Diego Rivera painted them, and Lila Downs sang about them: the beguiling women of Oaxaca, the southern state of Mexico that has seduced artists, intellectuals, and musicians with its ancient history, expansive blue sky, and delicious cuisine.

The Juchitán region in the Oaxaca isthmus of Tehuantepec has an unusual matriarchal culture in which indigenous Zapotec women run the local economy and make all the social decisions. Mexican photographer Graciela Iturbide (born 1942), once a student of Manuel Álvarez Bravo, was invited to Juchitán by local artist Francisco Toledo to document the everyday lives of these women before the modern world seeped in and changed the isolated area. Her images are a document of their fortitude, beauty, and capability.

When Iturbide was in the local marketplace, she saw this woman with her iguanas that were on sale for food. Iturbide asked her to put the lizards on her head and then used up all twelve shots on her Rolleiflex. She said: "Only one photo . . . was good, because it was the only one where the iguanas raised their heads as if they were posing."

In this majestic image, the Zapotec woman wears the iguanas like a crown, and the camera looks up at her as if in awe. Yet, Iturbide says, this is simply how the women carry everything.

Asked in an interview if she has a particular theme that she prefers to photograph, Iturbide was reluctant to set any limits, saying that her subjects are "Everything that surprises me in life," and adding that "I am interested in what my eyes see and what my heart feels." SY

"With close-up views of a closed society, Iturbide's work is photography at its most intimate." *Publishers Weekly*

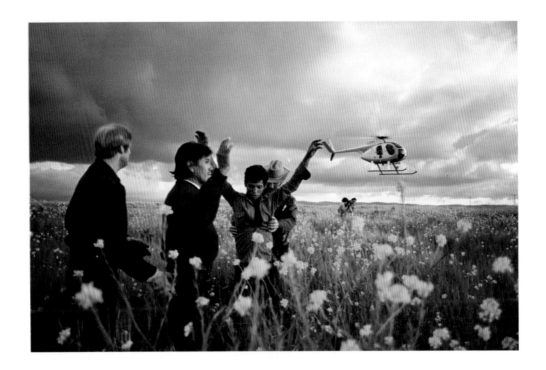

MEXICANS ARRESTED WHILE TRYING TO CROSS THE
BORDER TO THE UNITED STATES

ALEX WEBB

Date 1979
Location San Ysidro, California, USA
Format 35 mm

In the 1970s, Alex Webb (born 1952) tired of shooting US urban landscapes in black and white. Seeking a new direction, he was inspired to visit Mexico by Graham Greene's book *The Lawless Roads* (1939), and on arrival there, he was immediately drawn to photograph the border areas. Primarily a street photographer, albeit one whose work is also concerned with social justice, Webb has stated that the vibrancy of the border region transformed him into a color photographer, putting

him in the second wave of American color street photographers following after such luminaries as William Eggleston. For Webb, Mexico is where "color is somehow deeply part of the culture," and his work in that country formed an extended project undertaken over a long period. Images encompassing twenty-six years of Webb's work on the Mexican–US border are collected in his influential book *Crossings*, the creation of which involved the photographer in several illegal border crossings, some of which ended in his arrest, as here in San Ysidro, California.

With ongoing debates about US immigration, this image continues to have political and social relevance today. NG

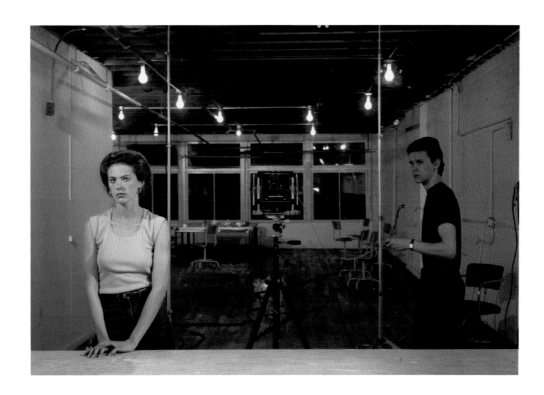

PICTURE FOR WOMEN

JEFF WALL

Date 1979 Location Unknown
Format Photographic transparency
in light box

This picture by Canadian Jeff Wall (born 1946) is loaded with an unusually complex range of historical, theoretical, and artistic references. According to writer David Campany, it "marks the transition of photography as contemporary art form from the printed page to the gallery wall." Wall himself describes it as a "remake" of Édouard Manet's 1882 painting A Bar at the Folies-Bergère, in which a woman looks out from behind a bar while a mirror behind her reflects a male figure who gazes at her.

Here is a subtle rearrangement of these elements. The camera itself is visible at the center, pointed toward the viewer, revealing the whole of the image as a reflection in a mirror. The artist uses a cable release to take the photograph, and the female model bears a contemplative expression similar to that of Manet's barmaid.

By playing with the pictorial space, Wall foregrounds questions of spectatorship, and the power relations between female subject and male artist. Influenced by the theory of the "male gaze," which came to prominence in the 1970s as a feminist critique of cinema, the "cinematic" style of this and subsequent works by Wall contributes an important additional layer of meaning. JG

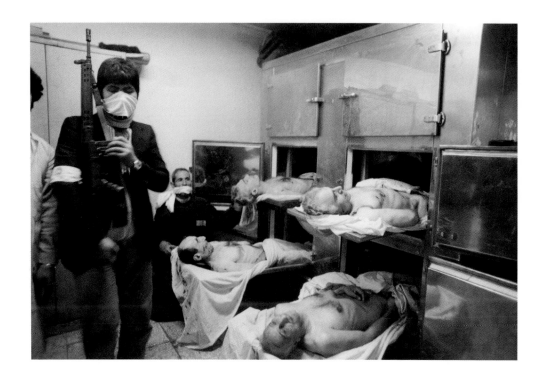

THE BODIES OF FOUR GENERALS, EXECUTED AFTER A SECRET TRIAL HELD AT AYATOLLAH KHOMEINI'S HEADQUARTERS. IRAN. TEHRAN. FEBRUARY 15, 1979

ABBAS

Date 1979
Location Tehran, Iran
Format 35 mm

Abbas (born 1944) is an Iranian photographer who came to prominence for his eyewitness record of the unfolding events of his country's 1979 revolution. Initially, he wanted to portray the overthrow of the shah through the eyes of twelve ordinary citizens, but having taken to the streets he felt more involved with the country as a whole, and the uprising against an unpopular despot. Abbas's images record how early optimism about a new, liberal dawn was quickly replaced with the

realization that the future was going to be rule by an autocratic theocracy.

This image, taken in Qasr Prison, Tehran, is dark, but not without irony. At the bottom right is the body of General Nematollah Nassiri, former chief of the notorious SAVAK secret police, infamous for their own extrajudicial killings. Abbas relates that he had seen the dignified face of one of the generals interrogated in front of the TV cameras a week before. On seeing that they had been denied an open and fair trial, Abbas said: "At that moment I knew this revolution would no longer be mine." The masked gunman's eyes are closed—a small but telling detail with a deep symbolic power. NG

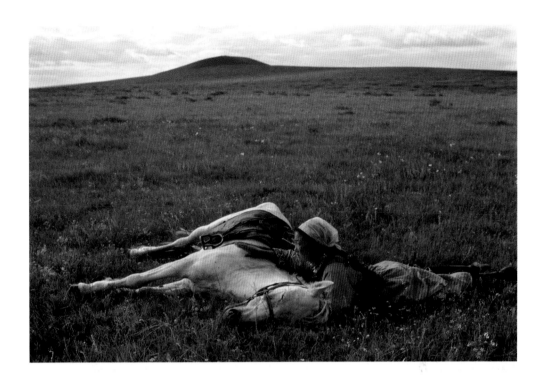

HORSE TRAINING FOR THE MILITIA

EVE ARNOLD

Date 1979
Location Mongolia
Format 35 mm

The first woman to be admitted to the Magnum agency, Eve Arnold (1912–2012) was one of a handful of female photographers of her generation to reach the profession's top flight, successfully combining advertising work with editorial portraiture of stars (including Marilyn Monroe), travel projects, and hard-hitting photo-essays. Magnum cofounder Robert Capa once suggested ironically that Arnold had an eye for "Marlene Dietrich's legs and the bitter lives of migratory potato pickers."

Arnold was self taught, having been given a Rolleicord by a boyfriend while she was studying medicine. She trained as a film developer and began photographing catwalks in the 1950s, before successfully migrating to magazine work, which took her all over the world. In 1979, the British *Sunday Times* magazine dispatched her for two three-month stints in China, Tibet, and Mongolia, which were then still barely accessible to foreigners.

The portrait above is characteristically humane, offering what could have been kitsch—a Mongolian girl trains her horse to lie down in the steppe, presumably as camouflage—without a trace of condescension. This woman is just doing her job; the photographer is doing likewise. AD

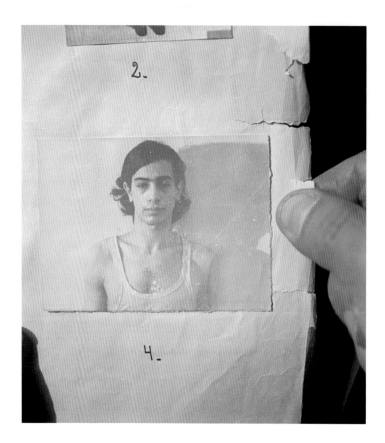

UNDERSHIRT

MARCELO BRODSKY

Date 1979
Location Buenos Aires, Argentina
Format 35 mm

"The undershirt was visible—a worn, basic, irregular item. A minimal, wrinkled undershirt clothing an adolescent body after a session of torture." This photo is of one of *los desaparecidos* ("the disappeared"), who were murdered in secret by the military dictatorship that ruled Argentina from 1976 to 1983. He was the brother of Marcelo Brodsky (born 1954), conceptual artist and human rights activist.

The years of terror took the lives of more than 30,000 Argentines and forced many of those who

disagreed with the military's policies, including Brodsky, into exile. While in Spain in the 1980s, Brodsky studied economics and photography and returned to Buenos Aires to publish *Buena memoria*, a study of state terrorism. Described as a "multifaceted biographical research project," it serves as a memorial to those who were erased by state violence. Brodsky's main goal was to "'reinstate' the disappeared in the collective memory of the nation."

The original photograph was taken during Brodsky's brother's detention in Buenos Aires's infamous ESMA—a building that was ostensibly the Navy Petty-Officer's School of Mechanics but in reality an illicit detention center. SY

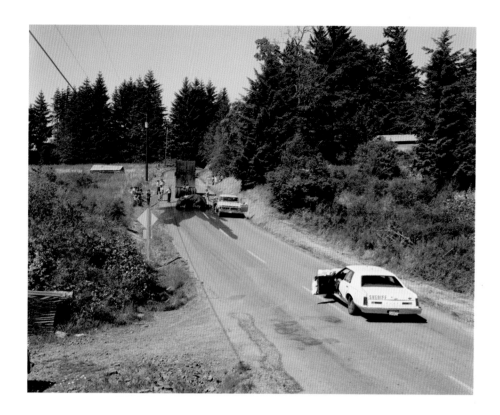

EXHAUSTED RENEGADE ELEPHANT, WOODLAND, WASHINGTON, JUNE 1979

JOEL STERNFELD

Date 1979
Location Woodland, Washington, USA
Format Large format

This picture of an elephant lying on a country road is so incongruous that the viewer's first reaction may be that it was staged or that the image has been manipulated. But truth is stranger than fiction; Joel Sternfeld (born 1944) struck it lucky and came across this bizarre incident while driving his Volkswagen bus around the western United States.

Sternfeld is known for his use of color and his sense of irony. This picture, although the result of a chance encounter with an escaped circus animal named Thai and police from Cowlitz County Sheriff's Office, still resonates with humor, while the dusky browns of the color palette help to camouflage the collapsed animal, making it hard to find—then, when the creature is located, the situation seems even more absurd. The police officer is visible only through the open door of his cruiser. Bystanders provide a range of reactions: teenagers look on curiously and a family cautiously peer out of their driveway. A zookeeper hoses down the exhausted pachyderm. The wide framing is because Sternfeld was asked to stand at a distance; that the animal is seen writhing in the background while a patrol car blocks the road adds a sense of a Keystone Cops-type calamity. CK

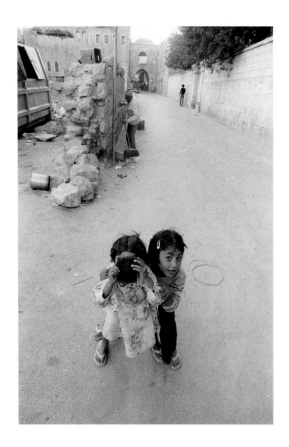

JERUSALEM, 1979

JEAN MOHR

Date 1979
Location Jerusalem, Israel
Format 35 mm

Jean Mohr (born 1925) is a Swiss documentary photographer whose practice has become renowned through his collaborations with writers, in particular English critic John Berger and Palestinian intellectual Edward Said.

This photograph is typical of the observant compassion inherent in Mohr's work, especially in the images he made for humanitarian organizations. It is from his widely celebrated book *After the Last Sky* (1986), a love letter to Palestine and its people. Mohr's images and Said's text combine powerfully to make vivid the experience of exile— what it means to love a person, a thing, or, as here, a place, and then to have it taken away. The two men did not work together in Palestine (Said was banned from entering), so Mohr's images were selected by the writer, a process that may add to the sense of dislocation that pervades the volume.

Said's poignant and precise sense of longing springs from the very heart of the images. What he saw in Mohr's work was rare: Palestinians, not as stateless people, or as terrorists, but simply as people. He said of Mohr: "He saw us [Palestinians] as we would have seen ourselves, at once inside and outside our world." MH

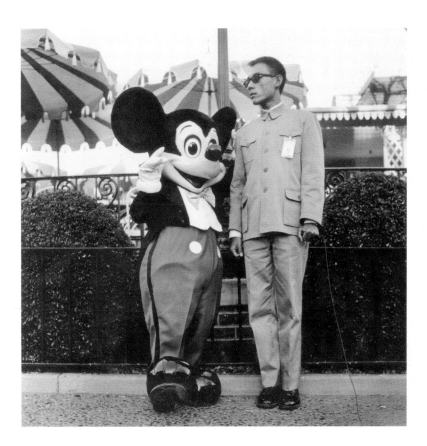

DISNEYLAND, CALIFORNIA

TSENG KWONG CHI

Date 1979
Location Anaheim, California, USA
Format Medium format

Hong Kong-born Tseng Kwong Chi (1950–90) studied fine art before emigrating to the United States in 1978 and settling in New York the following year. There he established himself as a prolific and diverse photographer, developing a photographic practice that rested on the boundaries between documentary, art, and performance.

Tseng's best-known work is his series *East Meets West*, which he produced from the late 1970s until his death. It began during the "ping-pong diplomacy" period in Sino-American relations that culminated in US President Richard Nixon's first visit to China in 1972. This initiative was supposed to herald a thaw in East–West relations, but Tseng regarded the changes as mostly superficial, and felt that US views of China remained mired in stereotypes and ignorance. Tseng discovered that when he dressed in a formal Chinese suit and visited major US tourist sites, strangers would often assume that he was an important Chinese delegate, and so he decided to adopt this persona, effectively becoming an unofficial Chinese ambassador. Visiting landmarks and often posing with passers by, Tseng used this conceit to explore cultural difference, cliché, and ignorance. **LB**

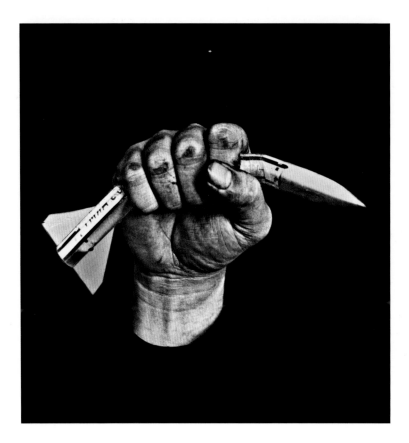

CRUSHED

PETER KENNARD

Date 1980
Location London, UK
Format Photomontage

Peter Kennard (born 1949) is an artist and educator whose photomontage channels the imagery and politics of earlier exponents of the medium. Throughout his career he has engaged with a wide range of political issues, from poverty and inequality to protesting wars in Iraq and Afghanistan. Some of his best-known images are those produced during the latter half of the Cold War, which were often produced for left-wing groups such as the Campaign for Nuclear Disarmament.

The Soviet invasion of Afghanistan and the subsequent Western boycott of the 1980 Moscow Olympics added to Cold War tension and increased the deployment of missiles with multiple warheads.

The peace movement responded to these developments with widespread protests. During this time, Kennard's photomontages often appeared in publications and on banners at demonstrations. In this image, one of Kennard's most famous, a hand closes around a missile, rendering it useless. It directly references German artist John Heartfield's political montage *The Hand Has Five Fingers* (1928), which depicts an outstretched open hand and includes the call to the viewer to use those five fingers to grab and destroy the enemy. LB

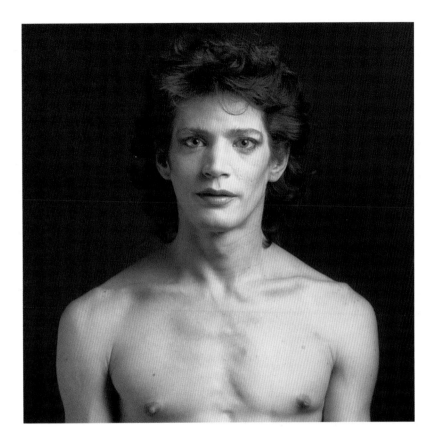

SELF-PORTRAIT

ROBERT MAPPLETHORPE

Date 1980
Location New York, New York, USA
Format Medium format

Robert Mapplethorpe (1946–89) started working with photography in 1971 and soon began to explore the themes that would define his oeuvre: homosexuality, eroticism, transgression, flowers, and portraits. Primarily, he worked in black and white to give his images a sense of minimalism, but he also reveled in the lush tones that a gelatin silver print could produce by emphasizing the textures of his subjects. In this self-portrait from 1980, Mapplethorpe plays with his sexual identity by

using make up to create an androgynous character who stares challengingly back at the camera.

Mapplethorpe continually challenged the conventions of acceptable subjects for art, exemplified by his *Man in a Polyester Suit*, also from 1980, in which he depicted his lover, Milton Moore, in a three-piece suit with the zipper undone and a flaccid penis hanging out. Masterfully lit, with careful attention to detail, it was typical of Mapplethorpe's aesthetic of technical perfection combined with content that often shocked the viewer. His work has attained iconic status not only for its technical excellence, but because it helped push artistic boundaries with its strong sexual imagery. CK

PRO-SHARIATMADARI DEMONSTRATIONS, TABRIZ

GILLES PERESS

Date 1980
Location Tabriz, Iran
Format 35 mm

In 1979 and 1980, Islamic fundamentalists supporting the Iranian revolution took control of the US embassy in Tehran, taking fifty-two people hostage. The crisis lasted for five weeks. Magnum photographer Gilles Peress (born 1946) was there for the duration in an attempt to document what was really happening as an antidote to the US coverage of the event, which widely portrayed Iranians as crazed fanatics. As a result he encountered problems in getting news sources to print his photographs without imposing captions and edits to communicate their own agendas.

This photo was taken during demonstrations outside the headquarters of Ayatollah Sayyid Mohammad Shariatmadari, a cleric who denounced the taking of hostages, and called for a separation between clerics and the government. Hours after the photo was taken, the headquarters was overrun by the Revolutionary Guard, who put Shariatmadari under house arrest.

The composition makes the photo seem divided into four parts and reveals Peress's innovative use of angles and shade in his imagery. A crop of it was used as the cover of his book *Telex Iran* (1984), a visual journey through the historical event and Peress's individual experience of it. LH

MUJAHIDEEN SURROUND ALLEGED TRAITOR

ALAIN MINGAM

Date 1980
Location Afghanistan
Format 35 mm

This photograph of mujahideen soldiers escorting an alleged traitor to an execution site raises one of the most important ethical questions for photojournalists: should they witness and photograph acts of extreme violence? The abiding question is whether the fate of this victim might have been different if no photographer had been present. Did the armed men stage a photo opportunity? Clearly the image itself does not answer these questions, but it does make viewers wonder what was the fate of the subject and consider what would they have wanted or been able to do if they had been present themselves.

Alain Mingam said that he was doing his professional duty and that the fate of the victim was already sealed.

The strong background light seems to create a halo around the captive's head. His facial expression suggests unfathomable calm—is he reconciled to his fate, or does he know that he has nothing to worry about? Around him, his captors pose: some look starkly into the camera; others show off their firearms. ZG

THE RINGS OF SATURN

NASA

Date 1980
Location Outer space
Format Digital

The first artificial satellite, *Sputnik*, in 1957, was followed by a spate of further space probes launched by the United States and Soviet Union. These missions gathered important information about the solar system. Gradually, as the nearer planets were explored and mapped, probes were launched on ever-longer missions deeper into the solar system, and eventually beyond.

In 1977, *Voyager 1* was launched on a mission to study the outer fringes of the solar system. Three years and 746 million miles (1.2 billion km) later it passed Saturn, taking a series of photographs of the planet, its rings, and its moons, including this one taken from a distance of 3 million miles (4.8 million km). The photograph is strikingly like speculative illustrations and drawings of the planet, and its dramatic lighting calls to mind the designs of science-fiction films.

Continuing its mission, in 1990, *Voyager* took a photograph of Earth from 3.7 billion miles (6 billion km) away, the most distant photograph of the planet ever taken. Shortly afterward, the probe's cameras were shut down to conserve its power supplies. In 2012, *Voyager* left the solar system; it proceeds to travel deeper into space and will continue to relay new readings and discoveries back to Earth until 2025. LB

CEAUSESCU GARDEN PARTY

UNKNOWN

Date c. 1980
Location Romania
Format 35 mm

Romanian Communist leader Nicolae Ceausescu carves meat at a barbecue for his friends and political cronies. This photograph, probably taken by one of the guests, shows that, for the ruling classes, there was no shortage of luxury goods. The ordinary people of Romania, however, had a different tale to tell: in an effort to pay off the national debt, Ceausescu led an export drive that left his own citizens desperately short of basic food, medicine, and fuel. Any dissent was ruthlessly crushed by the secret police, the Securitate.

In December 1989, the people finally rose against him, and after three days of concerted demonstrations throughout the country, the army mutinied. Ceausescu and his wife, Elena, fled, but they were captured, tried by a kangaroo court, and shot dead by firing squad on Christmas Day.

That was the end of Communism in Romania. After the establishment of democracy, information became more freely available than ever before. When the above photograph was made public, it confirmed what many had long suspected: that austerity was only for the masses; for the leaders, there was always plenty to go around. AZ

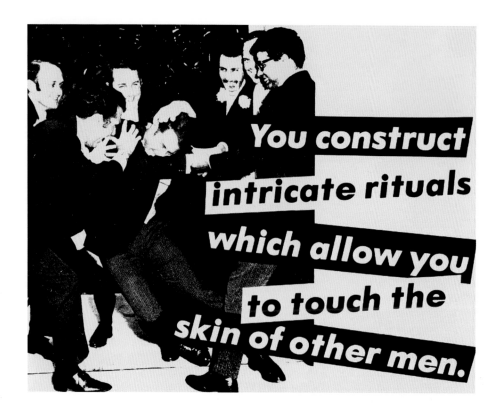

UNTITLED (YOU CONSTRUCT INTRICATE RITUALS WHICH ALLOW YOU TO TOUCH THE SKIN OF OTHER MEN.)

BARBARA KRUGER

Date 1980
Location Unknown
Format Collage

After studying art and design, Barbara Kruger (born 1945) initially worked as a designer at Condé Nast publications on magazines, including *Mademoiselle* and *House & Garden*, while also developing her own artistic practice. Over the course of her career, this practice has spanned painting, collage, video, and conventional photography, with a book of her architectural photographs and texts published in 1979. At around the same time, Kruger began to experiment increasingly with found or appropriated

photographs. By combining these found images with short texts, Kruger creates artworks that play on the way in which words can alter the meaning of pictures.

Kruger often works with imagery appropriated from fashion and advertising, pairing them with short pithy phrases that directly address the viewer. Using bold blacks, whites, and reds in conjunction with the Futura Bold typeface, Kruger developed this approach into a highly recognizable signature style, expanding it to create immersive exhibitions in which text and image sometimes span the floor and ceiling, as well as the wall. The influences of her early work as a graphic designer and editor are clear. LB

CATHERINE WILKE, 1980

SLIM AARONS

Date 1980
Location Capri, Italy
Format 35 mm

We can only just see the pool in this photograph of a hot summer's day, but its central presence is everywhere implied. Glistening droplets of water bead Catherine Wilke's bent leg, and notice Charlotte Tieken's wet hair under her hat, perhaps dripping onto her wrists as she leafs through her magazine. The atmosphere is still, but the lines are striking: the languid lengths of the three sunbathers interrupted only by the lean vertex of Catherine's bikini-clad body as she saunters past.

George Allen "Slim" Aarons (1916–2006) was famous for photographing the fabulously wealthy as they made the world their playground. Dubbed the "photographer laureate of the upper classes" by London's *Times* newspaper, Aarons honed his skills as the official photographer of the US military at West Point, New York; he was awarded the Purple Heart for his service in World War II. He then became a freelance photojournalist, declaring that the only beach worth landing on was one "decorated with beautiful, seminude girls tanning in a tranquil sun." Eschewing formal arrangements, he claimed that a good photograph was no more than an image of "attractive people doing attractive things in attractive places." **RF**

CAPE CANAVERAL, FLORIDA, USA, 1981

RENÉ BURRI

Date 1981
Location Cape Canaveral, Florida, USA
Format 35 mm

Swiss photographer René Burri (1933–2014) covered most of the major political and cultural events and figures of his age—one of the first photographs he ever took was of Winston Churchill in 1946. He went on to photograph Che Guevara and Pablo Picasso and traveled extensively on commissions for *Life*, *Look*, *Stern*, and *Paris Match*.

Burri's most recognizable work was shot in black and white. His color photographs, most of which were previously unseen, were published in the book *Impossible Reminiscences* (2013), a lyrical journey through Burri's color palette—even including some of his painting. Each image slightly echoes the previous one, and the text is relegated to the back of the book, where Burri provides anecdotes about each image.

On this photograph, Burri comments: "Back at Cape Canaveral the day came when I discovered that they were reworking one of the launch pads for a space shuttle program. I followed the whole story over three years, during which time I kept coming back again and again. I even became their artist in residence. I witnessed the building of Space Shuttle Columbia, the first orbiter to be launched into space." LH

JEWS IN FRANCE

PATRICK ZACHMANN

Date 1981
Location Paris, France
Format 35 mm

This image reflects the enduring interest Magnum photographer Patrick Zachmann (born 1955) has in Jewish cultural identity and memory. It was taken in Paris on the thirty-third anniversary of the state of Israel, and features on the cover of his book, *Enquête d'Identité* (*Inquest on Identity: a Jew in search of his memory*, 1987). He says, "I became a photographer because I have no memory. Photography allows me to reconstruct the family albums I never had, the missing images becoming the engine of my research. My contact sheets are my personal diary." This image can be read as being very personal, even autobiographical, reflecting something of the photographer's identity and experience as the child of Jewish postwar immigrants living in France.

Zachmann is also known for his immersive work on the Neapolitan police and mafia in the 1980s. Subsequently, for more than thirty years, he has dedicated himself to China and the Chinese diaspora. "I feel attracted by this country and its culture," he wrote in his diary before his first visit, "not knowing exactly why." In 2016 he received the Nadar prize for his book *So Long China*, surveying a range of subjects from the Tiananmen Square protests to the Chinese community in France. JG

VILLAGE IN THE PROVINCE OF BRABANT, BELGIUM.
COMMEMORATION OF THE BATTLE OF WATERLOO

HARRY GRUYAERT

Date 1981
Location Belgium
Format 35 mm

A parked car appears in a gap between Belgian soldiers in dress uniform marching on a nondescript street. Although ostensibly a documentary photograph, this image tells the viewer little of the event or the place. To establish the purpose of this picture, we need to know something of the photographer's intentions.

The attitude of Harry Gruyaert (born 1941) to his art can be summarized by his assertion: "There is no story. It's just a question of shapes and light."

Therein lies the solution. Or at least a major part of it. The rest of it comes from Gruyaert's ambivalence toward his native land, which he photographed over ten years for his book *Made in Belgium* (1981).

Gruyaert rejects the humanistic tradition in documentary photography. "I was much more interested in all the elements," he recalled. "The decor, and the lighting, and all the cars: the details were as important as humans. That's a different attitude altogether."

Such an attitude can be seen in this picture, the documentary content of which takes second place to the abstracted formal play of strong color and shape. **NG**

I enjoy the privileges of affluence—
a large house, a servant, exotic food.
I dislike many of my upper class obligations—
correct appearances, prescribed behavior,
impoverished ideas.
For better or for worse, I handle this
paradox by living alone – as an artist.

If you want to stunt your growth, be rich.

"I ENJOY THE PRIVILEGES OF AFFLUENCE . . ."

JIM GOLDBERG

Date 1981

Location San Francisco, California, USA

Format 35 mm

Jim Goldberg (born 1953) is an award-winning Magnum photographer whose multimedia work is founded on collaboration with communities on the margins of society. His book, *Rich and Poor* (1985), explores life at both ends of the economic spectrum in American society, pairing photographic portraits of his subjects in their homes with handwritten notes that reveal their personal reflections and aspirations. In this example, his subject sums up the ambiguities of privilege. Standing in her painting studio near a huge canvas, she poses with assertiveness, pride, and energy, and writes with equal assertiveness about the tension between "the privileges of affluence" and its "prescribed," "impoverished" "obligations." Other subjects in the series lead very different lives and offer very different testimonies. For example, below a portrait of her and young daughter, "Emily S." writes, "We look like ordinary people . . . we have a terrible life."

Goldberg has avoided some of the critiques of photojournalism as voyeuristic or exploitative of disenfranchised people because his subjects participate directly in the work. Specifically, the handwritten texts give them the space and the right to express their response to his portraits. JG

STREET SCENE IN NORTHERN IRELAND

LAURIE SPARHAM

Date 1981
Location Carrickmore, UK
Format 35 mm

Photographs of daily life can take on a poetic quality, often because of their unpredictability. During the Troubles in Northern Ireland, Laurie Sparham (born 1952) arranged to photograph Sally Hurson, the sister-in-law of Martin Hurson, a volunteer in the East Tyrone Brigade of the Provisional Irish Republican Army (IRA), who had died after joining the 1981 Irish hunger strike. Sparham drove to her house, where he found a lively scene. Hurson shouted, "Hello and I'll be with you as soon as I've got the kids sorted." She seemed to be caring for several children who were not all her own. Sparham recalled: "I spent two days with her and all those kids, eating mountains of toast and Marmite and witnessing group haircuts. It was enormous fun and beautifully chaotic."

This photograph exudes a sense of childhood exploration and energy. There seem to be three different stories: a relationship between the two children at the far left; a situation involving the boy, the horse, and Hurson in the center of the frame; and, finally, the intriguing figure apparently stuck in the doorway. Sparham's talent was to make order out of chaos, conveying it as one coherent, fascinating visual narrative. CJ

ATTEMPTED COUP IN THE SPANISH PARLIAMENT

MANUEL PÉREZ BARRIOPEDRO

Date 1981
Location Madrid, Spain
Format 35 mm

Six years after the death of dictator General Franco, photographer Manuel Pérez Barriopedro (born 1947) was covering tedious afternoon proceedings in the Spanish parliament when 200 members of the Guardia Civil (civil guard) burst into the chamber. Lieutenant Colonel Antonio Tejero Molina led the attempted coup, holding members of parliament hostage for twenty-two hours. From the rostrum, gun in hand, Tejero ordered everyone to be silent and await further instructions. They never came.

King Juan Carlos appeared in uniform on national television as the captain general of the armed forces, denounced the coup, and supported the democratic government.

Pérez Barriopedro took just eleven frames before removing his film and hiding it in his shoe. He and the other journalists present were released at around 10 p.m.; by midnight, this photograph was world news.

The next day the coup leaders surrendered to the police. Tejero served fifteen years in prison. The episode powerfully reinforced the monarchy in the eyes of the public and the politicians. The failed coup was the last time Spain's democracy was threatened by Francoists. CJ

CUESTA DEL PLOMO

SUSAN MEISELAS

Date 1981
Location Managua, Nicaragua
Format 35 mm

Susan Meiselas (born 1948) is best known for her award-winning coverage of the revolution in Nicaragua in the 1970s. She found this half-eaten body early one morning as she was driving on the outskirts of the capital, Managua. Cuesta del Plomo ("Lead Hill") was notorious as "the site of many assassinations" carried out by the National Guard of dictator Anastasio Somoza. Somoza's family had been in power since 1936, but he sealed his fate as the last of the line by becoming embroiled in a losing war against the Sandinistas, who represented the impoverished population.

The Sandinistas overthrew Somoza in 1979. Meiselas recalled: "One day I was driving on the outskirts of Managua when I smelled something.... I don't know how long it had been there, but long enough for the vultures to have eaten half of it. I shot two frames, I think, one in color and one in black and white, then got out."

At the time, many Nicaraguans were still searching for missing relatives and friends who had been captured by Somoza's army. Some of them may have been killed here, and the last thing they saw might well have been this view—the lush postcard setting of their own murder. **SY**

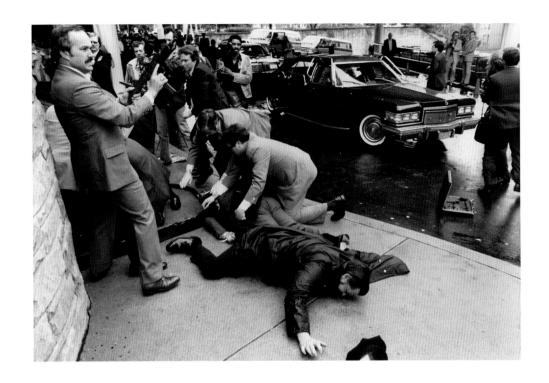

REAGAN ASSASSINATION ATTEMPT

MIKE EVANS

Date 1981
Location Washington DC, USA
Format 35 mm

Here, chaos ensues outside the Washington Hilton Hotel minutes after the attempted assassination of President Reagan on March 30, 1981. Mentally ill John Hinckley Jr. made the attempt on the president's life, shooting him in the chest and below his left arm. Hinckley also injured three others at the scene; White House press secretary James Brady was left permanently disabled. Hinckley was obsessed with the movie *Taxi Driver*, in particular its star Jodie Foster, whom he had been stalking. In the movie,

character Travis Bickle tries to assassinate a US senator who is running for president, and Hinckley believed that by emulating the shooting he would gain Foster's attention.

Several photographs of the event exist, but this color frame by official White House photographer Mike Evans (1944–2005) stands out for its striking composition. To the left, secret service agent Robert Wanko is seen brandishing an Uzi, looking like a cop from a TV series, and in the foreground police officer Thomas Delahanty lies wounded. Brady lies behind him. The secret agents and cameramen lend something surreal to the scene, and if it hadn't really happened it could easily be mistaken for a still from a movie. GP

IBM INTEGRATED CIRCUITS

ERICH HARTMANN

Date 1982
Location USA
Format 35 mm

Erich Hartmann (1922–99) fled Nazi Germany in 1938 for the US and later served in the US military in occupied Europe. From the early 1950s, his photography garnered attention for his poetic approach to industry. His main interest in his work was the way people related to their environs through the tools they use and the work they do.

Speaking in 1994 about his experiences photographing concentration camps in Europe, Hartmann said that the only lesson he learned from it is that "if we decide that we must link our lives inextricably—that 'me' and 'them' must be replaced by 'us'—we may manage to make a life in which gas chambers will not be used again anywhere." This statement may explain his fascination with computer technology and its utopic promise. Innovations like integrated circuits were often talked about in the late twentieth century as if the connectivity they brought would ensure against the global divisions that cause armed conflict. In this image, the microchips resemble skyscrapers, suggesting that the sum of human knowledge from the quintessentially human place—the city—can be held and retrieved in rows of silicon, affordable for all. MT

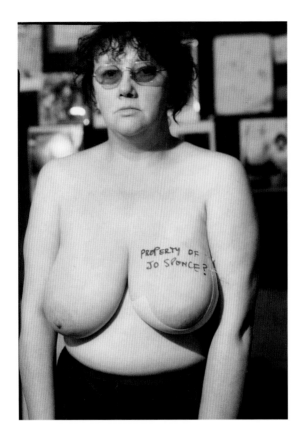

PROPERTY OF JO SPENCE?, 1982

JO SPENCE AND TERRY DENNETT

Date 1982
Location London, UK
Format 35 mm

When she was diagnosed with breast cancer in 1982, Jo Spence (1934–92) was already a highly innovative and committed activist who used photography to critique British society and visual culture. Her illness led her to develop "photo therapy": a way of using the camera to reflect on social and political issues. This photograph, taken before the removal of a tumor from her breast, is from *The Picture of Health?* (1982–86), a collaboration with Terry Dennett that used her experience of

illness as a way of highlighting inadequacies of the public health system. She later wrote: "Through photo therapy, I was able to explore how I felt about my powerlessness as a patient, my relationship to doctors and nurses, my infantilization while being managed and 'processed' within a state institution, and my memories of my parents."

With Terry Dennett, Spence had founded the Photography Workshop, an exhibiting and educational platform, in 1974, and later the Hackney Flashers, an East London collective of photographers. She survived her breast cancer, but died of leukemia a decade later. Her last work, *The Final Project*, an innovative exploration of the iconography of death, was left unfinished. JG

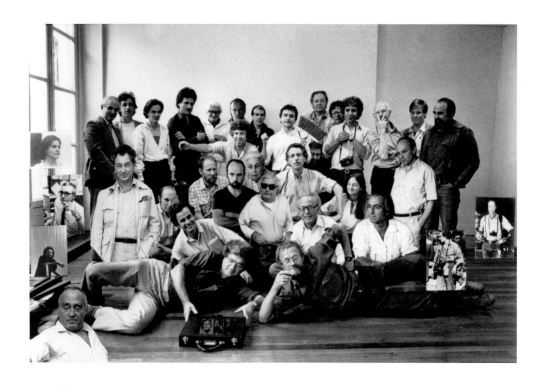

MAGNUM GROUP PORTRAIT

RENÉ BURRI

Date 1982
Location Paris, France
Format 35 mm montage

Magnum is regarded as the world's most famous photography agency. While it is known for the iconic images produced by its membership, part of its mystique lies in the fact that it is a cooperative, owned and run by its members since 1947, and notoriously hard to join. The manifest sign of this system of ownership is the Annual General Meeting that takes place every year in one of the major offices—New York, Paris, or London—where the members come together collectively to discuss the

management of the organization and to agree on which candidates might be invited to join. These meetings have become legendary for some of the fiery arguments that have taken place.

For more than thirty years it fell to the universally liked René Burri (1933–2014) to take the commemorative group portrait. This one was taken the year after several high-profile resignations but also shows new nominees Abbas and Harry Gruyaert, who joined in 1981 and became Magnum stalwarts. All are equal in this picture, with founders George Rodger and Henri Cartier-Bresson modestly taking their places at the back. With typical humor, Burri added cutouts of those members who were away on assignment and could not attend. **NG**

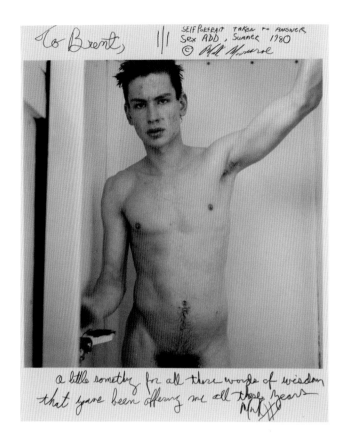

SELF-PORTRAIT (TO BRENT), 1982

MARK MORRISROE

Date 1982
Location Boston, Massachusetts, USA
Format C-print retouched with ink and marker

Mark Morrisroe (1959–89) created over 2,000 works during his career, which came to a premature end with his death from an AIDS-related illness. In life and art, Morrisroe self-mythologized, presenting many selves through his self-documentation and the worlds in which he moved: Boston, its drag and post-punk scenes, and the places of intimacy (beds, showers) where he recorded his transformation from boy (child prostitute), to youth (here, in a visual love letter "to Brent"), to a man ravaged by illness.

Morrisroe had a passion for masquerade and for embellishing the truth, representing himself over and over and making us question what is seen and what is reliable. Critic Fiona Johnstone writes that this image resembles "amateur pornography with the harsh lighting, seedy surroundings, and visible acne on Morrisroe's forehead contributing to an impression of unmediated reality." Here his body faces us so that we can see almost everything, his navel hair leading down to his message, "a little something" given in gratitude, yet the writing at the top contextualizes this as a response to a sex advertisement. All we can access is what we see: a burning gaze, a body in the pink of youth, and a man showing and not showing himself. **RF**

ISRAELI SOLDIERS STORM THE ROOF OF A HOUSE IN YAMIT

JUDAH PASSOW

Date 1982

Location Sinai Peninsula, Israel

Format 35 mm

Israeli-born, London-based photojournalist Judah Passow has worked on assignments for US and European magazines since 1978. His book *Shattered Dreams* (2008) reflects on twenty-five years of his coverage of the Israeli–Palestinian conflict. The photographs reveal rarely recorded moments of one of the world's most enduring conflicts, and in a climate of relentless fighting, his images— shot primarily in black and white—have a timeless resonance to them.

In this image, Israeli soldiers storm the roof of a house in Yamit, an Israeli settlement in Sinai. An accompanying caption in the book describes how, when the settlers refused to move, the army stepped in and sprayed them with immobilizing foam, taking them off the roof one at a time. In the tight frame, the viewer's eye is made to rove across the faceless soldiers thrashing around above the wall, before following the line of men clambering down. Passow captures the drama and dynamic intensity of the moment with a fast shutter, which freezes the moving bodies as they wrestle against the foam. It is an unexpected image from the conflict that illustrates Passow's clever eye for documenting the overlooked. **EC**

FROM *LOOKING FOR LOVE*

TOM WOOD

Date 1982–85
Location New Brighton, UK
Format 35 mm

Tom Wood (born 1951), born in Ireland, trained as a painter but has spent most of his life as a photographer working in England and Wales. Starting in the 1980s, he was a regular in Liverpool, Merseyside, where he was nicknamed "photieman" and spent his days aiming his lens at the people and scenes that passed before him, whether he was in a bar, on the bus, or in a market.

Looking for Love (1989) was Wood's first book and comprised images he shot from 1982 to

1985 at the Chelsea Reach, a popular nightclub in New Brighton. During that period, Wood shot thousands of photographs of people drinking, dancing, smoking, kissing, or hunched over in corners. The hedonism of the 1980s is palpable in this work, which he shot in color and with a flash—brash, vulgar imagery that exists as a perfect record of the decade.

The years spent on this project reveal Wood's approach to photography, one that is off the cuff and without a particular agenda. Although Wood was happy to exist under the radar, not seeking out success with his photography, the art world could not help but take notice, resulting in his first major show in 2012 and a retrospective in 2013. LH

GREENHAM COMMON PROTEST

UNKNOWN

Date 1982
Location Berkshire, UK
Format 35 mm

In 1981, a Welsh group, Women for Life on Earth, set off from Cardiff on a 120-mile (193-km) walk to the US military base at Greenham Common in Berkshire, England, to protest against cruise missiles with nuclear warheads being stored there. Thus began the Greenham Common protest. This image shows the women sitting down en masse to block movement to and from the base, a common tactic of civil disobedience used during the camp's nineteen-year existence.

The intentionally nonhierarchical approach to organizing foreshadowed the ethos of other modern protest movements: as well as working to achieve a stated goal (in this case, nuclear disarmament) the protest site itself became a place for a dialog on the nature of democracy itself.

The camp both harnessed and challenged the power of concepts of femininity and motherhood. The women's role as mothers allowed them an advantageous position from which to present their protest in the name of their children and future generations. But the women were vilified in the media, and stereotypes of the irrational feminist and irresponsible mother were used to obscure the wider relevance of their struggle. MT

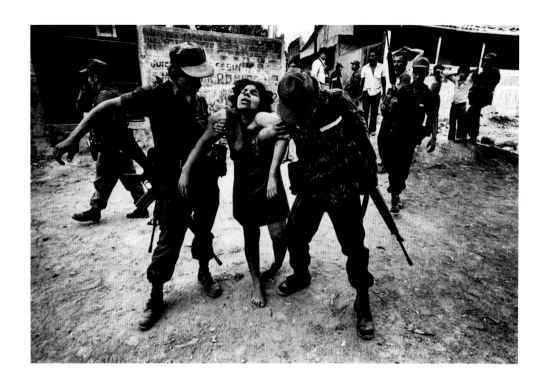

WOMAN TAKEN FROM HER HOME BY DEATH SQUAD

JAMES B. DICKMAN

Date 1982
Location El Salvador
Format 35 mm

The treatment of the woman in this distressing photograph by James B. Dickman (born 1949) epitomizes the fates of those whom the government believed supported guerrilla efforts in El Salvador's bitter civil war (1979–92). After decades of tension between the rich and poor in the Central American country, the civil war ran for twelve years. Supposed supporters of the leftist guerrillas—who were fighting for social and economic reform—were brutally murdered by government-backed military death squads, and in some cases whole villages were destroyed. Thousands lost their lives.

Dickman, a photographer with the *Dallas Times Herald* since 1970, captures a woman being taken from her home. The image appeared in Dickman's feature *El Salvador Diary* (1982); according to author Erika J. Fischer, who included it in her book, *Press Photography Awards, 1942–98*, the woman, caught amid clashes between guerrillas and a death squad, had fainted with fear and was unable to stand, so she was carried away. In 1983, Dickman, who is also a National Geographic photographer, was awarded a Pulitzer Prize in the feature photography category for his black-and-white and color photographs from El Salvador. **GP**

DIEGO MARADONA VS. BELGIUM, WORLD CUP FINAL

STEVE POWELL

Date 1982
Location Barcelona, Spain
Format 35 mm

This was the Argentine Diego Maradona's first appearance in the soccer World Cup finals, and the rising star had been identified as one of the key players to watch in the tournament. Photographer Steve Powell (born 1952) was also making his debut covering the event for *Sports Illustrated* magazine, and initially thought that he had been allocated a terrible position high above the pitch instead of on the touchlines close to the action. However, his elevated position allowed him to use his telephoto lens to isolate the action and compress the distance between the lone Argentine and the wall of Belgian players facing him. Powell analyzed the success of the photograph thus: "It happens to have great colors—the green of the grass and the orangey-red of the Belgium shirt—those are wonderful contrasts that make for a good image, and the composition is strong, too, with the beautiful fan-like effect of the players." Powell also admitted that, while preparation and knowledge of the sport are vital, chance always plays a significant part.

Ironically, this was not Argentina's finest hour—they lost the match 0–1—but, abstracted from the actual action on the day, the photograph captures the mystique of the star player. PL

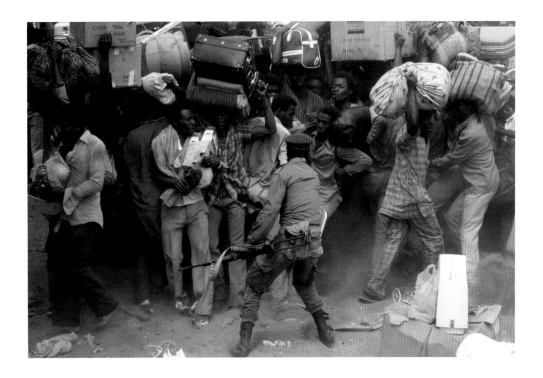

EXPELLED GHANAIAN IMMIGRANTS, NIGERIA

MICHEL SETBOUN

Date 1983
Location Nigeria
Format 35 mm

This photograph is a chaotic mass of activity, bodies, and movement packed together tightly. It was taken by Algerian-born Michel Setboun (born 1952) for news agency Sipa. The action is so intense that no person within the frame seems to notice the presence of the photographer taking the image at close and frontal range; they carry heavy packs overhead and a soldier in the foreground is seen from behind, apparently trying to control the situation. Sand from the ground is being whipped up into a storm at the feet of the men, further demonstrating the dynamic and dramatic atmosphere of the moment depicted.

The caption explains that this photograph shows the expulsion of Ghanaians from Nigeria for the sake of the Nigerian unemployed. With this knowledge, the image acquires an additional sense of urgency; the subjects have been forced from their homes and carry what is likely all of their possessions. The soldier looks frantic, wielding a gun and a length of rope, and the Ghanaians wear a shared expression of grim resolve. Viewers watch the scene from such a close range that they become enmeshed within it and the almost overwhelming, frenzied mood. AZ

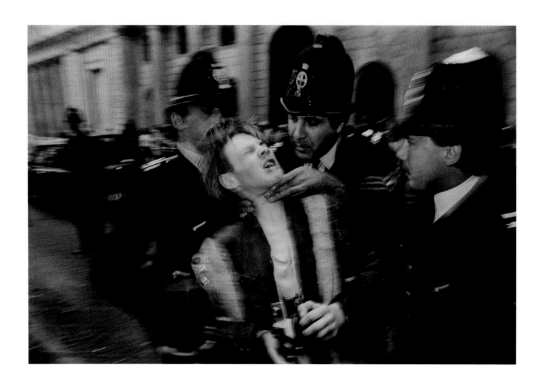

STOP THE CITY DEMONSTRATION

DAVID HOFFMAN

Date 1983
Location London, UK
Format 35 mm

David Hoffman (born 1946) has made a career covering social protest movements. This image was taken during the first "Stop the City" demonstration in London, a protest against globalization and big business. The police were totally unprepared. Hoffman was waiting near the Bank of England when he saw his colleague Kieran Moylett photographing a police sergeant throttling a protester. This policeman, Sergeant Bert Weedon, went for Kieran, dragging him off in the direction of Hoffman, who recalled: "As they reach me, I fire off three quick frames so Weedon and his mates dump the half conscious Kieran in the gutter and come for me. I run, jump into a passing cab, and the film is safely off to the newspaper picture desk." The police hauled Kieran off to the police station, confiscated his camera, exposed the film, and then rewound it, trying to destroy the evidence. Kieran was charged with obstruction, but at the trial he was able to prove from the pattern of scratches on the film what had happened while he was in custody. In court, Weedon denied ever touching Kieran but Hoffman's photo proved otherwise and Kieran was acquitted. Hoffman mused, "I hope that my photograph had a small part to play in that." CJ

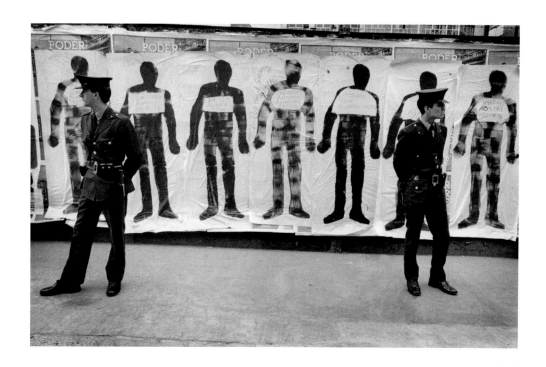

SILHOUETTES AND COPS

EDUARDO GIL

Date 1983
Location Buenos Aires, Argentina
Format 35 mm

In the 1970s and 1980s, Latin America was plagued by a series of brutal dictatorships that terrorized local populations and cultivated a "culture of fear." Thousands of citizens were "disappeared" or kidnapped. From 1976 to 1983, Argentina lived under a military dictatorship run by four generals during which up to 30,000 people disappeared. An important artistic action occurred in 1982 and 1983, when three artists collaborated with the mothers of the disappeared and decided to give visual form to the missing. For the public art project *El Siluetazo* ("The silhouette action"), families of the disappeared were asked to draw the silhouettes of their missing brothers and sisters, sons and daughters. These were hung in public places throughout capital cities, including Buenos Aires.

This photograph by Argentine Eduardo Gil (born 1948) documents this critical moment in his country's modern history. It shows two police officers actually guarding the silhouettes of those citizens who were killed by the security organizations of the state. The word *poder* ("power") appears clearly written above each of the drawings of the bodies. The image speaks to the end of a dark chapter in his country's history. **SY**

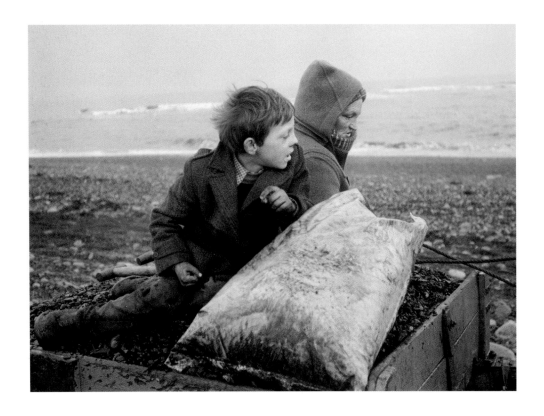

ROCKER AND ROSIE GOING HOME, SEACOAL BEACH

CHRIS KILLIP

Date 1984

Location Lynemouth, Northumberland, UK

Format Large format

Chris Killip (born 1946) grew up on the Isle of Man and became a beach photographer at the age of eighteen to earn money to leave home. After being inspired by an exhibition of photography at the Museum of Modern Art in New York, Killip decided to return to his village in 1969; there, he began a career-long documentation of the small, working-class villages of the UK.

In 1988, Killip published *In Flagrante,* a collection of fifty black-and-white images depicting life in England's industrial northeast during the 1980s. His images empathetically portray people struggling to survive in dire situations. This shot of children with the seacoal they have gathered to sell appeared on the book's cover. In 2016, twenty-eight years later, a redesigned version, *In Flagrante Two,* was printed; two more images were added to the original sequence and, perhaps more important, the redesign prevented images from being lost in the gutter (the book's center). Killip said: "It had become very important to me to let the images speak without interference, as I believe that they have their own eloquence and in some cases a degree of ambiguity—a mixture that leaves the work open to interpretation by the viewer." **LH**

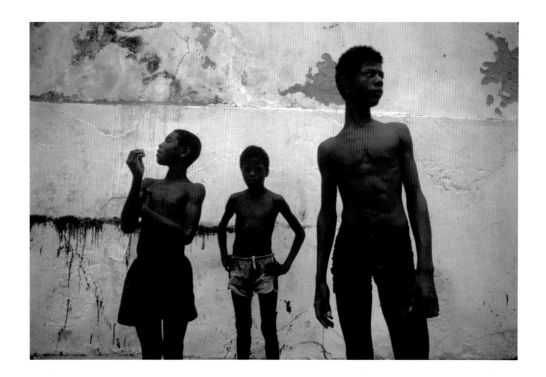

SALVADOR DE BAHIA

MIGUEL RIO BRANCO

Date 1984
Location Salvador, Brazil
Format 35 mm

Miguel Rio Branco (born 1946) has been a painter, photographer, and moviemaker. It was while he was still studying painting that he took up photography for the first time, which is perhaps why the most distinctive aspect of his photographic work is his striking use of color. Though he was born in Spain, his fascination with visual contrasts, tropical color, and light led him to work primarily in Brazil.

This image was featured in his book *Dulce Sudor Amargo* (*Bittersweet Sweat*, 1985), an exploration of the Brazilian coastal city of Salvador. The book is suffused with glowing primary colors and golden light, contrasted with the depiction of poverty, endemic prostitution, and urban decay.

The three boys cinematically pictured here are in the street taking a break from performing *capoeira*—a hybrid of martial arts and dance indigenous to Brazil. Other images in the series depict these same boys in elaborate acrobatic poses, but here they are still: reflective yet seemingly charged with energy. The photographer's encounter with these *capoeira* performers also led to an artwork called *Blue Tango* (1984), a series of nine images in sequence; other versions featured twenty images. JG

DAWN, HARD LINE, FROM THE SERIES *BAY/SKY*

JOEL MEYEROWITZ

Date 1984
Location Provincetown, Massachusetts, USA
Format Large format

In the 1970s, street photographer Joel Meyerowitz (born 1938) began to use a 10x8 large-format view camera. Since 1976, he has shot a series of views from the porch of his seafront house overlooking Cape Cod Bay. These images are an extraordinary engagement with the quality of light and color, exploring the point where the sea and sky meet and how the scene changes through different times of day. They are an ongoing meditation on the nature of representation. Meyerowitz has explained how he feels that color "describes more things. When I say description, I don't mean mere fact and the cold accounting of things in the frame. I really mean the sensation I get from things—their surface and color—my memory of them in other conditions as well as their connotative qualities. Color plays itself out along a richer band of feelings—more wavelengths, more radiance, more sensation." Five of these images appeared in his book *Cape Light* (1979); this one is from the later series *Bay/Sky* (1993), which features forty of these startling photographs of sea, juncture, and sky. Meyerowitz has since documented the devastation and rebuilding at New York's World Trade Center in his monumental book *Aftermath* (2006). PL

ROUNDABOUT, ANDERSONSTOWN, BELFAST

PAUL GRAHAM

Date 1984
Location Belfast, Northern Ireland, UK
Format Medium format

In the mid-1980s, Paul Graham (born 1956) traveled around Northern Ireland photographing traces of violence that are visible only to the keenest of eyes, or to those familiar with the region's sectarian struggle: curbstones painted in the colors of the Union Jack or the Irish Tricolor flags (depending on the area's allegiance) and British Army helicopters hovering in the distance. The work, collected as *Troubled Land* (1984–86), shows a geography of territory and control. Graham used medium format,

in color, and the style has led to his work being linked with the genre of "aftermath photography."

This image seems to show a banal suburban scene, but to the initiated it reveals subtle signs of unrest. Nationalist graffiti is scrawled on the railing in the foreground; the streetlights are all smashed; political posters adorn the lampposts but have been pasted high up where they cannot be tampered with. The edge of the roundabout itself has been torn apart, and, most tellingly, the tiny figures of three armed soldiers in camouflage gear make their way up the street. Rather than focusing in on these details, Graham stands back, thus making a statement about the normality of violence and the violence of normal life. **JG**

MY MOTHER POSING FOR ME

LARRY SULTAN

Date 1984 Location San Fernando
Valley, California, USA
Format Large format

In 1982, on a trip home to the San Fernando Valley,
Larry Sultan (1946–2009) came upon boxes of
family home movies and photo albums. He then
spent the next decade documenting his parents
and exploring the family as a complex social
institution in the series *Pictures From Home*. For
Sultan, "photography is about a worldview, not
truth outside of belief," and he was interested in the
hopes and dreams his parents had tried to project
through these old documents. Along with using stills
from the movies and photos, Sultan took his own
images, a self-described mix of documentary and
staged genres, of which this photograph is typical.

Sultan was concerned for any feelings of
pride and betrayal his parents might have in the
representation of their private life. To deal with this,
he asked his parents to comment on the work, and
he often recorded their responses. He quotes his
mother saying: "I don't care how you photograph
me as long as you're successful." This shot captures
much of her desire to please, as she poses slightly
awkwardly against a wall while Sultan's father
watches television, after becoming bored waiting
for his son to capture them as a couple. CP

BRIGHTON BOMB SURVIVORS

MARTIN MAYER

Date 1984
Location Brighton, UK
Format 35 mm

Five people were killed and thirty-four injured on
October 12, 1984, when the IRA (Irish Republican
Army) bombed the Grand Hotel in Brighton,
where the British governing Conservative party
was holding its annual conference. The target was
Prime Minister Margaret Thatcher; the bomb was
planted in the room next to hers and she was still
awake at 2.54 a.m., working on her speech, when
the bomb went off. She narrowly escaped injury.

This image by Martin Mayer (born 1945) shows
shocked survivors huddled together waiting for
assistance moments after the blast. Taken inside
the building, it shows thick dust everywhere,
creating a strange light. "It reminded me of
Sleeping Beauty," said the hotel's switchboard
operator, Pauline Banks. "One of the first calls I
took was from someone abroad asking if they
could have the toilet seat Margaret Thatcher had
sat on." The bomber, Patrick Magee, was caught
forensically by fingerprints left at the hotel. He
was sentenced to eight life sentences in 1986,
but released under the terms of the Good Friday
Agreement that brought peace to Northern Ireland
fourteen years later. CJ

POLICE CHARGE STRIKING MINERS AT ORGREAVE

JOHN STURROCK

Date 1984
Location Orgreave, UK
Format 35 mm

The British coal miners' strike that ran between 1984 and 1985 was the UK's most violent industrial confrontation of the twentieth century. John Sturrock (born 1950) took many memorable images during this period. This shot shows police charging striking miners who were trying to block the supply of coking coal from the Orgreave plant to a major steel works, an action designed to limit the production of steel and put serious economic pressure on the government. Sturrock recalled that on that occasion it was a hot and dusty day with a lot of waiting about; the atmosphere seemed relatively good-humored, with both the miners and the police treating it as something of a game, although the police were always in control on account of their superior organization.

Things were very different three weeks later, on June 18, when the infamous "Battle of Orgreave" took place. The police donned riot gear and used horses and dogs to intimidate the largely peaceful crowd of striking miners. Much of the subsequent violence was regarded as gratuitous and designed to break the will of the miners. The bitter year-long strike finally ended in March 1985. CJ

OLYMPIC DIVER GREG LOUGANIS

TONY DUFFY

Date 1984
Location Los Angeles, California, USA
Format 35 mm

Timing is everything in photography, as evidenced by this photograph of American Olympic diver Greg Louganis. At just the right moment, sports photographer Tony Duffy (born 1937) fires the shutter and captures Louganis mid-air as he takes part in the springboard diving preliminary rounds of the 1984 Summer Olympics in Los Angeles.

Duffy went on to found the sports photography agency Allsport, which Getty acquired in 1998. Duffy and others at Allsport took many impressive shots throughout the 1970s and '80s, but this one endures because of the sheer effortlessness, elegance, and poise on display. GP

NAN ONE MONTH AFTER BEING BATTERED

NAN GOLDIN

Date 1984
Location New York, New York, USA
Format 35 mm

Through the 1970s and 1980s, Nan Goldin (born 1953) created an autobiographical photographic record of the lives of her New York friends and lovers. Titled *The Ballad of Sexual Dependency*, and shot on slide transparencies because she could not afford to make prints, the work is unique in its intimacy and grit. Although made as a kind of personal diary, it has gone on to be hugely influential. Goldin regularly included herself in the frame, and this self-portrait records the aftermath

of a relationship that turned sour. The artist stares directly into the camera. She has carefully styled her hair; she wears jewelry and lipstick that matches the shade of her bruises and bloodshot eye. She has used a flash, casting a light that is almost violent in itself. Goldin is defiant in her attitude and in her presentation of herself, and makes no effort to conceal her bruises. This asserts her strength and her desire to testify to what has happened to her. Like all photographic self-portraits, it is a complex image, especially in view of the power dynamics involved. Goldin is surrendering power by subjecting herself in such a vulnerable state to the camera's gaze, but she simultaneously takes full control of the terms on which she is seen. JG

BALLS ON BEACH

ALFRED GESCHEIDT

Date 1984
Location Unknown
Format Unknown

A master of surrealism and photo wizardry with the camera, Alfred Gescheidt (1926–2012) built a successful career in advertising from the 1960s to the 1980s. He studied at the Art Center School in Los Angeles, where Will Connell and George Hoyningen-Huene encouraged him to try experimental approaches to image making.

Gescheidt began creating photo collages, but after graduating he focused on photojournalism. It was, however, upon opening his own studio

in 1955 and turning his hand to creating more conceptual photographs that his career really gathered momentum. Known in particular for his experimental photomontage works that combined many elements in strange ways, Gescheidt—once described by a photo editor as "the Charlie Chaplin of the camera"—became a dab hand at manipulating photographs many decades before the use of photo software became the norm. This image of colored balls on what looks to be a beach is a good example of Gescheidt's ability to create optical illusions through photography. His work—brash, unrealistic, satirical, and sometimes downright baffling—was widely published in many different formats. GP

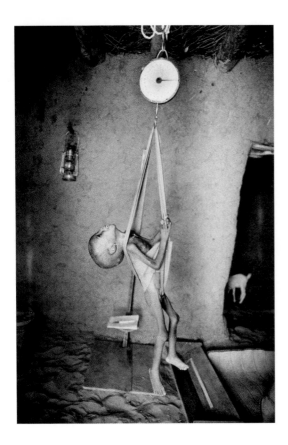

A CHILD BEING WEIGHED

SEBASTIÃO SALGADO

Date 1985

Location Sahel Region, Africa

Format 35 mm

"The Planet remains divided—the First World in a crisis of excess, the Third World in a crisis of need." So says Sebastião Salgado (born 1944), who trained as an economist in his native Brazil but turned to photography—he found on a trip to Africa that he could connect much more closely with the people and represent them in a truer form through images than he could do through theoretical papers. He produces "images of a world in distress," and some have become symbols of global suffering.

This disturbing photograph of a child being weighed was taken when Salgado undertook an eighteen-month project alongside the French Doctors without Borders organization in the Sahel, a vast, deserted region that extends into Chad, Ethiopia, Mali, and Sudan. Salgado was a first-hand witness to the drought there that caused a massive exodus of frightened, starving refugees. The crisis is said to have claimed more than one million lives due to malnutrition and affected fifty million others. Although Salgado has critics who are at odds with his so-called aestheticization or beautification of the horrors of the world, he maintains that his work "testifies to the fundamental dignity of all humanity." **SY**

EARTHQUAKE AFTERMATH

JOHN BARR

Date 1985
Location Mexico City, Mexico
Format 35 mm

This startling photograph, one that almost guarantees a double take, was taken in the aftermath of the deadly earthquake in Mexico in 1985. More than 10,000 people were killed by the quake, which originated 185 miles (300 km) from Mexico City on September 19. With a magnitude of 8.1, the earthquake also injured 30,000 people and destroyed 6,000 homes, and made tens of thousands of people homeless. A mighty aftershock, which struck just a day after the initial tremor, added to the trauma and devastation. But in one especially heartening incident, fifty-eight babies were reported to have been rescued from the wreckage of a shattered hospital a full three days after the quake took place.

Many photographs were taken to document the carnage, but none quite like this. Photographer John Barr chanced upon this highly unexpected view of the disaster zone in Mexico City. The unusual image depicts a toppled mannequin in the window of a clothing emporium; only its legs and part of its dress are visible. Debris lies all around. The mannequin is easily mistaken for an injured woman, but a closer look reveals that, thankfully, it is not a person at all. GP

TOSSER II

BOYD WEBB

Date 1985
Location UK
Format Large format

Man's quest for knowledge and truth, and the tension between nature and science, are among the great themes of art—themes that Boyd Webb (born 1947) pores over in his surreal, theatrical works. *Tosser II*, with its multiple globes suspended in mid-air pictured against a starry night sky, and a man who appears to have control over the globes' orbit, in a way embodies humankind's fascination with science. There is something Isaac Newton-like (as William Blake painted him) about the figure—

naked, arm outstretched, and clearly deep in thought. With its dreamlike feel, the work itself is suspended between reality and fiction.

New Zealand-born artist Webb trained as a sculptor before moving to work in photography. His work initially took the form of installations that featured life-size casts of people made from fiberglass, but in the 1980s the photographic works he made comprised bizarre mises-en-scène featuring elaborate sets and props, which he then photographed. Webb's work, as art historian Andrew Graham-Dixon puts it, falls between many genres—it is "not quite installation art, not quite sculpture, not quite collage or assemblage, not quite photography, but a slippery combination." **GP**

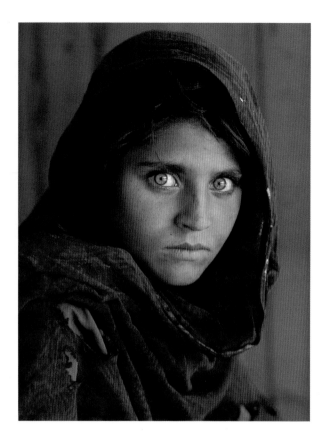

AFGHAN GIRL

STEVE MCCURRY

Date 1985
Location Pakistan
Format 35 mm

This photograph first appeared on the cover of *National Geographic* magazine in June 1985. When Steve McCurry (born 1950) entered the refugee camp in which Sharbut Gula lived, he had no idea that his picture would become one of the most recognized photographic portraits of all time.

Although Sharbut's parents had been lost to Afghanistan's war with the Soviet Union, the ease with which simple narratives of victimhood have been ascribed to her in the media has been questioned. For some, her face—exotic yet also commensurate with European ideals of beauty— allowed a Western public to project their own particular worldview onto a place they knew little about, thus rendering it universal. The way in which the image was viewed allowed Afghanistan itself, with all its complexities, to be rendered knowable, innocent, and childlike.

This picture serves as a caution to the idea that being moved by an image or feeling enlightened by it is the same as truly understanding an issue or connecting with another person. The image did little to help Sharbut's situation. Her name finally became known around the world in 2002, when McCurry tracked her down. MT

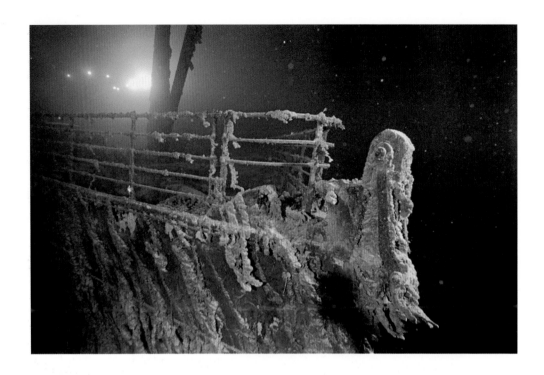

WRECK OF THE *TITANIC*

EMORY KRISTOF

Date 1985
Location North Atlantic Ocean
Format 35 mm

Emory Kristof (born 1942) is renowned for his innovations in underwater photography. He has developed and used robot-operated camera systems at great depths, as in this picture for *National Geographic* of the wreckage of the *Titanic* passenger ship, which infamously sunk in 1912 and was discovered in 1985. The photograph depicts the bow of the ship (the stern was completely destroyed when it hit the ocean floor), a powerful blue light illuminating it from deep in the image's background, and bathed also in a golden light that comes from out of shot. The effect is still and ghostly in that way particular to underwater photography; the ship looms out of a deep darkness that frames the image, giving a sense of the all-encompassing quiet of the ocean bed.

Sea mosses and lichens grow on the railings and structure of the ship, drifting in invisible currents; the wreckage almost appears to be covered in gold leaf. The viewer is struck by the complicated beauty of the evidence of a tragedy. Kristof's photographic coverage of the *Titanic* earned him many awards including the American Society of Magazine Publishers' Innovation in Photography Award in 1986. **AZ**

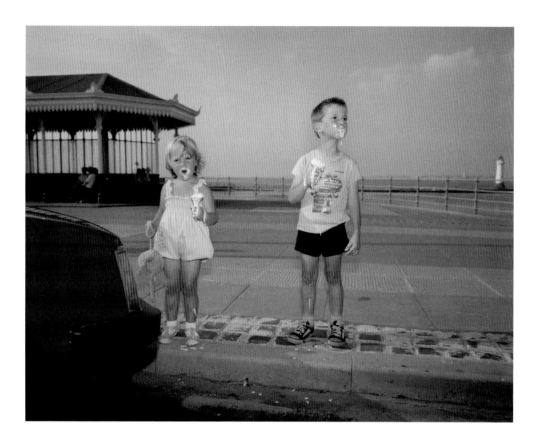

FROM *THE LAST RESORT*

MARTIN PARR

Date 1985
Location New Brighton, Merseyside, UK
Format Medium format

After studying photography at Manchester Polytechnic, England, Martin Parr (born 1952) began taking black-and-white images, but later, influenced by the work of William Eggleston and Garry Winogrand, he turned to color. Parr became known for his documentary photography, gaudy colors, and exaggerated close-ups. His pictures address mass tourism, consumerism, and globalization.

This image is from a series documenting life at the coastal resort of New Brighton, which attracts blue-collar day-trippers from nearby Liverpool. Although past its heyday, the resort still attracted local residents, who would take the ferry across the Mersey River. Parr portrays the town as awash with a sea of humanity as children, the elderly, couples, and families cram into every available space. Parr's brash, saturated colors, achieved by using daylight flash, capture the vulgar, picture-postcard crudeness unique to Britons at the seaside.

Parr exhibited the series at the Serpentine Gallery, London, and in 1986 published it as a book, *Last Resort: Photographs of New Brighton*. The series is seen as a critique of contemporary life in Britain at a time of economic depression, and helped to establish Parr's reputation. **CK**

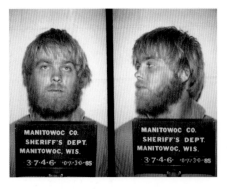

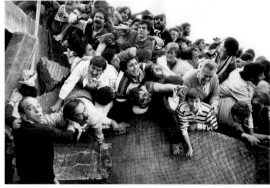

STEVEN AVERY MUGSHOT

UNKNOWN

Date 1985
Location Wisconsin, USA
Format Unknown

This nondescript mugshot of American Steven Avery, taken at Manitowoc Sheriff's Department in Wisconsin, became famous when it was used in the popular Netflix documentary TV series *Making a Murderer*, which aired on December 18, 2015. The ten-part long-form series, produced over the course of a decade, relates how Avery was convicted of sexual assault and attempted murder in 1985. After eighteen years in prison, new DNA evidence emerged; he was released and his name cleared in 2003. Two years later, he was charged with the murder of Teresa Halbach, a local photographer, and in 2007 convicted and sentenced to life in prison.

Avery and his lawyers continue to protest his innocence, maintaining that the authorities framed him, perhaps as a reaction to the multimillion-dollar lawsuit Avery filed after he was wrongly convicted the first time around.

Reactions to the series were mixed, with some critics calling it comprehensive and immersive, while others accused moviemakers Laura Ricciardi and Moira Demos of omitting important evidence, thus skewing the telling of events. Despite dividing critics, *Making a Murderer* won a large international audience and a second series is under way. GP

HEYSEL STADIUM DISASTER

EAMONN MCCABE

Date 1985
Location Brussels, Belgium
Format 35 mm

This stark image was taken at the Heysel Stadium in Brussels before the start of the European Cup soccer final between English club Liverpool and Italian club Juventus on May 29, 1985. Liverpool supporters charged the Juventus fans, forcing them against a concrete wall that then collapsed. Thirty-nine people, most of them Italian, were killed and 600 were injured. This disaster followed a sustained period of hooliganism among English soccer supporters and, as a result, English clubs were banned from European competitions for several years, while fourteen Liverpool supporters were imprisoned for manslaughter. The stadium's poor state of repair may also have played a part.

Sports photographer Eamonn McCabe (born 1948) got himself into the right place to convey the panic: "I got two quick shots with my little [compact] camera before getting out of the way, while these fans escaped on to the pitch." The drama is accentuated by the body language of the men in the foreground. Photographers are often criticized for taking shots during such terrible events but McCabe maintains "the responsibility is on us to try to tell the truth with our pictures." CJ

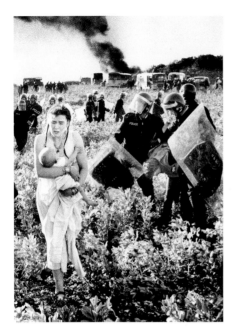

CHEDDAR NO 5

PETER FRASER

Date 1985/86
Location Somerset, UK
Format Medium format

BATTLE OF THE BEANFIELD

DAVID ROSE

Date 1985
Location Wiltshire, UK
Format 35 mm

For ten years, New Age travelers had organized a free festival during the summer solstice at Stonehenge in the UK, but in 1985 it was banned. On June 1, a convoy of around 150 vehicles headed there entered a beanfield to escape a police blockade. More than 1,000 police moved in and a violent confrontation ensued, ending with the arrest of some 500 people, including at least one journalist.

Photojournalist David Rose (born 1959) took this shot a year before he joined the *Independent* newspaper as a staff photographer. The image shown here is actually cropped to the left; missing is a "kindly" policeman in a peaked cap who escorted Rose Brash, the woman with the baby. Brash has since claimed that his only intention was to have her arrested, along with the others. **GS**

British photographer Peter Fraser (born 1953) began working with a Plaubel Makina medium-format camera in 1982. After an exhibition with the colorist photographer William Eggleston in 1984, Fraser went to the United States to spend time working with Eggleston, and decided to work only in color.

This image comes from Fraser's series *Everyday Icons*. It appeared on the cover of his book *Blue Buckets* (1988), which features still lifes of *objets trouvés* (found objects) in vivid color, and won the Bill Brandt Award in 1989. Fraser elevates the humble items by focusing on their materiality and color, helping viewers to become aware of the incidental beauty in their everyday surroundings. The two blue plastic buckets suggest domesticity, waste, work, and cleaning, yet, as Fraser shoots them side by side on the floor, they take on a deeper significance. They appear as two jewel-like receptacles floating in a black void, like planets joined in space. Fraser's eye for shape and color is poetic, and places his photographs in an artistic rather than a documentary tradition. **CK**

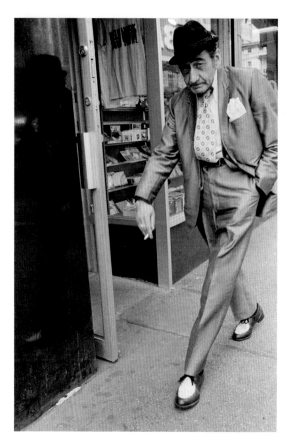

NEW YORK CITY

BRUCE GILDEN

Date 1986
Location New York, New York, USA
Format 35 mm

Brooklyn-born photographer Bruce Gilden (born 1946) is known for his candid portraits of people on the streets of his native New York City, which have resulted in books including *Facing New York* (1992) and *Coney Island* (2001). His later book of close-ups of the marginalized, *Face* (2015), contains images that verge on the grotesque. However, he has been taking photographs with a Leica rangefinder and a flashgun on the city's sidewalks since the early 1980s. His approach to street photography involves thrusting his camera and flash at subjects, and documenting their expressions, which are often of startled surprise, although in this head-to-toe portrait the man looks at Gilden with urbane disdain. When asked about his aggressive approach he has said: "I have no ethics."

Gilden has an eye for the unusual yet manages to also show the everyman in his tightly cropped, figurative pictures, including this one of an elderly man in a suit with a cigarette in hand, slightly hunched as he strolls purposefully along the street. In this instance, the man is evidently concerned with his appearance, wearing a flamboyant necktie, hat, handkerchief in his suit pocket, and smart two-tone shoes. Yet the man's efforts are too quirky to project the sartorial elegance he might wish for: the floral kipper necktie is a little too wide to be fashionable and is tucked in the waistband of his pants. His hat would look more at home in the 1960s than on the sidewalks of New York in 1986. His taste in fashion reveals his age and the fact that he has become a little out of touch with contemporary life, a man growing old who still wants to look like a young buck. **CK**

"The flash allows me
to visualize the speed,
the stress, the anxiety, and
the energy of the streets."

Bruce Gilden

"THE HAND OF GOD"

DANIEL MOTZ

Date 1986
Location Mexico City, Mexico
Format 35 mm

Argentina and England faced one another at Mexico's Estadio Azteca on June 22, 1986, in the quarter finals of the World Cup in what has become a legendary grudge match. Coming only four years after the Falklands War between the two countries, the soccer game included two of the most famous, or infamous, goals in the competition's history, both scored by Diego Maradona. His second goal in the fifty-fifth minute saw him evade four England players (including fearsome defender Terry Butcher twice) in a virtuoso dribbling display before finally putting the ball in the net behind England goalkeeper Peter Shilton. It was dubbed the "Goal of the Century."

It was Maradona's first goal, in the fifty-first minute, that generated one of the most controversial incidents in the history of the beautiful game. Maradona intercepted a pass by England's Steve Hodge, leaping above Shilton and deflecting the ball into the net with his hand. The fateful moment is seen in this shot by Daniel Motz. Despite protests from the England team, the referee allowed the goal and Argentina won 2–1. After the game, Maradona gave a press conference at which he described how he had scored the goal: "A little with the head of Maradona and a little with the hand of God." He stressed the sense of retribution for the losses in the Falklands conflict, saying that "It felt like we had done justice, well maybe not justice but made good for the mothers who had lost sons in the Falklands." Argentina later defeated West Germany in the final, with Maradona winning the Golden Ball for best player of the tournament despite his subterfuge in this historic match. PL

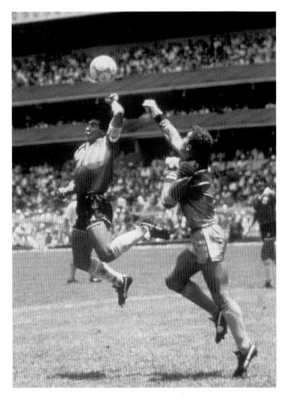

"The best player I've ever played against . . . he had strength, pace, and his passing was excellent. He also had a great leap for such a small man, as he showed with his Hand of God goal!"

England soccer player Terry Butcher

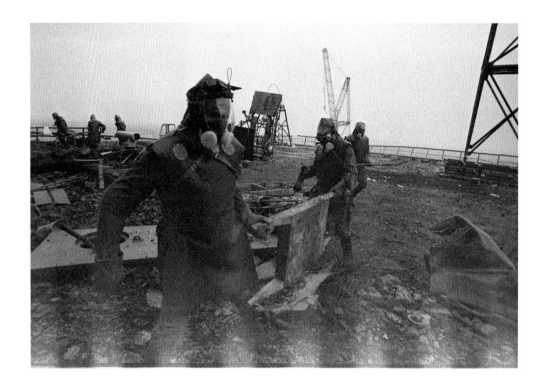

"LIQUIDATORS" ON THE ROOF OF REACTOR NO. 3

IGOR KOSTIN

Date 1986
Location Chernobyl, Ukraine
Format 35 mm

On April 26, 1986, an explosion at the Chernobyl nuclear plant in Ukraine (then part of the Soviet Union) blew one of the reactors apart, releasing 400 times more radioactive debris than the bombing of Hiroshima in 1945. Igor Kostin (1936–2015), a photographer based in Kiev, was awoken in the night by a helicopter pilot friend and the two flew out to the site. Kostin took the first photographs of the unfolding catastrophe, and he returned repeatedly over the following days, months, and years.

The Soviet government initially tried to cover up the disaster, evacuating the local population and deploying "liquidators" to clear the radioactive waste. One of the most dangerous tasks was to remove debris on the roofs of the reactors, where radiation was highest. Kostin went with them, and later said that he felt the images he took of them were the most important he ever made. Ionizing radiation is on the same electromagnetic spectrum as visible light, and high levels of it can expose photographic film. The radiation when Kostin took this picture was so intense that it fogged the camera's film, the light and dark banding along the bottom of the film corresponding to the sprocket holes on the film itself. LB

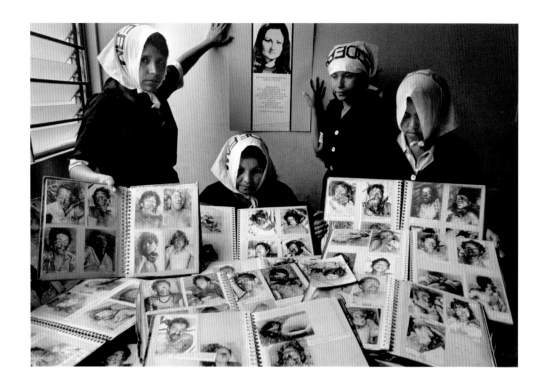

MOTHERS OF THE "DISAPPEARED"

LARRY TOWELL

Date 1986
Location San Salvador, El Salvador
Format 35 mm

A coup in El Salvador in 1979 is blamed for the start of the bloody Salvadoran Civil War between the government and the Farabundo Martí National Liberation Front (FMLN)—an umbrella organization of several left-wing guerrilla groups. For twelve years the small Central American country was enmeshed in extreme violence during which citizens were targeted and terrorized by government-sponsored death squads. The United Nations reported that more than 75,000 people were killed in total and

that around 85 percent of these killings were most likely committed by government forces.

This melancholy image was taken by Canadian photographer Larry Towell (born 1953). It shows mothers of the "disappeared" holding photographs of mutilated bodies that were found in the streets of San Salvador. It was common practice for the non-governmental Human Rights Commission to photograph cadavers so that family members could identify them. However, its offices were often invaded and its employees arrested or "disappeared" themselves. Death squads killed the founder of CODEFAM (a group of relatives of victims of the war), who is pictured on the poster in the background of Towell's moving image. SY

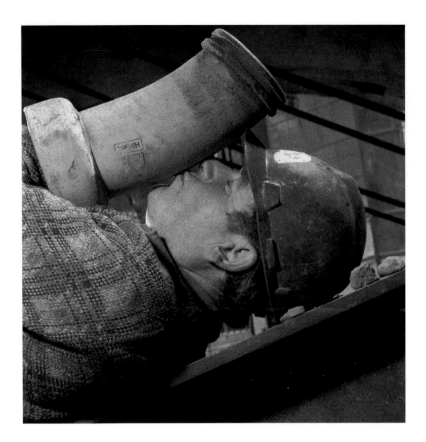

SEWAGE PIPELAYER

BRIAN GRIFFIN

Date 1986
Location London, UK
Format Medium format

Brian Griffin (born 1948) studied photography at Manchester Polytechnic in northern England along with Martin Parr. His first commission was in 1972 for the magazine *Management Today*, when he made his mark by shooting his subjects in almost surreal poses rather than the customary formal images of men in suits. Griffin's eye for the unusual meant that he was soon in demand from corporate clients to record industrial achievements. In 1985, he was commissioned to portray workers constructing

Broadgate in the City of London, what was then the largest office development in the capital. The new site prepared for "Big Bang," when dealing on computer screens replaced face-to-face trading.

This image is from the series *Workers* that Griffin created at Broadgate. It shows a pipelayer lying back and playfully kissing a sewage pipe as if it were his lover. Other portraits in the series feature a cladding engineer, a laborer, a plumber, a plasterer, an elevator engineer, and a carpenter. Each portrait is of a man in profile in a similar pose, lying down and wearing a hard hat while kissing a tool or piece of equipment, in what is both a wry comment on a predominantly male industry and the faith workmen place in their tools. CK

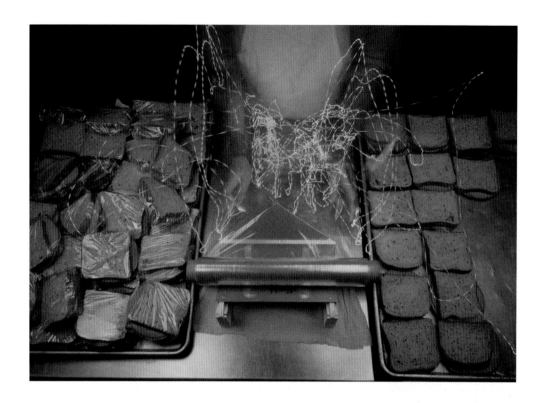

WRAPPING SANDWICHES

MIKE MANDEL

Date 1986
Location Unknown
Format Medium format

During his career Mike Mandel (born 1950) has produced a series of influential and often very funny works that pose questions about popular perceptions of photography. In 1977, in collaboration with fellow American photographer Larry Sultan, Mandel produced the seminal work *Evidence*, which repurposed governmental, scientific, and research imagery from various archives. Using this imagery to construct a visual narrative, Sultan and Mandel created a body of work designed to playfully

highlight the gradual public loss of faith in the authority of such images.

Later, in the early 1980s, Mandel worked on a series of light-painting images inspired by the time-and-motion studies of Frank and Lillian Gilbreth. In the early twentieth century, the Gilbreths had experimented with using lights and long exposures to document the movements of factory workers, in the hope that these studies would increase efficiency by eliminating unnecessary or wasteful movements. Mandel employed the same idea, but applied it, satirically, to daily life tasks that, in his words, "didn't need to be analyzed for efficiency's sake," such as diaper changing and sandwich making, as seen in this photograph. LB

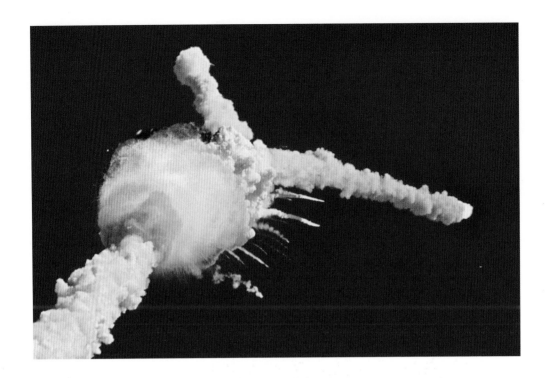

THE *CHALLENGER* EXPLODES

BRUCE WEAVER

Date 1986

Location Florida, USA

Format 35 mm

Former Associated Press photographer Bruce Weaver was assigned to cover the launch of the Space Shuttle *Challenger* on January 28, 1986, at the Kennedy Space Center. Seventy-seven seconds after liftoff, the *Challenger* exploded, and Weaver captured the dramatic blast in vivid color. At the time, Weaver did not have access to the rolls of film or the edit as they were owned by Associated Press.

Weaver's image recalls abstract painting, with its rich colors, bold graphic, and lack of usual photographic features such as people or buildings. The viewer's eye is drawn up and away from the bottom left corner of the frame as it follows the rocket's trail toward the explosion's orange blush, small channels of smoke trailing off from below it, and creating two larger pillars of smoke that fork away from one another. An unblemished, deep blue sky emphasizes the shape—with nothing to distract from the image's visual center, the explosion—and the indigo backdrop further enhances the orange of the explosion itself. Although it documents a disaster in which loss of life occurred, the photograph is highly aesthetic and compositionally balanced, creating an arresting and memorable image. AZ

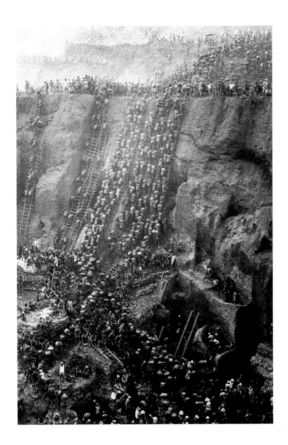

GOLD MINE, SERRA PELADA, BRAZIL

SEBASTIÃO SALGADO

Date 1986
Location Pará, Brazil
Format 35 mm

At first glance it looks like an anthill. In fact, it is thousands of human beings, men in search of gold at the vast Brazilian mine known as Serra Pelada or "Naked Mountain." Within a week of gold being discovered there in 1980, thousands of prospectors rushed to what became the world's largest open-air mine. Yet what they found was a living hell. A city of men, with as many as 100,000 prospectors working in small spots in perilous conditions, it was a mix of abysmal sanitation and extreme violence where as

many as eighty unsolved murders occurred every month. Furthermore, the hastily constructed "town" that served the mining population was an anarchic pool of violence, alcoholism, and prostitution, with underage girls selling themselves for gold flakes.

This haunting image is from a photo-essay by Brazilian documentary photographer Sebastião Salgado (born 1944) called *Workers: An Archaeology of the Industrial Age*. Salgado's work from the 1980s often recorded "a world in distress" and many of his images of genocide, famine, war, and environmental cataclysms have become symbols of global suffering. Although the mine was open for only five years, it left a deep scar on the social and geographical history of Brazil. SY

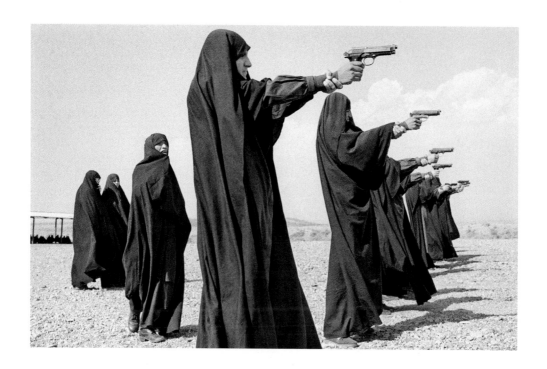

VEILED WOMEN PRACTICE SHOOTING
ON THE OUTSKIRTS OF TEHRAN

JEAN GAUMY

Date 1986
Location Tehran, Iran
Format 35 mm

A member of Magnum Photos since 1977, French photographer Jean Gaumy (born 1948) is known for his reportage on Iran, which he visited several times between 1986 and 1997. Taking advice from fellow Magnum photographer the Iranian Abbas—who told him not to believe newspaper reports about the country—he set out to document what he regarded as an entirely different way of life.

This image was taken on his third trip, in a period of heightened security during the Iran–Iraq War (1980–88). Under constant supervision by the Ministry of Communication, he was taken to a training camp for the Basij voluntary militia; Gaumy was the first Western photographer to gain access to the organization's training program. He has stated that the Iranian government certainly realized that this particular image of female militia would not be seen positively in the West. However, they made no move to suppress its publication, which he thought was their way of saying, "Look, even our women are determined to defend our country." The importance of this much-reproduced picture is that it has opened up debate about gender politics, religious representation, and the depiction of the Middle East. NG

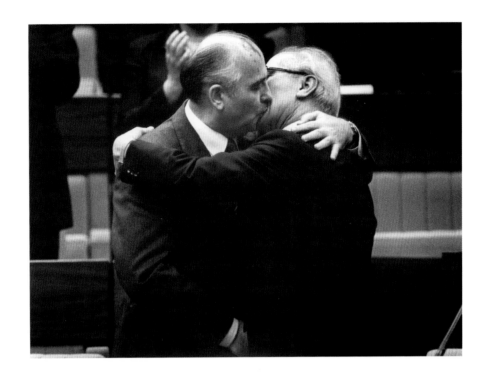

GORBACHEV AND HONECKER EMBRACE

UNKNOWN

Date 1986
Location Berlin, Germany
Format 35 mm

Anyone glancing at this photograph might think that Mikhail Gorbachev, General Secretary of the Communist Party of the Soviet Union, and East German leader Erich Honecker were lovers. In fact, the politicians are engaging in the fraternal hug and kiss sometimes used by statesmen of Communist countries to show mutual respect. The embrace typically involved three kisses on alternate cheeks, although the angle of the shot gives the impression that the kiss is more passionate than it was.

Gorbachev, in Germany on the occasion of the eleventh SED Party Congress in April 1986, is congratulating Honecker upon his reelection as General Secretary of the Communist Party Congress in East Berlin. The relationship between the politicians was then cordial, but Honecker would later fall out of favor with Gorbachev, who supported democratic reform. Honecker ruled with an iron grip and, although East Germany was prospering, he was eventually forced to step down by pro-democracy demonstrations and loss of support from Gorbachev; he resigned in October 1989. Gorbachev, who was instrumental in ending his country's domination of Eastern Europe, was awarded the Nobel Peace Prize in 1990. GP

FROM *HONEY HUNTERS*

ERIC VALLI

Date 1987
Location West Central Nepal
Format 35 mm

Renowned French photographer and filmmaker Eric Valli (born 1952) has a history of documenting inaccessible places, particularly in the Himalayas, for publications such as *National Geographic*. In 1987, he set out to photograph honey hunting by the Gurung tribe of West Central Nepal. Adopting working practices similar to those of anthropologists, Valli and his wife, Diane Summers, settled in Kathmandu, learned Nepali, and spent five years getting to know the Gurung in order to document their culture.

One of the largest insects of its kind in the world, the Himalayan honey bee builds its nests at altitudes of between 8,200 and 13,500 feet (2,500–4,100m). Each nest can contain up to 130 pounds (59kg) of honey, the value of which increases with the height at which it is obtained. Using the same handmade harnesses and ladders as the Gurung, Valli risked his life taking arresting shots that document the heights at which they harvest the honey. He hung with them on bamboo ropes suspended between 400-foot (122m) cliffs, with hundreds of bees attacking despite efforts to smoke them to sleep. His *Honey Hunters* photo-essay won a World Press Photo Award in 1988. CP

CONSTRUCT 32

BARBARA KASTEN

Date 1986
Location Chicago, Illinois, USA
Format Large-format Polaroid

Influenced by the Bauhaus school, and in particular by the work of László Moholy-Nagy, Barbara Kasten (born 1936) explores the representation of three-dimensional space in two-dimensional media. Her images also reference avant-garde, Constructivist art that used experimental photography. In the 1980s, Polaroid developed a new large-format film that created 24x20-inch (61x51-cm) images. Kasten employed it on the series *Construct*, for which she made sculptural arrangements of objects, mirrors, and colored lights before photographing them. The final images are directly inspired by the arrangements used by artists like Moholy-Nagy to create the photogram (an experimental image made without a camera). By adopting Polaroid, which like the photogram produces a single unique image, Kasten's works reference her forebears in photography and update them for the 1980s. LB

"THE WALK IN THE WILDERNESS"

JOHN VOOS

Date 1987
Location Thornaby, UK
Format 35 mm

This image shows British Prime Minister Margaret Thatcher on a visit to the economically depressed northeast of England shortly after winning her third term in office. It was taken at the premises of Head Wrightson, an engineering company that had been one of the area's major manufacturers, but which had just closed. After her victory Thatcher declared, "We must do something about the inner cities," and had flown to the area to launch the government-backed Teesside Development Corporation (TDC).

At a photocall for the TDC launch, John Voos, a staff photographer for the *Independent* newspaper, said that as security was so tight most of his negatives were of the backs of policemen. Finally, the Prime Minister was asked to walk toward the press and as she turned away to position herself he took this evocative shot. To Thatcher's critics this image symbolizes how her government destroyed British manufacturing. The TDC disagreed, calling it a "visual identification of the problems of Teesside and of the requirements for the future." GS

IMMERSION (PISS CHRIST)

ANDRES SERRANO

Date 1987
Location Unknown
Format Medium format

The monumental figure of Christ on the cross is bathed in golden light, glowing and swathed in something that might be a shower of stars. It is only in the work's title that Andres Serrano (born 1950) reveals what we are in fact looking at. Far from being a sublime religious tribute, it is a depiction of a cheap wood and plastic crucifix immersed in a glass container of the artist's urine. It was made as part of his *Bodily Fluids* series (1987–90), which depicted religious objects submerged in various liquids, including blood, milk, and semen, but this particular image—the best-known work of the series—led to Serrano receiving death threats and hate mail from Christian groups, and the image itself was repeatedly attacked by protestors. JG

MILAN

FERDINANDO SCIANNA

Date 1987
Location Milan, Italy
Format 35 mm

Snapped backstage at the Moschino fashion show in Milan in 1987, this photograph is like an unabashed stare at the torso of a female model. The camera is pointed directly level with her breasts, making her cleavage the overt focus of the photo, and the winglike lines of the room behind also direct our eyes there. By limiting our perspective, the photographer crops out the model's eyes completely, defying the codes of traditional portaiture; in doing so, he creates a bold composition. In the foreground, another woman is shown in profile, and more women are seen socializing behind. The women dazzle; their earrings, bracelets, teeth, and lipstick glint in the light of the flash. Seen from this angle, they appear more like mannequins than real people.

Ferdinando Scianna (born 1943) started photographing in the 1960s while he was studying literature, philosophy, and art history at the University of Palermo, Sicily. When he moved northward to Milan in 1966, he began working as a photographer for *L'Europeo* magazine and then as a journalist. He wrote about politics for *Le Monde Diplomatique*, and literature and photography for *La Quinzaine Littéraire*.

In the late 1980s, Scianna began to specialize in fashion photography. His first project, to photograph Dutch model Marpessa Hennink for Dolce & Gabbana's advertising campaign for their Fall/Winter collection in 1987, was a huge success. In addition to his fashion images, Scianna is known for the candid pictures he takes in his Sicilian homeland. Scianna became a full member of Magnum Photos in 1989. **EC**

THE WOMAN

FLOR GARDUÑO

Date 1987
Location Oaxaca, Juchitán, Mexico
Format 35 mm

For her project *Witnesses of Time*, Flor Garduño (born 1957) sought to depict descendants of those who have witnessed the violent changes that have occurred for centuries in the Americas, yet whose cultures persist and continue to adapt to the modern world. *La Mujer* (*The Woman*) is a hallucinatory depiction of a young woman from the state of Oaxaca in southern Mexico; in her region, Juchitán, the indigenous women are the matriarchs of the society and take responsibility for supporting the household. Here, the woman is bringing a string of iguanas to market. The image makes a powerful statement about the survival of a traditional people who recognize the losses of the past but also the promise of restitution in the present.

Originally dreaming of being a painter, Garduño turned to photography in the 1970s, studying with Hungarian war photographer Kati Horna (1912–2000) and Mexican photographer Manuel Álvarez Bravo (1902–2002). The strong influences of both of these artists can be seen woven throughout her remarkable work, yet Garduño's style moves beyond them in the way that she connects with her subjects and forms an almost meditative relationship with them. **SY**

TRACKS, BLACK ROCK DESERT, NEVADA

RICHARD MISRACH

Date 1987
Location Black Rock Desert, Nevada, USA
Format Large format

Richard Misrach (born 1949) is widely regarded as one of the pioneers who brought large-format, color photography into fine art. After completing a degree in psychology at the University of California, Berkeley, Misrach undertook his first photographic project about the homeless people who occupied a street in Berkeley, which was published as the book *Telegraph 3 AM*. Frustrated that his work had little effect on the issue of homelessness, Misrach shifted the focus of his work to landscapes and human-made environmental changes. He has said of his work, "My career, in a way, has been about navigating these two extremes—the political and the aesthetic."

Misrach began the ongoing series *Desert Cantos* in 1979 when he shot deserts in California, Arizona, and Mexico with an 8x10 inch camera. He has since spent almost forty years on the project, which is a symbolic, topographical study of place and the relationship between humans and the environment. The term "cantos" loosely refers to the different elements that make up a whole, in this case encompassing everything from the documentary to the metaphorical. "The desert is a larger metaphor for our times," he has explained. LH

UNTITLED

ROSALIND FOX SOLOMON

Date 1987–88
Location Unknown
Format Medium format

Over a period of ten months in 1987 and 1988, New York City-based Rosalind Fox Solomon (born 1930) created *Portraits in the Time of AIDS*—a series of photographs of seventy-five Americans whose lives were affected by the deadly virus: gay men, women who had been contaminated through blood transfusions, former drug addicts, and children with infected mothers. In the process she revealed the human face of AIDS victims. In the light of the public ignorance and fear about the virus at the time, Solomon's dignified and at times harrowing portraits show individuals who were in the shadow of death but still walking. The series is shot entirely in black and white, a medium in which the photographer works exclusively.

In this photograph—in which the sitter's grief is painfully palpable—we witness the furious ache of the bereaved. The man cradles a framed photo of himself with his partner, their arms wrapped around each other, their faces lit with happiness in a bright, outdoor location. In stark contrast, the subject sits in a dimly lit room with the blinds down, and his black shirt seems to melt into the darkness around him. His direct gaze demands that we see him, where he now sits alone. **RF**

MARIELLA

EUGENE RICHARDS

Date 1988
Location Brooklyn, New York, USA
Format 35 mm

Eugene Richards (born 1944) is an American photographer whose work is centered on social documentary. In the late 1980s, he began a project on drug addiction, which was later published as *Cocaine True, Cocaine Blue* (1994). The project began when Richards and a reporter from *Life* magazine, Ed Barnes, made contact with drug addicts and dealers in Brooklyn's Red Hook housing project. They worked on the project for six weeks, initially trying to gain the trust of their subjects.

The groundbreaking imagery that Richards shot features the unobscured faces of the drug addicts. In this image of Mariella—on the cover of Richards's book—the woman has a crazed look in her eyes as she is about to shoot up crack cocaine. It is a shocking yet intimate portrayal of someone who has been sucked into this underworld. However, in publishing and exhibiting the photographs, Richards encountered his fair share of controversy: the subjects were mostly African American and his own participation was called into question. Despite this, the project has since been recognized for being one of the most graphic and raw portrayals of the dark side of illegal drugs. **LH**

HOLLYWOOD BOULEVARD, 3 A.M.

JIM GOLDBERG

Date 1988
Location Los Angeles, California, USA
Format Large format

This picture is from the series *Raised by Wolves* by US street photographer Jim Goldberg (born 1953), which was published in book form in 1995. It shows a girl and her boyfriend as they are being busted for selling drugs out of a baby carriage. The girl is shown kneeling on the sidewalk in subjugation or even prayer, her boyfriend stands to her left, and a policeman is in the background taking notes. A baby carriage stands between the police officer and the young man.

Goldberg came to fame as a street photographer with his landmark book *Rich and Poor* (1985). He employed a similar approach for *Raised by Wolves*, which focuses on runaway teenagers, prostitutes, junkies, and panhandlers. He spent between 1987 and 1993 on the streets of San Francisco and Los Angeles photographing and interviewing his adolescent subjects, their social workers, and police officers. The book also contains handwritten texts by the teenagers, which add another dimension to what is a saddening insight into life on the street and the fringes of society. One of them wrote a poem that gave Goldberg's series its name: "Born a wicked child / raised by wolves / A screamin kamakazi / I never will crash." CK

BOY CONFRONTS VIOLENT FATHER

DONNA FERRATO

Date 1988

Location Minneapolis, Minnesota, USA

Format 35 mm

Donna Ferrato (born 1949) is a photojournalist known for her coverage of domestic violence and abuse. Having been commissioned by Japanese *Playboy* magazine to photograph a well-known swinger couple, she witnessed the man give his partner a merciless beating. She says of that evening, "That night changed me forever, and also altered the direction of my work for the next ten years...I was now driven to reveal the unspeakable things that were happening behind closed doors."

Ferrato began accompanying police to callouts for domestic violence, sleeping in refuges, and living with battered women. In this image from the series *I Am Unbeatable*, an eight-year-old boy named Diamond confronts his violent father. The latter's arms have been restrained, and a policeman reaches into the man's pocket, presumably conducting a search before making an arrest. Diamond is distraught and points his finger directly in his father's face as he cries, "I hate you for hitting my mom. I hope you don't come back to this house," while his father turns away from the reproach. Ferrato records this deeply personal domestic drama as though she were a fly on the wall. AZ

WATER TOWERS

BERND AND HILLA BECHER

Date 1988
Location Various, Germany
Format Large format

German husband-and-wife team Bernd (1931–2007) and Hilla Becher (1934–2015) worked together for forty years, establishing a distinctive visual language. Their collaboration began in 1959 when they photographed the industrial architecture in their immediate environment in an objective fashion using large-format cameras. Their output is recognizable by its systematic composition and standardized format. The subjects are usually shot frontally or at least from a similar, often elevated, vantage point. The images are cropped tightly so structures appear isolated, set against a neutral background of gray sky. Each subject in a series is positioned the same distance from the lens. When the images are printed in a grid format, the towers appear like sculptures rather than industrial buildings.

Water Towers is typical of the Bechers' work, and the viewer is able to recognize what the structures have in common, what is specific to the basic form, and where there is individual variation. The black-and-white format and its repetition create a pattern, because although structures are grouped by function, the focus is on the geometry and shape of the forms, rather than context or color. The couple's archaeological approach to their work involved gathering data on the buildings, too, which culminated in a comprehensive documentation of an industrial landscape that was disappearing at the end of the twentieth century. The artists went on to document gas tanks, silos, grain elevators, blast furnaces, pitheads, and oil refineries in Europe and the United States. **CK**

"To photograph things frontally creates the strongest presence and you can eliminate the possibilities of being too obviously subjective."

Hilla Becher

PRINCE AT THE AHOY

ROB VERHORST

Date 1988
Location Rotterdam, The Netherlands
Format 35 mm

Mention the name of the late legendary music icon Prince (1958–2016) and most fans would picture him as they had seen him in performance, live or recorded on television— a whirlwind of movement around the stage, and hypersensitive to every aspect of his act, from the sounds of his band to the details of his own androgynous visual image. But here Dutch music photographer Rob Verhorst (born 1952) caught a different side of his nature during his performance at the Ahoy arena in Rotterdam on August 17, 1988. Prince seems absented from the scene, his mind miles away, his fingers gently touching his face as he focuses on his thoughts. At the same time, it is almost as though he is posing specially for the photographer.

Prince was about a month and a half into his famous "Lovesexy" world tour, which took him to cities including Paris, Stockholm, Milan, Hamburg, Tokyo, and New York, as well as Rotterdam. He was promoting *Lovesexy*, his tenth studio album, which lacked the impact of other previous albums and had been hurried out as a replacement for the eagerly anticipated *Black Album*, which Warner Bros. did not release until 1994. *Lovesexy*'s cover, featuring a photograph of Prince posing nude with a phallic stamen on view and surrounded by flowers, caused some controversy. Verhorst's portrait, in comparison, is quieter and less contrived. It captures what appears to be a reflective moment in what would have been a rambunctious and energetic live show, yet the magnetism and aura of the provocateur who sold more than 100 million records worldwide are still very much in evidence. **GP**

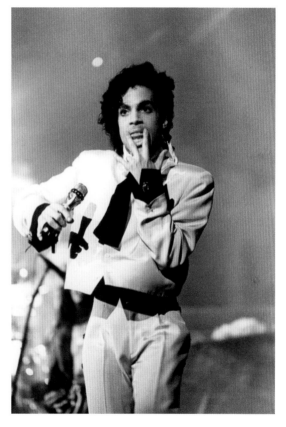

"So much has been written about me, and people don't know what's right and what's wrong. I'd rather let them stay confused." Prince

TOM

EUGENE RICHARDS

Date 1988
Location New York, New York, USA
Format 35 mm

Concerned with documenting the American condition, Eugene Richards (born 1944) has produced series of works examining cancer, social injustice, poverty, drug use, and emergency medicine in the United States. He aims for an emotional closeness with his subjects, striving for unflinching intimate access to often marginalized people. One such subject is Tom, a homeless beggar searching for coins dropped through the ventilation grilles in a New York street. Instead of portraying Tom as a passive victim, Richards offers an individual who is both alienated and defiant, a rugged figure rising out of the ground and taking his chances on the street, ignored by passersby. Richards likened Tom to a monster rising from a black lagoon in an old horror movie, a figure of power. By explicitly naming him, rather than merely referring to him as "homeless," Richards gives Tom humanity. Furthermore, the low-level shot invites viewers to treat Tom as an equal, perhaps someone to fear but not someone to pity. **NG**

SUSIE SMOKING

NICK KNIGHT

Date 1988
Location London, UK
Format Unknown

In his first photo-book, *Skinhead* (1982), Nick Knight (born 1958) traces the history of British skinhead subculture from the 1960s to the mid-1970s revival. The book features images of skinheads in the East End of London, and it has become an essential fashion reference work. Remarkably, Knight created it while still a student of design at Bournemouth & Poole College. On the strength of that work, *i-D* magazine commissioned him to create a series of one hundred black-and-white portraits for its fifth anniversary edition. These images came to the attention of art director Marc Ascoli, who hired Knight to shoot the 1986 catalog for avant-garde Japanese designer Yohji Yamamoto. Images such as his groundbreaking *Red Bustle*, showing a model in silhouette wearing one, turned Knight into more of an image-maker than a fashion photographer. His clients have included John Galliano, Christian Dior, Alexander McQueen, and Vivienne Westwood.

This photograph features model Susie Bick and is among those Knight produced for Yamamoto's Autumn/Winter 1988–89 catalog. Much of the image is empty of form but full of vivid color, as Knight opts for a minimalist style in keeping with Yamamoto's dramatic tailored shapes. The bob haircut hides Bick's face, and a hint of red lipstick accentuates her pallor. Knight is alluding to the traditional makeup of the geisha, and his simple yet formal composition recalls that of *ukiyo-e* woodblock prints of the seventeenth to nineteenth centuries. However, the slumped pose of his model, with her hand on her hip and the trail of smoke from her cigarette, places her firmly in modern times. **CK**

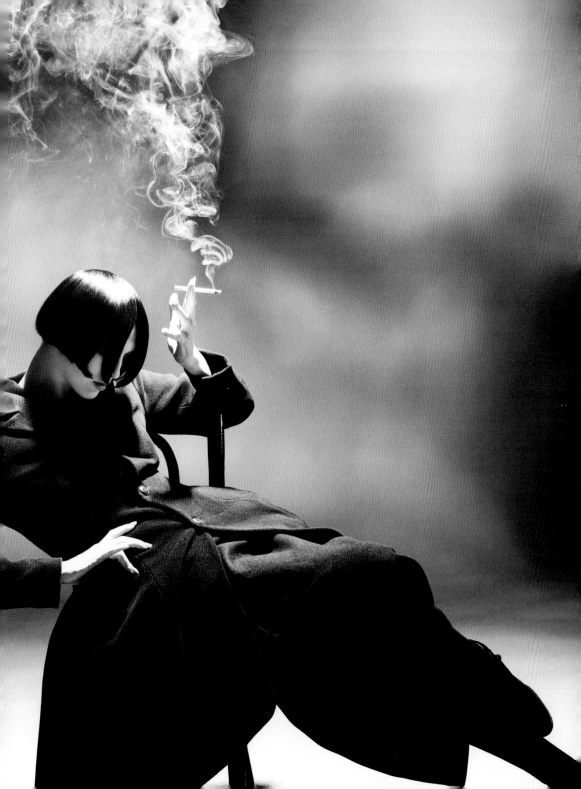

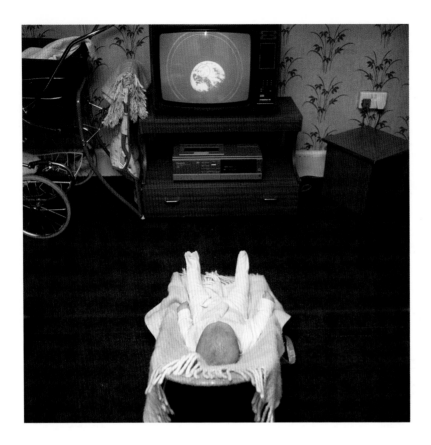

UNTITLED

DAVID MOORE

Date 1988
Location Derby, UK
Format Medium format

In 1986 and 1987, while he was studying photography at the West Surrey College of Art and Design in Farnham (under Paul Graham and Martin Parr), David Moore (born 1961) used to make portraits of people who were living on and close to housing estates near Derby in Nottinghamshire, where he lived. He also knocked on doors, asking if he could photograph inside these people's homes.

In 1988, for his degree-show project, Moore made a new series of striking color images that present a raw, grim view of the realities of living in Thatcher's Britain. His camera-flash lights up the dark domestic spaces, revealing families squashed into homes that are too small for them, bare floorboards, grubby walls, and food and household paraphernalia strewn everywhere. This photograph of a baby parked in a baby bouncer in front of a television set seems to typify the stretched and claustrophobic existence that was the norm for so many people at the time.

Moore's degree-show photographs were eventually published as a book, *Pictures from the Real World*, in 2013. As a window into working-class domestic life in Britain in the late 1980s, it is a model of color documentary photography. GP

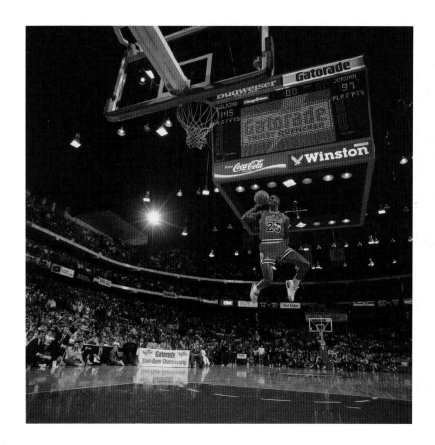

MICHAEL JORDAN AT THE SLAM DUNK CONTEST

WALTER IOOSS, JR.

Date 1988
Location Chicago, Illinois, USA
Format Medium format

Walter Iooss, Jr. (born 1943), began working for *Sports Illustrated* magazine in 1961 at the age of seventeen, and shot more than 300 covers during his lengthy career. He shot Michael Jordan more than any other athlete, saying that it was impossible to get a bad picture of him. One of his memorable images of the basketball star was the result of considerable forward planning, typical of Iooss's meticulous attention to detail and understanding of the dynamics of sport. He recalled how he approached Jordan before the contest, and asked him, "'Michael, can you tell me which way you're going to go, so I can move and get your face in the picture?' He looked at me as if I were crazy, but then said, 'Sure. Before I go out to dunk I'll put my index finger on my knee and point which way I'm going.' I said, 'You're going to remember that?' And he said, 'Sure.' So later, when they announced his name, I looked over to him on the bench and there was his finger pointing left ... He went left every time he dunked ... On the next-to-last one he landed in my lap. On the last one I set up in the same spot. He looked at me as if to say, 'Go left a little, give me some room this time.' And that was it, the picture was made: one thousandth of a second frozen in time." PL

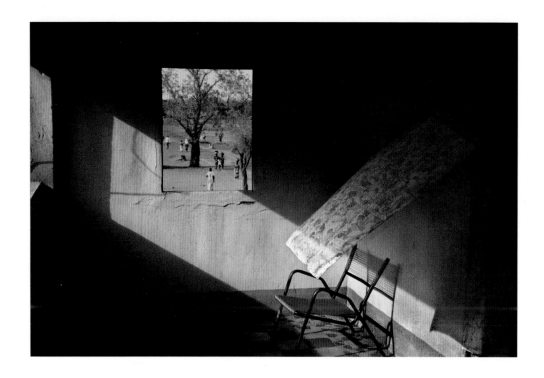

TERRACE OF A HOTEL, GAO, MALI

HARRY GRUYAERT

Date 1988
Location Gao, Mali
Format 35 mm

That something as unremarkable as the terrace of a hotel should seem so mysterious and atmospheric is due to the unique ability of Magnum photographer Harry Gruyaert (born 1941) to spot visual poetry in the ordinary. Gruyaert's talent for capturing subtle colors and lighting in his photographs has helped to make him one of the most highly respected color photographers of the past few decades.

Studying photography and cinematography in Brussels as a young man, Gruyaert spent every spare moment watching movies at his local cinema. It was during this time that he developed the love of movies that is so evident in his photographs. This image of a window, chair, and curtain billowing in a breeze, taken in Gao, eastern Mali, is a prime example. On the face of it, the combination of elements is not especially exciting. But by framing the shot straight on, and using the window to direct the viewer's eye outside, Gruyaert creates a wonderful sense of depth, while giving the impression that someone using the chair has just stepped away for a moment. Light itself becomes a key character here, and Gruyaert uses it to guide the eye from window to chair, giving the scene a sense of cohesion. **GP**

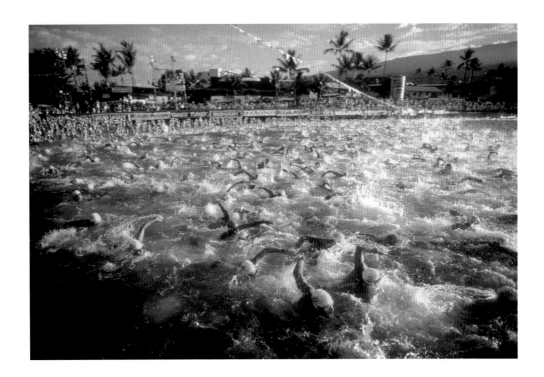

IRONMAN WORLD CHAMPIONSHIPS, KONA, HAWAII

WALTER IOOSS JR.

Date 1989
Location Kona, Hawaii
Format 35 mm

The Ironman format has grown massively in recent years, with thousands of amateur "age groupers" competing alongside the professionals each year. This image of hordes of competitors in yellow caps thrashing in the water at the start of the swim event was taken in 1989 in Kailua-Kona Bay, Big Island, Hawaii by Walter Iooss Jr. (born 1943); it graphically illustrates the scale of the event even then.

The battle between two of the greatest rivals in Triathlon, Mark Allen and Dave Scott, culminated in the Ironman World Championships of 1989, in a head-to-head confrontation that became known as the "Ironwar." In grueling conditions of extreme heat and humidity on Hawaii's Big Island, they led the field over the course that consists of a 2.4-mile (3.8-km) swim, a 112-mile (180-km) bike race, and a 26.2-mile (42-km) marathon, pacing each other stroke for stroke until the final moments, when Allen managed to pull away to finish in a then new record time of eight hours, nine minutes, and fourteen seconds, which is still one of the fastest ever times for the event.

Allen had failed to beat Scott in 1986 and 1987, but he went on to win a further five championships over the next few years. PL

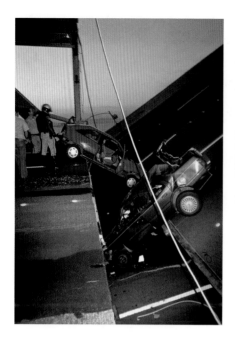

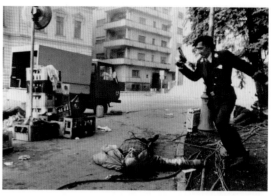

THE HEIGHT OF THE BATTLE

LEONARD FREED

Date 1989
Location Bucharest, Romania
Format 35 mm

Leonard Freed (1929–2006) was a documentary photographer responsible for powerful bodies of work. His coverage of Romanian revolution in 1989 and the fall of the dictator Nicolae Ceaușescu produced many memorable images, such as the frightened faces of bystanders caught in sniper fire. This image was taken at the height of the conflict. After a botched speech by the dictator and an attempt to censor and curtail public protests, the conflict escalated to a full-scale military revolt by rank-and-file members of the security forces. The subsequent street violence forced Ceaușescu and his wife from power and they were executed. This image captures a uniformed member of the security forces with a pistol in mid-run being fired at by government snipers in Palace Square, the epicenter of the evolving crisis, while a dead civilian lies at his feet. Like many of the greatest images of conflict, it captures the sense of drama and the urgency of the situation, which saw Freed in considerable danger. Shot in black and white, it recalls the imagery of previous failed uprisings against Communism in Hungary and Czechoslovakia, almost acting as a full stop to a particular period of history. **NG**

TWO CARS CAUGHT

CHUCK NACKE

Date 1989
Location San Francisco, California, USA
Format 35 mm

The deadly Loma Prieta earthquake, understood to be the second biggest earthquake to hit the United States, devastated San Francisco and Oakland when it struck at around 5 pm local time on October 17, 1989. Measuring 6.9 on the Richter scale, it occurred near Loma Prieta in the Santa Cruz Mountains before tearing through Santa Cruz and San Francisco. The top deck of Oakland's double-decked Interstate 880 highway collapsed, causing many deaths when concrete slabs fell onto cars below, and the San Francisco-Oakland Bay Bridge was also affected. Photographer Chuck Nacke caught the aftermath on camera, creating this disturbing photograph of two cars terrifyingly wedged in the broken bridge while onlookers survey the scene. The bridge was closed for a month following the incident. **GP**

SACRIFICIO V

MARIO CRAVO NETO

Date 1989
Location Brazil
Format Medium format

As one of the most acclaimed photographers of Brazil, Mario Cravo Neto (1947–2009) is remembered for his important work documenting the religious practice of Candomblé. His early years were infused with the colonial history of his birthplace, Salvador, the state capital of Bahia and the point of entry for millions of West African slaves to the Americas in the sixteenth century. When they arrived in Brazil, they combined their religious and oral traditions with those of the Catholic Portuguese colonizers to create a new syncretic faith called Candomblé. Cravo Neto's image of the sacrifice of a chicken comes from his larger study, *The Eternal Now,* about the Candomblé spiritualist community, where "the sacrifice of an animal is said to feed the deities." Indeed, his photographs are filled with animals, each with its own particular ritualistic meaning.

Cravo Neto's work has been called a "site of resistance" because it depicts a very small percentage of the Brazilian population, but whose migration story is part of the foundational history of the country and of the wider story of slavery. SY

TIM, PHIL, AND I

TINA BARNEY

Date 1989
Location Watch Hill, Rhode Island, USA
Format 8x10

The artist (center) is caught in mid-speech. Her skin is the same golden-brown as that of the young men on either side of her, whose faces mirror each other in what writer David Corey has described as a "visible genealogy." They are her sons, Phil and Tim. On closer inspection, small details emerge. The Band-Aid on Phil's elbow, the way the colors in the image show how these people belong together: viewers' eyes move between the white, the coral, the goldenrod hues of this outdoor gathering. We notice the clicker in Tina's hand, capturing this ordinary moment, a portrait of the relations between people and of the grace in everyday life.

Of the *Friends and Relations* series, from which this image is taken, Tina Barney (born 1945) said, "At a certain point in my life I realized how precious certain things were to me and that I had to record them ... these photographs are really a diary." And while revelatory, Barney's eye is also loving: "I want you to be with us and share this existence with us. I want every single thing to be seen, the beauty of it all." RF

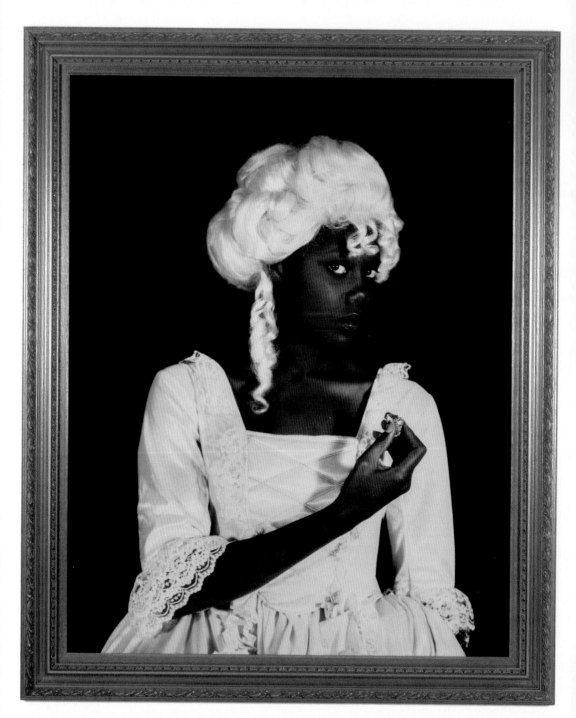

TERPSICHORE

MAUD SULTER

Date 1989
Location Unknown
Format 35 mm

This photograph is one of a series of portraits of contemporary black women in the guise of ancient muses. The title of the series, *Zabat*, is derived from the term used to refer to an ancient ritual dance performed by women. Its usage here reflects the ambitions of the photographer—who is of Scottish and Ghanaian parentage—to reposition black women in the history of photography. In fact, Maud Sulter (1960–2008) produced the *Zabat* series for Rochdale Art Gallery in northern England to coincide with the 150th anniversary of the invention of photography, and it came as a direct response to the visible lack of black presence at other celebratory events and exhibitions throughout the art world. With her work, Sulter declared that she wanted "to put black people back in the center of the frame."

In this particular photograph, the model—performance artist Delta Streete—wears a costume that she made as part of a dance installation named *The Quizzing Class*, which focused on relationships between women, especially that between slave and mistress. In each of the *Zabat* portraits, Sulter has depicted the women as one of the nine Greek muses. Here, Streete is presented as Terpsichore, the muse of dance and choral song. She wears a white wig like those historically associated with the slave-owning classes, which instantly subverts traditional representations and imbues her with a new sense of power. The juxtaposition of old and new is also made explicit by displaying the modern, restyled portrait in the type of gilt frame that is synonymous with classical art. **EC**

BRITISH MIDLAND AIR CRASH ON M1 MOTORWAY

RICHARD BAKER

Date 1989
Location Kegworth, UK
Format 35 mm

The work of documentary photographer Richard Baker (born 1959) not only addresses the aviation industry, but also focuses on other industrial contexts, providing an ode to the incongruity of the apparently banal. Showing the aftermath of the crash of British Midland Flight 92, in which forty-seven people died, the image appears epic, the rescue workers dwarfed by the broken shell of the plane.

The dramatic lighting, provided by emergency workers, affords a large tonal range and gives the otherworldly colors that render this image painterly and unfamiliar. Although shot on 35 mm film, hand held and at night, it is cinematic in quality, formally similar to the staged large-format work of contemporary conceptual photographers. Representing, as it does, a spectacular interruption to the sense of security that the sanitized space of the airport fosters, the image reminds us of the price that we pay for the ease of global travel, the ease with which things break down. **MT**

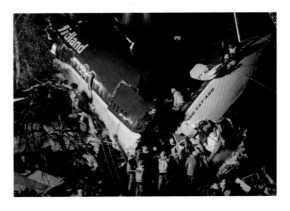

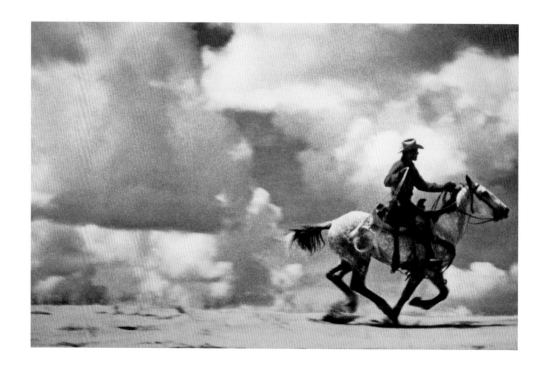

UNTITLED (COWBOY)

RICHARD PRINCE

Date 1989
Location Unknown
Format Composite

This photograph is a comment on the universal cultural icon that is the American cowboy. Instantly recognizable as embodying the values of freedom, strength, masculinity, and self-reliance, he occupies the equally iconic terrain of the Wild West. However, this cowboy is a secondhand icon: Richard Prince (born 1949) has created the image by rephotographing and cropping a press advertisement for Marlboro cigarettes. He explains his use of the originals: "The pictures I went after,

'stole,' were too good to be true. They were about wishful thinking, public pictures that happen to appear in the advertising sections of mass-market magazines, pictures not associated with an author. . . . It was their look I was interested in. I wanted to re-present the closest thing to the real thing."

In his *Cowboy* series, Prince makes use of the high-budget, aesthetically rich, and alluring photography of the advertising campaign and makes it his own. The result is a multilayered set of meanings, not only about American cultural ideals, but also about postmodern "intertextuality": the circulation and connectedness of images in the media landscape, artistic authorship, visual literacy, and the nature of photography itself. JG

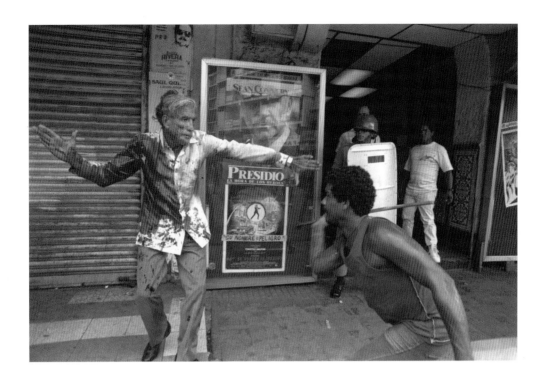

ELECTION VIOLENCE, PANAMA

RON HAVIV

Date 1989
Location Panama City, Panama
Format 35 mm

The first major international story covered by Ron Haviv (born 1965) was the 1989 Panamanian elections. After the results of the vote were annulled by General Manuel Noriega, the people took to the streets to demonstrate in favor of the rightful winners. Haviv was following the vice presidential candidate, Guillermo Ford, when he was attacked by a mob of opposition supporters. Haviv described how "they shot his bodyguard, then stabbed him in the arms. He stumbled around

and I photographed him. I barely recognized him, in his blood-soaked white shirt. Then, in Spanish, I heard someone say: 'Excuse me.' I stepped aside and a man in a blue shirt jumped in and started hitting him with a lead pipe. They fought for a few moments, then some soldiers stepped in."

This dramatic image was published all over the world and launched Haviv's career as one of the most successful photojournalists of his generation. He recounted how "President Bush used it in his TV speech to the nation to justify the US invasion. For me, it was a monumental moment: I suddenly understood the power of photojournalism. I realized this wasn't about me, it was about the people I was photographing." PL

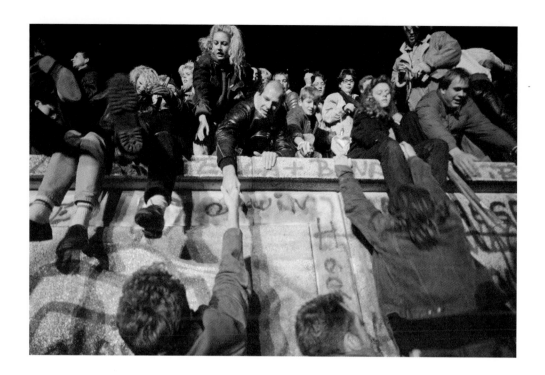

THE FALL OF THE BERLIN WALL

RAYMOND DEPARDON

Date 1989
Location Berlin, Germany
Format 35 mm

In November 1989, the Berlin Wall—constructed in 1961 to separate East Germany from West Germany, and widely referred to by its East German creators as an "Anti-Fascist Wall"—began to be deconstructed after the borders between East and West were declared open. This historic moment in Germany's history is here captured by Magnum photographer Raymond Depardon (born 1942).

Before the wall was taken down, many citizens began to climb in both directions, the border officials unable to contain them or document their crossings. In this image, Berliners are helping one another climb over the wall. Depardon's point of view is at the foot of one side of the wall, looking up steeply toward a closely packed group who reach hands down to haul up others standing at the base. None of the people in the photograph is looking into the camera; their focus is on the task at hand, helping one another over the wall. This gives a sense of the significance of the moment; the camera is irrelevant in the face of such a pivotal event. Looking closely, however, there are slight smiles played out on the lips of some of the subjects, despite their concentration; an air of subtly happy victory prevails. **AZ**

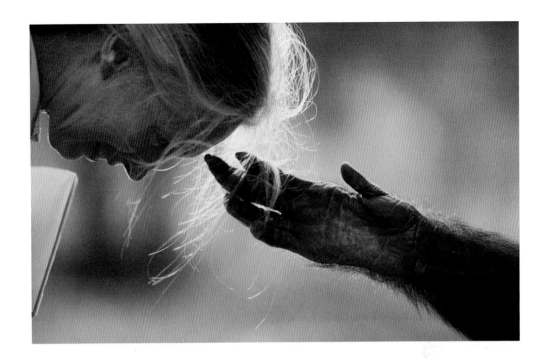

JANE GOODALL AND A CHIMPANZEE

MICHAEL "NICK" NICHOLS

Date 1990
Location Brazzaville, Congo
Format 35 mm

Dubbed the "Indiana Jones of photography" by *Paris Match*, Michael "Nick" Nichols (born 1952) has been photographing wild animals in the most extreme conditions for more than thirty-five years. One of his most enduring relationships photographically has been with renowned primatologist Jane Goodall, with whom he started collaborating in 1989. They began to work together to use his skills as a photographer and her understanding of chimpanzees to campaign against threats to the creatures' habitat. Nichols explained, "Jane's very pragmatic. If you met her, she'd be trying to convert you to change the world within a few minutes. ... She thought, 'This guy's got energy and talent, he'll speak for the chimps.'" They worked together on the project *Brutal Kinship*, after which Nichols collaborated with *National Geographic*, which wanted to do a story on relationships between apes and humans. Nichols tried to keep his photographs of Goodall as natural as possible, recalling, "During my time with Jane I never directed her, I just witnessed. She would say, 'Nick, stop. Don't take any more pictures today.' ... I didn't need to direct—if you stay with her long enough she's going to do something that makes a powerful photograph." PL

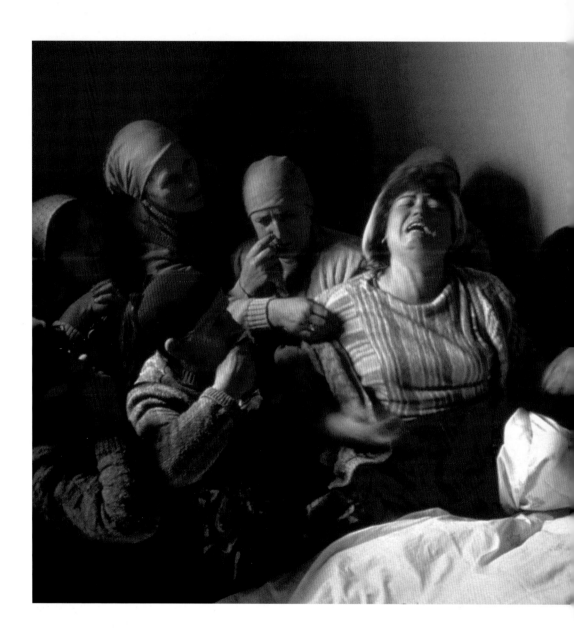

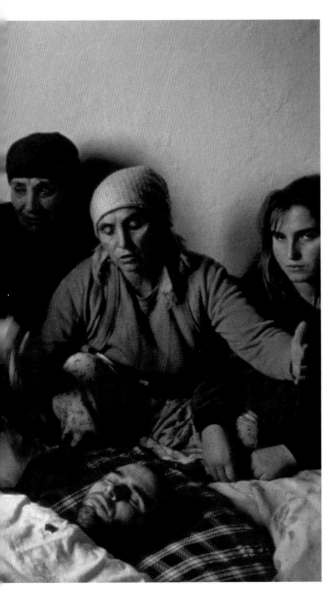

FAMILY MOURN THE DEATH OF NASIMI ELSHANI

GEORGES MÉRILLON

Date 1990
Location Kosovo
Format 35 mm

In this award-winning photograph shot inside a home in Kosovo, family members and neighbors are seen mourning the death of Nasimi Elshani, who was killed by Serbian police during a protest for Kosovar autonomy. While in Kosovo during the winter of 1990, French photographer Georges Mérillon (born 1957) heard from an Albanian journalist that a shooting had just taken place in the mountain village of Nogovac. Accompanied by a French television crew, they attempted to reach the village in a zone heavily controlled by the military. The group was admitted into the home of one of the victims, because the grieving family were moved by the fact that people cared about their plight.

Mérillon described how the sole light source came from a single moisture-covered window in the room, shedding a cold light over the subject and creating an almost biblical scene. Inside the frame, the women are stricken with grief and despair as they surround the body. In the center of the composition is Elshani's elder sister Ryvije, whose face is contorted with pain; to the right the mother, Sabrié, extends her hands as if to cradle her son's head, and younger sister Aferdita sits gazing emptily at the camera. In the left corner, a face half-materializes from the gloom. Mérillon's photograph has become emblematic of the universal suffering of Kosovar Albanians, who were deeply oppressed by Serbian leader Slobodan Milosevic, a man who was determined to drive the Albanians out of the country and wipe away their identity. The image won World Press Photo of the Year in 1991. EC

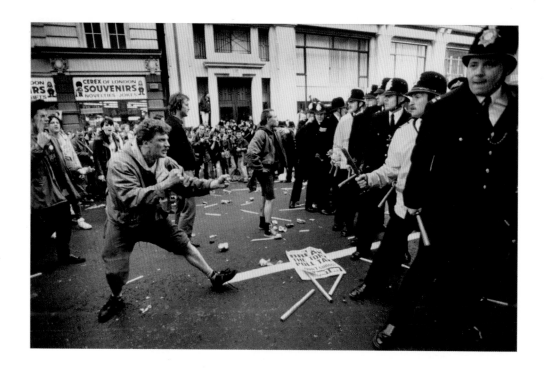

POLL TAX RIOT

CHRISTOPHER MORRIS

Date 1990
Location London, UK
Format 35 mm

This photograph was taken during the poll tax riots of 1990 in central London. On March 31, a crowd of around 200,000 people gathered to protest the poll tax implemented by Prime Minister Margaret Thatcher's Conservative government. It was an unpopular policy widely believed to be saving the rich money at the expense of the poor. The protest escalated after clashes with the Metropolitan Police, and rioting broke out, with looting and rampaging lasting until 3 a.m.

In this image by US photographer Christopher Morris (born 1958), a protester squares up to a line of policemen, his fists raised and an expression of anger and contempt on his face. His aggressive stance suggests that he is fully prepared to fight, despite his lone status. By contrast, the police appear nervous and bewildered, notwithstanding their strength in numbers and the batons they wield—likely a result of the scale of the day's violence and chaos. In the back of the frame, there is a cluster of press photographers; rioting of this nature was unusual in London, and so the events were well documented. Morris's tilted frame adds to the sense of drama, emphasizing the disorder of the scene. **AZ**

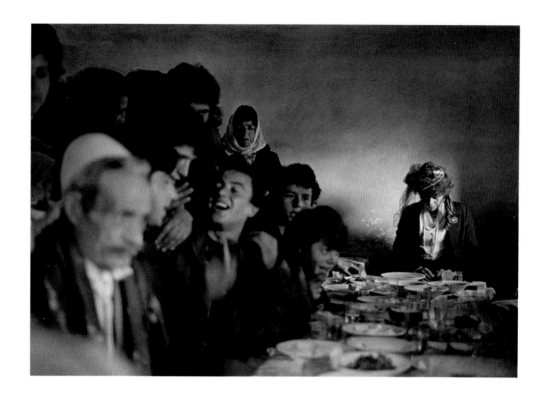

ALBANIAN WEDDING

BARRY LEWIS

Date 1990
Location Boga, Albania
Format 35 mm

This photograph was taken in a remote mountain region of northern Albania that was closed to foreigners during the dictatorship of Enver Hoxha (1944–85). For centuries, Albanian traditional law, known as the Kanun of Lekë Dukagjini, determined social behavior in the region and it remains widely enforced today. The law covers most aspects of life, including religion, family, marriage, housing, livestock, work, and crime; controversially, it also sets out rules for the conduct of blood feuds.

Barry Lewis (born 1948) photographed this wedding scene after an arranged marriage, evidently an unsettling time for the bride, who will shortly move into the groom's family's house, where she will live for the rest of her life. Moreover, she has just witnessed her father handing the groom a symbolic gift—a trousseau bullet—with the instruction that he should use it in the event of her desertion or infidelity. The Kanun decrees that a marriage feast must provide a "wedding ox" along with specified amounts of coffee, cheese, and *raki*. As for rules of hospitality, the master of the house should drink the first glass of *raki*, but the guest must take the first bite of food; violation of this rule is punishable by a fine. CJ

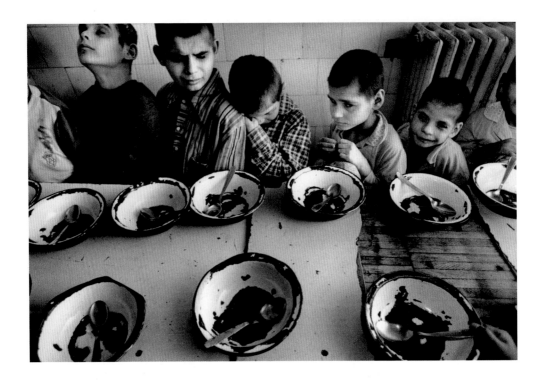

ROMANIAN ORPHANAGE

MIKE ABRAHAMS

Date 1990
Location Romania
Format 35 mm

On December 22, 1989, Romania's Communist leader Nicolae Ceaușescu was overthrown in a violent revolution and fled the capital, Bucharest. Three days later, he and his wife were executed by firing squad. Western journalists entering Romania came across appalling scenes of neglect. Mike Abrahams (born 1952) arrived at the Gradinari Hospital for the disabled near Bucharest in the freezing cold. It was no warmer inside. A staff of four nurses, a medical assistant, a cook, and a washerwoman were looking after ninety-six children and twenty-five adults. The medical assistant apologized for the poor facilities but explained that such institutions had been a low priority under Ceaușescu's regime. Indeed, the recently deposed head of state had claimed that there were no orphans in Romania.

Abrahams saw children huddled together in beds desperate for warmth from one another. Mealtime was a patient wait, followed by the urgent consumption of a meager broth ladled into chipped enamel bowls. Images such as this shocked the world, and subsequently many Romanian orphans were brought to Western countries for adoption. CJ

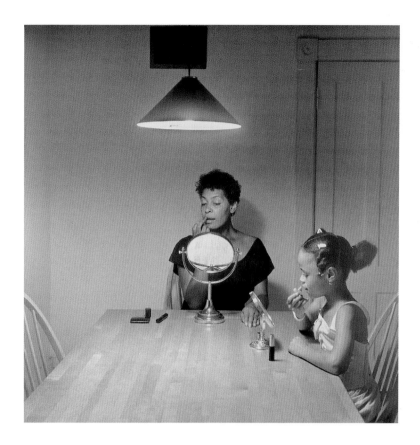

FROM *KITCHEN TABLE*

CARRIE MAE WEEMS

Date 1990
Location Massachusetts, USA
Format Medium format

The *Kitchen Table* series by artist Carrie Mae Weems (born 1953) has become a key work in the representation of the African-American experience. Weems began the series in 1989 and used herself as the subject simply because she was available. There was not a wealth of photographic art on the subject of gender, race, or identity politics at the time, and although this is no longer the case, her work stands the test of time. In this photograph, a woman and child, in the roles of mother and daughter, sit at the eponymous kitchen table, each applying cosmetic products, which necessitates a careful study of the face. Both are dressed for the possibility of an evening out and seem engrossed in the ritual of preparation. The room is stark, bar the bright overhead light, and the table and chairs.

Other images in this series continue to probe societal assumptions—the woman enjoying her own company, playing cards, and drinking wine; the woman observing a man lost to his own pursuits and pleasures—but there are no easy answers. This nuanced work is not self-portraiture, but rather a highly performative take on the politics of domesticity, in which race plays an important, but not central, role. MH

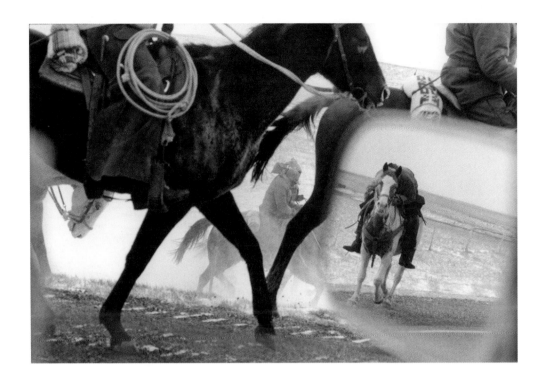

BIG FOOT MEMORIAL RIDE

GUY LE QUERREC

Date 1990
Location South Dakota, USA
Format 35 mm

Before making his professional debut in 1967, Guy Le Querrec (born 1941) was known for his images of jazz musicians. In 1969, he began to work for *Jeune Afrique* magazine, based in francophone Africa. Entrusting his archives to Agence Vu in 1971, he cofounded the Viva agency. Le Querrec began to direct movies in the 1970s, and in 1976 he joined Magnum Photos. He has documented a broad scope of subjects, ranging from Native Americans to the Portuguese Carnation Revolution of 1974.

This photo, taken in South Dakota, captures the fifth day of the Big Foot Memorial Ride of 1990, which commemorated the 100-year anniversary of the US-backed assassination of Sitting Bull during the massacre at Wounded Knee. The image documents Sioux Indians as they trace the route of their ancestors. Multiple layers within the photograph heighten the drama of the scene. Two horses are running directly alongside the car; another two gallop behind them. A rider is framed by a diamond shape formed between the two nearest horses, and a fifth horse, seemingly charging, is captured in a wing mirror. The complexity of perspectives seems to reflect both present and past events along the Big Foot Trail. EC

MASS GRAVESITE, CALAMA, CHILE, OCTOBER 1990

PAULA ALLEN

Date 1990

Location Atacama Desert, Chile

Format 35 mm

On September 11, 1973, Socialist president Salvador Allende's government was overthrown by the Chilean military, led by General Augusto Pinochet. One month after the coup, a contingent of soldiers embarked on a mission that came to be known as the "Caravan of Death." They traveled to five cities throughout Chile, executing people. The caravan's last stop was in the northern town of Calama. There, twenty-six men were executed and their bodies were buried in a secret mass grave in the Atacama Desert, a place that the perpetrators thought would be too desolate and unforgiving to allow anyone to ever uncover their crimes. Yet, this was far from the end of the story. Female family members of the "disappeared" men gathered together and spent the next seventeen years looking for their bodies. They set out into the Atacama with only their shovels, digging until they discovered the gravesite containing the crushed remains of their relatives, only 9 miles (15 km) from Calama.

This image shows the vast expanse of the desert on one side and on the other the quiet shadows of the relatives looming tall over the gravesite. It is from the series *Flowers in the Desert* by social documentary photographer Paula Allen. SY

WEDDING RECEPTION

WITOLD KRASSOWSKI

Date 1991
Location Kabul, Afghanistan
Format 35 mm

The little girl in this picture appears to be dancing on the table, but she is actually participating in a form of marriage advertisement. Photographer Witold Krassowski (born 1956) commented, "Of course, children do not marry in Afghanistan but deals can be arranged very early. Every social occasion offers potential. Well-dressed girls are put on tables for better display and appreciation. The harsh reality of life in Afghanistan doesn't allow for sentimentality."

By the 1990s, war had dominated Afghanistan for centuries—a familiar, local war, codified and part of the culture: no fighting inside villages, no targeting women and children, no destroying of irrigation systems. Russian invaders changed all that, hence the country's fight for survival. Traditional Afghan families found it hard to cope with economic hardship once their men had left, either to join various armies or to escape to refugee camps in Iran. At that time, women could not be seen alone in public spaces, thus limiting their chances of earning a living. Normal family life was rare in those times, but the logic of life was inexorable. Children had to work; people had to marry to have more children to fight the war. CJ

THE SON OF GOD

CARL DE KEYZER

Date 1991
Location Daytona Beach, Florida, USA
Format Medium format

The work of Magnum photographer Carl de Keyzer (born 1958) is heavily peopled: he composes bodies within his frame with apparent ease, using black-and-white flash photography to create stark, crisp images that reveal more the longer they are viewed. Looking at the groups he captures, often every face is interesting or suggestive. The effect he creates is one of broad and expansive representation, which he uses here to ask the question: "How religious is America?"

This image was shot during a biking event for which 400,000 bikers—members of a religious group named "The Son of God"—descended on Daytona Beach. In his book *God, Inc.*, de Keyzer explores American conceptions of and approaches to faith, ranging from Mormon holidays to church choirs. Everywhere the motifs of religion and Americana recur, and this is emphatically the case here: in a perfect Floridian beach setting ,two women sunbathing are bisected by the star-spangled banner and a man carrying a full-size wooden cross. The image's multilayered effect is suggestive of US religious fervor and ceremony—and it is likely that it was chosen for the cover of *God, Inc.* for this reason. AZ

FOAM PARTY, AMNESIA CLUB

DAVID ALAN HARVEY

Date 1991
Location Ibiza, Spain
Format 35 mm

For this photograph, taken on assignment for *National Geographic* magazine, Magnum photographer David Alan Harvey (born 1944) climbed onto the lighting rig above the dance floor. He wanted to capture the nightclub's foam party from an unusually high vantage point. The resulting image is intense: the tightly packed figures are anonymous and dynamic, while the photograph's strong yellow hue (captured on vivid Kodachrome film) suggests something sulfuric and ominous. The picture could be a vision of hell. Viewers' eyes are pulled straight into the frenzy frozen by the camera, the amorphous pattern of human shapes rising indiscriminately from the sea of foam.

Having planned to stay in Ibiza for only two days, Harvey extended his trip to two weeks; he was "pulled into the scene." He attended the foam party twice, and had to convince the managers to allow him to climb onto the lighting structure to take this shot. As the lights in the club were changing constantly, this was the only frame that looked like this. Taken at 4 a.m., the photograph serves as a document of 1990s nightclub culture on Spain's infamous party island. **AZ**

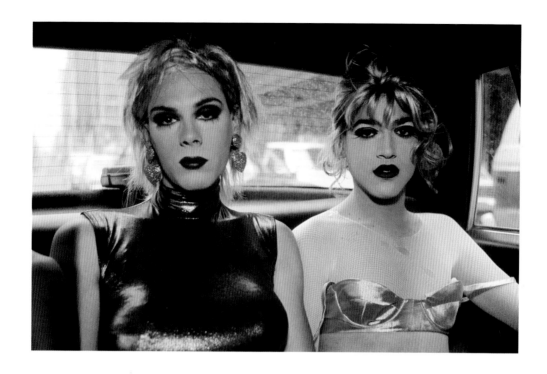

MISTY & JIMMY PAULETTE IN A TAXI, NYC

NAN GOLDIN

Date 1991
Location New York, New York, USA
Format 35 mm

Nan Goldin (born 1953) discovered drag queens in her hometown of Boston, Massachusetts, in the 1970s. She said: "They became my whole world. Part of my worship of them involved photographing them. I never saw them as men dressed up as women, but as something entirely different—a third gender that made more sense than either of the other two." One can see this homage in much of Goldin's work, which captures the humanity and normality of persecuted minorities, first the gay community and, by the early 1990s, transsexuals, too. This photograph has the aura of a snapshot, yet it does not feel like a stolen moment; although Misty and Jimmy Paulette are unsmiling, they appear open to Goldin and look straight into her camera. She took several photographs on this day, the day of the Gay Pride Parade in New York, at a time when the community was deeply affected by deaths from HIV/AIDS. The images have an intimate feel; Goldin's camera went largely unnoticed by a group that was accustomed to her presence. Years of friendship and time spent in the communities she documented helped her to create work that would not have been possible without the cooperation of her subjects. CP

THE TAVERN OF ALI

NIKOS ECONOMOPOULOS

Date 1991
Location Alexandroupolis, Greece
Format 35 mm

Greek photographer Nikos Economopoulos (born 1953) prefers to work independently, free from the editorial confines of press commissions, and likes to work in southern Europe and western Asia where he can understand the codes and make connections. Making connections is crucial to the longer in-depth stories that Economopoulos undertakes, which often deal with marginalized communities.

This image is a portrait of a man from one such marginalized group, Greek gypsies. Although they have been part of Greek life for hundreds of years, they were only recognized as Greek citizens in 1979. Within a wider population of roughly 300,000, Muslim gypsies form a much smaller group of 25,000 people, and both groups face multiple issues of poverty, illiteracy, and racism. In an expressive body of work, Economopoulos shows the extreme poverty of their lives, but there are also images of joy and celebration, of people making the best out of difficult circumstances. This is one such photograph: it shows a Muslim man drinking alcohol, which runs counter to preconceived notions of Islam being a homogenized religion. He is holding up a chair without losing his balance in order to prove his sobriety. NG

CHARRED CORPSE OF AN IRAQI SOLDIER

KENNETH JARECKE

Date 1991
Location Iraq
Format 35 mm

This horrific image shows an Iraqi soldier burned to a cinder at the wheel of his vehicle on the road to Basra at the end of the First Gulf War. Allied pilots relentlessly attacked the demoralized Iraqi troops as they retreated from Kuwait; some pilots referred to this action as a "turkey shoot."

Photographer Kenneth Jarecke (born 1963) was working on assignment for the US publication *Time*, but the magazine declined to publish his picture. The US agency Associated Press also refused it, saying, "Newspapers will tell us, 'We cannot present pictures like that for people to look at over their breakfast.'" *The Observer* in London was the only publication to print it as a news picture, with the caption: "The real face of war." Writing in the *British Journal of Photography*, *The Observer* picture editor justified the publication: " . . . war is disgusting, humiliating, and degrading, and diminishes everyone." Jarecke commented that he had not "risked his life to do his job, for nothing. If the US is tough enough to go to war, it should be tough enough to look at the consequences." CJ

THE HIGHWAY OF DEATH

UNITED STATES AIR FORCE

Date 1991
Location Southern Iraq
Format Gun camera screenshot

After Iraq's invasion of Kuwait in August 1990, the United States and its allies intervened militarily to force a withdrawal. From a media perspective, the First Gulf War (1991) was significant because camera technologies had been integrated into many of the weapons that were used to fight it, meaning that the conflict generated a wealth of visually striking imagery often filmed directly from aircraft, missiles, and bombs. With stringent restrictions on reporting from the ground, this imagery inevitably became a mainstay of press coverage of the war.

The reliance on these images was problematic, however, because the stills and video footage presented a deeply one-sided view of the conflict. Footage from bombers depicting surgical strikes using laser-guided bombs gave the impression of a bloodless "video game war," when the reality was very different. On the night of February 26–27, 1991, coalition aircraft attacked a column of around 1,400 Iraqi vehicles retreating along Highway 80 from Kuwait to Basra. Observers described it as a massacre, and estimates of the dead range from several hundred to as many as 10,000. "It was like shooting fish in a barrel," one US pilot said later. LB

PAVEMENT MIRROR SHOP

RAGHUBIR SINGH

Date 1991
Location Howrah, India
Format 35 mm

Raghubir Singh (1942–99) was an important figure in the history of photography not only because of his photographs, but also because of the political self-awareness that accompanied them. In an essay in *River of Colour* (1998), his final book, Singh wrote about the legacies of colonialism for Indian art and culture, and specifically how the photography of the British administration brought with it a way of seeing that was alien to India, implicitly laden with Christian ideas about guilt and death that he regarded as oppressive.

Singh photographed exclusively in color, which represented for him an intrinsically Indian way of seeing: Western photographers "know" color through the mind, he said, while Indians know it through intuition. This street scene demonstrates Singh's eye for the vibrancy and color of Indian life, without resorting to reductive or sentimental stereotypes. With remarkable skill he uses the mirrors for sale on the stall to fragment the picture plane, creating a compelling montage of pictures within pictures. Each vignette is perfectly composed, the elements of color and form impeccably balanced across the frame. JG

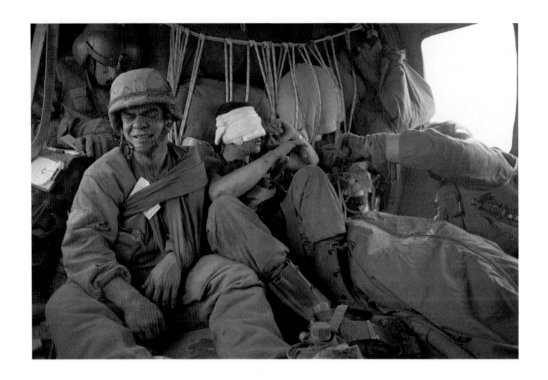

US SERGEANT KEN KOZAKIEWICZ MOURNS THE DEATH OF FELLOW SOLDIER ANDY ALANIZ, KILLED BY FRIENDLY FIRE

DAVID TURNLEY

Date 1991
Location Euphrates Valley, Iraq
Format 35 mm

Media coverage of the First Gulf War was more tightly managed than it had been during any previous conflict; the United States and its allies made strenuous efforts to show journalists only their new sophisticated weaponry and thus conceal the obverse side—the carnage and the chaos. This image, however, echoes key themes of earlier war photography, depicting the humanity and camaraderie of soldiers in difficult conditions. David Turnley (born 1955) took this picture while traveling with a mobile medical unit on an evacuation mission on what turned out to be the last day of the war. Journeying with the medics allowed the photographer greater freedom. After their Bradley fighting vehicle had been severed in two by a "friendly fire" missile, two injured soldiers were loaded into the helicopter, along with the bagged body of their driver. Turnley captures the moment when Sergeant Ken Kozakiewicz realizes that the dog tag of the dead soldier belongs to his friend Andy Alaniz.

Although the US military tried to delay the release of this photograph, it was transmitted globally by major magazines and wire services, and was awarded World Press Photo of the Year. CP

AFTER THE VOLCANO

PHILIPPE BOURSEILLER

Date 1991
Location Philippines
Format 35 mm

Mount Pinatubo on the island of Luzon in the Philippines erupted on June 15, 1991, killing hundreds of people; it is considered to be the second largest volcanic explosion of the twentieth century. The volcano produced rapid avalanches of hot ash and noxious sulfur dioxide gas, giant mudflows, and a cloud of volcanic ash that rose as high as 22 miles (35km) and spread more than 300 miles (480km), turning day into night over central Luzon.

As a young photojournalist, Philippe Bourseiller (born 1957) trekked through difficult conditions to document the after effects of this natural disaster. Although taken in color, this image verges on the monochrome, dominated by the silvery ash and the brooding sky. The contrast between the surreal environment depicted and the seemingly casual pose of the village inhabitant is extraordinary. Such a photograph can encourage empathy more successfully than the extreme scenes of death and destruction more often associated with natural disasters.

Bourseiller continued his interest in volcanoes, photographing about sixty of the estimated 1,500 that exist around the world. **CJ**

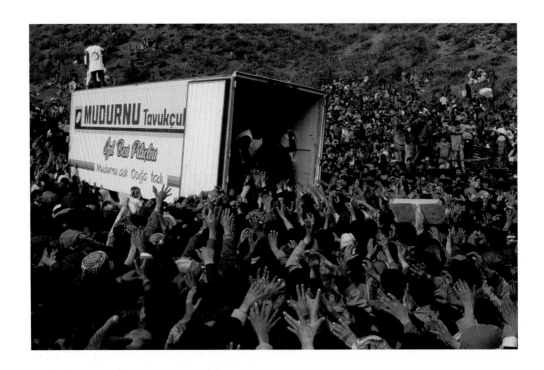

KURDISH REFUGEES FROM NORTH IRAQ MOB A
FOOD AID TRUCK AT ISIKVEREN REFUGEE CAMP

ROGER HUTCHINGS

Date 1991
Location Border of Turkey and Iraq
Format 35 mm

Taken literally, this photograph by Roger Hutchings (born 1952) shows starving Kurdish refugees reaching out to receive food supplies from an aid truck. Metaphorically, the outstretched arms can be read as a symbol of the desperation and dire needs of the displaced Kurds. In 1991, the end of the Gulf War was in sight. Kuwait had been liberated after the invasion by Iraqi troops under Saddam Hussein, but there was more bloodshed to come. Shia uprisings in southern Iraq and by the Kurds in the north were brutally quashed by Iraqi forces at Hussein's behest, triggering the evacuation of civilians to the borders of neighboring Turkey and Iran. An estimated 1.5 million Kurds fled across the mountains. Many made the journey on foot and hundreds perished due to exposure, disease, and hunger. Those who survived settled in so-called "safe havens" created by coalition forces on the freezing mountain slopes. The UN air-dropped supplies, and American military personnel at Isikveren—one of the largest camps with 80,000 Kurds—assisted in the distribution of food across mountain regions. This photograph is testimony to Hutchings's determination to record, simply but powerfully, the plights of ordinary people displaced by conflict. **GP**

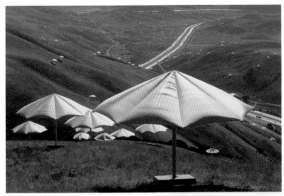

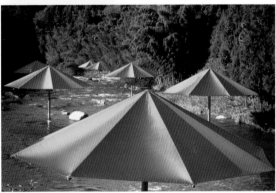

CHRISTO AND JEANNE-CLAUDE:
THE UMBRELLAS, JAPAN–USA, 1984–91

WOLFGANG VOLZ

Date 1991
Location California, USA/Ibaraki, Japan
Format 35 mm

They dot the landscape as far as the eye can see: the yellow and blue umbrellas of the remarkable work, *The Umbrellas, Japan–USA* by artists Christo and Jeanne-Claude. It was a breathtaking sight when they were installed on October 9, 1991. The temporary environmental artwork saw 1,340 giant yellow umbrellas erected across an 18-mile (29-km) long site north of Los Angeles, and 1,760 blue umbrellas installed on a 12-mile (19-km) long stretch of land in Ibaraki, Japan. The idea behind the

project was to reflect the similarities and differences between the two countries, in particular the uses of the land and ways of life in each place. Almost 2,000 workers installed the umbrellas, and members of the public were invited to admire them up close or from afar. But on October 26 tragedy struck when a gust of wind uprooted an umbrella on the California site and it crushed a woman to death. The installation was completely dismantled at Christo's request, but it claimed another life, this time of a worker dismantling the artwork in Japan.

Wolfgang Volz has documented the artists' life and work since 1971 and was the project's official photographer. These images brilliantly capture the scale of *The Umbrellas*. **GP**

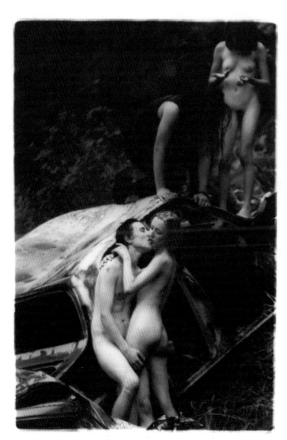

UNTITLED

BILL HENSON

Date 1992
Location Australia
Format 35 mm

Bill Henson (born 1955) is widely regarded as one of Australia's finest contemporary art photographers. He gained notoriety at an early age, when his first solo show was staged at the National Gallery of Victoria in 1975 before he had reached his twentieth birthday. Since then he has been the subject of numerous exhibitions worldwide, and was chosen to represent his country at the Venice Biennale in 1995.

This artist's aesthetic is instantly recognizable: dramatic lighting and blurred backgrounds of constructed, yet intimate scenes played out in ethereal, shadowy landscapes. The references to early Romantic paintings in his work are undeniable: nude figures feature prominently, their skin translucent against the twilight. In this image, a naked adolescent couple—a young Adonis and his Venus—embrace against a car wreck in a woodland glade.

Henson shoots primarily on film, preferring the depth of tone it can convey, and in the past he has been particularly drawn to the theme of adolescence. Focusing heavily on young subjects who are most often nude has meant that the photographer's work has not been without controversy. An exhibition in 2008 in a Sydney gallery was shut down by the police before it opened because it featured photographs of nude teenagers and was deemed to be pedophiliac. Ultimately no charges were brought against the artist, who stated that he did not intend to cause ill feeling: "Some people decide they want to be controversial," he said. "I don't know who in their right mind could be so stupid." **LH**

"Shadows can animate the speculative capacity in the viewer in a way that highlights can't." Bill Henson

I'M DESPERATE

GILLIAN WEARING

Date 1992–93
Location London, UK
Format 35 mm

At the heart of this photograph lies a question: really? The veracity implied by the handwritten statement and by the snapshot aesthetic of this candid portrait by British conceptual artist Gillian Wearing (born 1963) is belied by the self-assured expression and the suit of the man pictured. The tension here between appearance and inner life is exactly what Wearing brought into focus in her landmark series *Signs that say what you want them to say not signs that say what someone else wants them to say.*

Wearing approached strangers on the streets of London who struck her as interesting and asked them what they were thinking or feeling at that moment. They wrote their answer on a sheet of A3 paper that she provided, then held it up, and she photographed them. Wearing took 600 portraits in this way, creating a series of images that renders the complexity of personality and individual experience, and provides a snapshot of London lives at the time. The subjects' statements range from the frank to the philosophical to the poetic. A young homeless man holds his paper so that it obscures his face, one eye gazing dully at the lens: "Give people houses there is plenty of empty one's OK!" Some are enigmatic: a helmeted policeman with a walkie-talkie clipped to his shoulder holds up a sign that reads "HELP."

Wearing won the annual British fine arts award, the Turner Prize, in 1997. Of her work, she says: "Intuitively, I find ways to reflect life back and the audience relates to it because there isn't any judgment. That's one thing I would never do in my work: judge people." RF

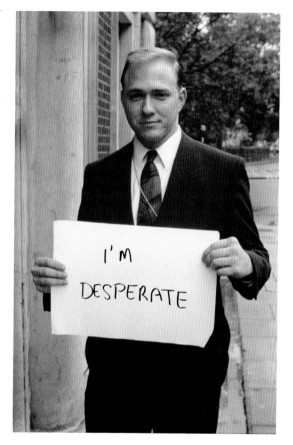

"I think he was actually shocked by what he had written, which suggests it must have been true."
Gillian Wearing

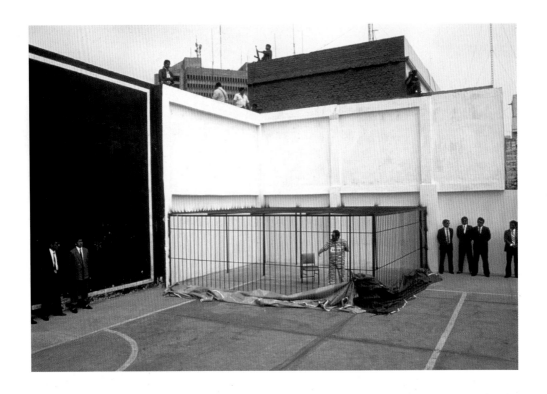

ABIMAEL GUZMÁN—SENDERO LUMINOSO

ANA CECILIA GONZALES-VIGIL

Date 1992
Location Lima, Peru
Format 35 mm

Organized as far back as the 1960s in Peru, the Shining Path (Sendero Luminoso) is a Communist military group. In 1980, it "launched" an internal conflict in Peru with the stated intention to eliminate the "bourgeois democracy" and install a "new democracy"—a type of cultural revolution leading to a "pure form of communism." What followed were years of terror during which villagers were caught up in a war between the guerrilla group and the Peruvian government. Children as

young as twelve were abducted from villages and indoctrinated so that they would commit heinous crimes. By the 1990s, thousands of people had been murdered.

This image by freelance photographer Ana Cecilia Gonzales-Vigil (born 1961) shows the leader of the Shining Path, Abimael Guzmán, in a cage after he was taken prisoner. He had been pursued for years, and this photograph shows that the government wanted a clear view of him at every moment even though he was heavily guarded. Tried by a military tribunal of hooded judges who feared retaliation, he was sentenced to a life in prison but the Shining Path continued to remain active without him. SY

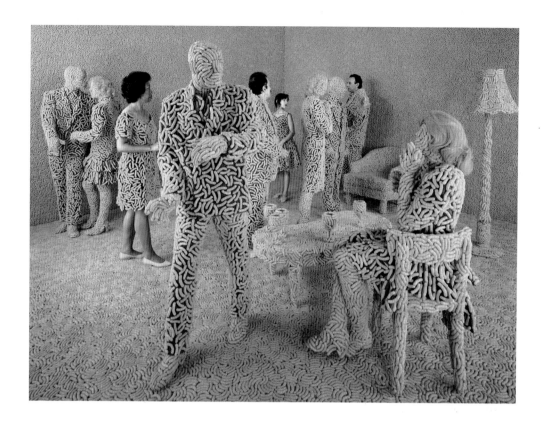

THE COCKTAIL PARTY

SANDY SKOGLUND

Date 1992
Location New York, USA
Format Unknown

For *The Cocktail Party* by Sandy Skoglund (born 1946), nothing, it seems, was too outlandish. Chairs were painted and models dressed in outfits covered in cheese puffs. Even the walls and furniture were given the cheese-puff treatment. Every inch of this surreal and elaborate tableau was painstakingly crafted by Skoglund and her assistants. But this was nothing new. She had for decades been making off-the-wall artworks that play with the overlap between photography and installation.

By creating sets that take a long time to install, all for the sake of a photograph—typically a more instantaneous medium—Skoglund raises important questions about what a still photograph could be. Her images ask viewers to consider where one artwork (the installation) ends and the other (the photograph) begins. There are no easy answers, but Skoglund delights in the ambiguity. At the heart of her work is the clash between what is real and what is not. Perspective is skewed, real-life models are indistinguishable from mannequins, and everything is turned upside down. Her sugarcoated, nightmarish visions are as unsettling as they are intriguing. Nothing is as it seems, but that is precisely the point. **GP**

PRINCESS DIANA

ANWAR HUSSEIN

Date 1992
Location Agra, India
Format 35 mm

This famous shot of Princess Diana sitting alone in front of the Taj Mahal epitomizes the mood of the trip she took to India with Prince Charles in 1992. The royal couple's marriage had lasted eleven years but it was no secret that it was on the brink of collapse. The photoshoot foreshadowed the pair's separation four months later and their eventual divorce in 1996, a year before Diana's death in an automobile crash in 1997. Ironically, Prince Charles had been photographed in the same spot twelve years earlier. The image accentuates Diana's loneliness, isolation, and vulnerability; she seems alone, but across from her were dozens of paparazzi vying to take the image that would appear in the next day's papers.

Diana Spencer, the Princess of Wales, was a major style icon and was celebrated for her charitable work, especially for her support of the International Campaign to Ban Landmines. She and Prince Charles married in 1981, and they had two sons, princes William and Harry, but the couple's incompatibility was soon apparent. Their visit to India was one of the last trips they took together. The bench featured in the photo is now known affectionately as "Lady Di's Chair." EC

BACKSTAGE AT THE OPERA

GÉRARD UFÉRAS

Date 1992
Location Salzburg, Austria
Format 35 mm

Born in Paris, Gérard Uféras (born 1954) started his career working for daily newspaper *Libération*. In 1988, he participated in a project about Opéra Garnier and became fascinated by the atmosphere backstage. He went on to photograph behind the scenes in many of Europe's best-known opera houses, including in London, Milan, Moscow, Barcelona, and Salzburg. This intriguing image was taken during a performance of Leoš Janáček's *From the House of the Dead* (1930) at the Salzburg

Festival, Austria. The low-lit mood is surreal but the narrative is more prosaic: the Crow is disappearing in search of a drink during the interval.

By choosing to show the hidden aspects of backstage life—the hard work, the interactions and machinations, the rest and relaxation—Uféras risks undermining the illusionary magic that audiences expect from the theatricality of opera. Yet by showing what is normally unseen, he allows the audience to leave their seats and experience a secret world, witnessing the hopes, fears, joys, and expectations of the creative spirits that produce and perform opera. The photographer's gaze is subtle, sensitive, and profoundly respectful; it is also often very witty. CJ

SOLOVKI, WHITE SEA, RUSSIA

PENTTI SAMMALLAHTI

Date 1992
Location White Sea, Russia
Format Panoramic

Pentti Sammallahti (born 1950) fell in love with photography at the age of nine, when he visited the groundbreaking *Family of Man* exhibition, which showcased hundreds of images by photographers working around the world, in his native Helsinki, Finland. By the age of eleven, he was taking his own photographs of everyday life, and when he was only twenty years old he had his first solo exhibition. He is widely recognized as the great pioneer of modern Finnish photography, and his reputation extends throughout Europe. Henri Cartier-Bresson featured Sammallahti in his foundation's inaugural exhibition; Danish critic Finn Thrane has written that Sammallahti "steps outside time and instead grapples with the great mysteries that existence offers the curious."

Most of Sammallahti's work is produced in black and white—dreary, dark, often snowy landscapes and seascapes shot while the light shifts during the transition from day to night. Rarely does his work contemplate humanity; it has been likened

to fairy tales or the supernatural, in which animals lead the narratives. This panoramic image of a dog carrying a handbag down a snow-covered path is typical of Sammallahti's preoccupation with animals in stark landscapes. Instead of shooting spontaneously, Sammallahti patiently waits for the perfect frame to come to him. "Finding myself on a rocky island," he has said, "I suddenly understood what the stone near me, the ship on the shore, the cloud navigating the sky, and the salient, sporadic calligraphies drawn by migrating birds were telling me . . . Then I understood that you don't take photographs, you receive them."

Almost everything that Sammallahti "receives" in his viewfinder in this way is enriched by the encounter—his best-known images are of wintry scenes, as here, but he has produced masterly photographs of every season, and of the subtle changes that take place between them.

The quintessence of Sammallahti is always the silence of the surroundings. Writing in the British newspaper *The Guardian*, critic Sean O'Hagan has perceptively commented that Sammallahti's best photographs transport the viewer to "the threshold of another, more mysterious world that is indeed here and far away." LH

MARKET

GUEORGUI PINKHASSOV

Date 1992
Location Tashkent, Uzbekistan
Format 35 mm

Brought up in Moscow, Gueorgui Pinkhassov (born 1952) studied cinematography and became a set photographer for Mosfilm studio. While there, he was deeply affected by the movie *Solaris* (1972) by legendary filmmaker Andrei Tarkovsky, which he has said completely changed his photographic vision. Often regarded as a poet of cinema, Tarkovsky introduced Pinkhassov to the work of Henri Cartier-Bresson, who encouraged the latter to become a photojournalist.

Part of a documentary story on Uzbekistan, this image of a chicken caught in a shaft of light against the silhouette of people in Tashkent's oldest bazaar offers an experimental approach that touches on the abstract. Pinkhassov admits a certain amount of luck was involved in capturing the shot: "I didn't think of the composition, it was just a reflex reaction—as Cartier-Bresson said, a photographer shouldn't think, just use their intuition." In addition, his choice of film—Kodachrome 200—helped to emphasize both the contrast and the red in the image. Tinged with a wry humor, like the best of Cartier-Bresson's early work, the image draws power from its surprising juxtaposition of elements and light. **NG**

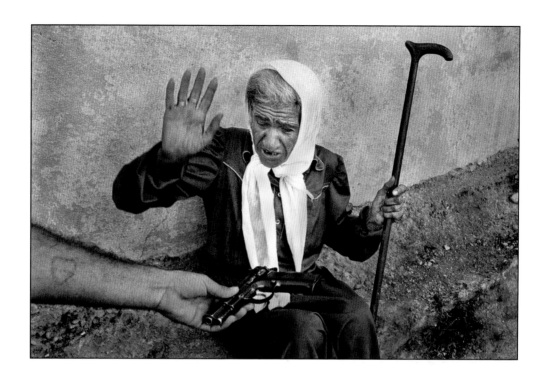

PALESTINIAN WOMAN REJECTS GUN

JUDAH PASSOW

Date 1992
Location West Bank, Palestine
Format 35 mm

Judah Passow (born 1949) spent four weeks living in the troubled Palestinian village of Fahme, just outside Jenin on the West Bank. All the men in the village were collaborators with Shin Bet—the Israel Security Agency—something that infuriated the local women because it had completely undermined the fabric of village life. They could not go into Jenin to buy food, and the children were unable to leave the village to go to school. Armed Palestinians from various militia factions

frequently ambushed cars that were entering or leaving Fahme. As Passow started to photograph this old woman, whose husband and son were both collaborators, her son drove into the yard. The son watched for a minute and then reached behind his back and pulled out his pistol, offering it to his mother, saying that it might make a better photograph if she held the weapon. Passow recalled: "I saw this photograph unfolding in slow motion, like a clip of cinema, watching through my viewfinder. The mother's anger peaked as she started cursing her son . . . " Her disgust summed up the feelings of the women of the village toward the endless cycle of violence that ruined their lives and those of their families. CJ

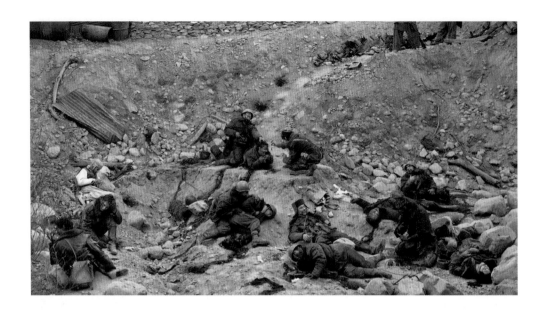

DEAD TROOPS TALK (A VISION AFTER AN AMBUSH OF A RED ARMY PATROL, NEAR MOQOR, AFGHANISTAN, WINTER 1986)

JEFF WALL

Date 1992
Location Vancouver, Canada
Format Large-format lightbox transparency

This image is typical of the work of Jeff Wall (born 1946): carefully constructed and fantastical, yet addressing serious historical matters. Here, Wall commemorates a fictional incident from the Soviet Union's attempt to occupy Afghanistan in the 1980s, using his characteristic black humor to comment on the senselessness of violence. He borrows from the aesthetic repertoire of war photography, zombie horror movies, and history painting to imagine a fiction in which soldiers recently killed in

an ambush come grotesquely back to life to reflect on their experiences in what he calls a "dialog of the dead." Their reactions seem to range from distress to confusion and perverse joking around.

The work was created in a studio in Vancouver, using a team of performers, special effects artists, and makeup designers, who "pored through graphic forensics imagery, studying sinew, bullet damage, bone fracture, ripped and shredded flesh. They then made life casts of the actors [and] sculpted the horrendous injuries . . . Some items were done as prosthetics, others were stand-alone pieces that had to be positioned extremely precisely in space." It was photographed in parts that were later digitally stitched together. JG

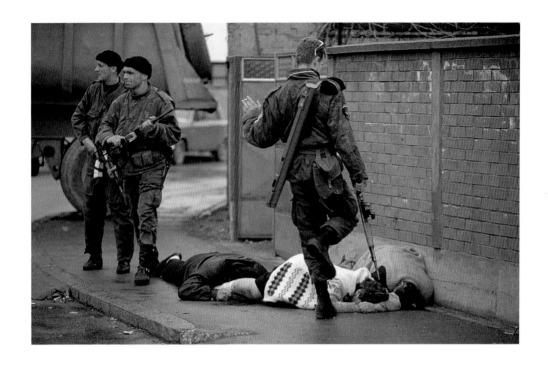

FROM *BLOOD AND HONEY*

RON HAVIV

Date 1992
Location Bilijenia, Bosnia-Herzegovina
Format 35 mm

Paramilitary units and militias played a crucial role in the early stages of ethnic cleansing during the war that engulfed the emerging state of Bosnia-Herzegovina in April 1992. Ron Haviv (born 1965) gained access to a unit led by the late criminal Željko Ražnjatović, known as Arkan, under the condition that he did not photograph any killings. However, once he entered the idyllic town of Bilijenia, he witnessed the summary executions of civilians in the streets. Haviv's image was taken with a telephoto lens from a safe distance while the perpetrators carried out the killings. There is a nonchalant sense of impunity, with the perpetrator casually holding a cigarette in one hand and an AK47 assault rifle in the other, sunglasses on his head. The three civilians lie in a pool of blood, and one covered her face with her hands to try to protect herself from the high-velocity bullets shot from point-blank range. What else could she do? Soon after Haviv's images were published, Arkan put the photographer on a death list, and he spent the subsequent years covering the war in former Yugoslavia while hiding from the warlord. This image became synonymous for the particular brutality of the Bosnian war. ZG

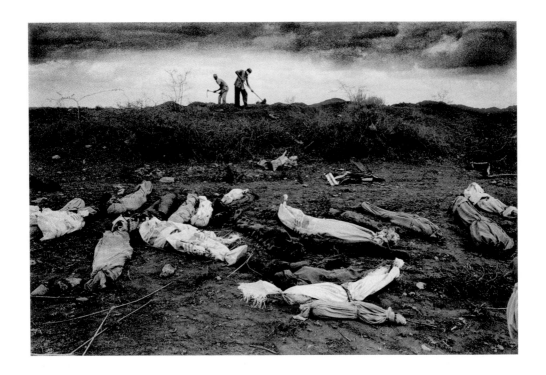

BURYING THE DEAD

PAUL LOWE

Date 1992
Location Somalia
Format 35 mm

In 1991, militia groups overthrew Somalia's totalitarian president Siad Barre. Their inability to agree on a successor plunged the country into civil war and lawlessness, creating conditions that led to a crippling famine. US Marines were sent to Mogadishu in 1992 to protect the United Nations peacekeeping force that was due to deliver relief supplies and to restore order. After a year, US troops withdrew and Somalia went on for a further thirteen years without a government.

British photojournalist Paul Lowe (born 1963), then working for Network Photographers, went to Somalia in 1992 to document the famine that was claiming the lives of several hundred Somalis every day. Because of looting by armed gangs, aid was not adequately reaching the victims of the famine until Operation Restore Hope was launched at the end of the year. In this apocalyptic image, the silhouettes of gravediggers are seen on the horizon, working to keep up with the amount of dead bodies arriving at the cemetery. The photograph is part of Lowe's series from Somalia that won a first prize story award in the General News category at the 1993 World Press Photo Awards. LH

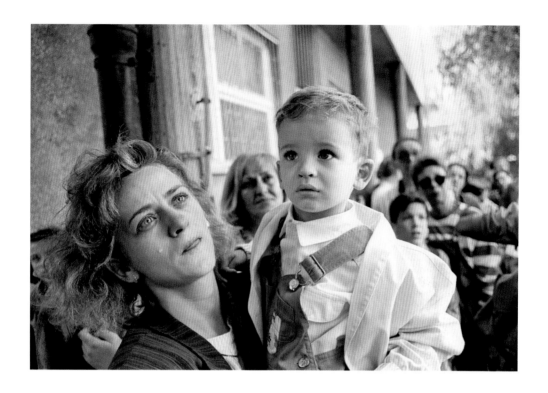

A WOMAN CRIES AS HER SON IS EVACUATED
FROM SARAJEVO

TOM STODDART

Date 1992
Location Sarajevo, Bosnia-Herzegovina
Format 35 mm

This image was taken by acclaimed photojournalist Tom Stoddart (born 1953) at the beginning of the Bosnian war of independence from Serbia. Here, a mother is lining up to put her son on a bus that is evacuating the city, a rare instance in which Serbian forces allowed children to escape. Stoddart said of the photograph: "I saw the woman—who was very striking, with blue eyes—fighting back her tears. She had dressed her little boy in his finest kit, and it was obviously a very emotional time.

There was also tension in the air; the Serbian forces were not averse to lobbing grenades into crowds. I shot a few frames up close and the picture was used around the world." More than a decade later, Stoddart learned that the woman, named Gordana, and her son lived in Perth, Australia. He tracked them down, and she explained how she always hated the photograph whenever she saw it. Even though Stoddart thinks the image is quite powerful—in that the viewer relates to the subject by "trying to read what's going on in their minds, without them even noticing you"—Gordana explained that it captured her at her most vulnerable, when she was trying her best to remain dignified in a dire situation. LH

HILTON HEAD ISLAND, SOUTH CAROLINA

RINEKE DIJKSTRA

Date 1992 **Location** Hilton Head Island, South Carolina, USA
Format Large format

Dutch photographer Rineke Dijkstra (born 1959) is known for her searingly frank portraiture, particularly that of young people. Her series *Beach Portraits* (1992–98), to which this image belongs, shows teenagers in coastal locations around the world, posed against a simple backdrop of the sea. The project dates from a time before social media and shows a view of adolescence that is very different from that projected by Instagram and "selfie" culture. The photographs convey the sensitivity, vulnerability, and awkwardness of their subjects, while at the same time betraying the influence of celebrity culture and the expectations of the adult world. Dijkstra says that she was "always trying to find an uninhibited moment, because when you work with a really big camera on a tripod people become aware of their own presence." At the same time, she was conscious of "how much the media played a role in how people think about how they want to be photographed."

This picture was taken in South Carolina, and it recalls not only modern media imagery, but also Italian Renaissance painting. The girl's pose is strikingly similar to that seen in Sandro Botticelli's *The Birth of Venus* (1482–86), the goddess emerging naked from the sea, shielding her body with her long blonde hair. However, Dijkstra's real interest is in ordinary people: "I realized if you strip everything away, with no backgrounds and just the sea and sky and a bathing suit, it's only about the pose and stance of people ... if somebody is making a little gesture or has a ring on, you see it because there's nothing else in the picture to look at." **JG**

"There has to be a tension in their posture or a gesture that distinguishes them from other people." Rineke Dijkstra

LUTZ AND ALEX SITTING IN THE TREES

WOLFGANG TILLMANS

Date 1992
Location UK
Format 35 mm

Wolfgang Tillmans (born 1968) is committed to the pursuit of an evolving, contemporary view of the world that does not resort to prior notions of beauty or to conventional ways of seeing. As a result, he is difficult to categorize, although he has made some of his most influential work within the genre of fashion photography. After first gaining a reputation for informal photographs of his friends, he went on to work for publications such as British fashion magazine *i-D*. In 2000, he guest edited *The Big Issue*, a magazine sold on the streets of the United Kingdom by homeless people, using it as a showcase for a range of boundary-breaking imagery.

Alex and Lutz are Tillmans's childhood friends, and they appear repeatedly as models in his work. The three moved from their native Germany to London in 1990. Tillmans writes of that time: "I didn't see my own vision represented in the photography that I saw; that was my motivation. A lot of photography was either stylized or overly artistic—I photographed what I saw with little artifice. What got a lot of people mad about my work was how un-artificial it looked, and that is exactly what I worked hard to control. They were anything but snapshots." In this image, Alex and Lutz are half-naked, modeling raincoats for a fashion label, but there is little to associate what we see with conventional fashion photography. Although clearly styled and carefully composed, it retains an air of informality. The photograph is an example of Tillmans's freshness of vision, which led to him winning the prestigious Turner Prize in 2000. **JG**

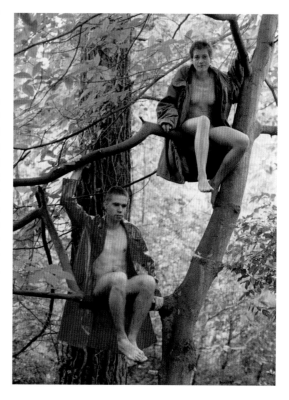

"Two people sitting naked in a tree is hardly a documentary picture, but it was somehow instantly seen as a picture of the zeitgeist, of the reality."

Wolfgang Tillmans

BUBBLE BOY

TIM CLAYTON

Date 1993
Location Australia
Format 35 mm

Sports photographers are always searching for that special shot that surprises the viewer, and shows them an aspect of the event that is unusual or visually arresting. Tim Clayton (born 1960) was shooting the Australian athlete Matthew Dunn in training when he captured this extraordinary image of his head emerging from the water surrounded by a "bubble," caused by the surface tension of the water, just before it was broken by the thrust of the swimmer's head. By shooting with a long telephoto lens, Clayton has compressed the distance between the viewer and the swimmer, throwing the background into soft focus so that all of the viewer's attention is concentrated on his eyes and the curve of the water's surface.

The dramatic image won first prize for sports singles at the World Press Photo competition in 1993. Originally from Yorkshire, England, Clayton moved to Australia in 1990 to work as a sports photographer for *The Sydney Morning Herald*, where he stayed for eighteen years until 2008. He has covered eight Olympic games, five Rugby World Cups, the FIFA World Cup, and World Series Baseball. Clayton has won an amazing total of eight World Press Photo Awards which include three first place awards in 1994, 2004, and 2007. PL

SNIPER'S ROOM

ALEXANDRA BOULAT

Date 1993
Location Mostar, Bosnia-Herzegovinia
Format 35 mm

In the early 1990s, French photographer Alexandra Boulat (1962–2007) witnessed chaos as she traveled around Yugoslavia and observed the tumultuous formation of the new states of Croatia and Bosnia. As a photojournalist she worked in a wide range of subject areas, from armed conflicts such as the fall of the Taliban to the latest fashions of Yves Saint Laurent. Published in *National Geographic*, *Paris Match*, *Newsweek*, and elsewhere, her images often depict the human side of war and its aftermath: child trafficking in Romania after the fall of Nicolae Ceaușescu, Palestinian leader Yasser Arafat's private life with his close-knit family, and the dire straits of Arab women living in the West Bank.

In this photograph of a sniper's den in Mostar, Bosnia, the marksman is noticeably absent but the power of the image lies in the subtle natural lighting of the pockmarked walls and the empty chairs in the industrial setting. Boulat's photograph leads us to ask: Where is the sniper now? Who has he or she killed? Where is this eerie room located? Boulat once said in an interview, "You can show a war without showing a gun." Her photographs reflect on absence as well as presence. SY

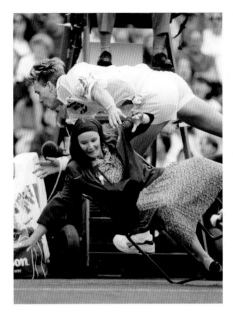

PABLO ESCOBAR'S BODY

UNKNOWN

Date 1993
Location Medellín, Colombia
Format 35 mm

Colombian drug lord Pablo Escobar is remembered for his incredible wealth, extravagant lifestyle, and ruthless tactics. He died a violent and inglorious death in 1993, but just a few years earlier, his empire had been at the height of its power with estimations that he was one of the ten richest men in the world. His "business," the Medellín Cartel, was in control of 80 percent of the global cocaine market. At the same time, he invested money helping out the poor in the greater Medellín area, including building houses, churches, and sports fields. In exchange for his support, the locals—many of them children and teenagers—gave Escobar the ears and eyes he needed to elude the authorities for years.

Finally, on December 2, 1993, the international team of drug officers that had been assigned to capture him received a tip and cornered him on a rooftop. It has never been made clear whether he was killed in the gunfight, was shot in the head after he was down, or committed suicide. Wearing the red shirt in this photograph is Agent Steve Murphy, who had joined the US Drug Enforcement Agency in the 1980s. He was transferred to Colombia in 1991 and became part of the manhunt team "Search Bloc." SY

THE NET CORD JUDGE

DAVID ASHDOWN

Date 1993
Location London, UK
Format 35 mm

As far as sporting moments caught on camera go, surely this is one of the most humorous. Demonstrating his lightning speed reactions, sports photographer David Ashdown (born 1950) fired the shutter just as British tennis player Chris Bailey collided with the net cord judge in his match against Croatian player Goran Ivanisevic. The year was 1993, and Bailey was playing in the second round of Wimbledon. In the end, he lost to Ivanisevic, but not without a fight. *The Independent* reported how, during the second game of the fourth set, "Bailey scurried toward the net in pursuit of a backhand drop volley, scraped the ball over the line and then collided with the net cord judge, knocking her chair over." The judge, so the article says, caught Bailey's racket and handed it back to him after he helped her back on her feet. GP

CYCLISTS IN THE RAIN

STUART FRANKLIN

Date 1993
Location Shanghai, China
Format 35 mm

Probably the most famous photograph taken by Stuart Franklin (born 1956) was not this one but an image taken in Tiananmen Square, China, in 1989. Showing a solitary human figure confronting a column of military tanks, the picture was destined to become an icon of photojournalism.

This image, taken a few years later, is part of Franklin's record of the ambiguities and complexity that the country went on to experience. Returning to Beijing and Shanghai, he sought to show Western audiences, and particularly Americans, that not all Chinese people were socialists or Maoists. In truth, this was also a capitalistic society and a rapidly changing environment. The depicted cyclists, moving en masse down a Shanghai street, represent something of this duality. On the one hand, the undifferentiated stream of commuting workers, photographed from above, seems to symbolize the ideal of Communist conformity: the mass-produced proletarian bicycle is itself emblematic of Maoist China. But the contrasting colors of their rainwear suggests at the same time a different reality. On closer inspection, Franklin has captured a wide range of facial expressions, personalities, and priorities—these people may be cycling in the same direction but their gazes stray left and right, some of them lost in thought, others deep in conversation. "I was standing on a bridge overlooking a railway junction one rainy late afternoon during Shanghai's bicycle rush hour," the photographer recalled. "There wasn't a great variety of colors but the dominant ones, yellow and purple, being complementary colors, helped bring the whole scene vibrantly alive." **JG**

THE SHIPPING FORECAST

MARK POWER

Date 1993
Location Malin, County Donegal, Ireland
Format 35 mm

Mark Power (born 1959) studied Fine Art at first, but discovered his passion for photography while traveling. In 1992, he embarked on a career-defining project named *The Shipping Forecast*, in which he visited the thirty-one locations covered by BBC Radio 4's British shipping forecast, on which seafarers of all kinds depend for their safety.

In this image from the *Shipping Forecast* series, shot from a high angle, the viewer's eye is drawn instantly into the frame by an erratic trail made by a boy dragging a pram through the sand. The trail leads to the center of the image, where, inside a ring formed by tire tracks, a woman stoops to take a photograph of the boy. Beyond is the blank horizon that features in many of the *Shipping Forecast* images. The BBC shipping forecast itself is a cherished institution in the UK, and by traveling to the mysterious, far-flung places that are mentioned, Power brought to life romantic names familiar to many radio listeners.

Among Power's other well-known projects was a commission to document the construction of London's Millennium Dome (completed in 1999); a selection of his photographs was published in the book *Superstructure* in 2000. **EC**

ENGLAND'S DREAMING (GEORGE SUNSET)

CORINNE DAY

Date 1993
Location UK
Format Unknown

Corinne Day (1962–2010) shot mostly fashion and documentary photographs, and the aesthetics of both genres often interwove in her work. She started taking photographs as a model in Japan, shooting her colleagues in their own clothes in their dingy homes. Later, she photographed documentary subjects doing the intimate activities of everyday life—having sex, hanging out. She shot models such as Kate Moss and Rosemary Ferguson in a mix of secondhand and new clothes in locations that were ordinary (an apartment with a string of fairy lights on the wall) or vast, lovely, and unpeopled.

So much is evident in this image from the series *England's Dreaming* that Day shot for *The Face* magazine. It is permeated with the sense of transience that frequently haunts her work: it is difficult to look at the model's rangy body and not be mindful of time passing, all the more so when the sun is setting. The beauty of the hazy marigold rays making a mirror of the water's surface is punctuated by the model's ungainly pose: his feet are shoved in his shoes, his body twisted uncomfortably to look at the view. Without a shirt, his back appears vulnerable, the low light not disguising his thinness. RF

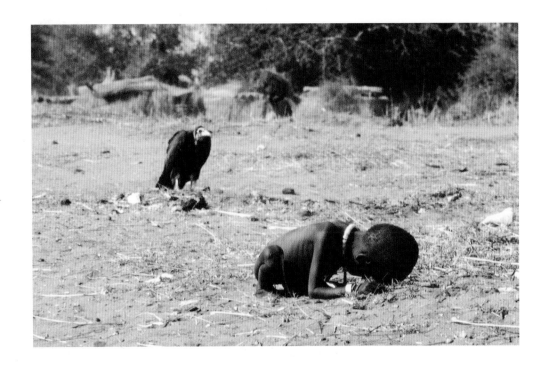

THE VULTURE AND THE LITTLE GIRL

KEVIN CARTER

Date 1993
Location Sudan
Format 35 mm

During a trip to Sudan in 1993, Kevin Carter (1960–94) was preparing to take a photograph of a starving child trying to reach a feeding center, when a hooded vulture landed close by. Careful not to disturb the bird, Carter positioned himself for the best possible image. He later claimed that he waited twenty minutes to capture the photograph, hoping the vulture would open its wings. The bird remained ominously still. Carter then chased away the bird and watched as the little girl resumed her struggle.

When this image was published in *The New York Times* on March 26, 1993, the reaction was intense. Hundreds called in to find out what happened to the little girl. Some people felt the photographer should have dropped his camera and run instantly to her aid. The photograph was also criticized for not telling the whole truth, as Carter intentionally left the feeding center out of the frame. In the picture, the child and the looming vulture seem to be alone. However, moral considerations aside, it was thanks to this photograph that the famine in Sudan was suddenly known internationally, as it was reproduced in newspapers throughout the world and went on to win the Pulitzer Prize for Feature Photography a few months later. **EC**

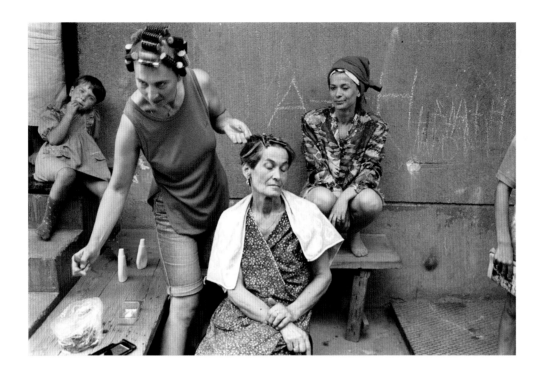

MAKESHIFT HAIR SALON

ROGER HUTCHINGS

Date 1993
Location Sarajevo, Bosnia-Herzegovina
Format 35 mm

From April 1992 to February 1996, the army of the Bosnian Serbs encircled Sarajevo, imposing the longest siege of a capital city in the history of modern warfare. During a lull in a period of heavy artillery, British photographer Roger Hutchings (born 1952) decided to walk to the city's hospital to see the consequences of the recent attacks. The main road was clearly visible to Serb snipers, and he saw two shots hit the road nearby. After the visit, he avoided the main road and made his way through

side streets into a courtyard where he came across this poignant scene. Hutchings remembered: "For a moment I could not believe what I was seeing. To me the faces and body language talk of despair, resignation, but also dignity and the weariness born from living in cellars for months without electricity or running water and [with] little food. Yet it also reveals the women's determination to endorse their self-respect, femininity, and identity." The photograph is rich with a mood of defiance in spite of the danger and death that were lurking all around. Hutchings was concerned with depicting daily life during the civil war: "I was interested in the human spirit, not the soldiers, how people lived and survived in extremity against the odds." CJ

VÁCLAV HAVEL

JOSEF KOUDELKA

Date 1993
Location Prague, Czech Republic
Format 35 mm

Václav Havel (1936–2011) was a Czech writer, philosopher, and politician whom many considered to be a leading force in the ousting of Communist rule in Eastern Europe. After years of being Czechoslovakia's most renowned dissident, as a playwright and politician, he was elected as the last president of Czechoslovakia in the Velvet Revolution of 1989, serving until 1992. He was then made the first post-Communist president of the Czech Republic; he continued until 2003, when deteriorating health forced him to resign. Havel oversaw Czechoslovakia's transition to democracy and played a major role in its peaceful split into the Czech Republic and Slovakia.

In this image by Josef Koudelka (born 1938), Havel is pictured on the first day of his presidency of the Czech Republic, on February 2, 1993. In the kitchen of his private apartment, a man and a woman help him prepare before leaving for the palace for his investiture. The image marks a significant turning point for Eastern Europe. The bright scene is filled with a palpable sense of optimism, with the light flooding through the window and the buttoning of a clean white shirt signaling a new era for the Czech Republic. EC

MU DRACONIS (MAGS 5.7 5.7)

JOAN FONTCUBERTA

Date 1993
Location Unknown
Format Contact print

Joan Fontcuberta (born 1955) initially worked in advertising before increasingly practicing as an artist, writer, and educator. His photography often plays with ideas about truth. Fontcuberta often cites both his previous career in advertising and his experience of growing up during the dictatorship of Francisco Franco in Spain as influences on his skeptical handling of photography.

For his series *Constellations* (1993), to which this image belongs, Fontcuberta created images that seem to show the night sky viewed through a high-powered telescope. In reality, however, these pictures were contact prints made on a sheet of photographic paper attached to Fontcuberta's car. What at first glance appear to be distant stars and nebulae are in fact dirt, dust, and splatters from dead insects that hit the paper as he drove, and which became permanent when he developed the photographic paper. Combining a series of these images with pseudo-scientific names and designations, Fontcuberta created a persuasive whole that challenges viewers not only to question their implicit faith in photographs, but also to reassess their assumptions about photographic truth in general. LB

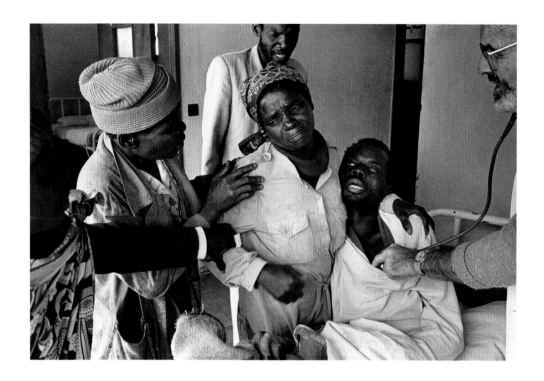

DEATH OF AN AIDS PATIENT

GIDEON MENDEL

Date 1993
Location Matibi, Zimbabwe
Format Unknown

Shortly before the first World AIDS Day, Gideon Mendel (born 1959) visited a small remote mission hospital in Zimbabwe. He was working on a long-term project about AIDS and came face to face with situations that forced him to question the ethics of his work. "I unwittingly photographed the death of a patient with AIDS. I had begun to photograph the man as his wife started to lift him up from the bed to change his position. He then had a seizure. I carried on photographing, not realizing until afterward that he had died." Mendel put his camera down, feeling that his presence as a photographer was too intrusive, but the Swiss doctor (right) remonstrated with him, saying, "Go on, man. Do your job." The doctor wanted the world to see what he was witnessing daily and did not recognize any moral conflict. In retrospect, Mendel regretted not interviewing the man's wife and family about their experiences of AIDS, and felt he had become too obsessed solely with the visual storytelling. He subsequently became more of an activist, more engaged with the people he met, allowing their voices to raise awareness of a "tragedy that is being repeated across Africa many times every day." **CJ**

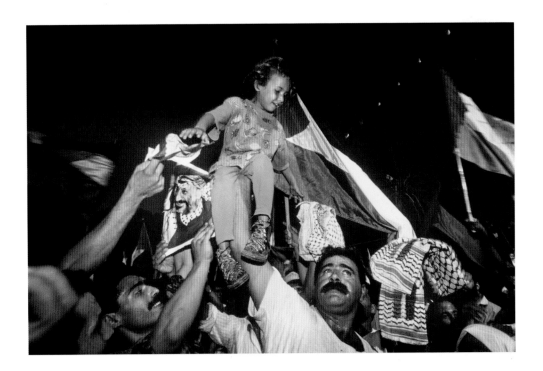

PALESTINIAN CELEBRATIONS

MIKE GOLDWATER

Date 1993 Location Jericho,
Occupied Palestinian Territories
Format 35 mm

Here, euphoric Palestinians are shown celebrating the signing of the historic peace accord between the Palestine Liberation Organization and Israel on September 13, 1993. The accord requested the withdrawal of Israeli troops from the Gaza Strip and the West Bank town of Jericho, and the establishment of a Palestinian self-government led by Yasser Arafat. After the news, the celebrations erupted like a shaken soda, sending thousands of Palestinians out into the streets. This was something

that had been unheard of in the bleak warrens of Gaza, where military rule had once presided.

In this image by British photographer Mike Goldwater, a little girl sits balanced on a man's upstretched hand, his expression proud and victorious and hers full of joy. The child being lifted into the air is symbolic of new hope that the young generation's lives might be more peaceful than those of their elders. Everyone else in the picture is dressed in white and black, but she is wearing bright colors, which immediately makes her the focus of attention. This image expresses a sense of joy that was totally absent during the military occupation. Not since the Palestinian uprising of 1987 had there been such crowds. **EC**

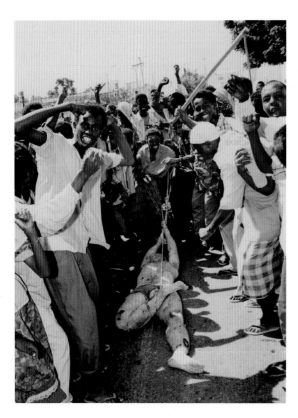

A SLAIN US SOLDIER'S BODY IS DRAGGED
THROUGH MOGADISHU

PAUL WATSON

Date 1993
Location Mogadishu, Somalia
Format 35 mm

Paul Watson (born 1959) risked his life to take this disturbing photograph of a Somali crowd beating and dragging the body of US soldier William Cleveland through the streets of Mogadishu the day after the now-notorious "Blackhawk Down" battle. Three months previously, four journalists had been beaten to death by Somalis enraged by the airborne attacks and many civilian casualties they were suffering as US troops attempted to capture or kill Somali general Muhammad Farah

Aydid. By October 1993, Watson was one of the few Western journalists still covering the protracted UN/US Somalia intervention. His images were widely broadcast and caused shock and outrage in the United States. Within months, US troops were withdrawn from Somalia. Watson suffered severe depression and was condemned for taking the picture by many in the military community and general public. However, Watson explains his motivation as truth-telling. Weeks before the Blackhawk Down events, images of the body parts of a US soldier being paraded through Mogadishu had been suppressed by the Pentagon, and Watson was determined that the dire situation in Somalia should not remain hidden from public view. CP

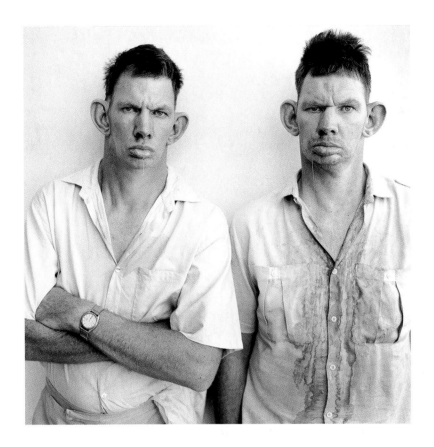

DRESIE AND CASIE, TWINS, WESTERN TRANSVAAL

ROGER BALLEN

Date 1993
Location South Africa
Format Medium format

This image is from the series *Platteland*, which Roger Ballen (born 1950) made over a period of almost twenty years. Photographing mainly the poor white Afrikaner population, he sought to highlight the irony that, despite their relatively privileged status in relation to black South Africans, many of them lived hard and impoverished lives.

Ballen's stark and often brutal aesthetic is strongly reminiscent of the work of Diane Arbus, who is also best known for her images of outsiders and disabled people (and twins). This photograph of brothers Dresie and Casie raises the same ethical questions that have been posed by much of Arbus's work: does the picture invite identification or revulsion? Is it exploitative or simply pragmatic? Both men look into the camera lens with an air of self-possession and strength, but Ballen captures the drool hanging from their mouths and makes no attempt to lessen the shocking impact of their appearance—they are both physically and mentally disabled. This photograph met with much controversy—even death threats—as well as great acclaim. Ballen says simply: "They're your cousins. You're related to them. You are seeing a picture of your insides." **JG**

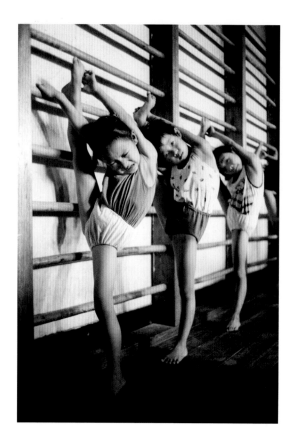

CHINA'S CHILD GYMNASTS

TOM STODDART

Date 1993
Location Beijing, China
Format 35 mm

London-based photojournalist Tom Stoddart (born 1953) began his career taking photographs for local newspapers in northeast England. In the 1980s, he worked extensively for *The Sunday Times* newspaper, covering conflict in places such as Beirut and Palestine. Stoddart reported from the war in Sarajevo in the early 1990s, producing some of his most memorable, harrowing images; in 1992, he was seriously injured there during fighting near the Bosnian parliament buildings.

After a year of recuperation, Stoddart covered the aftermath of flooding in Mississippi, then undertook a project on the harsh conditions under which Chinese child gymnasts were forced to train at a school. His award-winning photo-essay juxtaposed the elegance and grace associated with gymnastics along with the pain and anguish visible on the faces of these very young children as they trained—as in the photograph shown here. Another image captured by Stoddart for this series won a second-place award in the Sports category of the World Press Photo contest of 1993. The work helped to bring to light the harsh realities of training children as young as five to reach their peak as gymnasts by age fourteen. LH

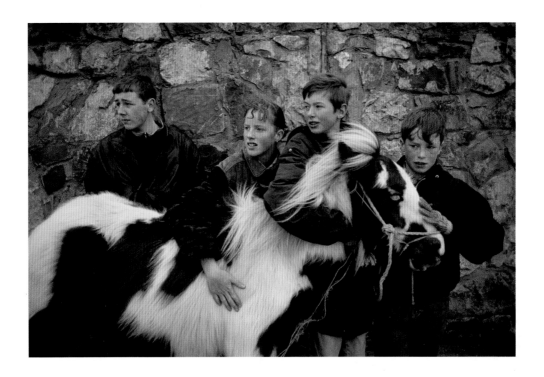

IRELAND

SAM ABELL

Date 1994
Location Dublin, Ireland
Format 35 mm

When *National Geographic* magazine sent American photographer Sam Abell (born 1945) on assignment to photograph Ireland in 1994, his intention was to tap into and capture the magic and mystery of the elusive Emerald Isle. He came away with a wide-ranging but hard-won set of photographs featuring subjects including U2's Bono, a wild dolphin, and this group of children with their pony Gypsy in the Clondalkin district of Dublin. In 2016, Abell recounted in *National Geographic* how the photograph came to be. The children with their pony stopped when they saw him and stared. "I composed the picture and I'm waiting . . . and then some friend of theirs went by in a car, honked the horn, and shouted. At that moment a blast of wind hit the horse and hit their hair . . . and they are looking off camera to see who's shouting at them."

The cover image of *National Geographic*'s issue of September 1994 was a crop focusing on the three children on the right; inside, Abell's photographs ran alongside the article about Ireland. Many years later, Abell told the *Sunday Independent* how he had wanted his photographs to evoke "an elusive Irish essence . . . part beauty, part humanity, part cultural history." GP

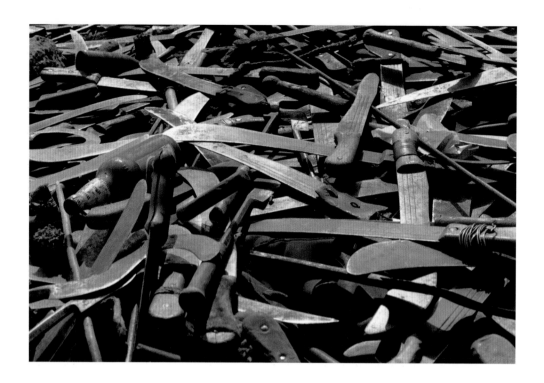

RWANDAN AFTERMATH

GILLES PERESS

Date 1994
Location Goma, Zaire
Format 35 mm

During a 100-day period in 1994 an estimated 500,000 to 1 million ethnic Tutsi Rwandans were slaughtered by the Hutu majority, wiping out around 20 percent of the country's population.

Magnum photographer Gilles Peress (born 1946), who had covered the conflict that had erupted in Bosnia during the early 1990s, traveled to Rwanda and its neighboring countries to document the aftermath of the genocide. He commented: "The immensity of this crime is beyond our imagination and is only surpassed by the unbelievable indifference of the West and the developed nations who would have been able to intervene and prevent the crime."

Peress's photographs do not shy away from the horrific—piles of bodies and bones of victims, Rwandan refugees forced out of their country only to succumb to the cholera outbreak that ravaged the refugee camps in Zaire, and the heaps of discarded, primitive weapons used to commit the atrocities. Peress published his images from Rwanda in a book titled The Silence (1995); the harrowing collection of photographs is printed on black pages to further emphasize the bleakness and death he encountered. LH

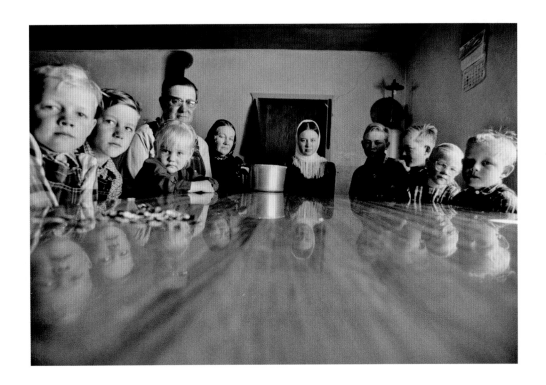

LA BATEA COLONY, ZACATECAS, MEXICO

LARRY TOWELL

Date 1994
Location Mexico
Format 35 mm

This photograph by Magnum photographer Larry Towell (born 1953) packs a powerful punch. The uncompromising, intense stares fixed firmly at the camera are reinforced by reflections of faces on the table's shiny surface, and by the unnerving low-angle perspective. The people pictured are probably from a single family, living in the Mennonite (a Protestant sect) colony of La Batea in Zacatecas, central Mexico. Towell first came into contact with Mennonites in Ontario where he lived,

getting to know them and documenting their way of life. He also traveled to Mexico to photograph the Mennonites there. The results of a decade's photography and research were published in 2000, with texts by Towell relaying his experiences, and this image was used on the book's cover.

Originating in the Netherlands in the sixteenth century, Mennonites are a little-understood people who live in a non-violent, simple way. In the 1920s, many migrated to Mexico from Canada, and have worked the land there ever since. Although Mennonite communities now exist across the world, Mexico has the most. As Mennonites are determinedly private people, Towell's intimate and lyrical images are all the more impressive. **GP**

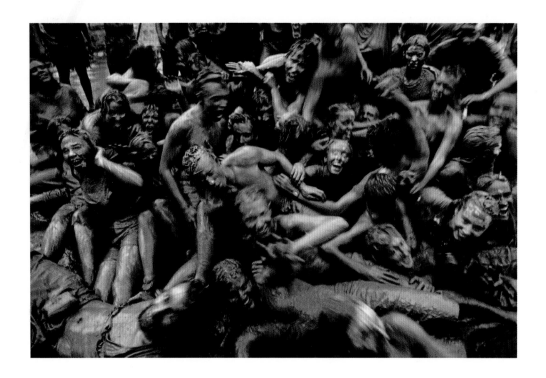

WOODSTOCK II

PAUL FUSCO

Date 1994
Location Saugerties, New York, USA
Format 35 mm

Magnum photographer Paul Fusco (born 1930) is best known for his pioneering and prolific photojournalism—on the Zapatista uprising in Mexico, AIDS sufferers in San Francisco, children disabled as a result of the Chernobyl disaster, and the Exxon oil spill near Alaska. His hard-hitting photographs often elicit visceral responses. Fusco has commented: "I want the viewers to be moved into the lives of the people that they are looking at; the visual experience is incredibly emotional."

Not all of Fusco's imagery depicts conflict, disease, and disaster, however. He documents social issues, but often in the context of people putting aside their differences for a greater cause. This was evident in his coverage of Woodstock II, commemorating twenty-five years since the original music festival took place. In a series of images, Fusco was able to capture the unbridled joy and delight of the festival-goers. Although the look and feel of his images are firmly rooted in nostalgia, they could almost be from any point in time. At first glance this group of people in mud look as if they are struggling, but then you notice that almost every last one of them is grinning, implying that Fusco was laughing, too. LH

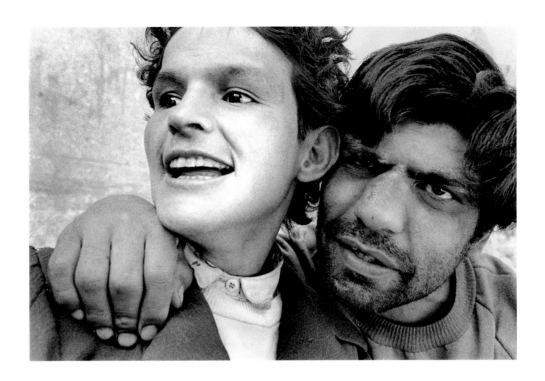

FROM *HEART ATTACK OF THE SOUL*

PAZ ERRÁZURIZ

Date 1994
Location Putaendo, Chile
Format 35 mm

Under the dictatorship of Augusto Pinochet, which lasted from 1973 to 1988, as many as 5,000 Chileans disappeared or were murdered, and many more tortured and imprisoned. Rather than fleeing the country, photographer Paz Errázuriz (born 1944) remained in Santiago, the capital, documenting the margins of society. Her images of subjects that others have ignored—prostitutes, the insane, the blind—have altered the way that Chileans see themselves and the way the world sees Chile.

This photograph, from her series *Heart Attack of the Soul*, is of a couple who are patients of the notorious Chilean psychiatric hospital Philippe Pinel de Putaendo. Not far from Santiago, this is an institution full of people who have been abandoned by their families and greater society. Yet many of the inmates have made connections inside the hospital, discovering love and forging a new life within the walls. Errázuriz's tightly cropped images capture what might seem to be unusual relationships to her viewers, though some might find them to be stark and almost claustrophobic in the way that the subjects confront the camera. Yet, at the same time, the photographs are disarming in their unequivocal humanity. **SY**

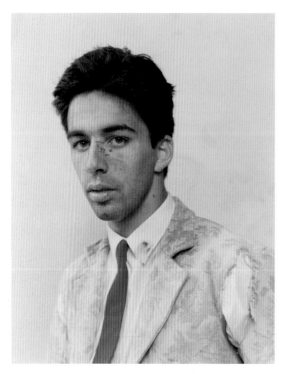

VILA FRANCA DE XIRA, PORTUGAL, MAY 8, 1994

RINEKE DIJKSTRA

Date 1994
Location Vila Franca de Xira, Portugal
Format 35 mm

At the 2012 opening of a mid-career retrospective of the work of Rineke Dijkstra (born 1959) at New York's Guggenheim Museum, museum director Richard Armstrong described the Dutch photographer as "an artist with very few peers." Since the 1990s, Dijkstra has been producing large-scale portraiture that has similarities to seventeenth-century Dutch paintings in its scale and aesthetic perception. Adolescence is an important theme—one of her first projects was of young people posed on beaches. She makes her subjects sit for a long time, waiting to catch the moment when the seater eases their pose.

In 1994, Dijkstra photographed three women moments after they gave birth; her portraits sought to reveal the reality of their experience rather than to glamorize it. That same year, she used a makeshift studio set up at Vila Franca de Xira, near Lisbon, to make a body of work on young bullfighters in Portugal immediately after they had exited the ring. The photograph reproduced here echoes Francisco Goya's *Portrait of the Matador Pedro Romero* (c. 1798). Dijkstra's subject, whose face and clothes are splattered with blood and whose jacket is ripped, looks stunned, his gaze penetrating past the camera. Dijkstra linked her two projects: "The matadors came out covered in blood and exhausted—very similar to the mothers . . . I did not intend to do the men like that, all macho, and the women as mothers, it just evolved from the experience . . . women make this extreme physical effort . . . while the men search for it as a kind of adventure. But still, both are exhausting and life-threatening actions." **LH**

"I am interested in photographing people at moments when they have dropped all pretense of a pose." Rineke Dijkstra

SOUTH AFRICA

IAN BERRY

Date 1994
Location South Africa
Format 35 mm

Founded in 1915 by Afrikaner nationalists, the National Party of South Africa was an all-white organization determined to preserve white supremacy in the country. When the Party was elected to power in 1948, it lost no time in rolling out its oppressive policy of racial segregation, commonly known as apartheid.

In this image by British photographer Ian Berry (born 1934), a young white girl and her black nanny are pictured together at a National Party meeting in 1994. The girl leans dreamily on the nanny's shoulder, a National Party flag hanging from the corner of her mouth, while the nanny looks fixedly into the distance. The photograph records a significant moment in history because the elections of that year culminated in a coalition government with a nonwhite majority; the official end of apartheid was in sight.

Berry had moved to South Africa in 1952 at the age of seventeen. In addition to working for the *Daily Mail* and later for *Drum* magazine, he worked as an apprentice to South African photographer Roger Madden, a former assistant of the well-known American Ansel Adams (1902–84). As the only photographer present to document the Sharpeville shootings of 1960, Berry was able to submit photographs as evidence in the defense of townspeople on trial, and some were exonerated.

In 1962, Berry was invited to join Magnum, and five years later he became a full member. Berry has covered many subjects in his career but is best known for his South African images, which stand out as a testament of the country's struggle and eventual rise against apartheid. **EC**

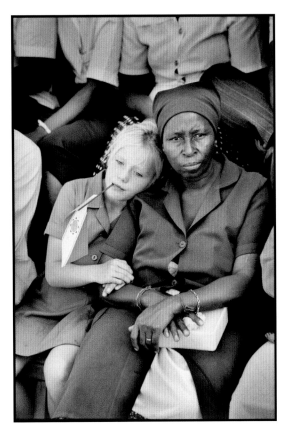

"A searing indictment and an important record to counteract amnesia—for those who forget the past are doomed to repeat it."

Archbishop Desmond Tutu, commenting on Berry's exhibition, *Living Apart*, 1996

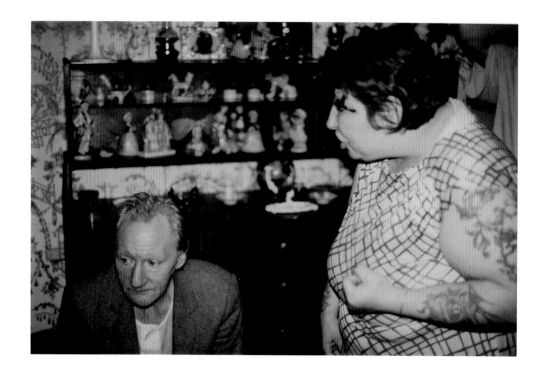

UNTITLED

RICHARD BILLINGHAM

Date 1994
Location Birmingham, UK
Format 35 mm

This is the antithesis of a family snapshot, capturing the photographer's mother, Liz, shouting at his alcoholic father, Ray. Richard Billingham (born 1970) documented his family's life in a cramped council flat in the Midlands from 1990; the results were published in a book titled *Ray's a Laugh* (1996). Originally intended as source material for his paintings—Billingham was an art student at the time—the photographs were taken on expired 35 mm film on a cheap Instamatic camera. When

developers printed his work badly, the mistakes gave him fresh ideas. Gradually, however, he began to see that the images had value in their own right.

Billingham feels that all photography is inherently exploitative, and this factor is mitigated only a little by taking good photographs. Although Ray did little more than drink in the flat every day, his son caught him in a range of poses: collapsed in the bathroom, clutching his bottle, tended affectionately by Liz, and in midair as he stumbled from a chair. The seeming obliviousness of the subjects to the camera is a testament to the photographer's patience as a documentarian, showing those close to him not only in difficulty but also in moments of humor and warmth. **CP**

GROUND #30

UTA BARTH

Date 1994
Location Unknown
Format Chromogenic print on panel

The photographs of Uta Barth (born 1958) may look simple, but there is more to them than meets the eye. Barth plays with the act of photographic seeing—how the camera sees versus human vision. In the early 1990s, she used out-of-focus photographs in her work. In her series *Ground*, to which this image belongs, she plays with the very notion of photographic composition. Working with a collaborator who was her initial subject, Barth continued to focus her camera on the same space when her subject stepped out of the frame. This seemingly empty space then became her subject.

The image appears to show the corner of a room, but it is difficult to make out what we are looking at. The scene in front of the camera creates a kind of void, which Barth invites viewers to fill with their own assumptions about what they are seeing. Barth deliberately draws our attention to the edges of the frame, encouraging us to tune into and consider the medium of photography itself—specifically, how the viewfinder frames parts of a scene but omits others. Her images ponder the nature of perception, what constitutes a subject in photography, and the medium's intrinsic ineffability. **GP**

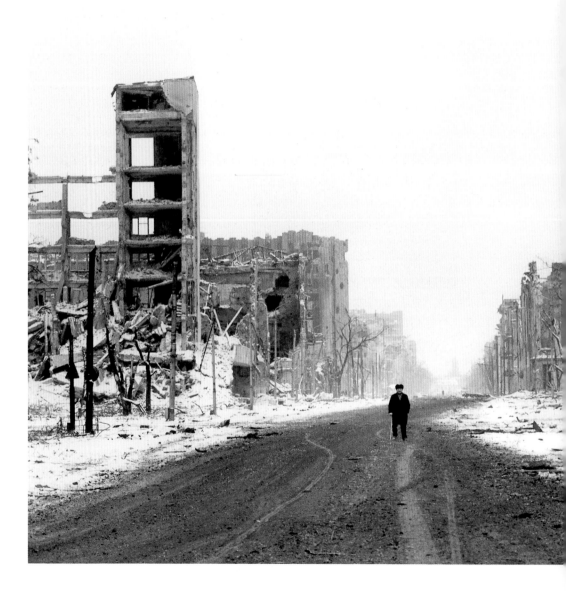

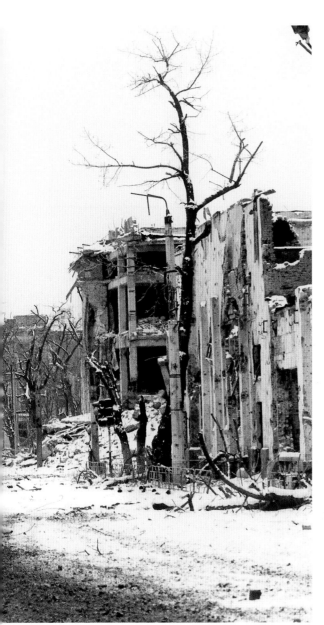

BEYOND THE FALL

ANTHONY SUAU

Date 1995
Location Grozny, Chechnya, Russia
Format 35 mm

Anthony Suau (born 1956) is an award-winning US photojournalist who began his career with the *Chicago Sun Times* before moving to the *Denver Post* and then working as a contract photographer for *Time* magazine from 1991 to 2009. In 1984, he was awarded a Pulitzer Prize for his work in Ethiopia during the famine, and he went on to win the Robert Capa Gold Medal Award in 1996 for his work in Chechnya. He is also the recipient of two World Press Photo of the Year Awards, in 1988 and 2009.

Suau published two books with French publisher Actes Sud in 1995, one of his work on the Rwandan genocide and the other on the war in Chechnya. This image of an elderly man walking down a wide street in Grozny, Chechnya's capital, has come to define Suau's extensive coverage of the war there. The city was reduced to complete ruins in only a matter of weeks, and this lone figure is risking death because both Russian and Chechnyan separatist snipers are holed up in the wrecked buildings. The image, published by *Time*, was awarded a second prize in the General News category at the 1996 World Press Photo Awards.

Suau spent ten years in the former Soviet bloc, documenting the region as it underwent extreme transition after the fall of the Berlin Wall in 1989. In 1999, he published his photographs in a book, *Beyond the Fall*. Suau has since turned to moviemaking, and also returned to the United States after twenty years domiciled in Europe. His first documentary, *Organic Rising* (2015), is an impassioned advocation of using organic agricultural techniques to enjoy the positive impact organic foods can have on health. **LH**

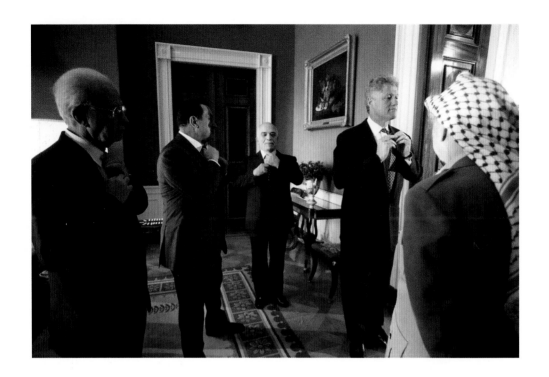

BILL CLINTON WITH MIDDLE EASTERN LEADERS

BARBARA KINNEY

Date 1995
Location Washington, D.C., USA
Format 35 mm

Barbara Kinney is best known for the six years she spent as Bill Clinton's personal photographer during his two-term presidency of the United States. In this image—which won her a World Press Photo award for the category People in the News—Clinton is pictured with (left to right) Yitzhak Rabin, Prime Minister of Israel; Hosni Mubarak, President of Egypt; and King Hussein of Jordan, all straightening their ties before signing a Middle East peace accord. In the foreground, with his back turned to the camera,

is Yasser Arafat, chairman of the Palestine Liberation Organization. The men are all positioned in such a way as to create a graphic composition that draws the eye into, and around, the frame.

Kinney here conveys the commonality of the men despite their respective countries' political differences. Each of the four main figures is concerned with his appearance, and it is this common impulse that Kinney highlights: the vanity and attention to detail of what is usually a private moment, away from the bright lights of the world's press.

Kinney's close attention to such intimate moments was a constant feature of her work in the White House. AZ

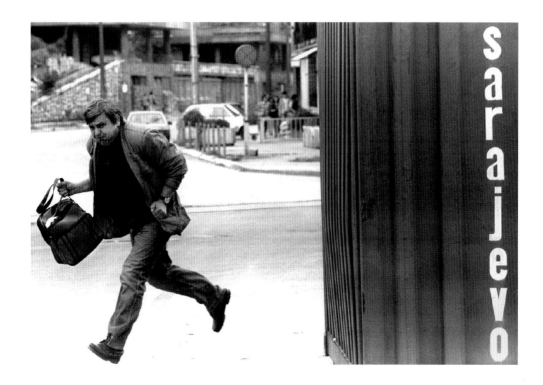

"SNIPER ALLEY," SARAJEVO

DANILO KRSTANOVIC

Date 1995
Location Sarajevo, Bosnia and Herzegovina
Format 35 mm

If this man looks as though he is running for his life, that is because he is sprinting across the infamous "sniper alley" in Sarajevo during the Bosnian War, which began on April 6, 1992 and lasted for three-and-a-half years. During the war, Bosnian Serb snipers hidden in high-rise buildings or burned-out houses would target civilians, including women and children, as well as emergency forces, international media, UN peacekeepers, and soldiers who were in the main boulevard of the besieged capital city.

Among the casualties was CNN camerawoman Margaret Moth, who was hit by a bullet and injured while traveling along the sniper alley on July 23, 1992.

Signs warning of snipers were dotted around, but since it was necessary to move about the city, people had no choice but to cross the boulevard. Individuals could often be seen running, like this man, captured in August 1995 by Reuters photographer Danilo Krstanovic (1951–2012). Colleagues have described how Krstanovic, who started working for Reuters at the beginning of the siege of Sarajevo in April 1992, would patrol the city's streets, recording the atrocities as they unfolded. His photographs, like this one, take the viewer uncomfortably close to the action. **GP**

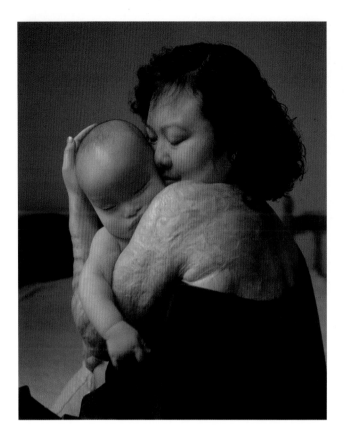

PHAN THI KIM PHÚC WITH BABY

JOE MCNALLY

Date 1995
Location Toronto, Canada
Format 35 mm

When she was nine years old, Phan Thi Kim Phúc's village of Trang Bang, Vietnam, was hit by a US napalm attack. Associated Press photographer Nick Ut, who was just outside the village in June 1972, captured a terrifying image of the burned child running at the camera. This fateful encounter was a pivotal moment in both their lives. Ut helped to save Phúc's life, getting her the medical attention she urgently needed, and the image he took on that day is believed to have hastened the end of the Vietnam War. It won every major photographic award of 1973, although editors hesitated to publish the image because of its full-frontal nudity.

In this photo, taken decades later by Joe McNally (born 1952), the grown-up "napalm girl" is seen with her baby son in Toronto, where she resides. In their close embrace, the baby seems sealed by his mother's protection. Her back remains heavily scarred, but Phúc is cradling new life in her arms and the image ultimately is one of survival. People familiar with Nick Ut's iconic image might think of the subject as being frozen in time, but McNally reveals Phúc to be living a happy life far removed from the horrors of her childhood. Only her scars tell a different story. **EC**

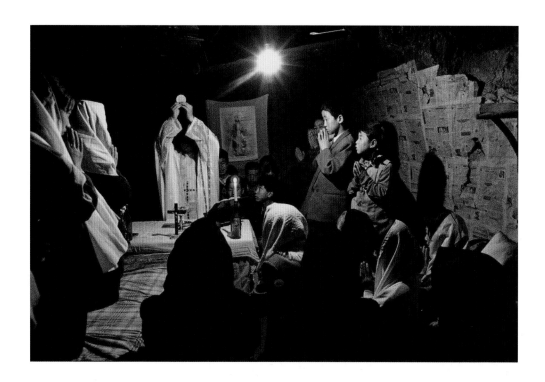

CHINA. SHAANXI PROVINCE

LU NAN

Date 1995
Location China
Format 35 mm

This image belongs to the second of a trilogy of series of photographs taken in China and Tibet by Magnum correspondent Lu Nan (born 1962). The series, entitled *On the Road: The Catholic Faith in China*, comprises religionists in secular China photographed between 1992 and 1996.

In the early 1950s, the Communist Party had banned the profession of all religions in China, and during the Cultural Revolution under Chairman Mao religion was banned outright. Chinese Catholic communities that refused to renounce their beliefs were forced to go underground.

In this highly atmospheric image, a gathering is illuminated by a single bulb. All eyes are fixed on the priest who holds up the sacramental bread. Hands are held together in prayer. The makeshift environment is evident, the stone walls partly covered with torn newspapers. Through Lu's lens, we witness subjugated people holding on to what they believe, despite the risks of so doing.

Born in Beijing, China, Lu is concerned with the margins of society and has been photographing those so-called "forgotten people" since the late 1980s. His haunting and poignant images leave a lasting impression on the viewer. EC

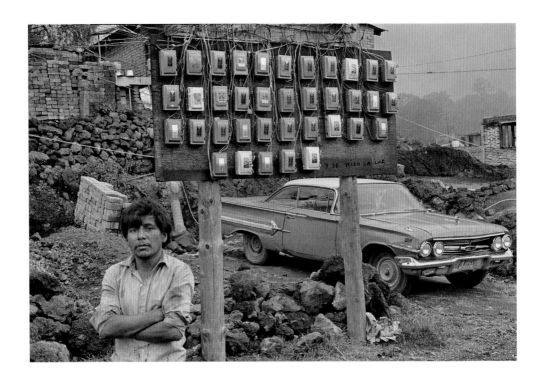

THE LAST CITY

PABLO ORTIZ MONASTERIO

Date 1995
Location Mexico City, Mexico
Format 35 mm

Mexican photographer Pablo Ortiz Monasterio (born 1952) said this about his project, *The Last City*: "My subject was an ever-changing monster full of energy, made of human beings struggling to survive and have a good life." Monasterio, having studied photography in London, had returned to Mexico City in 1994 to found the Centro de la Imagen for the promotion of the photographic arts.

The Last City is a collection of black-and-white photographs depicting the raging megalopolis of Mexico City. Monasterio is especially concerned with the downside of extreme urbanism—poverty, crime, and the social and environmental effects of a city population growing far beyond its scarce resources.

The man posing with his arms crossed and staring directly into the lens is far from the tourist zone in the center of the city. In what appears to be a construction site, he poses in soiled shirt and thick black hair in front of a complicated panel of electricity junction boxes that almost completely blocks the viewer's sight of the dirty city lying behind it. A solitary figure, he is just one of 20 million inhabitants who try to negotiate this enormous, blighted city every day. **SY**

BLAST #09420

NAOYA HATAKEYAMA

Date 1995
Location Japan
Format Large format

Naoya Hatakeyama (born 1958) studied painting at the University of Tsukuba, Japan, before becoming increasingly interested in photography. He examines humankind's impact on the Earth and the relationships between cities, societies, and the landscapes they inhabit. In the early 1980s, he began to photograph limestone mining operations. Exploring this industry made logical sense: "The quarries and the cities are like negative and positive images of a single photograph," he explained.

From 1995, Hatakeyama undertook studies of explosions for a series that he titled *Blast*. Collaborating with explosives experts in quarries, he triggered his cameras just as the explosives were detonated, capturing the monumental spires of rock and stone that were thrown forth.

The *Blast* series not only encouraged reflection on the destructive impact of humankind on the natural world, but also referenced Japan's own situation—earthquakes are a common occurrence due to interaction of two adjoining tectonic plates. Hatakeyama was present to record how his home town, Rikuzentakata, was seriously damaged by the Tohoku earthquake and tsunami of 2011, which caused thousands of deaths. LB

ANT WITH APHID

ANDREW SYRED AND CHERYL POWER

Date 1996
Location UK
Format Scanning electron microscope

This image of a garden ant carrying a rose aphid is an example of a micrograph, a photograph taken through a microscope. It is one of many taken by scientist Andrew Syred using a scanning electron microscope (SEM), which produces images of a specimen by scanning it with a beam of electrons. A SEM allows for up to 500,000 times magnification.

Syred captured thousands of images over a twenty-year period, assisted by Cheryl Power, who adds colors and light to the photographs. Their imagery fascinated the world in the 1990s. As well as making microscopic insects and plants visible to the human eye, the pair photographed everyday items such as salt and pepper pots, fizzy drinks, human eyelashes, and floss. Some of the results are completely otherworldly, encouraging contemplation of even the smallest details of mundane objects. Others, such as the details on the head of a fruit fly or tapeworm, underlined how grotesque and frightening nature can seem when viewed at high magnification.

In 2011, Science Photo Library, a science-based photography agency, launched the app "Mini-Monsters" featuring the pair's work. LH

THE EYES OF GUTETE EMERITA

ALFREDO JAAR

Date 1996 Location Rwanda
Format Color transparencies on two lightboxes

In 1994, Alfredo Jaar (born 1956) traveled to Rwanda as one of the few photojournalists to cover the genocide in which more than 1 million people died. On returning to his native Chile, he was disillusioned with the thousands of pictures he had taken, convinced that they could never communicate the reality of what he had seen. He resolved instead to take a radically different approach, creating a gallery-based installation series called *The Rwanda Project*, in which he communicates his message in iconoclastic and thought-provoking ways that rely as much upon invisibility as upon visual evidence.

The Eyes of Gutete Emerita is a lightbox installation in which the viewer is confronted with the eyes of a Tutsi woman who witnessed the execution of her husband and her two sons. Panels of text allow her to recount her story. In Jaar's opinion, it is better to be confronted with this one pair of eyes and engage with her individual story than to glance through hundreds of pictures that give us the false sense that we have understood a nation's suffering when all we have experienced is its outward signs. JG

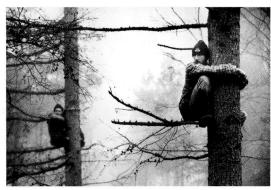

PRESIDENT BILL CLINTON HUGS MONICA LEWINSKY

DIRCK HALSTEAD

Date 1996
Location Washington, DC, USA
Format 35 mm

When Dirck Halstead (born 1936) shot this image of President Bill Clinton hugging intern Monica Lewinsky at a fundraiser in Washington in 1996, the couple's infamous affair was not yet public. Halstead, who was *Time* magazine's senior White House photographer, thought nothing of the photograph or the embrace depicted. It was only when news of the affair broke in early 1998 that Halstead realized its significance. He remembered taking a photograph of Clinton hugging someone who he thought was Lewinsky, but needed to find the photograph to be sure.

After his assistant found the photograph in his archives, a crop from it was used on the cover of *Time*'s issue of August 10, 1998, with the suggestive tagline: "Why She Turned … What He Can Do." "The frame was perfect," Halstead would comment in an interview published by the University of Texas at Austin. "If I were a movie director staging this with the lighting, it could not have been more perfect. Every face is turned toward her. The light is exactly in the right place."

When the affair became public knowledge, Clinton denied it; he later admitted that Lewinsky and he had been intimately involved. GP

TREE PROTESTERS

ANDREW TESTA

Date 1996
Location Newbury, UK
Format 35 mm

This photograph by Andrew Testa (born 1965) shows activists taking part in one of the largest anti-road protests in European history. The "eco-warriors" tried to prevent a British government proposal to fell nearly 10,000 mature trees to make way for a road bypassing the town of Newbury, Berkshire. Around 7,000 people demonstrated along the proposed route; they chained themselves to trees, dug tunnels, and caused a mass disturbance of a kind rarely seen in the United Kingdom. Six hundred security guards were brought in to marshal the site, at a cost of £25 million ($32.5 million)—one fifth of the total bill for building the road. The demonstrators were supported locally, and even the under-sheriff responsible for the evictions felt some sympathy: "They had a big sound system rigged up in the trees playing Bob Marley's 'I Shot The Sheriff' … It was unbelievably cold."

The road battles spawned a generation of young environmental and political activists who still influence public opinion in the United Kingdom. The Newbury bypass went ahead, but in 1997, the government halted its road-building program and pledged to look at alternatives. CJ

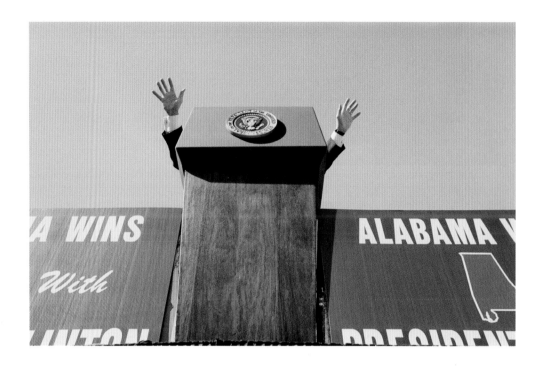

A SHOW OF HANDS AT THE PODIUM

DAVID HUME KENNERLY

Date 1996
Location Alabama, USA
Format 35 mm

In the fall of 1996, Bill Clinton took his presidential campaign to Birmingham, Alabama, where a 10,000-strong crowd greeted him. Photojournalist David Hume Kennerly (born 1947) captured him behind the podium at Birmingham Southern College, but, unusually, Clinton's face is hidden from view. Hume Kennerly, who was a contributing editor for *Newsweek*, deliberately framed his shot to obscure the soon-to-be-president's face. Instead, he drew attention to Clinton's hands—arguably a

more creative take on what could have been just another ordinary political podium photograph. Shooting from a severe angle and making use of stark shadows, Hume Kennerly created an image that symbolizes "Every Politician"—a faceless campaigning figure desperately trying to win votes.

Despite popular Democrat support, Clinton would lose Alabama to Republican Bob Dole, although he went on to beat Dole overall to win the US presidential election on November 5 of that year, and also his second term in office.

Hume Kennerly photographed politicians in Washington for *Time* magazine in the 1970s, and was also the White House's chief photographer during President Gerald Ford's term in office. **GP**

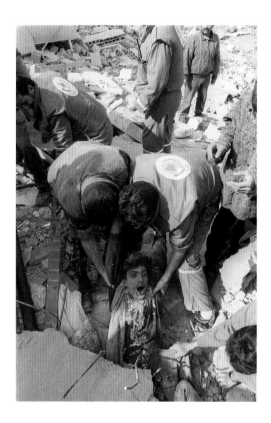

IBRAHIM ALAYAN IS PULLED FROM
THE RUBBLE OF HIS HOME

KARIM DAHER

Date 1996
Location Nabatieh, Lebanon
Format 35 mm

For a period of sixteen days in April 1996, Israeli defense forces instigated a campaign against Lebanon in response to the shelling of northern Israel by Islamist political and military organization Hezbollah. Israel was responsible for more than 1,100 air raids and extensive shelling in Lebanon, while Hezbollah conducted more than 600 rocket attacks across the border.

French photographer Karim Daher had traveled to Lebanon to cover the conflict for his agency, Gamma Liaison. In this image we see Ibrahim Alayan being rescued from the rubble of his home in the town of Nabatieh, south of Beirut and north of Tyre, after it was destroyed by a missile. The photograph's raw emotion, communicated exclusively by the horror-struck expression on Alayan's face at the bottom of the frame, has since become representative of the universal pain and suffering associated with war.

The image went on to win first prize in the World Press Photo Awards in the category of Spot News in 1997. Throughout his career, Daher has worked as a news photographer, also covering conflicts in Liberia and the former Yugoslavia for the Gamma Liaison agency. LH

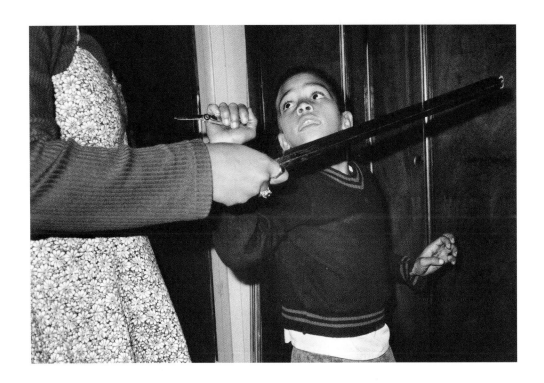

A NEIGHBOR'S IRON BAR VERSUS BRADLEY'S PENKNIFE

JODI BIEBER

Date 1996
Location Johannesburg, South Africa
Format 35 mm

For her first assignment, Jodi Bieber (born 1966) covered South Africa's first democratic elections in 1994 for Johannesburg's *Star* newspaper. The following year, she began a ten-year project on the young people living in Johannesburg's toughest neighborhoods. She wrote of starting the project: "At the time there were numerous articles in the press about the death of young gangsters in the area. I wanted to explore this world, but not in a superficial or sensationalist way . . . It was a closed community which detested the media for its inaccurate reporting of their situation, which they felt always depicted them as the 'other'. It took time to win their confidence."

Her work, published in 2006 as a book titled *Between Dogs and Wolves*, was an intimate look at the realities faced by both white and black lower-class communities marred by drug addiction and gang warfare. Her images focused heavily on children—brandishing weapons, smoking drugs, living in squalor—and depicted the extreme situations and violence that these children were subjected to every day, yet an empathy and intimacy between photographer and subjects made the charge of exploitation invalid. LH

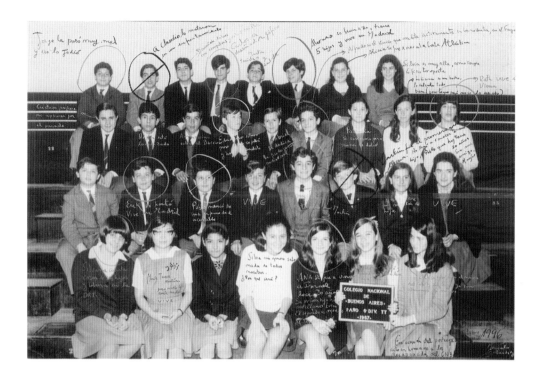

CLASS PHOTO 1967

MARCELO BRODSKY

Date 1996
Location Buenos Aires, Argentina
Format Composite

Argentine photographer Marcelo Brodsky (born 1954) grapples with the topic of the violence of the dictatorship that plagued his country from 1976 to 1983. His work is about the young people who, because their views may have differed from those of the government, or simply because they requested "a subsidized bus fare," were kidnapped and taken to clandestine prisons where they were tortured and "disappeared" in the thousands. His best friend, Martín, was one who never returned.

In *Class Photo 1967*, his most famous work, Brodsky made a very large reproduction of a class photo from his eighth grade, taken in 1967. He got the idea for this project when he returned to Argentina after many years of exile in Spain and needed to reconsider his identity. He held a reunion of his classmates from the Colegio Nacional de Buenos Aires to see which ones had survived. As part of the project, he took contemporary portraits with each of them and used the 1967 image as a background.

Brodsky covered the photograph with comments about his classmates in his own handwriting. On his own photo Brodsky inscribed: "I'm a photographer and I miss Martín." SY

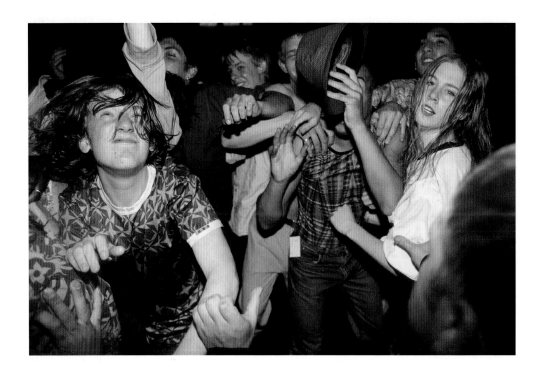

MOSH FOR *THE FACE*

ELAINE CONSTANTINE

Date 1997
Location UK
Format 35 mm

Photographer and moviemaker Elaine Constantine (born 1965) began her career in 1992 as an assistant for fashion photographer Nick Knight. Her work is primarily concerned with youth culture, rooted in some of her early commissions for magazines such as *i-D* and *The Face*. Her images for these publications, showing ordinary people doing ordinary things, successfully transcended the highly artificial, supermodel-saturated fashion photography that dominated the 1990s.

This image derives from Constantine's first ever fashion shoot, commissioned by *The Face*. Although staged, the images of jostling youth amount to a sort of anti-fashion shoot, capturing the energy and emotion of youth as they are expressed through club culture and dance.

Constantine's fascination with the various subcultures of dance has carried through to her other photographic and movie work. In one series, *Tea Dance*, Constantine shot large-scale images of elderly amateur dancers. And the first feature she both wrote and directed, *Northern Soul* (2014), is a love letter to soul music told through the story of two young boys in northern England, which went on to be an unexpected box office success. **LH**

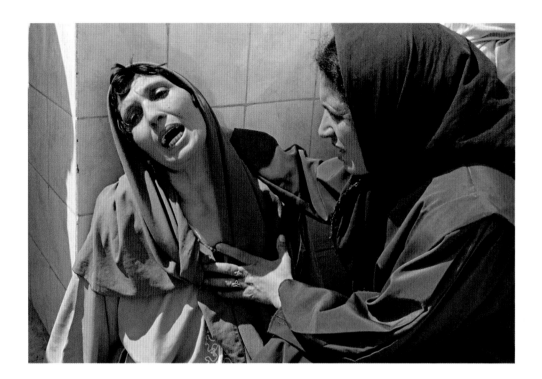

MADONNA OF BENTALHA

HOCINE ZAOURAR

Date 1997
Location Bentalha, Algeria
Format 35 mm

This, one of few photographs to emerge from the 1990s Algerian War and possibly the most famous, won World Press Photo of the Year in 1997. It was taken by Algerian journalist Hocine Zaourar (born 1952), working for Agence France-Presse (AFP).

On September 22, 1997, between fifty and one hundred men rampaged through the small town of Bentalha, killing more than 400 people. Barred from entering the local hospital, Zaourar quickly snapped three shots of a grieving woman being comforted outside. The photo appeared in more than 700 publications, briefly raising the profile of what was often described as a hidden conflict. Initially the grieving woman, Oum Saad, was said to have been mourning the death of her eight children, but it later emerged that she had instead lost three other relatives. Men in the original image were cropped out by AFP, reducing the context of the image and making the focus solely the two headscarfed women. The Muslim Oum Saad was said to have been frustrated by the naming and association of the photo with the Christian iconography of the grieving Virgin Mary (the Pietà) and, under pressure from the Algerian government, she tried to sue AFP for libel. CP

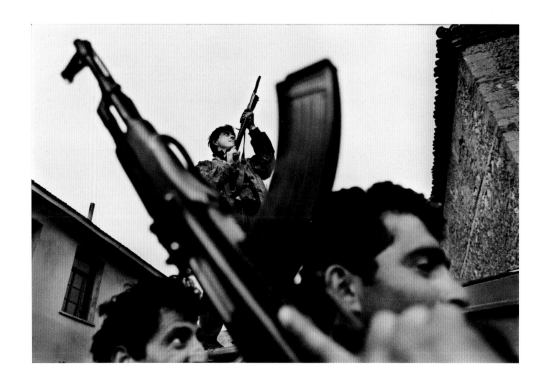

POLICE RETURN TO THE STREETS OF VLORA
TO PATROL AGAIN

JOACHIM LADEFOGED

Date 1997
Location Vlora, Albania
Format 35 mm

Joachim Ladefoged (born 1970) was one of the driving forces behind the new wave of Danish photojournalism—one characterized by high contrast and grainy black-and-white imagery. He has worked as a photographer since 1991, capturing images in more than fifty countries.

Ladefoged's series on Albania, commissioned by Danish newspaper *Politiken*, won first prize at the World Press Photo Awards in 1998 in the category People in the News. In 1997, Ladefoged traveled to Albania, Europe's poorest country and the last to transition from a Communist state to a democracy, to document the situation.

The year 1997 marked the beginning of rioting, looting, gang warfare, and drug violence as a pyramid scheme collapsed, resulting in thousands losing their life savings. Albania was also directly implicated in the neighboring war in Kosovo, and lawlessness was resulting in weapons crossing the border into the country. Police were forced out of the city of Vlora in January 1997, but returned to patrol the streets on April 11, as seen in this image. Ladefoged kept returning to the country over the course of the next two years, finally publishing his seminal book, *Albanians*, in 2000. LH

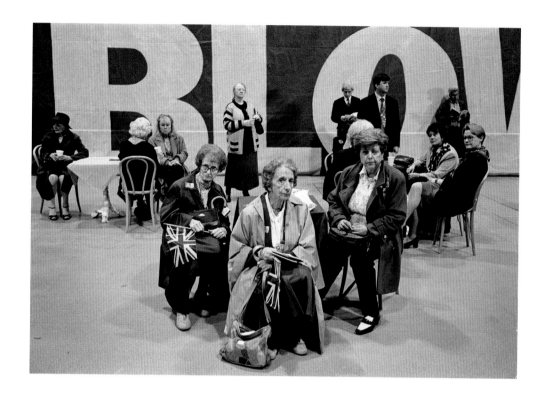

DISCONSOLATE TORY SUPPORTERS

DAVID MODELL

Date 1997
Location London, UK
Format 35 mm

In the UK general election of 1997, the Labour Party led by Tony Blair achieved a landslide victory over the ruling Conservatives (Tories), winning 418 out of 659 parliamentary seats. This success ended eighteen years of Tory government, most of them under the premiership of Margaret Thatcher, the "Iron Lady," and effectively killed off Thatcherism—an overriding belief in allowing a free market and reducing to a bare minimum the interference of state government in the lives of the citizens.

During the 1990s, many Tory supporters had come to believe that their party had an almost divine right to rule. This photograph by David Modell, part of an extended essay on the decline of the Tory party, was taken on the night of the election as the disastrous results came in and it became clear that the government had been decisively defeated. The facial expressions of the women supporters, the drooping Union Jack flags, and the general melancholic atmosphere encapsulate the sense that this really was to be the end of an era. At least the incumbent prime minister, John Major, accepted defeat graciously, musing philosophically, "When the curtain falls, it is time to leave the stage." CJ

BENIDORM

MARTIN PARR

Date 1997
Location Benidorm, Spain
Format Composite

Martin Parr (born 1952) is a prolific contemporary photographer and photojournalist who also works across a range of other genres, including movies and television. He is also a voracious collector and curator, and his fascination with vernacular photography is demonstrated by his obsessive pursuit of kitsch postcards, which he has reproduced in a series of books that include *Boring Postcards* (1999) and *Boring Postcards USA* (2004).

Parr is also absorbed by commercial studio portrait photography as a genre, so for the last thirty years he has had his photograph taken wherever his wide-ranging travels have taken him. His amazing collection of images spans the globe and reveals an extraordinary array of visual styles and approaches—each local studio has its own characteristic gimmick or trick to enhance the sitting. So, in this Benidorm example, his image is inserted into one of a shark for amusing effect.

And of course, Parr himself changes over the years, from a fresh-faced thirty-year-old to the sixty-year-old president of Magnum, but always with the same fixed expression. His book, *Autoportrait* (2000, updated 2015), is a testament to Parr's ironic and knowing wit. As photography historian Val Williams wrote, the series "with its constant remodeling of the Parr persona— from retouched teenager to muscleman, from astronaut to Arab, from Victorian gentleman to Jeffery Archer lookalike—is an acknowledgement, or even a reminder, that photography is often more accomplished, more freethinking in the vernacular than it is in the polished products of the photojournalist or the art photographer." PL

"Martin Parr's *Autoportraits* [uses] techniques such as green screens, retouching, or comical props to create imaginative millennial environments." Philomena Epps

CASE HISTORY

BORIS MIKHAILOV

Date 1997
Location Kharkov, Ukraine
Format Unknown

Self-taught Ukrainian photographer Boris Mikhailov (born 1938) studied to become an engineer before switching career. His photographs have documented everyday life under Communism in his home city of Kharkov; disintegration after the breakup of the Soviet Union; and the failure of the Soviet ideal. The images are often moving and frequently disturbing, for both the nature of his subjects and his implicit critique of Eastern European society in transition.

The image reproduced here is from Mikhailov's series *Case History* (1997–98), which is concerned with the extreme poverty of Ukraine's homeless people and the harsh conditions in which they live. The series depicts consequences of the collapse of the Soviet Union—people deprived of their jobs and shelter, forced to live on the fringes of Ukraine's new society. The gritty commentary does more than record people's suffering. Mikhailov collaborated with his subjects to reenact scenes from their own lives, and also scenes from Christian iconography.

In this life-size picture, a man and a woman carry a bare-chested young man who looks straight at the camera, his arms flung wide. The pose recalls the Descent from the Cross as it is depicted in paintings by masters including Rogier van der Weyden, Caravaggio, and Rembrandt. Although the couple carrying the man could be merely taking care of someone living rough in the freezing cold, the inference is that he is like Christ, but crucified for the sins of the contemporary state. A new life awaits him only when his country resurrects from the ashes of Communism. **CK**

"It's not important how you show something. It's important to show it at the right time." Boris Mikhailov

COMMON SENSE

MARTIN PARR

Date 1998
Location Unknown
Format 35 mm

Martin Parr (born 1952) selects particular visual styles both to affect and express his engagement with the world. In his series *Common Sense* (1995–99), he chose the close up to isolate details of the excesses of contemporary life, using amateur film and a ring flash to achieve a super-saturated, larger-than-life feel. By doing so he could also divert criticism that photography exploits its subjects. He maintains: "In more recent years I have photographed much closer, where bits of people and food become part of the

big picture, and one advantage of this is that . . . people are less recognizable." He still feels that photographers should be free to explore the world around them, however. "All photography involving people has an element of exploitation . . . it would be a very sad world if photographers were not allowed to photograph in public places. I often think of what I photograph as a soap opera where I am waiting for the right cast to fall into place."

Parr believes that strong and significant images can be found anywhere: "Most photographers are very attached to things that are exotic, and to people who are in extreme and dramatic circumstances. But I truly believe that the ordinary is much more interesting than people make out." **PL**

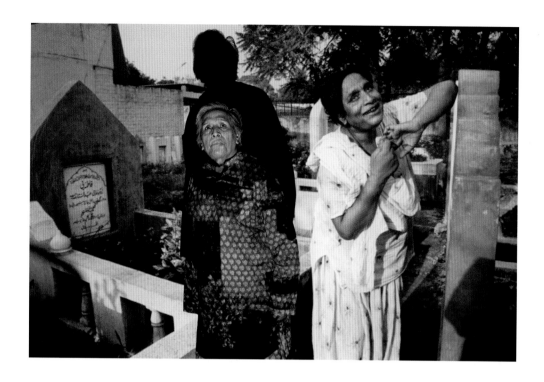

SELF-PORTRAIT WITH MONA

DAYANITA SINGH

Date 1998
Location Delhi, India
Format Unknown

In 2001, Dayanita Singh (born 1961) published *Myself Mona Ahmed*, a blend of biography, autobiography, photobook, and fiction that told the story of Mona Ahmed, a eunuch. As an Indian photojournalist, Singh was interested in working with stereotypes of her country and reflecting them back at the viewer. Mona was at first simply a subject for her project, but she became a close friend. The story of India's "third sex" is complex, steeped in superstition and myth, and Singh eventually found

that using Mona's own words would bring it to life, fact and fiction woven into a richly tantalizing tale.

Through photography, Singh found she was able to escape the class structure of Indian society and form what became the most important friendship of her life. Singh's long relationship with Mona began in 1989; she stayed in touch as her friend adopted a baby girl, Ayesha, succumbed to drink, lost her daughter, and eventually left the eunuch community to live with fellow "misfits" and animals in the local Muslim graveyard. This portrait, taken in the graveyard in 1998, shows Singh (right) with Mona. Her friend was also at the heart of a movie, *Mona and Myself*, that Singh showed at the Venice Biennale in 2013. MH

UNTITLED, OCTOBER 1998

HANNAH STARKEY

Date 1998
Location London, UK
Format Unknown

It is as if we have glanced over from another table. We see the natural light falling across the girl's face, one cheek resting against her hand as she looks at her mother with the expression of enduring boredom native to teenagers. But what appears at first to be a candid photograph—albeit, a carefully composed one—turns out to be a construct: photographer Hannah Starkey (born 1971) works with actors and acquaintances to create the evocative scenes she is known for. The aesthetics and compositions are stylized as if for a movie, ushering in cinema's suggestion of narrative and emotion as captured in a frame.

In mostly shooting women, Starkey seeks to explore "everyday experiences and observations of inner-city life from a female perspective." Her photographs place us in a familiar visual world, but her subjects seem disconnected from one another, and from us, as if appearing in a dream. RF

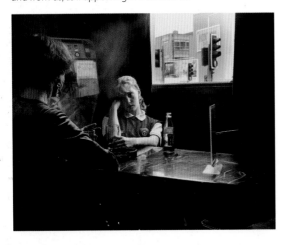

WOMAN READING POSSESSION ORDER

TOM HUNTER

Date 1998
Location London, UK
Format Large format

In this photograph, Tom Hunter (born 1965) references a well-known painting by Johannes Vermeer, *Girl Reading a Letter at an Open Window* (1657–59), to examine the effects of the outside world on domestic space. Vermeer has his model facing her window in what can be read as a state of melancholic dissatisfaction with the sphere of domesticity to which she is tied. A common interpretation suggests that she is reading a love letter that has been sneaked to her and is dwelling on the potential of a future that is prohibited.

Hunter's photograph, from his series *Persons Unknown*, depicts a woman reading a possession order promising to evict her from the building where she is squatting. Hunter ennobles his subject by picturing her reflecting in a measured manner in the face of a future made uncertain by external forces. In using the classic conventions of portraiture, he insists that a woman who is a member of a community that is commonly vilified—squatters—deserves as careful consideration as does Vermeer's gentlewoman.

The woman is separated from her baby by a distance that perfectly contributes to both the aesthetic perfection of the image and its message; neither too far, nor too close. While the baby is comfortable, cared for, and within the woman's reach, the mother is turning from it to the outside world. Without being overly didactic, Hunter is suggesting the negative consequences that eviction can have for family life. He freely recognized this as a propaganda image and it worked perfectly—the publicity it received helped to save the community from eviction. MT

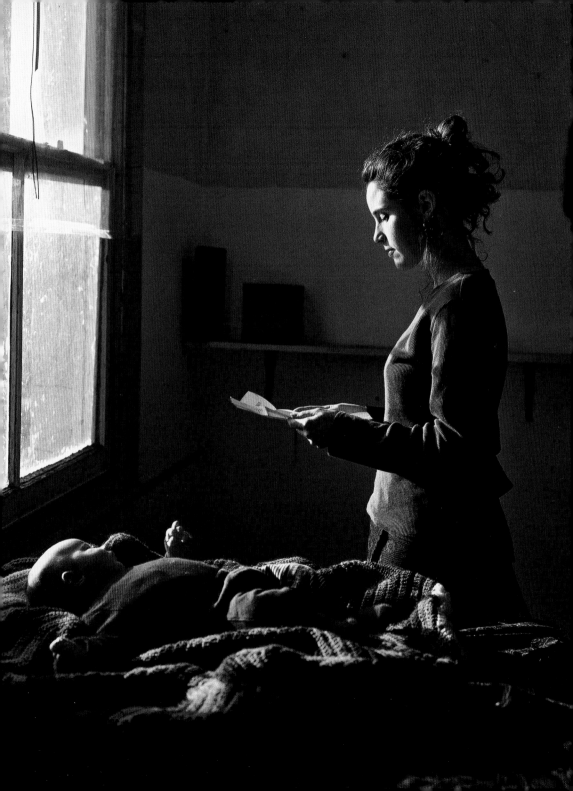

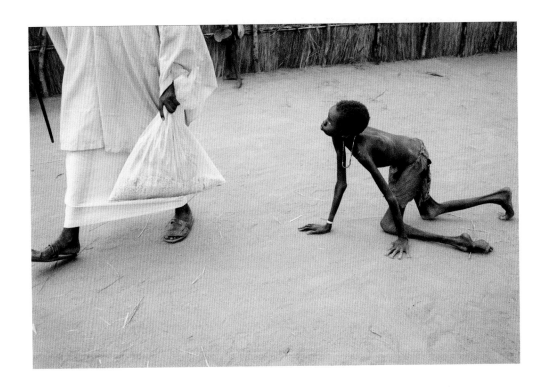

A WELL-NOURISHED SUDANESE MAN STEALS MAIZE FROM Λ STARVING CHILD DURING FOOD DISTRIBUTION AT A MÉDECINS SANS FRONTIÈRES FEEDING CENTER, AJIEP, SUDAN, IN 1998

TOM STODDART

Date 1998
Location Ajiep, Sudan
Format 35 mm

The shocking contrast between the condition of the emaciated, crawling boy and the well-dressed man carrying a sack of food in this photograph is heightened when the viewer grasps that the man has apparently stolen the bag of maize from the boy. Photographer Tom Stoddart (born 1952) faced public anger and questions about it: why had he not intervened to take the food back for the boy? Stoddart's answer was that it was not his place to intervene in this scenario of greed and indifference

to suffering; it may be shocking when depicted as such, but it happens all over the world.

In 1998, Sudan was in the midst of a bitter civil war, compounded by a largely unaddressed famine. Aware that there had been only sporadic news coverage, Stoddart flew to Ajiep in southern Sudan and worked alongside Médecins Sans Frontières (MSF), which had taken advantage of a ceasefire to set up feeding centers in the area. Shot exclusively in black and white, Stoddart's photos are compassionate and humanist but also brutal and unflinching in their exposure of the horrors of war and famine. *The Guardian* newspaper raised more than £100,000 ($125,000) for MSF when it published some of Stoddart's photographs. CP

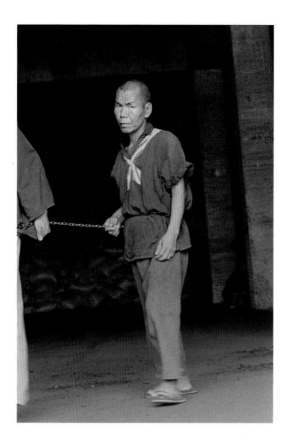

MENTAL PATIENT, LUNG-FA TANG TEMPLE

CHIEN-CHI CHANG

Date 1998
Location Kaohsiung, Taiwan
Format 35 mm

Magnum photographer Chien-Chi Chang (born 1961) focuses on the themes of alienation and connection. In this image of a mentally disabled man in Lung-Fa Tang Temple, a slight tilt draws the eye downward in the direction of the chain that appears to be pulling him toward the edge of the frame. The subject's gaze toward the camera, and by extension, the viewer, is highly loaded: the glance could signify a cry for help, or, just as easily, could be a look of disdain or reproach.

We are asked for compassion, but also accused, making this image an anomaly in the broader context of Chang's larger project, *The Chain*. In the other images, the eponymous chain joins two or more inmates together. Here, the subject stands alone and his dialog is with the viewer rather than a fellow, his stance being that of a boxer ready to throw a punch. Humor is common in the other images (some of the subjects mug and smile uninhibitedly), but this one is stark and challenging, difficult to look at yet difficult to look away from. Chang's themes are bound powerfully here: the man is alienated in his mental state and place in society, yet his connection to his inmates is embodied literally by the chain. **AZ**

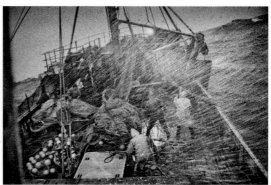

ONBOARD THE SPANISH TRAWLER *ROWANLEA*

JEAN GAUMY

Date 1998
Location North Atlantic Ocean
Format 35 mm

LAST FOOT ON THE MOON

STEVE PYKE

Date 1998
Location Houston, Texas, USA
Format Medium format

With its strong side lighting, striations, contours, and half-crescent shape, this close-up of the sole of a foot recalls photographs of the Moon, and indeed that was the intention. The foot belongs to NASA Apollo astronaut Gene Cernan, the last man to step on the surface of the Moon. The image, taken by English photographer Steve Pyke (born 1957) thirty years after the landing, was part of a project on the surviving Apollo crew members. Pyke explained that he was "after a very specific experience. What is it actually like to walk on the moon?" In seeking an answer to that question, Pyke met and photographed the astronauts, including Buzz Aldrin, one of the first men on the Moon.

Pyke usually shoots his signature direct, intimate portraits against a black background, using a twin-lens Rolleiflex medium-format camera fitted with a close-up lens. Seeing himself as a "collector of faces," he has photographed celebrities, musicians, actors, and movie directors, while also finding time for his own projects. PL

This dramatic image by French photographer Jean Gaumy (born 1948) is part of a collection, published as *Men at Sea* (2002), which manages to convey immense maritime power and the human courage involved in gathering an important food source.

Gaumy described life at sea: "Hurled when the boat dives, the steep and greasy stairs we climb become a pestle as we go over a wave. The iron airlock. The sticky air of diesel vapors. The large linoleum imitation floor, blistered, brown, and greasy. Everything flutters about. The portholes' light is dancing on the walls and behind the thick glass the sea runs off, distorting the vision. The unpredictable grey sky devastated with spindrifts, and the ocean at the edge, full of white flurries."

Though Gaumy is best known for his work documenting the French hospital and prison systems, and also his work in Iran, this image is part of a wider engagement with maritime stories linked by the common theme of human confinement. He has spent time on an Arctic icebreaker, as well as months documenting the lives of sailors aboard a French nuclear-powered submarine. NG

EINSTEIN'S ABSTRACT

CORNELIA PARKER

Date 1999
Location Oxford, UK
Format Photomicrograph

The interaction of disintegration and coherence resonates in the work of artist Cornelia Parker (born 1956). One of her most famous pieces is *Mass (Colder Darker Matter)*, an installation made in 1997 from the charcoal remnants of a Texan church that was struck by lightning. When displayed, it hangs in a petrified shower of black fragments.

This sense of elements forming a new whole, or having an afterlife, finds echoes in Parker's *Abstracts* series. She describes the works as "forensic forays into the minutiae of iconic thinkers." For each work the artist took macro-photographs of objects once used by thinkers like Sigmund Freud (she photographed the creases he made in his leather chair) and Charlotte Brontë (her pincushion and its constellation of needle holes).

For this *Einstein's Abstract*, Parker trained her lens on the blackboard that Albert Einstein used to outline his theory of relativity in a lecture at Oxford University in 1931. Markings made in chalk that signaled the transformation of the study of physics and astronomy seem themselves to embody these scientific fields: white particles of dust scud across an expanse of black, as suggestive as a stellar stream in orbit. In works like these, Parker opens perceptual space between what we see and our knowledge of its significance. **RF**

X-RAY OF ILLEGAL IMMIGRANTS

UNKNOWN PHOTOGRAPHER

Date 1999
Location Chiapas, Mexico
Format X-ray

In this haunting X-ray image we catch a glimpse of illegal immigrants being smuggled from the southern state of Chiapas, Mexico, into the United States. In between stacked crates of bananas, the backs of those nearest to us are clearly seen cramped together in the small space of the truck, along with the shadowy outlines of others on the opposite side. The sight is unexpected and startling, and demonstrates the frightening capacity of X-ray photography to penetrate exteriors and make the invisible visible.

The Chiapas authorities captured the image with the controversial backscatter X-ray technology used to check cargo for illegal immigrants and contraband, including weapons and drugs. Many people oppose the technology, similar to that employed in airports, believing it to be a violation of privacy; they liken its use to "virtual strip searching." Health concerns are also raised about the exposure to X-ray radiation.

In this X-ray image, the forms of the migrants inside the truck appear ghostlike and vulnerable. Human smugglers, often referred to as Coyotes, charge extortionate fees to transport people across the US border, without offering any guarantee that they will reach their destination. **EC**

GRAND PRISMATIC SPRING, YELLOWSTONE NATIONAL PARK, WYOMING, USA

YANN-ARTHUS BERTRAND

Date 1999
Location Wyoming, USA
Format 35 mm (with a variety of lenses)

The beauty and wonder of the Grand Prismatic Spring in Yellowstone National Park is here captured by a photographer with a passion for both aerial photography and the natural world. Yann-Arthus Bertrand (born 1946) began his photography while studying a family of lions in Africa. Working as the pilot of a hot air balloon, he became aware of the powerful perspective offered by shooting from above; from this vantage point, he was able to show not only the Earth's beauty but also the impact of humans upon it.

Bertrand went on to shoot environmental stories for *Geo*, *National Geographic*, *Life*, *Paris Match*, and other publications. He also founded the world's first aerial photography agency, in 1991. The following year, marked by the first Rio Environmental Summit, he decided to begin a major work on the state of the planet, called *Earth from Above*. The project was intended to educate the public, and durable, outdoor-mounted exhibitions of the photographs were seen by more than 200 million people. Bertrand also created the Goodplanet Foundation to raise public awareness of environmental issues and fund environmental protection measures.

The photograph shown is one from the book *Earth from Above* (1999) and straightforwardly shows the magnificence of nature, free of human impact. Located in the oldest national park in the world, the thermal basin is 367 feet (112m) in diameter, the third largest in the world. The rainbow colors within derive from microscopic algae, whose growth rate varies with the temperature and depth of the water. CP

THE OHIO PROJECT (6)

NIKKI S. LEE

Date 1999
Location Ohio, USA
Format 35 mm

Originally from South Korea, Nikki S. Lee (born 1970) migrated to the United States in 1994. This image from her *The Ohio Project* is part of a larger body of work, titled *Projects*, in which she effectively camouflaged herself into a variety of situations. Through makeup, clothing, and body language, she dramatically transformed her look to mimic those of chosen social groups—such as punks, drag queens, and senior citizens—immersing herself in their environments for weeks, sometimes

months, at a time. Following the chameleon-like transformation, Lee would ask friends or passersby to photograph her with a small auto-focus camera.

In this image, Lee appears with bleached-blonde hair, reclining suggestively on the hood of a canary-yellow lowrider. Beside her, a man dressed in stereotypically Midwestern clothes poses somewhat awkwardly in contrast to her. The result is a clever exploration of the changeability of social identity and the desire of immigrants to fit into a new culture. Lee cites Cindy Sherman as an influence, and she similarly melds photography and aspects of performance. Lee's work builds into a unique portrayal of the fluidity of identity and the search for a feeling of belonging. **EC**

OXFORD TIRE PILE #8

EDWARD BURTYNSKY

Date 1999
Location Westley, California, USA
Format Large format

This image is from a long-running and meticulous documentation of the international oil industry by Canadian photographer Edward Burtynsky (born 1955). The project examines the "big picture" of oil manufacture: its distribution, use, by-products, and environmental impact. Much of this impact is invisible, but Burtynsky has found ways to show its alienating breadth and scale.

Here, Burtynsky records the bleak human-made landscape created by a huge tire pile: a seemingly endless graveyard created by US motor culture and gasoline addiction. The work fits into the category of the "technological sublime," in the tradition of artists who mobilize a combination of horror and awe to deliver their political message. Burtynsky wrote: "In 1997, I had what I refer to as my oil epiphany. It occurred to me that the vast, human-altered landscapes that I pursued and photographed for over twenty years were only made possible by the discovery of oil and the mechanical advantage of the internal combustion engine ... These images can be seen as notations by one artist contemplating the world as it is made possible through this vital energy resource and the cumulative effects of industrial evolution." JG

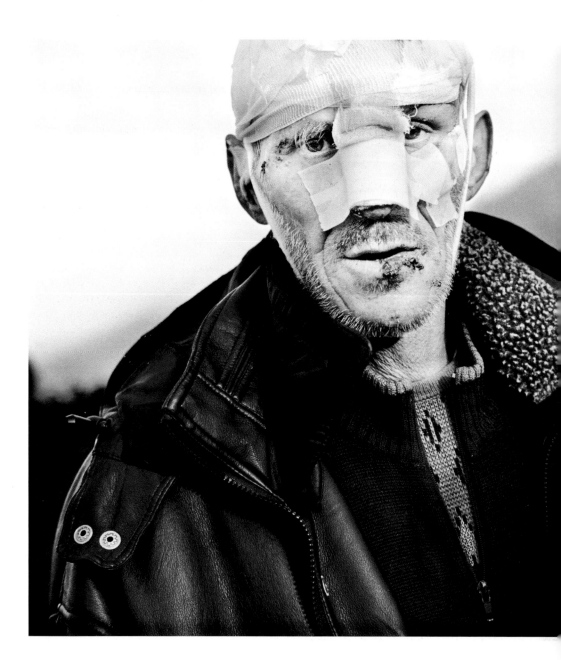

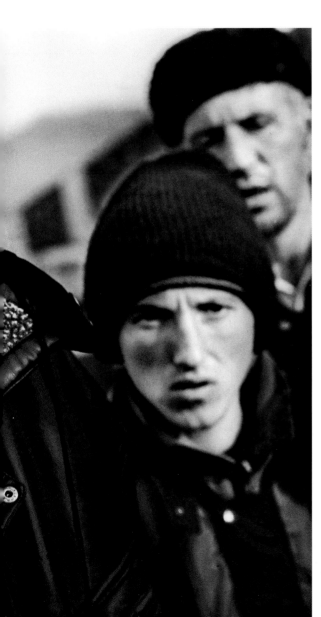

WOUNDED KOSOVAR-
ALBANIAN MAN

CLAUS BJØRN LARSEN

Date 1999
Location Kukës, Albania
Format 35 mm

Danish photographer Claus Bjørn Larsen (born 1963) started working in photography in 1983, straight out of high school, beginning as a darkroom volunteer at Danish tabloid *Ekstra Bladet*. He then studied photojournalism at the Danish School of Journalism in Aarhus, and in 1996 became a staff photographer for *Berlingske Tidende*, one of Copenhagen's daily newspapers. By 1999, Larsen was the paper's chief staff photographer, a position he retained for ten years, before becoming a freelance press photographer in 2009, working for various international newspapers and magazines.

From the time he first studied photojournalism, Larsen dedicated his career to covering wars and conflict around the world. His work took him to places such as Iraq, Israel, Afghanistan, and the former Yugoslavia. The photographs he took were almost always in black and white, and his newspaper afforded him the time to seek out images of conflict that were quiet but telling, rather than the more obvious photography associated with spot news.

Larsen was sent several times on assignment to cover the conflict in Kosovo. He was arrested and his film was confiscated three weeks into his first trip in the region, yet he continued to return. In April 1999 Larsen captured this image of an injured man among a crowd of Albanian refugees fleeing Kosovo. In an interview with the *Washington Post*, Larsen said of the photo (which won the World Press Photo of the Year in 2000), "I tried to talk to him. [But] he was in kind of a trance. I could see that he had very strong eyes. I took four or five frames and then he just disappeared." LH

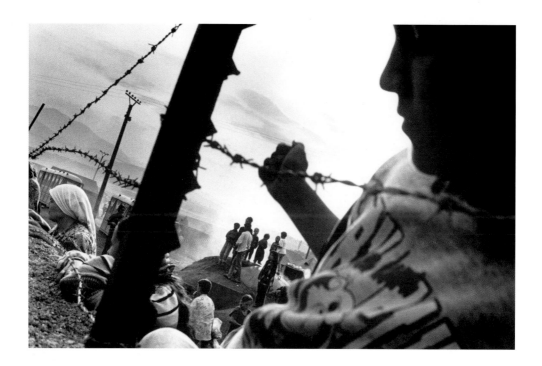

KOSOVO

PAOLO PELLEGRIN

Date 1999
Location Kukës 1 refugee camp, Albania
Format 35 mm

Italian photojournalist Paolo Pellegrin (born 1964) has documented conflicts in Darfur, Bosnia, Sudan, and Afghanistan. In 1999 and 2000, he was traveling between Kosovo, Albania, Macedonia, and Serbia.

By the end of the Kosovo War (1998–99), almost 850,000 people out of a population of 2 million had been displaced, and thousands had been killed. This photograph was taken at a Kosovan refugee camp in Kukës, northeastern Albania. The camp was overcrowded and, when tents ran out

in May 1999, families were given makeshift homes made from sheets of plastic, in which they lived for up to several months. Pellegrin captures the misery and chaos of the refugee experience. He portrays a boy clinging to the barbed wire of the camp as if imprisoned. The boy's face is shown in profile, obscured by shadow. By depicting the child anonymously as a mere silhouette, Pellegrin highlights the loss of identity and dignity of all humans seeking a safe refuge in a war.

Pellegrin's coverage of the Kosovo conflict won him a World Press Photo award; his photographs appeared in book form in *Kosovo, 1999–2000: The Flight of Reason* (2002). He has since become a member of the Magnum agency. **CK**

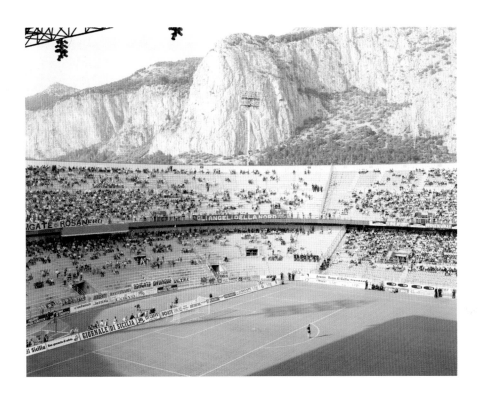

STADIO PALERMO

OLIVO BARBIERI

Date 1999
Location Sicily, Italy
Format Large format

If the camera is a tool to manipulate reality, to twist the way in which people apprehend the world, then Olivo Barbieri (born 1954) is a master of manipulating perception through photography. For many decades he has created photographs that present bird's-eye views of cities the world over, using a tilt-shift lens technique to make the scenes in his viewfinder appear as though they are in miniature. People appear as tiny specks in the ocean, or clustered in city squares, and buildings look as though they are made from Lego. Barbieri's disorientating and hyperreal images teeter thrillingly on the edge of reality and fiction; his subjects are familiar, and yet they look strange.

The Italian's technical wizardry is on display in this image of Stadio Renzo Barbera, a soccer stadium in Palermo, Sicily. Barbieri's elevated vantage point gives a stunning view of steep cliffs in the distance as the sprawling stadium opens out in front. Barbieri has commented that his work is concerned with how and why humans have constructed the world in the way they have. By photographing everywhere, from the Niagara Falls to the Dolomites, he presents myriad views of our varied yet disconcertingly uniform world. GP

FROM *MAKING DO AND GETTING BY*

RICHARD WENTWORTH

Date 1999
Location London, UK
Format 35 mm

Richard Wentworth (born 1947) is best known for his sculptures, created by transforming everyday objects into something else entirely through the juxtaposition of materials and found elements. Wentworth studied at the Royal College of Art, London, from 1968 to 1970, alongside artists such as Bill Woodrow and Tony Cragg. His work is identified with that of the New British Sculpture movement.

In the 1990s, he began using photography in his practice for the long-term project *Making*

Do and Getting By. He photographed objects he encountered on the street that had been repurposed from their original intention. He recorded this act of improvisation and the resulting oddities in the public landscape, such as in an image of a boot used as a doorstop or this photograph of a polystyrene cup placed on a spiked metal fence. For him, the act of these deeds is what makes them extraordinary. Wentworth has said of the project: "I find cigarette packets folded up under table legs more monumental than a Henry Moore. Five reasons. Firstly the scale. Secondly, the fingertip manipulation. Thirdly, modesty of both gesture and material. Fourth, its absurdity and fifth, the fact that it works." LH

MICKEY AT HOME WITH MARIA AND CHANELLE

JOCELYN BAIN HOGG

Date 1999
Location Tenerife, Spain
Format 35 mm

Jocelyn Bain Hogg spent twenty years documenting the interconnected lives of the British criminal underworld known as "The Firm." He initially followed the old guard of the gangs, photographing the funeral of Charlie Kray (father of the Kray twins) and underground boxing matches. This intense moment was captured while Bain Hogg was with London gangster Mickey Goldtooth during his enforced exile in Tenerife, Spain. Ten years after the release of Bain Hogg's first book, The Firm

(2001), he followed up on the extended groups of gangsters, publishing The Family (2011), which documented them as they moved out of the city into the suburbs, as the changing nature of society impacted on their activities. Bain Hogg is aware of the complications of working in tight proximity with such subjects, but argues that the photographer has to maintain a sense of journalistic fairness. He describes how he is able to work so closely to the gangs: "There are extraordinary moral ambiguities with a story like this, you get very close to people, but then you know their history and who they are; you become very intimate with them in the professional world but they are not part of your own personal life." PL

CAMERA OBSCURA IMAGE OF BOSTON'S OLD CUSTOMS HOUSE IN HOTEL ROOM

ABELARDO MORELL

Date 1999
Location Boston, Massachusetts, USA
Format Camera obscura

In 1962, Abelardo Morell (born 1948) fled Cuba with his family and settled in Boston, where he studied fine art and photography. In 1991, he began working with the camera obscura technique. He describes how he sets up in his own darkened living room: "I cover all windows with black plastic in order to achieve total darkness. Then, I cut a small hole in the material I use to cover the windows. This opening allows an inverted image of the view outside to flood onto the back walls of the room."

He developed the technique to record a series of room interiors with the outside world projected onto the wall. The exposures take from five to ten hours. He explains how "this project has taken me from my living room to all sorts of interiors around the world. One of the satisfactions I get from making this imagery comes from my seeing the weird and yet natural marriage of the inside and outside." Since making this image of the Boston skyline, he has refined the technique to shoot in color as well as black and white, and uses a prism to flip the image so that it appears the right way up. The camera obscura, also known as the pinhole camera, dates back hundreds of years, and was the earliest form of image projection. PL

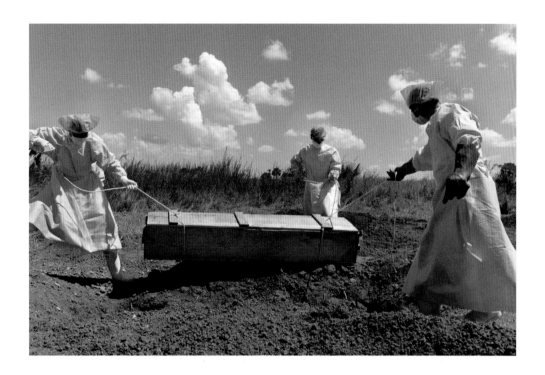

EBOLA BURIAL

JODI BIEBER

Date 2000
Location Uganda
Format 35 mm

From 2000 to 2001, Uganda experienced a massive outbreak of the highly infectious disease Ebola, which killed more than 220 people. There is no cure for the virus that causes fatal hemorrhaging and results in death for around half of the people who contract it. The most common way of spreading the airborne disease is through contact with family members or by attending the funeral of someone who has died from it. Ambulance workers who transported the sick and buried the dead, as seen in this photograph, had to be covered from head to toe to protect themselves from the virus.

South African photographer Jodi Bieber (born 1966) was on assignment to cover the outbreak for *The New York Times Magazine*. She, too, had to wear a protective gown, hat, mask, shoes, and gloves at all times and was sprayed with bleach each time she left a contaminated zone. In an interview with *Time* magazine many years later Bieber compared the experience to "playing Russian Roulette with your life." She fell ill after returning home from Uganda and feared for her life in the days that followed, only to eventually be given the all clear. "With Ebola, there's no turning back," she said. "It's a bitter death, as I saw in Uganda." LH

ALTAI TERRITORY, RUSSIA, 2000

JONAS BENDIKSEN

Date 2000
Location Altai Republic, Russia
Format 35 mm

This was the cover photograph of *Satellites* (2006), the first book by Norwegian photojournalist Jonas Bendiksen (born 1977). The work was the culmination of the seven years he spent photographing the countries that made up the former Soviet Union. Bendiksen started his photographic career as an intern at the London office of Magnum Photos. In 2004, after seeing the quality of his freelance photography, the agency took him on full time.

This dreamlike scene shows villagers collecting scrap metal from a spacecraft that had crashed in the southern Russian province of Altai, near the border with Kazakhstan. When Bendiksen first came upon the scene, he thought it was snowing; in fact, what his shot captures are thousands of white butterflies fluttering around the fields as storm clouds fill the skies. He recalls: "I've never seen anything like it. It was a truly magical situation. It was the perfect storm of different elements. I look back at [the] contact sheet from those days and it boggles my mind because I didn't really realize at the time that this was just truly unique and even a surreal, bizarre situation. But there was something about when I was there . . . all this seemed normal." LH

MEMPHIS HOUSEWIVES MEET AND COMPARE RECENTLY PURCHASED WEAPONS

ZED NELSON

Date 2000
Location Memphis, Tennessee, USA
Format 35 mm

This compelling image by British photographer Zed Nelson (born 1965) shows a group of Memphis housewives comparing their arsenal of handguns as if at a Tupperware party. The five women had gathered to share their fears about living in the United States. One of the women, Vicky Sykes, told Nelson: "The thought that some people would want to take our guns away, the right to carry our guns, to me is so ludicrous, because the bad guys: the thugs, the murderers, the rapists, are always

going to have guns . . . all you would be doing would be to take them away from the good guys, from us, the law-abiding citizens." The photograph is from Nelson's book *Gun Nation* (2001), which he states "explores the paradox of why America's most potent symbol of freedom is also one of its greatest killers." Nelson explained his initial motivation for the project: "Years ago, someone shot my friend and tried to shoot me. The experience inspired me to travel across America documenting the carnage created by the estimated 270 million guns in circulation nationwide." When Nelson returned to the United States to make his 2016 documentary *Gun Nation*, he was disturbed to find that little had changed in American gun culture. PL

NEW STREET STATION

JOHN DAVIES

Date 2000
Location Birmingham, UK
Format Large format

British landscape photographer John Davies (born 1949) grew up living in both coal mining and farming communities in County Durham and Nottinghamshire. After graduating in 1974, Davies began working on photographic landscape studies in rural Britain. In 1981, he began a long-term investigation into the urban centers of England and Wales, one that he has continued throughout his career and one that is primarily focused on how industry—such as coal mining, quarries, railroads, and shipping—and postindustrial activity have transformed the nation's major cities.

In 2000, Davies began *Metropoli*, a series of large-format landscape images that reveals the complex topography of Britain's postindustrial cities. This one shows Birmingham New Street Station, Britain's busiest rail interchange. The station, originally built above the city's canal system, was rebuilt in 1967 and again in 2006. This large tableau, shot from a high vantage point, emphasizes the layered history of the city's transformation. Davies has said of his project: "We are collectively responsible for shaping the landscape we occupy and in turn the landscape shapes us whether we are aware of it or not." LH

NEW YORK, SEPTEMBER 11, 2001

THOMAS HOEPKER

Date 2001
Location Brooklyn, New York, USA
Format 35 mm

This shot by Thomas Hoepker (born 1936) of a group seemingly relaxing against the backdrop of the smoking ruin of the World Trade Center is one of the most controversial of an event that has been seared into Western memory. Hoepker, who is from Germany but has lived in New York for decades, is a member of Magnum. By coincidence, on September 11, the US-based membership were meeting in New York and were able to record events; their images later formed the Magnum book *New*

York September 11. Hoepker chose not to feature this picture in the book, and it came to public light only through its inclusion in a book in 2006. It instantly caused debate, with some critics alluding to the callousness of the scene. One of the subjects shown, Walter Sipser, has strongly objected to this reading: "We were in a profound state of shock and disbelief, like everyone else we encountered that day." He said that they were in the midst of an animated discussion about the event and criticizes Hoepker for not taking time to talk to them. Hoepker points out, however, that he snapped the image only in passing. The photograph therefore represents a touchstone in debates concerning objectivity and representation in photojournalism. NG

PINOCHET WITH GRANDCHILD

BARRY LEWIS

Date 2001
Location UK
Format 35 mm

This avuncular portrait shows the former dictator of Chile, General Augusto Pinochet Ugarte, in 2001, holding his baby granddaughter while under house arrest in the United Kingdom. On the night of October 16, 1998, British police arrested Pinochet at a London hospital, where he was convalescing after a minor operation. They were acting on a Spanish warrant charging him with human rights crimes committed in Chile during his long period in power (1973–98), including the abduction, torture, and execution of thousands of political opponents. Pinochet's Chilean army death squad, commonly known as "the Caravan of Death," removed scores of prisoners from jail and executed them one month after he had led a 1973 military coup.

It was a complicated photographic commission, an unholy alliance between two British newspapers: the liberal *Guardian* and the conservative *Daily Telegraph*. Pinochet's Chilean delegation wanted only one photographer and a shared interview; chanting protesters outside the suburban sanctuary added to the tension. Photographer Barry Lewis (born 1948) recalled: "A close-up shot with the Chilean flag didn't work well, and in despair I suggested he held his newborn grandchild. I felt this got across a sense of sinister normality." To Lewis's chagrin, his nuanced approach was undermined when former prime minister Margaret Thatcher, a supporter of Pinochet, used the image without permission as part of a political campaign to free an "elderly wronged family man." Released on health grounds, Pinochet was later rearrested in Chile. He died in 2006 without being convicted of any of the crimes of which he was accused. CJ

"My difficulty in shooting this portrait was to evoke a 'darkness' within the tightly timed, stage-managed scene of a smartly dressed old man in an anonymous English garden." Barry Lewis

THE BODY OF A ONE-YEAR-OLD BOY IS PREPARED FOR BURIAL

ERIK REFNER

Date 2001

Location Near Peshawar, Pakistan

Format 35 mm

This emotive image shows a one-year-old Afghan boy who died of dehydration being prepared for burial at Jalozai refugee camp in northwest Pakistan. Squalid and extremely overcrowded, Jalozai was one of the largest of 150 transit camps in Pakistan that held Afghan refugees from the 1980s Soviet invasion of Afghanistan. Although workers at the camp tried to provide basic health services, children died from disease or dehydration. The image was taken by Danish photographer Erik Refner (born 1971), and in 2002 it was awarded World Press Photo of the Year. The jury described it as "simple," "iconic," and "symbolic."

Note the stark juxtaposition between the white of the child's burial shroud and the darker hands and forearms of his father, his brother, and an imam who gently tend him. The child looks peaceful, as if asleep, with the slightest hint of a smile. The aged skin texture of the hands and arms of the attendants also contrasts with the boy's smooth, well-lit face, accentuating the painful tragedy of the old burying the young.

Refner, a photojournalist who was at the time an intern for Danish national newspaper *Berlingske Tidende*, had been in the Jalozai camp of approximately 90,000 refugees for two weeks, working with nongovernmental organization Médecins Sans Frontières (Doctors Without Borders) before taking this photograph. He later described the difficulty of shooting the scene. Although he had been given permission to do so by the child's father, he could hear women crying in a nearby tent. He took the shot from above, careful not to disturb the family's grieving. **CP**

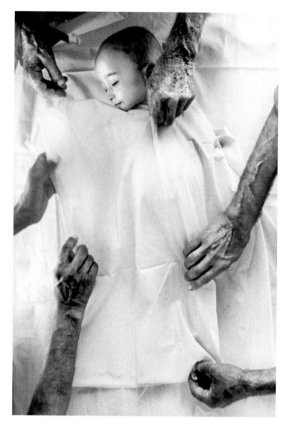

"The look of tranquility on the face of a young Afghan boy who died of dehydration . . . belied the years of suffering that these refugees had gone through."

Nicholas Chen, photojournalist

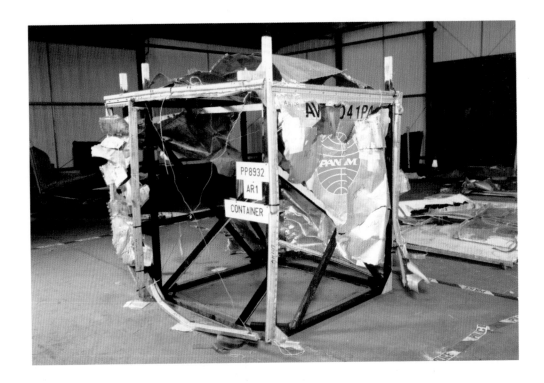

REBUILT BAGGAGE CONTAINER FROM PAN AM FLIGHT 103

UNKNOWN

Date 2001
Location Edinburgh, UK
Format Unknown

On December 21, 1988, a bomb exploded on board Pan Am Flight 103, traveling from Frankfurt to Detroit via London. Although the bomb was probably intended to detonate when the plane was above the Atlantic, a late departure from London's Heathrow Airport meant it instead exploded over the Scottish town of Lockerbie, killing 270 people. The investigation into the bombing was complex, with 4 million pieces of wreckage to investigate. Forensic examination initially pointed to a bomb hidden inside a Toshiba radio cassette player, contained in a suitcase in the cargo hold. Similar bombs had been used in attacks by Palestinian militants. The focus of the investigation changed when items of clothing from the same suitcase were traced to a Maltese merchant who in turn identified a Libyan, Abdelbaset al-Megrahi, as the buyer. This testimony appeared to be corroborated by the discovery of a fragment of circuit board from a bomb timer of a type supplied to Libya by a Swiss company. Both pieces of evidence remain controversial, but as a result, al-Megrahi was tried and found guilty. By reconstructing parts of the baggage containers, as seen in this image of AVE 4041, it was possible to show the one that contained the bomb. LB

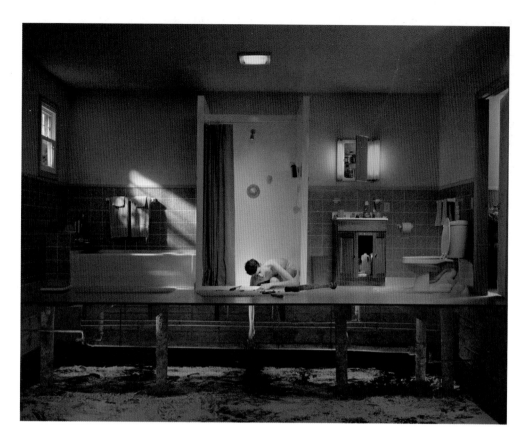

UNTITLED, FROM *TWILIGHT*

GREGORY CREWDSON

Date 2001
Location Unknown
Format Large format

In an odd mixture of fantasy and reality, a boy plunges his arm into a shower drain; a cutaway view of this tableau reveals what lies beneath the floor of the boy's seemingly normal, middle-class bathroom: a dank, subterranean place. The viewer's eyes move between the normal space and the strange and unsettling netherworld.

This image, with its rich array of set scenery and thoughtful lighting, is typical of the work of Gregory Crewdson (born 1962) and is taken from his acclaimed *Twilight* (2001–02) series. His photographs have a filmic quality, and their creation involves actors, lighting crews, set dressers, costumes, makeup, and more. Crewdson is influenced by the "in between" quality of twilight seen in Edward Hopper's paintings, and by the eerie ambience of David Lynch's movies. Many have described Crewdson's photographs as stills from films that never existed, and the viewer struggles not to create a story around his images. The abundance of detail in these large-scale pictures encourages this perception, as does the fact that his subjects rarely make eye contact with the camera/viewer, yet they convey a range of ambivalent and mixed emotions. **CP**

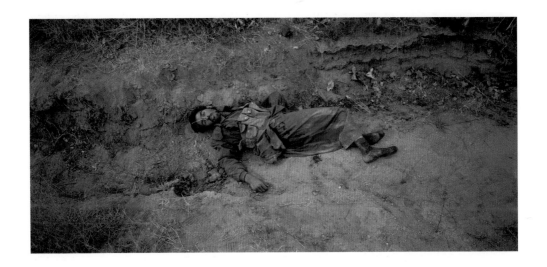

TALIBAN

LUC DELAHAYE

Date 2001
Location Near Kabul, Afghanistan
Format Large-format panoramic

A Taliban soldier lies in a ditch outside Kabul, his throat slit, boots stolen, eyes half-open, and wallet riffled. This image is from *History* by French photographer Luc Delahaye (born 1962), a series that chronicles world events in the early twenty-first century. Delahaye worked on contract for *Newsweek* in Afghanistan, Iraq, Palestine, and the United States, and *History* is an anthology of the images he kept for himself rather than handing them over to the magazine. The series

consists of thirteen painterly panoramic prints that, when displayed in a New York art gallery in 2003, went on sale for $15,000 each. This led some commentators to criticize Delahaye, claiming that this commercialization was at odds with his subject matter: the suffering of real people, and politically urgent current events. Shot in large format, this work differs from the "snapshot aesthetic" that tends to characterize photojournalism. Yet, Delahaye seems to have courted this kind of controversy and has spoken openly about the moment when he ceased to be a photojournalist and became an artist. His work is a reminder that the social readings and effects of photography can never be separated from their economic conditions. **JG**

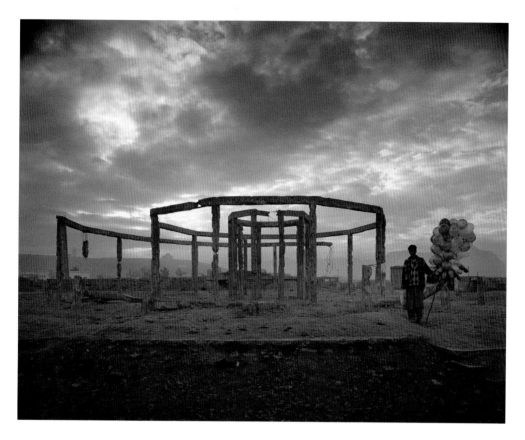

FROM *AFGHANISTAN: CHRONOTOPIA*

SIMON NORFOLK

Date 2001
Location Kabul, Afghanistan
Format Large format

Simon Norfolk (born 1963) is a leading practitioner of what has been dubbed "aftermath" photography, a genre that involves returning to sites of conflict to reveal traces of violence left embedded in the landscape. This approach takes the subject matter of photojournalism but applies a formal strategy, frequently using large-format cameras to give the level of detail required. Norfolk draws on art history, applying formal composition and technique to make images that are seductive and beautiful, as

well as loaded with meaning. In this image, from the project *Afghanistan: Chronotopia*, made after the allied invasion of 2001, the balloon vendor provides a poignant contrast to the teahouse ruins behind him, acting like the innocent shepherd boy of seventeenth-century art. At the time of the invasion in 2001, Norfolk felt that the future for the country might be more positive after a generation of conflict. He described it as: "A liminal moment at the close of one thing and the beginning of something new. To use the golden kiss of the dawn light seemed the right approach at the time." However, when Norfolk returned to Afghanistan in 2010 on another project, he found a country still in crisis and was more pessimistic in his viewpoint. PL

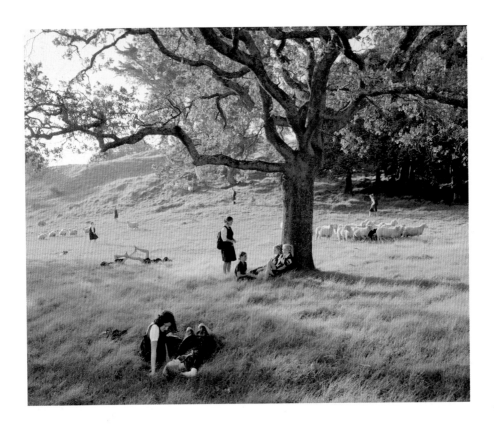

SHEEP WRANGLERS

JUSTINE KURLAND

Date 2001
Location Unknown
Format Unknown

A sense of escapism and romanticism runs through the work of Justine Kurland (born 1969). Everything in this carefully staged photograph is there for a reason: the children in the foreground, those beneath the tree just behind them, and the sheep in the distance. Paradoxically, given her meticulous framing and handling of natural light, Kurland creates a feeling of spontaneity, as though she just happened to stumble upon this idyllic pastoral scene. Fantastical and mythical, her work often

embodies a utopian ideal of figures frolicking in the American landscape, bathed in beautiful light.

But there can be a sense of strangeness or uneasiness, too—that all is not what it seems. The artist, who acknowledges the influence of fairytales and nineteenth-century English landscape painting on her work, came to attention in the late 1990s with a series of images showing teenage girls in nature. She later produced a series of Eden-like photographs in which naked pregnant and nursing women with infants would roam the landscape. Kurland lived "on the road" for her art and drew attention when she took her three-month-old son on a five-year road trip. She now lives and works in New York City. **GP**

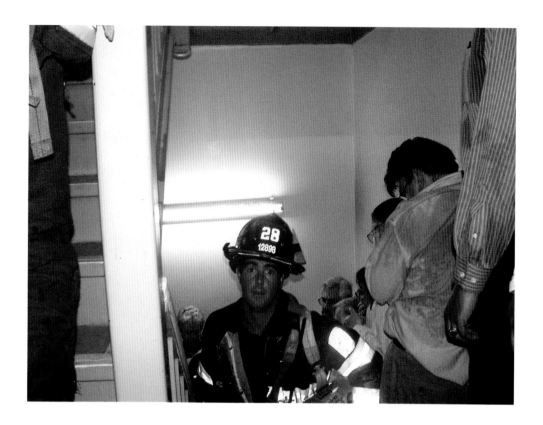

UNTITLED (MIKE KEHOE)

JOHN LABRIOLA

Date 2001
Location New York, New York, USA
Format 35 mm

John Labriola was on the seventy-first floor of the North Tower of New York's World Trade Center on September 11, 2001, when a hijacked airliner was flown into the building twenty floors above him. Along with thousands of office workers, Labriola began to evacuate the building, photographing with his Nikon digital camera the scenes he saw as he went. His collection of more than one hundred images is significant for showing the chronology of the attacks from within one of the buildings and is

an early example of the power of citizen journalism to show a perspective on breaking news events that might be inaccessible to professionals.

Among Labriola's images, one particularly stood out. It shows a stream of office workers descending a stairwell, while in the opposite direction a firefighter ascends to tackle the disaster above. Red-faced from the climb, he gazes directly into the camera: his expression conveys a mix of calmness, uncertainty, and even fear. In an event typified by images of the burning buildings, Labriola's photograph became one of the rare exceptions that put a human face on the disaster. It later emerged that the fireman, Mike Kehoe, had survived the collapse of the towers that claimed the lives of 343 of his colleagues. **LB**

PERGAMON MUSEUM III, BERLIN 2001

THOMAS STRUTH

Date 2001
Location Berlin, Germany
Format Large format

In 1989, German photographer Thomas Struth (born 1954) began working in museums, exploring the relationship between people and art. He is interested in the gaze of the spectator: at times the camera is pointed toward the faces of the crowd and sometimes over their heads or shoulders at the art on display, allowing us to see what they see in a manner that feels almost voyeuristic and which highlights the fetish quality of art objects. From 1996 to 2001, he turned his attention to Berlin's Pergamon Museum, which houses archeological treasures from the Middle East. However, this series is peopled entirely by subjects whom he has directed and posed. In common with his Düsseldorf School contemporaries, Struth is meticulous and restrained, and here he deploys all of his careful observation of museum environments in creating his own vision of cultural consumption. JG

MARCY BORDERS COVERED IN DUST AFTER THE COLLAPSE OF THE WORLD TRADE CENTER

STAN HONDA

Date 2001
Location New York, New York, USA
Format Unknown

While thousands of people fled Lower Manhattan immediately after the attacks on the World Trade Center on the morning of September 11, 2001, many journalists headed toward the burning towers. One of them, Stan Honda, a photographer for Agence France-Presse (AFP), was close to the South Tower when it collapsed, sending a plume of dust and debris through the surrounding streets.

Honda ducked into a nearby building to take shelter and was joined by others who had been covered in dust. One of these was twenty-eight-year-old bank clerk Marcy Borders, who had been working on the eighty-first floor of the North Tower. Honda recalled: "[T]his woman came in completely covered in dust. It was a strange sight. She paused for a second, and I took one photo. It was just that one frame . . . then somebody took her upstairs and she was gone." Honda's photograph became a defining image of the attacks. Borders herself described taking chase from the dust cloud: "Once it caught me, it threw me on my hands and knees. Every time I inhaled my mouth filled up with it, I was choking. I was saying to myself out loud, I didn't want to die, I didn't want to die."

Honda's image is a potent reminder of the human toll of 9/11. Although Borders survived, she found it hard to come to terms with the experience and suffered from anxiety and depression. In August 2014, she was diagnosed with stomach cancer, which she believed had been caused by carcinogens in the smoke and dust that enveloped her. She died one year later. LB

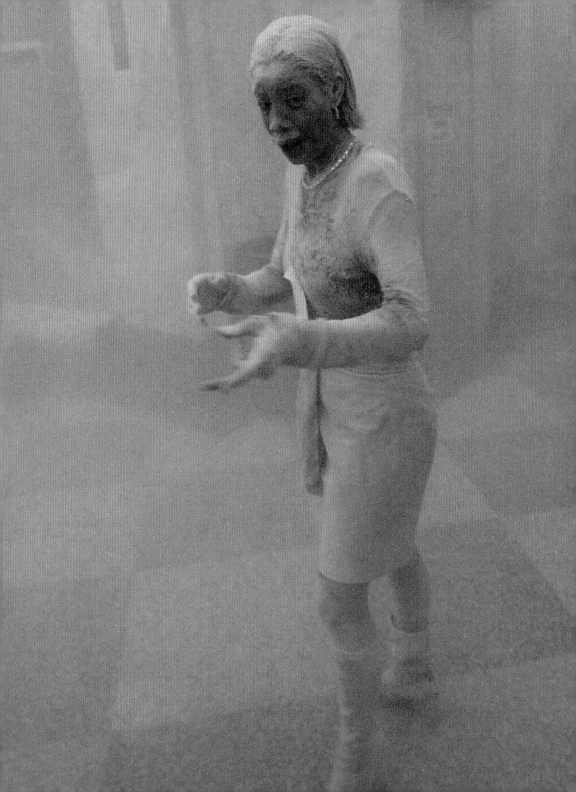

UNTITLED #35

LAURA LETINSKY

Date 2001
Location Unknown
Format Large format

For more than fifteen years, Canadian photographer Laura Letinsky (born 1962) has been making her distinctive and arresting still-life tableaux. The example shown here comes from her series *Hardly More Than Ever* (2001). The contemplative and carefully composed photographs, reminiscent of Dutch still-life paintings of the seventeenth century, often feature food elements, domestic objects, and other ephemera arranged in intriguing ways—crockery at the edges of a table, half-eaten meals to one side of the frame, or leftover items of food placed on top of each other. In creating these scenes, familiar in their components yet strange in their totalities, Letinsky draws attention to often overlooked details within the domestic space, and while doing so seems to question ideas surrounding consumption, waste, greed, and decay.

All of Letinsky's photographs have at their heart a search for beauty in imperfection, and much of her skill is devoted to bringing out and highlighting beauty that the onlooker might otherwise miss. She pays close attention to the properties of light: its softness or harshness; the results of it falling on the different surfaces of objects; the ways in which light shapes form; and the qualities of shadows. In an interview with *Aperture* magazine in 2013, Letinsky, who initially wanted to be a painter, offers an insight into how she creates her images. She piles two or three tables with objects and arranges them in different ways until "groupings emerge." After that, it is a case of waiting for the right light, she says, and rearranging the elements "until the picture reaches the level of precariousness that feels right." **GP**

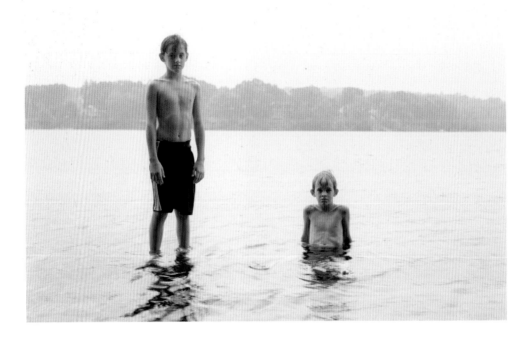

JESSE AND ROBERT, MYSTIC LAKE, MEDFORD, MA

KATY GRANNAN

Date 2002
Location Massachusetts, USA
Format Large format

Some people believe a camera can look deep into a person's soul; others say it can only ever capture a glimpse of personality. In the work of Katy Grannan (born 1969) there is a sense that her portraits get deep beneath the surface of the people depicted. As has been well documented, Grannan would find her subjects by posting ads in newspapers. She would visit those who responded, invite them to choose how they wanted to be photographed, and make portraits in their homes.

She has also approached strangers in San Francisco and on Hollywood Boulevard in Los Angeles, photographing them on the streets.

In *Mystic Lake*, the series to which this image belongs, Grannan captured her subjects in the rural setting of Mystic Lakes, Massachusetts. The images capture a certain awkwardness, vulnerability, and self-consciousness, but they are tender rather than critical. This photograph of two boys has a naturalness and magnetism that is hard to define. While one boy stands tall, his chest puffed out, trying to look grown up, the other seems more vulnerable. It is a simple photograph, but as is the case with all of Grannan's work, there is more going on than first appears. GP

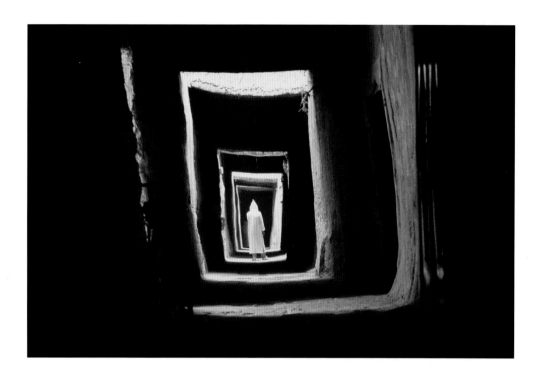

MOROCCO, VILLAGE OF MAADID, NEAR ERFOUD

BRUNO BARBEY

Date 2002
Location Maadid, Morocco
Format 35 mm

As a French photographer born in Morocco, Bruno Barbey (born 1941) has personal ties to the country in which he took this compelling shot. The image of a figure walking through a Moroccan corridor, punctuated by sunlight at regular intervals, is graphic and mysterious. The light creates an effect of *mise en abyme*—the figure surrounded by frames within frames that seem to radiate outward from his body, eventually ending with the frame of the image itself. The muted palette and centrality of the image allow for little distraction from the purity of the pale garb of the figure.

Barbey is known for his harmonious use of color, and the muted shades here allow the viewer's attention to rest on the graphic pattern created naturally by the sunlight, and the pointed hood of the solitary person. Barbey's image straddles the border between art, portraiture, and documentary photography as he uses the elements of the picture almost sculpturally to create a geometric and visually pleasing puzzle. The photograph's location, Maadid, is a village of long tunnels, but the effect of Barbey's photograph is almost placeless, the endless frames creating a world unto itself with the human figure its sole inhabitant. AZ

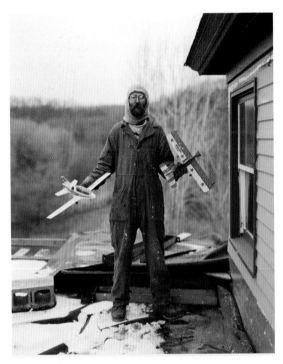

FROM *SLEEPING BY THE MISSISSIPPI*

ALEC SOTH

Date 2002
Location Vasa, Minnesota, USA
Format Large format

This portrait of a man called Charles—holding two model airplanes in his hands and dressed in an outfit that resembles an old airman's suit—is taken from a seminal body of work, *Sleeping by the Mississippi,* by Alec Soth (born 1969). Published by Steidl in 2004, this highly acclaimed book contains forty-six images photographed with a large-format camera and taken on a series of road trips along the Mississippi. These incredibly detailed images captivate viewers with an inescapable feeling of loneliness, melancholy, and even despair intertwined with mesmerizing landscapes.

A native of Minnesota, Soth is renowned for his use of the large format and his ability to merge "on-the-road photography" with intimate portraits and highly stylized landscapes. He vehemently merges traditional genres in his work and creates a unique view of the country and its people. His subjects and landscapes are often neglected, invisible, and mundane, yet he engages in a sublime conversation about solitude, longing, and reverie. His moody imagery is known for its immaculate composition and subtle colors. In his portraits, Soth regularly relies on the environment to tell the stories of people we would never have heard of otherwise. His landscapes recall those of another great American photographer, Joel Sternfeld, who, like Soth, roamed the barely known backwaters of America with his large-format camera. This portrait of Charles makes us wonder who he is, why he is holding these toys, and what has become of him. None of those answers is in the photograph, as Soth wants us to contemplate and imagine the possible fate of his subjects. **ZG**

"Anyone can take a great picture. But very few people can put together a great collection . . . the art, for me, is in the collection and interplay of images."

Alec Soth

FROM *THIN*

LAUREN GREENFIELD

Date 2002

Location Fort Lauderdale, Florida, USA

Format 35 mm

The work of documentary photographer and filmmaker Lauren Greenfield (born 1966) is largely concerned with contemporary notions of beauty, consumerism, and adolescence. She has explored topics including exhibitionism in modern female culture, growing up in Hollywood, and extreme wealth and financial loss through the story of one billionaire couple. *Thin* is a continuation of Greenfield's decade-long exploration of body image and identity crisis in relation to girls and women. It began in 1997, when *Time* magazine sent her on assignment to the Renfrew Center, a residential facility in Florida for the treatment of women with eating disorders. It was the beginning of a long-term photographic project that became a feature-length documentary commissioned by HBO and directed by Greenfield, together with a book published in 2006.

Thin is not only an unflinching look at the Renfrew Center's girls and women—their emaciated bodies with scars from self-harming—but also a sympathetic depiction of the mental health issues that underpin the eating disorders of anorexia and bulimia. Greenfield spent time gaining the trust of the nineteen women she photographed. The subject here is Cara, a thirty-one-year-old from Illinois who lost more than 50 pounds (27kg) in only two months during her first year of high school and was still struggling with her disease at the time the photograph was taken. Greenfield's composition shows Cara posing outside and in front of a tall, slender tree. Her painfully thin physique appears to mirror the elongated outline of the tree. **LH**

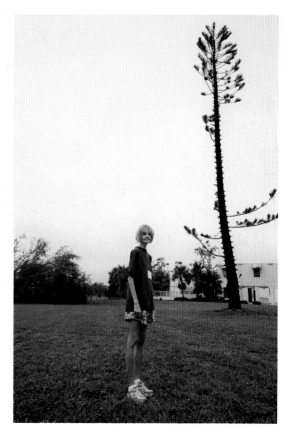

"The women in these photographs are incredibly brave to share their stories and the intimate details of their private struggles with a tragic illness."

Lauren Greenfield

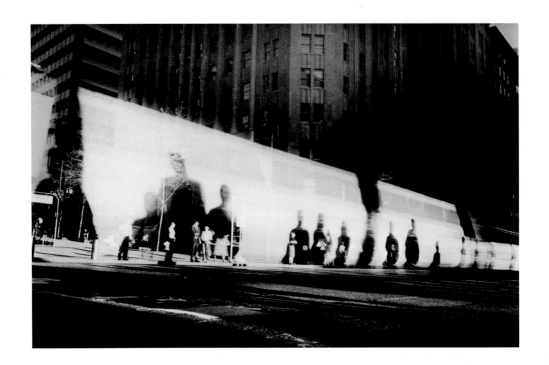

MOVING BUS

TRENT PARKE

Date 2002
Location Sydney, Australia
Format 35 mm

Trent Parke (born 1971) works on long-term projects that depict his homeland of Australia. He likes to take forty to fifty images and sequence them in order to tell a story, most often in the form of books. For Parke, this editing and sequencing of images to tell new stories is the real art of photography. Underpinning his work is a strong understanding of light and its possibilities, and he chooses to use film for its particular qualities in handling light. The element of chance is also at the core of his work.

Parke initially worked as a sports photographer for a Sydney newspaper; at that time, he would roam the streets doing black-and-white, street-based work. He believes that sports photography taught him a way of seeing: "Photography is about anticipation, it is about being there before the actual photograph takes place. You learn to do that in sport." Such skills are evident in this shot from the series *Dream/Life and Beyond*. Parke would return to favored spots at times when he knew the light would be good. Playing with slow-time exposures, he noticed a fragment of a blur of a bus that offered possibilities, and he went back to photograph in the same spot at Sydney's Martin Place for a month in order to capture the optimum image. NG

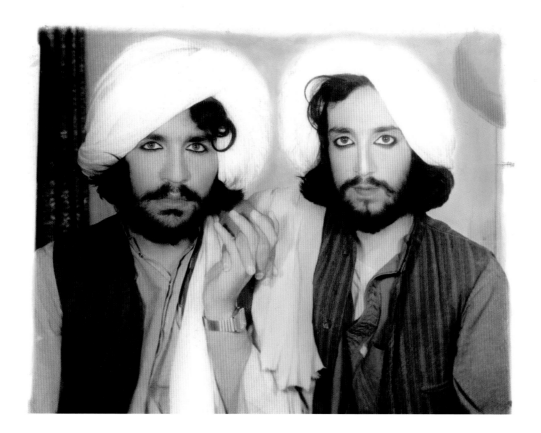

TALIBAN PORTRAIT

THOMAS DWORZAK

Date 2002
Location Kandahar, Afghanistan
Format Unknown

Having been commissioned to cover the conflict in Afghanistan for *The New Yorker* in 2001, Magnum photographer Thomas Dworzak (born 1972) began to collect photographs of Taliban members. Taliban interpretation of the Koran had previously banned the depiction of mammals, human or animal, on any signage or products. Dworzak's 2003 book, *Taliban*, documents the defacing of offending images that ensued. However, when passport photography was allowed, soldiers secretly visited the back rooms of photo studios to have flattering pictures taken. It is thought that the images Dworzak collected were left behind when the situation changed suddenly and soldiers had to leave.

This image was taken in black and white, with color hand-painted onto the print, making the colors unreal and vivid. The men look glamorous: their kohl-rimmed eyes and limpid, seductive gazes combine with the gesture of their entwined hands. Although the Western perception of Taliban fighters is characterized by violence and brutality—most of the images show them posing with guns—the retouched studio portraits present an altogether more sensitive side, one that rests on vanity and intimacy. AZ

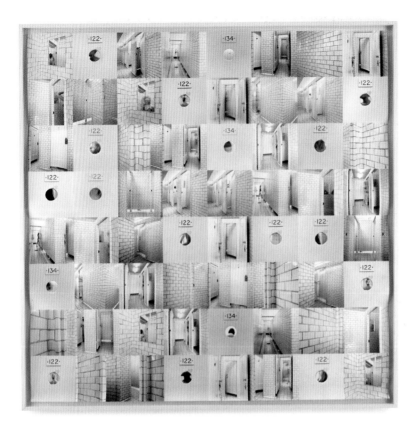

HER, HER, HER, AND HER

RONI HORN

Date 2002–03
Location Reykjavik, Iceland
Format Composite from 64 separate images

After studying art at Rhode Island School of Design and Yale University, Roni Horn (born 1955) began to make trips to Iceland, a country that has become a recurrent topic for her. Horn is a multidisciplinary artist working across sculpture, photography, installation, and books, and her works explore the landscape, culture, and identity of this island nation.

For the work *Her, Her, Her, and Her*, the artist focused her attention on the Sundhöll Reykjavíkur, a 1920s indoor swimming pool located in the

Icelandic capital Reykjavík, which has become one of the city's architectural landmarks. Horn's work focuses specifically on the building's locker rooms, a series of spaces rendered confusing and repetitive throughout her series of images because of the white tiled walls and bewildering layout. As Horn's camera leads the viewer into these spaces, it also captures glimpses through peepholes in the doors of the locker rooms. These views reveal a series of women—the "hers" of the title—in various stages of undress, but blurred by the camera's long exposure, they appear only as a series of spectral traces, ghostly reminders of the countless people who have used Iceland's oldest public bath. **LB**

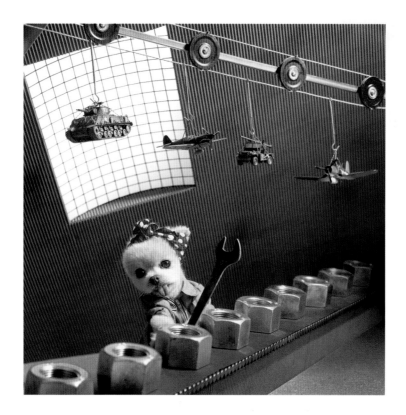

MR. WINKLE AS ROSIE THE RIVETER

LARA JO REGAN

Date 2002
Location USA
Format Medium format

Mr. Winkle is the canine muse of the successful documentary photographer Lara Jo Regan (born 1962). Regan adopted the diminutive dog as a stray, and soon found that his unique appearance prompted extraordinary reactions from people when she took him for walks. His lineage is uncertain, but possibly mixes Pomeranian and Chihuahua.

Regan began photographing Mr. Winkle in a series of constructed studio sets as a variety of "characters," including this pastiche of the famous feminist icon Rosie the Riveter. Mr. Winkle became an unexpected international phenomenon, with Regan producing a series of calendars of him. Mobbed by crowds at personal appearances, Mr. Winkle even appeared as a guest star on *Sex and the City*, where he upstaged Carrie Bradshaw (played by Sarah Jessica Parker) at her first book signing. *Time* magazine named him "Best Internet Celebrity of 2002" and he rapidly became the first global Internet animal superstar, gaining 65 million hits by 2006.

Regan is an acclaimed photographer in her own right and won the World Press Photo of the Year in 2001. She has extensively documented the complexities of life in Southern California. PL

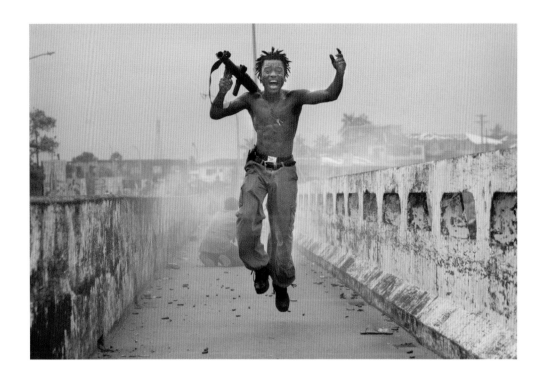

A GOVERNMENT MILITIA COMMANDER EXULTS AFTER FIRING A ROCKET-PROPELLED GRENADE AT REBEL FORCES

CHRIS HONDROS

Date 2003
Location Monrovia, Liberia
Format 35 mm

Joseph Duo, the young Liberian man in this image, had left school to become a soldier for President Charles Taylor during the second civil war of 1999–2003. As rebels closed in on the capital, Monrovia, fighting centered on either side of a bridge, with soldiers and rebels exchanging fire across it. Chris Hondros (1970–2011), who was covering the conflict for Getty Images, was on the scene at a key moment. Duo fired across the bridge into a group of rebel soldiers and scored a direct hit. He

celebrated, leaping joyfully and making direct eye contact with the camera. As Hondros himself noted when discussing the shot, which became a defining image of the protracted war: "This is a picture of fighting that shows some of the uncomfortable realities of war. One of those is that [some] people in war enjoy it—they get a bloodlust."

Taylor fled power shortly after the photograph was taken, in mid-2003, and Duo was left with no job and no way to care for his family. When Hondros returned to Liberia to cover elections, he found Duo living in a slum and paid for a year of schooling for him in an effort to help him develop a career. Hondros was killed in 2011 in a mortar attack while covering the Libyan war. CP

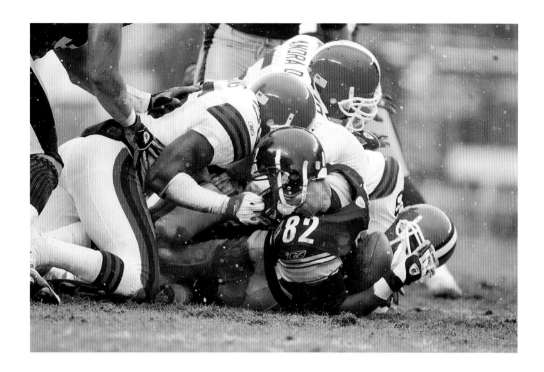

AFC WILD CARD PLAYOFF

BOB ROSATO

Date 2003
Location Pittsburgh, Pennsylvania, USA
Format 35 mm

This dramatic shot was captured by *Sports Illustrated* photographer Bob Rosato on a 600mm lens from the sidelines. It shows the moment when Chris Akins of the Cleveland Browns twisted the helmet of the Pittsburgh receiver Antwaan Randle El, seemingly trying to tear his head off from his body. The AFC wild card playoff game on January 5, 2003, ended in defeat for the Browns as they went down 36–33 to the Steelers. Thankfully, Randle El was not seriously injured, but this image does illustrate the risks of American football. Every year there are an estimated 1.2 million head injuries across the game, and a recent study found that nearly 40 percent of retired NFL players showed signs of brain trauma on MRI scans. Rosato is an award-winning photographer, who is now chief of sports photography for the *USA Today* group. He has this advice for shooting the US national sport: "The key to shooting football is to anticipate the action, who the players are and how they like to play . . . I like to go where I think the player is going to go, the corner of the end zone, somewhere between the goal and end line, on the side line, so many players go to that position. I've made so many covers and big pictures from being in that position." PL

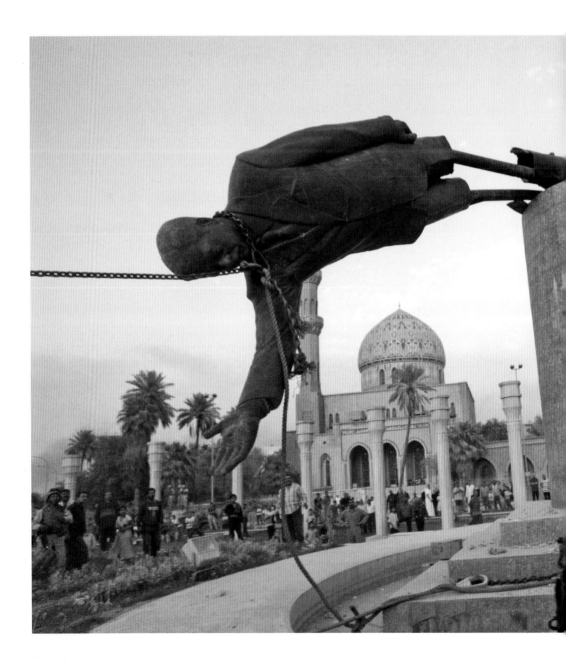

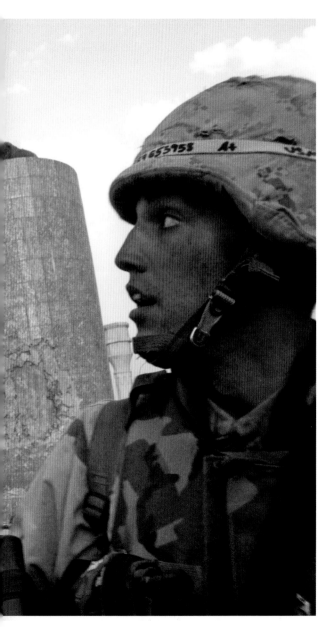

TOPPLING THE STATUE
OF SADDAM HUSSEIN

GORAN TOMASEVIC

Date 2003
Location Baghdad, Iraq
Format 35 mm

For many Iraqi people who had suffered under the repressive regime of President Saddam Hussein, it was a triumphant moment. On April 9, 2003, in the center of Baghdad, civilians watched as US troops—with excrutiating slowness, as it was a strongly built construction—toppled a huge statue of the president. Many millions more saw the event unfold on television. In March of that year, American forces had entered the country as part of a US-British operation to seize control of Baghdad, and while Saddam Hussein himself would not be captured until December, it was clear that his regime was a thing of the past.

In this photograph, by Reuters photographer Goran Tomasevic (born 1969), a US soldier looks behind him with a startled expression as the statue of the former leader is dragged town. While numerous images of the event exist, Tomasevic's shot has become well known. The soldier's facial expression is what distinguishes the image; although he was probably simply reacting to an unexpected sound, he looks almost awestruck, as though suddenly aware of the significance of what is happening.

In the moments leading up to the toppling of the statue, men attacked the marble plinth with sledgehammers and attempted to pull the statue down by dragging on a rope that had been wound, like a noose, around its neck. The US flag was draped across the statue's face, but was replaced by the Iraqi flag when onlookers voiced their disapproval. In the end, US troops used an armored vehicle for the task; upon falling to the ground, the statue was torn apart by Iraqis. GP

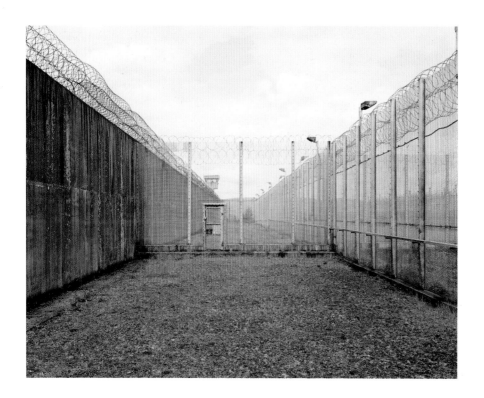

THE MAZE PRISON, STERILE, PHASE 1

DONOVAN WYLIE

Date 2003
Location Northern Ireland, UK
Format Large format

Donovan Wylie (born 1971) grew up in Belfast during the Troubles and remembers being unable to venture into parts of his hometown for many years. The use of geography and architecture to control populations and public space on both sides of the sectarian conflict was a key feature of this period. HM Prison Maze was unique in that it existed for the sole purpose of housing paramilitary prisoners who were segregated according to their paramilitary groups within an architecture that was designed to strip them of their individuality. Infamously, they used their bodies—engaging in hunger strikes until death, refusing to wear uniforms, and smearing excrement over the walls of their cells—to agitate for recognition as political prisoners. Wylie's documentation of the Maze is a testimony to his perseverance in finding a way of shooting that fitted his subject. Much of his year at the Maze yielded no tangible output, but he had an epiphany on discovering the architect's plans. Realizing how the prison functioned like a machine allowed him to understand that it was designed to enable "repetition as a form of control." Only then did he settle on this way of photographing the almost identical, relentlessly repeated, empty spaces. **MT**

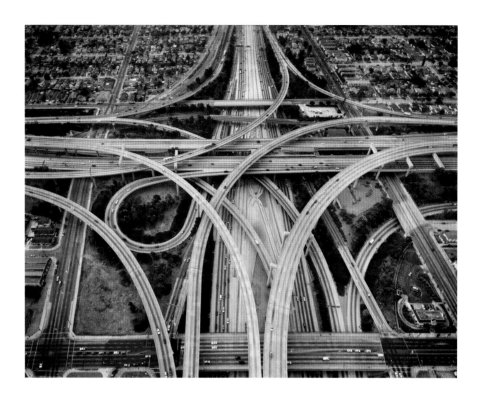

HIGHWAY #1

EDWARD BURTYNSKY

Date 2003
Location Los Angeles, California, USA
Format Large format

Canadian photographer Edward Burtynsky (born 1955) describes 1997 as his "oil epiphany" moment. Although he had been interested in photographing manufacturing landscapes for more than twenty years, having grown up near a General Motors engine plant in St. Catharines, Ontario, it suddenly occurred to him that all the industrial landscapes he had photographed were in some way related to oil. This graphic image is from Burtynsky's *Oil* series, which documents the entire life cycle of oil from extraction and refinement to use and, finally, the dirty, heavy labor of decommissioning oil tankers in South Asia. Like his contemporaries Andreas Gursky and Thomas Struth, Burtynsky uses large-format cameras to take pictures of great detail and size; these are often aerial shots taken from helicopters. Viewers can stand back from the works to appreciate their abstract beauty, seen here in the strong lines and swooping curves of Highway 1 outside Los Angeles, meeting and overlapping in the center of the frame. One can also get close to pick out the minute details that illustrate the toll industrial development takes on the natural world; here, a key subtheme is the North American dependence on the automobile. CP

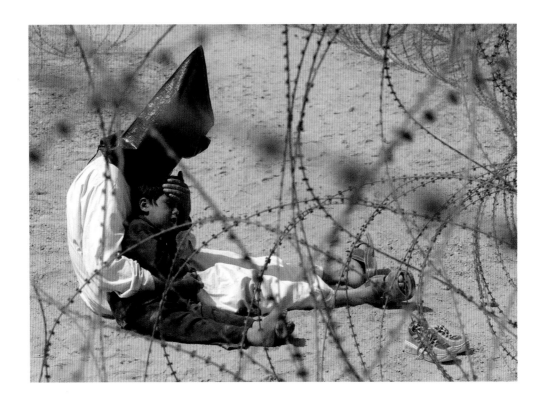

AN IRAQI MAN COMFORTS HIS FOUR-YEAR-OLD SON AT A HOLDING CENTER FOR PRISONERS OF WAR

JEAN-MARC BOUJU

Date 2003
Location Near An Najaf, Iraq
Format 35 mm

At first sight, this color image by French Associated Press photographer Jean-Marc Bouju (born 1961) appears to contemplate the inhumanity of war. Sitting exposed in bright sunlight behind barbed wire, a man, rendered unidentifiable by a black plastic hood over his head, comforts a small boy, clutching him around the waist and stroking his forehead. The familiarity and love in such a gesture make the harsh, captive surroundings of the two figures seem all the more jarring and cruel. Yet

Bouju's explanation of his photograph highlights a small kindness amid a difficult situation—he related that an American soldier at the base camp of the 101st Airborne Division, where the Iraqi father and son were being held prisoners, cut the plastic handcuffs initially placed on the man to allow him to hold his child, who was panicked by the treatment of his father. Hoods were commonly used during the Iraq War, mainly to disorient prisoners but also to protect their identities; they were also quicker to put on than blindfolds.

Thanks to a faulty satellite link, this powerful image was the only one that Bouju was able to transmit that day. In 2004, it won the prestigious World Press Photo of the Year Award. CP

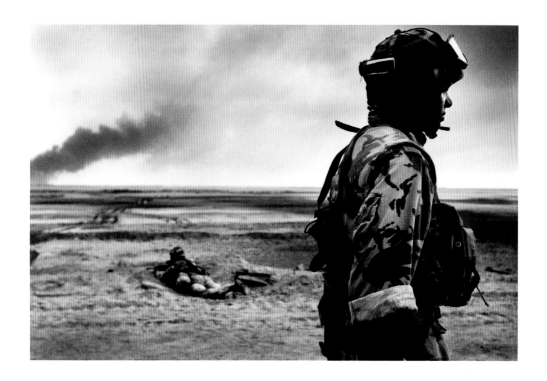

THE BATTLE OF BASRA

KATE GERAGHTY

Date 2003
Location Basra, Iraq
Format 35 mm

Apparently deep in thought, a British female soldier walks out of the frame while conflict plays out all around. A comrade lies down to her left, and thick black smoke wafts up into the sky. What we can see of her solemn expression says a great deal about the bloodshed occurring outside of the frame. She is in Iraq during the Battle of Basra, which took place between March and April 2003, during the controversial invasion of Iraq by the United States and the United Kingdom.

Australian photojournalist Kate Geraghty (born 1972) took this photograph on March 28, 2003. She also photographed casualties inside a hospital in Baghdad, a discarded Iraqi tank, and young Iraqi men on the streets of Baghdad protesting the invasion. But it is this image with its cinematic feel that really draws the eye. Perhaps it has something to do with the light, which seems to create an aura around the soldier, highlighting parts of her face and uniform, and the dark, brooding sky—a compelling backdrop. While more strident, bloodier conflict photographs undoubtedly have a role to play in reportage, quieter, contemplative images such as this one possess a unique magnetism and can be equally telling. GP

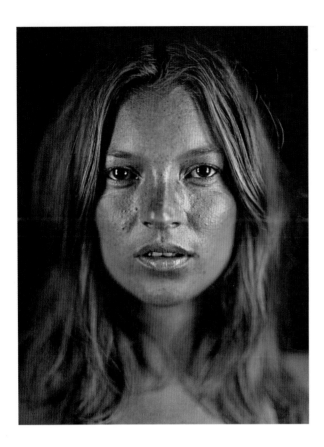

KATE

CHUCK CLOSE

Date 2003
Location USA
Format Daguerreotype

In this photograph, supermodel Kate Moss is pictured against a dark backdrop, emerging from the shadow, looking directly at the lens. To make the image, Chuck Close (born 1940) used a technology of photography that dates back to 1839: the daguerreotype. Lit by six flash strobes to accelerate the typically slow exposure of the daguerreotype, Moss's beauty appears at once haunting and radiant. Yet the daguerreotype provides an honest and confronting depiction of the supermodel, and no attempt is made to conceal her blemishes or imperfections.

Although primarily a painter, Close extends his portrait-making practice to encompass printmaking, photography, and, most recently, tapestries based on Polaroids. A medically rare spinal artery collapse in 1988 left Close paralyzed and wheelchair bound, so these days he works with the aid of assistants. In addition, since childhood, he has struggled with a rare neurological disorder known as "face blindness," which means he cannot recognize people by their facial features in three-dimensional form; it is only when presented with a two-dimensional image that he can identify them accurately. EC

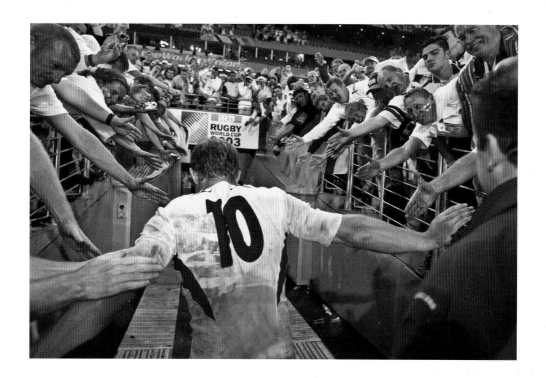

JONNY WILKINSON RECEIVES PLAUDITS FROM THE CROWD

TOM JENKINS

Date 2003
Location Sydney, Australia
Format 35 mm

The aftermath of a great sporting event. The man with his back to the camera—head bowed, hair dripping sweat, shirt muddy and sodden—is clearly exhausted. His arms are stretched wide, his right hand about to brush the palm of a spectator. The eye is then drawn to the sea of fans, ecstatic and jubilant, all trying to touch him. The man himself avoids any eye contact—he is looking down at the gray concrete tunnel that will take him away from the maelstrom. This shot was taken moments after the 2003 Rugby World Cup final. The man in the number ten shirt is Jonny Wilkinson, who, in the dying seconds of the game, had scored a drop goal, providing the points that gave England victory in a hard-fought match against the hosts, Australia. Wilkinson, an intensely private person off the field, said after that he was so drained that all he wanted was the quiet of the locker room. Photographer Tom Jenkins is noted for his ability to catch the crucial moment, the one that other sports photographers miss. Here, while the celebratory mayhem was taking place on the pitch, Jenkins saw Wilkinson leave and quietly followed him, thus capturing the dichotomy between the euphoria of the crowd and their idol's vulnerability. **GS**

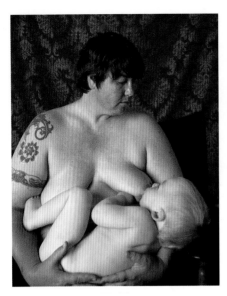

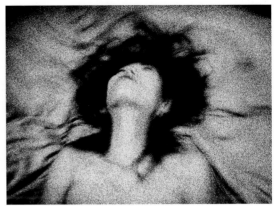

JAPAN

ANTOINE D'AGATA

Date 2004
Location Tokyo, Japan
Format 35 mm

SELF-PORTRAIT/NURSING

CATHERINE OPIE

Date 2004
Location Unknown
Format 35 mm

This image by artist Catherine Opie (born 1961) is in some ways a continuation of a project of ten years prior. For that work, she had created a series of portraits documenting San Francisco's gay leather subculture, photographing its participants, as well as herself, in the paraphernalia of fetish. *Self-Portrait/Cutting* showed a blood-red drawing of two stick-figure women holding hands in front of a house carved into her back. In *Self-Portrait/Pervert*, Opie stood facing the camera, albeit with her face concealed by a leather mask, arms patterned with needles, with "Pervert" inscribed into her skin.

While Opie here adopts a maternal pose common to classical artworks of mothers, the reality that she is a gay woman with her breasts bare, feeding her naked son, offers a new, sensuous, and arresting vision of motherhood, one that is rarely seen in contemporary culture. RF

Antoine D'Agata (born 1961) is best known as a photographer of sex, drugs, and darkness. His work focuses on the pursuit of escapism and satisfaction by people on the edges of society: people he calls "ignored communities," such as the prostitute of *Japan*, from his book, *Anticorps* (2012). To images that are often physically and psychologically brutal, he brings an otherworldly quality that offsets their despair. The aesthetic techniques that make his work immediately recognizable, such as heavy use of blurring, darkness, and long exposure (qualities that have led to comparisons with painter Francis Bacon), create imagery that is deeply disturbing.

A crucial element of D'Agata's work is his own participation in the scenes he photographs. His exploration of the depths of human nature is his own personal journey, rather than that of a detached observer. He writes: "In a world where brutal forces of capitalism have frozen life, the only available choice, imposed by the glittering screens of mass communication, is an existence reduced to consumerism, a pornographic utopia of total communication, and globalized boredom." JG

MAPLANK AND NAOMI. POLLSMOOR MAXIMUM SECURITY PRISON.

MIKHAEL SUBOTZKY

Date 2004
Location Cape Town, South Africa
Format Unknown

South African Magnum photographer Mikhael Subotzky (born 1981) had never seen a dead body before he saw the corpse of Christopher Sibidla, who had burned to death in Pollsmoor Prison, Cape Town, in 2004. Sibidla's mother had asked Subotzky to take a photograph of her son at the mortuary, which he did, agonizing afterward over how he could present such a violent image to her. But show her he did, and the mother kissed the print before thanking him for helping to lay her son to rest. But some years later, Subotzky had an overwhelming desire to smash the surface of the print. This, he realized, gave him a way to direct the violence, trauma, and fear he felt back into the photographic object.

The gesture inspired Subotzky's *Smashed Works* series, from which this image is taken. He describes the act of smashing the photographs as "drawing attention to the photographic surface itself as an intermediary between the representational world of the subject and the physical world of the viewer . . . reminding [them] of what they are looking at in objective terms [with the hope of making] it impossible for them to be complacent either with the image's or their own subjectivity." **GP**

EBOCHA GAS FLARE

GEORGE OSODI

Date 2004
Location Ebocha, Nigeria
Format 35 mm

Nigerian photographer George Osodi (born 1974) studied business before in 1999 beginning work as a photojournalist for the *Comet* newspaper in Lagos, Nigeria. In 2001, he joined Associated Press and later Panos Pictures, which specializes in global social issues.

The image *Ebocha Gas Flare* was captured for *Oil Rich Niger Delta* (2003–07), an extended body of work in which Osodi documents the often severe environmental effects of the oil industry in this region, and reveals how little of the enormous wealth generated by it reaches local communities. Instead, the people are affected by pollution, poverty, violence, and instability.

The burning of natural gas, a practice banned in many countries because of the poisonous byproducts that result, is one such example. In this photograph, Osodi depicts a local woman on a laden bicycle silhouetted against the gas flare of an oil platform. The image highlights the stark contrast between the unrestrained and unregulated might of the Nigerian oil industry and the powerlessness of the local people who must live with the consequences of it. **LB**

AVI TORRES, 200M FREESTYLE HEATS AT THE PARALYMPIC GAMES, ATHENS

BOB MARTIN

Date 2004
Location Athens, Greece
Format Ink-jet print

Swimming has been a major Paralympic sport since the Games were first held in 1960. Standard international rules are followed, with a few exceptions allowing for in-water starts. Here, Spanish athlete Avi Torres is seen starting in one of the heats for the men's 200m freestyle. Torres, a double amputee, achieved only sixth in the 200m final, but won silver in the 150m and bronze in the 450m relay medley.

One of the key attributes of great sports photographers is a deep understanding of each event and the ability to previsualize a shot so that the camera can be positioned at the best spot. Bob Martin (born 1959) is a multi-award-winning sports photographer who has photographed every major global sporting event, including such obscure sports as horse racing on ice and elephant polo. Martin was shooting "from the catwalk above the water, where the floodlights are fixed, but when the competitors came out for this particular heat there was this one guy in a tracksuit who didn't have any noticeable disability. Then I saw him start to take his large prosthetic legs off and put them next to his chair and I realized it would make a great picture. But I was half a pool length away so I had to rush over there as quick as I could along all these narrow, rickety catwalks. I didn't quite make it in time for the start, but luckily for me there was a false start, so they had to get out and line up again, which is when I got the shot." The resulting photograph's crisp, clean lines focus all the attention on the dynamic between the swimmer's body leaving the right of the frame, and the prosthetic legs he left behind. PL

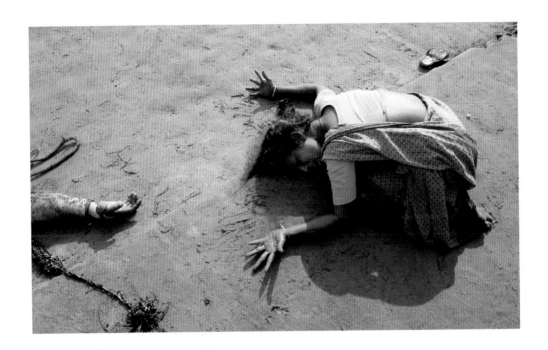

AN INDIAN WOMAN MOURNS A RELATIVE KILLED
IN THE TSUNAMI IN CUDDALORE

ARKO DATTA

Date 2004
Location Near Cuddalore, India
Format 35 mm

While many dramatic images and videos emerged of the deadly Indian Ocean tsunamis of 2004, this simple and striking image by Indian photojournalist Arko Datta (born 1969) became a widely used icon of the tragedy. The coastal communities of Tamil Nadu were severely impacted by the devastation wrought by the tsunamis, triggered on December 26, 2004 by a huge 9.3 magnitude earthquake, underwater off the coast of Indonesia. Datta's image, taken at Cuddalore, 112 miles (180km) south of Madras, on December 28, 2004, won World Press Photo of the Year in 2005 and was also made into a European postage stamp.

The image is strong in composition; the grieving woman in her brightly colored sari prostrates herself elegantly (if unintentionally so) on the packed sand. The viewer can see only the forearm of the person she is mourning, a family member, who has just been brought ashore. Datta remembers staying at the scene for five minutes to take this photo, struggling to keep composed in the face of his subject's grief. Five years later, he returned to find the woman shown here. She had become famous locally when the picture was published and had kept a copy. CP

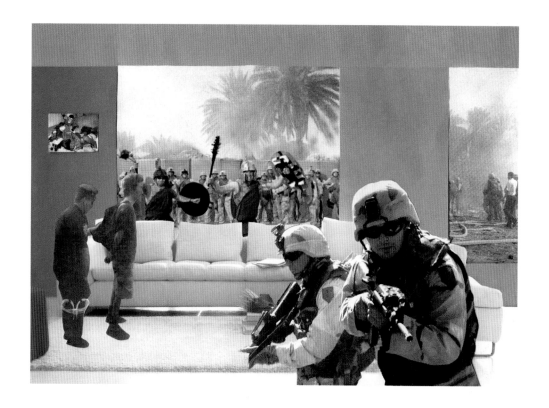

GLADIATORS FROM THE SERIES *HOUSE BEAUTIFUL: BRINGING THE WAR HOME, NEW SERIES*

MARTHA ROSLER

Date 2004
Location Unknown
Format Photomontage

Martha Rosler is a US artist and writer whose work since the mid-1960s has often questioned ideas about gender and the point of intersection between public and private spheres. While she has worked across an array of media, including video, installation, and performance, her best-known works are photographic collages. Her series *House Beautiful: Bringing the War Home* (c. 1967–72) combined press imagery of the Vietnam War with advertising photographs of ideal homes,

creating strange juxtapositions between two seemingly unconnected worlds.

Following the invasion of Iraq in 2003 by a US-led coalition, Rosler produced a new series of *House Beautiful* images, including *GLADIATORS*. Here, the simple cuts belie a complex arrangement of elements, including armed soldiers in the foreground and a police officer apparently arresting an antiwar demonstrator. On the back wall hangs a formerly secret photograph of Iraqi civilians being abused at the Abu Ghraib prison camp, while beyond the back window are US Marines dressed as gladiators, an incident that occurred in 2004 prior to a massive military attack on the insurgent-held Iraqi city of Fallujah. LB

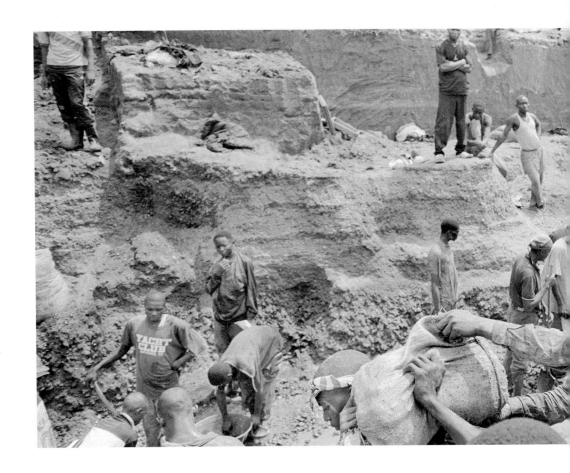

CARRYING GRAVEL OUT OF THE MINE AT BAKWA-BOWA

KADIR VAN LOHUIZEN

Date 2004
Location Democratic Republic of Congo
Format Panoramic

Dutch photographer Kadir van Lohuizen (born 1963) began working as a freelance photojournalist in 1988, covering the First Palestinian Intifada—the uprising against the Israeli occupation of the West Bank and Gaza that lasted from December 1987 until the Madrid Conference in 1991—and shooting extensively in Africa, focusing first on conflicts and then, from 1990 to 1994, on the transition

from the apartheid regime to democracy in South Africa. In addition to this work, van Lohuizen is known for a number of long-term projects he has undertaken: traveling along and photographing the seven major rivers of the world, documenting the continuing aftermath of Hurricane Katrina in 2005, investigating the impacts of climate change, and covering immigration to the Americas.

In 2004, van Lohuizen began a new project on the diamond industry, tracing the journey of gemstones from the mines of Sierra Leone, Angola, and the Democratic Republic of Congo (DRC), through the hands of dealers in local markets, on

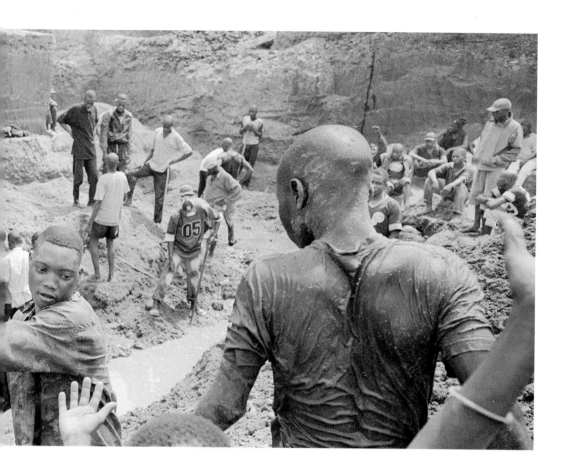

to Europe and beyond, and to the consumers of end-product diamond jewelry, who rarely have any knowledge of, or interest in, the hardships endured by the workers who source the gems. He wanted to show "dealers and those who really profit from the industry." Also part of the story are the thousands of low-paid workers who process the diamonds, such as the diamond polishers in Surat, India, who handle 70–80 percent of the world's total diamond production. Van Lohuizen's photographic record also pays close attention to the army of middlemen who control the trade in such centers as Antwerp, London, and New York.

This image of men in the DRC, quarrying gravel and carrying it out of a mine at Bakwa-Bowa to be washed and examined for gems, is one of many that suggest the corrupt and ungoverned nature of the diamond industry, which stands accused of human rights abuses and fomenting conflict.

Van Lohuizen's photographs were collected together and published in 2007 in a book titled *Diamond Matters*. The book was originally in a 4-¾-square-inch (12 sq cm) hardback format with a tiny diamond embossed in the cover. There exists no more telling reminder of the human cost of the lucrative industry. LH

LITTLE ANIMALS

MASSIMO VITALI

Date 2004
Location Italy
Format Large format

Massimo Vitali (born 1944) is best known for his large-format images of crowds on beaches around the Mediterranean. His project, *Little Animals* (*Animaletti* in Italian), began in his native Italy in 1994, when Silvio Berlusconi was first elected as prime minister. Vitali took to the beaches of Italy in an attempt to understand why his compatriots had voted as they had; the beaches because they are "where the best and worst, the banal and mundane merge. On the beach Italians paradoxically represent innocent bareness, a reconciliation with nature, along with pathetic hedonism."

Vitali's shoots are meticulously planned. He stands atop a 10-foot-tall (3m) platform, facing the coast and the people scattered around its margins. Clearly influenced by Andreas Gursky, he shoots mainly in the middle of the day, when the sun is high, maximizing the light and reducing shadow, and he often seeks out white sand or rocks to make the beachgoers stand out most strongly.

Vitali's choice of series title gives a subtle hint that he is not simply making idyllic postcard images. Rather he has a serious point to make about human limitations and poor judgment, especially at the ballot box. LH

FROM *SCHOOL DAYS*

TOMOKO SAWADA

Date 2004
Location Japan
Format Digital collage

Tomoko Sawada (born 1977) uses self-portraiture to explore notions of identity. Her first series, *Early Days* (1995–96), was made while she was still a teenager, and she subsequently studied media design and photography. Sawada's works often involve her adopting different guises and personas for her self-portraits, and consequently, she has drawn comparisons with Cindy Sherman.

This image is part of Sawada's *School Days* series of appropriated formal photographs of female Japanese school groups. These formal group photographs have a long history in Japanese culture and a prominent role today. They are an almost ritual occurrence in a wide range of contexts: domestic, educational, and professional. Because of the uniform dress of the students, it can take a few moments for viewers to notice that Sawada has created the image out of full-length self-portraits of herself. While this can be interpreted as a comment on conformity in Japanese society, Sawada's manipulations also have the contrasting effect of drawing the viewer's attention to the participants' small variations in hairstyle and dress, making it a work that also draws attention to markers of individuality. LB

BOYS AT PLAY IN THE SHIITE MUSLIM SUBURB OF SADR CITY, IRAQ

YURI KOZYREV

Date 2004
Location Sadr City, Iraq
Format 35 mm

Taken by photojournalist Yuri Kozyrev (born 1963) while on contract for *Time* magazine, this photograph is a subtle portrayal of everyday life in Iraq after the US invasion. A group of Iraqi boys play soccer in front of a wall painted with a representation of the now-infamous image of a prisoner being tortured at Abu Ghraib prison. To its left, a Statue of Liberty stands poised holding its *tabula ansata*, representing the rule of law, while flicking a switch with its other hand to inflict

electric shocks. The satiric point of the artist is clear: despite US proclamations of democratic values, occupation of Iraq has resulted in something quite the opposite. But as the viewer absorbs this narrative, the boys appear uninterested in it; despite being forced to live in a war zone, they are continuing the games and rituals of childhood. War has changed many things, but not all things.

Kozyrev photographed in Afghanistan in the immediate aftermath of 9/11 and arrived in Iraq in 2003, staying throughout the country's shift into sectarian violence. Since then, he has had firsthand experience of much of the war on terror and the Middle Eastern sociopolitical landscape, and from 2011 covered the Arab Spring uprisings. CP

AL PACINO AT THE ACTORS STUDIO

CHRIS ANDERSON

Date 2004
Location New York City, New York, USA
Format 35 mm

Chris Anderson (born 1970) first gained recognition in 1999 when he and fellow writer Mike Finkel accompanied forty-four Haitian refugees as they tried to cross the Caribbean to the US in a small, handmade boat. The pair had been sent by *The New York Times Magazine* to document the treacherous journey. The boat eventually sank, but they were rescued at the last moment. Anderson's images from the perilous voyage were awarded the prestigious Robert Capa Gold Medal in 2000.

Anderson's more recent work encompasses documentary, art, and celebrity portraiture. This study of Al Pacino, taken at the Actors Studio in New York, is far from being a conventional portrait. The actor is captured lost in thought in the place where he was taught "method acting" by famed acting coach Lee Strasberg, whom Pacino credits as being a huge influence on his acting career. The two arcs of light cast on the brick wall behind the brooding, distant form of Pacino lend a moody intensity to the scene and reinforce the gangster image synonymous with the actor's name.

In 2005, Anderson joined Magnum Photos. He became the first ever "photographer in residence" at *New York* magazine in 2012. EC

OXFORD STREET

MATT STUART

Date 2004
Location London, UK
Format 35 mm

A fascination with people and the way they live is what makes photographing on the streets so enjoyable, says English street photographer Matt Stuart (born 1974). A nominee member of Magnum Photos, as well as the street photography collective In-Public, Stuart spends many hours walking the streets in search of moments to photograph. What drives him is an insatiable curiosity, and he has learned over the years that patience, optimism, and an ability to photograph quickly and discreetly are as essential as having a camera to hand. Stuart estimates that he uses three rolls of film a day.

Stuart's serendipitous and often humorous shots present slices of everyday life, but with a twist: a skip covered with blue tarpaulin in front of a poster becomes a peacock, or a passerby looks to be headless because of the angle Stuart has shot from. He cites renowned street photographers Garry Winogrand, Joel Meyerowitz, and Lee Friedlander as among those to have influenced him. This image of a woman shielding her eyes from bright sunlight is perhaps one of his less bizarre or comical shots, but it encapsulates a well-seen moment, as a man to her left coincidentally appears to imitate her gesture. GP

EVENING PRAYERS

SEAMUS MURPHY

Date 2004 Location Hisarak Balkh
province, Afghanistan
Format 35 mm

In the fifteen years from 1994 to 2009, Seamus
Murphy (born 1959) made fourteen trips to
Afghanistan, exploring how the daily life of the
population carried on amid successive waves of
conflict. His book, *Darkness Visible* (2009), refers to
the fighting only parenthetically—noticeable in
their absence are the standard dramatic images of
heavily armed soldiers, captured by photographers
embedded with the forces. Instead, Murphy was
drawn to the everyday rituals of life in the country.

Typical is this poignant photograph, of shoes left
by worshipers at the entrance to a mosque during
evening prayers. The delicate tones and the use of
light suggest a strong connection between the
material world and the spiritual one.

Murphy was initially drawn to the country by
"intense curiosity." "My sister had been there on
the hippy trail and along with tales of India there
was this other place that almost defied description,
and that was Afghanistan, so it was lodged in my
psyche waiting to be satisfied." He found a place "so
intense, exotic, and yet real and whose story was
momentous, its landscape breathtaking, that it was
hard not to want to go back. Then 9/11 happened
and it became so central to world events." PL

ELIZABETH TAYLOR

VIK MUNIZ

Date 2004 Location Unknown
Format Color coupler print mounted
on aluminum

Brazilian artist Vik Muniz (born 1961) is famous for using unexpected materials such as caviar, dirt, and children's toys to form elaborate tableaux before photographing them. For his *Diamond Divas* series, he employed diamonds: 500 carats of them. The "divas" represented are icons of twentieth-century cinema, each identifiable by a single name: Marlene, Bette, Rita, Brigitte, Sophia, Marilyn, Grace. But of all of these stars, who could be more appropriate to immortalize in these glittering gems than Elizabeth

Taylor, a woman who named her memoir *My Love Affair with Jewelry*?

Muniz based his depiction of Taylor on the well-known silk-screen print Andy Warhol made of her in 1964. Her image is so faithfully recreated here, and her gaze so compelling, that it is easy to overlook the artistry that was involved in its creation—that the delicate line of her violet eyes and the softness of her hair are suggested by nothing but an absence of diamonds.

Art critic Lois Fichner-Rathus points out that the image's monochromatic palette is "suggestive of the so-called silver screen of a bygone cinematic era." At the same time the glitter of the diamonds reminds us of the unearthly quality of the star. RF

FUNERAL OF POPE JOHN PAUL II

PAOLO PELLEGRIN

Date 2005
Location Rome, Italy
Format 35 mm

If there is something Madonna-like about this woman's face—the tilt of her head and absent, sorrowful expression—it is fitting, given that she is mourning Pope John Paul II, who had died aged eighty-four after a long illness.

In this image, taken at Vatican City in Rome, Paolo Pellegrin (born 1964) immortalized the grieving woman, one of thousands who descended on St. Peter's Square on April 2, 2005, to pay their respects. Pellegrin, who that same year became a full member of Magnum Photos, was commissioned by *Newsweek* to photograph the aftermath of the Pope's death. Among the images he took was a series of stark black-and-white portraits of mourners that won first prize in the Portraits (Stories) category in the 2006 World Press Photo contest. Pellegrin composed the images to make his subjects' faces stand out against a black background, tightly framing his shots to remove all extraneous details. The simple but effective approach draws attention to the spectators' thoughtful expressions at a time of high emotion. Pellegrin is a master of capturing the human condition, and here he demonstrates the ineffable power of portrait photography. **GP**

NEW ORLEANS, SEPTEMBER 4, 2005: ONE WEEK AFTER HURRICANE KATRINA

MICHAEL APPLETON

Date 2005
Location New Orleans, Louisiana, USA
Format 35 mm

In 2005, tropical storm Katrina formed in the Caribbean, sweeping across the Gulf of Mexico and growing in strength to become the most powerful storm ever recorded in the region up to that point. Hurricane Katrina caused widespread damage along the coast, and in particular to the city of New Orleans, where a massive storm surge caused fifty-three breaches in the aging flood-protection network that surrounded the city. Massive flooding submerged three-quarters of the city, and while the majority of the inhabitants had been evacuated prior to the hurricane, more than a thousand were killed. The flooding quickly became a political issue, with the federal government drawing criticism for both underfunding the levies' maintenance and responding too slowly to the disaster—many of those remaining in the city were left to fend for themselves. Journalists were among the first to enter the flooded city and in some cases became involved in search-and-rescue efforts.

Originally from Maine, Michael Appleton became interested in photography in high school; later he worked as a staff photographer for the *NY Daily News* and as a freelancer. In this photograph, which Appleton took in the Garden District neighborhood, a man stands knee-deep in water, watching as a house burns. In his hand is a bucket, suggesting that he might have considered attempting to put the fire out, but the atmosphere of the image is one of futility—clearly, in the face of a major calamity such as this, the individual has very limited power. In 2006, Appleton won a World Press Photo award for his coverage of the aftermath of the disaster. LB

MANUFACTURING #17

EDWARD BURTYNSKY

Date 2005
Location Dehui, China
Format Large format

Working through diplomatic channels, Canadian photographer Edward Burtynsky (born 1955) was granted rare access to China's industrial sites. Equipped with a large-format camera, he visited both old and newly established zones of Chinese industrialization to provide a visual documentation of China's rapid modernization.

This image offers an unprecedented glimpse inside China's principal chicken processor, called Deda. We look down upon assembly lines of pink-and blue-clad, masked workers laboring in a windowless factory, illuminated by strip lights. The overhead perspective gives a staggering sense of scale as what seem to be infinite lines of workers diminish into tiny specks. The image is disturbing: the workers resemble robots, and no interaction appears to be occurring between them as they toil in their dystopian environment. The high-angled view gives an uneasy sense that the workers are under constant observation.

The strangely beautiful images were later compiled into a book. Other locations Burtynsky visited included villages devoted solely to the recycling of electronic waste; and Yu Yuen, a shoe factory that employs 90,000 workers. EC

BUREAUCRATICS

JAN BANNING

Date 2005
Location Bihar, India
Format Medium format

Bureaucratics is a humorous, clever, but also deeply enlightening study by Jan Banning (born 1964) of the complexity and scale of civil services and administration across the globe. He photographed civil servants from Bolivia, China, France, India, Liberia, Russia, the United States, and Yemen, allowing a comparative study to be made of the various rituals, cultures, and symbols of the different forms of government apparatus from across the world. In each country, Banning visited

numerous government offices to photograph civil servants across a range of departments and levels of seniority. He explained that the "visits were unannounced and the accompanying writer, Will Tinnemans, by interviewing kept the employees from tidying up or clearing the office. That way, the photos show what a local citizen would be confronted with when entering."

This image depicts Sushma Prasad, assistant clerk at the cabinet secretary of the state of Bihar, India. She seems literally weighed down by the piles of paperwork that crowd the tops of cabinets and threaten to topple on her head, and the edges of her table are worn down by the passage of countless customers she has dealt with. PL

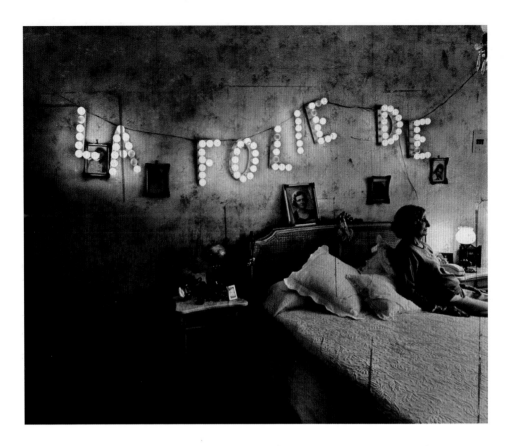

STRATEGY THAT UNITES US

LUIS GONZÁLEZ PALMA

Date 2005
Location Guatemala
Format Composite

This image, from the series *Hierarchies of Intimacy* by Luis González Palma (born 1957), focuses on an ever-present theme in his work: "the complexity of communication found in all intimate relationships." Begun in 2002, the series incorporates four themes: encounter, mourning, the annunciation, separation.

Strategy That Unites Us is from the artist's mourning sequence. A photograph of other photographs, it depicts an elderly woman seated on a bed and looking beyond the edge of the frame. She is seemingly frozen in time, surrounded by apparently personal objects, including photographs. Spelled out in illuminated lightbulbs, the unfinished phrase "La Folie de . . ." hovers above her resting place, perhaps invoking the ironies of life and death.

The mysterious image, captured with high-contrast Kodalith film, is nearly 3 square feet (0.27 sq m) in size. To get the surreal effect, González Palma attached enlarged transparencies to gold leaf mounted on red paint, covering all with a layer of bitumen. This gives the image an emotional subtlety where, as the artist says, "shadows of memory appear and disappear in empty spaces . . . creating encounters with ghostly presences." **SY**

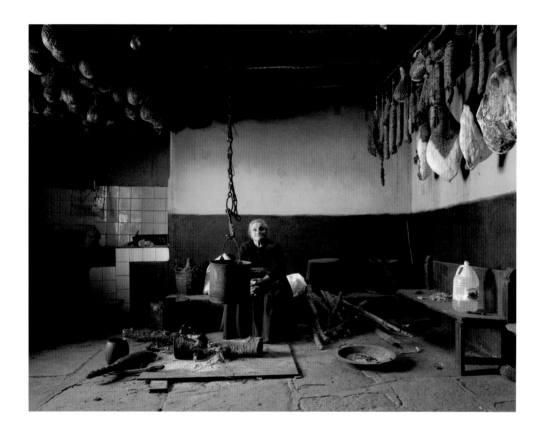

LA ALBERCA #6, 1/3/2005 12:56

BERT TEUNISSEN

Date 2005
Location Spain
Format 35 mm

In 1996, Dutch photographer Bert Teunissen (born 1959) began his *Domestic Landscapes* project. It began after he happened upon the home of an elderly woman in France. He felt some sort of familiarity with the light in the house and sensed an atmosphere that harked back to his own early childhood, one that is reminiscent of the paintings of the old Dutch masters. He later realized that it all had to do with architecture and the way that buildings were constructed before the advent of electric lighting, when the maximization of daylight was of paramount importance.

Teunissen was soon searching all corners of Europe for this atmosphere in the interiors of homes, documenting a certain way of life that is, he says, "fated to disappear as a consequence not only of architectural standardization but also of social displacement and shifts in public opinion about life and how it should be lived." He eventually captured 790 images of ancient structures in Europe—mainly homes that have been passed from generation to generation. His images, published in *Domestic Landscapes—A Portrait of Europeans at Home* (2007), memorialize a way of life destined to become a rarity. LH

7/7 LONDON: EVACUATION OF PASSENGERS

ALEXANDER CHADWICK

Date 2005
Location London, UK
Format Cell phone

On July 7, 2005, coordinated terrorist suicide bomb attacks took place around London, targeting civilians using public transport during rush hour. The attacks on subway trains and a double-decker bus resulted in the deaths of fifty-two people and the injury of hundreds more. The event, the UK's first ever Islamic extremist suicide attack, signaled a turning point for news coverage.

Alexander Chadwick was traveling on a Piccadilly Line subway train on the morning of July 7 when one of the bombs went off. As passengers walked through the dark tunnel toward King's Cross station, Chadwick and others used their cell phones to photograph the chaos. Their photographs were quickly disseminated on social media, from where they were shown on national and international television networks.

For one of the first times ever, civilian journalists were able to report from the "front line" of a news story. Despite its crude representation of the event, with blurry figures and little light, Chadwick's image communicated very forcibly what it was like to be there as a victim and a witness; it went on to form part of the capital's collective memory of the 7/7 bombings. LH

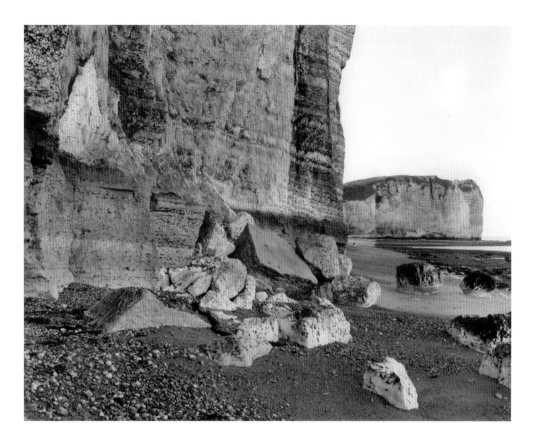

VAUCOTTES, NOVEMBER 2005

JEM SOUTHAM

Date 2005
Location Vaucottes, France
Format Large format

Jem Southam (born 1950) developed a fascination with the English countryside in 1975 when he walked from Berwick-upon-Tweed to Bristol, taking in the landscapes in a very slow and deliberate manner. Southam's approach to landscape photography is unique in that he will shoot at a single location over several months or years to discern both the subtle and the drastic changes that occur.

Southam's oeuvre has developed through five main series, one of which, titled *Rockfalls,*

Rivermouths and Ponds—begun in 2000—includes the project *The Rockfalls of Normandy.* That series saw Southam travel across the English Channel to the cliffs of Normandy, France, where he took a number of his signature large-format photographs of the eroding and crumbling shore, including this one in November 2005 at Vaucottes.

In Southam's photography, the inherent history of the location is an unspoken but ever-present factor. He returned to Vaucottes in February 2006, and his photographic intention becomes clear when his pairs of images of the same place are viewed. Shot from the exact same angle, they encourage careful comparison for any changes in sea level, rock formations, or land erosion. LH

POLAR PANORAMA

PÅL HERMANSEN

Date 2005
Location Svalbard, Norway
Format Panoramic

In this wide-angle image—with its palette of frozen whites, blues, and greens—our eye is immediately drawn to the stark red on the polar bear's floe—blood from its recent prey. For us, red represents danger; we are instinctively drawn to the color, and in this image it adds a stroke of warmth to a scene that is otherwise ice cold. The photograph's panoramic perspective emphasizes the scale and expanse of the untouched Arctic landscape—a great swath of emptiness where scattered blocks of ice float on the water's surface. At the horizon are snow-covered peaks, but they break just above where the lone polar bear is positioned on its floating island, creating a triangular line of vision that also directs our line of vision on to the bear. Caught poised above its breakfast of ringed seal, the bear creates a dark reflection in the water beneath, which makes it look menacing.

Nature photographer Pål Hermansen (born 1955) had come across numerous polar bears in the Arctic before, but this bear seemed remarkable

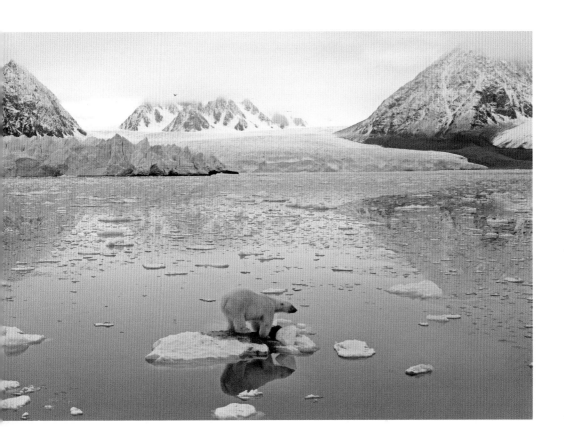

for the setting in which it was found. Hermansen's expedition vessel managed to approach to a distance of 50 feet (15m), enabling Hermansen to capture the scene from the edge of the boat. Waiting patiently until the bear had lifted its head, he proceeded to shoot a series of photographs to be put together later as a panoramic stitch. He has pointed out that in the year he made the dramatic image, "[T]he timing was perfect to highlight the latest news about the effects of climate change in the Arctic: less summer ice forces the bears to hunt where they find ice—along the edge of glaciers." For many, the photograph was a wake-up call.

Environmental scientists estimate that there are approximately 26,000 polar bears surviving in the wild around the Arctic ice cap, but they stress that their existence is threatened by a wide range of pressures, including the destruction of their habitat by global warming, the pollution of their food sources by toxic chemicals, and the disruptive effects of oil exploration. Hermansen's image offers multiple possibilities for interpretation, and the viewer may focus on the damaging effects of climate change thinning the Arctic ice, on rising sea levels, and on the literal shrinking of the "table" upon which the polar bear stands. **EC**

ABANDONED WARSHIP IN THE KOLA BAY, MURMANSK, NORTHWESTERN REGION, JANUARY 2005

SIMON ROBERTS

Date 2005
Location Murmansk, Russia
Format Large format

The work of photographer Simon Roberts (born 1974) is largely concerned with identity, belonging, and how those notions tie into landscape. He is influenced by his training as a cultural geographer. Most of his photographic projects are shot on large-format cameras from elevated positions.

Roberts spent a year traveling around Russia, from July 2004 to August 2005, visiting more than 200 locations. The resulting book, *Motherland* (2007), was a fresh depiction of the country that

steered clear of stereotypes of depression and poverty and instead focused on the people's national pride. Deriving from this project was another one, titled *Polar Nights*, shot in Russia's far north in December and January, when the sun does not emerge above the horizon. Images such as this one, taken in the scarcely populated industrial northwest, portray the constant blue-gray gloom and reveal something of the harsh reality of Russian winters. Roberts uses landscape to allude to larger themes: "I was interested in exploring the idea that landscapes need to be decoded; exploring the layering of social activities and of history, and the different ways in which landscape is used and how it changes over time." LH

BLUE MARBLE: NEXT GENERATION

NASA

Date 2005
Location Outer space
Format Digital composite

The original *Blue Marble* photograph of Earth was taken in 1972 by the crew of the Apollo 17 Moon mission. Released at a moment of growing awareness about ecological damage, it became one of the most widely disseminated images in history, becoming an icon of environmentalism.

Aware of the photograph's enormous cultural influence, the National Aeronautics and Space Administration (NASA) gave the same name to a subsequent series of images taken of Earth from space; the same *Blue Marble* name was also used for a series of composite images released in 2002, showing Earth without cloud cover, that were taken by the Moderate Resolution Imaging Spectroradiometer (MODIS) instrument on NASA's Terra satellite.

In 2005, NASA released a fresh set of imagery titled *Blue Marble: Next Generation.* Unlike the original single image of 1972 or the composites of 2002, this was a much larger collection of images taken by NASA's Terra satellite. Drawing on a vast number of photographs taken over the whole of 2004, NASA used computer-processing techniques to meld the images together, creating new images of Earth entirely without cloud cover. LB

CHINESE WEDDING

THOMAS SAUVIN

Date 2005
Location China
Format 35 mm

This bizarre moment is one of many discovered by collector and curator Thomas Sauvin (born 1983) in his work with a treasure trove of amateur images saved from destruction in China. While living in Beijing, Sauvin became fascinated with a haul of discarded negatives that he saved from a laboratory that was selling them off in bulk. As he recalls: "I got in touch with a seller specializing in recycling trash that contained silver nitrate. I bought 35 mm negatives by the kilo, without knowing what I

would do with them." His growing collection, titled *Beijing Silvermine*, now provides a unique insight into daily life in contemporary China.

Sauvin has looked through more than half a million negatives, sorting and organizing them into categories, including the one from which this image is taken. It shows a peculiar tradition where a bride, as a mark of appreciation for her new husband, would light a cigarette for each of the men invited to the wedding party, and he would then smoke them. Sauvin collated images of the rituals that he found into a book, published as *Until Death Do Us Part* (2015). The book is tiny and has a unique form—it is presented inside an original Chinese Shuang Xi cigarette pack. PL

WAR SOUVENIR

PAOLO VENTURA

Date 2005
Location Italy
Format Large format

Paolo Ventura (born 1968) grew up hearing his relatives reminiscing about World War II. Although primarily a fashion photographer, he wanted to capture something of the essence of his relatives' memories, rather than their exact stories, through photography. He designed sets in miniature—using everyday paint, wood, dirt, and fabric—and model dolls for his photographic subjects. It might typically take at least a week to prepare a scene like the one shown here. Simple desk lamps or overhead lighting were used to create the deep shadows that are typical of the *War Souvenir* series. The most difficult part of the work, according to Ventura, was deciding from which angle to shoot, so he took several Polaroid photos in advance to help him choose the one that would be shot by his trusty old Pentax 6x7 camera.

The *War Souvenir* photos have a foreboding atmosphere; most show the everyday cruelties, kindnesses, and tragedies of living through a conflict. In this work, the viewer does not need to see the full body of the subject to understand that he has been hanged, or hanged himself. The eye is drawn to the clutter on the floor in an effort to understand who he might have been. **CP**

SATURDAY MORNING, STAMFORD HILL

POLLY BRADEN AND DAVID CAMPANY

Date 2006
Location London, UK
Format Medium format

When Polly Braden (born 1974) and David Campany (born 1967) began photographing London's Lea Valley in 2004, they were unaware that part of it would become the site of the London Olympic Games in 2012. The couple simply wanted to explore an area they found mysterious, contradictory, and intriguing. Traveling mostly by bicycle, they set off to explore the strange landscape, sharing a camera and light meter between them. What they found was an "unplanned patchwork of nature reserves,

social housing, yuppie apartments, small industries, scrapyards … forgotten architecture and vast areas of nothing in particular," all linked by the Lea River and canal. Braden would often take portraits, while Campany was drawn to the landscapes.

Responding to chance encounters and allowing themselves to be drawn by light and color, they came across scenes such as this one, where children play amid a pile of refuse. It is the exquisite light, rather than the subject, that makes the photograph beautiful, yet the image also serves as a reminder that children have an enviable ability to enjoy themselves wherever they are. A crop of this image featured on the cover of their book, *Adventures in the Lea Valley* (2016). GP

HAMPSHIRE VILLAGE PRAM RACE

ANNA FOX

Date 2006
Location Hampshire, UK
Format Medium format

Long fascinated by the social fabric of English village life, in particular everyday festivities, customs, and rituals, Anna Fox (born 1961) began shooting a series of color portraits in her home county of Hampshire in 1999. The ten-year series, *Back to the Village*, features strange and surreal portraits of people dressed up and celebrating events such as Halloween and Guy Fawkes' Night, and performing in local plays. The series drew inspiration from photographs of May Day festivities, processions,

pageants, and fairs taken in the late nineteenth and early twentieth centuries by Sir Benjamin Stone.

Fox's images revel in the possibility that beneath the surface of seemingly playful rituals, darker forces are at work. Indeed, Fox has commented that masked performances in her images act as metaphors, concealing sinister undertones. This photograph of two girls wearing masks is a good example of how ordinary scenes can be read in different ways. The girls are pictured at a "pram race" in a Hampshire village, and their masks may seem humorous and silly. But there is also something quite unnerving about their appearance, especially given how seamlessly the masks blend in with the girls' faces and hair. GP

PERFECT TRAWL: A GREATER BULLDOG BAT CATCHING A FISH

CHRIS ZIEGLER

Date 2006
Location Barro Colorado, Panama
Format 35 mm

Bats form the second-largest order of mammals after rodents, with around 1,240 species. Among them is the greater bulldog bat, or fisherman bat (*Noctilio leporinus*), a native of Latin America. The bulldog bat is distinctive not only because of its large size, with a wingspan of up to 3 feet 3 inches (1m), but also because it is one of the few bat species that have adapted to eating fish. Using echolocation to detect the water ripples made by its prey, the bat is able to scoop up the fish into the

pouch between its legs, securing it there with its sharp claws. The bat can even swim and take off from water if necessary.

To get this stunning image of the moment of capture, wildlife photographer and conservationist Chris Ziegler (born 1972) worked with a team of researchers who had created a small lake where they could study the bats' use of sonar. To light the shot and freeze the action, Ziegler positioned nine flashes around the lake. Three were fired from above and one from behind, while five more were arranged along the bat's possible flight path: two straight on, two low down and close to where the bat was likely to strike, and one placed just above the surface of the water, under the camera. PL

SOUTHEAST VIEW OF GOLF 40, A BRITISH ARMY
SURVEILLANCE POST

DONOVAN WYLIE

Date 2006
Location South Armagh, UK
Format Large format

The interest that Donovan Wylie (born 1971) has in the architecture of conflict is evident in both his work on British army watchtowers in South Armagh—of which the photo here is an example—and his documentation of the infamous Maze prison in County Down as it was prepared to be razed. The two series share a similar aesthetic, which is reminiscent of the well-known and earlier documentary work on industrial architecture by Bernd and Hilla Becher: neutral in character,

detached, and free of human subjects. The watchtowers, like the Maze, were captured by Wylie in the months leading up to their demolition, a result of the Northern Irish peace process.

Surveillance Post Golf 40 was photographed from a helicopter, which enables the viewer to confront it from a level viewpoint and also appreciate its vantage point over the surrounding area. Its appearance is much like a hill fort of past times, yet it would have contained sophisticated cameras, aerials, and recording equipment to document activity on both sides of the Irish border. Wylie has since gone on to photograph the surveillance posts used in more recent conflicts in Iraq and Afghanistan. CP

THE ORION NEBULA

HUBBLE SPACE TELESCOPE

Date 2006
Location Outer space
Format Telescope

The Hubble Space Telescope, successfully launched into orbit aboard the space shuttle *Discovery* in 1990, was designed to observe astronomical events from outside Earth's atmosphere. Since it began its work, Hubble has produced a vast quantity of remarkable imagery. It has revealed previously unknown planets and phenomena, resolved long-standing debates, and stimulated new ones. Hubble's photography has also been influential far beyond astronomical science; the images have captured the public imagination and appeared in a range of other contexts, from fine art exhibitions to merchandise decoration. In 2001, NASA (the National Aeronautics and Space Administration) even polled Internet users to choose targets for the satellite to observe, a reflection of the extent to which the agency sees the satellite as a tool for outreach as well as research.

This image, taken sixteen years into Hubble's mission, is currently the sharpest produced of the Orion Nebula, some 1,500 light years from Earth. Created from 520 individual photographs, along with images of the nebula taken from the ground, it reveals a dramatic landscape of dust, gas, and more than 3,000 stars. LB

US MARINE TY ZIEGEL POSES WITH RENEE KLINE BEFORE THEIR WEDDING

NINA BERMAN

Date 2006
Location Illinois, USA
Format 35 mm

Although in many ways this photograph follows the stylistic expectations of a classic US wedding photo, it is impossible to overlook the severe facial disfigurement of the groom, Ty Ziegel. He looks down, his injuries making his expression inscrutable. The couple seem alone in their own emotions, even as they stand together ready to commit for life. His bride Renee's expression is opaque and has been read in many different ways: is she overwhelmed, frightened, stoic? These questions have been much debated on prowar and antiwar platforms, and many others, too.

The photo was taken by documentarian Nina Berman (born 1960), who initially was sent by *People* magazine to cover Ty's long recovery process after a car bomb in Iraq left him and a fellow US Marine with severe burns. Berman wanted to make it clear how the wars on terror in Iraq and Afghanistan were deeply impacting the lives of many Americans. Renee and Ty were high-school sweethearts who got engaged shortly before Ty was injured. Berman described Renee's commitment to Ty through his recovery, even though the couple were divorced within a year of their marriage. Ty died in 2012. CP

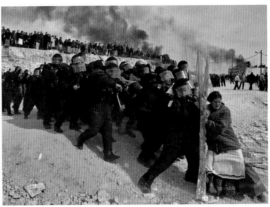

FEMALE MAOIST REBELS

YANNIS KONTOS

Date 2006
Location Nepal
Format 35 mm

This photograph was taken by Greek documentary photographer Yannis Kontos (born 1971), who has captured images of political change in many parts of the world, from psychiatric institutions in Yugoslavia to antiglobalization demonstrations in Italy to immigration issues on the US–Mexican border. Here, he is in the highlands of Nepal, where he depicts young girls recruited to fight as Maoist guerrillas in the Himalayas.

One of the poorest countries in the world, Nepal has faced complex political problems for many years, with high levels of poverty, drug abuse, and child trafficking. But these smiling girls almost make us forget the realities they face as they march together along the picturesque mountain path.

Usually, the reality is harsher. Poor children tend to be the ones who are recruited as child soldiers, and an estimated 300,000 of them fight in armies around the world, mostly in developing countries. Many are forcibly recruited or abducted, and suffer beatings and other forms of torture as part of their training. Often on drugs and in fear for their lives or the lives of their families, they suffer severe psychological damage from having been forced to kill others, as well as enduring rape and sexual servitude, sometimes for years. SY

DEFENDING THE BARRICADE

ODED BALILTY

Date 2006
Location West Bank, Palestine
Format 35 mm

This photograph by Israeli Oded Balilty (born 1979) won a Pulitzer Prize. It shows a lone Jewish settler, sixteen-year-old Ynet Nili, on February 1, 2006, struggling against Israeli security officers as they try to clear the West Bank settlement of Amona, east of the Palestinian town of Ramallah. Thousands of troops in riot gear clashed with hundreds of stone-throwing Jewish settlers after Israel's Supreme Court ordered the demolition of nine homes at the site. Such illegal settlements have hindered peace negotiations with the Palestinians.

The contrast between the passive line of spectators in the background and the desperate struggle in the foreground gives an edge to the image, as do the replicated facial expressions of the combatants on either side of the shields. Interviewed later, Nili criticized the highly acclaimed photograph: "Instead of defending the people and land of Israel, security forces destroy Jewish homes. A picture like this one is a mark of disgrace for the state of Israel and is nothing to be proud of. The picture looks like it represents a work of art, but that isn't what went on there." CJ

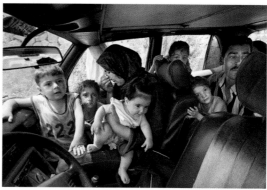

1923 LAMANCHE STREET

ROBERT POLIDORI

Date 2006
Location New Orleans, Louisiana, USA
Format Large format

Robert Polidori (born 1951) specializes in large-scale architectural photographs of neglected, unused, and abandoned areas in cities. Most famous are his pictures of Versailles, Havana, and Chernobyl.

In September 2005, *The New Yorker* magazine sent him to New Orleans two weeks after the city had been devastated by Hurricane Katrina. He went back in January, March, and May of 2006, taking detailed photographs using long exposures, to document the aftermath of the catastrophe on stores and homes, their demolition, and their eventual reconstruction. His pictures of interior spaces—sad tributes to their former occupants that reveal broken, empty, soulless shells—were published in a book, *After the Flood* (2006).

This image of 1923 Lamanche Street shows the traces of a home and its occupants. The sagging Stars and Stripes flag is symbolic of the collapse of the flooded city. Polidori wrote: "The interior spaces that I photographed in New Orleans were still moist from the receding flood—and indeed the stench of organic rot, the sagging carpets, and waterlogged floorboards made photographing difficult—but it was nevertheless important to me to record for posterity a panorama of mementos of interrupted lives." CK

LEBANON

STEPHANIE SINCLAIR

Date 2006
Location Lebanon
Format 35 mm

Photojournalist Stephanie Sinclair (born 1973) has spent a significant amount of time in conflict zones, concentrating on civilians caught in the middle trying to protect their families. This black-and-white image shows a family fleeing from a border town of Lebanon via the highly dangerous coastal route between Tyre and Sidon in 2006, during the Israeli bombardment of the south of the country.

Travel had been declared unsafe because the Israelis were targeting roads in the offensive against Hezbollah bases situated in Lebanon, and armed drones were flying above, targeting suspicious vehicles on the road. Cramped with their children inside the car, the parents are highly apprehensive. The mother bows her head, feeling the weight of their uncertain fate, and the father sits with eyes frozen in reflection and brow creased with anxiety. Four of the children gaze directly at the lens, their eyes expressing fear, confusion, and exhaustion. The tension of the scene is palpable.

The Lebanese government estimated that more than 900,000 people—approximately 25 percent of the population—were displaced as a result of the conflict. EC

RAY

WILLIAM WEGMAN

Date 2006
Location New York, New York, USA
Format Large format

William Wegman (born 1943) is a conceptual artist who paints and creates videos. Yet he is best known for his posed photographs of his floppy-eared Weimaraner dogs, who are sometimes in costumes.

Wegman was a pioneering video artist when in 1970, he acquired his first Weimaraner as a puppy, naming it Man Ray. He filmed and photographed his pet until 1982, when the animal died. Four years later, Wegman got a new dog, Fay Ray, and when Fay had a litter in 1989, Wegman captured her offspring. His books include *Fay* (1999), *William Wegman: Polaroids* (2002), and *Dogs on Rocks* (2008).

Wegman anthropomorphizes his animals, sometimes straightforwardly, using anything from duffel coats to ties, capes, and roller skates, but often in more subtle ways. He says his dogs have the "cool, blank" gazes of fashion models, making them the perfect foil for him to project his own ideas on them and at the same time play with the viewer's perceptions. In this image a blanket draped across the dog's head is sufficient to make it appear more than an animal. The triangular shape of the cloth, the head held high, and the eyes staring out are enough to suggest the Madonna in a Renaissance painting. CK

FROM *A PERIOD OF JUVENILE PROSPERITY, 2006–2009*

MIKE BRODIE

Date 2006
Location USA
Format 35 mm

Mike Brodie (born 1985) began his photography in 2004, at age nineteen, when he was given a Polaroid camera. He later became obsessed with railroads and immersed himself in the US train-hopping culture. He spent four years, from 2006 to 2009, traveling around the United States, becoming known as "the Polaroid Kid." Although he has since given up photography, the archive he amassed in those early years was quickly recognized as one of the great collections of travel imagery.

Brodie now works as a mechanic in California, yet acclaim for his work—which first came to public notice after he posted images online—has led to the publication of two books—*Tones of Dirt and Bone* (2006) and *A Period of Juvenile Prosperity, 2006–2009* (2013). The images collected together in the latter volume document a tightly knit teenage subculture of outsiders, all on the move and often for reasons known only to themselves. Importantly, Brodie was not among them as "a photographer," but instead was himself deeply embedded in the subculture. He has stated his position: "In my heart I do not feel like a photographer. I don't know if I ever have. But what I've always felt like is a railroader." LH

CURSE OF THE BLACK GOLD

ED KASHI

Date 2006
Location Niger Delta, Nigeria
Format 35 mm

In 2010, American photojournalist, filmmaker, and educator Ed Kashi (born 1957) published *Curse of the Black Gold: 50 Years of Oil in the Niger Delta*. The book is an unflinching look at the human and environmental cost of the expansion of the oil industry, with photos shot over a five-year period.

Nigeria is one of the main producers of oil for the United States, and transnational corporations have been operating in this area for decades, exacerbating environmental and human rights problems. The local communities that provide workers to companies such as Shell struggle to make enough money to survive and are living in land poisoned by decades of neglect. In this image, we see a young farmer carrying the corpse of an animal that was poisoned by a local refinery.

Kashi traveled with armed insurgents of the Movement for the Emancipation of the Niger Delta (MEND). His images, which in the book are accompanied by the writings of local Nigerians—from activists and poets to insurgents—is an attempt to contextualize a very complex situation, one that cannot be blamed solely on oil companies, but also on the corruption and lack of infrastructure in Nigeria as a whole. LH

BUKIMA, VIRUNGA NATIONAL PARK, EASTERN CONGO, JULY 2007

BRENT STIRTON

Date 2007 Location Virunga National Park, Democratic Republic of Congo
Format 35 mm

It is estimated that around 4.6 million people have been killed during the civil wars in the Democratic Republic of Congo (DRC). Often overlooked, however, is the catastrophic effect that this conflict has had on the environment and endangered species of the DRC.

South African photographer Brent Stirton (born 1969) went to Virunga National Park in the eastern DRC on assignment for *Newsweek* to document reports of clashes between park rangers and one of the seventeen paramilitary groups operating there. What he discovered were unlikely victims of that conflict: five dead gorillas that had been shot, execution style. One of those was a silverback male, Senkwekwe, who in this photo is being carried by rangers back to their headquarters to be properly buried.

The photograph, awarded a World Press Photo first prize in 2008, gave Stirton's work a new focus: the intersection between war and the natural world. LH

RAYMOND PLAYS WITH *STAR WARS* LIGHTSABERS WITH HIS SONS BRADY AND RILEY

PETER VAN AGTMAEL

Date 2007
Location Wisconsin, USA
Format 35 mm

Peter van Agtmael (born 1981) has worked to document the wars following the 9/11 attacks and their consequences. From 2006 to 2008, he was an embedded photographer with the US military, covering conflict in Afghanistan, Iraq, and the United States. The images, collected in his book *2nd Tour, Hope I Don't Die* (2009), record the effects of conflict on soldiers: split-second decisions in the heat of combat, battle fatigue, injury, the longer-term psychological and physical impairment that soldiers have to endure, and the mourning of bereaved families.

This image at first appears to be a conventional one of a father playing *Star Wars* with his sons. The viewer then notices that the father, former soldier Raymond Hubbard, is wearing a prosthetic limb, his metallic prosthesis contrasting ironically with the play weapons and sci-fi mask. As a US Army sergeant, he was injured in Baghdad in 2006, losing a limb and nearly his life. Van Agtmael sensitively documented his recovery and his adjustment to civilian life and a lifelong disability. **NG**

WHITE FLAG

PAUL SEAWRIGHT

Date 2007
Location Belfast, UK
Format Medium format

The image on this wall, near the strongly Unionist Shankill Road in Belfast, was photographed by Paul Seawright (born 1965) in 2007, almost a decade after the peace agreement that had supposedly consigned Northern Ireland's Troubles to history.

Having grown up not far from the building, Seawright reflects on the layers of meaning in the image: "Each community would read it differently— in almost entirely opposite ways. The loyalist, Protestant side . . . might see a British flag refusing to be washed away; the nationalist, Catholic side might focus on the whitewashing, the idea of this flag being replaced by something new." He recalls that his childhood was characterized by an everyday proximity to violence and an "awareness of limits"—his tightly cropped view of this wall appears very much like a barrier. It fills the frame, leaving little symbolic space for context, questions, understanding, or connection. Despite the various possible readings of the mural itself, Seawright's picture acknowledges, somewhat bleakly, that this community has a long way to go before deeply ingrained social divisions will disappear. **JG**

TAKE CARE OF YOURSELF. PROOFREADER, VALÉRIE LERMITE

SOPHIE CALLE

Date 2007
Location Paris, France
Format Unknown

Although French artist Sophie Calle (born 1953) used photography in her project *Take Care of Yourself*, which was exhibited at the French Pavilion at the Venice Biennale in Italy of 2007, it was only one aspect of the work. When her partner, a famous (though unnamed) writer, decided to end their relationship, he did so via email, signing off with the phrase that would become the project's title. Responding to his directive in a way any artist would, Calle took him at his very word; she took care of herself, actively and effectively.

Determined to reframe her hurtful experience of rejection in a helpful way, Calle commissioned more than one hundred female professionals to analyze his words, using the approaches, methods, and vocabularies of their respective specialisms. A forensic psychiatrist, for example, focused on his use of language and found him to be a "twisted manipulator." A markswoman literally fired shots at his words. And in this image, a proofreader marked up the wording of his email for editorial correction, as though it eventually were going to print, while deeming it to be a repetitive text. In this particular case, the double meaning of the word "proof" is typically witty of Calle; she is searching for useful evidence by analyzing every word of the email that he must wish he had never sent.

The book of the exhibition, published in 2007, contains portraits of many of the female experts, including a parrot (the only feathered respondent), and as such becomes a sister text to André Kertész's work *On Reading* (1971), except in this case they are all engrossed in the same text. **MH**

IRAN. A FAMILY PERFORM WEDDING RITUALS AT A PUBLIC WEDDING HALL IN TEHRAN.

OLIVIA ARTHUR

Date 2007
Location Tehran, Iran
Format Medium format

For many years, Magnum photographer Olivia Arthur (born 1980) has focused her work on varied aspects of the cultural divide that exists between the East and the West. This photograph of a traditional Iranian wedding ritual is drawn from a series in which she documented a journey she made along the border between Europe and Asia, Iran, and Saudi Arabia. During her travels, she paid particular attention to the nature and behavior of the women she encountered.

What Arthur captures in this marriage scene is a complex web of ambiguous gazes. The bridegroom is reading from a book that the bride is holding, but her attention is pulled out of the frame, along with that of the two women who hold the veil above her. They each give a look of ambivalence toward something or someone out of shot. The three women whose eyes we can see appear bored, frustrated, and judgmental; their expressions are markedly at odds with the bright colors and textures of the traditional wedding regalia that surrounds them.

Arthur's view of Middle Eastern womanhood is nuanced, and the gaze returned by her subjects is often loaded, knowing, world-weary, or bold— a subversion of traditionally held views about the women of Middle Eastern or Arab cultures. In this image, the bride—as seen by Arthur—appears resplendent but bored. The viewer must negotiate the contradiction of the supposed happiness of the occasion—a wedding—with the seeming emotional resistance of the women in attendance and the bridegroom's passivity and subtly implied dependence on his future wife. AZ

"In Iran, the women I met know what they think and they aren't afraid to say what they think, they are far more confident and tougher [than those of Saudi Arabia]."

Olivia Arthur

SWEET NOTHINGS: SCHOOLGIRLS OF EASTERN ANATOLIA

VANESSA WINSHIP

Date 2007
Location Turkey
Format Large format

This portrait is part of a seminal study by British photographer Vanessa Winship (born 1960) of schoolgirls in Eastern Anatolia, Turkey. The series of large-format, black-and-white photographs is an intimate examination of vulnerability, childhood, gender, and growing up. The project echoes another renowned work by Richard Avedon, *In the American West* (1979–84). With similar composition and impeccable use of the demanding large format, it seems as if Winship is making a considered visual

homage to the celebrated photographer. Each of these portraits is a small stand-alone masterpiece, but when it is seen as a part of the series, the true strength and clarity of the photographer's vision come together.

Winship's choice of black and white reflects a shift away from the photograph as a purely narrative vehicle and constitutes, in the words of the artist herself, a "marvelous instrument of abstraction that enables us to move between time and memory." Winship cleverly uses the fall-off in depth of field that is characteristic of the large format to isolate her subject from the background, managing to keep the viewers fixed on the girls while retaining a glimpse of the environment. **ZG**

ARMS

TORBJØRN RØDLAND

Date 2008
Location Unknown
Format Unknown

Torbjørn Rødland (born 1970) studied photography in Norway and currently divides his time between Oslo and Los Angeles, California. His artistic practice initially focused primarily on photographs of female nudes. Since the late 1990s, his photography has garnered growing acclaim for the ways in which it employs and blends multiple genres, comfortably crossing the conventional boundaries between portraiture, landscape, and still life. While individually these genres might seem dated, Rødland uses them knowingly, either to draw attention to their inherent clichés or by manipulating and combining stale methods in ways that feel fresh and distinctive.

In this photograph, titled *Arms*, the tentacle of an octopus emerges from a woman's sleeve to coil around her fingers; the image appears in Rødland's book *Vanilla Partner* (2012) and is typical of his work. A series of apparently hackneyed photographic styles, sensual juxtapositions, and visual jokes create a sense of what has been termed "melancholic eroticism." Rødland remains interested in, and committed to, the book as a form for disseminating his work, and has published seven volumes to date. LB

LOL MISSILES (CLICKABIGGEN)

ARE WE LUMBERJACKS?

Date 2008
Location Unknown
Format Digital photomontage

Photography has always been subject to distortion and manipulation, but increasingly powerful computer software, starting with the first version of Adobe's Photoshop in 1989, has made such practices common. The ease with which images can be doctored has made it harder than ever before to distinguish the real from the fake.

In 2008, Iran carried out a series of missile test launches. Sepah News, the information arm of the Revolutionary Guards, then released a photo showing four missiles rising into the sky. The image was published around the world and used on the front pages of newspapers, including the *Los Angeles Times* and the *Financial Times*. Shortly afterward, a second image emerged, revealing that the missile second from the right had not launched at the same time as the other three, and that this had been concealed by digital manipulation software.

This led to a spate of spoof and satirical images appearing on social media. This is one of them. In a final twist to the story, in 2012, Iran's semiofficial Mehr News service unintentionally used one of the satirically manipulated images to illustrate a serious article on Iran's missile program. LB

CEMETERY

GHAITH ABDUL-AHAD

Date 2008
Location Baghdad, Iraq
Format 35 mm

This haunting image by Ghaith Abdul-Ahad (born 1975) tells something of the scale and intensity of the violence that engulfed Iraq after the US-led invasion in 2003. What may first appear to be an insignificant and random agglomeration of trash and rubble is, in fact, a burial site on the eastern outskirts of the poor Shia slums of Sadr City in Baghdad. The often unidentified bodies—shot by Shia militiamen at Al-Sadda, a nearby killing ground—were piling up so quickly that they had to be hastily buried by locals who used whatever was handy to mark the final resting places of the victims. They marked the graves with stones, pieces of scrap metal, and old boxes. The yellowish-brown tone created by the sand in the air makes the whole scene appear apocalyptic, which to many Iraqis it was. Ghaith is one of the few photojournalists who has covered the conflict in his homeland from a native perspective. Most of the images produced during the Iraqi crisis were the work of visiting Western journalists embedded with different factions. Ghaith had no such constraints, and consequently, his work offers unparalleled insights into the events that unfolded in Iraq after the fall of Saddam Hussein. ZG

THE PRESS CONFERENCE, JUNE 9, 2008 (DETAIL), FROM *THE DAY NOBODY DIED*

ADAM BROOMBERG
AND OLIVER CHANARIN

Date 2008
Location Helmand, Afghanistan
Format C41-type print

In June 2008, two photographers—South African Adam Broomberg (born 1970) and Briton Oliver Chanarin (born 1971)—traveled to Afghanistan to record British Army operations on the front line in Helmand province. Along with their cameras, they took a roll of photographic paper in a lightproof cardboard box. Their visit coincided with a series of deadly attacks on British personnel and Afghan civilians throughout the region. In addition to taking conventional photographs of these horrific events, Broomberg and Chanarin unrolled a 20 feet (6 m) section of the paper and exposed it to the sun for twenty seconds. The result is a series of abstract and unique photograms—what they term an "evacuation of content." *The Day Nobody Died* comprises these images together with a twenty-three-minute movie made to record both the process, and, on a different level, the whole performance that was the making of the work itself.

As the British Army protected and transported the artists' box from location to location, they unknowingly played the leading role in a critical performance that draws attention not only to the institutionalized system of war reporting but also to the nature of photographic "truth." The images are entirely faithful in their recording of the light and heat of the desert war zone, but they do not give viewers any of the conventional visual information that news audiences are accustomed to receiving in coverage of conflict. Broomberg and Chanarin think that this is preferable to the censorship and obfuscation of normal reporting.

The later work of Broomberg and Chanarin has increasingly synthesized photography with language and literature. This is a development of Bertolt Brecht's *War Primer* (1955), a collection of what the author termed "photo-epigrams"—photographs (sometimes original, sometimes cut from newspapers or magazines) mounted on black backgrounds and accompanied by four-line poems. One of the works that they have used in this way is the Bible.

They also run the Chopped Liver Press, which is based in their London studio and publishes limited editions of their book and posters. JG

UNCERTAIN TIMES, THE BUND, SHANGHAI

MA KANG

Date 2008
Location Shanghai, China
Format 35 mm

Ma Kang (born 1962) is a Chinese photographer based in Nanjing. Originally trained as an oil painter, he turned to photography in the 1990s because he found it a more suitable medium through which to engage critically with, and reflect on, Chinese society as a whole. One of Kang's best-known bodies of work is titled *Uncertain Times* and comprises his photographs of urban architecture as a comment on the way of life in contemporary, post-Cultural Revolution China, one that is hinged on uncertainty and a constant search for faith.

Kang creates images of iconic and historical buildings that are then deliberately blurred with multiple exposures. He shoots on film, preferring the end product that expired color film can offer—more of a gray hue, and reduced contrast—and creates multiple exposures by holding down the rewind button while opening the camera's shutter. After doing this several times for just one subject, he scans the film, and adjusts the result in Photoshop. He then prints the images on a large scale, allowing minute detail and movement to be seen in an almost pixelated form.

The Bund—a district on the waterfront of the Huangpu River—is one of Shanghai's most popular tourist attractions. The clock tower, shown here, forms part of Customs House, one of the outstanding landmarks in the district, from which there are great views across the city. By reimagining such iconic buildings in this way, Kang is able to question notions of history, modernity, and urban development while forcing viewers to look closely at the structures that define a city. **LH**

"Ma Kang is not just an explorer of photographic language. He uses the photographic language to . . . present the specific shape of the uncertainty of history." Gu Zheng, *Popdam Magazine*

PRESIDENCY I, 2008

THOMAS DEMAND

Date 2008
Location Los Angeles, California, USA
Format Large format

Thomas Demand (born 1964) is best known for his combination of sculpture and photography, which often sees him construct painstaking re-creations of real rooms and other spaces before rephotographing them. These have varied widely from domestic spaces to seats of government power, but all are invariably laden with social or political subtexts. The models themselves are sometimes life size, requiring extensive preparation, and they are typically dismantled after they have been photographed.

Demand's *Presidency* series was a commission from the *New York Times Magazine* to mark Barack Obama's election as US president. In response, Demand re-created the White House's Oval Office—"the most powerful room in the world"—in Los Angeles, California, 2,700 miles (4,300km) away from its real-life location in Washington, D.C. While the attention to detail in the model is remarkable, the absence of any human figures, the lack of small details, and a few intentional differences from the real room create a mounting sense of the uncanny in observant viewers, who gradually come to realize that this image is an elaborate reconstruction.

The absence of people is one of the recurrent themes found in Demand's work. Indeed, the only human figure that appears in his output to date is that of former British prime minister Edward Heath. Also noticeable is the removal of writing—every sheet of paper on every desk, and all the other places in which one might normally expect to see words, are intentionally blank, which increases the pervasive sense of unworldliness. LB

"German photographer Thomas Demand's work addresses the question of veracity that remains at the heart of photography's role in shaping the representation and understanding of history."

Susan Laxton, writer

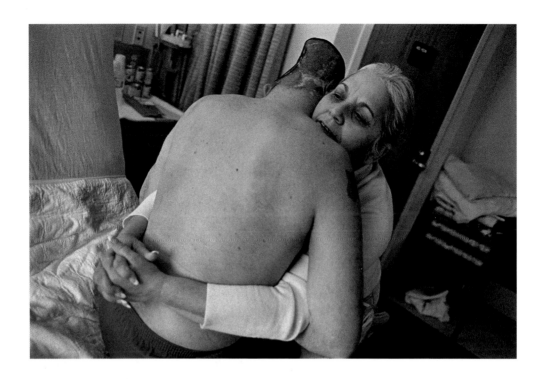

NELIDA BAGLEY HELPS HER SON SGT. JOSÉ PEQUEÑO FROM HIS BED AT THE WEST ROXBURY VETERANS MEDICAL CENTER IN MASSACHUSETTS

EUGENE RICHARDS

Date 2008
Location West Roxbury, Massachusetts, USA
Format 35 mm

In this deeply moving black-and-white image, a woman struggles determinedly to care for the deeply wounded man she holds in her arms. The angle of the photo reveals Sergeant José Pequeño's severely misshapen skull; he was serving in Iraq when a grenade was thrown into his Humvee. Despite the extent of his brain injuries, his mother, Nelida, doggedly cares for him. As the acclaimed documentary photographer who took the photo, Eugene Richards (born 1944), suggests: "War all

comes down to these little tiny stories about people's lives that will never be the same."

Having documented America's social and political landscapes since the 1960s, Richards was in little doubt that the 9/11 events in New York would lead to decades of further violence. By 2006, he was frustrated by what he regarded as the mainstream media's failure to document adequately the human costs of the war on terror, particularly in terms of the treatment of returning service personnel, whose suicide rates were high and who were often receiving inadequate medical care. Richards's *War Is Personal* series follows the stories of just fifteen families, but they are representative of many more untold tales. **CP**

POBIEROWO

MARK POWER

Date 2008
Location Pobierowo, Poland
Format Large format

British photographer Mark Power (born 1959) first came to public attention in 2000 with his acclaimed *Superstructure* series, which chronicled the transformation of a patch of wasteland on the south bank of the Thames River in London into the magnificent, if controversial, Millennium Dome.

He then produced *26 Different Endings* (2003), a series of landscapes of places that were just outside the area mapped in the *A–Z London Street Atlas* then used habitually by many Londoners.

Although his subject matter is diverse, Power has always retained two main preoccupations. One is with large-scale constructions. The other is with Poland, which he has visited regularly since the 1980s, chronicling its transformation from Soviet vassal state into one of the more influential powers in the European Union, of which it became a member in 2004.

The image reproduced here, of an incongruous observation tower on a beach on the Baltic Sea coast, is atypical of Power's oeuvre in that it features people. That the couple shown are engaged in an affectionate embrace is regarded by some commentators as a reflection of Power's long-term love affair with the nation. MH

MICHAEL PHELPS WINS THE GOLD MEDAL IN THE MEN'S 100M BUTTERFLY, BEIJING OLYMPICS

HEINZ KLUETMEIER

Date 2008
Location Beijing, China
Format 35 mm

Heinz Kluetmeier (born 1943) is a legend of sports photography. He has shot more than 125 covers for *Sports Illustrated* magazine. One of Kluetmeier's specialties is the use of remotes to allow him to position his cameras in unusual spots to get unique angles: in the 1980 Olympics, he was one of the first to use the technique to capture the face of British athlete Sebastian Coe as he crossed the line to win the men's 1,500 m. Then, Kluetmeier was the only one using the idea; today, as he says: "You go to the Olympics and there are like fifty remotes at the finish line."

He used the same approach to freeze the moment when US swimmer Michael Phelps's fingertip touched the wall to win Olympic gold ahead of Serbian Milorad Čavić. It took Kluetmeier's assistant in scuba gear almost one hour to position the camera underwater. Shooting eight frames a second, the motor-driven camera caught how Phelps actually came from behind. Kluetmeier remembers: "He was so lucky to win. Yes, he worked hard for years, he swam his butt off, but then he got lucky. The guy was drifting and Michael got in one more stroke. I bet you it was less than hundredths. I bet it was less than a heartbeat." PL

HOME WORKS #3

MILES ALDRIDGE

Date 2008
Location Unknown
Format Unknown

Miles Aldridge (born 1964) studied illustration at Central St. Martins in London. He then directed music videos before turning to photography. By the 1990s, he was a fashion photographer, working internationally for *Vogue*, *GQ*, and *Harper's Bazaar*. He also quickly rose to success with his commercial photography, shooting for fashion designers Armani and Paul Smith.

Unlike most fashion photographers, Aldridge is widely acknowledged as an artist in his own right, and his work has been the subject of several international solo exhibitions.

Aldridge's photographic style is almost instantly recognizable. The scenes he creates are perfect, highly artificial, and highly controlled environments in which the colors are hyperreal, and the models communicate a certain uneasy luxury. "I want to set a sort of unsettling message," Aldridge has said. "But my trick is to sugarcoat it in these bright colors."

The image reproduced here harks back to the 1950s in its psychedelic use of color, and the deadpan expression of the typical "Stepford wife" model—the latter is a feature of almost all of Aldridge's photographs. LH

"DOC" KELSO SLEEPING

TIM HETHERINGTON

Date 2008
Location Korengal Valley, Afghanistan
Format 35 mm

In 2008, British photojournalist Tim Hetherington (1970–2011) was embedded with a US Army platoon during its year-long combat tour of Afghanistan. The pinnacle of his work here is the series titled *Sleeping Soldiers*, a set of images that stands out as a tender, deeply humane portrait of tough men. Soldiers are rarely seen so vulnerable, photographed in the fetal position with just a few bits and pieces of military gear to identify them as warriors.

Hetherington's work is a reminder that most soldiers are very young, often in their teens, and it gives an unmistakably human face to a devastating conflict. Hetherington regularly declined to be identified as a war photographer. In his own words: "Trying to understand my own fascination with conflict and war has become something that's started to focus on what it means to be a man. What is it about war that really draws men?"

In Afghanistan, Hetherington also produced *Restrepo*, which earned him an Oscar nomination in 2011 for best documentary. He went on with his coverage of young men at war in Misrata, Libya. It was there in 2011 that he was killed in a rocket attack along with his comrade Chris Hondros. ZG

UNTITLED NO. 25

RONGRONG AND INRI

Date 2008
Location Unknown
Format Unknown

RongRong (born 1968) and inri (born 1973) are husband-and-wife photographers who, since 2000, have been working together. They have led the way for contemporary Chinese photography since that time, producing black-and-white images that focus on the human form in natural and urban settings. They often create work that reflects their own intimate relationship, and they experiment with darkroom techniques to push the boundaries of their image making.

RongRong began working in the early 1990s, creating art in Beijing's East Village, a community of artists that in 1994 was raided and emptied by police. He then moved to a new district, which was also demolished a few years later. These events have drastically impacted the work of RongRong and inri, which, although highly autobiographical, comments on China as a whole. In one series, they staged self-portraits against the backdrop of demolished buildings.

In 2007, RongRong and inri opened the Three Shadows Photography Art Centre in Beijing, China's first independent center for photography. Their space was designed by dissident artist and architect Ai Weiwei. LH

LAUNCH OF A DELTA II ROCKET FROM CAPE CANAVERAL, FLORIDA, CARRYING A SATELLITE

SIMON NORFOLK

Date 2008
Location Cape Canaveral, Florida, USA
Format Large format

Simon Norfolk (born 1963) studied philosophy and sociology before completing a course in documentary photography. He then worked for left-wing publications on stories about extreme far-right political groups. In 1994, he abandoned traditional photojournalism to focus on landscapes and what they told about events that had taken place in them in the past. His subsequent career has been divided into two main themes: the battle to dominate space, and technologies.

In this image of a rocket launch in Florida, Norfolk explores the contradiction between the beauty of technology and the sense of fear and power it induces. The image is part of his series *Full Spectrum Dominance*, along with photographs of nuclear launch sites and the intricate interiors of rockets and missiles. Ultimately, Norfolk's work is a study of the military prowess of the United States. "The satellites and missiles at America's disposal are a crucial projection of its global power," writes Norfolk. "An invisible, iron fist that allows America to intercept all our communications, photograph our every movement, and, using envisaged space-based weapons, eliminate America's opponents at the flick of a switch." LH

AURAS: HOMAGE TO MARCEL DUCHAMP (DETAIL)

SUSAN HILLER

Date 2008
Location Unknown
Format Special aura camera

This photograph is one of fifty digital images that make up *Auras: Homage to Marcel Duchamp*, an installation by Susan Hiller (born 1940) that pays tribute to work by twentieth-century artists. The images are modified found "aura photographs" showing individuals surrounded by spectral auras of colorful light. The installation's title alludes to Duchamp's *Portrait of Dr Dumouchel* (1910), in which an aura outlines the doctor's body and vibrating colors seem to emanate from his healing hands.

Hiller used images taken using the aura photographic technique, which was developed by Guy Coggins in the 1970s. First, the sitter's hands were attached to devices that recorded their electrical frequencies; second, the person's aura was captured by translating the frequencies into color. "Auras are supposed to be wholly individual, like a transcendental fingerprint," says Hiller, "and detectable only by clairvoyants (and a few scientists), that is, until photography came into the picture." Thus, the camera makes visible what is invisible to the naked eye and presents us with "visible traces of the unseen, of the phantasmal." Hiller has interpreted the images as "metaphors of ourselves in a digital age." EC

FLASHING (FROM *OTHER PEOPLE'S PHOTOGRAPHS*)

JOACHIM SCHMID

Date 2008–11
Location Unknown
Format Unknown

Between 2008 and 2011, Joachim Schmid (born 1955) made a series of ninety-six books that amount to an encyclopedia of vernacular photography. Each volume covers a different theme, with such titles as *Airline Meals*, *Parking Lots*, *Red*, *Sex*, *Sunset*, *Various Accidents*, *Hands*, and *Cleavage*. They each explore the "themes and visual patterns" found in amateur photography, gathered from photo-sharing sites such as Flickr. The number of volumes in the set, as well as the volumes' titles, are arbitrary

and potentially endless, as the artist explains: "The selection of themes is neither systematic nor does it follow any established criteria—the project's structure mirrors the multifaceted, contradictory, and chaotic practice of modern photography itself."

Berlin-based Schmid is one of the leading contemporary exponents of "appropriation art"—the creation of meaning: not by making images, but by recontextualizing images made by others. The results are known as "found photography." He has also been a pioneer of print-on-demand technology, which enables him to minimize his costs and avoid the unsold overstocks that had previously always been a deterrent to mass-marketing. **JG**

SOUL STEALER: WORLD OF WARCRAFT #11

ZENG HAN AND YANG CHANGHONG

Date 2008
Location Chongqing, China
Format Large format

The work of Zeng Han (born 1974) explores the relationship between reality and imagination against the backdrop of a rapidly industrializing China. For him, the country bears the trappings of "hyperreality," a condition in which the proliferation of new cultural forms and objects renders people unable to distinguish between fact and fiction.

After eight years at *City Pictorial* magazine, Han decided that young Chinese urbanites had lost their connection with the myths and stories that had structured Chinese ways of understanding the world for generations. The promise of the future—of glittering skyscrapers and Westernization—had suddenly rendered the past distinctly foreign; those urbanites' souls were being stolen.

In *Landplay*, part one of the *Soul Stealer* series, Han, in collaboration with Yang Changhong, photographed peasants wearing the masks and costumes of traditional theater. Thus attired, they seemed to connect with their ancestry better than they ever had before.

This photograph, from the culmination of the series, is a meditation on the question of whether the characters we assume in our day-to-day lives connect us to our past or separate us from it. MT

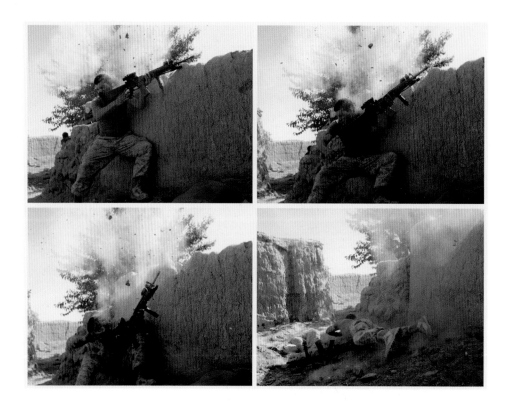

US MARINE SERGEANT WILLIAM BEE UNDER FIRE
FROM THE TALIBAN

GORAN TOMASEVIC

Date 2008
Location Garmsir, Afghanistan
Format 35 mm

This dramatic photographic series of a US Marine shooting and receiving fire in Afghanistan was the result of both experience and good luck. Serbian freelance photographer Goran Tomasevic (born 1969), embedded with the 24th Marine Expeditionary Unit, was wondering when he might have a chance to try his new 24 mm lens when Marines started firing near the perimeter of their compound. As he arrived there with his camera, Sergeant William Bee also rushed up to help with

his M16, leaving his helmet and Kevlar vest behind. When Tomasevic focused on Bee as he stood up and fired over a wall, his camera happened to be in sequence mode. The luck of this accident was that Tomasevic inadvertently captured what happened in the seconds that followed: an incoming shot hit the wall, blasting it into pieces near Bee's head, and Bee fell to the ground. Tomasevic imagined him to be seriously or mortally injured, but within minutes of being evacuated by colleagues, Bee was conscious and marveling at his good luck. Tomasevic and Bee were delighted with the images, and they received widespread media coverage, with Bee's name being released only after he called his wife to tell her he was okay. CP

HUSKY WOLF

TOM BROADBENT

Date 2009
Location London, UK
Format 35 mm

In his series *At Home with the Furries*, Tom Broadbent (born 1974) set out to document British members of the Furry Fandom subculture. In their free time, "Furries" dress up as anthropomorphic animals, communicate via online forums, attend Furry conventions, and socialize. The Furries have a rule of not speaking to journalists, but Broadbent earned their trust and was accepted into their private lives.

Respecting the Furries' wish to remain anonymous, Broadbent captured them against the backdrops of their private environments—usually bedrooms, living rooms, and backyards—in a way that almost normalizes them. Broadbent's photos make us wonder about the people inside the fur suits as we try to build a mental picture of them from small clues provided by their possessions.

In this image, a husky wolf called Smirnoff sits at a piano supporting family photos. Also in the series are a disco gryphon, a pink boar, a steampunk lion, and a Welsh red dragon, all examples of the anthropomorphic range to be explored. Broadbent cleverly uses color, contrast, and juxtaposition to introduce the subculture through a nonjudgmental lens, allowing the characters space to be themselves. **EC**

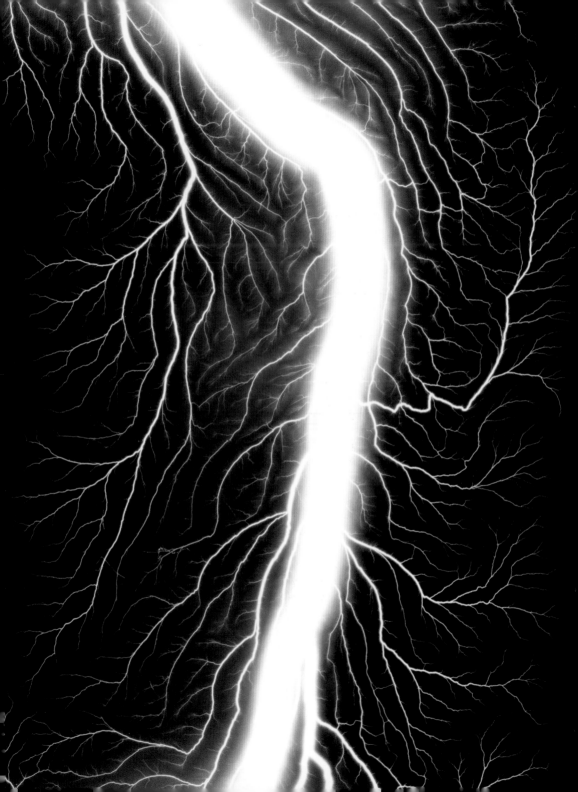

LIGHTNING FIELDS

HIROSHI SUGIMOTO

Date 2009
Location New York, New York, USA
Format Film sheet

Hiroshi Sugimoto (born 1948) became interested in photography at an early age but studied politics and sociology at Rikkyo University (aka St. Paul's University) in Tokyo, Japan. In 1974, he retrained as an artist in the United States, and after graduation he relocated to New York, where he traded in Japanese antiquities while developing his own artistic practice. His distinctive photographs show the influence of both conceptual art and minimalism, and often play with ideas about time and perception to make visible what is normally impossible to see, or to present a similar sight in an unfamiliar and thought-provoking way. One of Sugimoto's celebrated series, *Theaters*, involved photographing cinema screens, using an exposure equivalent to the length of the movie being projected, resulting in the screen emerging as a rectangle of brilliant white light.

Sugimoto's *Lightning Fields* series demonstrates many of his concerns and interests as an artist, and hints at the continuing influence of early scientific and photographic experimenters on contemporary art photographers. Using a Van de Graaff generator to build a current, Sugimoto then discharges as much as 100,000 volts into a 6x3-feet (1.8x0.9m) sheet of photographic film resting on a metal table. Using different objects to transfer the voltage from the generator to the film causes the current to behave differently. When the film is later developed, it reveals the passage of the current through the film, creating abstract patterning that recalls the work of earlier electrical experimenters, such as Scottish engineer Archibald Campbell-Swinton. LB

WONDERLAND

SLINKACHU

Date 2009
Location Unknown
Format 35 mm

It is a simple but novel concept: depositing tiny model people and props into the urban landscape and then taking photographs to suggest a world in miniature. English street artist Slinkachu (aka Stuart Pantoll, born 1979) first began to create his little so-called street installations in 2006.

In search of a creative pursuit outside of his day job at an advertising agency, the artist began painting and remodeling miniature train-set figures before placing them in locations across London. The idea was to create mini dramas to reflect the feelings of loneliness, melancholy, or confusion that people experience in a big city. Slinkachu leaves the installations in-situ after taking photographs of the tableaux.

In this image, two figurines—one on a toboggan and the other pulling him along—are seen alongside a tree on a white road marking, which we interpret as snow. Slinkachu's works, humorous and playful, ask viewers to suspend disbelief and see their surroundings anew. GP

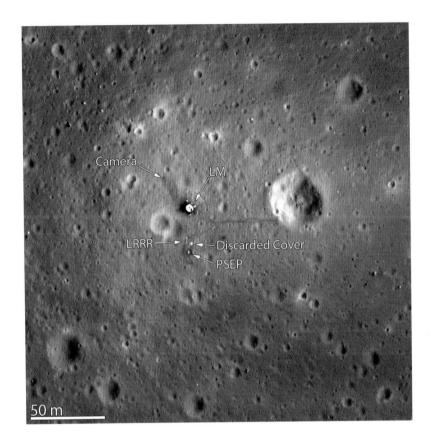

Camera
LM
LRRR — Discarded Cover
PSEP

50 m

SITE OF THE APOLLO 11 MOON LANDING

NASA

Date 2009
Location Outer space
Format LROC cameras

This extraordinarily detailed image shows the footsteps of US astronaut Neil Armstrong, still embedded in the surface of the Moon forty years after his historic spacewalk on July 21, 1969. His traces remain exactly as he left them because there is no atmosphere, and hence no wind erosion.

The photograph was taken from a height of only 15 miles (25km) by an array of Lunar Reconnaissance Orbiter Cameras (LROCs), consisting of two Narrow Angle Cameras (NACs)

and a Wide Angle Camera (WAC). These form parts of a suite of seven instruments on board the Lunar Reconnaissance Orbiter (LRO), launched by the National Aeronautics and Space Administration (NASA) in 2009 to survey the Moon, provide data on its history and topography, and identify potential future landing sites. The LRO currently orbits the Moon four times a day and sends 56,575 gigabytes of data back to Earth every year.

The thin trail of footsteps runs around 164 feet (50m) toward the Little West Crater, an unplanned excursion by Armstrong toward the end of his two and a half hours on the surface. The base of the Lunar Module (LM) and other scientific equipment can still be seen as bright highlights. PL

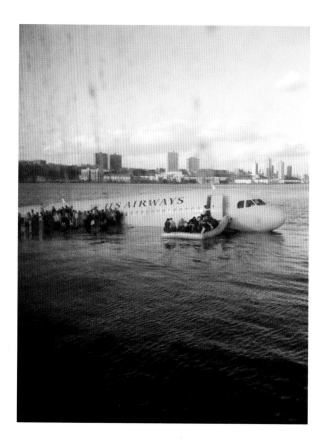

MIRACLE ON THE HUDSON

JANIS KRUMS

Date 2009

Location New York, New York, USA

Format iPhone

On January 15, 2009, a US Airways Airbus A320-214 piloted by Captain Chesley B. "Sully" Sullenberger hit a flock of Canada geese shortly after takeoff from New York LaGuardia Airport and was forced to make an emergency landing on the Hudson River. Amazingly, all 155 passengers and crew survived.

Latvian American Janis Krums (born 1985), who was on board a commuter ferry rushing to rescue passengers, captured the scene on his iPhone and then posted it on Twitter.

His image was one of the first to appear following the incident, and it went viral. It was later reprinted on newspaper front pages worldwide. Krums himself became something of a celebrity and was lionized as the author of one of the greatest pieces of what has become known as "citizen journalism."

In 2014, Krums told CNN that he had no idea that the picture would "do what it did," adding that he was surprised it attracted so much interest so quickly. He told the interviewer: "I posted to my 170 followers and did not send it to any news outlets. It was incredible to see the power of Twitter and how news can spread around the world in a matter of minutes." GP

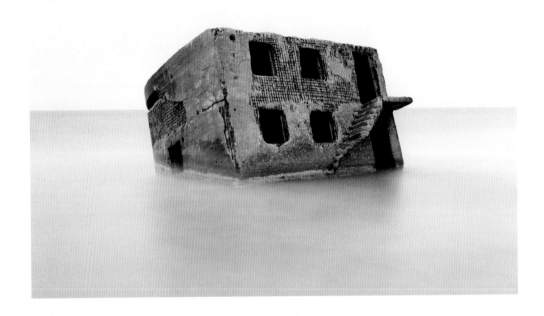

BUNKER IN THE BALTIC SEA, LATVIA

MARTIN ROEMERS

Date 2009
Location Latvia
Format Medium format

Martin Roemers (born 1962) studied photography at the Royal Netherlands Academy of Arts in Enschede. He then worked freelance for various publications, including *The New York Times*, *Newsweek*, and *The New Yorker*, as well as on his own personal, long-term projects that have largely been concerned with the lasting effects of warfare—on people, environment, and countries.

In one of the first of these projects, *Relics of the Cold War* (2010), Roemers sought out the traces left behind in Europe from the Cold War—weapons, bunkers, shelters, and other detritus littering the continental landscape. The almost dreamlike image reproduced here, of an abandoned bunker, looks as if it was shot in a studio rather than where Roemers actually encountered it—floating in the Baltic Sea off the coast of Latvia.

Another major Roemers undertaking focused on the megacities of the world—throughout Africa, Asia, Europe, and the Americas—that he photographed from 2007 to 2015. Titled *Metropolis*, the award-winning project comprises eighty-five photographs and serves to expose the scale, pace, and energy of these cities and provides an insight into the daily lives of their inhabitants. **LH**

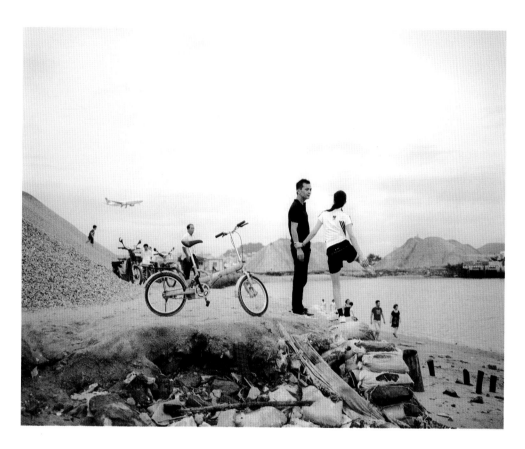

COASTLINE NO. 14

ZHANG XIAO

Date 2009
Location Shenzhen, China
Format Medium format

Zhang Xiao (born 1981) graduated in architecture in 2005 from Yantai University in Shandong province. He worked for the *Chongqing Morning Post* as a photojournalist until 2009, and throughout his time there he carried two cameras, one for work, and a cheap Holga medium-format for his own personal photographs.

In 2009, Xiao decided to photograph China's coastline, all 9,000 miles (14,500km) of it. Because of the rapid economic transformation occurring in China, unprecedented numbers of people from the rural interior were moving to the coast for work, and thus transforming the appearance and character of the seaside. However, instead of focusing on the workers and the proliferating building works, Xiao was drawn to the sea itself. As he said: "The sea is the beginning of lives and dreams; at the same time, I am looking for the homeland in my heart."

The muted tones here are reminiscent of old family photographs, and Xiao also reveals warmth and intimacy. Scenes like this are layered with detail and pops of color and almost seem more fictional than real. In 2011, Xiao's *Coastline* series was awarded the Prix HSBC pour la Photographie. LH

DIMA, MATSESTA SPA, SOCHI REGION, RUSSIA

ROB HORNSTRA

Date 2009
Location Sochi, Russia
Format Medium format

From 2007 to 2014, Rob Hornstra (born 1975) and journalist Arnold van Bruggen, both Dutchmen, focused on Sochi during the period when the city and surrounding area were redeveloped as the venue for the 2014 Winter Olympics.

"Never before have the Olympic Games been held in a region that contrasts more strongly with the glamor of the Games than Sochi," they wrote. "Just 20 kilometers [12 miles] away is the conflict zone Abkhazia. To the east, the Caucasus Mountains stretch into obscure and impoverished breakaway republics such as North Ossetia and Chechnya . . . By 2014 the area around Sochi will have been changed beyond recognition."

Hornstra and van Bruggen took a particular interest in the early twentieth-century sanatoria along the Black Sea coast. It was to these buildings that sick workers had been sent under Communism (1922–91) to recuperate. In readiness for the Games, however, they were now being converted into luxury hotels. In this image, a young boy named Dima receives a sulfite water treatment for a burned leg at the Matsesta Spa, which had been in operation since 1902 and was now a soon-to-be-dismantled relic of old Russia. LH

BURNT BUILDING

ZHOU JUN

Date 2009
Location Beijing, China
Format Large format

Zhou Jun (born 1965) studied photography in Nanjing before moving to Beijing in 1995 to participate in an artist-in-residence program at the Red Gate Gallery. It was not long before he found himself living in a city that was preparing to host the 2008 Olympics, as a result of which there were years of construction and the demolition of traditional buildings and neighborhoods. Cranes dotted the skyline, and the city's monuments were covered in protective material as they were restored.

Zhou turned to photography to come to terms with the massive transformation Beijing was undergoing. He used a large-format film camera to take black-and-white shots of the buildings, highlighting the details of construction in red. He first tried traditional hand-painting of the prints, but then turned to a digital approach as another way to communicate the push and pull between modern and traditional that pervaded the city.

This photograph shows the unusual and controversial design of Beijing's CCTV building, which had been the subject of an arson attack and was being reconstructed. The thin red strips of color indicate where scaffolding or other construction materials are located. LH

BARCELONA CELEBRATE WINNING THE UEFA CHAMPIONS LEAGUE FINAL

SHAUN BOTTERILL

Date 2009
Location Rome, Italy
Format 35 mm

This wonderful image encapsulates the joy of winning a major sporting tournament and the affection of the players for their manager. In his first season in charge of Barcelona soccer club, Pep Guardiola guided the team to the UEFA Champions League title with a victory over Manchester United in the final at the Stadio Olimpico in Rome, Italy.

This magical moment was captured by Getty sports photographer Shaun Botterill, a veteran of hundreds of high-profile athletic events. He knows exactly where to position himself to get the best shots, partly through experience and partly through lifelong interest in the sports he covers. And, of course, he has the very latest, most technologically advanced equipment. However, he is anxious to stress that amateurs without his advantages can also take great pictures. "The key," he insists, "is to work with the equipment you've got.... You have a different angle because you're in the crowd. Maybe there are people celebrating in the foreground. And if something that's happened looks great from where you are, nowadays with the Internet, if somebody picks up that picture and it's a good angle—hey, you could be published all around the world." PL

TO CONQUER HER LAND

POLOUMI BASU

Date 2009
Location Punjab, India
Format Medium format

This intimate moment between two female soldiers was captured by Indian photographer Poloumi Basu (born 1982) as part of *To Conquer Her Land* (2009–12), her project about the first ever cohort of women soldiers to be deployed as part of the Border Armed Force. The women, aged between seventeen and twenty-five, Hindus and Muslims, and from mixed castes, were undergoing training before deployment along the contested frontier between India and Pakistan. Basu noted how the training changed them, binding them together: "This transformation is so . . . close to nature that it is almost impossible to recreate or restore what they've left behind. One land that is so vast that all lines seem to disappear, yet a deathly silence that is so white, haunting, and exact that it can create peace even in the land in the brink of war."

Basu has devoted herself to covering women's issues in the Indian subcontinent. She is one of the founders of the "Just Another Photography Festival." She explains: "So far we have shown to a diverse audience, from slum and blue collar communities, to universities, outside mosques, women's centers, Dalit [formerly "Untouchable"] villages, and everywhere in between." PL

FROM *ILLUMINANCE*

RINKO KAWAUCHI

Date 2009
Location Unknown
Format 6x6 medium format

In using everyday subjects—flowers, birds, oceans, streets, food, and light—Japanese artist Rinko Kawauchi (born 1972) might be classified as a photographer of the banal. However, the way in which she represents her subjects elevates them from the commonplace into the realm of the poetic and dreamlike, resulting in imagery that is inherently beautiful in its unworldliness.

Kawauchi's work has been described as "visual haiku," and she often composes haiku (poems of three lines with five syllables in the first line, seven syllables in the second, and five syllables in the last) to accompany the individual images.

Her tricks of light imbue the everyday with an ethereal quality, and a luminosity that arouses anticipation, and hints that something is about to take place—but exactly what is deliberately left unclear. "I want imagination in the photographs I take," she has said. "It's like a prologue. You wonder, 'What's going on?' You feel something is going to happen." Such is the case with this image, a pyramid-like structure with a beam of light emanating from it. "It's not enough that the photograph is beautiful. If it doesn't move my heart, it won't move anyone else's heart." LH

FROM *CASPIAN*

CHLOE DEWE MATHEWS

Date 2010
Location Kazakhstan
Format Large format

Over a five-year period, British photographer Chloe Dewe Mathews (born 1982) traveled throughout the countries bordering the Caspian Sea: Kazakhstan, Turkmenistan, Iran, Azerbaijan, and Russia.

Camping and hitchhiking in Kazakhstan, Dewe Mathews saw men in white masks using brightly colored oil drums as their workbench. Returning later to photograph them, she discovered that they were Uzbek migrant workers, who lived for many months of the year in Koshkar-Ata, a cemetery.

The masks were, in fact, sheets to protect their faces from the intense heat. Their industry was a new one, because their client base was new: the oil-rich middle class. The Uzbek men were cutting marble, to build elaborate mausolea. As Dewe Mathews says: "Even the landscape of the dead is transforming as a direct result of the nearby oil industry."

This image is purely documentary but looks like carefully staged theater. This aesthetic is particular to Mathews, whose large-format camera allows her to slow down the moment: to distill it to its very essence, offering insights that would otherwise pass us by, like an image from a half-remembered dream. MH

MARCEL

RYAN MCGINLEY

Date 2010
Location Unknown
Format 35 mm

They are exhilarating, full of passion and joie de vivre: the intimate, raw photographs that Ryan McGinley (born 1977) takes of friends, models, and artists in nature have made him one of the most famous, highly respected, and sought-after photographers of his generation. In 2003, the solo exhibition of McGinley's debut series *The Kids Are Alright* at the Whitney Museum of American Art, New York City, raised the then twenty-six-year-old to prominence, and he has reigned in art and commerce ever since.

Initially enrolling in 1996 at New York's Parsons School of Design with ambitions to be a painter, McGinley found his calling in photography, and set about photographing every detail of his life in Manhattan—the skateboarding circles he moved in, the parties he went to, lovers he had, friends he got into trouble with; nothing was off limits. The images he made in those early years celebrate what it means to be young, free, and beautiful. In later years McGinley has used his unique photographic style and vision to achieve phenomenal commercial success. "Don't compete; find what's uniquely yours," he advised the audience upon returning to the Parsons School to give a speech to students in 2014.

Here, McGinley's image of the Canadian-born model Marcel Castenmiller, his head thrown back in a moment of intense emotion, embodies everything that makes his work extraordinary. The image may be more refined and polished in comparison to McGinley's early photographs, but there is no denying the passion that emanates from the frame. **GP**

"When it comes to photography and making a photo that I'm happy with, it's all about excess. Shooting and shooting and shooting, and the subject doing the action over and over and over." Ryan McGinley

FROM *A SERIES OF UNFORTUNATE EVENTS*

MICHAEL WOLF

Date 2010
Location Unknown
Format Unknown

German photojournalist Michael Wolf (born 1954) moved in 1994 to Hong Kong to work under contract for *Stern* magazine. In 2001, he began to undertake less commissioned work and increasingly focused instead on his own projects, which often examine urbanization, production, and consumerism. For one particular installation, *The Real Toy Story*, Wolf displayed photographs of workers in Chinese factories alongside the children's playthings they produce, many of which are exported for sale in distant parts of the world.

In 2008, Wolf relocated temporarily to Paris, France. Finding the city difficult to photograph in, he began to experiment with Google's street view mapping platform, which had been launched the previous year and which allows users to explore major cities from ground level using imagery collected by car-mounted cameras. Spending hundreds of hours searching through the street view platform, Wolf would identify the types of strange moments or juxtapositions that traditional street photographers might search for while exploring the city, and on finding these, he would then rephotograph the moments from his computer screen.

The result, *A Series of Unfortunate Events*, is a collection of bizarre and funny moments, like the one shown here, captured by roving camera cars. In 2011, Wolf's project won an honorable mention in the World Press Photo competition, much to the annoyance of those who do not regard the rephotographing of a computer screen as deserving of recognition from the sponsors of photojournalism awards. **LB**

"Wolf explores the complex, sometimes blurred distinctions between private and public life." Natasha Egan

FOLLOW HIM

WANG QINGSONG

Date 2010
Location Beijing, China
Format Unknown

Wang Qingsong (born 1966) is a Chinese artist who originally trained as an oil painter. He turned to photography in the 1990s because he felt that it was a more appropriate medium through which to comment on the complex cultural, social, and political issues that China was experiencing. As Wang's artistic practice developed over the years and became more nuanced—in his critique of

everything from the emptiness of consumerism to the role of the art critic in contemporary China— he became regarded as one of the foremost artists in the country.

His large photographs are elaborately staged scenes that have been compared to the work of Gregory Crewdson, in both their scale and their theatrical detail. Wang constructs them in film studios and sees them as a way to express— and, to some extent, to tackle—the inherent contradictions he observes in Chinese life. He spends months of preparation on every one of his photographs, which frequently require hundreds

of models, but each shot is completed within a single day. Wang does not employ any form of digital manipulation.

The themes that Wang tackles in his work are not relevant only to China; most of them have global applications. *Follow Him*, which is printed at more than 3 feet (1m) long, is a critical commentary on formal education. We see a lone figure almost drowning in a sea of books and crumpled blank sheets of paper. Wang has said of the image: "Knowledge is taught but not learnt by many people who fail to understand the real meanings."

The eclectic artist has a wide range of influences, but Wang resists suggestions that his genius comes from anywhere other than his own brain. In the painters Courbet and Ingres, for example, of whom many critics have detected echoes in Wang's work, Wang himself professes little interest. The only person to whom he readily acknowledges any debt is Andreas Gursky.

Wang is also quick to correct those who suggest that he regards the growth of consumerism in China as an unqualified evil. He says that there is good in it, too, but that it is only the undesirable aspects that fire his imagination. LH

QUEST FOR IDENTITY

ZIYAH GAFIĆ

Date 2010
Location Sarajevo, Bosnia
Format Unknown

In July 1995, in Bosnia, approximately 8,000 Bosnian Muslims (Bosniaks), mostly men and boys, were murdered by the Bosnian Serb Army of the Republika Srpska under the command of General Ratko Mladić. Their bodies were hidden in mass graves in Srebrenica. The war ended soon after this event, and the search for the graves began, yet many of the bodies have remained missing for years, and identification of those who were recovered was difficult. The possessions of the dead

became extremely important aids to identification. In *Quest for Identity*, Bosnian photographer Ziyah Gafić (born 1980) seeks to create a searchable online database of photographs of thousands of personal items recovered from the mass graves in and around Srebrenica. Aside from body parts, these belongings are the last vestiges of the victims' identities. Gafić hopes that simple items—family photographs, keys, glasses, a toothbrush with toothpaste—will provide surviving relatives with "primary visual identification." Forensic scientists call these objects "artifacts," but Gafić reminds us: "These are items people carried with themselves as they were running away from the Serb army or when they were taken for execution." **SY**

FLOAT FROM *YOUNG BRITISH NATURISTS*

LAURA PANNACK

Date 2010
Location Macclesfield, UK
Format Medium format

This delicate image, with its monochromatic, fleshlike tones, is one of the early photographs from the extended series made by Laura Pannack (born 1985) between 2010 and 2014. The artist explained her work thus: "I wanted to learn more about photographing groups. I wanted to challenge myself with regards to how I photograph people in a natural way and how not to disrupt what I want to photograph. But at the same time [to] capture some sense of reality."

Like her nudist subjects, she was naked. She recalled: "It made me very uncomfortable. It's rare for a photographer to be in that situation. Usually you're the one pointing the camera and the subject is vulnerable.... That's part of my working method. I always try to experience what the other person's experiencing."

Pannack remains wedded to shooting film for her own projects, relishing "the fact that analog completely changes the way that I work. The process is much more intimate and it's much more of a physical process, and the reaction to shooting in analog is different as well." And, she adds, the additional cost of analog makes her think twice before pressing the button. PL

COMMON GROUND 02

DILLON MARSH

Date 2010
Location Gaborone, Botswana
Format Medium format

The work of South African Dillon Marsh (born 1981) is, like most art, fundamentally an attempt to create or depict beauty. But Marsh's landscapes have an underlying didactic purpose: by illustrating some of the ways in which humans engage, both deliberately and unintentionally, with the world around them, the photographer hopes to encourage them to treat the planet with care.

The danger with the desire to instruct is that it may lead to pedantry, and thus alienate audiences who do not want to be told what to think. Marsh avoids this trap by creating images that are unfailingly vivid and arresting.

Here, we see a giant termite mound rising from the roadside. It is a beautiful and, to people unfamiliar with African wildlife, remarkable image. But the commentary that accompanies the image compares and contrasts the insect city with its human equivalents. The termites live within clearly defined borders and do not sprawl out incontinently in all directions; their common dwelling place thrives without damaging the residents or the environment—these are lessons that humankind needs to learn in order to preserve Earth's precious finite resources. MT

INTERROGATION II

DONALD WEBER

Date 2010
Location Ukraine
Format 35 mm

During the winter of 2010, Donald Weber (born 1973) traveled to Ukraine, where he created a remarkable series of photographs. At first sight the assumption is that the photographs are staged. Yet, through a contact in the local police force, Weber gained access to the interview rooms, and was able to document some of the brutal interrogation methods that soon led him to the conclusion that his Canadian concept of justice had no relevance in a society still emerging from Communism.

The young man in this room, with its pastel wallpaper and stark table, looks as though he is praying for his life. Yet, according to the original caption, he is nothing worse than a "Delinquent and Shoplifter."

Weber was horrified by the violence used by the interrogators, perhaps especially the psychological violence. The rooms look empty; the subject isolated, but of course Weber is within, as is the interrogating officer. Weber says the real subject, vividly present in the room, is power itself. "It expands in proportion to its invisibility," he says, succinctly making manifest his ethical reasons for being there. Any complicity, he has said, rests with the subsequent viewer. MH

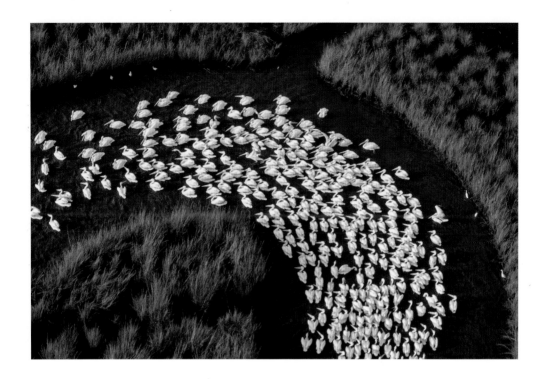

WHITE PELICANS, MISSISSIPPI

ANNIE GRIFFITHS

Date 2010
Location Mississippi, USA
Format 35 mm

Annie Griffiths (born 1953) became one of *National Geographic*'s first female photographers when she joined the magazine in 1978; she was also its youngest. Since then, she has photographed in almost 150 countries and won numerous awards for her images of natural history. She has also been sent to all fifty of the United States for stories.

This picture of migrant white pelicans featured as Photo of the Day in the magazine in November 2010. It shows the birds in the Mississippi Delta

cooperatively herding fish into small areas on the surface of the water, where the pickings are easy.

Griffiths says that traveling "makes you recalibrate how you view the world and your place in it." That sense of place informs her work. She believes that color imbues a picture with a mood. In this case, the white of the birds adds a sense of beauty and purity to the image, accentuated by the shades of dull brown and sage green that surround them. The birds are flecks of white against a dark background as they float on the surface of the water, forming an arch shape against the riverbanks. They seem part of a pattern as Griffiths's careful composition shows how they form part of a natural order. CK

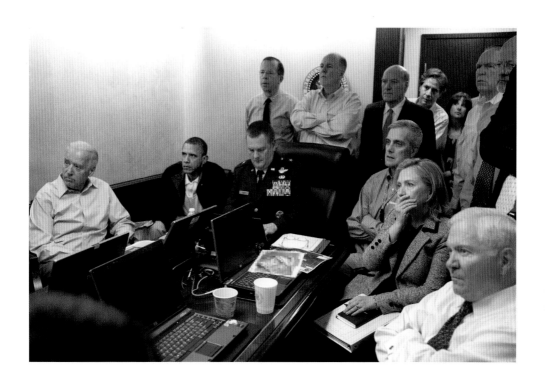

SITUATION ROOM

PETE SOUZA

Date 2011
Location Washington D.C., USA
Format 35 mm

Infamous for his role in the organization of the 9/11 attacks on the United States, Saudi-born al-Qaeda leader Osama bin Laden was killed by U.S. Special Forces on May 2, 2011 in a secret operation.

Called a "photo for the ages," this intense image was taken by photographer Pete Souza (born 1954) in the White House Situation Room. It depicts President Barack Obama, Vice-President Joe Biden, and Secretary of State Hillary Clinton, along with others on the national security team, receiving live updates from the operatives as they raided the bin Laden compound in Abbottabad, Pakistan, and subsequently shot and killed the terrorist leader. Clinton seems to be the focus of the compelling image as she stares at something with her right hand over her mouth, looking shocked. She says that those were the longest thirty-eight minutes of her life, yet claims that in this photo she was suppressing a cough, nothing more. No one except those in the room knows what they were looking at, and no one ever will. One Navy SEAL claims to have an image of the corpse, but the White House has never officially released pictures of the operation or of bin Laden's body, and so his death remains shrouded in mystery. **SY**

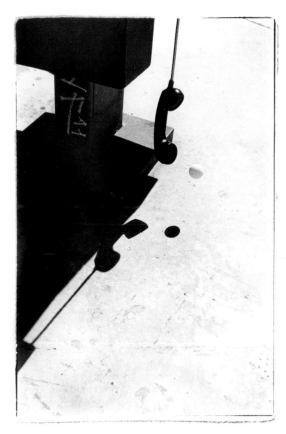

L.A. PONG

ROBIN MADDOCK

Date 2011
Location Los Angeles, California, USA
Format 35 mm

Robin Maddock (born 1972) produced two acclaimed in-depth documentary projects on life in the UK. *Our Kids Are Going to Hell* (2009) examined relations between the police and youths in Hackney, London, while *God Forgotten Face* (2011) explored the seaside city of Plymouth. However, for his next project, published as *III* (2014), he adopted a more playful and serendipitous approach.

Switching his Leica from color to 35 mm black and white, he traveled to Los Angeles and San Francisco to make a series of linked images connected by the elements of a ping-pong ball, a sheet of white paper, and spilt milk. He comments: "'California has a different light. I was inspired by the streets of L.A., which are so well known . . . I wanted to explore the exactness of the photographic moment: simple picture-taking with simple equipment." He valued the sense of uncertainty that the project gave him, noting that "maybe this being lost is part of the journey . . . I'm lost visually, but there's at least a feeling I know I want. Every project can start like this, groping around." *III* pays homage to American photography and conceptual art, but also to the simple pleasures of just walking and looking. **PL**

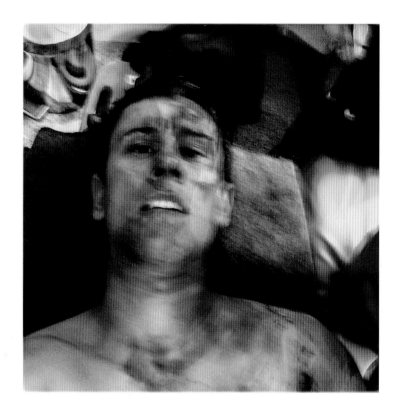

PHOTOGRAPHER MICHAEL CHRISTOPHER BROWN IN AN AMBULANCE AFTER BEING HIT BY A MORTAR SHELL

MICHAEL CHRISTOPHER BROWN

Date 2011
Location Misrata, Libya
Format Cell phone

From his book *Libyan Sugar*, shot entirely using a camera phone, Michael Christopher Brown's image is a self-portrait depicting his distress and injury following a mortar attack on Tripoli Street, which killed two of his colleagues, photojournalists Tim Hetherington and Chris Hondros. Brown was hit by shrapnel and survived after two blood transfusions. The image is remarkable in its depiction of a moment of extreme distress: slightly blurred, presumably by the movement of the ambulance, and colored by the sickeningly vivid pinks of Brown's own blood.

Originally using a camera phone out of necessity—he dropped his digital camera soon after arriving in Libya—Brown was forced to change his whole approach. The app he was using tended to crash, and it could record an image only every fifteen to thirty seconds, so he had to capture each frame strategically. He turned the disaster of breaking his camera into a new way of photographing warfare. By using the vernacular of camera phone photography, Brown aimed to personalize the experience of war; he made himself, "for better or worse, a part of the story." AZ

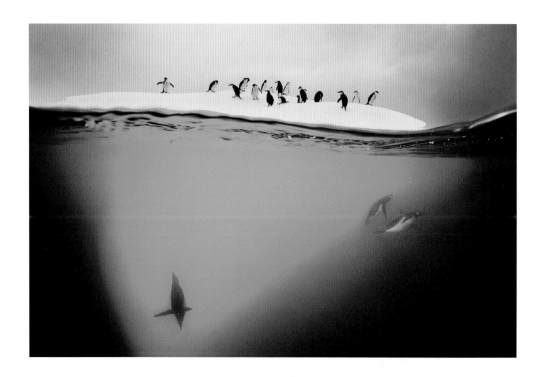

CHINSTRAP AND GENTOO PENGUINS ON AN ICEBERG, ANTARCTIC PENINSULA, 2011

DAVID DOUBILET

Date 2011
Location Danko Island, Antarctica
Format Unknown

David Doubilet (born 1946) is one of the foremost wildlife photographers, and a specialist in marine images. He began his photographic journey early: after learning to snorkel, he started to shoot underwater at the age of twelve using a Brownie Hawkeye camera. He has worked as a photographer for *National Geographic* since 1970, when his first story on garden eels in the Red Sea was published. Doubilet's great innovation was the invention of the split-lens camera, which allowed him to photograph above and below the water's surface in the same image. The lens can be focused separately on the top and the bottom of the frame to allow for the different density of the water and the air.

Doubilet says he has fallen in love with icebergs and calls the setting for this image "a bergy bit." This, he explains, is "like a mini iceberg . . . This one had a small group of gentoo and chinstrap penguins on top of it that were squabbling. They would push each other off the bergy bit, like a game of king of the hill, fall in the water with a splash, then fly down and pop up on the other side. Others were flying down the side to feed on tiny shrimp. Then they'd pop back up and the whole game would begin again!" PL

NATURAL INSIDE

JONNY BRIGGS

Date 2011
Location UK
Format Medium format

On completing his studies at London's Chelsea School of Art, and the Royal College of Art, Jonny Briggs (born 1985) began to compile a body of work that has become distinguished above all by its collaborative element and by what he terms its "performativity."

He explains the term thus: "The performative aspect of the photograph is completely private. It's just my family and me." Indeed, his parents often feature in his work. In the above photograph, his father, Norman, in body paint and wearing a mask, crouches between two tree trunks.

Viewers may wonder why, and that is exactly the point: the image aims to make them look closely, with fresh eyes, at objects that are so common that, in their natural greens and browns, they might escape active notice.

Natural Inside uses the trope of the wood to conjure fairy tales, with their dark associations, but also plays with the idea of nature itself. What is natural? Is it natural to be pink or brown? Or neither? Briggs invites consideration of such questions by creating a strikingly original visual landscape, a kind of parallel universe in which the homely becomes alien. MH

KEYHOLE IMPROVED CRYSTAL FROM GLACIER POINT
(OPTICAL RECONNAISSANCE SATELLITE; USA 224)

TREVOR PAGLEN

Date 2011

Location Yosemite, California, USA

Format Large format

Trevor Paglen (born 1974) is an American artist and geographer, much of whose work has explored intelligence gathering and surveillance. His books and photographs are underpinned by extensive research and examine such issues as the practice of extraordinary rendition, and the US government's operation of secret bases and projects around the world. Paglen's photographs often seek to depict topics that are inherently difficult or impossible to visualize, employing a variety of conceptual strategies to reveal things that have often been carefully designed to be nearly invisible.

Paglen uses astrophotography techniques, including very long exposures, to document satellites, some of them highly classified, as they transit the night sky. Using information collected by amateur observers, Paglen can often predict where and when a particular satellite will appear. He then records the reflection of sunlight off the satellite as it passes overhead. Some of the satellites he has recorded are well documented; others are mysterious. This image depicts a KH-12, a type of optical reconnaissance satellite thought to be operated by the United States and a development of the first Corona spy satellites. LB

CHAPTER VII FROM *A LIVING MAN DECLARED DEAD AND OTHER CHAPTERS I–XVIII*, 2011

TARYN SIMON

Date 2011
Location Multiple
Format Large format

Of *A Living Man Declared Dead and Other Chapters I–XVIII*, the series from which these images are taken, American conceptual artist and photographer Taryn Simon (born 1975) said: "We are all the living dead, and we in some ways represent ghosts of the past and the future." For this project, Simon "traveled around the world . . . researching and recording bloodlines and their related stories." The eighteen chapters that comprise the work deal with "legacies of territory, power, religion, and violence."

These photos from Chapter VII of the work are of a Bosnian Muslim family who lost six of its members in the 1995 Srebrenica massacre. The leftmost framed element is one of Simon's "portrait panels," which depict bloodline members in small portraits. Fifteen family members are still alive, and the six who were killed by Serb forces are represented only by their remains as forensic evidence. Bajazit Mehic's skeleton was recovered from a mass grave; Ahmedin Mehic, Hazim Mehic, Enis Mehic, Mustafa Muminovic, and Ibro Nukic are depicted by teeth and bone samples photographed next to a measuring tape. Although the tape is a simple tool, and the samples are only small, they are often the only means of identifying human remains. SY

WAYNE ROONEY

ROBIN PARKER

Date 2011
Location Manchester, UK
Format 35 mm

This image, of soccer star Wayne Rooney making an overhead kick for Manchester United in a 1–0 win against Manchester City in the English Premier League, was awarded the Barclays Shot of the 20 Seasons award. With laser-sharp precision, Fotosports International photographer Robin Parker captured this euphoric moment for Manchester United at exactly the right time, as Rooney's foot hovers just inches from the ball. Parker commented: "For my photo to be chosen

as the best shot in the history of the league is very humbling, and something I will cherish for the rest of my career. It was an iconic moment, and one that was seen all over the world, so to capture it in the way that I did was extremely satisfying."

Rooney is center frame, framed by helpless defenders and backed by the crowd in the stands. A second after the photograph was taken, Rooney fired home an unstoppable overhead bicycle kick, sending the ball soaring over Manchester City goalkeeper Joe Hart, a goal that Rooney later remarked was the best of his career. Manchester United's former manager Sir Alex Ferguson said that this was the best goal he had ever witnessed at the club's stadium, Old Trafford. EC

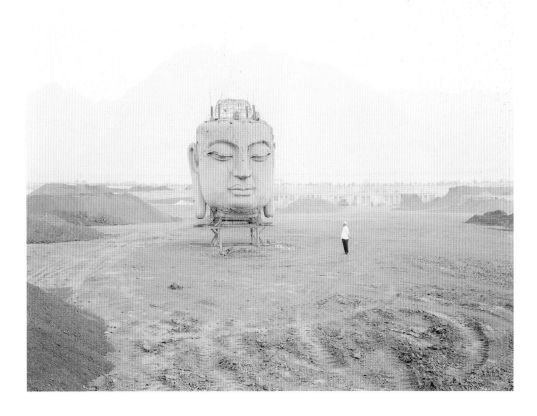

THE RIVER RUSHES NORTH

ZANG KERCHUN

Date 2011
Location China
Format Large format

Zang Kerchun (born 1980) set out to document China's Yellow River in order to record some of the legends that he felt were rapidly disappearing in the face of modernization. His original aim was to create romantic images of the cradle of Chinese civilization, but he encountered so much pollution on his journey that he could not ignore it. The resulting work, *The River Rushes North*, explores humans' relationship with the land they are changing at an unprecedented rate.

Zang's restrained use of color gives his images an otherworldly quality. Half-finished building works—which politicians hail as signs of the nation's bright future—appear in his work as ruins, as if their time has already passed. Human figures seldom feature, but when they do they are used to emphasize their insignificance beside nature and, indeed, beside the massive earthworks being made by construction engineers.

In the picture reproduced above, a man looks up at a giant Buddha's head. Because of the even toning of the image, the statue appears as if it possesses a similar scale to that of the mountains behind it—impenetrable, absolute, almost geological in its power. **MT**

UNTITLED

BEN LOWY

Date 2011
Location Libya
Format iPhone

When rebels erupted against Colonel Gaddafi's government in Libya in 2011, those on the ground photographed events using their smartphones and shared images through social media networks.

Photojournalist Ben Lowy (born 1979) decided to use his iPhone to photograph what he was witnessing—it was less obvious than his camera and allowed him to get closer to his subjects. He eventually produced a three-part body of work called *iLibya*, and this image, from the first part, *iLibya 1 Uprising by iPhone*, shows Libyan rebels celebrating in a square outside the Libyan Revolutionary Council headquarters in Bengazi. The man in the center has a frenzied expression and is flanked by comrades who are equally impassioned. Using his smartphone, Lowy was able to transmit his images quickly, and he soon gained an impressive Instagram following. **GP**

XANA NYILENDA, NEWTOWN, JOHANNESBURG

ZANELE MUHOLI

Date 2011
Location Johannesburg, South Africa
Format 35 mm

Zanele Muholi (born 1972) is undertaking a lifetime project to promote awareness of South Africa's queer black community. Her photographs primarily focus on black lesbian women and transgender men who are living in a society rife with homophobia, under threat of discrimination, violence, and horrific hate crimes.

Muholi asks her sitters to "think about being black, being a lesbian, being a woman." The complexities of these identities have resulted in expressions that show fear, vulnerability, defiance, shy pride, or here, in Xana Nyilenda, a steady, tough calm. Muholi's photographs speak of the resilience of these men and women, and by extension, of the diversity and dignity of humankind. **RF**

FEMALE WITNESS 132

ARMIN SMAILOVIĆ

Date 2012
Location The Hague, The Netherlands
Format 35 mm

FROM *EVIDENCE*

DIANA MATAR

Date 2012
Location Libya
Format Unknown

This looks as though it is an image of water, perhaps the sea lapping a shore, but it is, in fact, a road, photographed at night. Diana Matar sought a visual language to reveal the invisible. She wanted to tell the story of her father-in-law, who was abducted by the Colonel Gaddafi regime, taken to the infamous Abu Salim prison in Libya, and never seen again. Using only film to record her painstaking, searching journey, Matar had to create a language of absence and loss. Existing frames of reference could not be useful in such a narrative, and, without a subject, she turned to metaphor and to the night sky.

In this image, as in several others in her *Evidence* series, Matar photographs trees as the only witnesses to events unseen by human eyes. Birds feature heavily throughout her work, as though messengers from elsewhere. Although she photographs sites where atrocities are known to have taken place, she promised her husband that she would not go to Abu Salim. The horror she felt emanates from her photographs, despite or because of their terrible beauty. MH

Bosnian-German photojournalist Armin Smailović (born 1968) made an extensive documentation of the postwar situation in the former Yugoslavia, concentrating in particular on the aftermath of sexual violence on the victims. This striking image is of Female Witness 132 (FW 132) giving testimony in the landmark trial of Dragoljub Kunarac, Radomir Kovač, and Zoran Vuković at the UN International Criminal Tribunal of Former Yugoslavia (ICTY) in 2000. The witnesses were all given anonymity by the court, and their identities were disguised by pixelating the video feed of their testimony.

The three men were Bosnian Serb paramilitary commanders who were accused of gang rape, torture, and enslavement of women in the Bosnian town of Foča in 1992 and 1993. In 2001, they were convicted of rape as a crime against humanity.

Between 2010 and 2014, Smailović, driven by a "vision of making the unimaginable and unspeakable visible," re-photographed the ICTY testimony of a number of victims. The results were presented as part of an exhibition that toured the region to raise awareness of the long-term consequences for victims of sexual crimes. PL

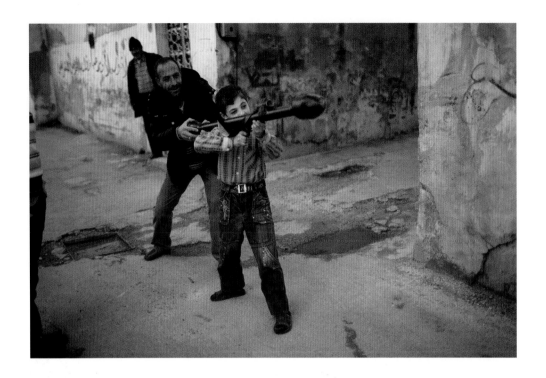

A MAN TEACHES BILAL, 11, HOW TO USE A TOY ROCKET PROPELLED GRENADE IN IDLIB, NORTHERN SYRIA, MARCH 4, 2012

RODRIGO ABD

Date 2012
Location Idlib, Syria
Format 35 mm

According to the BBC, the civil war in Syria involved "as many as 1,000 armed opposition groups . . . commanding an estimated 100,000 fighters." The conflict arose in 2011 out of the unrest of the Arab spring, when President Bashar al-Assad's government violently suppressed protests that were calling for his removal from office. As the tension escalated into an armed uprising, the vulnerable civilian population found itself caught between the government and various jihadist groups, including Al-Nusra, the Islamic State of Iraq and the Levant (ISIL), and the Syrian Free Army.

In the midst of the dangerous chaos, Argentine photographer Rodrigo Abd (born 1976) took this disturbing image of a young boy holding a toy rocket launcher. Although it could be regarded as a depiction of nothing more than a little boy playing a game in the street, in context—framed by broken road surfaces and damp, dilapidated, graffiti-lined walls—it demands that the viewer consider the effect that war and its toys, real and imagined, have on young children. Taken during a conflict that killed many of Syria's children, Abd's photo remains imprinted in the global memory of this devastating event. SY

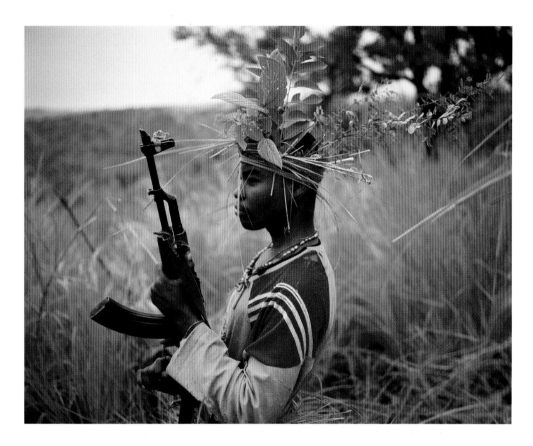

SAFE FROM HARM FROM *THE ENCLAVE*

RICHARD MOSSE

Date 2012
Location Democratic Republic of Congo
Format Six-channel video installation

Shot using an obsolete type of infrared military film, *The Enclave* was created by Irish photographer Richard Mosse (born 1980) as a multichannel immersive video installation about the legacy of violence in the eastern Democratic Republic of Congo (DRC). Inspired by Joseph Conrad's modernist literary masterpiece *Heart of Darkness* (1899), Mosse sought to explore the blurred line between fiction and humanitarian agendas in the representation of this region of the world. The

16 mm color infrared film stock, developed by the US military as a reconnaissance tool during World War II, captures parts of the spectrum that are invisible to the human eye, resulting in an almost hallucinatory vision of the Congolese bush in vivid purple, crimson, and red. The video installation is accompanied by a soundtrack based on field recordings combined with an electronic score.

Mosse recognizes that part of his motivation to present his subject in such an unfamiliar visual language has to do with defamiliarization—a need to find new ways of communicating a story that is still urgent but subject to "compassion fatigue": since 1998, 5.4 million people have died in the eastern DRC from war-related causes. JG

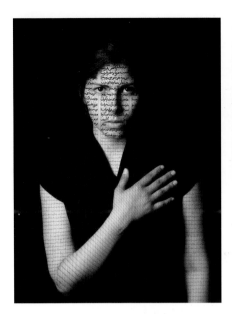

DIE ANTWOORD: SHACK SCENE

ROGER BALLEN

Date 2012
Location South Africa
Format Medium format

SARA KHAKI (PATRIOTS) (DETAIL) FROM *THE BOOK OF KINGS*

SHIRIN NESHAT

Date 2012
Location Unknown
Format Unknown

Shirin Neshat (born 1957) has lived in the United States since the 1979 revolution in her native Iran. Working across a variety of media, she often explores issues of gender, identity, and politics in Muslim and Middle Eastern countries. *The Book of Kings* is a series of stark, black-and-white portraits of Iranian and Arab youth (here, film director Sara Khaki), which are written and drawn over with calligraphic texts and images taken from the eponymous 50,000-verse poem (aka *The Shahnameh*). Written around 1000 CE, the poem tells an epic history of Iran through a blending of fact and myth. Neshat uses it as a starting point to explore modern Iran and the consequences of the abortive 2009 Green Protest movement. LB

Since the 1970s, American photographer Roger Ballen (born 1950) has been living and working in Johannesburg, South Africa. His widely acclaimed series *Platteland* from the 1990s was a look at the downtrodden and often strange white people of South Africa. Finding his own style throughout the decades, he began blurring the lines between reality and fiction, his work taking on an increasingly jarring aesthetic. By the 2000s, Ballen's photographs were dark and psychological, with more emphasis on the staged and sculptural, and often including his own drawings.

In 2012, Ballen collaborated with South African pop-rave group Die Antwoord, a band associated with the counterculture movement known as *zef*—an Afrikaans word meaning "common," "uncool," and "trashy." He directed Die Antwoord's music video for their hit *I Fink U Freeky* in his signature style—and the video has had more than 86 million views since being uploaded on YouTube. Ballen's behind the scene photographs from the video shoot, including this image, were published in his 2013 book *Die Antwoord*. LH

BLUE BOTTLES

LUCAS BLALOCK

Date 2013
Location USA
Format Large format

Much of the labor that underpins modern-day photographs is concealed in the final product, the overall goal being to conceal the digital manipulation. Lucas Blalock (born 1978), in contrast, uses the editing tools with an explicit bluntness. He shoots his images on a large-format camera before using Photoshop to manipulate the image with a variety of tools.

In *Blue Bottles*, the shadows of the two bottles suggest two physical, solid, and three-dimensional objects, yet the cloning stamp makes them appear two-dimensional, as though torn from a sheet of plastic mimicking the real thing. The clone tool also creates a kind of camo-pattern that plays on the theme of camouflage—again making us reflect on how much of today's digital processing is done discreetly, with the aim of "camouflaging" or erasing flaws and imperfections. EC

NORTH KOREA

DAVID GUTTENFELDER

Date 2013
Location North Korea
Format 35 mm

When American photographer David Guttenfelder (born 1969) began to make images with his iPhone and send them to the photo-sharing service Instagram, he became the world's first professional photographer to post directly to Instagram from inside North Korea. In this Instagram image, taken on September 19, 2013, North Korean soldiers gather at a cemetery for military veterans near Pyongyang. The turned head and searching gaze of the man in the foreground make us aware of the photographer's presence and draw us into the scene. In the background, soldiers look formal and almost dehumanized in their identical military uniforms. In the awkward composition, Guttenfelder calls our attention to the alien qualities of the secluded country. As *Time* magazine's Instagram Photographer of the Year 2013, he has since worked on commissions for publications such as *National Geographic*. EC

SIGNAL

JOHN STANMEYER

Date 2013
Location Djibouti City, Djibouti
Format 35 mm

John Stanmeyer (born 1964) was on assignment in Djibouti for *National Geographic* magazine, working on a story on collective human migration out of Africa. Wandering around the streets of Djibouti City, he came across this scene on the city's beach: a group of people at dusk, standing motionless, holding their cell phones up in the air, searching for a signal. He quickly learned that these people were mostly Somalis who were trying to "catch" inexpensive signals from neighboring Somalia in order to reach relatives. Djibouti is a well-known transit point for migrants from Somalia, Ethiopia, and Eritrea trying to get into the Middle East and Europe.

In 2014, the image was awarded World Press Photo of the Year. Stanmeyer has said that the photograph "is an image of all of us as we stand at the crossroads of humanity, where we must ask ourselves what is truly important, demanding our collective attention in a global society where the issues of migration, borders, war, poverty, technology, and communication intersect." LH

UNTITLED (SEATED NUDE)

LAKIN OGUNBANWO

Date 2013
Location Unknown
Format 35 mm

Lakin Ogunbanwo (born 1987) is a Nigerian fashion and portrait photographer. His many assignments have included commissions for *i-D* and British *GQ* magazines, and his work has been the subject of several exhibitions in Lagos, New York, London, and Johannesburg.

In the tradition of West African portrait photographers, such as Malick Sidibé and Seydou Keita, Ogunbanwo's work is shot in a studio, but the similarities end there. Ogunbanwo, unlike his West African predecessors, is not shooting the people who come to him; neither is he using photography to document a people or an era, but rather creating work over which he has full creative control. "As opposed to photojournalism, documentary or reportage photography, shooting fashion and art in a studio means that you—the photographer—are in control of everything in the frame," Ogunbanwo has said.

Since 2011, Ogunbanwo's style has straddled portraiture and fashion. He often uses models in various states of undress—such as in this image in which a man is wearing only shoes—and often shoots just one, solitary figure against a minimal background. His imagery is intended to subvert the stereotypical views of Africa that are still pervasive. While a place like Lagos might be more commonly associated with crowds and the bright, vibrant colors that dominate African market scenes, Ogunbanwo's work allows for a re-evaluation of these visual tropes with a sense of stillness and serenity. "As long as I'm the one holding the paintbrush or camera and telling the story, then this is my truth and my art," he says. LH

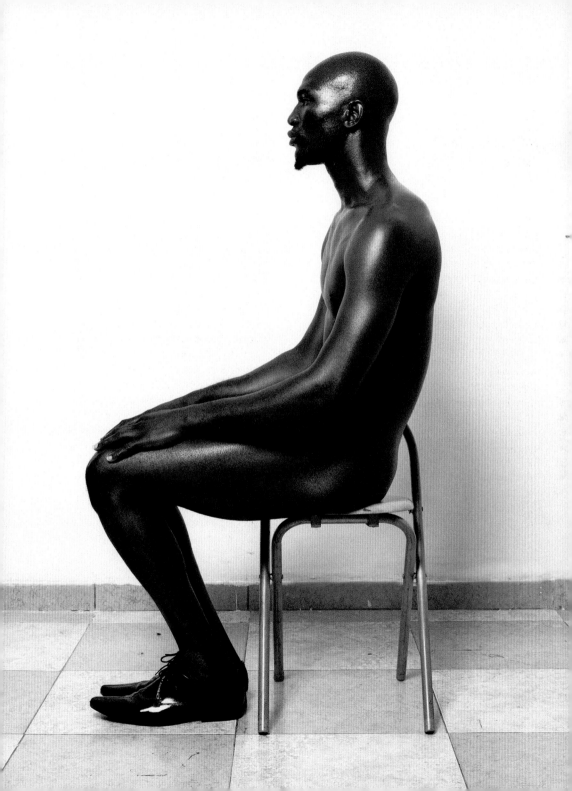

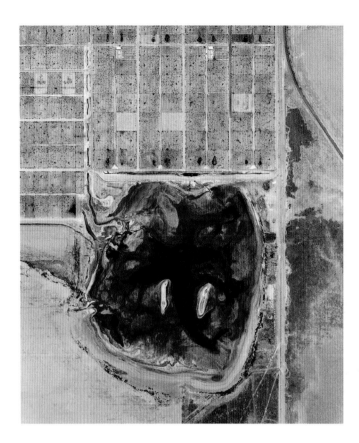

CORONADO FEEDERS, DALHART, TEXAS

MISHKA HENNER

Date 2013
Location Dalhart, Texas, USA
Format Composite satellite images

Mishka Henner (born 1976) stitched together hundreds of satellite images in order to build his extraordinary composite aerial views of the "feedlots" used in industrial-scale beef production in the United States.

The grids in the upper part of this image are pens containing cattle, and the red shape that occupies the lower part of the picture is a "lagoon" of the animals' waste. The work is an example of the "contemporary sublime": it uses the awe-inspiring and shocking scale afforded by Henner's satellite viewpoint to present an environmental critique of these agricultural practices that would not be possible using conventional photography.

As an idea within art and philosophy, the contemporary sublime is closely associated with the history of aesthetics and essentially refers to experiences that evoke fear and delight in comparable measure. More complex and nuanced than either the beautiful or the horrible, "sublime" experiences challenge our understanding, and may force us to face our own inadequacy, mortality, and helplessness. Today, the power of technology is more likely to evoke the qualities of this form of the sublime than volcanoes, avalanches, or storms. JG

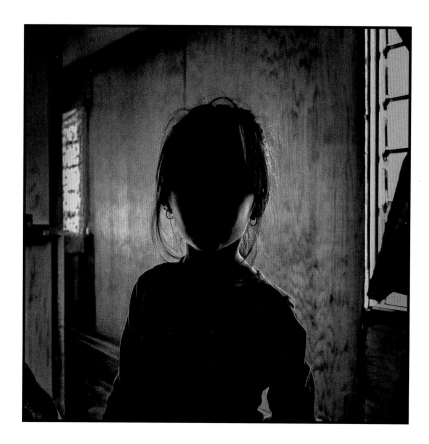

FARMWORKER CAMP, ALPAUGH, CALIFORNIA

MATT BLACK

Date 2013
Location Alpaugh, California, USA
Format Medium format

The work of Matt Black (born 1970) explores the nature of migration, poverty, and agriculture in his native California as well as in Mexico. In this image, the silhouette of a young girl faces the Magnum photographer's lens at close range, the features of her face completely obscured by shadow. We are offered little information about the girl herself, being able to make out nothing much more than her slight frame and her hoop earrings, but the wall behind her is made of exposed plywood. The combination of Black's dramatic use of black and white, along with the poverty of the minimalist backdrop, allows us to extrapolate something of the subject's circumstances.

Alpaugh, the town in which the image was taken, has a population of 1,026 and 55.4 percent of its residents live below the poverty level. Black documented the conditions of farmworkers and their homes in California's Central Valley as part of a larger project, *The Geography of Poverty*, which, as a whole, is similarly graphic and spare: silhouettes, the twisting lines of an illuminated road, the shadow of a dog. Black suggests, through his photographs, an existence that is simple but relentlessly hard. AZ

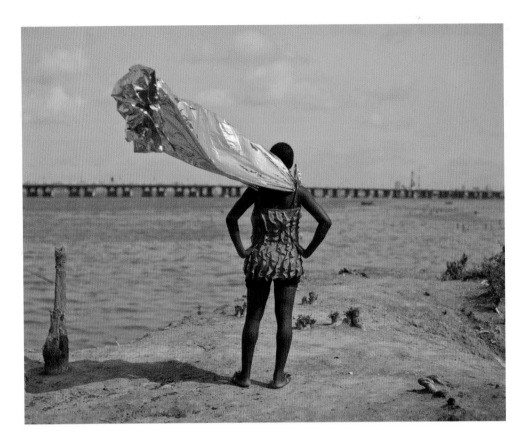

THIS IS WHAT HATRED DID

CRISTINA DE MIDDEL

Date 2014
Location Lagos, Nigeria
Format Unknown

Photojournalist Cristina de Middel (born 1975) became disenchanted with her assignments for Spanish newspapers and resolved to approach her work in a completely different way.

Her breakthrough was *Afronauts*, a photoseries about the 1960s' Zambian space program. She staged photographs of a man dressed in her interpretation of African space gear, posing in the desert. The work was such a refreshing angle on a little-known subject that the book (self-published

in 2012) quickly sold out and established her as a photographer who seeks reality through fiction.

This Is What Hatred Did takes its title from the concluding line of Amos Tutuola's *My Life in the Bush of Ghosts* (1954). In her series, de Middel reimagined the young boy in the novel, who retreats from fighting and hides out in the bush, where a series of magical and tragic events occur. De Middel thought this the perfect simile for life in one of Lagos's most notorious slums, Makoko. She created mystical and dreamlike imagery that straddles both documentary and fiction to communicate this story and provide an antidote to the overwhelmingly negative media coverage of the slum. LH

SKULLS AND SEASHELLS

DANIEL GORDON

Date 2014

Location New York, New York, USA

Format Digital composite

To create this dizzyingly complex image, Brooklyn-based artist Daniel Gordon (born 1980) took photos from the Internet and then digitally manipulated them. In the process, he enhanced and printed the images to incorporate them into an elaborate studio set resembling classic still-life compositions.

It takes some time to absorb all the individual elements of the image. The colors are intensified against the black-and-white background, and parts of the image bear striking similarities to some of the paintings of Paul Cézanne, Henri Matisse, and Pablo Picasso. The skull sits to the right of the center—a prominent *memento mori*. The seashells lie scattered below. Looking at the image, we are invited to consider the future of the photographic image itself, as it becomes less and less of a physical object in the digital age, giving way to new forms of seeing and creating.

Gordon specializes increasingly in the use of photography to reject the transparency and clarity of the traditional picture plane. Instead, he devises new, radical ways of presenting and viewing images. The photograph reproduced here is selected from his acclaimed series *Screen Selections and Still Lifes* (2014). EC

UKRAINE PETROL BOMB

DONALD WEBER

Date 2014
Location Kiev, Ukraine
Format Unknown

Donald Weber (born 1973) trained and worked as an architect before turning to photography. He has devoted his subsequent career to what he calls "the study of how power deploys an all-encompassing theater for its subjects, recording its secret collaboration with both masters and victims."

One of his most successful bodies of work was *Interrogations*, a photographic document of suspected criminals being interrogated by police in Ukraine. Weber first traveled to the country in 2004, during the Orange Revolution. He soon returned, spending six years there and in Russia exploring notions of the influence of hidden power. The photographs from *Interrogations* make for uneasy viewing: cowered in a claustrophobic room and threatened with violence, the suspects are shown helpless at the mercy of the unseen interrogators.

Continuing his coverage in Ukraine, in 2014, Weber shot a series of images of Molotov cocktails. The homemade bombs were used by Kiev's Euromaiden protesters—whom Weber has described as "a weird medieval dystopian army armed with whatever was found on the streets"— to attack the government's heavily armed forces.

Weber decided to shoot these objects as still lifes, drawing attention to the details of each, such as the labels and the rags and wires sticking out of the top. Instead of photographing the action and violence, Weber regards this project as taking "a macro view of the situation." It is thus representative of his general way of working, a process that involves constantly reevaluating the role of photojournalism in the increasingly complex conflicts of the twenty-first century. **LH**

"Donald Weber is a thoughtful man, and a brave and talented photographer."

Jim Casper, LensCulture

COMPOSITION 013

KATE STECIW

Date 2014
Location New York, New York, USA
Format Collage

The artwork of Kate Steciw (born 1978) is frequently associated with the post-Internet movement, which emerged as a response to the greater possibilities the World Wide Web has opened up in terms of image sharing and distribution.

After working for ten years as a commercial image retoucher, Steciw used her knowledge to source stock images of objects online and then assemble them into unique and complex collages. In this way, she removed the images from their initial contexts and reinterpreted them as art objects, bringing the images offscreen and into the physical gallery space. Like many post-Internet artists, she interrogates the relationship between reality and virtual representation in an age when most images are viewed online.

Splicing together a disparate group of objects, Steciw here creates mosaics that aim to "move beyond the 2-D and exist in 3- and even 4-D spaces or implied spaces but also juxtapos[e] the mundane or expected with the altered or intangible." The photos of rolled bread are entwined with the synthetic green-and-yellow-striped wires, creating a clash of textures. Also, the maze of elements within the collage reflects the bombardment of images we face today in the modern visual world. Of her work, the artist says she that is "interested in the collision between representation (mostly virtual or computer-mediated) and materialization, which I think is so characteristic of contemporary experience." Often influenced by popular and mass media, she also draws theoretical inspiration from Karl Marx, Max Weber, and Knut Hamsun. EC

"Kate Steciw's work investigates the shifting relationship between objects in the physical reality of everyday living and their two-dimensional representations on the Internet."

Charles Marshall Schultz,

"Art in America"

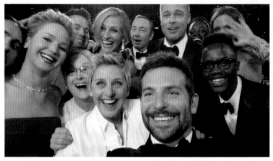

ELLEN DEGENERES
OSCAR SELFIE

BLONDIE

HALEY MORRIS-CAFIERO

Date 2014
Location Los Angeles, California, USA
Format Unknown

"Fat shaming" is a term created to describe the practice of mocking people publicly for their body shape and size. Haley Morris-Cafiero (born c. 1975) encountered this unsavory phenomenon while photographing in Times Square, New York. On reviewing her images, she noticed a man in several shots, staring at her and sneering at her unmistakably. This inspired the *Wait Watchers* project, in which Morris-Cafiero photographs herself, and the reactions of others to her, on previously set-up cameras in busy areas. She has thus captured on film the disdain of police officers, tourists, and teenagers as she goes about her daily life.

The joy on the face of Morris-Cafiero in this image is at odds with the negative reaction to her pose in the middle of a boardwalk. The photographer does not claim to know what people are thinking, but she is interested in the role of the gaze within society. Photography is the perfect site to study such power relationships. It is easy for viewers to condemn the gawping people, but it may also lead them to question what they would do in the same situation. **MH**

ELLEN DEGENERES
AND BRADLEY COOPER

Date 2014
Location Los Angeles, California, USA
Format Cell phone

Shared more than a million times in the first hour after posting, and spawning countless parodies, this is the first photo that "broke the Internet," predating Kim Kardashian's winter 2014 cover of *Paper* magazine. Twitter temporarily crashed under the weight of retweeting and liking.

It is no surprise that the most widely shared image of all time is also a selfie. Intrinsic to that medium is its indelible link to social media—to the idea that we no longer take images merely to record events, objects, landscapes, and things, but to show others that we were there. The more others look, and the more we know they look, the more successful the selfie.

This picture presents celebrities—often seen only in manicured photoshoots or grainy paparazzi shots—getting excited about something many of us do: taking a selfie. The photograph gives us something in common with people from whom we may normally feel immeasurably distant. In contrast to the failed attempts of some politicians and other public figures to appropriate the visual language of modern youth, this was an apparently effortless tapping in to the zeitgeist. **MT**

NOT A BUG SPLAT

FFR

Date 2014
Location Khyber Pakhtunkhwa, Pakistan
Format Drone

For a US Predator drone operator, a kill is known in military slang as a "bug splat," since viewing the victim as a grainy video image from on high gives the sense of an insect being crushed to death underfoot. Since 2004, drone strikes in Pakistan have killed more than 1,000 civilians, including more than 200 children. To question the widespread use of drones against alleged terrorists, and the "collateral damage" that they inflict on innocent civilians, the FFR (Foundation for Fundamental Rights) artists' collective created the campaign #NotABugSplat. They installed this huge portrait—90 feet by 60 feet (30mx20m)—of a child facing upward in the heavily bombed Khyber Pakhtunkhwa region of Pakistan, the site of regular attacks from these deadly "eyes in the sky." One of the artists says that the intention was to "shame drone operators and make them realize the human cost of their actions."

The team behind #NotABugSplat obtained the image via British-based legal charity Reprieve. The girl, a nameless Afghan refugee, had lost her parents in 2010 to a drone strike. The campaign garnered more than 3.5 billion web views and contributed to a change in Western policy that reduced drone-related civilian deaths to almost zero. PL

SELFIE

KIM KARDASHIAN WEST

Date 2014
Location USA
Format Cell phone

Her name is the first hit that comes up when you type "Kim" into a search engine, and she has almost 100 million followers on Instagram. Welcome to the world of Kim Kardashian West—reality TV star, entrepreneur, fashion designer, producer, and author. She made her name through the long-running series *Keeping Up with the Kardashians*, which was first broadcast in 2007; since then she has conquered social media and is renowned for the countless selfies she takes and shares with the public.

In fact, Kardashian West took her first selfie long before she or indeed the word became familiar names; a self-taken picture with her sister in 1984 is featured in her 2015 book *Selfish*, alongside a selection of images she has taken as an adult. The above photograph appeared on the front cover. GP

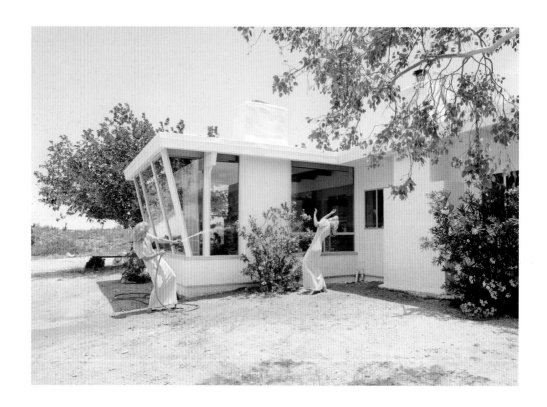

THE GARDEN HOSE

ANJA NIEMI

Date 2015
Location California, USA
Format Unknown

Anja Niemi (born 1976) is a Norwegian who studied in London and is now based on the Pacific coast of the United States. She always works alone and constructs her images with elaborate theatricality. Every detail is immaculate. Niemi is photographer, stylist, choreographer, and subject (twice over), and she plays each role to obsessive perfection.

As with much of her other work, *The Garden Hose* explores the condition of solitude and the dangers and delights it may hold. It is part of the series *Darlene & Me*, which uses the concept of the double to create an uneasy disruption in seemingly mundane or playful scenes. Niemi appears in most of her photos, but they are not about her: they are about the similarities and differences between loneliness and solitude. Each of these conditions has pluses and minuses, but there is also, in some of Niemi's most striking images, a strong suggestion that whatever else may happen, we all die alone. As she puts it: "Life is filled with moments where humor blends into tragedy and ugliness into perfection, but we often seem to prefer them apart. In my work I try to create environments and characters where it all comes together." MH

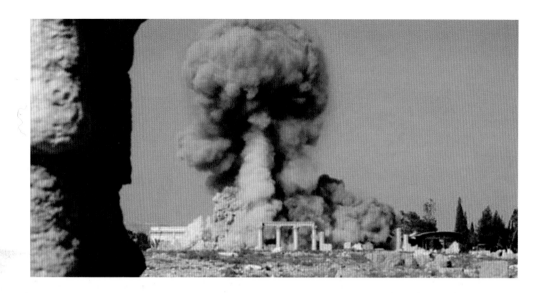

THE TEMPLE OF BAALSHAMIN IN PALMYRA
BEING BLOWN UP BY ISIL

ISIL

Date 2015
Location Palmyra, Syria
Format Unknown

In the summer of 2015, the world witnessed the destruction of an important part of its heritage. In the Syrian city of Palmyra, the terrorist group calling itself the Islamic State of Iraq and the Levant (ISIL) broadcast images across the Internet of its destruction of the 2,000-year-old Temple of Baalshamin. A UNESCO World Heritage Site, the temple was dedicated to the "Phoenician god of storms and the sky" and had stood since the first century CE.

ISIL took control of the site in May 2015, but had initially stated that the archeological gem would remain intact and that they had no intention of destroying it. Yet, a few months later, parts of the complex were blown up with mines in a spectacular destruction of history. And as part of its extensive propaganda campaign primarily used to recruit new "soldiers" to its cause, ISIL sent out pictures on social media proclaiming that the temple was a "heresy to its ideology." Soon after the destruction of the temple, the terrorists kidnapped Palmyra's retired chief of antiquities, eighty-one-year-old Khalid al-Assad, brought him to the still-intact ancient Roman amphitheater nearby, and publicly beheaded him. SY

ARMENIA

DIANA MARKOSIAN

Date 2015
Location Armenia
Format Unknown

In this photograph 105-year-old Movses Haneshyan stands in front of a life-size landscape beneath blue, cloud-streaked skies. It is the first time he has seen his original home in ninety-eight years since he fled the 1915 Armenian genocide. The "great crime"—as Armenians refer to it—saw vast numbers of Armenians killed by the Ottomans between 1915 and 1923, in order to eliminate their presence in the Ottoman Empire. By the end of the war, more than one million people had been killed. This image captures a theme central to much of the work of Diana Markosian (born 1989)—the relationship between memory and place. Movses stands static, faced with the memories that the picture inevitably evokes.

In 2015, exactly a century after the genocide began, Armenian American Markosian traveled back to her ancestral homeland to meet Movses and other survivors and ask them about their remaining memories of their original home. To find the people she was looking for, she studied voter registration records, looking for people born before the genocide. She eventually noted down just twenty addresses.

After meeting the survivors, Markosian crossed the border into Turkey to retrace their steps from the memories they had disclosed. Her project *1915*, which focuses on three survivors, includes not only photographs but also telegrams, video clips, hand-drawn maps, and archival images. With impressive depth and compassion, Markosian's photographs tell the stories of these remaining survivors of a genocide that the Turkish authorities have constantly denied ever took place. **EC**

UNTITLED FROM *NEGATIVE PUBLICITY: ARTEFACTS OF EXTRAORDINARY RENDITION*

EDMUND CLARK

Date 2015
Location Antaviliai, Lithuania
Format Medium format

This photograph shows a CIA "black site" in a village near Vilnius. Edmund Clark photographed sites linked to the extrajudicial practice known as "extraordinary rendition," in which suspected terrorists were secretly transported from one country to another for interrogation and torture.

Working with counterterrorism investigator Crofton Black to track rendition flights, as well as the offices of the small private contractors to whom the CIA outsourced the work, Clark's images reveal a specific type of evidence: not of the act of torture, but of a mundane network of people doing their jobs—building facilities, scheduling flights, or running hotels. The war on terror, declared by US President George W. Bush after 9/11, is thus revealed as a Kafkaesque bureaucratic labyrinth.

This image, of former riding stables, is typical of Clark's style. The subject is almost hidden from view. It first appeared in his book *Negative Publicity: Artefacts of Extraordinary Rendition*, alongside documents released into the public domain but often heavily redacted. There is a sense in every photograph and every document that something is hidden from view, like the body of someone being tortured. MH

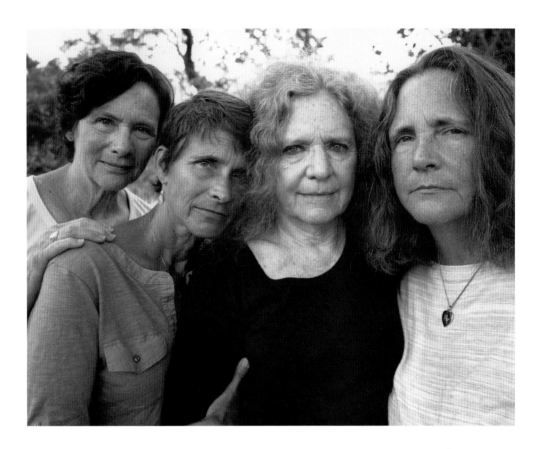

THE BROWN SISTERS, OCTOBER 24, 2015

NICHOLAS NIXON

Date 2015
Location Wellfleet, Massachusetts, USA
Format Large format

Since 1975, Nicholas Nixon (born 1947) has photographed his wife, Bebe, and her three younger sisters once a year. Each time he takes the picture, he follows set guidelines to ensure visual continuity. He poses them in the same order, left to right: Heather, Mimi, Bebe, and Laurie. He always positions his camera at eye level, and he usually takes the shot outdoors in natural light. However many exposures he takes at a sitting, he chooses one image to represent the women that year.

Viewed together, the photographs in *The Brown Sisters* series record the passage of time indicated by the style of the women's clothing and hairstyles. The women's aging is evident as they transform from teenagers and young women through to middle age and beyond. So, too, are their attitudes to one another—in some years, they stand farther apart than in others.

Nixon uses a large-format view camera on a tripod that captures every detail. In this picture, such clarity shows up in the women's wrinkled skin; wiry, graying hair; and sun-damaged faces. They almost cradle one another, as if acknowledging the passage of time and the importance of the yearly ritual they have agreed to participate in. CK

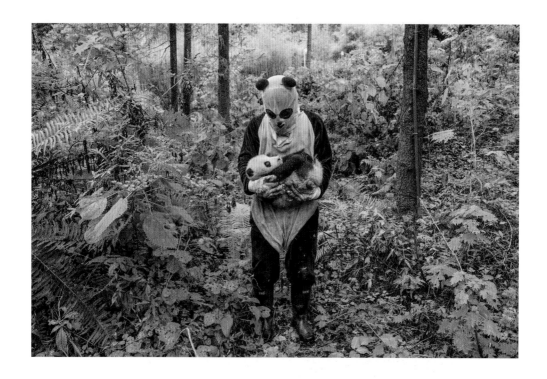

PANDAS GONE WILD

AMI VITALE

Date 2015
Location Wolong Nature Reserve, China
Format 35 mm

This charming image shows a keeper wearing a panda suit at the wild-training center in Wolong Nature Reserve, Sichuan Province, China. The idea is to keep the vulnerable bears as sheltered as possible from human contact before they are released into the wild. Once an endangered species, the giant panda is now regarded as vulnerable, due in no small part to the work of the Chinese in eliminating poaching, protecting the animal's natural habitat, and reintroducing pandas born in captivity to their native bamboo forests. The China Conservation and Research Center for the Giant Panda oversees three bases in Sichuan Province, home to over two-thirds of the global panda population.

Amy Vitale (born 1971) has worked as a photographer in over ninety countries, and has recently commited herself to documenting attempts to preserve endangered wildlife. She works regularly for *National Geographic*, who published this story in 2016. She describes how "in the beginning, photography was my passport to meeting people, learning, and experiencing new cultures. Now it is more than just a passport. It's a tool for creating awareness and understanding across cultures, communities, and countries." PL

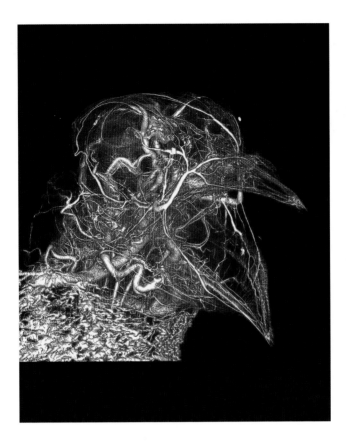

MICROVASCULATURE OF PIGEON HEAD

SCOTT ECHOLS

Date 2015
Location USA
Format CT scan

This extraordinary photograph shows the network of tiny blood vessels that can be found in the head of a pigeon, demonstrating a complex and intricate system that is at once both incredibly beautiful and scientifically valuable. The image was created using a CT (computerized tomography) scanner and a special contrast agent called BriteVu that allowed the fine detail of the animal's microvasculature system to be seen. This unique tool for visualizing the interior workings of nature was developed by Dr. Scott Echols, an avian veterinary specialist, to help better understand the anatomy of birds. Echols is director of the Grey Parrot Anatomy Project, which develops technology to improve anatomic visualization and better to identify and ultimately treat abnormalities. The technique used here allows the cardiovascular system to be explored in three dimensions.

The discoveries made through the research have been applied to a wide variety of animals, including grey parrots, pigeons, and American alligators, as well as humans. This image is part of a long tradition of scientific imaging that, in addition to increasing knowledge, produces photographs with extraordinary esthetic qualities. PL

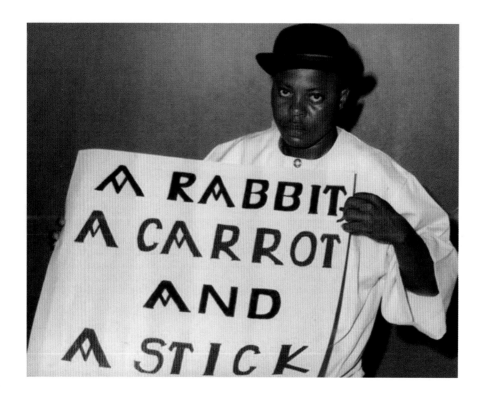

FROM *SCAM BAITERS*

MISHKA HENNER

Date 2015
Location Manchester, UK
Format Composite

"Scam baiting" is a form of Internet vigilantism where the vigilante poses as a victim to waste scammers' time and resources, gather information for the authorities, and publicly expose the scammer. A "bait" is initiated by answering a typical scam email and pretending to be receptive to the financial hook used by the scammer. The key objective is to divert the scammer from conning genuine victims. As a pastime, scam baiting has flourished with the spread of email and the Internet.

As well as creating some elaborate scam baits himself, Mishka Henner (born 1976) has made a series of artworks playing on visual material that he found online, generated by others. In the case of this photograph, a scam baiter online had asked a scammer to photograph himself holding a prescribed sign—a typical time-wasting ploy that is presented to the scammer as a security measure for the purpose of assuring his identity. Henner made his own handpainted version of the sign, photographed it, and used digital software to place it within the original photograph of the scammer. In creating an exact copy of the original picture, Henner redoubled the scam to include viewers of his artwork, such as ourselves. **JG**

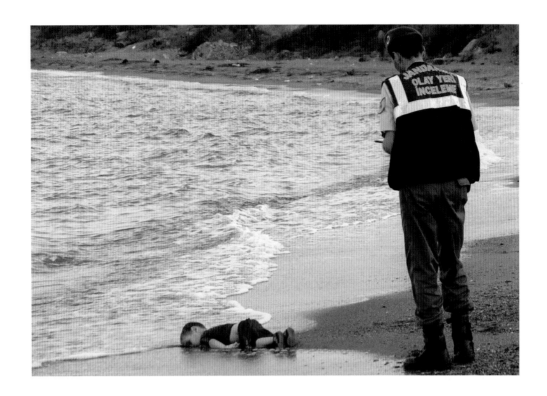

DEATH OF AYLAN KURDI

NILÜFER DEMIR

Date 2015
Location Bodrum, Turkey
Format Unknown

The shock of what photographer Nilüfer Demir (born 1986) saw on the beach in Bodrum was incommensurable with anything that she had seen before. As she was walking along the shoreline of this Turkish resort, she saw something at the edge of the surf and realized it was the lifeless body of a young boy. She reported: "There was nothing to do except take his photograph . . . I thought, 'This is the only way I can express the scream of his silent body.'"

In 2015, little Aylan was one of many Kurds trying to make the dangerous journey across the Aegean Sea from Syria to Greece. When his boat capsized, a dozen people on it were drowned, including other children whom Demir found scattered farther up the beach. One of them was Aylan's brother. None of them wore life jackets.

Demir's image went viral on social media and shifted the world's focus onto the Syrians who were trying to escape the terrible war in their country. Almost overnight this powerful image transformed them from "dangerous migrants" to "helpless refugees" desperately in need of global assistance, and spurred debate about immigration as nation-states were pressured to increase their quotas. SY

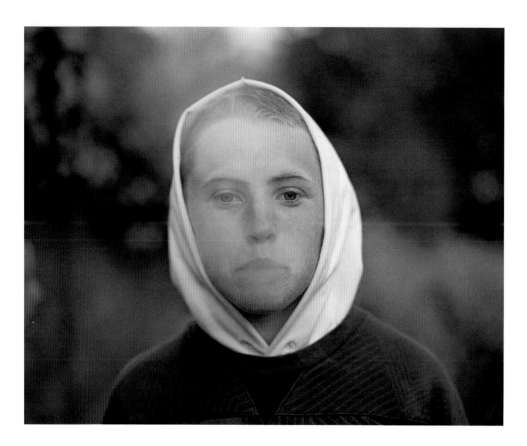

UNTITLED

DOUG DUBOIS

Date 2015
Location Cobh, County Cork, Ireland
Format Large format

In 2009, American Doug DuBois (born 1960) took up the post of artist in residence at the Sirius Arts Centre in Cobh, Ireland. He was taken under the wing of two young residents of the seaport town's Russell Heights council estate, Eirn and Kevin, who introduced him to their close-knit community. DuBois went on to spend five years collaborating with the youths of the estate, documenting the last stretch of their childhood. His photographs, published in his book *My Last Day at Seventeen*

(2015), detail the bravado and fragility of this fleeting time. Kids are typically seen leaping over brick walls, sparring playfully on the edge of a pagoda, and vaulting off a pier into the gray ocean.

This image, of a boy named Lenny, derives from DuBois's first night on "The Steps," a drinking spot used by underage kids from Russell Heights. DuBois explains that "he was a bit drunk and it was noisy and chaotic all around, but somehow I convinced him to hold still and simply stare into the lens." It is both a spontaneous moment and a posed one; through the cigarette smoke, Lenny looks just below the eye of the camera, there is a twinkle in his eye, and it is easy to imagine him making a bright wisecrack the moment he has finished exhaling. RF

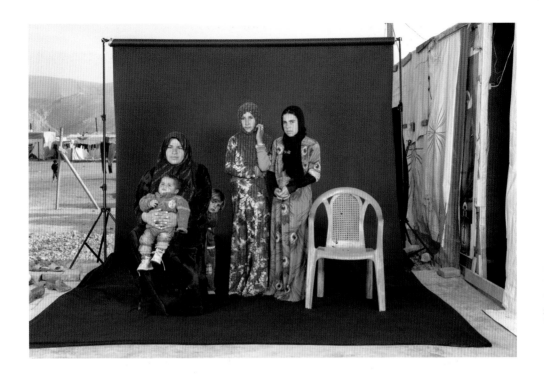

LOST FAMILY PORTRAITS

DARIO MITIDIERI

Date 2016

Location Bekaa Valley, Lebanon

Format 35 mm

In the series *Lost Family Portraits*, Dario Mitidieri (born 1959) uses the power of absence—here, an empty chair signifying a lost family member—to forge a connection between the viewer and Syrian families displaced by the civil war in their home country. Mitidieri photographed ten families in two refugee camps in Lebanon, focusing on those left behind at a time when most images of refugees focus on those seeking asylum in Europe. The numbers are staggering: 1.5 million Syrian refugees in Lebanon comprise one-third of that country's population. Many of them are women and children, with men either engaged in the conflict or seeking further migration for the economic betterment of their families.

Mitidieri uses a traditional studio setup to create a portrait in which its subjects show poise and elegance in a region that is more often seen in turmoil. He pulls back the camera, allowing elements of the camp to frame the subjects. Commissioned by an advertising agency and produced for a humanitarian charity, this work exemplifies the commercial partnerships that are necessary to enable in-depth visual storytelling at a time of decreasing media revenues. MT

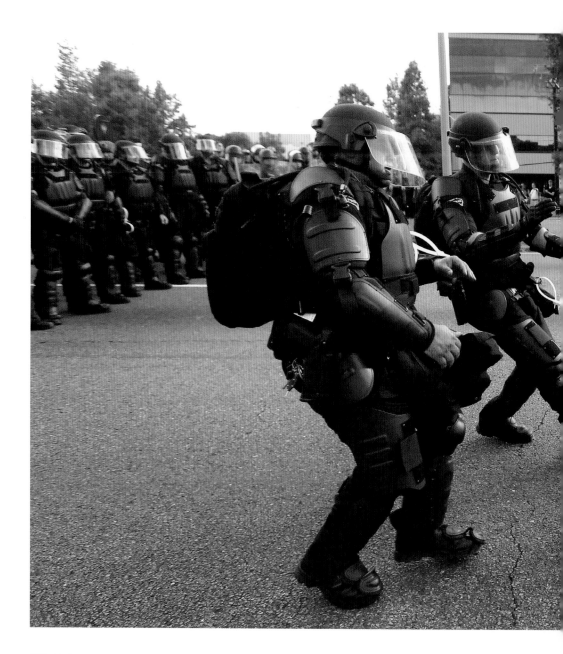

BATON ROUGE, BLACK LIVES MATTER PROTEST

JONATHAN BACHMAN

Date 2016
Location Baton Rouge, Louisiana, USA
Format Unknown

The intense press and social media attention this image received after its publication demonstrates its deep resonance with an American public both traumatized and divided over the killing of unarmed young black men by law enforcement officers. The Black Lives Matter movement became nationally recognized as a street protest movement after the 2014 killings of Michael Brown in Ferguson, Missouri, and Eric Garner in New York City. Since then, regular demonstrations have taken place after the killings of other African Americans by police officers.

Taken by New Orleans-based photographer Jonathan Bachman, this is a classic protest photo, using the vulnerability of the body in the face of armed might to question the notion that such a power functions to protect us all. Its subject, Iesha Evans, appears calm, measured, and in control. The police appear as if pushed back by her presence. She remains silent and does not seem to be afraid. Evans's explanation of her actions shows how silence, traditionally associated with passivity, functioned for her as a key tactic to insist that black people's lives matter—a recognition that should not have to be asked for: "I'm human. I'm a woman. I'm a mom. I'm a nurse. I could be your nurse. I could be taking care of you. Our children could be friends. We all matter. We don't have to beg to matter." She adopts the positon of an everywoman, pointing out the connections (and therefore the vulnerability) we all have to one another. In the picture's depiction of her as both strong and vulnerable, we are called to heed her message, and to care. **MT**

SNOW FALLS OUTSIDE
A SHUTTERED K-MART

MATT BLACK

Date 2016
Location Flint, Michigan, USA
Format Medium format

Photography has extraordinary power to mislead the eye and the brain, presenting ugly aspects of the world in ways that are touching and beautiful. A visually poetic image can belie, for example, the extreme hardship and poverty that is depicted. Viewers find themselves conflicted: their aesthetic sense is gratified, but at the same time their conscience and sense of social justice are piqued.

At a glance, there is something quite magical about this image of snow falling outside a K-Mart store in Flint, Michigan. But a closer look reveals that the subject is an old mattress—the first indication that all is not as charming as it seems. The image is from a powerful body of work by Matt Black (born 1970), centered on the impoverished city of Flint, which was once the thriving home of General Motors. The company opened its doors there in 1908 and in its heyday employed more than 80,000 local people. But in the 1980s it downsized with catastrophic consequences. Flint's population dwindled severely, houses were abandoned and demolished, crime and murder rates soared, and the city became crippled by debt.

As a cost-saving measure, the authorities began to source water from the Flint river, but failed to treat it properly. Many cases of Legionnaires' disease have been reported and there are signs of lead poisoning among the youngest in the community. Despite efforts to provide clean water, the situation remains dire. Committed to telling Flint's story, Black has returned several times, creating a compelling body of work that records the harrowing reality for local people and a legacy of deep betrayal and neglect. **GP**

"Essentially, I report. I go places and take my camera. I talk to people, I look, and I feel stuff. I try to get all that into photographs."

Matt Black

AN ASSASSINATION
IN TURKEY

BURHAN OZBILICI

Date 2016
Location Ankara, Turkey
Format 35 mm

On December 19, 2016, Russian ambassador Andrey Karlov was assassinated by an off-duty police officer while giving a speech to journalists at an art gallery in Ankara, Turkey. The gunman, Mevlüt Mert Altıntaş, shouted "Allahu akbar" (God is great) and "Don't forget Aleppo. Don't forget Syria." The assassin was killed soon afterward in a shootout with the Turkish Special Forces.

Veteran Associated Press photographer Burhan Ozbilici happened to be at the gallery, not in a professional capacity but to socialize with friends, and he was able to capture a series of pictures of the event. In this image, the gunman shouts and points defiantly into the air while still holding his weapon in his right hand; the body of his victim lies on the floor nearby.

Weeks later, Ozbilici's image was awarded first prize in the headlining category of the World Press Photo of the Year competition. Associated Press Executive Editor Sally Buzbee announced: "Burhan's striking image was the result of skill and experience, composure under extreme pressure, and the dedication and sense of mission that mark AP journalists worldwide." Even so, giving the award to Ozbilici caused some controversy. World Press Photo Jury chairman Stuart Franklin said that he did not vote for the image to win. In a *New York Times* interview, he said that he had a "moral concern" about how conferring the award upon such a violent image would be perceived by the public. "I don't think we can forget that this was a premeditated, staged murder at a press conference. It seemed to me to reaffirm the compact between martyrdom and publicity." JG

"I was thinking: 'I'm here.
Even if I get hit and injured,
or killed, I'm a journalist.
I have to do my work.'"

Burhan Ozbilici

WELL HEELED

DOUGIE WALLACE

Date 2016
Location Milan, Italy
Format Unknown

Nicknamed "Glaswegee"—in reference to his Scottish accent and to his use of flash, like the US crime photographer Arthur "Weegee" Fellig—Dougie Wallace is one of the most exciting contemporary street photographers, with his acerbic wit and close-up style making for dramatic yet humorous images full of color and energy.

Wallace works close to his subjects, prowling the streets looking for an unusual face in the crowd, a moment of heightened reality, or, in *Well Heeled*, wealthy people's dogs. He began this series after noticing how pets in Milan were displaying as many designer logos as their owners. As with his surveys of human behavior, he has his study of the animals down to a fine art, saying that "this dog was yawning.... When a dog yawns you get about four sec[ond]s, their mouth opens up like a reptile!" He uses multiple flashguns mounted on his camera to create a hyper-saturated effect. He explains: "I can create an outdoor studio with my own lights. Then I set a trap and lure the dog into it." He claims he gets so close to the animals that "you can make out their wet noses" and jokes that "unlike people they don't chase me down the street asking me to delete the photo." PL

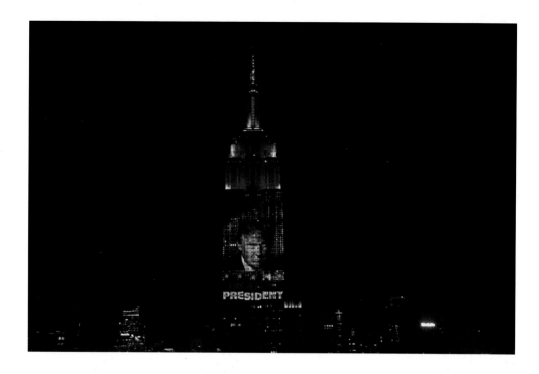

DONALD TRUMP ON THE EMPIRE STATE BUILDING

BRYAN R. SMITH

Date 2016
Location New York, New York, USA
Format 35 mm

The face of Republican candidate Donald J. Trump is projected onto the side of the Empire State Building on the night of November 8, 2016, moments after the property tycoon and star of *The Apprentice* television show had won election as the forty-fifth president of the United States.

The historic landmark building in Manhattan is often adorned with colors marking key moments around the globe and domestically: for example, it displayed the red, white, and blue of the flag of France in solidarity with the French after the November 2015 terror attacks in Paris; every year it displays the colors of the winners of the World Series in baseball.

Bryan R.Smith (born 1972) became the official photographer of the building in 2005. The image reproduced here first appeared in the *New York Daily News*; Smith also works for Associated Press, Agence France-Presse, UPI, the Press Association, *The New York Times*, *The Wall Street Journal*, *Newsday*, and ZUMA Press. Another of his projects, *Love City*, is an ongoing photographic record of moments and ephemeral graffiti, such as chalk drawings on the sidewalk, all over his native New York City. SY

GLOSSARY

35mm format
Introduced originally for cinema film in 1909, 35mm was soon adopted for still cameras and became the most widely used format, producing a negative or transparency measuring 35x24 mm. This format continues in "full frame" in digital cameras.

Albumen print
A process of producing photographic prints by using paper coated in albumen from egg whites.

Calotype
A photographic process patented by William Henry Fox Talbot in England and Wales on February 8, 1841; also known as talbotype. The process used silver iodide combined with gallic acid to enhance its sensitivity. After exposure the paper was developed to produce a negative and then chemically fixed to make it permanent. The calotype was the first negative/positive photographic process, and it provided the basis of modern photography.

Collodion process
A dry—or more commonly—a wet process using collodion as a medium to support a light-sensitive emulsion. Collodion was also used to produce direct positives on glass (ambrotypes) and tin (tintypes).

Combination printing
A technique using two or more photographic negatives or prints to make a single image.

Cropping
Altering the boundaries of a photograph, negative, or digital image to improve the composition, remove unwanted elements, or to fit a method of display.

Documentary photography
A photographic depiction of the real world intended to show the subject in a literal and objective way. A key subgenre is social documentary photography, which records the human condition within a wider context.

Double exposure
The recording of two superimposed images on the same piece of photo-sensitive material. This may be through error or as part of the creative process.

Dye-transfer print
A subtractive process for making color prints from color positives or negatives.

Exposure
The process of allowing light to act on a sensitive material. Within the camera this is controlled by the shutter and aperture.

Field camera
Usually refers to a large-format camera that can be folded to reduce its size, therefore making it easier to transport.

Filter
An optical-colored or neutral glass or plastic usually mounted in front of the camera lens. Most remove or reduce particular parts of the light spectrum; others, such as neutral density or polarizing filters, affect light absorption in other ways.

Fine art photography
Photographs that are made by a photographer as artwork and are usually intended to be offered for sale.

Frame
A term that can refer to a single image within a series on a length of film or a single digital image; a border made from one of a number of materials to enclose and protect a photograph; or the boundaries of a subject seen through a camera viewfinder.

Inkjet print
A print made up from tiny droplets of ink being expelled onto paper using electromagnetic fields to guide charged ink streams.

Kodachrome
A color transparency film introduced by Eastman Kodak in 1935 in 35mm, sheet, and motion picture film formats. For many photographers it was the standard by which all other films were judged.

Large-format camera
A camera that takes a negative larger than 5x4 inches (13x10cm), typically as a single sheet of film or a glass plate negative. These cameras can go up to 20x24 inches (51x61cm) and are often mounted on a tripod. The large size of the negative gives very high resolution prints, and they often have movements via the bellows of the camera that allow for verticals to be corrected.

Mammoth plate
An outsize plate format approximately 18x21 inches (46x53cm), used by some nineteenth-century outdoor photographers.

Medium-format camera
The medium-format camera takes 6cm roll film, creating negatives of either 6x4.5cm, 6x6 square, or 6x7 format.

Overexposure
The exposure of light-sensitive material with too much light. With negative film this has the effect of increasing shadow contrast and the total density range.

Photobook
A book in which the photographs make a significant contribution to the content.

Photogram
An image produced without a camera or lens, by placing an opaque, translucent, or transparent object between—often directly onto—a piece of photographic paper or film and a light source.

Photogravure
A photomechanical, intaglio ink-printing process capable of rapid, high-quality reproduction of photographs that preserve detail and tone on paper.

Photojournalism
Coined in 1924, this term designates a sequence of photographs that emphasizes photographic reportage, requiring the skills of both photographer and journalist. This distinguishes it from press or news photography.

Photomontage

A composite image created by assembling a number of different images, sometimes in other media, by cutting and pasting, projection, or digital techniques.

Pictorialism

A term that was used generally by photographers from the late nineteenth–century to define an artistic approach to photography. In the 1920s pictorialism gave way to realism and objectivity in photography, although interest in it continues today.

Polaroid

The Polaroid Corporation was founded by Edwin Land, in the United States, in 1937, to produce polarizing glasses for three-dimensional applications. In 1948, Land launched the Polaroid Model 95 camera, which offered almost instant photography. In 1963 instant color film was introduced and in 1972 the iconic Polaroid SX70 camera was launched, which introduced true instant photographs that developed without the need for peeling or the subsequent coating of the photograph.

Post-processing

A term that refers to the work done on a negative or print after the normal process has been completed. With the digital era, the term is more usually associated with adjustments made to the RAW image file using software such as Photoshop.

Rangefinder

A camera that is fitted with a rangefinder, whereby the photographer views the scene through a window mounted to the side of the camera rather than through the lens itself.

Retouching

In terms of film and paper this referred to work done with a brush or knife to the emulsion of a negative or print to either remove parts or add to it. The advent of digital working has added these and other tools via software, of which Photoshop is the best known.

Roll film

A length of light-sensitive film rolled on a spool, usually with a backing paper, and able to be loaded into a camera in daylight. Cellulose nitrate roll film was commercially introduced in 1889, daylight-loading film cartridges in 1891, and paper-backed film, which remains in production today, in 1892. A large number of roll film formats and lengths have appeared since 1889 with the most common being 120, 620, and 127 sizes. The safer film base cellulose acetate was increasingly used from 1934; in the late 1940s, cellulose triacetate was introduced, and in the 1980s polyester bases became the norm.

Salted paper print

The earliest form of silver halide printing paper developed by William Henry Fox Talbot around 1834. Talbot used paper soaked in salt; this was dried and then brushed with silver nitrate before being exposed and subsequently fixed with a concentrated salt solution or, later, sodium thiosulphate.

Silver print

Also known as gelatin silver print, this refers to photographs mainly produced since the early 1870s using gelatin as a colloid. More recently the term has been applied in the photographic art market to differentiate images produced using traditional silver-based techniques from digital printing.

Staged photography

A posed scene or performance enacted before the camera similar to tableaux vivants (living pictures). It can include studio portraiture and scenarios involving people that are directed or manipulated by the photographer.

Stereograph

A pair of photographs mounted together that are designed to be viewed with a stereoscope. The term applies to any medium used to create the pair of images, but can be refined to be process specific, for example, stereo-daguerreotype.

Straight photography

Photography that attempts to depict a scene or object as realistically and objectively as possible. The term first emerged in the 1880s as a reaction against manipulated photography. In 1932 Group f/64 defined it as: "possessing no qualities of technique, composition or idea, derivative of any other art form."

Street photography

A style of documentary photography that features subjects in public spaces. It became popular from the 1890s with the introduction of hand cameras. The genre has attracted renewed interest since the early 2000s.

Underexposure

The exposure of light-sensitive materials with too little light or light that is insufficient to produce normal image contrast. In negative film this reduces density with a resultant loss of contrast and detail in the darker subject areas. In transparent film it results in an increase in density.

Vernacular photography

Refers to images usually created by amateur or "unknown" photographers and often depicts family or people in everyday and domestic situations. Their frequent banality, humor, or photographic errors and occasional artistic merit can give them an unintentional artistic quality or charm. They have attracted increasing interest from collectors and galleries. Walker Evans in particular was influenced by vernacular photography.

View camera

Also known as a technical camera. The term refers to a large-format camera, usually with lateral and vertical movements plus swing or tilt adjustment on the camera back and/or front lens standard. Traditionally the image was viewed on a ground-glass screen on the camera back. Increasingly this has been replaced with a digital back with the subject viewed on a monitor.

INDEX BY PHOTOGRAPHER

PICTURE CREDITS

Hermansen **844** © Simon Roberts **845** NASA **846** © Thomas Sauvin **847** © ARS, NY and DACS, London 2017. Courtesy of the artist. **848** Polly Braden and David Company **849** © Anna Fox. Courtesy James Hyman Photography, London **850** Christian Ziegler/Minden Pictures/FLPA **851** © Donovan Wylie/Magnum Photos **852** NASA **853** Nina Berman/NOOR/eyevine **854 L** Yannis Kontos/Polaris **854 R** Oded Balilty/AP/Press Association Images **855 L** Courtesy the artist and Paul Kasmin Gallery **855 R** Courtesy Stephanie Sinclair **856** © William Wegman **857** © Mike Brodie, Courtesy Yossi Milo Gallery, New York **858 L** Ed Kashi / VII / Redux / eyevine **858 R** Brent Stirton/Edit by Getty Images **859 L** © Peter van Agtmael/Magnum Photos **859 R** © Paul Seawright **860** © Sophie Calle / ADAGP, Paris & DACS, London 2017. Courtesy Galerie Perrotin **861** © Olivia Arthur/Magnum Photos **862** © Vanessa Winship / VU **863** Courtesy the artist and Gladstone Gallery, New York and Brussels **864** Courtesy Lumberjack **865** Ghaith Abdul-Ahad/Edit by Getty Images **866** The Press Conference, June 9, 2008 (detail), The Day Nobody Died, 2008, Unique C-type, 762mm x 6000mm. Image courtesy of the artists and Lisson Gallery **868** © Ma Kang **869** Courtesy Sprueth Magers © DACS 2017 **870** © Eugene Richards **871** © Mark Power/Magnum Photos **872** Sports Illustrated/Getty Images **873** Miles Aldridge/Trunk Archive **874** © Tim Hetherington/Magnum Photos **875** RongRong&inri, courtesy of Three Shadows +3 Gallery **876** Simon Norfolk/INSTITUTE **877** © Susan Hiller. All Rights Reserved, DACS 2017 **878** Courtesy Joachim Schmid **879** Courtesy Zeng Han **880** Reuters/Goran Tomasevic **881** Courtesy Tom Broadbent, www.tombroadbent.com **882** © Hiroshi Sugimoto, courtesy Fraenkel Gallery, San Francisco **883** Courtesy Slinkachu **884** NASA **885** Courtesy Janis Krums **886** Martin Roemers/Panos Pictures **887** Courtesy Zhang Xiao **888** © Rob Hornstra / Flatland Gallery, Amsterdam. From: An Atlas of War and Tourism in the Caucasus (Aperture). **889** Courtesy the artist and Red Gate Gallery, Beijing **890** Shaun Botterill/Getty Images **891** Courtesy Poulomi Basu **892** Courtesy Rinko Kawauchi **893** © Chloe Dewe Mathews 2010 **894** Courtesy of Ryan McGinley and Team (Gallery, inc.), New York **895** © Michael Wolf **896** Courtesy of the artist **898** Courtesy Ziyah Gafic **899** Courtesy Laura Pannack **900** Courtesy the artist and Gallery Momo **901** Courtesy Donald Weber **902** Annie Griffiths/National Geographic Creative **903** The White House **904** Courtesy Robin Maddock **905** © Michael Christopher Brown/Magnum Photos **906** David Doubilet/National Geographic Creative **907** Courtesy Jonny Briggs **908** Courtesy of the artist and Metro Pictures, New York **909** © Taryn Simon. Courtesy Gagosian **910** © Fotosports/Photoshot **911** Courtesy Zhang Kechun **912 L** © Zanele Muholi. Courtesy of Stevenson, Cape Town/Johannesburg and Yancey Richardson, New York **912 R** Benjamin Lowy/Getty Images Reportage **913 L** Courtesy the artist and Purdy Hicks Gallery, London **913 R** Armin Smailovic / Focus / eyevine **914** AP Photo/Rodrigo Abd/Press Association **915** © Richard Mosse. Courtesy of the artist and Jack Shainman Gallery, New York **916 L** Copyright Shirin Neshat. Courtesy the artist and Gladstone Gallery, New York and Brussels **916 R** Courtesy Roger Ballen **917 L** Courtesy the artist and rodolphe janssen **917 R** David Guttenfelder/National Geographic Creative **918** John Stanmeyer/National Geographic Creative **919** Courtesy Lakin Ogunbanwo, and the Whatiftheworld Gallery **920** Courtesy Mishka Henner **921** © Matt Black/Magnum Photos **922** Cristina de Middel/INSTITUTE **923** Courtesy Daniel Gordon **924** Courtesy Donald Weber **925** Courtesy Neumeister Bar-Am **926 L** Courtesy Haley Morris-Cafiero **926 R** Ellen DeGeneres/Twitter via Getty Images **927 L** © Kim Kardashian West **927 R** Courtesy #NotABlugSplat **928** © Anja Niemi / The Little Black Gallery **929** REX/Shutterstock **930** © Diana Markosian/Magnum Photos **932** Courtesy of Flowers Gallery, London and New York **933** © Nicholas Nixon, courtesy Fraenkel Gallery, San Francisco **934** Ami Vitale/National Geographic Creative **935** Scott Echols/Wellcome Images **936** Courtesy Mishka Henner **937** Nilufer Demir/AFP/Getty Images **938** Courtesy Doug DuBois **939** Courtesy Dario Mitidieri **940** Reuters/Jonathan Bachman **942** © Matt Black / Magnum Photos. **943** Ozbilici/AP/REX/Shutterstock **944** Dougie Wallace/INSTITUTE **945** Smith/ZUMA Wire/Rex/Shutterstock

CONTRIBUTORS

Eva Clifford (EC) is a writer and photographer based in London. She writes regularly for Feature Shoot.

Andrew Dickson (AD) is an author, journalist, and critic. A former arts editor at the *Guardian*, he writes regularly for the paper. He also reviews photography for *The New Yorker* and the *New Statesman*.

Rosie Findlay (RF) is a lecturer in cultural and historical studies at the London College of Fashion. She is the author of *Personal Style Blogs: Appearances that Fascinate* (2017).

Nick Galvin (NG) is a photographic archivist and researcher. He was an archive manager at Magnum Photos for many years and has been a freelance lecturer on the history of photography and photojournalism.

Ziyah Gafić (ZG) has received multiple grants and awards for his photography work, including World Press Photo, Arles Rencontres de la photographie Grand Prix, and Visa Pour l'Image Young Reporter of the Year.

Jennifer Good (JG) is senior lecturer in the history and theory of photojournalism and documentary photography at London College of Communication. She is a teacher, author, and critic.

Colin Harding (CH) is a doctoral student at the University of Brighton. Prior to that he was curator of photography and photographic technology at the National Media Museum in Bradford, UK.

Lauren Heinz (LH) worked in London for over ten years as an editor, curator, and researcher. She is now based in Los Angeles, where she works for Magnum Photos.

Max Houghton (MH) is senior lecturer at London College of Communication and a regular contributor to the international arts press. She is the coauthor of *Firecrackers: Female Photographers Now* (2017).

Carol King (CK) studied fine art at St. Martin's in London. She has contributed to books, magazines, and newspapers on the arts, travel, and business.

Colin Jacobson (CJ) worked as a picture editor for UK magazines before setting up a Masters course in photojournalism at the University of Westminster, London. He was the founder and editor of *Reportage* magazine.

Dr. Morna Laing (ML) is senior lecturer in cultural studies at Chelsea College of Arts, London. Her research explores the representation of the "woman-child" in British fashion photography from 1990 to 2015.

Dr. Paul Lowe (PL) is an award-winning photographer and is the course leader of the Masters program in photojournalism and documentary photography at London College of Communication.

Gemma Padley (GP) is a writer and editor specializing in photography. She has written for numerous publications and is a contributor to the *British Journal of Photography*.

Dr. Caitlin Patrick (CP) worked on the Photography & International Conflict project from 2008 to 2011. She currently manages the London Interdisciplinary Social Science Doctoral Training Partnership.

Rachel Segal Hamilton (RSH) is a London-based culture journalist. Her writing on photography has been featured in the *British Journal of Photography*, the *Telegraph*, *VICE*, and *Photomonitor*, among others.

Elizabeth Roberts (ER) is editor of *Black+White Photography* magazine.

George Staines (GS) is an actor and musician with experience as a photographer. He still works as an assistant for two well-known theater and ballet photographers.

Joe Staines (JS) is a freelance writer and editor specializing in the arts. He is a regular contributor to *Black+White Photography* magazine.

Michael Thomason (MT) is a photographer and writer. His work addresses the mutual constitution of place and self, and the political significance of that conviviality.

Stephenie Young (SY) is an educator, writer, and researcher. Her work focuses on the relationship between aesthetics and political violence in contemporary visual culture in Latin America and southeastern Europe.

Alice Zoo (AZ) is a writer and photographer based in London.